Georges de La Tour and His World

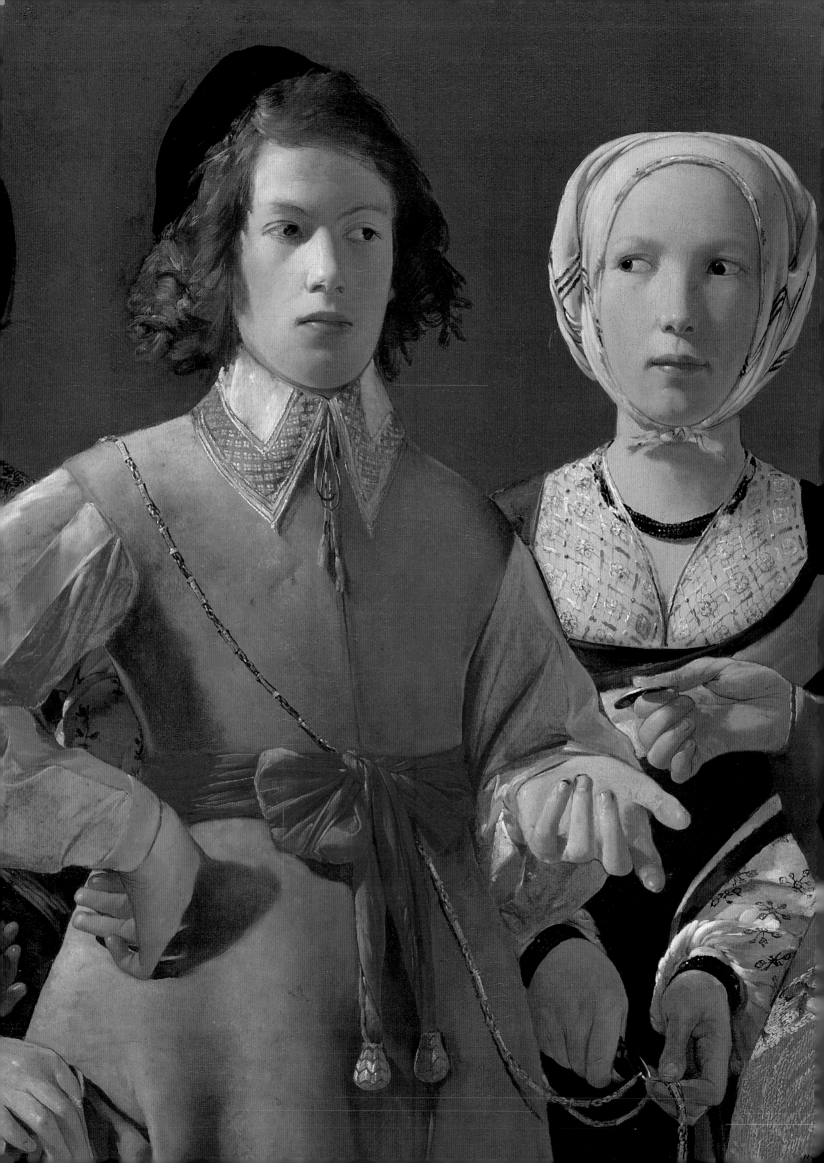

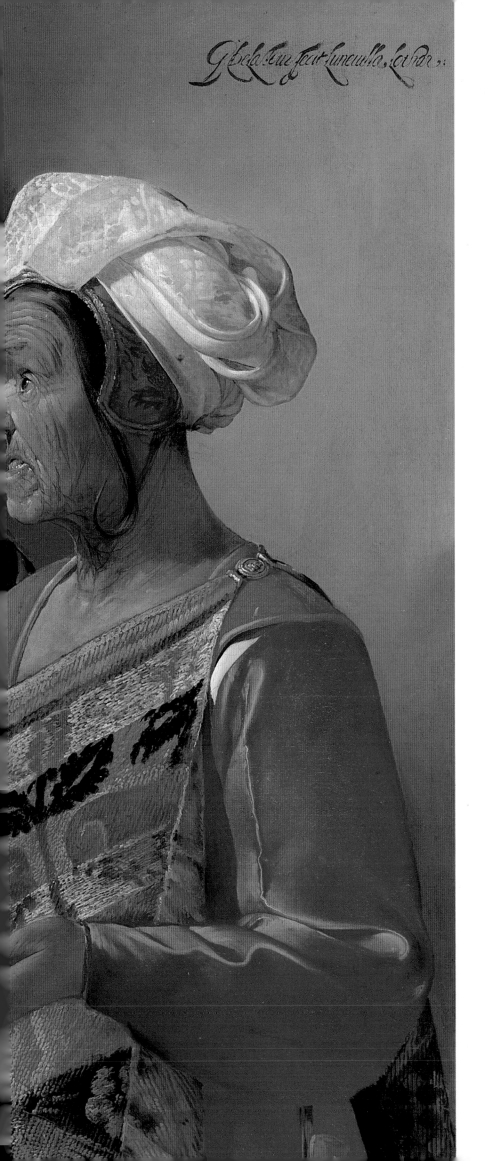

Georges de La Tour

AND HIS WORLD

PHILIP CONISBEE

Essays by

Jean-Pierre Cuzin
Gail Feigenbaum
Patricia Behre Miskimin
Edmund P. Pillsbury
Leonard J. Slatkes

Technical essays by

Claire Barry
Barbara Berrie
Melanie Gifford
Michael Palmer

National Gallery of Art, Washington

The exhibition in Washington is made possible by Republic National Bank of New York, Safra Republic Holdings, S.A., and Banco Safra, S.A. Brazil

It is supported by an indemnity from the Federal Council on the Arts and the Humanities

The exhibition has been coorganized by the National Gallery of Art, Washington, and the Kimbell Art Museum, Fort Worth

Exhibition dates

National Gallery of Art, Washington
6 October 1996–5 January 1997

Kimbell Art Museum, Fort Worth
2 February–11 May 1997

This book was produced by the Editors Office,
National Gallery of Art
Editor-in-chief, Frances P. Smyth
Editor, Tam Curry Bryfogle
Designer and production manager, Chris Vogel

Type is Fournier, set by Duke and Company,
Devon, Pennsylvania
Printed on Gardamatte Brillante by
Mondadori, Verona, Italy
The hardcover edition is distributed by Yale University Press

Front cover: Detail from Georges de La Tour, *The Cheat with the Ace of Clubs*, c. 1630–1634, Kimbell Art Museum, Fort Worth (cat. 18)

Back cover: Detail from Georges de La Tour, *The Magdalene at the Mirror*, c. 1635, National Gallery of Art, Washington, Ailsa Mellon Bruce Fund (cat. 22)

Frontispiece: Detail from Georges da La Tour, *The Fortune-Teller*, c. 1630–1634, The Metropolitan Museum of Art, New York, Rogers Fund, 1960 (cat. 17)

Library of Congress Cataloging-in-Publication Data

Conisbee, Philip
 Georges da La Tour and his world / Philip Conisbee; essays by Jean-Pierre Cuzin…[et al.].
 p. cm.
 Exhibition dates: National Gallery of Art, Washington, 6 October 1996–5 January 1997; Kimbell Art Museum, Fort Worth, 2 February–11 May 1997.
 Includes bibliographical references and index.
 ISBN 0-300-06948-0 (hardcover). –
 ISBN 0-89468-262-8 (softcover)
 1. La Tour, Georges du Mesnil de, 1593–1652 –
Exhibitions. 2. La Tour, Georges du Mesnil, 1593–1652 –
Psychology. I. La Tour, Georges du Mesnil de, 1593–1652.
II. Cuzin, Jean-Pierre. III. National Gallery of Art (U.S.)
IV. Kimbell Art Museum. V. Title.
ND553.L28A4 1996
759.4 – DC20 96–26801
 CIP

Contents

Lenders to the Exhibition

Allen Memorial Art Museum, Oberlin College

Art Gallery of Ontario, Toronto

Bibliothèque Nationale de France, Paris

The Bob Jones University Collection, Greenville

The Chrysler Museum, Norfolk

The Cleveland Museum of Art

Conseil général de la Moselle

The Detroit Institute of Art

The Fine Arts Museums of San Francisco

The Frick Collection, New York

Ishizuka Tokyo Collection

The J. Paul Getty Museum, Los Angeles

Kimbell Art Museum, Fort Worth

Los Angeles County Museum of Art

Lviv Picture Gallery, Ukraine

The Metropolitan Museum of Art, New York

The Minneapolis Institute of Arts

Musée de Bergues

Musée de Grenoble

Musée de Tessé, Le Mans

Musée des Beaux-Arts, Chambéry

Musée des Beaux-Arts, Nantes

Musée des Beaux-Arts, Rennes

Musée du Louvre, Paris

Musée historique lorrain, Nancy

Musée Toulouse-Lautrec, Albi

Museo del Prado, Madrid

National Gallery of Art, Washington

National Gallery of Canada, Ottawa

Nationalmuseum, Stockholm

Alte Pinakothek, Munich

Preston Hall Museum, Stockton-on-Tees

Private Collection

Saul P. Steinberg

Staatliche Kunstsammlungen, Dresden

Staatliche Museen zu Berlin, Gemäldegalerie

The State Hermitage Museum, St. Petersburg

Tokyo Fuji Art Museum

Wadsworth Atheneum, Hartford

Directors' Foreword

This is the first exhibition devoted to the genius of Georges de La Tour to be presented in America, where about a quarter of the artist's surviving *oeuvre* resides. It is also the largest group of works by La Tour to be assembled at one time since the pioneering and memorable retrospective held in Paris a quarter of a century ago.

Building on new scholarship and advances in conservation technology, this exhibition and its accompanying catalogue consider many of La Tour's great masterpieces in terms of style and subject matter as well as in relation to works by forerunners such as Caravaggio and contemporaries such as Jean Le Clerc and Simon Vouet. Although La Tour's reputation was totally eclipsed for some two centuries after his death, he is widely recognized today as one of the most original and important masters of seventeenth-century French painting.

The popularity of La Tour's work has been growing around the world since the 1920s, but understanding of his artistic development remains clouded by uncertainties regarding his training, his travels, and his patronage. There is little agreement about whether the artist ever went to Italy or to the Netherlands from his native Lorraine to experience firsthand the revolutionary work of Caravaggio or interpretations by the most talented of Caravaggio's northern followers such as Hendrick ter Brugghen. There is a similar lack of consensus concerning how – and even whether – La Tour's painting may have evolved from a so-called daylight manner to a tenebrist or nocturnal style, or how his subjects changed from moralizing scenes of secular life – brawling, cheating, and fortune-telling – to highly poetic and deeply spiritual meditations on religious subjects in his images of the newborn Christ, the Virgin as a child, or individual saints such as Peter, Jerome, Sebastian, and the repentant Magdalene.

This exhibition and the underlying scholarship shed fresh light on many of these questions, without proclaiming definitive solutions. Indeed, within the present publication, authors propose different dates and interpretations for particular paintings. La Tour is considered in the context of contemporary historical, religious, and artistic developments, and the iconography of works such as *The Fortune-Teller* from New York, *The Cheat with the Ace of Clubs* from Fort Worth, *The Cheat with the Ace of Diamonds* from Paris, and *The Flea Catcher* from Nancy are studied in detail. Technical essays provide a more intimate look at the materials and stylistic practices of La Tour. We would like to thank all of the contributors to this volume for sharing their insights into La Tour's working methods and intentions and thus establishing a new basis for our appreciation of the artist's supreme achievement.

The exhibition owes its conception to Philip Conisbee, curator of French paintings at the National Gallery of Art, who developed the theme of the show in discussions with the Kimbell Art Museum while he was curator of European paintings and sculpture at the Los Angeles County Museum of Art. We are grateful to the trustees of the Los Angeles County Museum of Art for their cooperation in the development and organization of this exhibition in its early phases.

Georges de La Tour and His World is made possible in Washington by the generous support of Republic National Bank of New York, Safra Republic Holdings, S.A., and Banco Safra, Brazil. This marks Republic National Bank's eighth exhibition sponsorship at the National Gallery, and we owe particular thanks to Walter H. Weiner, chairman and chief executive officer of Republic National Bank of New York, for his commitment to the National Gallery of Art.

A profound debt of gratitude is owed to those lenders in the United States and abroad who agreed to part with their precious objects to ensure the project's successful and full realization.

Earl A. Powell III
Director
National Gallery of Art
Washington

Edmund P. Pillsbury
Director
Kimbell Art Museum
Fort Worth

Preface

The idea for this exhibition began in 1991 during a conversation I had with Earl A. Powell III, then director of the Los Angeles County Museum of Art, and Edmund P. Pillsbury, director of the Kimbell Art Museum. About a quarter of Georges de La Tour's paintings can now be found in public and private collections in North America – a tribute to the taste and energy of these museums in the last half-century – and we realized that such holdings were sufficiently rich to create an exhibition devoted to "Georges de La Tour in America." Among the most beautiful and haunting works in American collections are the National Gallery of Art's *Magdalene at the Mirror*, the Los Angeles County Museum's *Magdalene with the Smoking Flame*, the Kimbell's *Cheat with the Ace of Clubs*, the Cleveland Museum of Art's *Saint Peter Repentant*, the Metropolitan Museum of Art's *Fortune-Teller* and *Magdalene with Two Flames*, the Fine Arts Museums of San Francisco's *Old Man* and *Old Woman*, and the J. Paul Getty Museum's *Musicians' Brawl*.

The last and only major exhibition ever devoted to La Tour was held in Paris in 1972, and no significant gathering of the artist's works has ever been seen in America, except for a small but fine selection brought together in Paris, New York, and Chicago in 1982 as part of a show organized by Pierre Rosenberg on French seventeenth-century paintings in American public collections. We decided to make American holdings the starting point for our exhibition but also to request from abroad the loan of several of La Tour's most famous paintings: *The Hurdy-Gurdy Player* from Nantes, the remarkable *Flea Catcher* from Nancy, *The Newborn Child* from Rennes. Thus the present exhibition, with the generous support of many lenders, expanded considerably beyond our original concept to include more than two dozen paintings by or attributed to La Tour from collections around the world.

We have been able to consider La Tour's art in the light of new scholarship, scientific research, and even recently discovered works by the master. For example, we compare the Chrysler Museum's *Saint Philip*, once in Albi Cathedral, with the compelling *Saint James the Less*, still in Albi, and the *Saint Thomas*

from the same series of Apostles, rediscovered in 1991 and now in a private collection. Similarly the *Old Man* and *Old Woman* from San Francisco, where they have been since 1956, are given a context among La Tour's early, realist, daylight works by being exhibited for the first time with the *Old Peasant Couple Eating* from Berlin, discovered in 1975, and with the Getty Museum's *Musicians' Brawl*, one of Mr. Getty's finest personal old master acquisitions, purchased in 1972. We also thought it would be useful for scholars and moving for all visitors to bring together other works by La Tour that have now emerged from obscurity, such as the previously unexhibited *Magdalene with a Document* from a private collection; the monumental *Saint Thomas*, acquired for the Musée du Louvre by public subscription in 1988; the Museo del Prado's *Hurdy-Gurdy Player*, discovered in 1986; and the *Saint John the Baptist in the Wilderness*, a sensational saleroom discovery in 1993, which has happily found a home in the artist's native region.

La Tour was one of the great religious painters of the seventeenth century, which will be powerfully felt in this exhibition in his several images of saints. Along with three quite different autograph variations on the theme of the repentant Magdalene already mentioned – all in North American collections (the fourth, the Metropolitan's *Magdalene with Two Flames*, cannot be lent under the terms of its gift to the museum) – we are privileged to be able to place side by side for the first time since 1972 La Tour's two full-length depictions of *Saint Jerome*, one from Grenoble and the other from Stockholm.

The Magdalenes and the two versions of *Saint Jerome* are here primarily because they are masterful, representative religious paintings by La Tour. But their presence, along with two comparably close variants on the secular moralizing theme of cardsharps – namely, the Kimbell's *Cheat with the Ace of Clubs* and the Louvre's *Cheat with the Ace of Diamonds* – will enable us to study the issue of autograph replicas and variants, possible "studio" copies and variants, and copies done at several removes from the source. Thus we have included one unquestionable copy of the Getty *Musicians' Brawl* (Musée des

Beaux-Arts, Chambéry) as well as several works whose attribution to La Tour (though not their *invention* by him) has been the source of considerable scholarly discussion: the monumental *Ecstasy of Saint Francis* from Le Mans, for example, and the *Saint Sebastian Tended by Irene* now at the Kimbell. The Frick Collection's *Education of the Virgin*, acquired in 1948 as by Georges de La Tour but speculatively attributed in the museum's catalogue of 1969 to his son Etienne, is exhibited here in public for the first time alongside a significant body of works undisputably by Georges.

Questions of replication, both autograph and otherwise, and the role played in our judgment and connoisseurship by a work's condition have attracted a growing interest among art historians in recent years. Indeed the contemporary replication and dissemination of La Tour's work was an important aspect of his "world," and the vagaries of time and history and the sometimes overzealous attention of restorers have taken a toll on several of La Tour's subtly executed paintings. This exhibition and publication seek to focus scholarly debate on some of these problems.

The happy circumstance that the Kimbell Art Museum is also the owner of Caravaggio's celebrated *Cardsharps*, the source for La Tour's and many other early seventeenth-century painters' images of cheating cardplayers, inspired our further idea of studying La Tour in a larger European context. We have attempted to do this on a scale that does not dilute the essence and impact of La Tour's art in the exhibition, and we hope that our selection of related works by other artists will suggest what some of La Tour's sources might have been, or what parallels might be found in the art of his native Lorraine, or Paris, Rome, and the Netherlands. The debate is ongoing. We are still frustratingly uninformed about the artist's travels, for instance.

Many visitors to the exhibition will not know that La Tour has been "rediscovered" relatively recently. Apart from the most fleeting references, La Tour and his art passed virtually unnoticed in critical and historical literature until the early twentieth century. The handful of works that found their way into French museums in the nineteenth century did so under other artists' names. In 1863 information on La Tour's life gleaned from archives in Lorraine was first published by Alexandre Joly in a local scholarly journal. It was not until 1915 that paintings by La Tour were identified, when Hermann Voss deciphered signatures on *The Denial of Saint Peter* and *Saint Joseph and the Angel* in Nantes, which enabled him to connect these nocturnal scenes with the artist discussed by Joly. On the basis of connoisseurship, Voss also correctly attributed *The Newborn Child*, previously given to artists as diverse as Gottfried Schalken and Le Nain, and recognized that an engraving of another version of *The Newborn Child*, easily associated with Jacques Callot because of a misleading inscription, must in fact be after a lost work by La Tour. A second important article published by Voss in 1931 revealed a new aspect of the artist by attributing several daylight scenes to him, including *The Hurdy-Gurdy Player* in Nantes.

La Tour came to the attention of a larger public in a 1934 exhibition organized in Paris by Paul Jamot and Charles Sterling, who wrote catalogue entries on the twelve works by La Tour exhibited there. Not the least part of La Tour's appeal in the 1930s was the sympathetic insight with which he portrayed the common man and woman. Jamot and Sterling's exhibition prompted further research, by François-Georges Pariset above all, who published many articles on La Tour in the 1930s and 1940s, culminating in his groundbreaking monograph of 1948. This book did much to locate La Tour in the artistic and intellectual world of Lorraine in the early seventeenth century. More than twenty years later, in 1972, came the memorable exhibition mentioned above, with its remarkable catalogue and detailed documentation assembled by Pierre Rosenberg and Jacques Thuillier and an impassioned foreword by Pierre Landry. The exhibition brought together all available works by La Tour, along with many copies and other problematic and questionable works; all the archival references to La Tour known at the time were published in the catalogue. It elicited stimulating reviews, especially from Anthony Blunt, Anna Ottani Cavina, and Pariset. Three important mono-

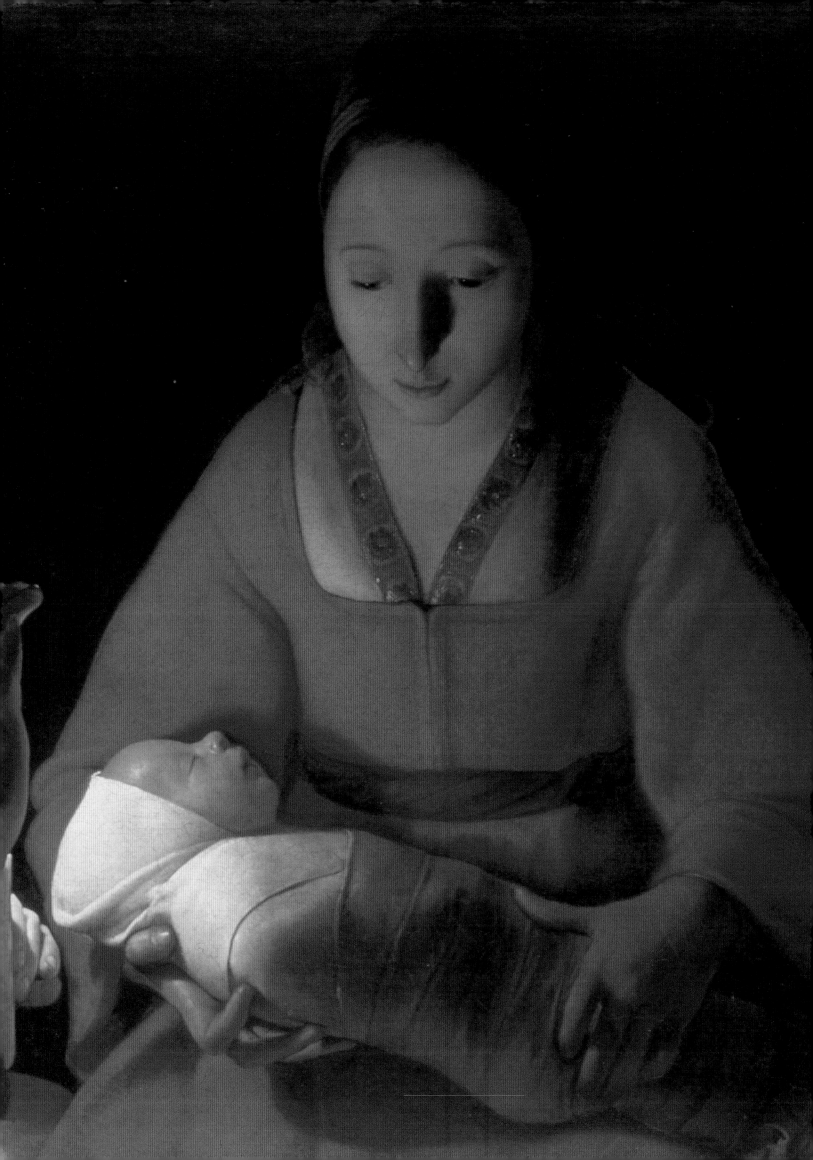

graphs were published more or less as consequences of the 1972 exhibition: a complete catalogue of La Tour's works by Thuillier in 1973; a discursive text with a catalogue by Pierre Rosenberg and François Macé de l'Epinay in 1973; and a comprehensive discussion as well as another catalogue by Benedict Nicolson and Christopher Wright in 1974. A number of works by La Tour, including several in the present exhibition, were exhibited at the Musée des Beaux-Arts in Nancy in 1992, which helped to show La Tour, too often discussed in isolation, in a larger context. All further research on La Tour since 1972 has been assimilated into the magisterial 1992 publication by Thuillier, which includes an up-to-date *catalogue raisonné*.

Here it is my pleasant task to thank those who have made this exhibition and its catalogue possible. Our first debt is to the several generations of scholars, some named above and most acknowledged in the bibliography, who have rediscovered La Tour. Starting with Joly in 1863, diligent researchers in archives have revealed a wealth of information about his life. The French positivist tradition of archival research has been continued in our own time by scholars who have unearthed major documentary references to La Tour, including Michel Antoine, Richard Beresford, Paulette Choné, Hubert Colin, Honor Levi, Claude Mignot, Anne Reinbold, Michel Sylvestre, and Henri de Tribout de Morembert, not to forget the important contributions of Pariset.

A huge debt of gratitude is owed to friends and colleagues whose advice, discussion, and collaboration have been indispensible. I would also like to thank the museum trustees, directors, curators, conservators, registrars, as well as town mayors and private lenders, whose generosity in parting with significant treasures for more than half a year has made the exhibition a reality: lenders are acknowledged in a list preceding the directors' foreword.

I would like to add a personal note of thanks to those who have supplied information or photographs and with whom I have discussed La Tour problems at varying lengths: Jean Aubert, Jack Baer, Colin Bailey, Claire Barry, Hugh Brigstocke, David Bull, Gilles Chomer, Christopher Comer, Jean-Pierre Cuzin, Gail Feigenbaum, Joe Fronek, Melanie Gifford, J. Richard Judson, Steve Kornhauser, Elizabeth Mention, Anna Ottani Cavina, Ted Pillsbury, Joachim Pissarro, Pierre Rosenberg, Erich Schleier, Leonard Slatkes, and Jacques Thuillier. In my department at the National Gallery of Art, assistant curator Kimberly Jones provided an excellent translation of the essay by Jean-Pierre Cuzin, while staff assistant Kate Haw and College Art Association Professional Development Fellow Eik Kahng gave tremendous administrative, editorial, and research assistance; thanks also to interns Gabriele Becchina, Katherine Hamm, and Felicia Rupp. My greatest debt is to my wife, Faya, who has had to live with Georges as long as I have; that my catalogue essay got done, and is (I trust) readable, is due to her support and her sure editorial eye.

Philip Conisbee
Curator of French Paintings
National Gallery of Art
Washington

Detail, cat. 27

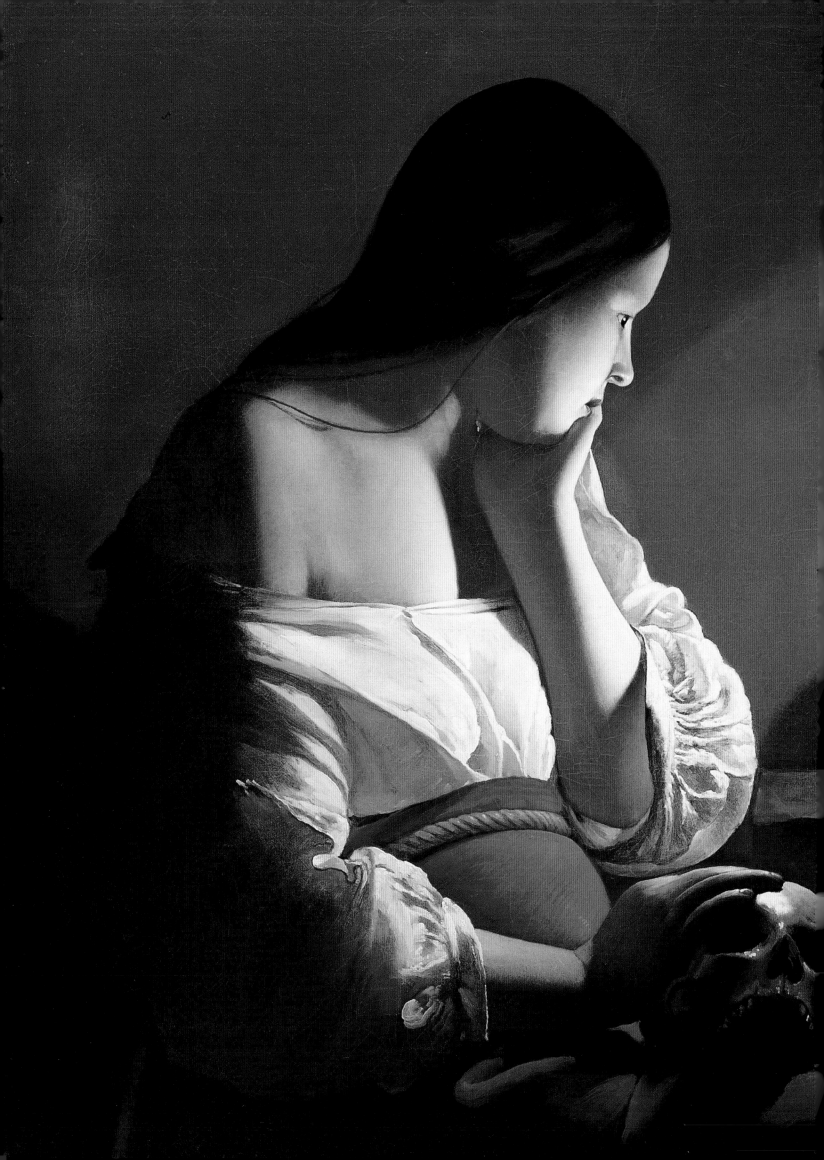

*An Introduction
to the Life
and Art of
Georges de La Tour*

PHILIP CONISBEE

Thanks to the impressive archival research of scholars such as those acknowledged in the introduction to this catalogue and many others, we are quite well informed about the milieu and the circumstances of much of Georges de La Tour's life. Indeed we know more about certain aspects of this artist than about many of his fellow French painters in the seventeenth century – from relatively mundane occurrences, when he witnessed a marriage contract, or signed a legal or financial document, or leased a grain store, or had a dispute with neighbors, to events of importance such as his petition to the duke of Lorraine in 1620 to move to the ducal town of Lunéville where he wished to pursue his career as a painter. Yet we have far too few documents of the last kind to enable us to establish more of the major events of his life as an artist. Too often we are left in the realm of speculation and hypothesis when it comes to matters such as La Tour's training as a painter, his association with other artists, his relationships with patrons, or his travels. These are all issues of vital importance for a more complete understanding of La Tour's life and development as an artist and in order to gain a sense of how he thought about his art. Would that we had a correspondence like that of his exact contemporary Nicolas Poussin; or a "Liber Veritatis" – a careful record of the works he painted – such as the one compiled by Claude Gellée (or Claude Lorrain, as he became more commonly known, because of his origins in the same duchy as La Tour), who was conceivably an acquaintance of La Tour.[1]

Unfortunately we know virtually nothing about La Tour's life, artistic training, or travels between 14 March 1593, when he was baptized at Vic-sur-Seille, and 20 October 1616, when in his twenty-third year he signed a baptismal register as godfather to a child in the same town. A tantalizing mention in a register of the Parisian artists' guild has recently come to light, however, suggesting that La Tour may have been active in the French capital in 1613.[2] Of course, it is quite possible that a researcher will discover further documents even as this catalogue is in the press, for the archives are still being scoured; on the other hand, archives are never complete, especially in the former duchy of Lorraine, which has suffered some of the most destructive vagaries of history from the seventeenth century to our own. Jacques Thuillier's magisterial monograph, published in French (1992) and English (1993) editions, gives a thorough biography of La Tour with all the supporting documents, while Anne Reinbold's painstaking biography of 1991, published only in French, explores very carefully the network of his social connections, in Lorraine especially, that can only be fully understood with a detailed knowledge such as hers of the local archives.[3]

Jean de La Tour, a baker in Vic-sur-Seille, married Sybille de Cropsaux in 1590. The first of their seven children, Jacob, was born in 1592 and the second, Georges, on 14 March 1593. The godparents of Georges were Jean des Boeufs, a haberdasher and alderman of Vic, and Pentecoste Le Meusnier, the wife of an owner and leaser of mills in the town. The La Tours, like Georges' godparents and the other local notables who are usually associated with them in surviving legal documents, were people of some means and position in Vic. We should not imagine Jean de La Tour with flour up to his elbows kneading bread by the light of a hot baker's oven. Rather we should understand him as a figure of some importance in the commercial life of the town, whose contacts ranged from artisans and shopkeepers to the mayor, and who supervised the production of one of the staples of life, traded in grain, and bought and sold a little property, as the records show. More than once the La Tours came into contact with the social elite of the region, as, for example, in 1594 when Jean witnessed a marriage in Vic in the company of Alphonse de Rambervilliers, the bishop of Metz' lieutenant-general in Vic, La Tour's social superior by far and a brilliant and influential figure who might have facilitated the young Georges' artistic development and connections, as we shall see.

Vic was a much more important town in the sixteenth and early seventeenth centuries than it is today. Israël Silvestre's watercolor (fig. 1) shows a prosperous looking, fortified town set in rolling, fertile countryside. The modern viewer is struck by the many towers and spires, indicating the large num-

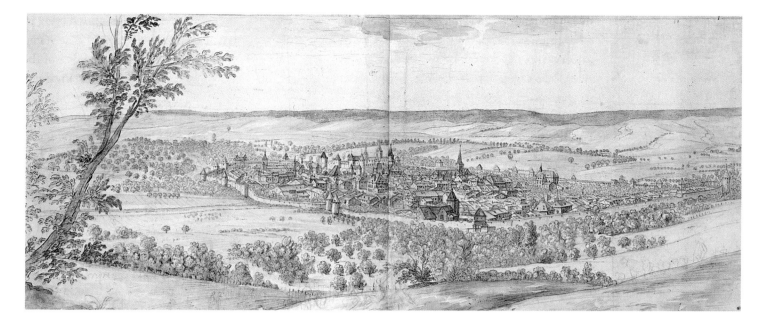

1. Israël Silvestre, *A View of Vic-sur-Seille*, Cabinet des Dessins, Musée du Louvre, Paris

ber of religious establishments in the relatively small town, a reminder of the power of religion in people's lives in La Tour's day. The River Seille was an important tributary of the Moselle, which it joined at the city of Metz about thirty miles away to the north. The waters of the Seille were employed to run the many mills and tanneries in Vic, while nearby salt beds were exploited for that valuable mineral. The town supported goldsmiths and other metal workers, weavers and dyers, barrel makers, carpenters, masons, and so on. Market gardens and the surrounding countryside provided most needs of the table, including local wines from vineyards on the low hills.

In 1552 the French king Henri II had annexed Metz as a French protectorate and established a governor and garrison of troops there. As a consequence the bishops of Metz made Vic the center of their temporal administration and frequently came to reside at the bishop's palace there. They effectively entertained a small court at Vic with a team of administrators and advisors, including a treasurer-general, a procurer-general, and a lieutenant-general, supported by his own counsellors, lawyers, bailiff, clerks and other officers. Thus the bishopric of Metz was a French protectorate, located within the bounds of the huge duchy of Lorraine but ruled independently by its bishops. As Patricia Behre Miskimin points

out in her essay in this catalogue, there was considerable tension inherent in the complex religious and temporal allegiances to the great powers of France and the Holy Roman Empire, which sandwiched the duchy of Lorraine: tensions that effectively brought an end to the duchy in La Tour's lifetime. During La Tour's youth and until 1607, the bishop of Metz was none other than the cardinal of Lorraine, second son of Duke Charles III, who thus established quite a close tie between Vic and the ducal family. Moreover, the ducal capital of Nancy was only about twenty miles away, so although Vic was not a ducal possession, it must in many ways still have felt like part of Lorraine. One can only imagine that there must have been administrative tensions at times within Vic itself – between the mayor and aldermen of the town, and the representatives of the bishop – not to speak of the nearby presence of the great power of France, and the surrounding duchy of Lorraine. But mixed loyalties were a part of life in Lorraine at the time, and the professional life of La Tour would prove to be no exception.

Indeed it all made for a lively and stimulating place, located at a minor European crossroads of sorts, in Lorraine but between France, the German states of the Holy Roman Empire, the Spanish Netherlands, and not far from Protestant German states.[4] The commercial prosperity and administra-

2 and 3. Title page and *The Contemplation of Death* (folios 1 and 83) from *The Pious Learnings of the Christian Poet*, written and illustrated by Alphonse de Rambervilliers, c. 1600, Département des Manuscrits (FR. 25423), Bibliothèque Nationale de France, Paris

tive importance of Vic, along with the fact that like other nearby towns such as Pont-à-Mousson it was a very active center of religious life during this period of the Catholic reform, encouraged the lively cultivation of the visual arts, supporting architects, sculptors, masons, painters, and decorators. But the negative side of the political and geographical position of Lorraine is revealed in the fact that the vicissitudes of its history from the time of Georges de La Tour's manhood onward have left only a few vestiges of what was once a tremendously rich cultural heritage. Nevertheless we can imagine that the cultural environment of Vic in the first decade of the seventeenth century was sufficient to stimulate the interest of an artistically inclined young man from a prosperous family.

It is more than likely that Georges received encouragement from the highly cultivated lieutenant-general Alphonse de Rambervilliers, who had known Jean de La Tour at least since 1594 and who, twenty-three years later in 1617, was a witness on the bride's side at the marriage of Georges and Diane Le Nerf.[5] In addition to his official duties, Rambervilliers was a collector of books, manuscripts, antiquities, curiosities, and paintings; he was a connoisseur, intellectual, correspondent with other learned men, devout poet, and talented amateur artist. Indeed some of the best preserved works of art made in Vic during La Tour's youth are from the hand of Rambervilliers. They are the illuminations that accompany a volume of his own devotional verse, *Les dévots élancemens du poète chréstien* (*The Pious Learnings of the Christian Poet*),[6] which probably survived the ravages of war in Lorraine only because they were sent as a gift to Henri IV, king of France, in celebration of the new year of 1600 (figs. 2 and 3). These carefully wrought little scenes are as accomplished as the work of any professional Lorrainese painter of the day. It was not as an artist but as a cultural luminary of Vic that Rambervilliers was likely of importance to La Tour. His art collection was one of the few in Vic at this period of which a documentary record survives, and according to his will and testament, it included paintings of *The Four Evangelists, Saint Anne, The Magdalene, Saint Jerome,* and "a

large painting of Our Savior represented lying in the darkness, lamented by three angels."[7] The young La Tour might also have learned something of the perfect courtier from Rambervilliers – the loyal servant of three successive bishops of Metz, who not only flattered Henri IV but who also sent editions of his verses to Duke Charles III of Lorraine and to François de Vaudémont, the duke's son and, albeit only for a matter of months during 1624, future Duke François II. These are acts of homage that might seem to us like the hedging of political bets, but they were typical of the time and place.

We know very little about the character of artistic life in Vic during La Tour's day, except for the names of a few painters, of whom Claude Dogoz seems to have been the most important local figure. He is one of many artists documented as active in Lorraine at the turn of the sixteenth and seventeenth centuries, but whose work has completely disappeared.[8] He is recorded as taking apprentices during the first decade of the new century, and although La Tour's name is not among them, it is frequently assumed that Dogoz was his first master. Years later, in 1647, La Tour's son Etienne married Anne-Catherine Friot, a niece of Dogoz, but such a local liaison between the Dogoz, Friot, and La Tour families does not enlighten us about Georges' training. Another possible teacher was Barthelemy Braun, a painter to Duke Charles III who is documented as working in Metz, Vic, and Nancy, but again his work has all disappeared and there is no document to connect him with La Tour. Normally an apprenticeship at the time would have begun at the age of about fourteen – in La Tour's case in about 1607 – and would have lasted some four years.[9]

During La Tour's youth, Nancy, with its powerful ducal court and its many churches and other religious establishments, was an important artistic center enjoying a rich and a brilliant period of creativity in the reign of Duke Charles III (1545–1608). This activity was to continue for the first three decades of the seventeenth century during the reign of Duke Henri II (1608–1624) and for the first few years of the reign of Duke Charles IV (1624–1675). Not only was Nancy the capital of the duchy, but it

was an important international crossroads, strategically located on the political and geographical map of Europe. If La Tour's parents were ambitious for their son's artistic career, they surely would have sent him off to Nancy for his apprenticeship as a painter, possibly after he had learned the rudiments with a local artist in Vic such as Dogoz. If that were the case, Rambervilliers would have been able to provide him with some solid introductions in the capital and even at court. In the frustrating absence of documents, all of the above is pure speculation, yet it has a certain likelihood because Rambervilliers evidently had close connections with the court at Nancy and is recorded on occasion giving advice and assistance in some of its artistic ventures.[10] Two great artists who emerged from Nancy to develop international reputations were exact contemporaries of La Tour: Claude Gellée, who made his name in his adopted home of the more cosmopolitan center of Rome; and Jacques Callot, who was celebrated in Florence and Paris as well as Nancy. Because of the literally international dimensions of their careers, Claude and Callot have always had places in the canon of the great seventeenth-century masters. The fact that La Tour's reputation was above all a local Lorrainese one means that it faded along with the diminishing cultural importance of the duchy of Lorraine in the second half of the seventeenth century. It took a local archivist in the nineteenth century to rescue the name of La Tour from oblivion; and our understanding of his art is taking on a new resonance, now that recent scholarship has emphasized the regional diversity of artistic activity during the seventeenth century in the geographical area we call France.[11]

It is hard to believe that an aspiring young painter like La Tour was not drawn to the cultural capital of Nancy, an easy twenty miles from his small hometown, when he was considering his future career as an artist. In addition to the obscure Braun already mentioned, Duke Charles III honored a number of painters with titles at his court, including Jacques-Charles Bellange (c. 1575–1616), who was the dominant figure in Nancy of the generation before La Tour, and to whom we shall return.[12] Among the

other ducal artists much less familiar to us was Jean de Wayembourg, active in the 1590s and until his death in 1603; and Rémond Constant (c. 1575–1637), painter and valet-de-chambre to Charles, cardinal of Lorraine and bishop of Metz (1567–1607), and in whose household earlier members of the Constant family had served. Bellange and Constant, who were exact contemporaries, are recorded as working together on several court commissions. Thus Constant was well placed, and with his important workshop, was one of the principal painters in Nancy, where several of his altarpieces have survived (figs. 5 and 62). With the exception of a number of altarpieces from churches in Nancy and outlying towns, and a few portraits and other easel paintings, almost nothing has survived of the painted artistic heritage of the Lorraine of La Tour's youth, such as the ceremonial and festive decorations or the extensive palace decorations, which we know now only from documents.[13]

Nevertheless the rare surviving paintings by artists such as Wayembourg, Constant, and Bellange give us an idea of the art with which La Tour could be said to have grown up, and are also indications of the sorts of patronage an artist could expect in Lorraine in the late sixteenth and early seventeenth centuries. Among the important works we can still see is Jean de Wayembourg's *Institution of the Rosary* (fig. 4), which was a commission from Duke Charles III for the high altar of the church of the Minims in Nancy. Painted c. 1597, it is a reminder of the strong devotion to the Virgin in Lorraine. In the heavenly sphere the Virgin and Child, attended by angels and cherubim, are distributing rosaries to Saint Dominic on the left and to Saint Francis of Paul on the right, who was the founder of the Minims, one of the new orders recently established during the Catholic reform. In the earthly sphere kneels the ducal family, men on the left accompanied by Pope Pius V, and women on the right accompanied by Saint Catherine of Siena. Duke Charles III is seen opposite his wife Claude de France (who had died in 1575, however). Of the personages mentioned further in this catalogue, the man in the voluminous cloak behind Pope Pius V is Charles, the second son

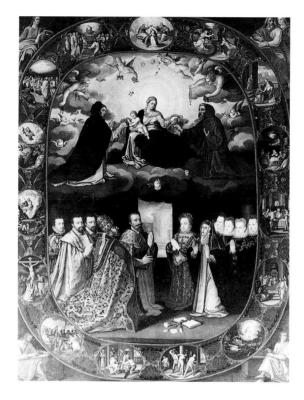

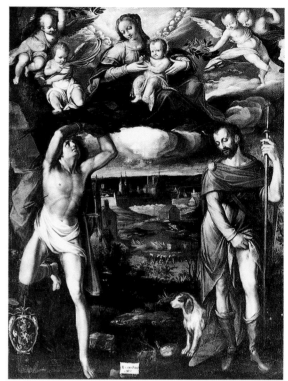

4. Jean de Wayembourg,
*The Institution of the
Rosary*, c. 1597, Musée
historique lorrain, Nancy

5. Rémond Constant, *Saint
Sebastian and Saint Roch,
Patrons of the Ville Neuve
of Nancy*, 1610, Musée
historique lorrain, Nancy

of Duke Charles and cardinal of Lorraine; behind the cardinal is his elder brother Henri II, who was to rule as duke of Lorraine from 1608 to 1624 and who was a patron of La Tour. The bright, clear colors and the careful attention to realistic detail in the sensitively observed portraits of the ducal family betray Wayembourg's Flemish origins. Around the main image are fifteen medallions with scenes from the lives of the Virgin and Christ, with the four Evangelists in the corners. The narrative of this large, ten-foot-high painting has all the clarity of a work inspired by the demands of the reforming Council of Trent: that religious imagery should be legible and understandable to all.

By contrast the two altarpieces by Rémond Constant illustrated here, which are about the same size as *The Institution of the Rosary*, are grand, monumental, and more Italianate in conception, but no less legible and clear in their message. His *Saint Sebastian and Saint Roch, Patrons of the Ville Neuve of Nancy* (fig. 5) was executed in 1610, when it is quite possible the seventeen-year-old La Tour was studying in Nancy. On the left is Saint Sebastian, tied to a tree and shot through with arrows, while on the

right stands Saint Roch, identified by his pilgrim's shell, his staff, his faithful dog, and displaying a plague sore on his leg. Above the saints, hovering protectively over them and a distant view of part of the city of Nancy, are the Virgin and Child accompanied by cherubim. This altarpiece was commissioned in 1610 for the Church of Saint Sebastian in Nancy by the wealthy merchant François Serre, who had recently been ennobled and whose coat of arms is displayed on the tree below the knee of Saint Sebastian. The Ville Neuve or New Town section of Nancy was constructed during the early 1590s, which was also the time of one of the plague epidemics that sporadically ravaged Lorraine. As a consequence, in 1593 the Ville Neuve was put under the protection of Saint Sebastian and Saint Roch, who were traditionally the principal saints invoked against the plague.[14] In Constant's moving painting they are seen to intercede with the Virgin and Child on behalf of the inhabitants of the Ville Neuve.

Wayembourg (who died in 1603 when La Tour was just ten years old) and Constant, among the other now more-or-less forgotten painters, were possible models for the aspiring young painter from Vic-

sur-Seille. Another might have been Georges Lalle-
mant (c. 1575–1630), a native of Nancy who had es-
tablished himself in Paris by 1601 when La Tour was
still a child. Lallemant, whose reputation was quickly
outshone in the 1630s by the rising star of Simon
Vouet, has only been accorded serious study in re-
cent years. We shall mention Lallemant again, but
observe here in passing that La Tour would certainly
have known of him, his paintings (and their inter-
pretation through the engravings of Ludolph Büs-
inck), and his successful Parisian practice during the
first three decades of the century.[15]

Bellange, however, was the preeminent artist in
Nancy during the first two decades of the seven-
teenth century and La Tour's most likely model and
teacher there.[16] Bellange has only very recently be-
gun to regain his reputation as a painter, but, along
with his even more famous compatriot Callot, his
name has survived as one of the greatest printmakers
of the early seventeenth century. The origins of Bel-
lange are nearly as obscure as those of La Tour, un-
til he takes an apprentice in Nancy, recorded in a
document of 1595. He very likely worked in France
in the 1590s, for he was closely associated with the
household of the French Catherine de Bourbon, who
came to Nancy in 1599 as the Protestant fiancée of
the duke of Bar, future Duke Henri II of Lorraine.
Bellange's engagement in 1602 as painter to Charles
III brought him an annual pension until his death in
1616. Among his other recorded apprentices was
Claude Deruet, whose four-year contract was signed
in 1605. Although in modern eyes Deruet is judged
a rather mediocre artist, he went on to a brilliant and
astonishingly lucrative career. After a period in Italy,
he returned to Nancy in 1619, there to succeed Bel-
lange as court painter.[17]

Bellange's official position involved him in artis-
tic enterprises both great and small in and around
the ducal palace in Nancy. His first major work was
the decoration in 1602 of a room for Catherine de
Bourbon with scenes from Roman history; in 1607
he executed scenes of the hunt in the Galerie des
Cerfs; and in 1611 he decorated a new gallery in the
palace with scenes from the *Metamorphoses* of Ovid.
Alas, not a trace of these works has survived; but at

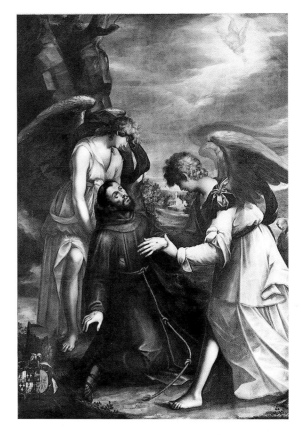

6. Jacques Bellange, *The
Stigmatization of Saint
Francis*, c. 1600–1610,
Musée historique lorrain,
Nancy

the time such commissions would certainly have
given a young artist such as La Tour something to
which he could aspire. Among Bellange's many oc-
cupations at court were minor projects such as
restoration work and painting devices on carriages,
as well as designing substantial but ephemeral dec-
orations such as the triumphal arch for the entry of
Margaret of Gonzaga to Nancy as the second wife
of Henri II in 1606. Bellange seems to have worked
for the church only rarely, a semi-public activity of
the type we have seen undertaken perhaps more read-
ily by Constant. One large altarpiece convincingly
attributed to Bellange is *The Stigmatization of Saint
Francis* (fig. 6), which may originally have been in
the Franciscan Church of the Cordeliers in Nancy.[18]
It is Bellange's prints, however, where his fabulous
sense of decoration and his rich fantasy are often put
at the service of an intense, attenuated religious sen-
sibility, that are his best preserved and therefore best
remembered contributions to the history of art. In
the history of printmaking the power of his inven-
tion and his mastery of the medium of etching rank
him among the greatest mannerist artists in Europe.

The audience for Bellange's prints was evidently a private one, beginning with members of the court and the ducal administration in Nancy. It must have been for this same rather specialized audience that Bellange made the handful of easel paintings that have been attributed to him.

There is no proof that La Tour was a pupil of the great mannerist Bellange, although several scholars have made the persuasive suggestion.[19] If this hypothesis is accepted, the question remains: when did La Tour study with Bellange? Probably not before his fourteenth year in 1607; more likely after a local apprenticeship in Vic, which would mean a move to Nancy around 1611. It is quite possible that La Tour went at about that date to finish off his training, after learning the rudiments of the art in his hometown. A parallel would be the early career of Rembrandt, who, after about four years with the local master Jacob van Swanenburgh in Leiden, went off in 1624 (at the age of eighteen) to work in Amsterdam for six months with Pieter Lastman, who was by far the greater influence on the young man. In the absence of documents, we are left guessing. Did La Tour spend time in Paris around 1613, as suggested above? Could he have continued to work in

the shadow of the master until the latter's death in 1616? Even if La Tour did not work directly with Bellange, the latter's influence on the younger artist was nonetheless profound.

The art of Bellange is represented in the current exhibition by *The Lamentation of Christ* (cat. 37). This work has been attributed to Bellange on the basis of a preparatory drawing in Dijon (fig. 7), which is generally accepted as being by Bellange. Two additional heads appear in the painting, one above the figure of Christ and another at the top left, but the composition of the drawing and the painting are essentially the same. There are awkward passages in the painting, however, especially its cramped space and the strange anatomy of the figures, which have led to the suggestion that it is a copy after a lost original by Bellange.[20] It has to be admitted that it reveals little of the sophisticated elegance we normally associate with Bellange's fluid and courtly style as an etcher. But it shares these gaucheries with other paintings that can be given to Bellange, such as his *Magdalene in Ecstasy*, with her oddly inflated looking face (fig. 8), which is also a night scene illuminated by artificial light.[21] Bellange may not have been a great painter in modern eyes, but he was a strik-

7. Jacques Bellange, *The Lamentation of Christ*, c. 1611–1616, Musée des Beaux-Arts, Dijon

8. Jacques Bellange, *Magdalene in Ecstasy*, c. 1611–1616, Musée historique lorrain, Nancy

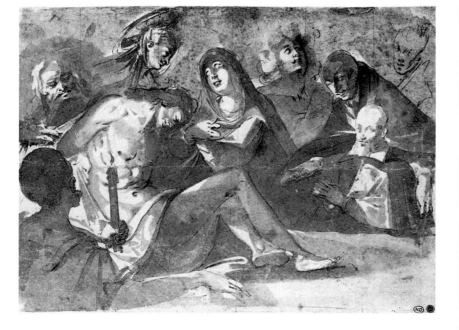

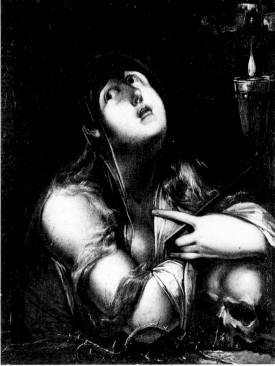

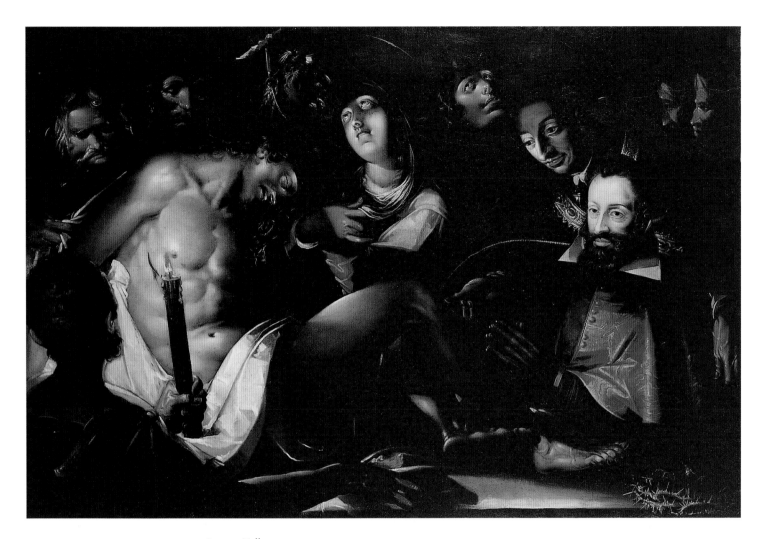

cat. 37. Jacques Bellange,
The Lamentation of Christ,
c. 1616, The State
Hermitage Museum,
St. Petersburg

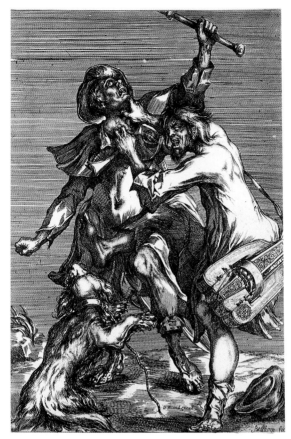

ingly original and inventive one. *The Lamentation
of Christ* is eerily illuminated by the light of a candle
held by the silhouetted figure who is placed low down
in the left corner of the composition. The dead Christ
appears to be set up on the lid of a sarcophagus, but
the figures surging around him do not inhabit a space
that can be logically explained. The pictorial space
is cramped, claustrophobic, and creates a highly
charged mood. The elegantly clad, praying donor
at the right may be the cardinal Charles of Lorraine
(1567–1607), whom we have already encountered:
the second son of Duke Charles III, bishop of Metz
in 1578, cardinal of Lorraine in 1589, who was elected
primate of Nancy in 1602. We can compare his like-
ness with the one in the sympathetically rendered
portrait group of the ducal family in Wayembourg's
Institution of the Rosary (fig. 4). Charles (?) is pre-
sented with a solicitous gesture by a figure who seems
to have the features of his namesake, the Blessed
Carlo Borromeo, the Milanese bishop who was one
of the most influential figures of the Catholic refor-
mation and whose beatification took place in 1601
before his canonization in 1610. If the identification

of the cardinal of Lorraine as the donor is correct,
then the year of his death in 1607 would be a prob-
able *terminus ante quem* for the date of this painting,
although a date of c. 1616, right at the end of Bel-
lange's life, has also been suggested.[22]

This later dating has a certain attraction, because
it suggests that Bellange was aware of the most re-
cent developments of Italian-inspired northern tene-
brist painting, especially among the artists of the
Utrecht school. Hendrik ter Brugghen was the first
of the Utrecht tenebrists to bring the bold contrasts
of Caravaggio's nocturnal effects and *chiaroscuro*
back to the Dutch Catholic city in 1614. Bellange
could certainly have transmitted such artistic ideas
to La Tour. But at the same time there is always an
ornate or exaggerated side to Bellange's work: a self-
consciously cultivated stylishness that makes him a
typical representative of mannerism.[23] In this he was
different from La Tour's other potential models,
artists such as Wayembourg, Constant, and Lalle-
mant, who avoided the emotional extremes and con-
voluted forms of mannerism in favor of balance,
observation, and clear narrative. In Bellange, La

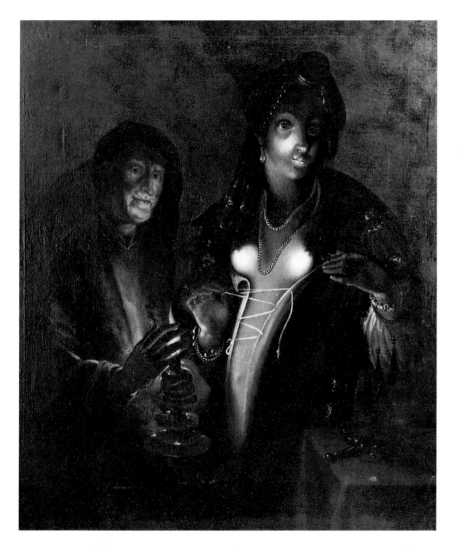

11. Jacques Bellange (?), *Judith and Her Servant*, c. 1616, Musée de Dôle

vant (fig. 11) reveal that Bellange was himself an established painter of nocturnal scenes at the end of his life.[24]

There is a regrettably long hiatus in the story of Georges de La Tour from the time of his baptism in 1593 until 20 October 1616, when he signed a baptismal register as a godfather in Vic. By then he was twenty-three and must have been formed as a painter, although we have no idea what his art or his reputation were like at that time. It has been plausibly suggested that La Tour may have reappeared in Lorraine late in 1616 in the hope of succeeding Bellange as court painter to Duke Henri II. But we do not know if La Tour had actually been absent from Lorraine during this period. Jean-Pierre Cuzin, in his essay in this catalogue, is positive that La Tour was in Paris in 1613; yet it is difficult to say what impact the considerable variety of art he would have seen in the French capital had on the twenty-year-old painter. Nor do we know if La Tour made a trip to Rome during these early years. The issue of a trip to Rome arises because the style and subject matter of La Tour's typical nocturnal scenes are ultimately indebted to the vivid realism and dramatic effects of chiaroscuro in Caravaggio, whose works in Rome exerted an enormous influence throughout Europe in the early seventeenth century. Whether or not La Tour fell under this influence in Rome has exercised scholars ever since Hermann Voss identified the Caravaggesque roots of La Tour's nocturnal works in the very first article about him as a painter. But Voss was characteristically subtle in his reading of La Tour when he described him as an artist "who followed the tradition of chiaroscuro pieces of the Caravaggio circle, especially of Gerard [*sic*] Honthorst and his school, in a somewhat provincial but unique and personal manner."[25]

It was routine practice for ambitious artists from Lorraine to spend some time – months or years – in Rome, the artistic as well as the spiritual center of Catholic Europe. There was a constant come-and-go between Nancy and Rome, where there was a large population of expatriates from Lorraine, especially clerics and artists. Artists went there to study and to seek patronage. With the notable exception

Tour would have found an artist very aware, not only of his own stylishness but of the unique and personal nature of that style. On that model La Tour may well have set out to create his own self-consciously unique style.

The only two subjects Bellange etched from modern life, the *Hurdy-Gurdy Player* and the *Brawl Between a Beggar and a Pilgrim* (figs. 9 and 10), are closely related to the art of La Tour. A group of works offering moralizing commentaries, ostensibly on the costumes and manners of Italy, were engraved by Crispin de Passe after lost designs by Bellange (see fig. 53) and suggest interesting parallels with some of La Tour's later subjects taken from modern life (cats. 17–19). Moreover, the recent discoveries of *The Lamentation of Christ*, the *Magdalene in Ecstasy*, and the attributed *Judith and Her Ser-*

of La Tour, all of the famous painters from Lorraine are documented as residing there, usually for several years, including Claude Deruet, Claude Lorrain, and Jean Le Clerc, to name the most distinguished.[26] The dukes of Lorraine had close ties with Italy, especially with the court of the Medici in Florence, where Callot worked from 1612 to 1620. If La Tour had served an apprenticeship at the normal age, from about 1606 to 1610, and then spent a few years with Bellange, and even in Paris, he might still have made a trip to Rome, even one of several years' duration, before his acknowledged presence in Lorraine in 1616. The years between about 1610 and 1616 are the most likely ones for La Tour to have gone to Rome, as did most artists of his generation – such as Simon Vouet from Paris, or Baburen and ter Brugghen from Utrecht, to name three of the artists represented in this exhibition – after their initial training and before settling into their careers at home. It is the feeling of the present writer, however, that even if La Tour did make a visit to Rome in this period, its influence is not visible in any obvious way. Yet La Tour's paintings have an ambition, even a grandeur of conception, that seems at odds with his provincial roots: he had a sense of what was possible in art that suggests a strong cosmopolitan influence.

The alternative argument, already hinted at by Voss in his allusions to Honthorst and to the provincial nature of La Tour's art, is that La Tour could have absorbed the widely disseminated Caravaggesque style secondhand at home in Lorraine. Indeed, there was little that La Tour could not have assimilated in a lively cultural center such as Nancy, or on visits to Paris, or on trips to the important artistic centers of Utrecht or Antwerp in the neighboring Netherlands. In his essay for this catalogue, Leonard Slatkes is the most recent scholar to make a case for the influence of Utrecht rather than Rome on La Tour. But again there is no conclusive evidence. There is little doubt that La Tour was strongly influenced by the art of Dutch and Flemish artists of the sixteenth and early seventeenth centuries: his art has more visual and thematic affinity with theirs than with any southern, Italianate tradition, an issue discussed by Cuzin in his catalogue essay, which

leans heavily in favor of a wide variety of northern influences. But La Tour did not necessarily need to travel to see their work, which he could have known through prints or experienced in the ducal and other local collections.[27]

We next hear of La Tour on 2 July 1617, when he married Diane Le Nerf and finally entered the history of art by documenting himself as a "paintre" [sic] in their marriage contract.[28] La Tour's witness at this ceremony was the mayor of Vic, Jean Martiny, while the bride's witnesses were lieutenant-general Rambervilliers and Jean du Halt, treasurer-general of the bishopric of Metz. All three witnesses were important and influential local dignitaries. Rambervilliers, whom we have already mentioned, was married to one of Diane's first cousins, so now La Tour became related by marriage to the lieutenant-general. The Le Nerfs were a wealthy family of recent nobility from the ducal town of Lunéville: most importantly, Diane's father Jean Le Nerf was the superintendent of finances for the duke, so that by marriage La Tour entered the circle of the court. Thus Georges enjoyed a degree of social advancement over his parents, an upward mobility that eventually led to the ennoblement of his own son Etienne in 1670.[29]

Georges and his bride followed the usual practice of the time and lived in Vic with his parents for about three years. Both Jean de La Tour and Diane's father, Jean Le Nerf, died during the course of 1618. In August 1619 Georges and Diane had a son, Philippe, who died in infancy. He was the first of ten children, of whom only three were to survive into adulthood. The second was Etienne, who was born in April 1621 and was to follow in his father's footsteps as an artist. Philippe's godparents were Jean Philippe Demion, lord of Gombervaux, and Diane de Beaufort, lady of Saulcerotte, an aunt of Diane and the donor of her bride's dowry in 1617. It will be evident to the reader that La Tour was now quite well connected socially, not only to leading civic figures in Vic but also, through his wife's family, to the minor nobility of Lorraine.

It would not have been unusual for Diane to return home to be near her widowed mother in Luné-

ville, and Georges' artistic ambitions seem to have made such a move all the more practical. Claude Dogoz dominated artistic production in Vic – and this could have been a considerable practice, in view of the importance of the town and its many religious establishments. But it seems that Lunéville was without a painter of note, and La Tour clearly saw an opportunity for advancement there, not least because it was a ducal town. Lunéville was a small fortified town on the river Meurthe, about fifteen miles south of Vic and a couple more southeast of Nancy, and it had a château that was frequently occupied by the dukes of Lorraine and their entourage. But because it was a ducal town of Lorraine, La Tour, as a native of the bishopric of Metz, a French protectorate, needed permission to reside and work there, which did not come automatically with his marriage. Hence La Tour submitted a petition to Duke Henri II: a petition for the significant privileges – such as freedom of movement and exemption from certain taxes – of citizenship in Lunéville and a request, or rather offer, to work there as a painter:

> *To His Highness*
> *In all humility, Georges de La Tour, painter born in Vic, where he now lives, remonstrates that, having married a young woman of noble rank in Lunéville, he wishes to retire thither, to render there most humble service to Your Highness, there being no other person engaged in the art and the profession of the Remonstrant there nor in the vicinity. And though his art be noble in itself, he dares not hope, however, to live under your sovereignty exempt from the customary taxes and other constraints, if he does not receive letters of exemption from Your Highness, whom he very humbly beseeches to be willing to grant him this by special grace, that he may not be subject to worry or annoyance on his head, and that he may enjoy all the franchises afforded to the other freemen under your sovereignty. And he shall beseech Our Lord that Your Highness may know greatness and prosperity.*[30]

La Tour was duly granted all the privileges and freedoms, including freedom from most taxes, of a burgher of Lunéville. Quite likely he had made a gift of a painting to the duke and marshalled all the influential recommendations at his disposal by this time to achieve his privileged position in the ducal town.

The move to Lunéville was a timely one for the La Tours, both professionally and domestically. For Georges, this step was probably significant in the light of the fact that the position of court painter in Nancy had just recently been granted to Claude Deruet. Deruet had made a name for himself in Rome, and on his return to Nancy in the autumn of 1619 he was feted by Henri II, who provided him with a grand house and soon elevated him to the nobility. Deruet may have guarded his privileged provincial artistic empire as jealously as Simon Vouet did his Parisian one in the 1630s and 1640s. Within a couple of years and certainly by 1622, the painter Jean Le Clerc returned to Nancy after spending several years working in Rome and Venice, where he achieved considerable celebrity.[31] He soon established a busy studio in the capital and worked for François of Lorraine, count of Vaudémont, and Duke François II in 1624, for the church, and above all for the Jesuits. He too was early granted noble status for his services to the house of Lorraine. If in 1616 La Tour had entertained the vain hope of succeeding Bellange as court painter in Nancy, he was perhaps being more realistic in settling for the smaller town of Lunéville, where he also had the support of family connections and a late father-in-law who had worked in the service of the duke. It may be significant that in his petition La Tour does not vaunt his prior experience, nor claim the distinction of foreign travel nor recognition abroad: these were important factors contributing to the prestige accorded to both Deruet and Le Clerc, whose prior honors in Rome and Venice respectively were acknowledged by their new patrons in Nancy.[32] That La Tour did not claim the distinction of foreign travel may be evidence that he did not make a trip to Italy.

The Early Work:
Scenes from Everyday Life

As only two paintings by La Tour are dated – the Cleveland *Saint Peter Repentant* in 1645, and the Nantes *Denial of Saint Peter* in 1650 – and in the absence of documentary evidence about most of the others, it is difficult to establish a chronology for La Tour's artistic development before the last decade of his life. Yet when he moved to Lunéville at the age of twenty-seven in 1620, he must have had an established and recognizable style. *The Payment of Taxes* (cat. 1), a night scene illuminated by candlelight, is surely one of his earliest surviving works, probably painted before 1620. It has proved impossible so far to decipher the date on this signed and apparently dated picture, and scholars have disputed whether it is an early or a mature work: most are in

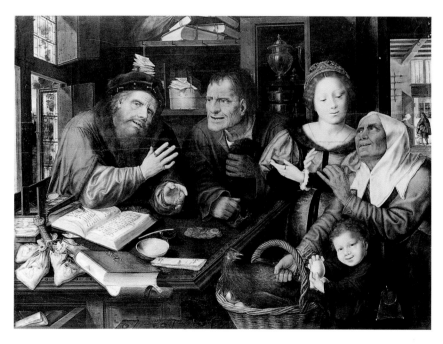

12. Jan Metsys, *The Payment of Taxes*, 1539, Staatliche Kunstsammlungen Dresden, Gemäldegalerie Alte Meister

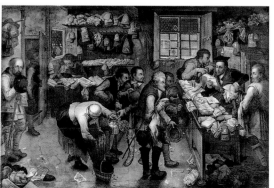

13. Pieter Brueghel the Younger, *The Payment of Tithes*, 1618, Burghley House

agreement that it is the earliest of La Tour's surviving nighttime scenes. While Slatkes in his essay for this catalogue suggests that it is a mature work in an archaizing style – and Cuzin places it after most of the daylit scenes, which will be discussed shortly – to the present writer it seems most likely painted even before the surviving daylight scenes, which are usually agreed to have preceded the full development of La Tour's signature style nocturnes in the 1630s.[33]

The subject of *The Payment of Taxes* has given rise to a good deal of speculation. It is clear that the elderly man is paying a debt or tax to the tough-looking group gathered around him, under somewhat stressful and even threatening circumstances. It has been convincingly suggested that its source lies in the tradition of tax-paying scenes, a well-established theme in Netherlandish art since the sixteenth century. This is exemplified in *The Payment of Taxes* attributed to Jan Metsys (fig. 12),[34] or in the same theme depicted by the Antwerp painter Marinus van Roemersvaele (Cuzin fig. 8), as discussed by Cuzin in his catalogue essay. There is an element of humor in the Metsys, however, and some of his characters verge on the grotesque. The popularity of scenes showing the universally unpleasant business of paying taxes or other dues may have been enhanced by the opportunities it gave artists to show a range of gesture and expression. In the van Roemersvaele the tax collector adopts an unpleasant air of superiority over the payer. This northern tradition of representation continued into La Tour's time in the work of Pieter Brueghel the Younger. Slatkes has pointed out that, according to the standard catalogue, Brueghel and his workshop treated the subject of *The Payment of Tithes* (fig. 13) no less than thirty-seven times, with examples dated between 1615 and 1621.[35] Bruegel's scene is full of anecdote and is a sort of visual inventory of a tithe collector's premises, where the artist has taken pleasure in detailing how the peasants pay in kind rather than coin. By contrast, La Tour's treatment is remarkable for its focused intensity.

In *The Payment of Taxes* La Tour employs a crowded space, somewhat awkward, eccentric poses,

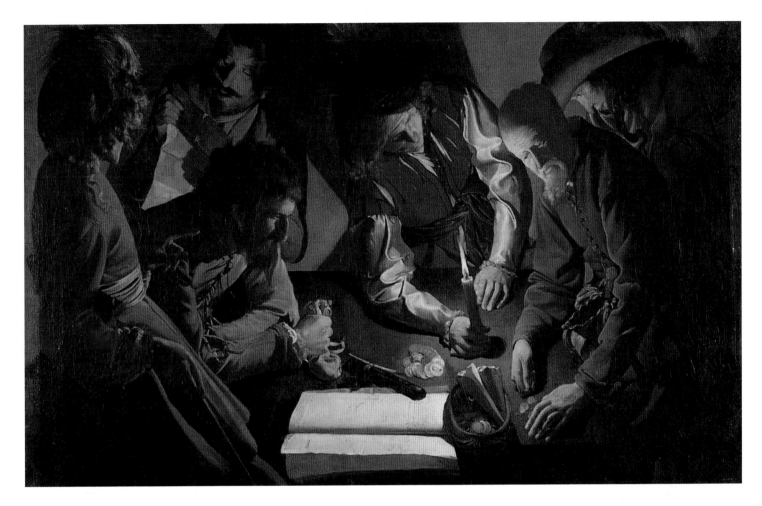

cat. 1. Georges de La Tour,
The Payment of Taxes,
c. 1618–1620, Lviv Picture
Gallery, Ukraine

and a self-conscious use of artificial light to create the atmosphere of a silent and unsettling drama. Every feature of the painting – gestures, expressions, enigmatic poses, the play of light and shade – works to produce a tense, concentrated mood. Even the elevated viewpoint adds to the tension we experience from this encounter. The hypothesis that La Tour studied with or was influenced by Bellange comes to mind when we consider that the mannered folds of drapery, and the unusual sheen cast on the arms of the man holding the candle and on several faces recalls the art of the court painter of Nancy. The young blade with his back to us at the left, with his precious pose, plumed hat, and elaborately tressed hair concealing his face might have wandered in from a print by Bellange. Several of the great mannerist's etchings contain just such figures, who act as *repoussoir* features to frame a scene.[36] The eerie, flickering lighting of *The Payment of Taxes*, the deeply shadowed eyes of the leaning figure clutching a purse, and the crowding of the composition in a space that is not clearly defined echo works by Bellange such as *The Lamentation of Christ* in this exhibition (cat. 37). Nor does this source preclude the influence, suggested by both Cuzin and Slatkes, of an earlier mannerist tradition, such as that represented by Jan Cornelisz Vermeyen's *Marriage at Cana* (Cuzin fig. 9), with its strange viewpoint, perspective, and lighting.

There is a closedness about La Tour's composition and a tightness about the handling of the paint that speak more of the concentration and deliberation of a younger artist feeling his way than of the confidence of a mature master. Yet *The Payment of Taxes* is already characteristic of La Tour's approach to painting: he rarely chooses an innovative subject, but he meditates on it deeply and presents it in a highly focused or concentrated way. There is no visual distraction, no ornament for ornament's sake. Forms are reduced to essentials, as are the gestures and expressions of his actors, establishing in this case a threatening mood.

In *The Payment of Taxes* La Tour applied his paint with deliberation, modeling the solid and resistant forms with light and shade. How beautifully observed is the still life, where the open pages of the ledger absorb the candlelight. We sense a painter exploring the expressive potential of his medium. Here and there are lively calligraphic touches of the brush, describing details such as hair and feathers. Prototypes for these details are found in Bellange's *Lamentation of Christ*: Linnik referred to the "graphisme" of Bellange as a painter in the fine, linear draftsmanship of the hair and beard of Christ and the hair of the donor, comparing them with Bellange's work as an etcher.[37]

La Tour's careful observation and his precise brushing of features such as hands and faces, are found again in the smaller-scaled features of his *Old Man* and *Old Woman* (cats. 2, 3). They also share with *The Payment of Taxes* a relatively high viewpoint, and are likely about the same date, 1618–1620, or a year or two later. These are not nocturnal scenes, and are usually considered to be La Tour's earliest surviving daylight pictures, although Cuzin places them after the other scenes from daily life discussed here. But there is a controlled and almost theatrical element about their illumination that makes them "daylight" only in contrast with the deep shadows and dramatic lighting of the night pieces.

The subject and meaning of these pictures are even more enigmatic to the modern spectator than *The Payment of Taxes*. The protagonists are too well dressed to be peasants, which they have sometimes been called, and are more likely to be townspeople.[38] The woman in particular appears decked out in her finery, displaying her expensive silk apron, which is decorated at the top with a fancy band of embroidery. As proud as she is of her apron, La Tour revels in his ability to depict the creases of the silk satin, its folds and selvedges, and its shimmering highlights. The woman has the aspect of a stern character, with her piercing eyes and thin-lipped expression; to some viewers her husband seems cowed before her. It has been suggested that the couple represent stock characters from the popular farcical theater of the late sixteenth and early seventeenth centuries, the henpecked husband and his nagging wife, who are also found in popular prints of the time.[39] Does the old man really look henpecked? As far as we can tell the two paintings were always conceived

Detail, cat. 3

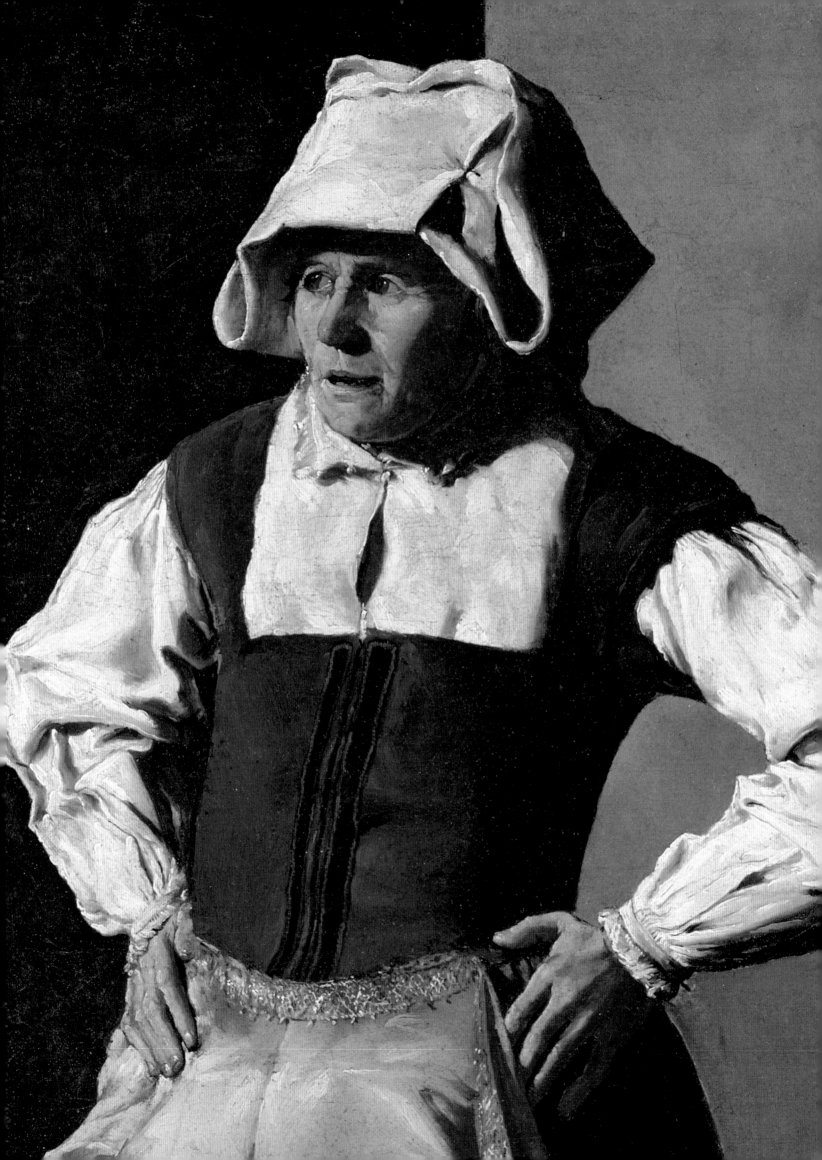

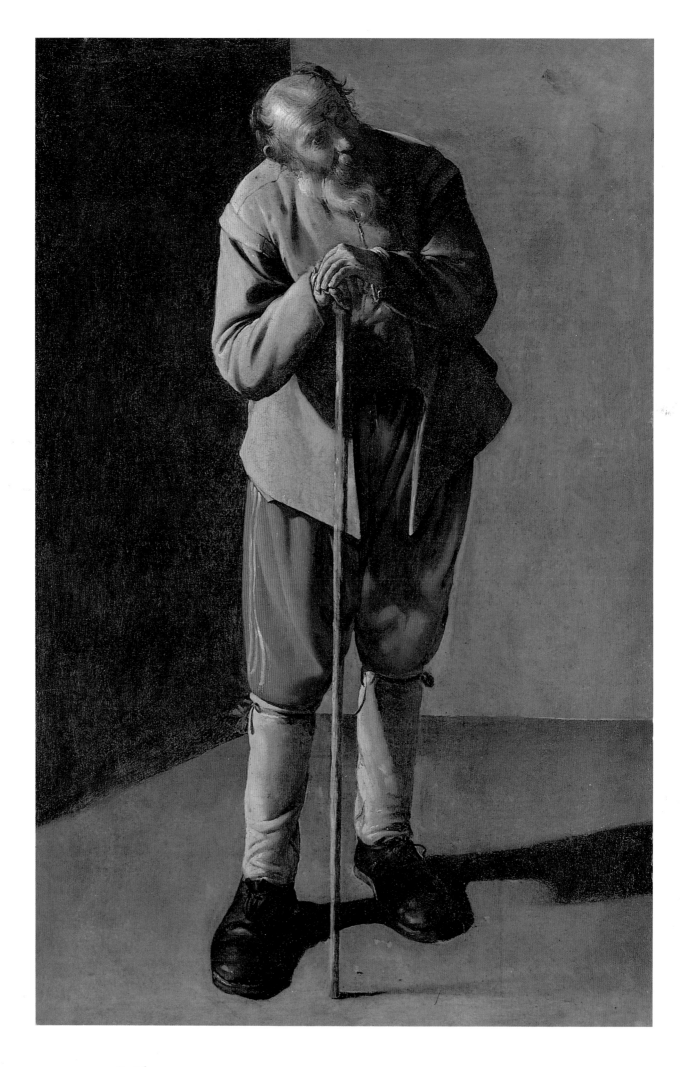

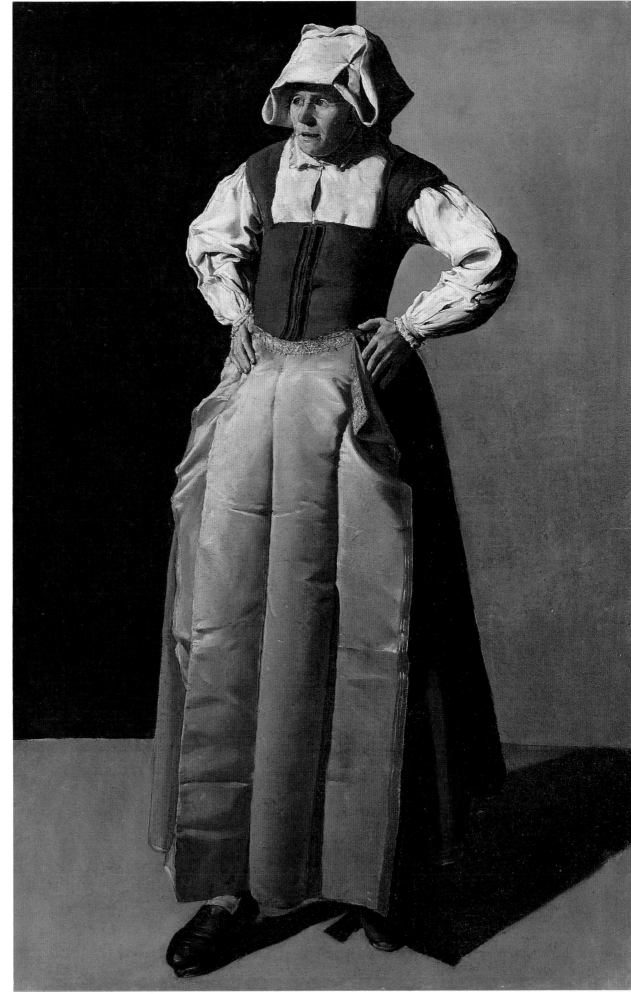

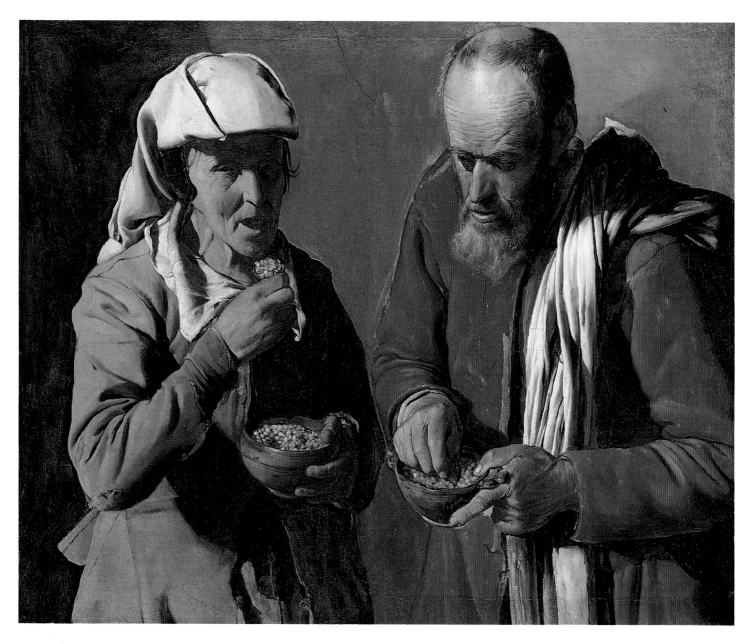

cat. 4. Georges de La Tour,
Old Peasant Couple Eating,
c. 1620–1622, Staatliche
Museen zu Berlin,
Gemäldegalerie

as pendants, with the two figures inhabiting discrete pictorial spaces. There is no indication that the two canvases were once a single one, like the *Old Peasant Couple Eating* discussed below.

Old Man and *Old Woman* are cautiously executed works – in the careful delineation of their hands, for example, which can be compared with the hands depicted in *The Payment of Taxes*. La Tour explores more adventurously the way the substance of paint can stand for what it represents in the *Old Peasant Couple Eating* (cat. 4), about 1620–1622. Here two rather careworn old folks, portrayed by La Tour with insight and sympathy, are eating a thick legume soup from simple earthenware bowls. It is difficult to see if they are using shells as spoons, which has been proposed as a further sign of their poverty, or if they are holding short wooden spoons.[40] La Tour has observed this couple rather seriously: there is none of the humor we find in *The Bean Eater* depicted by Annibale Carracci in Bologna earlier in the 1580s (Colonna collection, Rome), nor of the more theatrical ribaldry of the theme by La Tour's compatriot Georges Lallemant in his *Georges and the Bowl of Soup* (fig. 14).[41]

14. Georges Lallemant(?), *Georges and the Bowl of Soup*, c. 1625, National Museum, Warsaw

La Tour really seems to have mastered the tactile expressiveness of oil paint in the *Old Peasant Couple Eating* – in the light, sketchy, graphic handling of the old man's hair and beard, for example, or in the paint-loaded vertical brush strokes that describe the length of white cloth draped over his shoulder. The woman's worn, putty-colored coat was once quite a finely tailored garment, which has been altered, patched, and repaired: with light touches of the brush, La Tour has carefully accented the pulled stitches. There is a strong pictorial contrast between her coat, where the paint itself seems to be intentionally rubbed thin in places, and that of her companion. It is a daylight, not a nocturnal scene, yet the contrasts of light and dark are exaggerated to model forms forcefully and to give the hard-bitten old couple a greater presence. They powerfully fill their pictorial space, although we should note that the picture has been cut down. There are three known copies of *Old Peasant Couple Eating* (attesting to a healthy market for this kind of subject), and it is to be hoped that Erich Schleier will soon publish in detail his reconstruction, which will show that the painting was originally a few centimeters larger at top and bottom and was considerably more horizontal in format: it must have been wider at the right, so that the old man is not cut off by the edge of the canvas.[42] There are visual analogies between the deep dark folds of the woman's headdress and the craggy features of her face, shadowed by the overhang of her headdress, or between the furrows of her neck and the soft forms of the white collar as it folds over the coat. In their strong features, shadowed eyes, and creased skin, the two old people belong to the same coarse population we see in *The Payment of Taxes*. The wrinkles of both old folks' faces – around the eyes, on the cheeks, across their brows – are drawn with a web of thin brown lines and accented with fine highlights, like a delicate play of hatching on the surface. *Old Peasant Couple Eating* is less labored in handling, however, and shows a greater confidence of touch and broader modeling than both *The Payment of Taxes* and the pendants, *Old Man* and *Old Woman*, which suggest to the present writer that it might be dated a little later.

34 *Conisbee*

15. Paul La Tarte, *Feeding the Cat*, 1628, Private Collection, France

16. Paul La Tarte (?), *The Market Stall*, c. 1625–1630, Musée des Beaux-Arts, Chambéry

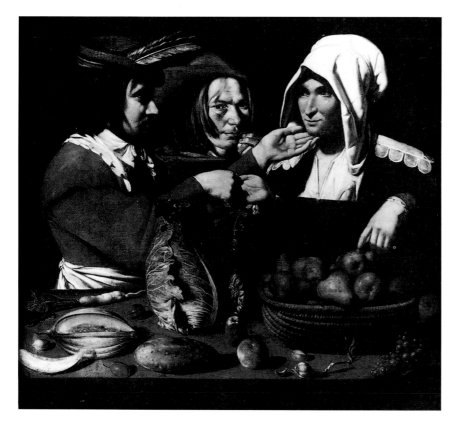

cat. 5. *The Hurdy-Gurdy Player with a Dog*, c. 1620–1622, Musée de Bergues

Old Peasant Couple Eating presents something of a dilemma for the modern viewer, for there are no clues about how the artist and his public understood such a picture: should we pity their plight, look down on them, or just savor their picturesqueness? We have no trouble admiring La Tour's powers of imitation, nor the skill and beauty of the execution. Is that as far as we need to go, or should we pity the old couple in their evident poverty? La Tour invests them with a certain dignity, which perhaps means we should admire them as "the salt of the earth," the humble folk whom Christ said would "inherit the earth" and gain "the kingdom of heaven" (Matthew 5). Ferdinando Bologna, who discovered this painting, saw in the couple a seriousness, "as though they were involved in the rites and ceremonies of prayer."[43] Slatkes describes their eating as "a solemn, even pious moment," comparing them with an earlier print of an old couple saying grace before a meal (Slatkes fig. 4). But La Tour offers no such clues to a religious meaning.

Related to these early daylight pictures is the first of La Tour's great series of images devoted to hurdygurdy players, the monumental *Hurdy-Gurdy Player with a Dog* (cat. 5). In spite of its poor condition today, it is still a work of great visual power. Its scale alone is commanding. We must imagine its surface originally to have been similar to the San Francisco *Old Man* – only on the much larger scale of life. The bold, even hard modeling of forms in light and shade is still impressive, and there are passages of delicate painting in the face, hands, and the appealing little dog. The illumination, the neutral setting, the high viewpoint, even elements of the costume in *Hurdy-Gurdy Player with a Dog* are also reminiscent of the *Old Man*, and a similar date is proposed here, in the late 1610s or more likely the early 1620s.[44]

La Tour's *Old Man* and *Old Woman*, his *Old Peasant Couple Eating*, and the *Hurdy-Gurdy Player with a Dog* are remarkable because of the intense scrutiny the artist has accorded nondescript subjects drawn from everyday life. La Tour's gaze is remorseless, and he has turned his observations into painted form with a hard-edged clarity. Variously bawling, grimfaced, embittered, or resigned, La Tour's population

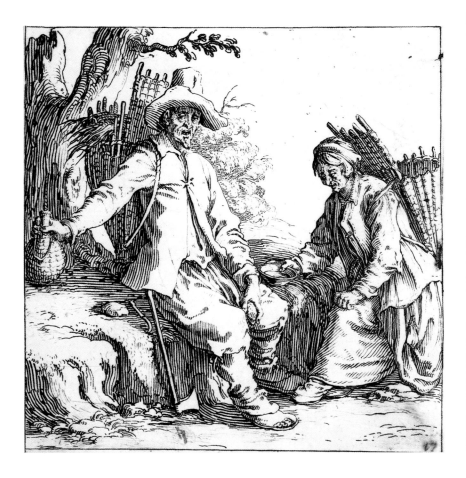

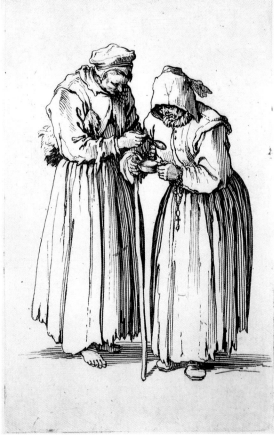

seems to suffer in its existential isolation of poverty.
Paintings of this type derive from a realist tradition
of northern Europe: their characters are drawn out
from the crowded and often cruel worlds of Hierony-
mous Bosch or Pieter Bruegel the Elder and writ
large. Such closely observed scenes from everyday
life, which often take a humorous look at the coarse-
ness, misfortunes, or even the disabilities of com-
mon people, seem to have been popular in early sev-
enteenth-century Lorraine. A rude yet congenial
cast of characters appears in *Feeding the Cat* (fig. 15),
1628, by Paul La Tarte, a little-known contempo-
rary of La Tour, who worked at Pont-à-Mousson.[45]
The exact identification of the subject has yet to be
made, but it appears to be a burlesque on the feed-
ing of the Christ Child and it may be associated with
the feast of Candlemas. The painting has been cut
down, cramping the figures into the top right-hand
corner of the composition. But we cannot fail to be
struck by La Tarte's vivid observation of these char-

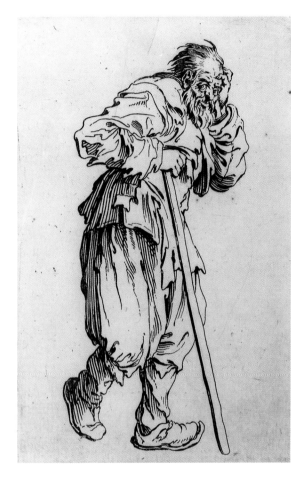
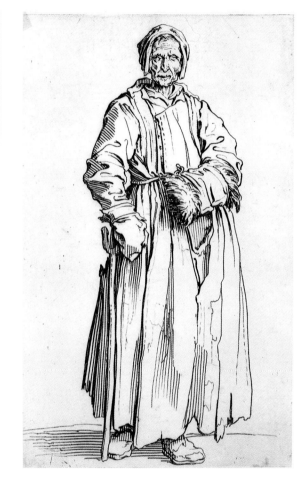

acters, or the still life of the leg of lamb in the foreground that could have inspired Chardin a century later. This and other keenly observed scenes apparently taken from everyday life by artists whose identities are still lost to us, such as *The Market Stall* (fig. 16) at Chambéry, help to provide a larger context for La Tour's realist works, such as those discussed above, or *The Musicians' Brawl* (cat. 9) discussed below, and remind us that he did not work in isolation.[46] Such paintings are in a northern tradition of the observation of everyday life, but if they can all be dated to the 1620s, we can take account of the impact in Lorraine of Callot's return from Italy in the spring or summer of 1621. In his etchings and drawings Callot made unusually penetrating observations of a variety of social types. Immediately upon his return, he explored the theme of the old peasant couple (fig. 17) in one of three prints he added to his Italian series of *Varie Figure* (fig. 18) for their publication in Nancy in 1621 or 1622.[47] Here an old couple of working peasants rest their loads by the side of the road while they share a frugal meal. All the more intense for its tiny scale, Callot's incisive observation of their sour and unpleasant mien and the bold contrasts of light and richly hatched shade with which he has modeled their forms could well have suggested a whole pictorial world to La Tour.

Callot developed his idea of representing common types in his suite of etchings of *The Beggars*, conceived in Italy but published in Nancy in 1622 or 1623: they are discomfortingly realist works by this normally courtly artist. Quite differently from the usual deployment of his rich visual fantasy, Callot in his *Beggars* enters with profound imagination and penetrating insight into the banal yet absorbing preoccupations of his subjects' daily struggle for existence, all the more impressively observed given the tiny scale of the etchings. Erich Schleier has tellingly compared *Two Beggarwomen* (fig. 19) with La Tour's *Old Peasant Couple Eating*.[48] The *Two Beggarwomen*

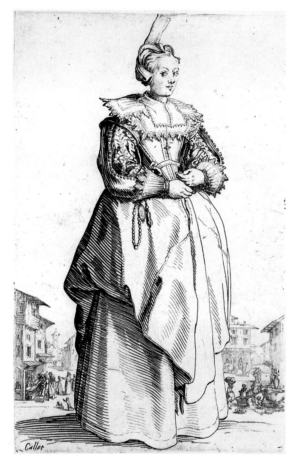

share a meal from a small bowl of food, the one avidly clutching the container with both hands, the other taking a turn with the spoon. In its brilliant economy of means, a few hooked lines for a ragged sleeve or a bitter grimace, a simple contrast of black and white, Callot encapsulates a world of misery as the two old women, disfigured by poverty and disease, grasp with hungry obsession at a scrap of food. Callot's print, however, should give us pause to ask if the old couple represented in La Tour's *Old Peasant Couple Eating* are in fact beggars rather than peasants, for there is no indication that they work. Different in scale and medium as the works of La Tour and Callot are, we should not underestimate the degree to which an artist with La Tour's imaginative powers might derive inspiration from the insights of a Callot, where diminutive scale is more than compensated for by intensity of vision.

Two prints in Callot's *Beggars* suite, an old man leaning on a stick and a one-eyed old woman (figs.

20 and 21),[49] could have suggested to La Tour the idea of his *Old Man* and *Old Woman*, except of course that the paintings do not seem to represent indigents. Socially, they are a step or two nearer the people depicted in Callot's companion suite of prints representing *bourgeois nobles*, such as the reputed portrait of the artist's wife, *Lady with a Small Headdress* (fig. 22).[50] But if we acknowledge the influence of Callot, we have to move the *Old Man* and *Old Woman* forward in date by a few years, into the early 1620s. We are on more solid ground with Callot's etching of *The Hurdy-Gurdy Player* (fig. 23), which belongs to his series of *Beggars* and has a strong affinity with the art of La Tour. Along with the haunting image of *The Hurdy-Gurdy Player* by Bellange (fig. 9), it was surely the inspiration for La Tour's monumental *Hurdy-Gurdy Player with a Dog* and its successors, to which we shall return below.

In this same decade of the 1620s the engraver Ludolph Büsinck made a suite of bold woodcuts rep-

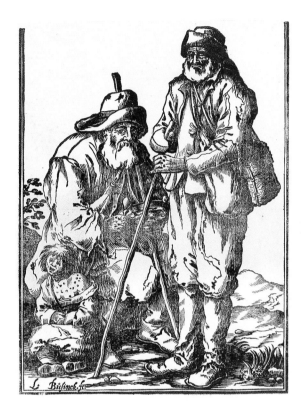

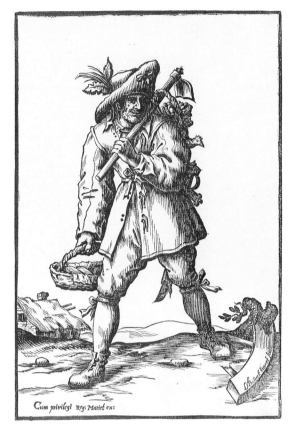

resenting beggars, which were probably inspired by Callot. One of them shows a forlorn, disease-ridden group, including a man eating from a bowl with a short spoon (fig. 24). Büsinck was also connected with the Lorraine school through the interpretative chiaroscuro woodcuts he made after paintings and drawings by Lallemant.[51] His *Peasant with a Hoe, Basket, and Hen* (fig. 25) shows a positive image of a peasant on the way to or from market. Along with Büsinck's suite of *Beggars*, this print, published by Mariette in Paris, is confirmation that there was in the French capital as well as elsewhere a taste for such images of ordinary life.

The Early Work: Religious Themes

On 12 July 1623 La Tour was paid 123 francs from the ducal accounts for a painting of an unspecified subject, and a year later just before the death of Henri II he was paid a further 150 francs for an "im-

age of Saint Peter": the earliest reference to a painting by La Tour.[52] This work was likely – but not necessarily – the same painting that, according to another archival document (cited in 1875, but subsequently destroyed), was presented by the duke to the Church of the Minims in Lunéville.[53] It could also have been the same, or yet another *Repentant Saint Peter*, that found its way to the collection of the Archduke Leopold Wilhelm in Brussels by the middle of the seventeenth century, which is now known only through a mezzotint engraving (fig. 26) and a miniature copy.[54] These three documented images of Saint Peter could all be one and the same painting, passing first from Henri II to the convent; if the picture was not destroyed in the sacking and burning of Lunéville in 1638 – and indeed we know for certain that at least one painting of a *Magdalene* by La Tour survived this tragic period in Lunéville[55] – it may subsequently have found its way to the archduke's collection. Alternatively Leopold Wilhelm's picture

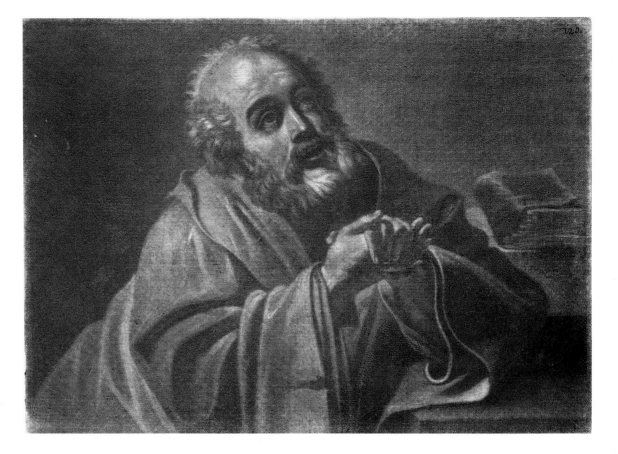

26. Anton Joseph Prenner, after Georges de La Tour, *Repentant Saint Peter*, 1731, in *Theatrum Artis Pictoriae*, vol. 3, National Gallery of Art, Washington

27. Hendrik Goltzius, *Repentant Saint Peter*, 1589, National Gallery of Art, Washington, Rosenwald Collection

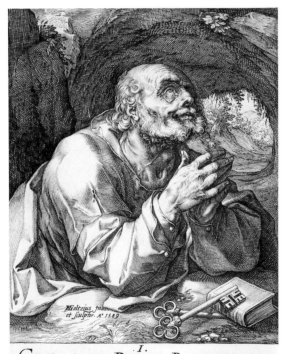

CREDO IN DEVM PATREM OM-
NIPOTENTEM, CREATOREM
CŒLI & TERRÆ.

could have been received as a diplomatic gift from the dukes of Lorraine, for example. Or perhaps the Brussels version was acquired directly from the artist: quite possibly there were two or even three separate paintings of Saint Peter. From what we know of La Tour's later practice, it would not be surprising if he were already producing several versions of the same subject. Later in his career La Tour seems to have repeated successful and popular designs, with and without variations, and there was a ready market for copies by other hands.

The lost *Repentant Saint Peter* offers a clue, tenuous it must be admitted, to La Tour's style between the early and mid-1620s. The engraving (fig. 26) and the miniature show us that the anguished saint was a half-length figure represented in a confined pictorial space. When it was engraved in the eighteenth century, La Tour's name was long forgotten and it was given an attribution to Guido Reni: not so surprising when we remember that Reni was still famous for his half-length figures of saints, and the collection of Leopold Wilhelm even included a half-

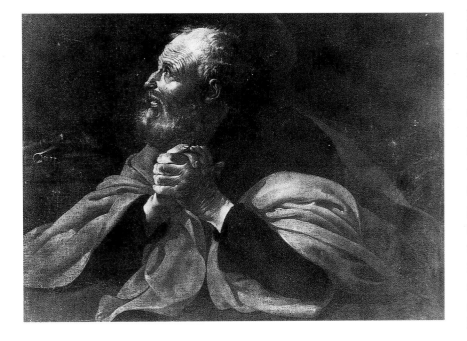

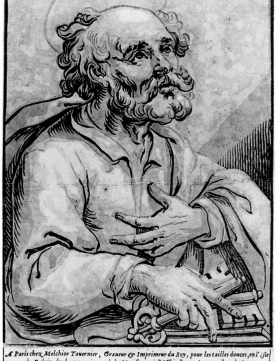

28. After Hendrick ter Brugghen, *Repentant Saint Peter* (original c. 1621), location unknown

29. Ludolf Büsinck, after Georges Lallement, *Saint Peter*, c. 1625-1630, The Metropolitan Museum of Art, New York, Harris Brisbane Dick Fund, 1944

length *Repentant Saint Peter* by Reni (now Kunsthistorisches Museum, Vienna), which could easily if superficially be confused with the similar image by La Tour. But we can imagine that La Tour's Saint Peter must have been a more down-to-earth-looking character than Reni's idealized type.[56] In any case La Tour's prototypes seem rather to be found in the art of northern artists such as Hendrick Goltzius, whose 1589 engraving of *Repentant Saint Peter* (fig. 27) could have provided a model for the design.[57] A painting by ter Brugghen on the same theme (see fig. 28)[58] is datable to about 1621 by comparison with the same artist's series of Apostles in Deventer (see Slatkes figs. 5 and 6), and seems to be quite a close source both for the design and for La Tour's style around this time. Closer to home, La Tour must have been aware of the *Saint Peter* (fig. 29) in Büsinck's suite of chiaroscuro woodcuts after Lallement's designs of Christ and the Apostles, dating from the 1620s. It will be evident from the several examples cited above that images of the repentant Saint Peter were hardly uncommon in the late sixteenth and early seventeenth centuries. Nevertheless, it is noteworthy that one of a suite of mystical devotional poems, dedicated to Marguerite of Gonzaga in 1624 by Henry Humbert, concerned "the unhappy night of Saint Peter," a reminder that La Tour's art was inextricably of his time and place, connected to the court and the Church, and profoundly involved with the ideology of the Catholic reform movement.[59] It is quite likely that already La Tour was contending with the spiritual aspects of nocturnal imagery in his early *Repentant Saint Peter,* which was probably a nocturnal scene. In any case, it is significant that Humbert's poetical reflections dwell on night imagery surrounding the Passion of Christ, as Paulette Choné has pointed out.[60] Humbert refers to the "dolorous night" of the Virgin, and the "night" of Longinus' suffering. Peter's lament is framed with the imagery of darkness: "Darkest night of nights, / Never will the luminous lamp / overcome you with its brightness."[61] There is no reason why La Tour should not have painted nocturnes throughout his career – from the late works of Bellange, through the latest Caravaggesque importation of Le Clerc

and the literary imagery of Humbert in the 1620s, it is evident that nocturnal themes were well received in court circles in Lorraine.

A drawing that almost certainly represents a *Repentant Saint Peter* (fig. 30) has recently been attributed to La Tour by Christopher Comer, with the suggestion that it is a preparatory study for the painting engraved by Prenner.[62] Comer's suggestion deserves serious consideration, when he compares the style of drawing of the hair and eyes, for example, with similar passages in La Tour's paintings, such as the *Old Peasant Couple Eating* (cat. 4) or *Saint Jude Thaddeus* (fig. 32), one of the so-called Albi Apostles discussed further below. For all the reservations we

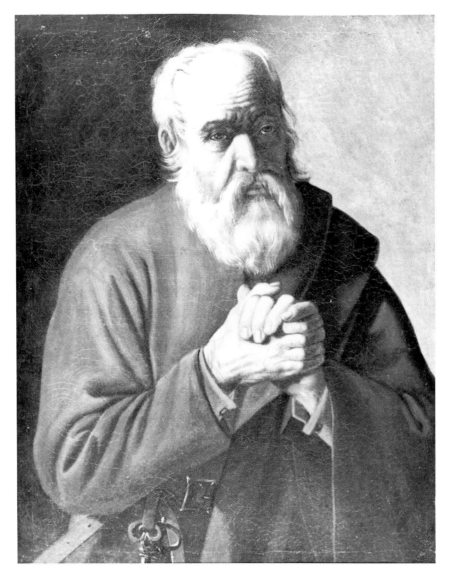

must have about comparing drawings and paintings in this way – especially when not a single certain drawing by La Tour is known to us – the attribution of this one, formerly given to La Tour's compatriot Lallemant, has plausibility.

A hint of documentary evidence that La Tour made drawings is found in a contract he signed in 1648 with an apprentice, Jean Nicolas Didelot, which states that Didelot was expected to serve as a model for drawing, among other duties.[63] While the intensely graphic nature of La Tour's touch has already been noted, the figures in the early paintings we have seen often have sections of their contours outlined on the surface in brown paint. Moreover the scientific researches of Claire Barry, published in an appendix to this catalogue, have located traces of underdrawing in some paintings, although such sketchily painted lines are tenuous evidence for a drawing style. Nevertheless, it seems more likely than not that La Tour did make drawings; but there is as yet no conclusive evidence that the *Repentant Saint Peter*, nor any of the other candidates that have been put forward, are from La Tour's hand. Only a relatively small number of La Tour's paintings have survived the vicissitudes of time, so it is

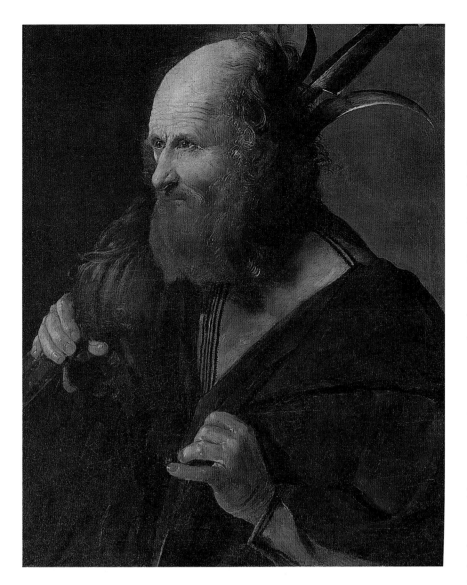

32. Georges de La Tour,
Saint Jude Thaddeus,
c. 1624, Musée Toulouse-
Lautrec, Albi

likely that his much more fragile drawings have fared
even worse.

The subject and format of La Tour's lost paint-
ing of the *Repentant Saint Peter* has been compared
by several scholars with the half-length figure of
Saint Peter (fig. 31) from the suite of paintings rep-
resenting Christ and the twelve Apostles that were
donated to Albi Cathedral in 1694, three of which
are included in this exhibition (cats. 6, 7, and 8). The
Saint Jude Thaddeus (fig. 32) is too fragile to travel
for exhibition; the original *Saint Andrew* (fig. 33) has
also recently been rediscovered.[64] The Albi Apos-
tles are more softly modeled and their facture is more
painterly and modulated than any of La Tour's other
early works. The *Saint Philip* (cat. 7) has suffered
from old abrasions and restorations, including a harsh
relining; but there are striking passages where La
Tour's keen eye is present, such as the crystal but-
tons refracting drops of light onto the old man's
jacket, or his gnarled, arthritic hands.[65] In both *Saint
James the Less* and *Saint Thomas* (cats. 6 and 8) there
is a richer play of half-lights between the extremes

of highlights and shadows. The handling is often
loose and brushy – in the brown cloak draped around
Saint Thomas and the impasted surface of the gar-
ments of Saint James, for example. There is a con-
sensus that these works are relatively early in date,
no later than the mid-1620s. They were most likely
commissioned for a church or monastery in or around
Lunéville or Vic, and found their way to Paris at an
unknown date before being sent to Albi in the 1690s.
All but two of them were removed from the cathe-
dral in the 1890s to be replaced by copies, but three
of the eleven dispersed pictures have reappeared in
recent years, making a total of five surviving origi-
nals. It has recently been shown that the thirteen
original paintings were placed in the funerary chapel
of Canon Jean-Baptiste Nualard in Albi Cathedral,
in accordance with his will, having been sent for the
purpose from Paris in 1694 and 1695 by Abbé
François de Camps (1643–1723).[66] De Camps was
a major collector in Paris, whose antiquarian interests
were reflected in his cabinet of coins and medals,
which was famous in the seventeenth century. But
he was also an important collector of paintings, with
a special interest in Raphael and his school and the
Bolognese artists of the early seventeenth century
such as Guido Reni, Francesco Albani, and Francesco
Barbieri, called Guercino. His collection was later
absorbed into that of the dukes of Orléans. We do
not know if the thirteen paintings by La Tour formed
part of de Camps' own collection, or whether he
acted simply as an intermediary or dealer for his
friend Nualard in Albi. But it is important to remark
that, along with other works by La Tour as we shall
see, these paintings were at least for a time in the
hands of a discriminating Parisian collector.[67]

The early history of the Albi Apostles is un-
known. It is possible they were painted for a church
or monastery, but comparable sets of images of Christ
and the Apostles, such as those by Rubens and Van
Dyck, were also done for private patrons as moral
exemplars.[68] The figure of *Saint James the Less* (cat.
6) is one of the most remarkable of the Albi series.
La Tour has taken as his model an ordinary man,
with the tanned, leathery skin that comes from work-
ing outdoors, wearing a battered and scuffed leather

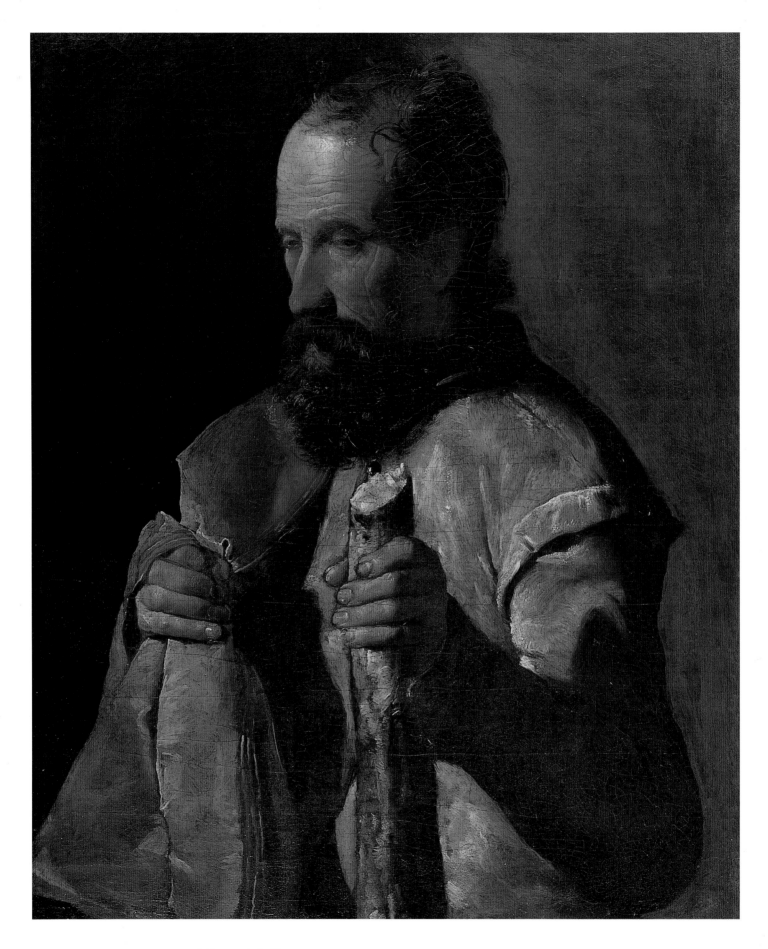

cat. 6. Georges de La Tour,
Saint James the Less,
c. 1624, Musée Toulouse-
Lautrec, Albi

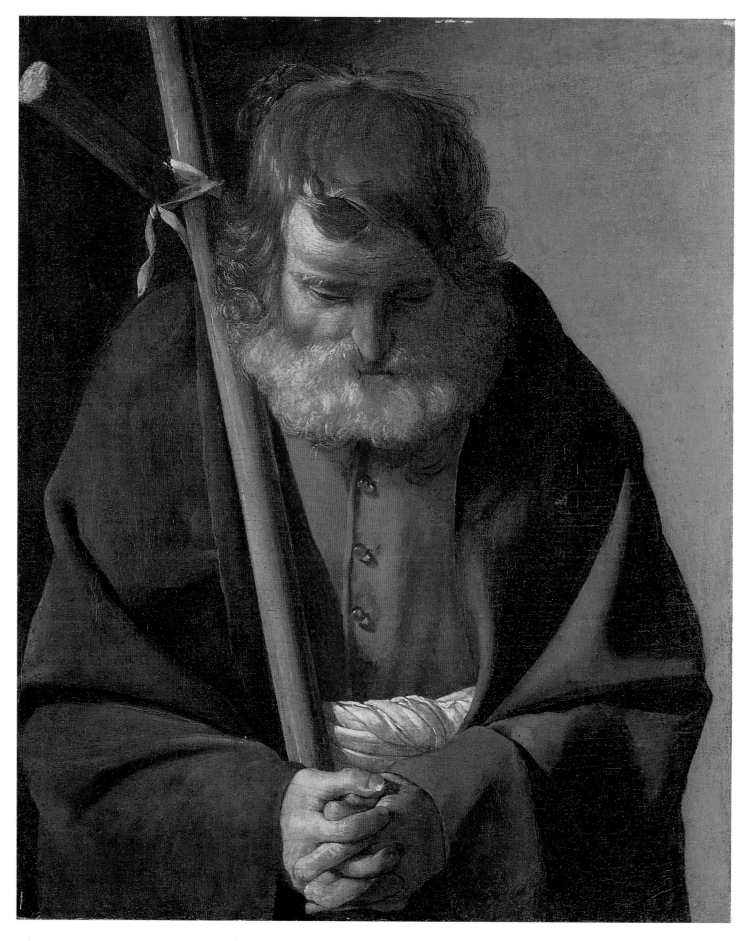

cat. 7. Georges de La Tour,
Saint Philip, c. 1624,
The Chrysler Museum,
Norfolk, Gift of Walter
P. Chrysler Jr.

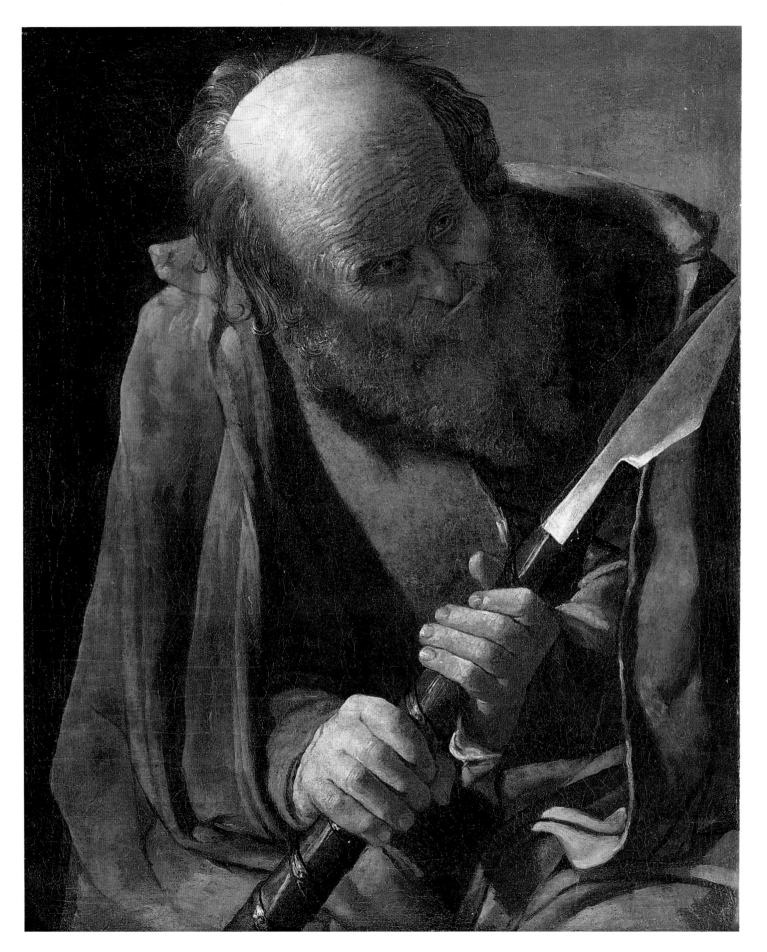

cat. 8. Georges de La Tour,
Saint Thomas, c. 1624,
Ishizuka Tokyo Collection

jerkin, and holding a coarse knotty stick he might have just cut while clearing ground. If it were divorced from its context, we might be forgiven for thinking this painting was a study of a careworn old soldier, or even La Tour's gardener, a northern ancestor of Cézanne's Monsieur Vallier. *Saint James the Less*, evidently a man observed from life, stands out as the least idealized and conventional in a group of figures already remarkable for their realism.

The Apostles were among the most important intercessors between the mortal world and the divine one, because they had been Christ's chosen companions and personal witnesses. But in La Tour's interpretation they are not the remote, glorious saints criticized by the Protestant reformers in the sixteenth century. Rather they are of their time and place, men of flesh and blood who still seem extraordinarily immediate and credible. La Tour's early paintings of figures and scenes from contemporary life, with their novel and uncompromising veracity, have been readily adapted by the artist to introduce the Apostles into the modern world. If the reformed Christian, be he beggar or king, could speak directly to God, anyone might feel encouraged to put his trust in these

33. Georges de La Tour,
Saint Andrew, c. 1624,
Walpole Gallery, London

34. Anthony van Dyck,
Saint Peter, c. 1620-1621,
private collection

plain men to intercede on his behalf. It is a matter of regret that we have no information about what must have been an important commission early in La Tour's career. Lorraine was at the forefront of the Catholic reform, and we can imagine a zealous and radically minded canon, perhaps a devotee of Saint Carlo Borromeo, soliciting the artist to represent the Apostles as men of the people, men who might speak directly of a more personal communication with God, addressing individuals or communities tempted by the alluring possibilities presented by the new religion.[69]

As we have mentioned, La Tour's veristic approach to religious subjects was original in French art in the 1620s. For the Apostles we might rather have expected him to have followed the more ideal patterns recently established by Rubens in his famous set of Apostles painted for the duke of Lerma in 1610, or Van Dyck's no less celebrated Apostles painted in Antwerp in 1620 or 1621 (fig. 34),[70] or even the somewhat stereotyped gruff old sages he would have known from Büsinck's cuts after Lallemant (fig. 29). The print of *Saint Peter* is one of a set of thirteen after a suite of (now lost) images of Christ and the Apostles painted by Lallemant probably in the 1620s, and engraved by Büsinck in Paris in the same decade.[71]

With the Albi Apostles, La Tour introduced into Lorraine in the 1620s one of the important innovations made by Caravaggio in Rome some two decades earlier: casting a religious subject with the ordinary people of the streets around him. Perhaps Caravaggio's most significant contribution to the art of the Catholic reformation was to re-present the often-told truths of religion in an arresting and, for some, iconoclastic form that seemed to bear a direct relationship with the everyday world. Caravaggio's innovative assimilation of common folk into the morally elevated world of religious art had been adopted by his closest followers in Rome and Naples during the second decade of the century: by Vouet and Valentin among the French, by Baburen, Honthorst, and ter Brugghen among the Dutch, by Ribera among the Spanish. It should be noticed that the approach filtered back to Caravaggio's native Lombardy in work of a painter such as Tanzio da

Varallo. We have noted that La Tour could have been among the number of Caravaggio's international followers in Rome some time before 1616, although so far the archives have remained frustratingly silent on this important point. But even if La Tour had not been in Rome nor seen the art of Caravaggio at first hand, he understood the concept to a rare and penetrating degree. Caravaggio was already a legend in his lifetime, and the stories that must have gone around the studios of Europe – about his saints with dirty feet, his dead Virgin a common woman fished from the suicidal waters of the Tiber, his pilgrims taken from the streets of Rome, his Matthew in the French church in Rome gambling with real *bravi* from that very neighborhood, and so on – might have been enough to fire an original mind. There was an abundant traffic of artists, clerics, even pastry cooks between Lorraine and Rome to keep such studio talk alive and up-to-date.

An artist who brought a modified version of Caravaggio's tenebrism directly to Lorraine from Italy was Jean Le Clerc, who settled in Nancy around 1622. His influence is discussed further in Gail Feigenbaum's essay in this catalogue. Le Clerc had studied in Rome with the Venetian Carlo Saraceni, just at the time when Saraceni was in thrall to Caravaggio's style. He absorbed the soft light and painterly handling of Saraceni, along with his modulated version of Caravaggio's chiaroscuro. Le Clerc's *Nocturnal Concert* (cat. 42), of which three versions are known and probably date from the end of his Italian period, shows how Caravaggio's bold chiaroscuro could be softened by one of his followers in the decade after his death. It is quite possible that a version of the *Nocturnal Concert* was known in Lorraine. Le Clerc's painting, with its subject matter derived from Caravaggio's early scenes of musicians, has a hedonistic air conveyed by its soft lighting, rich textures, and passages of free handling. It may represent the carousals of the Prodigal Son as he embraces a courtesan in a tavern.[72]

Not only did Le Clerc paint at least three versions of the *Nocturnal Concert* but he also made an etching of it (fig. 35), which fully exploits the play of light and shade and the luminosity of its shadows.

cat. 42. Jean Le Clerc,
Nocturnal Concert, c. 1621–
1622, Alte Pinakothek,
Munich

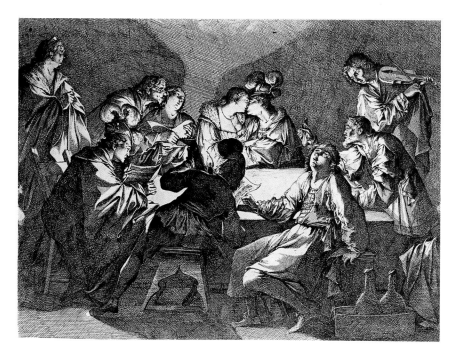

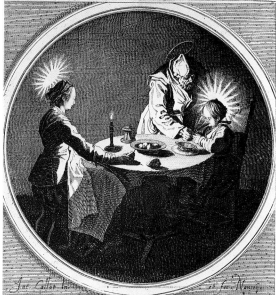

EIA AGE CARE PVER, CALICEM BIBE,TE MANET ALTER
QVI TENSIS MANIBVS NON NISI MORTE CADET

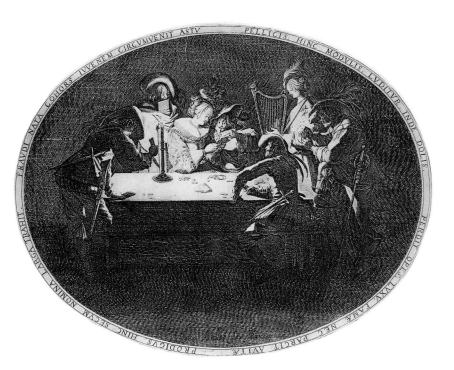

35. Jean Le Clerc, *Nocturnal Concert*, c. 1621–1622, Albertina, Vienna

36. Jacques Callot, *Le Brelan* (*The Gaming House*), 1628, National Gallery of Art, Washington, Rosenwald Collection

37. Jacques Callot, *Le Bénédicté* (*Saying Grace*), c. 1628, National Gallery of Art, Washington, R. L. Baumfeld Collection

It may have inspired Callot's 1628 etching known as *Le Brelan*, or *The Gaming House* (fig. 36), a scene showing the Prodigal Son engaged in duplicitous nocturnal revelry. Both its chiaroscuro and the fact that it seems to be poised between being a religious and a modern moralizing subject make *Le Brelan* rare in Callot's work. In style it can be compared with Callot's one other nocturnal scene worked in rich chiaroscuro, *Le Bénédicté* (fig. 37), an intensely felt image of the Holy Family at table.[73] Thus along with the nocturnal scenes of Bellange, the work of Le Clerc and even Callot shows a positive response to tenebrism in Lorraine well before La Tour developed it as his distinctive style in the mid-1630s. It was probably later in his career that La Tour painted several works with musical revelry as their theme, but nevertheless at least two pictures, *Pipers Playing by Candlelight* and a *Night Picture with Musicians*, which are now lost but recorded with these titles in early inventories,[74] could have been inspired by Le Clerc's *Nocturnal Concert*.

Le Clerc had an active career in and around Nancy until his early death in 1633. Among his few surviving works, an *Adoration of the Shepherds* (fig.

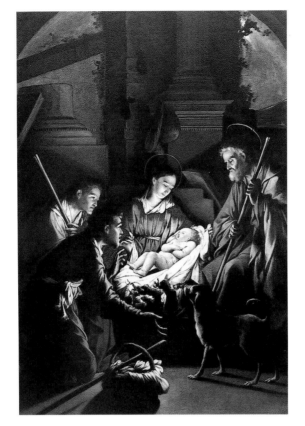

38) illustrates how he must have introduced a breath of soft, warm Italianate air into the rarified court atmosphere of Nancy. In this work, which is derived ultimately from Correggio's famous *Adoration of the Shepherds* (Gemäldegalerie, Dresden), Le Clerc demonstrates once again his absorption of Saraceni's luminous grace. Yet it is tempered with an earthy realism Le Clerc would have found in the rustically interpreted religious works of the Bassano family of artists, who worked in and around Venice. Their influence is especially present in Le Clerc's figures of the shepherds and the dog, who are real rural types, well suited for the altarpiece of a church in a small country town. The realist lessons of such a painting would not have been lost on the La Tour, who was working on the Apostles between about 1623 and 1625.

Hurdy-Gurdy Players

The lively execution of the two best-preserved Albi Apostles may offer a clue to the dating of the J. Paul Getty Museum's *Musicians' Brawl* (cat. 9), here pro-

posed as about 1625–1627. This painting is sometimes called *The Beggars' Brawl*[75] – but we have chosen to call the participants "musicians," if only because the trio of wandering musicians on the right seems to be a cut above abject indigence. Two street musicians, a piper and a hurdy-gurdy player, are fighting: the hurdy-gurdy player on the left is attacking with the handle of his hurdy-gurdy in one hand and a knife in the other. The piper on the right wards him off with one of his flutes, while with his other hand he appears to be squeezing a spray of juice from what may be a lemon into the aggressor's face.[76] Hurdy-gurdy players were traditionally blind (La Tour seems always to show them so), but the grimace of this one as the juice goes into his face might be intended to show that his blindness is bogus: at best he is one-eyed. If this reading is correct, the old woman behind him at the left, no doubt his companion and guide, must be groaning in distress as their ruse has been discovered. At the right two other musicians – a bagpipe player and a fiddler who are the piper's companions – share their humor with the spectator and offer a silent commentary on the scene, which seems to say that even the most wretched of people find something about which to squabble.

We only need to look as far as Bellange for La Tour's likely source of this subject: his powerfully expressive etching of 1615 shows a hurdy-gurdy player and a ragged pilgrim (another false beggar?) engaged in a vicious fight (fig. 10). A copy of this print by Mathieu Merian carries the legend "Mendicus mendico invidet," or the beggar envies the beggar, which is to say that however miserable you are there is always someone more miserable who will envy you. That is not quite the message of La Tour's painting, which is rather a humorous commentary on the follies and perhaps the deceptions of mankind. Paulette Choné has convincingly suggested that Callot's suite of etchings of duplicitous-looking beggars of about 1622 represents a variety of just such false beggars, including the one-eyed (or blind?) *Hurdy-Gurdy Player* (fig. 23), phony pilgrims, falsely devout beggars, and so on. The cheating and deceptions of beggars had been the subject of frequent admonitions from the time of Sebastian Brant's

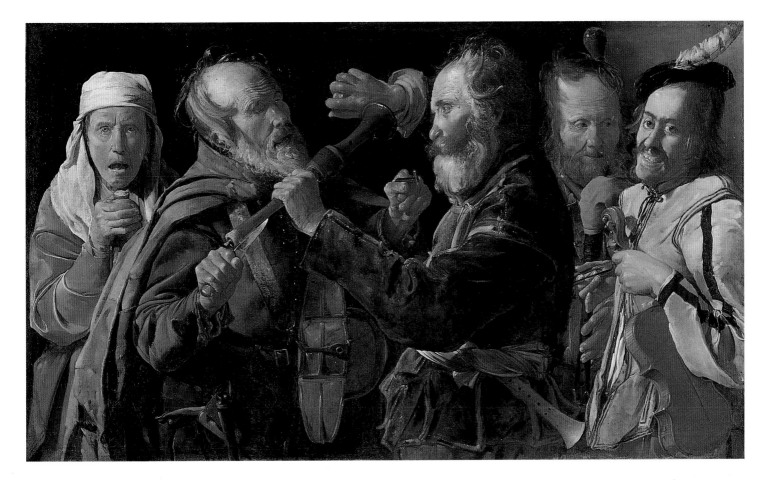

cat. 9. Georges de La Tour,
The Musicians' Brawl,
c. 1625–1627, Collection of
the J. Paul Getty Museum,
Los Angeles

39. Adriaen Pietersz van de
Venne, *"Poverty Leads to
Cunning,"* c. 1625–1630,
private collection

moralizing picture book, *The Ship of Fools* (1494),
through the often-reprinted *Liber Vagatorum* (*The
Book of Vagabonds*), first issued in 1509 and again in
1528 with an admonitory preface by Martin Luther,
to many another popular publication about beggars'
deceptions and mendacity.[77] La Tour's *Musicians'
Brawl* may be a variant of such an admonition, al-
beit rendered as a humorous narrative. The theme
of mendacity is introduced in a painting of the 1620s
by the Dutch artist Adriaen Pietersz van de Venne,
who painted a hurdy-gurdy player with his haglike
companion playing a *rommelpot*, in a work verging
on the grotesque, which takes its title from the ban-
derolle carrying the warning that these beggars are
duplicitous: "Poverty Leads to Cunning" (fig. 39).
In contrast, its pendant shows a well-off and elegant
couple, captioned, "Wealth Leads to Luxury."[78]

A *Blind Beggars' Brawl* (fig. 40) by an unknown
follower of Pieter Bruegel the Elder, which includes
two hurdy-gurdy players among other fighting
figures, can be seen as a prototype for La Tour's paint-
ing.[79] This sort of Bruegelian low-life scene, ren-
dered in a somewhat stiffly angular and archaic style,
survived in the Netherlands well into La Tour's life-
time, and its subject matter reminds us again that La
Tour was not only a compatriot of Callot but also
worked within a tradition of imagery peculiar to the
neighboring countries of northern Europe. Another
painting of a *Beggars' Brawl* (fig. 41), probably by a
Lorrainese artist, falls within this iconographic tra-
dition of the Bruegel school, and even in style lies
between the angularity of that school and the fuller
modeling and more naturalistic observation of La
Tour.[80] The composition of *The Musicians' Brawl*,
with its half-length figures arranged close to the pic-
ture plane, may have a more modern, Caravaggesque
model, however. In his essay in this catalogue Slatkes
has drawn attention to the compositional prototype
of Bartolommeo Manfredi's *Taking of Christ*, which
in the seventeenth century was in the Antwerp col-
lection of Archduke Leopold Wilhelm. While the
theme of *The Musicians' Brawl* is closer to being a
secularized mocking of Christ, rather than his cap-
ture, the visual analogies with Manfredi's painting
are striking.[81]

40. After Pieter Bruegel the Elder, *Blind Beggars' Brawl*, late sixteenth century, Öffentliche Kunstsammlungen Basel

41. Unknown artist, *Beggars' Brawl*, c. 1625–1630, private collection, Paris

La Tour tells the story of *The Musicians' Brawl* with brilliant characterization, narrative clarity, and above all humor. There is no attempt to describe a location, and the pictorial space occupied by the musicians is cramped, recalling some of Bellange's compacted scenes with groups of figures seen at half length. But the play of gesturing hands and arms and the juxtapositions of heads and expressions convey the action and confusion of the captured moment with great skill. La Tour took illusionism to a high level in *The Musicians' Brawl*, from the beautifully rendered musical instruments, to the variety of characters and expressions, to the physiognomic details of bad teeth, cataracts, or other disorders of the eyes. The rich impasto and lively handling of paint in *The Musicians' Brawl* demonstrate La Tour's full control of his expressive means. The gray hair of the protagonists is painted with gusto, while the fine, lively highlights of wrinkled, weather-cracked faces and gnarled hands are applied with a satisfying combination of descriptive precision and painterly relish. Indeed this painting has one of the most active surfaces of all La Tour's works – perhaps in response to its agitated theme. La Tour's other surviving early

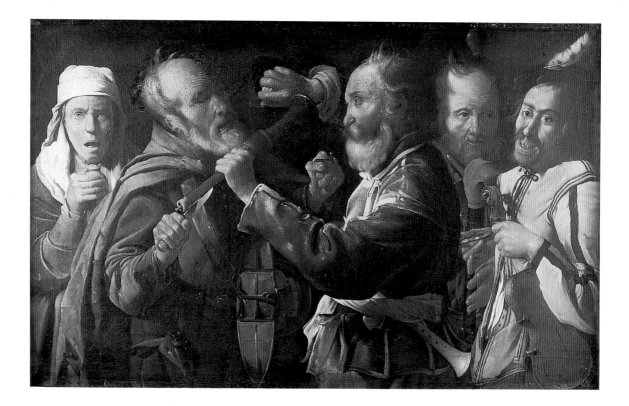

works are more reflective in mood and his brushwork correspondingly more deliberate. La Tour's cast of old musicians comes from the same stock as the Albi Apostles; but from the ambitious choreography of the scene to the broadly painted garments and spirited handling of the swirls of the musicians' hair, *The Musicians' Brawl* seems to be a new and dramatic development in his art.

The Getty *Musicians' Brawl* inspired an impressive early copy (cat. 10), which, although lacking many refinements of the original, captures much of its energy in the thick, unusually impasted facture. Such a copy attests to the early popularity of the Getty picture and is further evidence of the positive reception given such genre scenes in Lorraine.[82]

It has been argued, most recently by Slatkes in this catalogue, that the fiddle player on the right of *The Musicians' Brawl* is modeled after a now-lost painting by ter Brugghen (Slatkes fig. 1). To the present writer the similarities between these two figures seem more generic than specific, but this does not preclude other analogies of design and facture between La Tour's paintings and those of ter Brugghen and other Utrecht painters such as Honthorst

and Baburen. Slatkes takes the argument further to suggest La Tour not only was aware of the work of his contemporaries in the Netherlands but that he actually visited Utrecht. While we still await documentary evidence of such a trip – after all, it is conceivable that La Tour saw such paintings in Lorraine or perhaps in Paris – we have to acknowledge that the visual evidence for the influence of ter Brugghen's paintings as pointed out by Slatkes is intriguing.

A rare print, almost certainly after a lost painting by La Tour of about the same time as *The Musicians' Brawl*, shows a *Cornet Player* (fig. 42) playing by candlelight. If this etching does in fact represent a lost painting by La Tour, rather than a work of some other northern artist, the musician could almost be the same model as the laughing violinist at the right of the Getty painting.[83] As Slatkes shows, this type of half-length image of a musician was popular throughout northern Europe in the 1620s – as in ter Brugghen's bucolic *Bagpipe Player* (fig. 43), or we might also cite Büsinck's chiaroscuro woodcut after *The Flute Player* (fig. 44) by Lallemant.[84] La Tour continued to paint hurdy-gurdy players and other musicians throughout the 1620s, and what sur-

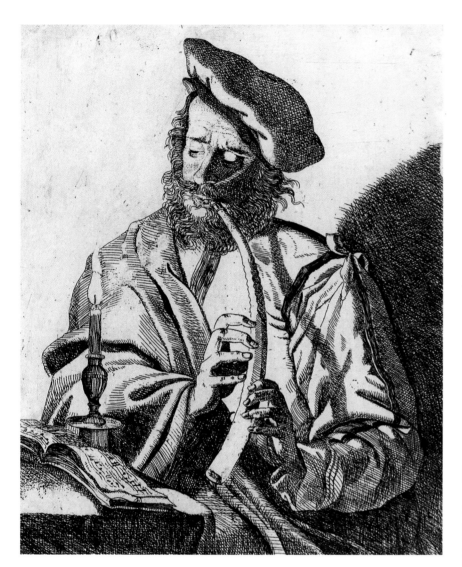

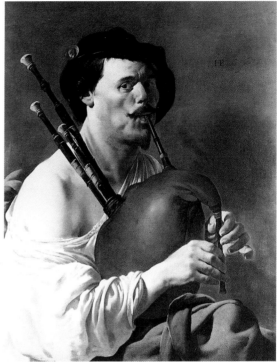

42. After Georges de
La Tour(?), *Cornet Player*,
mid-1620s(?), The British
Museum, London, Depart-
ment of Prints and
Drawings

43. Hendrick ter Brugghen,
A Bagpipe Player, 1624,
Ashmolean Museum,
Oxford

44. Ludolf Büsinck,
after Georges Lallement,
The Flute Player, The
Metropolitan Museum of
Art, New York, Rogers
Fund, 1917

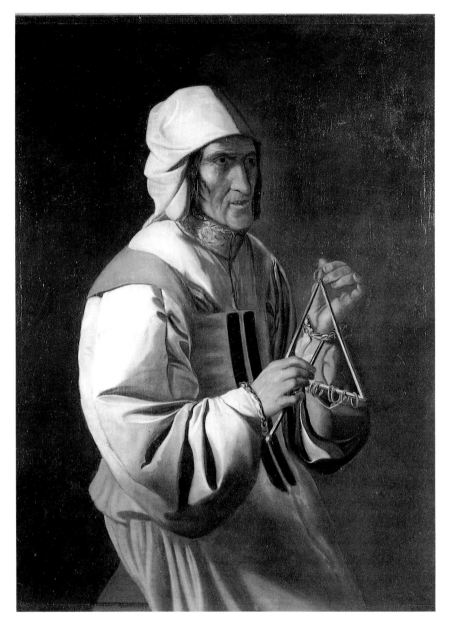

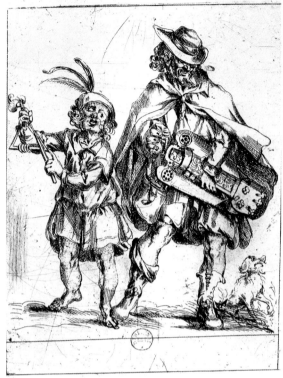

45. After Georges de La Tour, *Woman Playing a Triangle* (original 1620s?), private collection, Antwerp

46. Attributed to Jean Appier, called Hanzelet, *The Triangle Player and the Hurdy-Gurdy Player*, c. 1615(?), Bibliothèque Nationale de France, Paris

vives may be only a small proportion of a potentially large production of such subjects, for which there was likely as good a market in Lorraine as in the Low Countries during this period.

A badly abraded and overpainted half-length figure of a hurdy-gurdy player in Brussels is actually a fragment of a more complex composition. X-rays reveal that originally to the left of this hurdy-gurdy player was another musician playing a stringed instrument;[85] quite likely they formed part of a musical group in a format similar to the Getty *Musicians' Brawl*. There also exists in a private collection an old copy of a half-length figure of a woman play-

ing a triangle (fig. 45).[86] She is our only surviving record of a lost composition by La Tour, which was almost certainly a pendant to a painting of a hurdy-gurdy player. These two musicians were often associated in the seventeenth century, as in the etching *The Triangle Player and the Hurdy-Gurdy Player* sometimes attributed to the younger Jean Appier, a Lorrainese artist also known as Hanzelet (fig. 46).[87]

Without doubt La Tour's masterpiece of the hurdy-gurdy player theme is the version in Nantes, probably painted in 1628–1630 (cat. 11). It is the only one of the four nearly life-size and full-length hurdy-gurdy players to have survived well enough to give us a complete sense of La Tour's powers in depicting this theme. It is a masterwork in the equilibrium of its design, the harmonious accord of its colors, and the refinement La Tour attained in his ability to match the substance of his paint with the variety of stuffs it represents. The artist must have prided himself on the forceful sense of actuality he conveyed. There is little doubt that the spectator is meant to respond to the manifest presence of this figure: who can help but notice that his shoelace needs

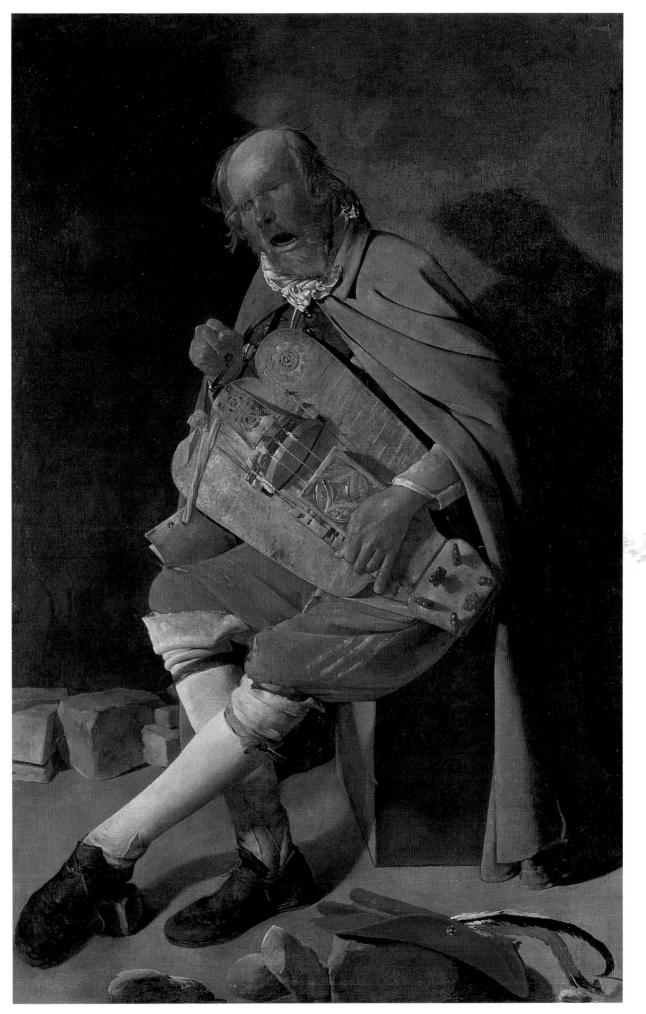

cat. 11. Georges de
La Tour, *The Hurdy-
Gurdy Player*,
c. 1628–1630, Musée
des Beaux-Arts,
Nantes

to be tied? The pegs on the hurdy-gurdy – with their skillful foreshortening, cast shadows, and glistening highlights – beg to be turned. La Tour (or the hurdy-gurdy player) has set back the bridge-cover of the instrument, revealing the bridge and strings. The observant viewer will notice that the player has slipped pieces of paper under the strings in places, and wound threads around them where they rest on the bridge, presumably in order to modify the sound; in small details like this La Tour gives the image a striking specificity. Moreover, we are tempted to brush away the fly that has alighted on the removed bridge-cover – but is the fly on the instrument or has it settled on the surface of the painting? The motif of the *trompe-l'oeil* is an old conceit in illusionistic painting, with a history that can be traced back to descriptions of veristic Roman paintings by the ancient writer Pliny.[88] La Tour was certainly familiar with the literary and modern visual models of such a humorous motif, which became especially common in Dutch still-life painting during the 1620s in the work of painters such as Balthasar van der Ast, Osias Beert the Elder, and Johannes Bosschaert.[89] We cannot rule out the possibility that La Tour's fly has a witty extra connotation here, comparing the insect's pesky drone to that of the buzzing hurdy-gurdy.

47. Pieter Bruegel the Elder, detail of a hurdy-gurdy player from *Triumph of Death*, c. 1560–1565, Museo del Prado, Madrid

For all the vivid presence that La Tour gives his hurdy-gurdy player, however, the setting is an abstract, timeless one. Or so it must seem to the modern spectator, for whom the specific context, if there is one, is lost. Seated and resting his foot on some cut masonry, is the player supposed to be in the street, against the wall of a tavern, or in the porch of a church? The sixteenth-century *Liber Vagatorum* warned of one type of false beggar, the blind singer (although accompanied by a lute, not a hurdy-gurdy): "There are blind men who sit before the churches on chairs and play the lute, and sing various songs of foreign lands whither they have never been, and when they have done singing they begin to lie and deceive in what manner they had lost their eyesight."[90] Yet, La Tour employed a remarkably similar setting as a rocky retreat in his two paintings of *Saint Jerome* (cats. 14 and 15): was this an actual space,

a room, or a courtyard where the artist worked? La Tour uses the illuminated and shadowed surfaces of the stone blocks to create a sense of volume and space, almost like an academic exercise in the creation of volume through light and shade. Indeed a major *leitmotif* of this painting is the extraordinary variety of light and shadow the artist has depicted, more important to him here than color. The saturated red of the hat establishes the foreground and is only faintly echoed in the dusty pinks of the hurdy-gurdy player's costume, the ribbon, and his sunburnt face. But we are otherwise more aware of the fall of cool light from somewhere outside the picture at the top left, the way it strikes a range of solid forms and different stuffs, and the intriguing patterns created by the curved and angular shadows of varying densities. Exploiting a restricted tonal palette, La Tour here explores a corner of the visible world,

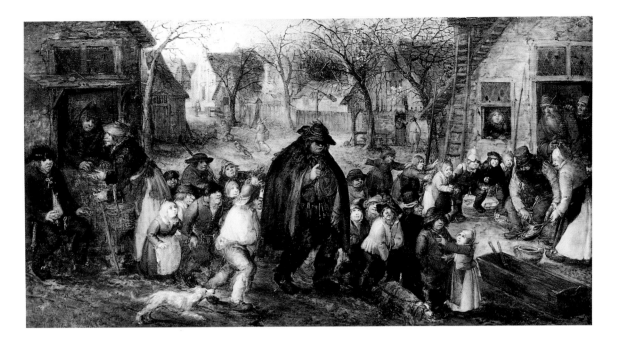

48. David Vinckboons, *The Hurdy-Gurdy Player with Children*, 1606, Rijksmuseum, Amsterdam

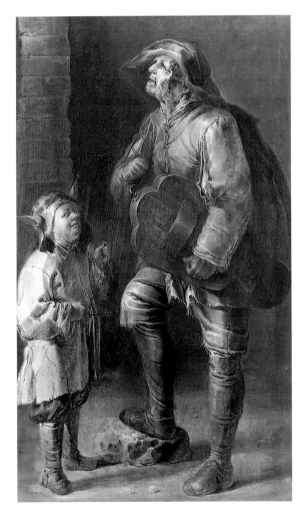

49. Jan van de Venne, *The Hurdy-Gurdy Player*, 1620s, Kunsthistorisches Museum, Vienna

transforming it into a powerful and convincing work of art.

La Tour's hurdy-gurdy players are noticeably similar in dress to the image of the hurdy-gurdy player in Callot's etching from his series of *Beggars* (fig. 23): they wear similar wide flat hats decorated with feathers, ruffed shirts, cloaks, baggy britches, leggings, and boots. We might deduce that this was the raiment conventionally worn by this type of beggar. Jean-Yves Ribault has published an archival document from Bourges in the early seventeenth century that shows an apprentice hurdy-gurdy player to have been kitted out in just such garments.[91] Even among beggars there were degrees of hierarchy and social organization: Ribault's archival researches have shown that in the city of Bourges in La Tour's time the local blind musicians and their guides were organized into an association to protect their interests, with the support of the Augustinian fathers of the Abbey of Saint Ambroix nearby.

Why did La Tour choose to depict hurdy-gurdy players so often? Is there a sinister aspect to this figure? Is he bringing a message we would prefer not to hear? In one terrifying image included by Pieter Bruegel the Elder in his *Triumph of Death* (fig. 47), a figure of Death plays the hurdy-gurdy, as he and his accomplices drive their cart through the bleak

landscape, collecting bodies. If La Tour perceived the hurdy-gurdy player as a beggar, this itinerant musician type was only one among the many categories of beggars he might have represented, considering the twenty-eight varieties etched by Callot in his series mentioned above (figs. 19–21, 23). We might recall in this regard that the only two secular prints Bellange ever executed were representations of hurdy-gurdy players (figs. 9–10). Was it because the hurdy-gurdy playing beggar was specially regarded in some way, had a prominence in Lorraine, some significance for the artist, or was it because La Tour became famous for one of his representations of one? It is worthy of note that all of La Tour's hurdy-gurdy players seem to show the same model, his expressive head thrown back in song: with thinning, straggly hair, deep eye-sockets, broken nose, and the same physique, heavy-ankled and large-footed.

Although in the middle ages the hurdy-gurdy had been a respectable instrument played in churches and by minstrels at court, by the end of the sixteenth century it was out of fashion, archaic, and had moved down the social scale.[92] By the seventeenth century it was associated only with lowly, rustic music-making or with the street musicians we have seen depicted by Bellange, Callot, Hanzelet, and La Tour in Lorraine, or by Adriaen van de Venne in the Netherlands. A representation in Netherlandish art from the first decade of the century is David Vinckboons' *Hurdy-Gurdy Player with Children* (fig. 48), which derives from the tradition of Brueghel the Younger and shows the hurdy-gurdy player as a grotesque figure of fun.[93] This association with foolery is also present in the Antwerp master Jan van de Venne's *Hurdy-Gurdy Player* (fig. 49), in which the musician is accompanied by a child wearing a fool's cap and bells.[94] In about 1640 the French music expert Pierre Trichet observed of the hurdy-gurdy: "It is played only by idiots and poor beggars, most of whom are blind; it would not be surprising if it served only to arouse pity."[95] Certainly the familiar drone of the hurdy-gurdy would have drawn the attention of the passerby to the plight, real or feigned, of the player. On the other hand, the evangelical current of the

Catholic reform movement accorded a spiritual value to poverty, humility, and suffering, and we cannot rule out the possibility that a local tradition in Lorraine associated these conditions with hurdy-gurdy players.

We must emphasize again the life-size scale and number of surviving pictures of hurdy-gurdy players by La Tour. As a series they stand out in the entire seventeenth century. Quite possibly we miss the point by emphasizing the hurdy-gurdy in our modern title. It is important to notice that La Tour's hurdy-gurdy players are all apparently blind and are all invariably singing: this might have been as significant to contemporary viewers as their instruments. In the *Liber Vagatorum* mentioned above, it is the singer, his song, and its false words that are the objects of criticism. The hurdy-gurdy may have been understood not only as the accompaniment but also as the attribute of these blind singers. But if we consider them more positively and call them "blind seers," whose attribute is the hurdy-gurdy droning away on their knees, there is a greater resonance to the representations, perhaps an association with the blind seers and sages of ancient times. This may explain why La Tour painted them so often, so grandly, and invested them with such dignity. Callot's *Hurdy-Gurdy Player* is certainly the most dignified of his beggars, and it is hard to deny that La Tour, for all that he depicts a series of rather wretched-looking human beings, treats them with great seriousness by their scale and monumentality. Although they suffer material poverty and their features uncompromisingly express the anguish caused by their disability, they are not dressed in the worst rags and tatters.

An important feature of La Tour's paintings of the hurdy-gurdy players is that they are not figures of fun or burlesque. La Tour approaches them with respect, as Annibale Carracci does the different types of urban workers represented in his *Arti di Bologna* (engraved by Simon Guillain in 1646), or Pierre Brebiette, cataloguing tradespeople in their daily rounds, in his *Cris de Paris*, another print series. But these popular prints are by no means on the monumental scale of La Tour's paintings. The closest parallels for his hurdy-gurdy players in early seventeenth-century

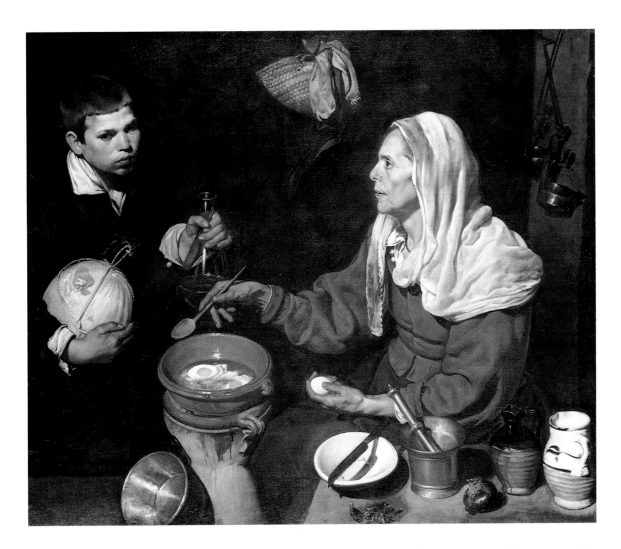

50. Diego Velázquez, *Old Woman Frying Eggs*, c. 1618, The National Gallery of Scotland

painting have to be sought at the other end of Europe, in the contemporary Sevillian *bodegones* painted by Velázquez, such as *The Water-Carrier* (Apsley House, London) or *Old Woman Frying Eggs* (fig. 50). Velázquez' low-life characters are not indigents: they have a positive role, and in selecting his subjects and constructing his images, Velázquez gives a strong sense of their humble yet dignified place in the social scheme of things. Velázquez' street vendors are observed with a care and clarity very comparable to La Tour's hurdy-gurdy players or his *Old Peasant Couple Eating*. But in the substantial, meditatively applied paint of the Spanish master, these everyday figures are represented with a feeling for the human and even spiritual wealth beyond any material poverty. It is not surprising that at the time the Nantes *Hurdy-Gurdy Player* entered the museum in 1810, as part of the impressive collection acquired

from the estate of François Cacault, it was attributed to Murillo, then subsequently given to the other Spanish seventeenth-century masters – Ribera, Velázquez, Herrera the Elder, Zurbarán, and Maino – before Voss identified it as by La Tour in 1931.[96] A close look at this series makes it all the more frustrating not to know the original destinations of these paintings. The one telling clue is tantalizing: in 1764 a painting of a *Hurdy-Gurdy Player* was hanging in the king's bedroom in the former ducal château of Commercy near Toul.[97] It is not so easy for the modern viewer to establish La Tour's moral stand in relation to *The Hurdy-Gurdy Player:* should we admire him for his modest enterprise, or is he a pest and a trickster? Is the wisdom he dispenses any less valuable than the insights of a Saint Jerome (cats. 14 and 15)? Should we not perhaps compare him with the low-life sages of Shakespeare?

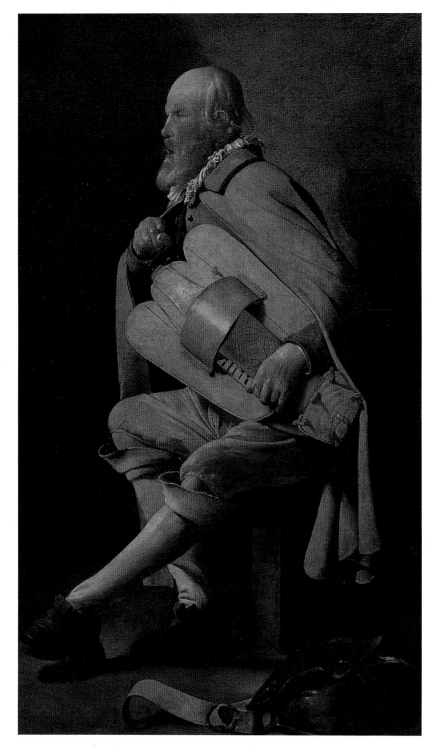

51. Georges de La Tour, *The Hurdy-Gurdy Player*, c. 1628–1630, Musée Municipal Charles-Friry, Remiremont

OPPOSITE PAGE:
cat. 12. Georges de La Tour, *The Hurdy-Gurdy Player*, c. 1630–1632, Museo del Prado, Madrid

We have seen that musicians were a popular form of genre painting in northern Europe during the early seventeenth century. They tend to fall into two categories: one has jolly carousing musicians in quite fancy costumes, usually in a tavern setting; the other is rustic or arcadian in mode. La Tour seems to have established his specialty in the genre as hurdy-gurdy players, perhaps consciously in a local tradition inspired by the engraved examples of Bellange and Callot. What certainly sets La Tour's images apart from other contemporary representations of musicians is the uncompromising – and dare we say objective? – realism of his approach. There is certainly no hint of the arcadian literary ideal of the bucolic Virgilian musician we encounter in ter Brugghen's typical *Bagpipe Player*, nor of the panache of Lallemant's *Flute Player* (see figs. 43 and 44). But nor are La Tour's hurdy-gurdy players singing and making music as part of social intercourse. His blind players are abandoned to the droning world of their own isolation.

The Prado recently acquired a well-preserved fragment of a *Hurdy-Gurdy Player* (cat. 12), a canvas that again shows only the upper half of a player; it was originally a full-length figure, but the canvas was cut down at a later date. It is broadly and confidently handled, with a rich variety of brushwork and fully modeled forms, suggesting a later date than the Nantes picture, perhaps in the early or even mid-1630s. The handling and modeling can be compared with the Stockholm *Saint Jerome* (cat. 15), discussed below as another work possibly from the early 1630s. La Tour's touch is refined here – in the softness of the hair and beard and in the carefully brushed highlights of the face, hands, and the instrument, for example. There is a parallel, refined harmony in the use of color, too, which is restricted to muted browns, beiges, and dusty pinks. A full-length *Hurdy-Gurdy Player* in Remiremont is close in composition to the Prado picture and most likely painted at about the same time, although La Tour made some slight variations in pose and costume (fig. 51).[98] The Remiremont *Hurdy-Gurdy Player* has recently been cleaned and restored, but it has suffered so much in the past that it is but a ghost of its former self.

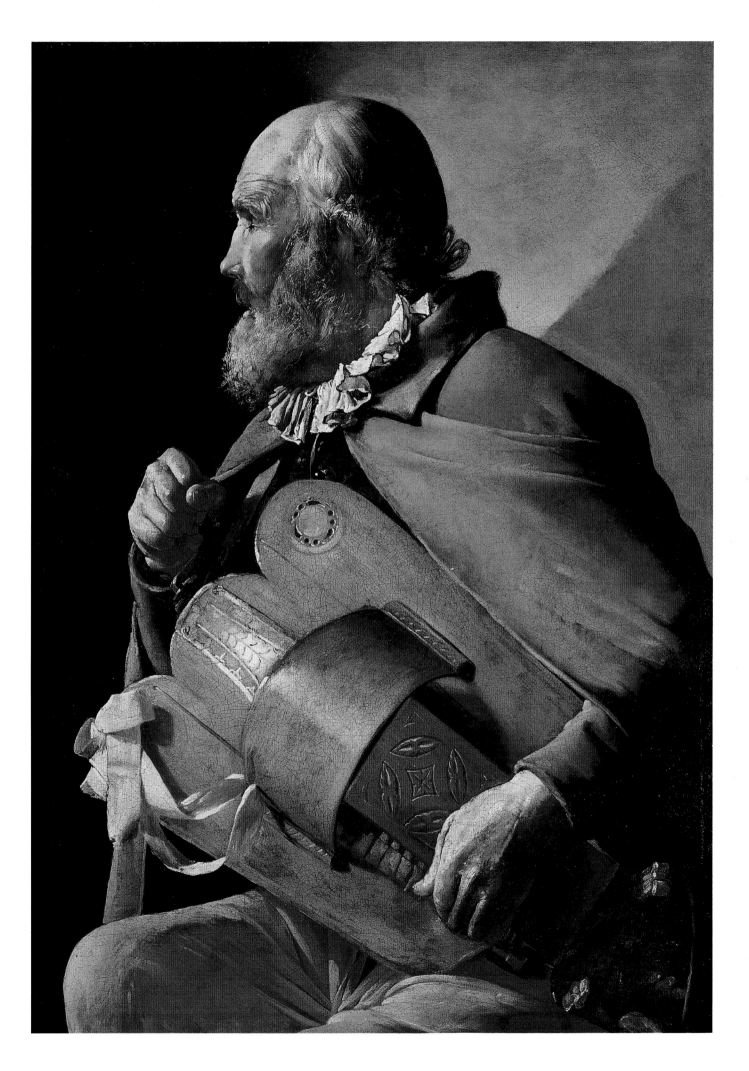

Life and Art of La Tour

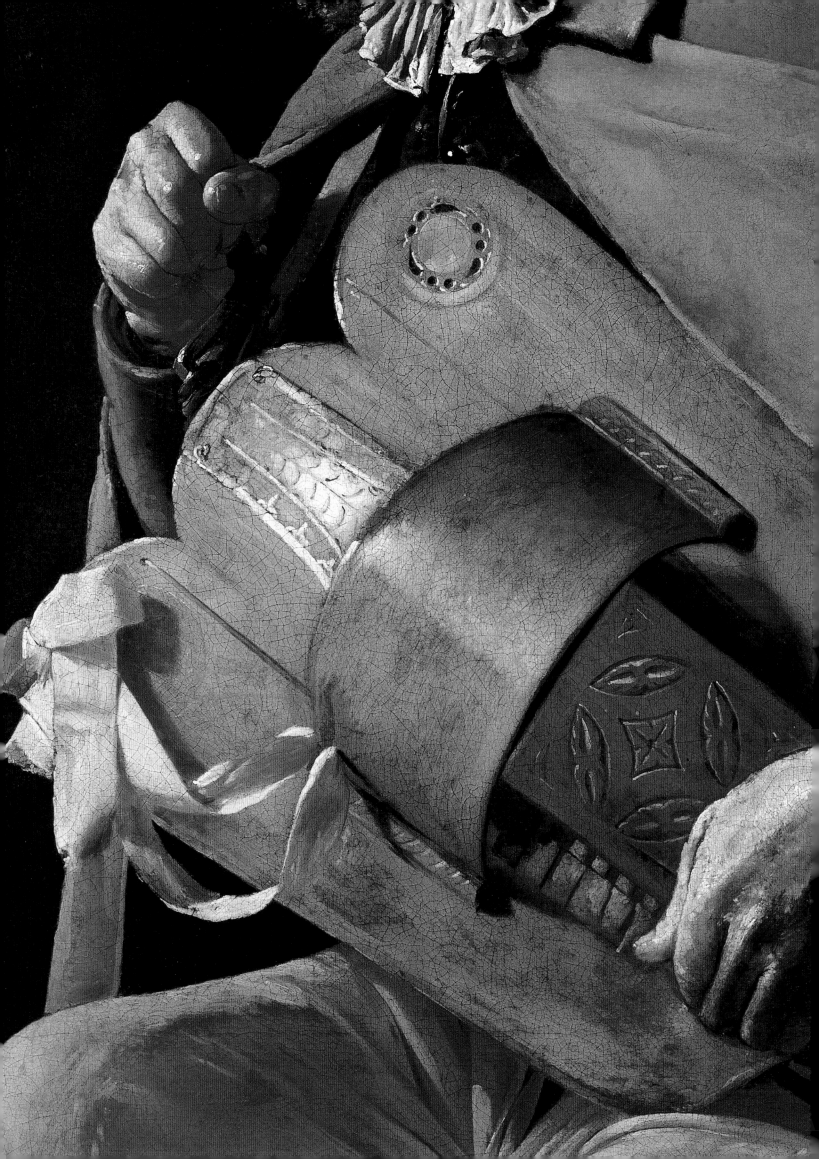

Now an artist with impressive powers of invention and fully confident of his means of expression, La Tour in his mid-thirties must have enjoyed a considerable local reputation. Yet for all his apparent isolation in Lunéville, La Tour shared a common vocabulary with the greater European language of art from Italy in the south to the Low Countries in the north. These issues are explored in Gail Feigenbaum's essay on the theme of "Gamblers, Cheats, and Fortune-Tellers" in this catalogue, where she discusses the context and meaning of La Tour's major modern moralizing subjects, paintings that were probably executed about 1630 or in the early 1630s: *The Fortune-Teller*, and the two related scenes of card-sharps, *The Cheat with the Ace of Clubs* and *The Cheat with the Ace of Diamonds* (cats. 17, 18, and 19). These three major secular works of La Tour's maturity are closely analogous in subject matter and style, and they derive from iconographic prototypes by Caravaggio. Yet they are also more modern versions of the moralizing, sometimes risqué subjects, with large half-length figures close to the picture plane, which are encountered in the art of the preceding generation of northern painters, such as Lallemant, Bellange, and Honthorst (figs. 52–54), or artists such as the unnamed masters working in the style of the School of Fontainebleau illustrated later in this catalogue by Feigenbaum (her fig. 5) and Cuzin (his fig. 13).[99]

The Cheat with the Ace of Diamonds was among the first of La Tour's daylight scenes to be identified in our century, and when it was published by Voss in 1931, he assumed it to be an early work.[100] After all, it was very different in style from the nocturnal *Denial of Saint Peter* (fig. 81), inscribed with the date 1650, which Voss had also been the first to publish in his pioneering article of 1915, where he resurrected the "peintre de nuits" of seventeenth-century Lorraine.[101] Moreover, the Caravaggesque origin of its theme not only confirmed for Voss that it was a youthful work, on the assumption that La Tour would have been more susceptible to influence as a young man, but also pointed to an early (although undocumented) visit to Rome. An Italian journey for La Tour must have been particularly appealing to Voss, who was

one of the pioneers of the study of Roman baroque art.[102] Later students of La Tour – especially and influentially Sterling in 1934, Blunt in 1972, and Nicolson and Wright in 1974 – followed Voss in placing *The Fortune-Teller* and the stylistically and thematically related *Cheat with the Ace of Clubs* and *Cheat with the Ace of Diamonds* early in La Tour's career, around 1620. But in 1972 Rosenberg and Thuillier dated this group of works a decade later;[103] more recently, Thuillier has suggested an even later date of the mid-1630s for the Kimbell's *Cheat with the Ace of Clubs*, followed by the Louvre version, and 1636–1638 for *The Fortune-Teller*.[104] Further discussion of the relative dating of these three works is found in the essays by Feigenbaum and Claire Barry, whose scientific research suggests that *The Cheat with the Ace of Clubs* may in fact have been painted after *The Cheat with the Ace of Diamonds*; the question remains open. The more somber and more painstakingly executed Louvre *Cheat* seems, as Rosenberg has suggested, to announce the nocturnes of the 1630s, implying a date later than the Kimbell picture,[105] which this writer is still inclined to accept.

All three of these moralizing scenes from modern life are definitely mature paintings, with a perfect equilibrium in the understanding of space, volume, and grouping; the principal monumental forms are solidly painted. The artist then worked over these forms with his characteristically brilliant calligraphy of the brush, rendering details of hair, costume, ornamental threads, feathers, and scattered, gleaming highlights and thus creating surfaces of willfully glittering superficiality. Alongside this interest in surface, which we have seen developing already in La Tour's presumed earliest works, a significant change occurs in these scenes of gambling and fortune telling of the early 1630s: La Tour's palette is lighter and more colorful. As we shall see in more detail below, the 1630s was the decade when La Tour began to solicit French patronage and protection, as a result of political events in that decade. Surely it was not just an accident of fate that brought a painting of "Fortune-Tellers" by La Tour to the important collection of Jean-Baptiste de Bretagne in Paris.[106] The light and colorful palettes of such works,

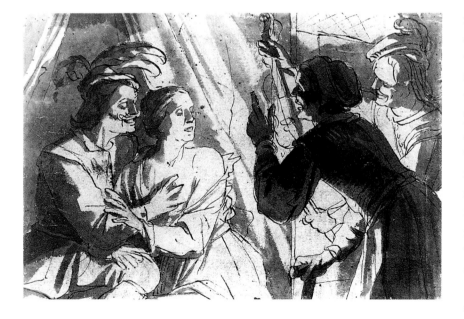

and their delightful depiction of fine stuffs, are not without echoes of the work of Vouet and his school, artists much in the ascendant in Paris around 1630. We cannot rule out the possibility that La Tour, by adapting his style and his palette, and by exploring such worldly subjects, was soliciting a place among them. If *The Fortune-Teller* (cat. 17) – whose arrangement of figures, incidentally, is uncannily reminiscent of an engraving after the early *Fortune-Teller* by Vouet himself (see cat. 45) – was painted for the home market in Lorraine, we must ask why the artist declared his origins with such ostentation in signing it *G. de La Tour fecit Lunevillae Lhothar:*? It is much more likely that such a signature, also stating the artist's town and region of origin, indicates the work was intended for consumption outside Lorraine. And we cannot rule out the possibility that it was even painted somewhere else, such as Paris, where La Tour needed to establish his identity.

Although a case can be made for the subjects of these paintings having their origins in the art of Caravaggio, Feigenbaum shows convincingly how little La Tour's style owes to the Italian master; or even to the influence of any of Caravaggio's followers who worked in the "Manfredi method," as she reminds us the tenebrist manner current in Rome (and disseminated throughout Europe) was known for three decades after Caravaggio's death. Rather, and in a way we shall see increasingly to be characteristic of his approach, La Tour tackled well-tried subjects but interpreted them in his own style and with a highly personal degree of insight. His love of costuming is striking in these works, as is his brilliant facility with paint in brushing them convincingly. It is to be hoped that one day costume historians will focus their attention on these pictures, to assess the relative roles of the contemporary, the archaic, and the theatrical in the attire of La Tour's protagonists, as well as what is the product of the artist's fancy. No doubt for the audience of La Tour's time certain costumes carried meanings that are lost on us today. Yet the degree to which the costumes are real or imaginary hardly stands in the way of appreciating his artistry, and above all his ability to tell a story well, with wit and convincing psychological insight.

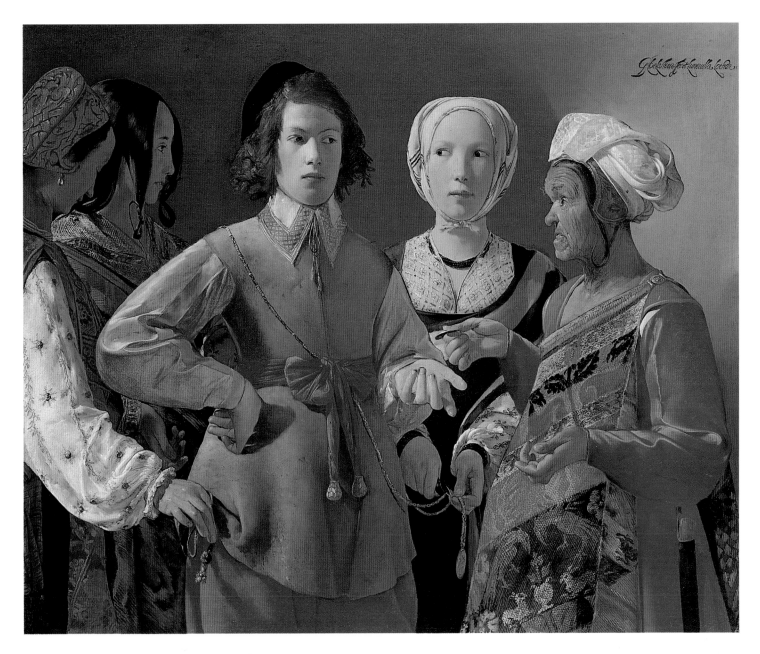

cat. 17. Georges de La
Tour, *The Fortune-Teller*,
c. 1630–1634, The Metro-
politan Museum of Art,
New York, Rogers Fund,
1960

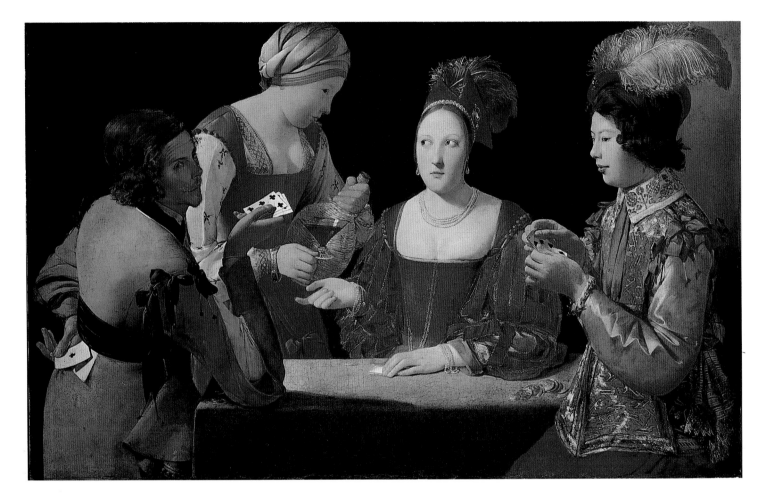

cat. 18. Georges de La
Tour, *The Cheat with the
Ace of Clubs*, c. 1630–1634,
Kimbell Art Museum, Fort
Worth

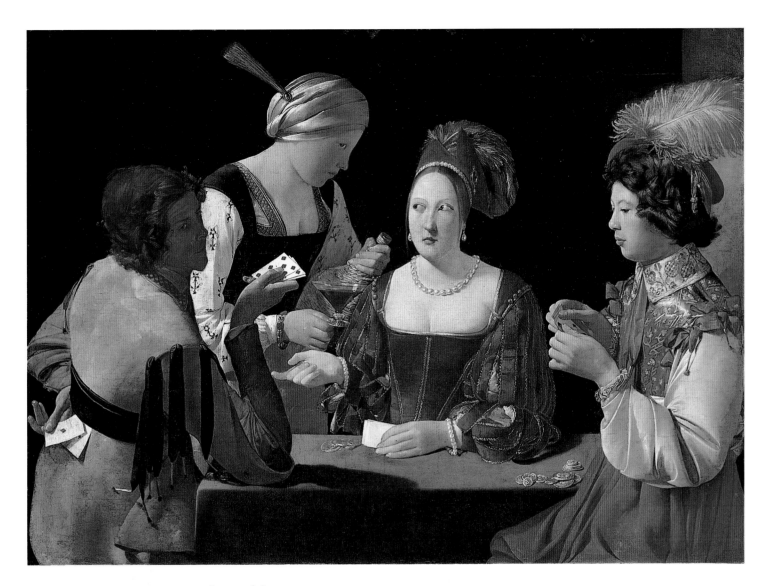

cat. 19. Georges de La
Tour, *The Cheat with the
Ace of Diamonds*, c. 1630–
1634, Musée du Louvre,
Paris

La Tour's fortune-tellers, courtesans, gypsies, and cardsharps set about duping and fleecing their victims with all the sharp-witted precision of glance and gesture, all the cool calculation of the rationalist dissection of the world we will meet in the brutal emotional detachment of Choderlos de Laclos' novel, *Les liaisons dangereuses* of a century later. It may be that in addition to *The Payment of Taxes, The Musicians' Brawl*, the cheats, gamblers, and fortune-tellers of around 1630, the later *Dice Players* and a lost but recorded *Card Players*, La Tour painted other such secular moralizing narrative works that have not survived. But based on the present evidence, the three surviving scenes of duplicity under discussion represent a relatively isolated moment in La Tour's art: as brief and intense a flirtation with such themes of cardsharping and fortune-telling as Caravaggio's had been in the 1590s.

The above-mentioned ability of La Tour to tell a story vividly by means of carefully calculated gestures and expressions makes all the more surprising the fact that he so rarely – as we shall see – undertook narrative subjects in his religious works, but, with few exceptions such as the 1650 *Denial of Saint Peter*, settled for solitary, or sometimes two, contemplative figures. It is with La Tour's religious works that we must continue the present narrative around 1630.

Art and the Catholic Reformation

The Catholic reformation of the late sixteenth and the seventeenth centuries affected every artist who produced religious works in the Catholic parts of Europe and the Americas. Its aims and its courses of action against the perceived threat of Lutheranism and Calvinism from the north of Europe were officially discussed and codified by the Council of Trent, which met from 1545 to 1563. In the decree of its twenty-fifth and last session in December 1563 the Council established the role of religious imagery:

> Let the bishops diligently teach that by means
> of the stories of the mysteries of our redemp-
> tion portrayed in paintings and other represen-

tations the people are instructed and confirmed in the articles of faith, which ought to be borne in mind and constantly reflected upon; also that great profit is derived from all holy images, not only because the people are thereby reminded of the benefits and gifts bestowed on them by Christ, but also because through the saints the miracles of God and salutary examples are set before the eyes of the faithful, so that they may give God thanks for those things, may fashion their own life and conduct in imitation of the saints, and be moved to adore and love God and cultivate piety.[107]

The principal requirements for the presentation of this imagery were clarity, simplicity, intelligibility, realistic interpretation, and emotional stimulus to piety.[108] These demands can be seen as part of the larger reaction against the formal and iconographic complexities of the various mannerist styles that had developed in European painting by the middle of the sixteenth century. While the decrees of the Council of Trent were laconic, they generated an extensive theoretical literature with a variety of detailed clerical directives to artists. But no homogeneous nor official reformed Catholic style developed, given the wide variety of local traditions in Rome or Paris, Naples or Utrecht, Madrid, Prague, or Nancy. While there are occasions on which artists can clearly be shown to have followed the programmatic and stylistic demands of a particular commission,[109] more often we can say no more than that a painter adopted one of the several possible anti-mannerist styles, while necessarily conforming to the subject matter of the Catholic reform. Documentary evidence to explain La Tour's choice of subjects in particular instances is usually lacking, but his religious works are conventional in their themes. He opted to work in the Caravaggesque style, one of the most forceful of the anti-mannerist styles, which he developed in a personal way. Other options would have been the middle-of-the-road classicism of Constant – which was a local version of the clear and didactic classicism developed in Rome and Bologna in the 1580s and

1590s by artists such as Scipione Pulzone, the Cavaliere d'Arpino, and the Carracci – or Wayembourg's more Flemish and realist version of the same.[110]

The decrees of the Council of Trent were well known in Lorraine.[111] The Jesuit Louis Richeôme, author of a typical post-tridentine pamphlet on the didactic use of art – *La Peinture spirituelle ou l'art admirer, aimer, et louer Dieu en toutes ses oeuvres et tirer de toutes profit salutaire* – taught at the Catholic university in Pont-à-Mousson: "There is nothing," Richeôme wrote, "which pleases more and which more suavely slips something into the soul than painting, nor which imprints it more deeply in the memory, nor which more effectively pushes the will to get it going and then moving energetically."[112] Although it is unlikely that La Tour thought consciously of his paintings as weapons to further Catholic orthodoxy, the economy of design, the clarity of narrative, and the emotional intensity of his devotional works conform to the demands of the reformers epitomized above, while his preferred subjects read like a list of their recommendations.

Lorraine in the late sixteenth and early seventeenth centuries was an active participant in the Catholic reform movement, by virtue of its geographical location, the religious conviction of the dukes, and a long history of allegiance to Rome. The Council of Trent's demands for the reform of the institutions of the church and reassertion of its spiritual primacy found fertile ground in Lorraine. Against the threat of Protestantism, the duchy readily became part of a Catholic line of defense running from Rome, through Tuscany, Lombardy, Savoy, the Catholic cantons of Switzerland, Franche-Comté, Lorraine, and the Spanish Netherlands to the North Sea. Unlike the Gallican (French) church, which maintained political and doctrinal independence from Rome and paid scant attention to the Council of Trent, the duchy kept close contacts with the Holy See in all matters political, religious, and cultural.[113]

The close alliance of politics and religion had a long history in Lorraine. Since the fifteenth century the Cordeliers, a powerful branch of the Franciscan order, had been closely associated with the dukes, a relationship that was confirmed when the order was permitted to establish an important monastery in Nancy adjacent to the ducal palace of René II in 1477. Their church became the ducal sepulchre, which was expanded by Charles III with the addition of a circular mortuary chapel for his family and supporters in 1609–1612, somewhat on the model of the Medici Chapel in Florence. In the early seventeenth century this monastery was inhabited by some fifty monks and became the central guiding agency of the Franciscans throughout Lorraine. Not only was it the center of Franciscan administration in the duchy but it continued to offer advice to the dukes on political as well as religious matters. In the early 1590s Charles III had been encouraged to take sides with The League, an association of Catholic states and groups within France, who agitated against the Protestant French king Henri IV; and in the late 1620s Charles IV was advised, ill-fatedly as it turned out, to take the Catholic and imperial side against Louis XIII and Richelieu, whose cynical alliances with Protestant states threatened Catholic hegemony.

The monastery of the Cordeliers in Nancy was an important center for the development and dissemination of doctrine and practice, notably veneration of the Virgin, considered the protector of the dukes, their city of Nancy, and their duchy of Lorraine. Wayembourg's altarpiece of *The Institution of the Rosary* (fig. 4), commissioned for the Church of the Minims, is a good illustration of the cult of the Virgin that was encouraged in Nancy, with its representation of the ducal family in adoration of their protector. The magical power of the Virgin's and saints' intercessions, the orthodoxy of miracles, and other mysteries of faith were all encouraged by the Cordeliers through the publication of hagiographic pamphlets, edifying sermons, *Lives* of the saints, and by the encouragement of popular forms of devotion such as pilgrimages and the promotion of local miracles. In 1630 Callot provided the frontispiece (fig. 55) for a pamphlet by Father Nicolas Julet, superior of the Minims in Lorraine: *Miracles et grâces de Notre-Dame de bon Secours lès Nancy*.[114] Published in Nancy under the patronage of the cardinal of Lorraine, the pamphlet extolled a miracle-working statue of the Virgin in a local church founded in the fifteenth cen-

55, 56, 57. Jacques Callot, title page from *Miracles et grâces de Notre-Dame de bon Secours lès Nancy*, by Nicolas Julet, 1630; *Saint Livier*, 1624; and title page from *La Saincte Apocatastase* by André de l'Auge, 1623, National Gallery of Art, Washington, R. L. Baumfeld Collection

tury by Duke René II. Good Catholic reformer that he was, Julet observed, "It is commonly said that images are the books of the ignorant; and I say that images are the books both of the ignorant and the knowledgeable."[115]

It was an important strategy of the Catholic reform to revive the reputations of long-neglected saints or near-forgotten miracles, and numerous examples of this practice can be found in Lorraine. In this spirit of reformatory revivalism the pamphlet *Les Actes . . . admirables du bienheureux Martyr Sainct Livier* (Vic-sur-Seille, 1624), written by Alphonse de Rambervilliers, related the story of a Christian nobleman from Metz who was martyred in the fifth century. Callot provided a frontispiece representing the saint and his martyrdom (fig. 56).[116] Vireval, where Saint Livier met his death, had become a place of pilgrimage and miraculous cures in the fifteenth century, and this reputation was revived during the early seventeenth-century reforms. Callot frequently gave visual expression to the ideology of the Catholic reform by designing frontispieces of modest artistic scope, such as the image of Saint Livier, or another he provided for *La Saincte Apocatastase*, a publication of the celebrated sermons against Protestant heresy delivered by Father André de l'Auge in the Church of the Cordeliers in Nancy in 1619 (fig. 57).[117] The same committed spirit moved his more ambitious suites of intense and moving prints, such as the *Passion of Christ* and the *Life of the Virgin*, and his several images of penitent or martyred saints such as *Saint Sebastian* (fig. 58).

Throughout the first half of the seventeenth century, numerous abbeys, monasteries, convents, priories, and confraternities were established or augmented. Nancy, with a population of about 15,000, had thirty-two religious houses. Various orders of Franciscans revived spiritual traditions rooted in the reforms of their founding father in the thirteenth century and became prominent throughout Lorraine, with 105 establishments in town and country: they included Cordeliers, Capuchins, Minims, Recollects, Tiercelins, and their female counterparts such as the Clarisses, Soeurs Grises, and Annonciades. The Franciscan orders joined Augustinians, Benedictines, Cis-

tercians, and many another, as outposts that served to protect against any incursions of Protestant thought. They maintained popular religious fervor by encouraging the worship of local saints, facilitating pilgrimages to miraculous shrines – such as that of Saint Livier at Vireval or Saint Sebastian at Dieulouard – and promoting the belief in miracles. Popular credulity and traditional beliefs were easily encouraged in rural areas, while ducal towns such as Nancy and Lunéville were strongholds of the faith. The Cordeliers had been supported in Metz and Vic-sur-Seille by the dukes since early in the fifteenth century, but their presence took on a new importance in the later sixteenth century as many of the educated merchant bourgeoisie were attracted to Protestantism. While they lived in more or less peaceful accord with their Catholic neighbors, and under French protection, they represented the type of heretical infiltration that the Catholic reformers wished to arrest. Thus the bishopric in which La Tour was raised was a center of Catholic orthodoxy and apologetic ardor. Numerous religious houses were established in Vic, including the Capuchins in 1613, with the sponsorship of Charles Bouvet, chamberlain of Duke Henri II. Two of La Tour's first cousins, Claude de La Tour on the paternal side and François Mélian on the maternal, were Cordeliers. Claude rose to a respectable administrative office as assistant to Jacques Saleur, who was the *ministre provinciale*, or superior, of the Cordeliers in Lorraine from 1637 to 1642. On the more mundane level of day-to-day business in Lunéville, Georges purchased a plot of land adjacent to his house from the Soeurs Grises in 1620 and bequeathed it to the Capuchins in his will.[118]

Not only did the duchy support the augmentation of the old established religious orders but it welcomed the new and zealous Jesuits, who made their presence felt in Lorraine through vigorous campaigns of strictly orthodox Catholic education. It was no accident that the important Jesuit college founded at Pont-à-Mousson in 1572 was placed more or less at the geographical center of the three bishoprics of Metz, Toul, and Verdun, and on the road and river routes between Nancy and Metz. Pont-à-Mousson joined other strongly ecclesiastical towns

58. Jacques Callot, *The Martyrdom of Saint Sebastian*, 1632/1633, National Gallery of Art, Washington, R. L. Baumfeld Collection

such as Saint-Jean-lès-Marville, Saint-Mihiel, Saint-Nicolas-de-Port, and Vic as bastions against heresy.[119] The famous Lorrainese reformer Pierre Fourier (1565–1640), who had studied at the university in Pont-à-Mousson, described it in a letter of encouragement to the nuns there in 1622 as "a fountain of all manner of doctrine and consolation, which spreads throughout the land and carries its water even further up and to more places than the Moselle."[120]

Fourier was an exemplary example of the spirit of Catholic reform in action. Educated at Pont-à-Mousson, he combined a strongly rational and practical approach to pastoral concerns with an intense piety derived from Saint Ignatius Loyola and the Spanish mystics of the sixteenth century. He joined the monastery of the Chanoines reguliers de Saint Augustin at Chaumousey, near Epinal, where he instituted important reforms in the late 1580s. On a more local level he became famous as the model reforming curé of the small town of Mattaincourt. From the time of his move there in 1597, he encouraged the early participation of children in the exercise of religious lessons. He inspired the foundation of the Congrégation de Notre-Dame, an order of nuns dedicated to the education of girls and women, whose influence spread quickly throughout Lorraine. In 1623 Fourier was delegated by the bishop of Toul, who was in turn responding to the reforming zeal of Pope Gregory XV in Rome, to reform

the moribund Augustinian Abbey of Saint-Rémy in Lunéville, where religious life needed to be rejuvenated and monitored for orthodoxy. The frequent presence of members of the ducal household and their court in Lunéville meant that this move had a political as well as a religious significance: Fourier was both an advisor to the ducal family and a passionate advocate of Lorraine's spiritual alliance with Rome. Fourier resided in Lunéville most of the time for over a year from 1623 to 1624, so there must have been many occasions when La Tour could have come into contact with him. This is not to suggest some sort of influence of Fourier on La Tour, which cannot be demonstrated one way or the other. On the other hand Fourier was well aware of the potential power of images as aids to devotion: at Pont-à-Mousson he had studied under Louis Richeôme, cited above for his belief in the efficacy of art in the campaign for souls.[121] In 1616, for his parish church at Mattaincourt, Fourier commissioned from the painter Claude Bassot an altarpiece devoted to the life of the local Saint Evre (a bishop of Toul in the sixth century). Bassot (born c. 1580), who was active in Epinal, the Vosges, and elsewhere in southern Lorraine, worked in a somewhat archaic style, with figures often borrowed from prints by and after early sixteenth-century northern artists such as Albrecht Dürer and Jan Gossaert. The Germanic style of Bassot, with its angular forms and what Jacques Choux has called

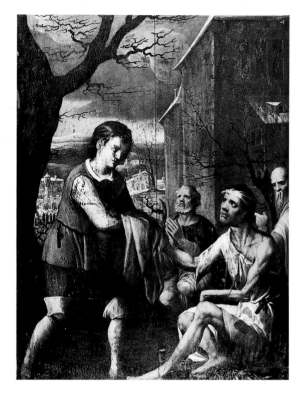

La Tour lived in a society, not much changed since the middle ages, where religion still penetrated every aspect of daily life. Its truths, superstitions, and consolations must have been all the more meaningful in a fragile world menaced by heresy, plague, famine, and war. Religion could be a matter of cynical political expediency, unquestioning credulity and primitive superstition, a profoundly meditated and sincerely felt aspect of the mind and the spirit, or, increasingly in sophisticated circles, doubt. So far as we know, La Tour did not execute commissions for churches, as did painters such as Wayembourg, Constant, Le Clerc, and even Bellange. Yet his art was far from untouched by the spirit of the Catholic reform. Most of his religious subjects are exemplary of its favored imagery: the Apostles; Mary Magdalene, embodying repentance and pure spiritual love; other repentant saints such as the Apostle Peter; Saint Jerome, one of the early Fathers of the Church; Saint Sebastian, martyred for his unflinching fidelity to the faith, receiving the loving attention of the holy woman Irene; the humble and paternally loving Saint Joseph; Saint Anne, paragon of maternal love, instructing the Virgin; Saint Francis in a rapture of divine ecstasy; Saint Alexis, who renounced worldly honor and riches for a life of ascetic devotion, and so on. But as we shall see, La Tour's reading of a theme was always thought through in a personal manner: he never made religious painting a matter of superficial persuasion. For him it was an occasion for reflection and meditation, which led him to envision and execute some of the most moving pictorial images of the Catholic reform.

A compelling example of La Tour's intense originality of vision is his gritty image of *Saint Thomas* (cat. 13). He is another solitary and sharply observed individual, clearly descended from the same stock as the Albi Apostles. But in the clarity of his illumination, in the firm and assured way the whole is executed, and in the particular modeling of the face, the finely impasted handling of the wrinkled brow, the creased eyes, and the hair and beard, he must be close in date to the Nantes *Hurdy-Gurdy Player*. Here is an old soldierly companion for the Albi *Saint James the Less* (cat. 6), another hardy man of the people –

a "popular realism," is an important reminder of the proximity of Lorraine to the Rhenish states and confirms Cuzin's suggestion elsewhere in this catalogue that we might look eastward for some of La Tour's sources. The scrawny and awkwardly posed beggar in Bassot's *Saint Evre Giving His Clothes to a Beggar* (fig. 59), a panel from the Mattaincourt altarpiece, seems to point the way to La Tour's *Saint Jerome* (cat. 14) discussed below.[122]

Thus La Tour must have encountered many different approaches to the expression of faith. The intense, ascetic Fourier, reader of the works of the Spanish sixteenth-century mystics at Pont-à-Mousson, would have been quite a different type of prelate than Alphonse de Rambervilliers, with his collection of curiosities and international correspondence with humanists and antiquarians. Whereas Rambervilliers solicited French favor, Fourier, who was passionately committed to the cause of the Catholic dukes of Lorraine, went into exile after the French occupation in 1634. La Tour was worldly wise and certainly no ascetic; yet in his art he could express intense religious ardor.

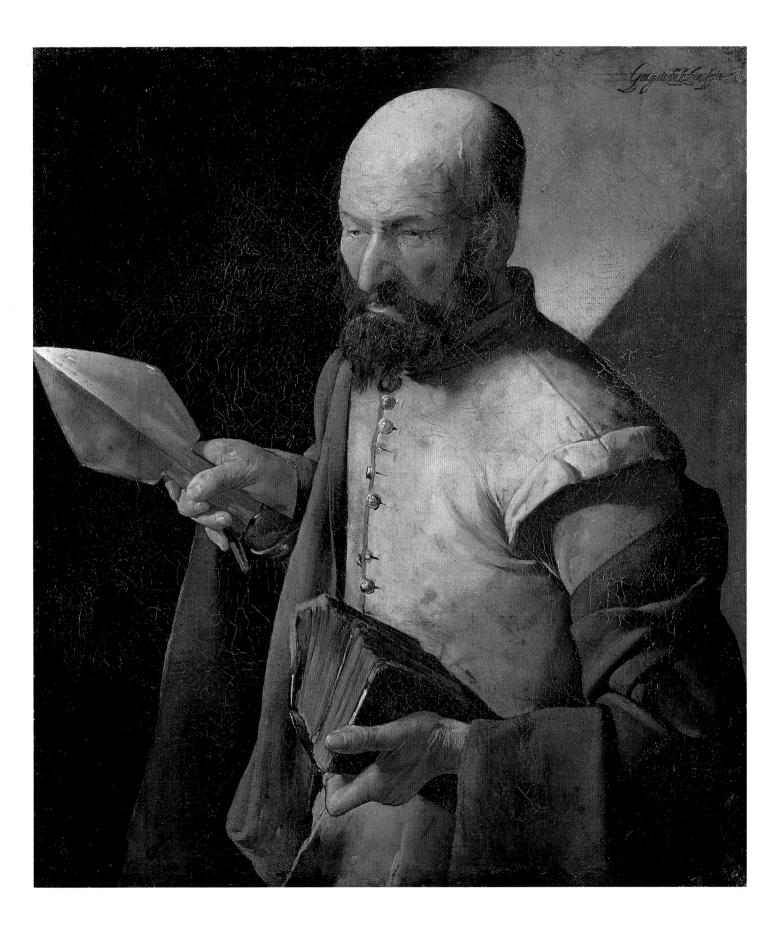

Life and Art of La Tour

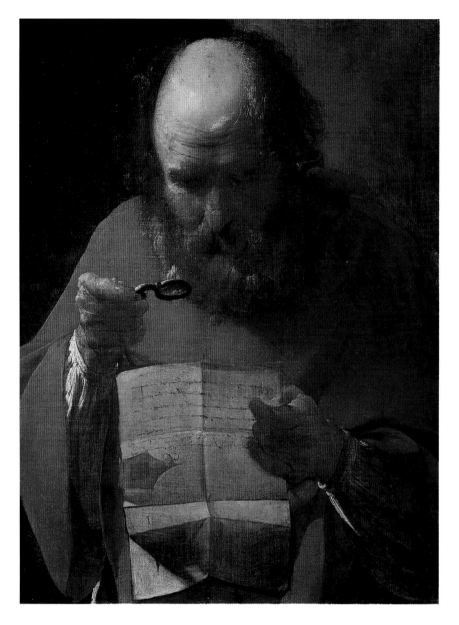

60. Georges de La Tour, *Saint Jerome Reading*, c. 1624, The Royal Collection, Her Majesty Queen Elizabeth II

modified depiction) – painted with an assured hand, brilliantly conveys the meaning of his image. And what a declaration we see in the determined flourish of the artist's signature.

Saint Jerome was a more typical example of those saints whose stock rose during the Catholic reform. This fourth-century saint was one of the so-called Fathers or Doctors of the early Christian church (along with Ambrose, Augustine, and Gregory), whose historical importance lay in their formation of the fundamental doctrines and practices of the Latin church in its early centuries. The Catholic reformers were eager to reassert the precedence and the time-honored traditions of their faith, so attention was focused on these formative figures, with Jerome ranked as the most important one by the Council of Trent.[123] La Tour painted an almost half-length figure of *Saint Jerome Reading* (fig. 60) in the mid-1620s, at about the same time as the Albi Apostles: the format of the picture, its brushy style, and even the everyday type of the old man, with his arthritic-looking hands, are comparable to *Saint Philip* (cat. 7) in this exhibition, for example.[124] La Tour emphasizes Jerome the scholar, as he concentrates on reading a document with an eyeglass. This painting was the prototype for several variations on the theme by La Tour, including a painting in the Louvre and one recently acquired by the Musée historique lorrain in Nancy, although both of these works seem to be contemporary copies of good quality, which record lost originals by the master.[125] They both expand the viewer's field of vision to include a desktop with a book – no doubt alluding to Jerome's Latin translation of the Bible – and writing implements. The emphasis is on Jerome's role as a scholar, for which there is a long and venerable tradition in European art.

Another side to Saint Jerome's character was his asceticism: he retired to the desert to deny himself the pleasures of the world and the flesh. But still he suffered visions and dreams of worldly temptations; to deny and to repent for these sinful thoughts, Jerome mortified himself by beating his breast: in pictorial representations of the Renaissance, he is shown beating himself with a stone. Penance for

tough, unflinching, and now sure of his faith, where he once wavered in doubt until seeing the evidence of the spear wound in the side of the resurrected Christ. Clutching a much-studied book, in itself a beautifully observed and rendered still life, we sense the old man's relentless determination as he contemplates his holy mission in Asia, where he was to spread the word of Christ and eventually meet his own martyrdom impaled by a lance. The cool palette – the gray of the spear, the leaden blue of the cloak, the somber earth tones of his carelessly buttoned, military-like jerkin (the same silver-buttoned leather garment worn by *Saint James the Less*, but now in a

one's sins, or repentance, was one of the major sacraments of the Catholic Church, and was duly given a new emphasis during the period of the Catholic reform. Thus La Tour's several representations of Saint Jerome are in the mainstream of Catholic ideology of the day.

In several respects the two autograph versions of *Saint Jerome* in Grenoble and Stockholm (cats. 14 and 15) can be seen as religious counterparts to the Nantes *Hurdy-Gurdy Player*: the elderly men are represented full-length, almost as large as life, and are described with an arresting degree of veracity. The saint's stony cave was the austere location of his penance. The large stone lying in the foreground serves to remind us that in most accounts of his life Saint Jerome mortified his flesh by beating himself, although in both paintings La Tour has followed a very rare iconographic tradition by showing him holding a knotted rope. Glinting highlights draw the spectator's attention to the end of the gruesomely bloodstained rope, and the drops of blood staining the cave floor. This type of penitential self-flagellation was usually intended to help the penitent identify with the sufferings of Christ. In this case the rope probably also relates to one of Jerome's dreams: he was an admirer of the rhetoric of Cicero and regularly read the Roman author's works; in a guilty dream, Jerome appeared before Christ, who reprimanded him for reading the pagan author and had angels flog him as punishment. La Tour has conflated the breast-beating Jerome and the Jerome flogged by angels: no doubt this iconographic peculiarity was specified by the artist's patron, who was most likely the abbot of the Antonite monastery at Pont-à-Mousson, if this was indeed the painting's first home.[126]

The hefty volume on the floor to the right must allude to Saint Jerome's Latin translation of the Bible. Here there is a tiny but arresting detail, present in both paintings but sharper in the Grenoble one: the undone book tie catches the light and casts a loop of shadow. The learned old man has been perusing his Bible and meditating on the transience of our mortal life on earth, evidenced by the skull that supports the book. These two objects may have been so con-

joined to remind us that while life on this earth is ephemeral, the inspired words of the holy text point the way to eternal life. The simple wooden crucifix that Jerome holds in his left hand also reminds him, and the viewer, that it was Christ's suffering and sacrifice on the Cross that redeemed humankind of its sins.

The light shining into the cave of the Grenoble picture is quite harsh, but we cannot tell if it is day or night: the sharpness of the shadows and the brightness of the illuminated passages suggest that La Tour set his model up in his studio and employed some form of artificial illumination. The light is brilliantly deployed to reveal the old man's dry, wrinkled skin and the soft sagging of the declining flesh on his old bones. The steep angle of the floor and the strange, studied shadows cast by the saint look back to the Bergues *Hurdy-Gurdy Player with a Dog* (cat. 5), while the careful observation of his frayed and ripped cloak recalls La Tour's rendering of the worn garments in his *Old Peasant Couple Eating* (cat. 4). The highlights of Jerome's wrinkled brow are rendered with thick paint, while his unkempt beard and tousled hair are sketched with great brio in a lively cascade of brushmarks. This facture is reminiscent of La Tour's treatment of the fighting flautist in the *Musicians' Brawl* (cat. 9) and suggests that the Grenoble *Saint Jerome* might be dated sometime between the Getty picture and the more softly lit and handled Nantes *Hurdy-Gurdy Player* (cat. 11), that is to say between about 1627 and 1630. The nervous energy of the execution of certain passages in the Grenoble *Saint Jerome* gives the painting an urgent expressive force that is held in tension with the relentless and almost cruel yet tender scrutiny of the old man's body. Pontus Grate has captured eloquently the perfect accord of form and content in this great picture: "There is a passion for the truth which would seem painful, were not the rigor of the pictorial structure and the psychological expression so contained. The face is closed off, the gaze turned away: the imperious physical presence of the ascetic finds its counterbalance in a certain moral distance. He holds the bloodstained scourge tightly in his hand, but the rope is immobilized by the rigid design of the composi-

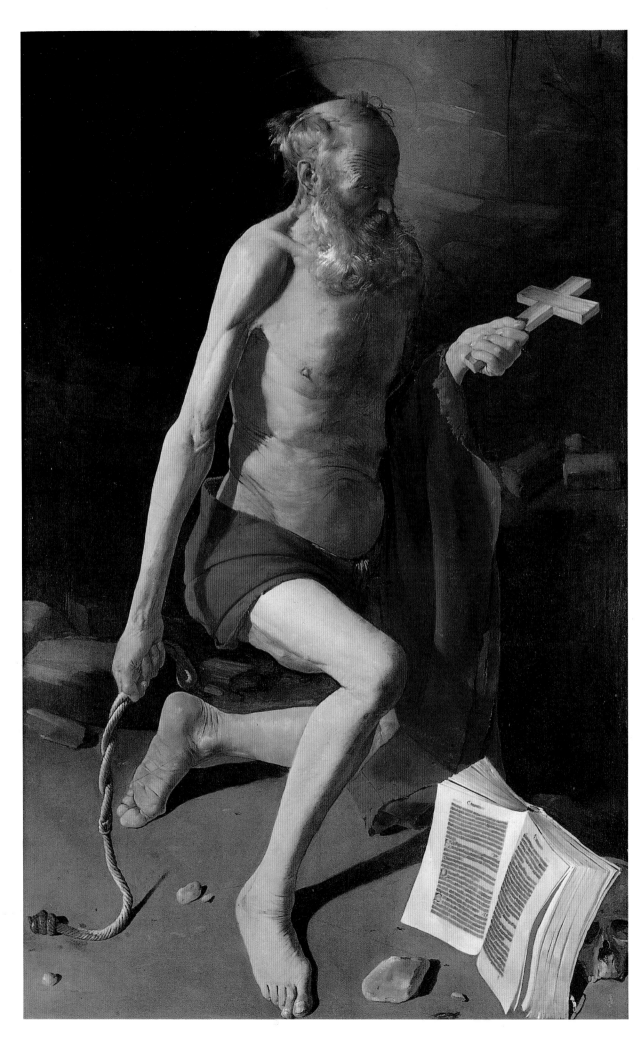

cat. 14. Georges de La Tour, *Saint Jerome*, c. 1628–1630, Musée de Grenoble

OPPOSITE PAGE: cat. 15. Georges de La Tour, *Saint Jerome*, c. 1630–1632, Nationalmuseum, Stockholm

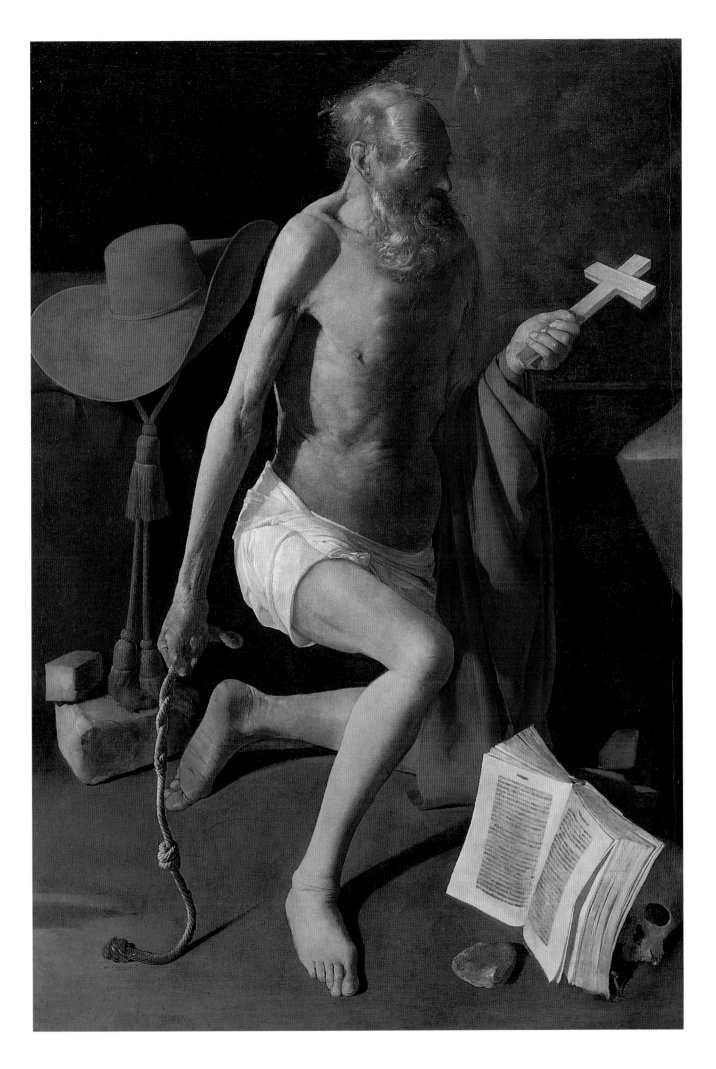

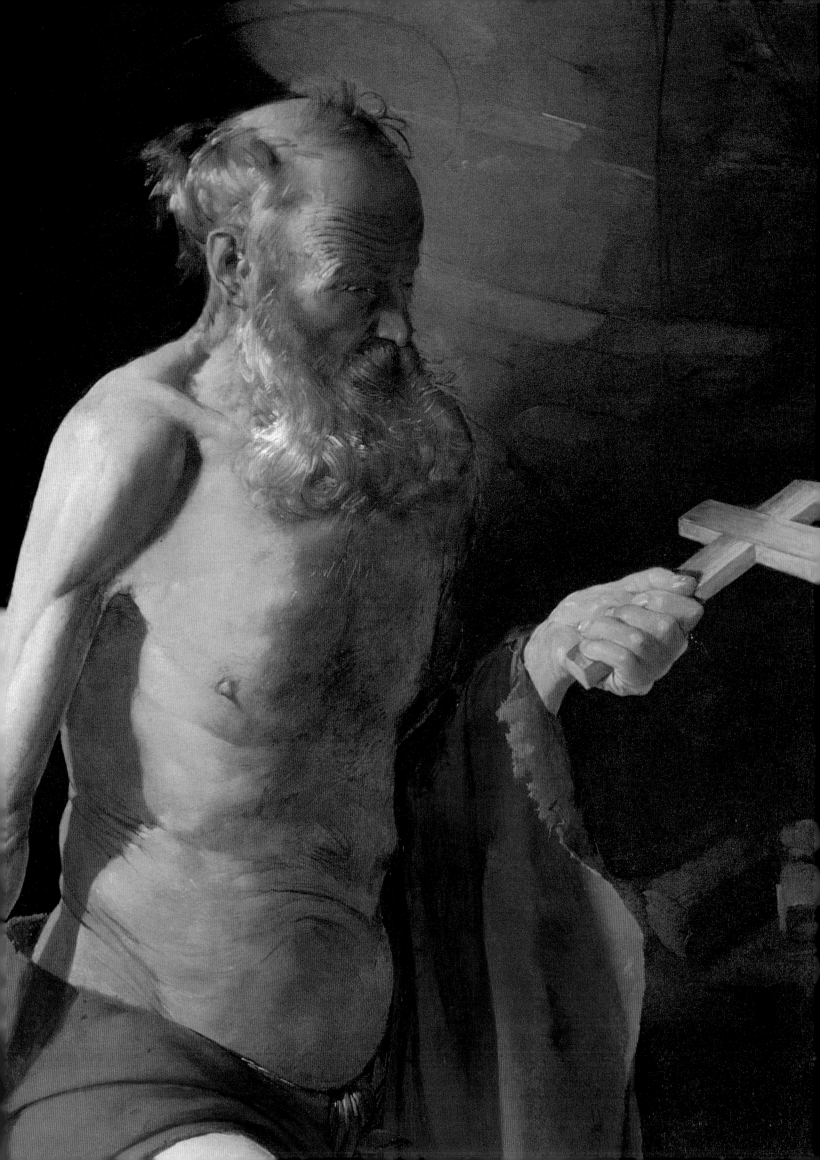

tion. It is not flagellation, a momentary action, but a grievous and tensed-up meditation on the vanity of life and the redemption of the Cross which becomes the essential content of the painting."[127]

As mentioned above, the Grenoble *Saint Jerome* (cat. 14) is said to have been located in the Antonite monastery at Pont-à-Mousson at the time of its dissolution in 1680, when the painting was transferred to the headquarters of the order, the Abbey of Saint-Antoine-en-Viennois near Grenoble; from there it went to the local museum during the French Revolution. Unfortunately this early history cannot be verified in documents, but it would not be surprising to learn that such an intense, even fanatical image of religious devotion was originally conceived for the rarified atmosphere of a religious house. It is significant in this regard that this Saint Jerome is the only saint La Tour depicted with a halo, which is only very discreetly present in the form of a subtle ring of light.

In the postmortem inventory of Cardinal Richelieu's collection taken in 1643 at the Palais Cardinal in Paris is listed a large painting of *Saint Jerome* by La Tour.[128] This is generally agreed to be the version now in Stockholm (cat. 15), on account of the prominent addition of a cardinal's red hat in the background, and because of the similar dimensions of the inventoried and the extant works. This version is less harshly lit and somewhat softer in handling than the Grenoble painting, and it conveys a greater sense of decoration. The most astute comparison of the two works remains the essay written by Pontus Grate in 1959, quoted above in part, after he had studied them side by side at an exhibition in Stockholm.

The relative dates of the two works have been much discussed, but on stylistic grounds the Stockholm painting must date after the Grenoble version.[129] This is not in spite of, but because of, the fact that x-rays have revealed several *pentimenti* in the Stockholm picture, whereas the Grenoble picture has none. Normally such *pentimenti* are interpreted as evidence of artistic changes of mind during the execution of a first version, on the assumption that the design in subsequent versions is copied with

little or no alteration.[130] The Grenoble painting was executed without hesitation or apparent changes and with great sureness of hand. The head in particular is rendered with lively and spontaneous brushwork. But in painting the Stockholm *Saint Jerome*, the artist seems to have worked with more deliberation and made adjustments to the original design as he worked on it. X-rays reveal that underneath the present surface of the Stockholm version is an outline of the figure that corresponds exactly to that of the Grenoble painting. But La Tour subsequently modified parts of the Stockholm figure's contour: he reworked the profile of the saint's right leg and heel to reveal the ankle bone and covered more of his left wrist with red fabric.

The large red cardinal's hat – Saint Jerome was traditionally the first cardinal – is the most striking difference between the two versions and the key to La Tour's modification of the color balance throughout the painting. All of the saint's white loincloth is depicted in the Stockholm version, not just a hint of it, a change surely made to relieve what would have been an overwhelmingly red picture. The open manuscript volume with its colored capital letters is carefully observed in the Grenoble picture, but in the Stockholm version La Tour has suppressed these accents. While there are only minor adjustments to the details of the setting, it is significant that in the Stockholm work Saint Jerome's robe is no longer tattered and even his loincloth is embroidered at the edge. By these means the saint's status is raised, so to speak, and indeed his face is more dignified, less pained and ascetic than that of the Grenoble *Saint Jerome*. The mien of the saint, his costume, the scheme of colors, and the handling of the paint have been adjusted to modify the moral content of the work to one that is more reflective and philosophical, with less of the painful intensity and ascetic rigor of the earlier version. Instead Saint Jerome assumes more of his moral dignity as one of the Fathers of the Church, an intellectual and doctrinal scholar, who pauses to contemplate all the implications of the mortification of the flesh – possibly because it was destined for the collection of Cardinal Richelieu.

The two *Saint Jerome*s have not been seen side

Detail, cat. 14.

by side since 1972, so the present exhibition will be another opportunity to consider the two works in relation to one another and to other paintings by the artist. Some practical questions remain about La Tour's methods of replication: did he have the first version at hand when he painted the second? Was an even earlier *Saint Jerome* the prototype for the two under discussion? How might the design have been transferred from one canvas to the other? Did the artist have a cartoon or preparatory drawings? Indeed, did La Tour ever make cartoons or preparatory drawings? We do not know the answers to these questions, but it seems most likely that La Tour employed a cartoon or template, as his original outline was identical in both works.[131] Similar questions have been raised concerning the closely related Kimbell *Cheat with the Ace of Clubs* and Louvre *Cheat with the Ace of Diamonds* (cats. 18 and 19), addressed by Claire Barry in her appendix to the present publication. On the basis of her scientific research, she proposes that most likely the Louvre painting was done first, and that the Kimbell picture, which alone has a number of significant *pentimenti,* was done second. Her arguments are persuasive, although the evidence is not absolutely conclusive. Owing to their close relationship, probably only a few years separate the two paintings of *Saint Jerome*: if the Grenoble version was painted around 1628–1630, the Stockholm version could have been painted in the early 1630s.

Sacred and Secular: The First Nocturnes

At this point it is necessary to come up to date with historical developments in Lorraine and to consider their possible impact on La Tour. The death of Duke Henri II in July 1624 marked the end of a relatively peaceful and prosperous period in the history of the duchy. The duke and his duchess, Marguerite of Gonzaga, had favored Lunéville as a place of residence, and with their demise La Tour lost the patron who paid him in 1623 for an unknown work and in the following year for the image of *Saint Peter* discussed above. In the absence of a direct male heir, the succession was problematic, but, by a series of outrageous and picaresque political maneuvers, Henri's

nephew and son-in-law Charles de Vaudémont assumed the title of Duke Charles IV at the end of 1625.[132] He preferred Nancy as a base, where he favored Deruet, Le Clerc, and Callot, among other artists, although he spent relatively little time in the capital during his troubled years of rule and misrule.

The early years of the 1630s were the beginning of the end of the duchy of Lorraine as an independent state, culminating in the establishment of French rule in 1634. This situation was brought about by the bad political judgment of Charles IV and the aggressive policy of Louis XIII and Richelieu. The allegiance of Charles IV was to the Holy Roman Empire, on whose side he had fought as a military commander at the battle of the Montaigne Blanche in 1620. This was an alliance with enemies of France, which left Louis XIII a weak frontier in the northeast of his realm. In the late 1620s Charles was fighting in the Palatinate against the Swedes, allies of France, and was receiving financial support from Philip IV of Spain, another enemy of Louis XIII. Moreover, Charles welcomed French exiles in Lorraine: notably Gaston d'Orléans, brother of Louis XIII and at that time heir to the French throne, who had to flee France in 1629 after the discovery of his plot against his own brother and king. Louis XIII and Richelieu took action, and between the spring of 1630 and the end of 1631 the French and their allies the Swedes faced imperial troops and the army of Charles IV, did battle, laid siege to each other all across Lorraine, and signed a series of short-lived treaties. These unhappy events brought Louis XIII and his court to Metz in December 1631 in order to make their presence felt in their protectorate in Lorraine. Then in early January 1632 they spent a week in Vic, where the Treaty of Vic was signed on 6 January. It was soon discovered, however, that only a few days before, on 3 January, Gaston d'Orléans had secretly married Marguerite of Lorraine, a sister of the duke, making Charles IV the brother-in-law of the French king and putting the duchess of Lorraine in direct line for the French crown. Another two years of military conflict ensued, until in September 1633 Louis XIII took possession of Nancy and his Maréchal de Sourdis en-

tered Lunéville. A parliament was established in the old French protectorate of Metz, consolidating French rule there and in the three bishoprics. Charles IV went into exile and abdicated in favor of his brother, Cardinal Nicolas-François, in February 1634. The cardinal quickly arranged his own marriage to his niece Claude, daughter of Charles IV, much against the wishes of Louis XIII and Richelieu, who had hoped to find her a French husband. France further tightened its grip on the duchy, established French governors in Nancy and Lunéville, and demanded from the citizens of Lorraine an oath of allegiance to Louis XIII. Georges de La Tour was one of those who swore allegiance to the French crown on 7 November 1634, as did the majority of people. Some had to be coerced, particularly in certain religious establishments, while the most fervent supporters of the house of Lorraine, such as Pierre Fourier, went into exile.

The presence of Richelieu and members of his administration in Metz and Vic in December 1631 and January 1632 with Louis XIII may well have been significant for La Tour; the cardinal returned in July 1632 with a retinue of French officials for a diplomatic conference in Pont-à-Mousson.[133] It is possible that during one of these visits Richelieu came into contact with the artist and even saw and admired the first version of *Saint Jerome*. Richelieu was collecting works of art in this period to display in the Palais Cardinal in Paris and other residences.[134] It is also possible that La Tour painted the second *Saint Jerome* on his own initiative for presentation to the cardinal: he could hardly have wished for a more powerful and interested patron to appear on his doorstep.

There is no question that La Tour sought favor where he could find it, nor that he would continue to court French interest in the troubled years to come. During the royal visit to Vic in January 1632 Alphonse de Rambervilliers presented the French king with some verses and three crystal medallions. La Tour too would have taken whatever advantage he could of the presence of the king of France. There was nothing unusual about an artist from Lorraine enjoying patronage at home and in Paris, as Bellange,

Callot, Deruet, and Le Clerc had already done.[135]

In the absence of solid documentation from La Tour's own time, modern scholars have attached considerable credence to the brief account concerning a painting of *Saint Sebastian* recorded by the local Lorrainese historian Dom Calmet in 1751: "He presented to King Louis XIII a painting of his representing a nocturne of Saint Sebastian; this work was of such perfect taste that the king had all the other paintings removed from his room in order to leave only this one. La Tour had already presented one like it to Duke Charles IV. Today this painting is in the château of Houdemont near Nancy."[136]

La Tour painted the subject of Saint Sebastian in two formats: vertical with five figures and horizontal with only three. It is generally agreed that the vertical *Saint Sebastian Tended by Irene* now in the Louvre (fig. 78) dates from the late 1640s on stylistic grounds and is probably the documented painting given in 1649 by the city of Lunéville to the French governor, the marquis de La Ferté. This and a second version in Berlin will be considered below, with La Tour's other late works.

Of the horizontal *Saint Sebastian Tended by Irene* (cat. 16) at least ten examples are known, ranging in quality from the creditable to the negligible.[137] It was by far the most copied of La Tour's works in the seventeenth century, partly on account of its topical and moving subject (discussed further below), and perhaps also because a prototype belonged to Louis XIII. Whether or not the two most studied and most frequently exhibited examples in Orléans and Rouen are close to La Tour himself, suggesting they are some sort of studio products, remains an open question. At present there are not sufficient grounds to modify the general scholarly view that they are respectable seventeenth-century copies. Neither has a known provenance before the late eighteenth century, and both of them are dirty, layered with varnish, and have many repainted passages.

Christopher Wright has recently proposed as an autograph work the version of *Saint Sebastian Tended by Irene* included in this exhibition, and has further boldly suggested that it is the painting made for Duke Charles IV of Lorraine and known by Calmet to be

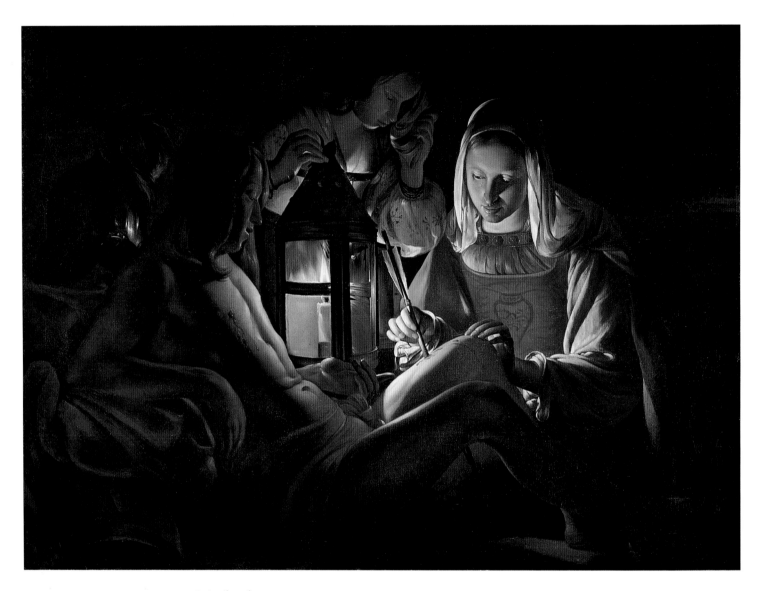

cat. 16. Attributed to
Georges de La Tour, *Saint
Sebastian Tended by Irene*,
c. 1630–1633, Kimbell Art
Museum, Fort Worth

at Houdemont, near Nancy, in the mid-eighteenth century.[138] The condition of the work, however, which has suffered grievously over time and from aggressive relining and harsh cleaning, means that there are few passages left where standard judgments of connoisseurship can be applied. In an appendix Claire Barry presents fascinating scientific evidence, which is one of the bases of Wright's attribution.

One feature that brings the Kimbell picture closer to La Tour's invention than other extant examples is its coloration, especially the bold use of contrasting reds in Irene's costume: crimson in the bodice and magenta in her sleeves. This adventurous use of color is also found in *The Fortune-Teller*, the *Cheat with the Ace of Clubs*, and the related *Cheat with the Ace of Diamonds* (cats. 17, 18, 19), works that may be similar in date to the original horizontal versions of *Saint Sebastian Tended by Irene* and in which La Tour plays with reds as nowhere else in his oeuvre.[139]

Dom Calmet was apparently working from local written or oral traditions and was quite specific about the presentation to Louis XIII. But was he reporting an event that took place in Paris (which implies a later date, as most recent scholars have assumed) or – as Pariset suggested and as seems most plausible to the present writer – was he recounting an essentially local story?[140] It is surely more likely that La Tour presented the French king with his version of *Saint Sebastian Tended by Irene* during one of the royal visits to Lorraine between 1631 and 1633. This could have taken place on the occasion of the king's visit to Vic in January 1632, when a treaty was negotiated for the neutrality of Charles IV and uninhibited passage across Lorraine for French troops. It could also have taken place in Nancy, where Louis XIII stayed during September and October 1633 in the house of Deruet on the edge of the elevated New Town (to benefit from *le plus bel air*, "the finest air," after a summer of the plague).[141] It is surely not just the stuff of a historical novel to imagine Louis XIII staying in a picture-lined room in such a place, only to be overwhelmed by La Tour's nocturne when it was brought in and to clear the room to enjoy its magic spell, as Calmet recounts.

If we accept the implication of Calmet's story

that both Duke Charles IV of Lorraine and the French king received autograph versions of the same composition, La Tour surely executed them within a relatively short span of time, rather than over a period of years. That suggests 1630 or 1631 at the latest for the presentation to Charles IV. In any case, political events in Lorraine between 1631 and 1634 (with hostilities between France, her allies, and Lorraine; the ascendance of French influence; and the abdication of Charles IV in February 1634) make it likely that La Tour's presentation of a first version of *Saint Sebastian Tended by Irene* to the duke took place no later than the beginning of the decade.

In some respects the horizontal *Saint Sebastian Tended by Irene* is one of La Tour's most old-fashioned compositions. Rosenberg has pointed out the similarity of its composition to Bellange's *Lamentation* (cat. 37).[142] Certainly, the raising up of the nude figures and the indeterminate space occupied by their attendants and witnesses are uncannily similar in the two works, and they are both nocturnal scenes. Was *Saint Sebastian Tended by Irene* one of La Tour's first nocturnes since such early works as *The Payment of Taxes* (cat. 1)? That could well explain why he looked back to an earlier prototype, like that of the *Lamentation* of Bellange, and why this painting betrays a certain awkwardness both in the design and in the characterization of the participants. The long-haired and limp-wristed Sebastian is a cousin of sorts to the youth in the left foreground of *The Payment of Taxes*.

These somewhat mannerist aspects of *Saint Sebastian Tended by Irene* locate it in what was already the relatively *retardataire* world of the older generation of Lorrainese artists such as Georges Lallemant. Lallemant's *Saint Sebastian Tended by Two Angels* (fig. 61) probably dates from the later 1620s and is typical of the Lorraine mannerism he took with him to Paris in about 1600, with its closed and rather claustrophobic space, the curious disparity of scale between the angels and the figure of the saint, and the self-conscious elegance of his unlikely attitude; yet there is an attempt to do something new in the realism with which the saint's upturned features are studied.[143] In a Parisian art world of the late 1620s

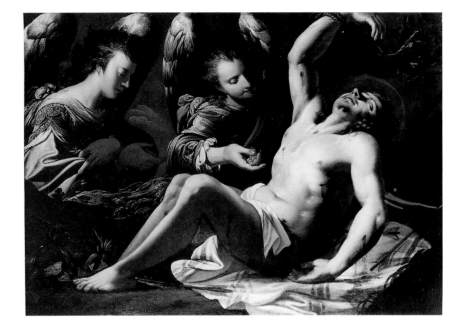

61. Georges Lallemant, *Saint Sebastian Tended by Two Angels*, c. 1620–1630, Museo de Arte de Ponce, The Luis A. Ferré Foundation, Inc., Ponce, Puerto Rico

The emperor responded by having his former guard beaten to death and his body dumped into the sewers of Rome. His body was recovered and taken for burial to the Christian catacombs outside the city walls. Soon afterward the first basilica of San Sebastiano fuori le Mura was erected there. The presence of Saint Sebastian's relics in Rome assured his continuing reputation among the most important martyrs after Peter and Paul.

At the time of the Catholic reform, when the Church was studying with renewed interest its earliest history, Saint Sebastian became especially popular. While his second martyrdom was rarely represented in devotional art, the first near-martyrdom by arrows lent itself to vivid visualization. It was a subject of great interest to artists since the Renaissance, because it allowed the depiction of the idealized nude male body. Unflinching in the face of his would-be executioners, Sebastian epitomized absolute steadfastness of faith. Legend related that, although lacerated with arrows, his body remained intact, uncorrupted, and perfect in form, exempt from the common lot of disfiguration. His recovery from the first attempt on his life demonstrated the Christian triumph over death. The wounded saint tied to a stake or tree could evoke a powerful emotional response in the Christian viewer for many reasons: the immediate empathy evoked by the painful sight of the arrows, the conviction of his faith, and the association with Christ's flagellation and Crucifixion. Perhaps because the plague sores were likened to piercing with arrows, Saint Sebastian was invoked against the plague from early times.

The plague and other similar epidemics were terrible realities of life and death at this time in Lorraine; the area was frequently ravaged by the plague during La Tour's lifetime, not least because epidemics were often carried by the troops who went to-and-fro across the duchy. Lunéville was badly afflicted in the summer of 1631, a date that is not without resonance in relation to La Tour's painting. La Tour's own household in Lunéville was visited by the plague in 1636, when his nephew and apprentice François Nardoyen was one of its victims, within only two months of entering his uncle's studio.[145] La Tour,

and early 1630s that was being transformed by the modified Italian baroque style of Simon Vouet, or alternatively by the rigorous Flemish sense of observation imported by Lallemant's own sometime student Philippe de Champaigne, this *Saint Sebastian Tended by Two Angels* must already have looked out-of-date, or at least provincial. Nor does La Tour's *Saint Sebastian Tended by Irene* betray any knowledge of the advanced artistic tendencies in the work of Vouet or Champaigne around 1630.

Sebastian, one of the first Christian martyrs, remained one of the most popular saints until the seventeenth century on account of his reputation as a protector against the plague. The true details of his life are long lost in the elaborations of hagiographic legend.[144] But he was reputedly a praetorian guard of the emperor Diocletian at the end of the third or early in the fourth century and was denounced for encouraging two Christian friends to remain firm in their faith. Diocletian ordered him attached to a stake, where he served as a target for the emperor's archers. The holy woman Irene, perhaps the widow of one of Sebastian's persecuted friends, came by night to remove Sebastian's lacerated body for burial. She discovered that he was still alive, removed the arrows, and nursed him. After his cure, Sebastian reproached Diocletian for his cruelty to Christians.

who was quarantined outside the city with the rest of his family, had to pay for the corpse to be carted away and buried and for the house to be fumigated. It is most likely that La Tour's wife, Diane Le Nerf, succumbed to an epidemic disease on 15 January 1652, to be followed only a week later by a servant, and then on 30 January by her husband. The fear of a horrible and unexpected death in an epidemic, unprepared, unrepentant, in a state of mortal sin was ever present. Hence the invocation of the early saints Sebastian and Roch, and the more recent Saint Carlo Borromeo (canonized in 1610), for their intercession and protection at times when the plague brought its scourge. We should not underestimate the power of religious ceremonies and images in the early seventeenth century, as Patricia Behre Miskimin reminds us in her essay in this catalogue. The plague knocked at Lunéville's door in the summers of 1630 and 1631, and on 4 July of 1631 it was decided that Mass should be said every day in honor of God and Saint Sebastian, for their favors and intercession.[146]

The research of René Taveneaux and other historians has done much to elucidate the many aspects of religious life in Lorraine in the sixteenth and seventeenth centuries, from arcane doctrinal issues to popular manifestations of faith. Taveneaux has recently drawn attention to an important confraternity devoted to Saint Sebastian, which was founded in 1504 at the monastery of Dieulouard, between Nancy and Metz.[147] The confraternity was dedicated to the safekeeping and veneration of some relics of the saint. In his mid-sixteenth-century *Chroniques de la ville de Metz*, Philippe de Vigneulles recounts how he, his wife, and their servant, stricken with the dreaded disease, made the pilgrimage to Dieulouard to pray at the reliquary shrine and implored the saint to cure them. Their prayers were answered. In the spirit of the Catholic reformers' revitalization of such early Christian saints, a new church was dedicated to Saint Sebastian in Nancy in 1588 and constructed during a series of plague epidemics in the early 1590s. On its completion, most of the ancient relics of Saint Sebastian were moved there from Dieulouard in 1602, and the saint became one of the official protectors of the city. We have already examined Constant's large altarpiece commissioned for this church in 1610 (fig. 5). Years later, in 1636, Constant was commissioned to paint another votive altarpiece for the same church, *Saints Roch, Sebastian, and Carlo Borromeo Place Nancy under the Protection of Our Lady of Loreto* (fig. 62). His patron was Claude Beaujean, a citizen of Nancy who had devoted himself to the care of the victims of another plague that struck the city. The large altarpiece represents the three saints imploring the Madonna of Loreto to come to the aid of the plague-stricken Nancy. The effects of the disease and the good works of Beaujean (whose features were given by the artist to his figure of Saint Roch) are graphically represented by Constant in the landscape.[148]

As far as we know, La Tour did not undertake this type of large altarpiece, with its votive, didactic, and semi-public function. Like Poussin, he seems to have preferred to work for a private clientele, where devotional needs could be combined with aesthetic delectation. Although we do not know how La Tour came to paint the two presentation pieces for the duke and the king, nor who was responsible for the choice of *Saint Sebastian Tended by Irene*, the

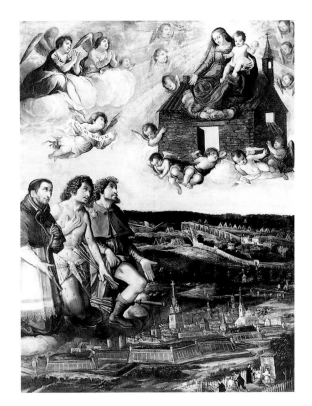

62. Rémond Constant, *Saints Roch, Sebastian, and Carlo Borromeo Place Nancy under the Protection of Our Lady of Loreto*, 1636, Musée historique lorrain, Nancy

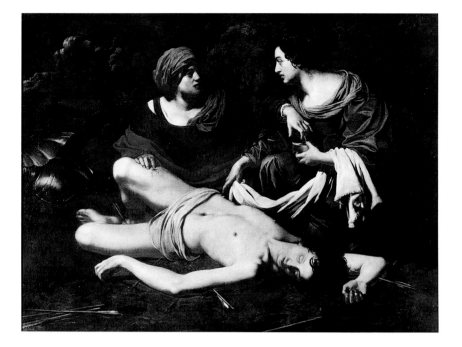

63. Nicolas Régnier, *Saint Sebastian Tended by Irene*, c. 1626, Musée des Beaux-Arts, Rouen

Ter Brugghen's *Saint Sebastian Tended by Irene* (cat. 39), painted in 1625, is one of the most moving depictions of charity and solicitude of the early seventeenth century. It is an evening rather than a nocturnal scene, although ter Brugghen and his contemporaries Baburen and Honthorst are usually associated with the bold chiaroscuro effects of the Utrecht Caravaggists: all three artists traveled from their native, Catholic Utrecht to study in Rome and there fell under the influence of Caravaggio's realism and his use of strong chiaroscuro. This *Saint Sebastian Tended by Irene* was painted in Utrecht, however, a full decade after the artist's return from Italy in about 1614. The spectator looks up from slightly below to the figure of Sebastian, whom ter Brugghen has brought close to the picture plane. His sagging, greenish body contrasts with the rich golden drapery Irene has spread for him. Her servant, marvelously observed from the life, it seems, is untying Sebastian's blackening hand from the tree, while Irene pulls at an arrow. The heads of the two women are full of vitality, in contrast with that of the almost lifeless young man. The dramatic side lighting, which so powerfully models forms in a deep, bold relief, and the elegiacally descending rhythms of the figures, especially the collapsing body of the saint, make this a powerfully affecting work. Unfortunately the earliest provenance of this masterpiece is unknown, but whether it was originally intended for a small altar, which seems possible given its size and vertical format, or was the prize of a sophisticated art collection, the force of its deeply meditated human and spiritual meaning cannot be denied.

Closer to La Tour in its employment of artificial light is the *Saint Sebastian Tended by Irene,* several versions of which are known, by an artist known as the Candlelight Master (cat. 40).[149] The exact identity of this painter is problematic, and the reader is referred to the catalogue entry for a discussion of what has been suggested for his life and activity. He was certainly of the same generation as La Tour, and their art has sometimes been associated and even confused. For all that it is in a tenebrist style, the Candlelight Master's *Saint Sebastian Tended by Irene* is quite different from La Tour's: it infuses a sweet-

subject was likely prompted by the recurring presence of the plague in Lorraine as elsewhere in Europe. Certainly La Tour was aware of the variety of ways Saint Sebastian could be represented, from the altarpieces of Constant to the diminutive etching by Callot, which dwelt on Sebastian's loneliness and vulnerability as a tiny Christian victim in a hostile and violent pagan world (fig. 58).

La Tour, however, did not depict the suffering of the saint, but rather the more tender and charitable moment when Irene and an assistant are removing the arrows and sponging his wounds. Depiction of this pathetic episode is rare before the period of the Catholic reform. The idea of a caring faith and of a faith that had a visible dimension of social responsibility – put into memorable practice in the modern world by the example of Carlo Borromeo caring for the destitute in Milan, for example – was a notion that could counter Protestant allegations of Catholic venality and doctrinal obscurantism. The fact that Irene's visit to Sebastian took place at night must have made it attractive to tenebrist painters, especially the international group who worked in Rome and were directly inspired by the art of Caravaggio, such as Giuseppe de Ribera, Nicolas Régnier (fig. 63), the Candlelight Master (cat. 40), or ter Brugghen (cat. 39).

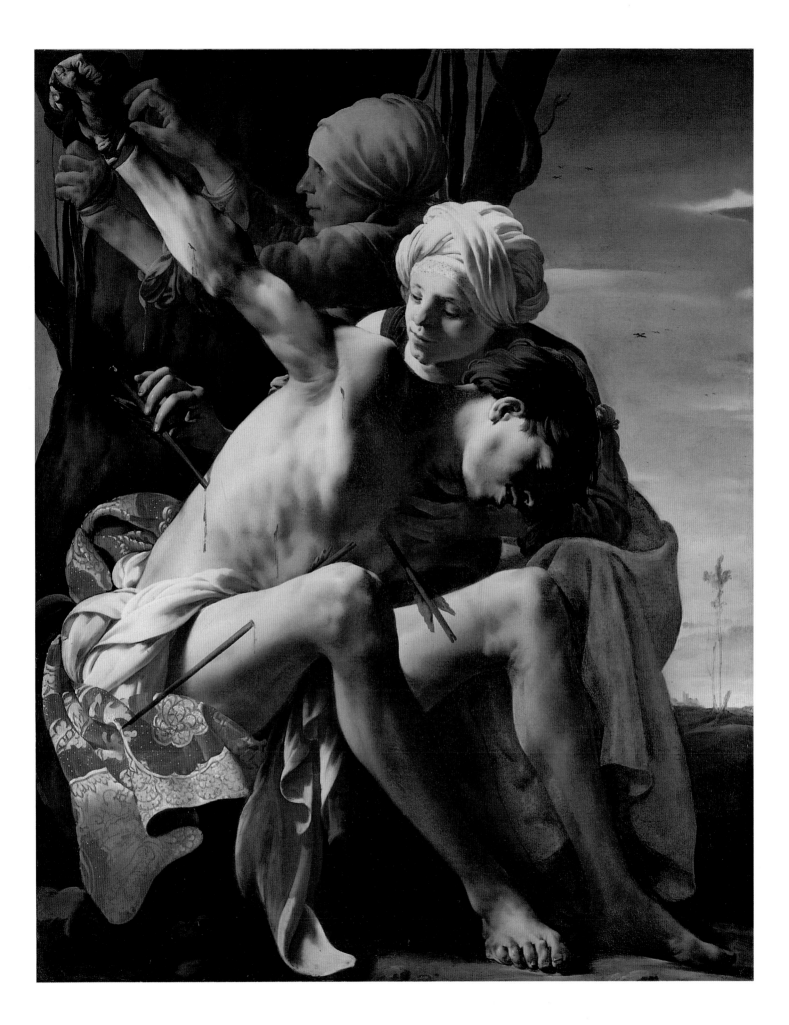

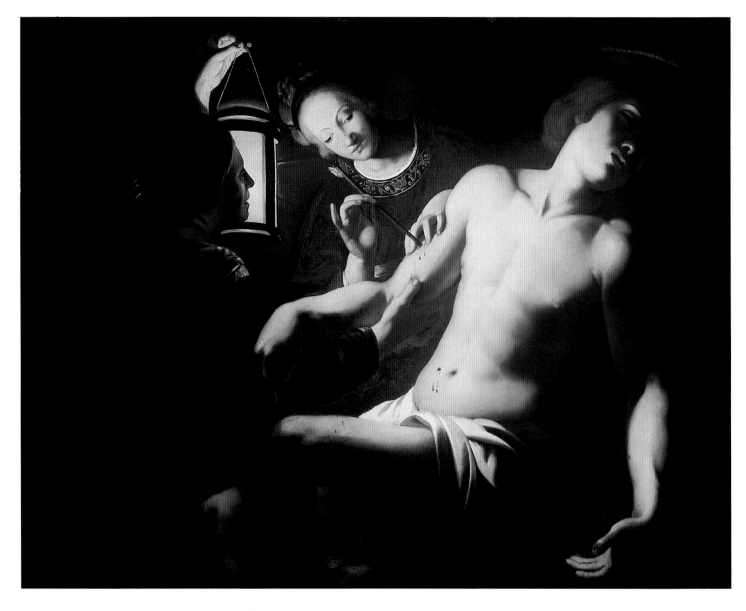

cat. 40. The Candlelight
Master, *Saint Sebastian
Tended by Irene*, c. 1630,
The Bob Jones University
Collection, Greenville

64. *Lucet et Ardet*, from
Henri Engelgrave, *Lux
Evangelica*, 1659 ed.

study of the symbolic use of light in Lorraine in this period, particularly in relation to the light imagery found in emblem books, with their somewhat hieroglyphic images and pithy captions employed to teach and to stimulate reflection at many levels of understanding, from the mundane truism to the learned and recondite conceit. Such literature and visual imagery were part of the mental furniture of the age and can be of assistance in reading its art – as long as we keep the context in mind. Typical of such emblem books is *Lux Evangelica* (*Evangelical Light*) by the Antwerp Jesuit Henri Engelgrave, which went into five editions between 1648 and 1659.[150] An image of a lantern casting its rays of light into every dark recess of an obscure interior (fig. 64) carries the motto *Lucet et Ardet* (*It Lights and Burns*). Thus we are invited to reflect on the meanings that can be attached to what would otherwise be little more than an everyday household item: the burning, or ardor, of the flame within the lantern suggests the interior, passive life of the spirit, while the light it casts suggests the active life, lighting the way. If we transfer such meanings into the context of a religious painting of the period, such as *Saint Sebastian Tended by Irene*, the large canvas takes on additional resonance.

Was La Tour's *Saint Sebastian Tended by Irene* copied so often because it was by Georges de La Tour, or because he had created an especially compelling image of tenderness and devotion? The latter suggestion might reflect the times better: the ideal virtues of Irene's gentle care must have had considerable resonance at this time of pestilence. If a date around 1630–1633 is accepted for the two original versions mentioned by Dom Calmet, we might ask how important was the name of Georges de La Tour outside Lorraine at that time? It seems only during the course of the 1630s that his name became better known in Paris, after the French had taken control of Lorraine. Was it the ducal or the royal version that was the prototype for the copies? The fact that several of them have provenances from west of Paris, located within an arc from Orléans in the south to Honfleur in the north and including Evreux and Rouen, suggests the presence there of Louis XIII's picture (possibly deposited in a royal residence, or

ness and grace in the attitudes of the women and a nonchalant elegance in the pose of Sebastian, all of which seems calculated to evoke worldly and aesthetic responses as much as to arouse feelings of Christian piety or sympathy for this act of charity.

When we turn again to La Tour's composition, we can only regret that no version survives in pristine condition. We have to use our imaginations and what we know of his other works to reconstruct this image in our minds. A painting by La Tour in a good state of preservation is vivid, arresting, and moving. The nocturnal setting of *Saint Sebastian Tended by Irene* reinforces the contemplative, rather sepulchral mood. The selective light cast from the lantern draws our attention to the essential features of the religious drama: the still beautiful body of Sebastian, a glint of the armor on which he is reclining, the tearful assistant, and above all the tender concentration of Irene. La Tour gives the scene a meaningful resonance by its visual similarity to the Lamentation, when the Virgin and sometimes other figures are represented mourning over the body of Christ.

The different forms of artificial light employed by artists in the sixteenth and seventeenth centuries had a more nuanced and resonant range of meanings for contemporaries than they do for the modern spectator. Paulette Choné has made a thorough

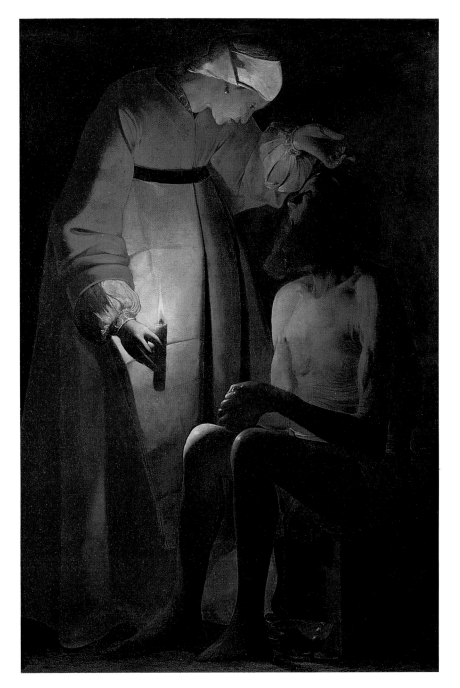

65. Georges de La Tour, *Job and His Wife*, early 1630s, Musée départemental des Vosges, Epinal

sent out to a religious house or as a diplomatic gift to a loyal supporter) – or at least a high-quality copy that could have served as the model for the others at an early date.[151] It is much less likely that so many copies of such varying quality were sent from Luné-ville, or later from Paris, to this one region of north-western France. If the horizontal treatment of *Saint Sebastian Tended by Irene* presented by the artist to Louis XIII was a work "of such perfect taste that the king had all the other paintings removed from his room in order to leave only this one," the royal provenance must have given it an added luster and esteem. The possession of a copy of the king's picture may well have made it all the more desirable, perhaps even more talismanic.

It is proposed here that the two original hori-

zontal versions of *Saint Sebastian Tended by Irene* were the prelude to La Tour's great series of noc-turnes of the mid-1630s and 1640s. If he painted other night scenes between the early *Payment of Taxes* and about 1630, which is quite likely, they are now lost. On stylistic grounds two of La Tour's most re-markable nocturnes – *Job and His Wife* (fig. 65) and *The Flea Catcher* (cat. 20) – appear to the present writer to have been painted at a date close in time to the horizontal versions of *Saint Sebastian Tended by Irene*. *Job and His Wife* has suffered severely: the paint is flattened and abraded, with only a few pas-sages of modeling and graphic surface detail un-affected. La Tour's Job is a cousin of his Saint Jerome, not just in physical type but in the way the shadowed creases of his wrinkled skin (or what remains of them) are drawn with the brush. The raised hand of Job's wife and the sagging skin folds of the old man's torso, which we must imagine with their lost and abraded paint in place, can be compared with the raised hands and the creased face of the old crone in the *Fortune-Teller* (cat. 17). The hand of Job's wife holding the candle, far from being a precocious piece of abstraction, is not so much modeled by light and shade as reduced to a grotesque prong by the loss of the nuancing glazes. There is a mannerist aspect to this bizarre and cramped composition, as Job's wife arches awkwardly over the old man. Her spectral, high-waisted figure is descended from the women of Bellange. La Tour has reduced the trappings of his narrative to the barest emblematic necessities, an approach to composition that will prove to be char-acteristic of his religious works of the mid-1630s and 1640s. The setting is even more austere than Saint Jerome's rocky cell; the broken bowl at Job's feet provides the only clue to his identity, for according to the biblical account (Job 2:8) he scraped his sores with a potsherd.[152] We are closer here to the world of the *Payment of Taxes* than to the serene and mea-sured perfection of a truly late work such as the ver-tical version of *Saint Sebastian Tended by Irene* (fig. 78), in whose company *Job and His Wife* is usually considered.[153]

The Flea Catcher, usually assigned a date in the late 1630s or the 1640s, shares a warm palette with

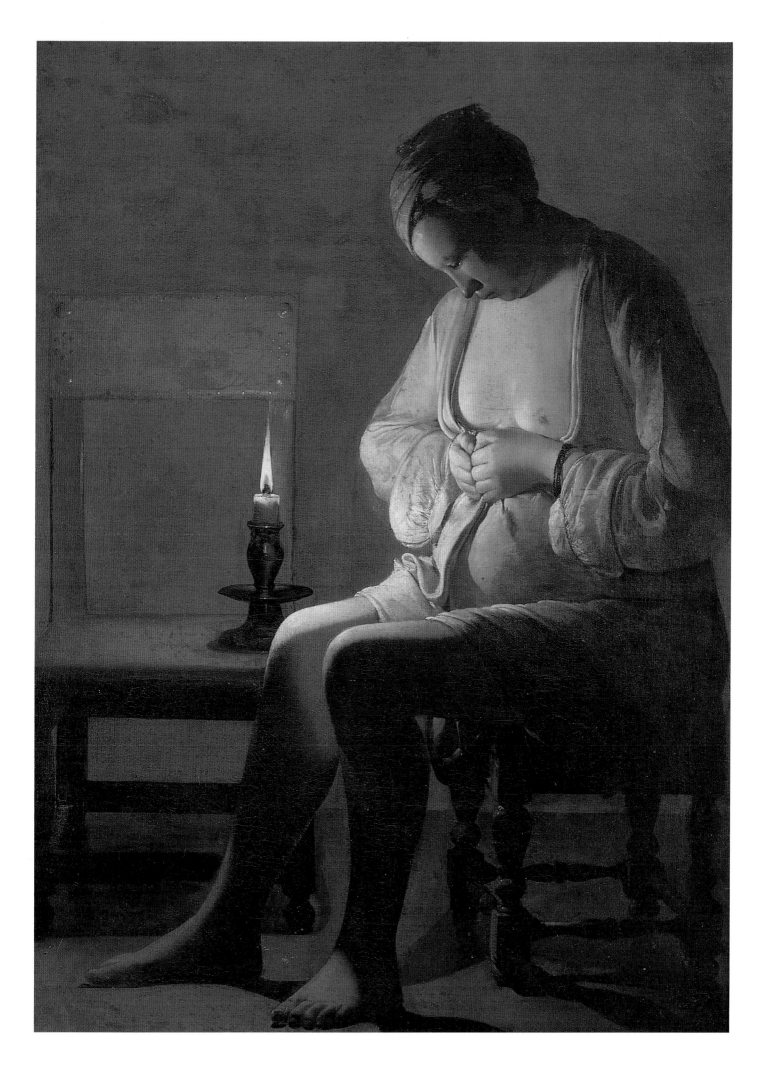

both the horizontal *Saint Sebastian Tended by Irene* and *Job and His Wife*. The studs on the back of the chair, which catch the light of the candle in glistening highlights rendered by blobs of paint, are reminiscent of the embroidered neckband of Irene. The handling of paint is confident, with vigorous impasto in the sleeves, and there are visible *pentimenti*: for example, around the sleeve in the center of the composition. These freer passages of handling also ally *The Flea Catcher* with other works that seem to be datable to the early 1630s, such as the two versions of *Cardsharps*, whereas the works of the late 1630s and the 1640s are characterized by a more perfected and smooth finish.

Is the young woman with a bulbous forehead who crushes a flea between her thumbnails the same model La Tour employed for the attendant holding the lantern for Irene? Quite possibly. If so, the model is cast in the role of a servant in both pictures. In each work she is wearing a bracelet made of a string of small jet beads. Since antiquity jet had been attributed with magical, amuletic powers. Does this adornment in any case signify a woman of modest rank? A similar jet necklace is worn by the gypsies' assistant in *The Fortune-Teller*. Paulette Choné has noted that a bracelet of jet beads was part of the costume of a young servant girl whose suicide was reported in Nancy in 1607.[154] Slim evidence: but such clues, or attributes as we might call them in La Tour's paintings, should not be neglected. In the nocturnal religious scenes, where the settings are reduced to a minimum and the selective deployment of light focuses the eyes and the mind of the viewer, the accessories always stand out as possible carriers of meaning.

There have been many attempts to identify the subject of *The Flea Catcher*. If it is a simple genre subject, it is unusual in La Tour's works on this large scale for its candlelight illumination: this and other forms of artificial light are normally reserved for their symbolic value in his profoundest religious paintings. The seriousness and the air of contemplation with which La Tour invests this apparently banal subject give it all the feeling of a religious work. Rosenberg has hinted that it may represent a scene from the Bible, yet to be identified. Others have interpreted the woman as Hagar, the Magdelene, the Virgin sequestered by Joseph when he heard of her expectant state, and as a pregnant girl given shelter by a charitable foundation such as the Order of Notre-Dame du Refuge in Nancy.[155] Is she really crushing a flea? Would it not rather be a louse? And is another one visible on her stomach?[156] Alternatively, could she be cracking the shell of a rosary bead, as one scholar has suggested?[157] Or is La Tour's painting a variant of the popular erotic theme in the period, about the intimate adventures of a flea on a woman's body?[158] As there is no trace of humor or playfulness in the scene, and as the young woman is not erotically attractive by the conventions of the time, this last theory is not very plausible. The originality of La Tour's treatment is in marked contrast to the usual ribald approach of other northern tenebrist painters, such as Honthorst, who in his *Flea Hunt* (fig. 66) of 1622–1623 made the subject the vehicle for anything but the meditative scene depicted by La Tour.[159] With less ribaldry, but more discreet eroticism, the Candlelight Master painted a modestly attractive-looking young servant girl pursuing a flea inside her chemise (fig. 67).

The clues to the meaning of *The Flea Catcher* may lie rather in the high seriousness of La Tour's interpretation, conveyed by the absorption of the woman, the grandeur and simplicity of her figure and the furniture, and by the steady intensity of the light; in the woman's lowly status, indicated by her simple attire, modest bracelet, proletarian physique, and humble surroundings; and in the steadfast light of the candle, surely a carrier of religious meaning. Paulette Choné has shown the remarkable range of meanings that candles, oil lamps, lanterns, and torches could have in the emblematic literature of Lorraine in the sixteenth and seventeenth centuries. While we should probably not look too hard in the paintings of La Tour for the more esoteric meanings that are proposed in the emblem books, yet it is valuable to be reminded that the candle could signify Christ, divine light, the truth of the Gospels, fervent faith, and manifest virtue, to name but five of the more obvious possible interpretations.

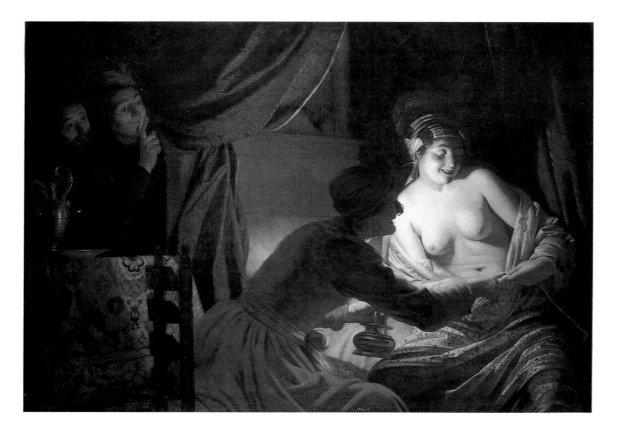

66. Gerrit van Honthorst, *The Flea Hunt*, 1628, Dayton Art Institute, Museum Purchase with Funds Provided in Part by the 1980 Art Ball

67. The Candlelight Master, *Girl Catching Fleas*, c. 1630, Galleria Doria-Pamphilj, Rome

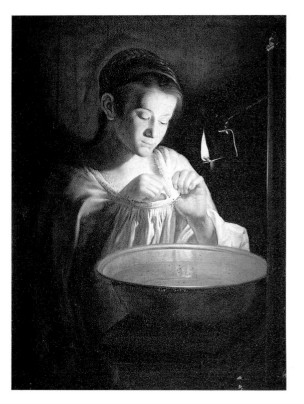

In a painting as carefully meditated as *The Flea Catcher,* there is surely a conceit or irony in the serious treatment given to such a banal, even abject subject. The burning candle could signify both the presence of Christ and the manifest virtue of this young woman: her virtue being her purity. Slatkes has tellingly compared *The Flea Catcher* with a *Young Woman Searching for Fleas* attributed to, or perhaps after, Paulus Bor (Slatkes fig. 9), where the figure also has a rosary draped across her knee. But Choné has also proposed quite a different reading, whereby the burnt-down candle signifies degrading servitude, the sad lot of those who use up their lives in the service of others: "Sad candle that I am, I consume myself and destroy myself";[160] when all else is given in service, little is left but to be consumed by fleas and lice, at least when the master has been a bad one, for: "One only learns about sin and vice, And acquires too often nothing but lice." But the short-lived candle can signify the human condition: "We resemble the candle, which consumes itself in a short time."[161]

How we would like to know the original destination for such a painting. Would contemporary

spectators have pondered some of these ideas, drawn parallels between the meanings of the flaming candle and this humble girl ridding herself of fleas? Before we limit a painting such as *The Flea Catcher* to being a simple description of a scene from everyday life,[162] we should also consider the rich hieroglyphic and emblematic possibilities of visual images in La Tour's time. Simple visual forms could even embody the complicated twists and turns of meaning and interpretation found in the reflective and exegetic language of the clergy.

French Connections

We know rather little about how political and military events in Lorraine affected La Tour and his family during the 1630s and 1640s. We have seen that he could have presented his *Saint Sebastian Tended by Irene* to Louis XIII in Vic in January 1632, or in Nancy in September or October 1633. Such an act of homage to the French monarch would also have been a solicitation of patronage. The king had good relations with other artists in Lorraine. He had commissioned from Callot some of his greatest etchings, commemorating French victories at the Island of Ré and La Rochelle. He had even requested a print of his siege of Nancy, which was a commission Callot was permitted to decline on account of his divided loyalties. Louis XIII stayed in the splendid home of Charles IV's court painter Deruet, who in fact was equally at home in Paris or Nancy, enjoying the patronage of king or duke. It is quite possible that La Tour traveled to and from Paris and Lunéville during the 1630s – or earlier, for that matter, if we accept that he was in the French capital around 1613. But it was not until the end of 1639, as we shall see below, that he was able to call himself *Peintre ordinaire du Roy,* an honorific title accorded to painters who worked for the crown, which brought with it certain privileges, such as exemption from guild regulations in Paris.

There is no doubt that La Tour benefited from the influx of high level French military and administrative personnel into Metz, Vic, Lunéville, and Nancy in the 1630s. An inventory taken in 1673 of the estate of André de Marsal, king's counsel and a former senior legal administrator in Metz, lists several works, which sound like paintings by La Tour: "Card Players," "Two Women with a Little Child in Swaddling Clothes," "A Night," "A Man Holding a Candle."[163] The official who administered La Tour's oath of allegiance to Louis XIII was another French administrator posted to Lorraine, Jean de Bullion. Other members of this family were involved in governing Lorraine: Jean's nephew Nöel was a counsellor at the French parliament instituted in Metz in 1633; Jean's brother and Nöel's father Claude, close to Richelieu, was the king's superintendent of finances and as such was in 1639 one of the signatories of an authorization to reimburse La Tour for a visit to Paris. Claude Bullion was a man of vast wealth, with a superb hôtel in Paris designed by Louis Le Vau and decorated by Jacques Blanchard and Simon Vouet in the 1630s. The inventory of Bullion's substantial art collection taken after his death in 1640 by the painter Simon Vouet included a painting by La Tour: "A night scene representing Saint Peter denying Our Lord, painted by Latour, complete with its stretcher and burnished gold frame." This horizontal painting, about three feet high and four feet wide, must have been a composition something similar to the later *Denial of Saint Peter* (fig. 81), executed in 1650.[164]

La Tour was evidently prepared to associate openly with the French occupiers: he was close enough to Sembat de Pédamond, the first governor of Lunéville, for the governor to be present as godfather at the baptism on 28 March 1636 of La Tour's tenth and last child, Marie. Pédamond had a modest collection of paintings, including images of a lute player, a flute player, cardplayers, kitchen servants, and a number of portraits of Lorraine notables, Pope Urban VIII and Cardinal Barberini.[165] It was this same Pédamond who, on 30 September 1638, was to order the burning of Lunéville to prevent its occupation by soldiers of Lorraine. But La Tour had grown up in the French-dominated bishopric of Metz and had mixed (which is not to say conflicting) loyalties to both France and Lorraine. In any case, from what little we know of the man, La Tour looked af-

ter his own interests and seems to have been little interested in the partisanship of political and religious disputes. Charles d'Escoubleau, marquis de Sourdis (1588–1666), whose troops entered Lunéville in September 1633, was a highly cultivated amateur of the arts and a collector of medals, antiquities, and paintings, especially of the sixteenth-century Italian school. He was to some degree an artistic advisor to Richelieu.[166] We do not know if de Sourdis owned works by La Tour.[167] Maréchal Henri de La Ferté-Senneterre, who became governor of Lorraine in 1643, had a veritable passion for the art of La Tour, as we shall see. The French military was usually under the command of the nobility, bringing with them another army of administrators and representatives of the French crown bearing quill pens rather than swords, often themselves of noble or at least wealthy and well-educated stock. Robert Arnauld d'Andilly, later a religious reformer and translator of Saint Augustine and Theresa of Avila, and an admirer of the painter Philippe de Champaigne, spent time in Lunéville, Nancy, and Metz, when in 1634 he was in charge of provisions and supplies for the army of Maréchal de Brézé.[168]

These French connections in the 1630s indicate that by early in the following decade La Tour's work was well known in Paris, as in the collection of Claude Bullion. We have seen that the Albi Apostles were in the Parisian collection of François de Camps by the 1690s, but they may have been in Paris well before that time. As suggested above, it was quite possibly during his visits to Metz in 1631 or Pont-à-Mousson in the summer of 1632 that no less a personage than Richelieu commissioned or acquired his *Saint Jerome*. An inventory taken in 1643 of Richelieu's château at Reuil included an unattributed "nocturne with musicians," which may be the same work that appeared only two years later in the Parisian collection of the cardinal's niece, the duchess of Aiguillon, but given the name of La Tour.[169] It is notable that a high proportion of works by La Tour in Parisian collections were nocturnes, suggesting that he was indeed known and admired for this specialty. Five works by La Tour found their way into the important Parisian collection of Jean-Baptiste de Bretagne, where they were

inventoried after his death in 1650. This member of the Bretagne family was superintendent of war and served in that capacity in Nancy in 1639 and 1645; he was on another campaign in Lorraine in 1642. He was almost certainly related to the Antoine de Bretagne whom Richelieu sent to Metz in 1633 as first president of the parliament and whose inventory taken in 1670 reveals a tantalizing "oil painting representing a Night."[170] Antoine was succeeded at the parliament in 1639 by his son Claude. The collection of Jean-Baptiste de Bretagne included "a large picture . . . representing two Capuchins meditating by candlelight"; it may be connected with *Saint Francis in Meditation*, a work recorded in one of the rare prints after lost works by La Tour (cat. 34), or even with a painting such as *The Ecstasy of Saint Francis* (cat. 25). Several other works in this collection were perhaps related to works by La Tour that have survived, such as "a sleeping monk" (see cat. 26); "a nurse and child" (see cats. 27 and 28); "a large picture . . . representing fortune tellers" (see cat. 17). Another, "representing pipers, by La Tour, playing by candlelight," sounds perfectly plausible as a painting by La Tour, although no work fitting this description has survived. The engraved *Cornet Player* (fig. 42) is the closest record we have of such works by him. Given the huge inventory of some 350 paintings listed in Bretagne's modest apartment, it has been convincingly suggested that he was an art dealer; quite possibly he took advantage of his postings to Lorraine and elsewhere to accumulate works for sale in Paris.[171] Later in the century we find "a painting representing a Night, an original by La Tour," in the death inventory of Louis XIV's famous minister Michel Le Tellier, marquis de Louvois, while the great gardener André Le Nôtre also had a "Night" picture by La Tour.[172]

Lorraine continued to be ravaged by warfare through the 1630s, and mercenary troops of all nationalities, including those who were supposedly fighting on behalf of Lorraine itself, were merciless in their cruelty and brutality to the population. Contemporary accounts are graphically represented with uncompromising vividness in Callot's two famous series of prints devoted to *The Miseries of War*. In

such circumstances it would not be surprising to find that La Tour made efforts to move to Paris, or at least to spend some time there, where his art had found some support. But he seems not to have done so on any long-term basis. Although the archives provide little information – there are years when we have no idea where he was – it is clear that La Tour remained very much rooted in the local world that he knew best.

Legal transactions, baptisms, a sale of land or grain, the engagement of an apprentice, give a sense of the continuity with more peaceful times. Occasional colorful incidents show a somewhat selfish and arrogant side to La Tour's personality, but we cannot expect an aspiring provincial "nobleman," as he designated himself when he swore allegiance to France in 1634, to conform to any of our post-Enlightenment norms of socially responsible behavior. A couple of examples must suffice here. In April 1642 the town of Lunéville was still in the process of recovering from the devastation of war and tried to raise some revenue by imposing a tax on all citizens based on the number of head of cattle they owned. La Tour refused to pay his share, claiming the exemption from taxes granted to him by Duke Henri II when he moved to Lunéville in 1620. When a sergeant came to his house to serve a writ, La Tour screamed abuse and kicked him. It became a complicated case, with La Tour eventually taking the town to court before the parliament of Metz. In the end it was decided that the privileges La Tour claimed were among those suspended by royal edict in 1640, because of the dire circumstances of war (they were restored in 1644). But La Tour probably exercised considerable connections, for he did at least manage to maintain before a French tribunal that he was entitled to such ducally granted privileges.[173] On this occasion the "nobleman" Georges de La Tour was probably more concerned with privilege than with the relatively small sum of money involved, although in several other documents he reveals himself as a tough negotiator in financial matters.[174] This issue of tax exemption came up again in 1646, when the people of Lunéville petitioned Duke Charles IV (who had a government-in-exile in Luxembourg, creat-

ing a curious situation of alternative French or ducal government of Lorraine) against the privileges of tax exemption claimed by La Tour, two noblewomen of the town, and the local monks and nuns. Among them, they owned more land than the rest of the population and a third of all the livestock. This apparent prosperity of Lunéville meant that taxes were high but were borne only by the poorer majority of the community, most of whom had been reduced to desperate circumstances by the wars. La Tour, moreover, was said to be "odious to the people by the number of dogs he keeps, both greyhounds and spaniels, as if he were the local lord, hunting hares through the cultivated fields, trampling and spoiling them."[175] La Tour was clearly not altogether popular: he was ill-tempered, acting like a haughty country squire with French allegiance and connections, and maintaining the privileges that exempted his property from looting and billeting in the time of war.

Although there are many gaps in the surviving records, it is through archival sources such as those drawn on above that we know La Tour and his family remained based in Lorraine. In May 1638 La Tour was given possession for two years of the house of a local widow, Jeanne Aubry, and he purchased her furniture: this enabled her to finance a trip to France, no doubt as a refugee from the continuing bad situation in Lorraine. Wisely, La Tour had seen to it that he was exempt from any responsibility for the care of the Aubry house.[176] Where were the La Tours when Lunéville was burned by their friend Pédamond in September 1638? Probably enough notice had been given for the remaining population to escape with a few possessions; nevertheless the destruction must have been almost complete, and no doubt it included works by La Tour. We know that at least from February 1639 until early in 1641 the La Tours took refuge in Nancy, where they lived in the house of Olivier Brossin, a nobleman and first chamberlain to the late François of Lorraine, brother of La Tour's patron, the former Duke Henri II.

In Nancy on 22 December 1639, Georges de La Tour described himself for the first time as *Peintre ordinaire du Roy*.[177] The reported presentation to

Louis XIII by La Tour of a version of his *Saint Sebastian Tended by Irene* has often been linked with the award of this title. While it is quite likely that the painting and its presentation were made in about 1632 or 1633 in Lorraine, as is argued above, rather than at the end of the 1630s in Paris, a connection between the gift to the king and a later conferral of the honorific title need not be ruled out. Rather, the title was likely the culmination of several years' solicitation of French, and even royal protection. Another precious document confirms that La Tour did indeed spend some time in Paris in the royal service, late in 1638 or early in 1639, for in May the royal treasury disbursed: "To Georges de La Tour, the sum of a thousand livres payable to him in respect of the journey that he made from Nancy to Paris on affairs relating to the service of His Majesty, together with his stay of six weeks and his return journey."[178] Moreover, a further document of 25 August 1640 concerning one Baptiste Quarin describes him as "the agent of Monsieur de La Tour, peintre ordinaire du Roy, residing in the galleries of the Louvre."[179] Was it Quarin or La Tour who occupied the grace-and-favor apartment in the Louvre? Thuillier has suggested that the wording implies short-term residence, rather than long-term habitation at the Louvre and rightly advises caution in the interpretation of this and other aspects of the document. It does seem reasonable, however, that La Tour should have someone in Paris to look after his affairs in the French capital, as he was clearly not there on a permanent basis: in February 1641 he is described again as living in Lunéville. All the indications are that La Tour did have a Parisian reputation, but not much of a Parisian career. There was a taste for his nocturnes among certain collectors in the French capital, but it was on the home ground of his native Lorraine that his art continued to flourish.

In any case, the artistic climate in Paris was changing quickly, not least with the deaths of Richelieu in December 1642 and Louis XIII in May 1643. Nor would it have been easy for an outsider to find a place among the generation of artists who had secured their positions in the capital during the 1630s and early 1640s, who were resident there with established studios and carefully cultivated clienteles, and who were developing the idea of an exclusive academy, which would come to fruition in the foundation in 1648 of the Royal Academy of Painting, Sculpture, and Architecture, under the new regime of Louis XIV and Cardinal Mazarin. To take one well-documented example, when Nicolas Poussin arrived from Rome in 1640 to work on decorations for the Louvre, he was not well received by Parisian artists, particularly the jealous Vouet and his circle, and was only too happy to find a pretext to return to Rome in 1642. La Tour would not have brought with him the international and perhaps threatening reputation of Poussin; nevertheless we can imagine that it would not have been easy for him to find a niche in the rather closed artistic world of the French capital. Moreover, his tenebrist style must have looked out-of-date and perhaps provincial by 1640 – it was something a number of French painters had already tried in Rome in the 1610s and 1620s, which survived in provincial centers in the work of artists such as Nicolas Tournier in Toulouse, Trophime Bigot in Provence, or Guy François in Le Puy.[180] Caravaggesque tenebrism made quite a contrast with the colorful baroque sophistication of a Vouet, who was the dominant artistic personality in Paris and at the height of his powers in the early 1640s.[181]

The Nocturnes

There is no question that the symbolism, as much as the illumination, of lamps and candles plays a major role in La Tour's nocturnes of the 1630s and 1640s: the type of paintings often referred to as *nuits* and *nuicts* in the inventories of the seventeenth century and for which he was best known in his day as in ours. La Tour's tenebrism is highly motivated, meaningful, and specific to the subject in hand. Just as he invests an everyday object with a meaning that is the key to reading one of his paintings, such as Job's broken bowl, so his choice of Caravaggesque chiaroscuro is not just a matter of stylistic option, but is another vehicle of meaning. At its most basic level the darkened interior enabled the artist to play on the theme of light and reflected light in contrast with

the surrounding obscurity. It could set a mood conducive to contemplation and meditation, both for the actors in his pictures and for the participating spectator. Light and darkness had symbolic values on several levels: most obviously in the contrast between the spiritual darkness of our mortal world, illuminated by the light of the divine. At a more esoteric level, light and darkness are discussed in the devotional literature of La Tour's time, often in a rather prolix style full of literary conceits and teasing paradoxes. Such exegetics serve to remind us that multiple readings of a motif were the norm, not the exception, in the seventeenth century. The aforementioned sermons given by Father André de l'Auge before the ducal court in the Church of the Cordeliers in Nancy, collected and published as *La Saincte Apocatastase* with a frontispiece by Callot (fig. 57), are characteristic of this literature. Evidently inspired by his reading of the Spanish mystics of the sixteenth century, such as Saint John of the Cross, de l'Auge's sermons contain such conceits as the statement that the night on which Christ the Savior was born was brighter than any day, or that the night of our ignorance can only be illuminated by the night of Christ's tears and suffering.[182] Thus the night that envelops La Tour's saints and other religious figures could incorporate many nuances of meaning: the night of Christ's torment, or of the personal torments of Job, or of Saint Peter, will illuminate the night of our earthly ignorance. Even a superficial acquaintance with contemporary sermons such as de l'Auge's can remind us that eyes of the time must surely have read something complex and meaningful in one of La Tour's devotional nocturnes. They were more than the stylistic assimilation of Caravaggio's chiaroscuro, which is found by the modern art historian; the Magdalene's mirror, for example, was perceived as something more than just an accessory of the vainglorious woman.

In a wordy and convoluted exegetic sermon on Christ as a mirror, de l'Auge exclaims:

My Lord, what a beautiful comparison! There are two sides to a mirror, one which is opaque and dark; the other clear and brilliant; in

Jesus Christ, two natures: humanity which is like the reverse side, darkened by the burden of our infirmities, which he assumed; the other, divinity, is like a very clear and transparent crystal, for the infinite glory that is inherent in it. As the Word, he is the candor and the light of the eternal knowledge of the Father, and the infinitely radiant mirror of his person; as the man, he is the mirror of the divine essence, where we see the admirable grandeurs of his grace and his glory. And thus his Gospel is a very clear mirror of the glory of God, by which, when we are reflected in it, we are accidentally transformed and illuminated as if by an emanating reflection of the light of Jesus Christ, as if in a beautiful looking-glass: being the face of our soul seven times more radiant than the sun.[183]

Such a passage makes us regret even more that we do not have a single contemporary commentary on any of La Tour's paintings. No doubt a cleric, with a mind accustomed to exegetics, would have read one of his images of the repentant Magdalene in a more complex way than a layperson. But we should not underestimate the levels of response of the seventeenth-century layperson, familiar with mystical writings or with the interpretation of emblems. Moreover, there is always a fundamental visual clarity and emotional directness about La Tour's images, which slip them easily and agreeably into the mind or soul in a way that would have pleased Father Richeôme.

La Tour's nocturnes most in demand seem to have been those representing the repentant Mary Magdalene, insofar as we can judge from the number of surviving works. Five autograph versions of this subject are known today, of which three are in this exhibition (cats. 21–23), while three other variations on the theme are known from contemporary copies, of which one example is illustrated (fig. 68), another engraved (cat. 33).[184] The repentant Magdalene was a subject much in favor throughout Europe during the period of the Catholic reform. Not only did the sacrament of penitence receive special attention as one of the most important steps to sal-

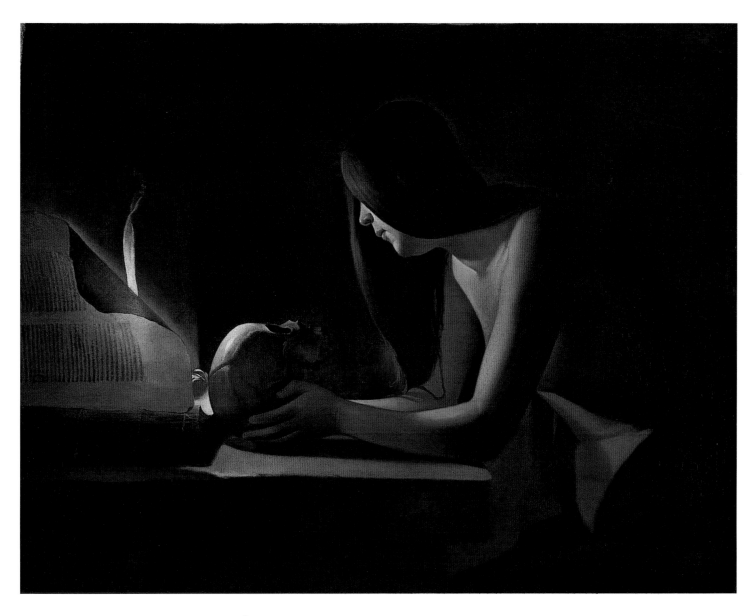

cat. 21. Georges de
La Tour, *The Repentant
Magdalene with a
Document*, c. 1630–1635
(or c. 1645-1650), private
collection

vation, as we have noted above in connection with La Tour's images of the penitent Saint Jerome, but the Magdalene's story had an especially popular and human appeal. She was a direct follower and witness of Christ, yet she had been the most worldly of sinners. After her conversion and repentance, Mary Magdalene matched her former sinfulness with the intensity of her pure and enduring love for Christ. Any mortal sinner might identify with her wrongs and thus be encouraged to follow the example of her self-denial and self-examination on the path to enlightenment and righteousness.

"Mary, called Magdalene, from whom seven demons had gone out" (Luke 8:2), makes only nominal appearances in the Gospels as one of the women who followed Christ in Galilee after he pardoned her for her seven deadly sins. She was present at the Crucifixion, and later with two others also named Mary she went to Christ's tomb, only to find it empty. According to Saint Mark (16:9), the Magdalene was the first person to whom Christ appeared after the Resurrection. In early Christian times she became identified with the woman, unnamed in the Gospel, who washed and anointed Christ's feet at the feast in the house of Simon the Pharisee (Luke 7:37–50) and whose many sins Christ forgave at this time. The Magdalene also came to be identified with the devoted Mary, sister of Martha (Luke 10:38–42). In this connection she was associated with the ideal of the contemplative life, in contrast with Martha, who embodied the ideal of the active life. According to legend, she came by sea, along with Martha, Lazarus, and Maximin to Marseilles, bringing Christianity to the south of France. Later, Mary Magdalene retreated to Sainte-Beaume in Provence.

The Magdalene's legend, a conflation of all the above with many other apocryphal stories, is developed most fully in *The Golden Legend*, a collection of saints' lives written by Jacobus de Voragine in the thirteenth century. This compilation became one of the most popular Christian books and remained a primary source for artists' depictions of the life of the Magdalene as well as of many other saints. According to *The Golden Legend*, the Magdalene had been a courtesan who "gave herself wholly to the pleasures of the senses."[185] Voragine's popularizing work describes three phases of her religious development: penance, inward contemplation, and heavenly glory. He says of the second phase, "she is called 'light-giver,' because therein she drank avidly that which afterward she poured out in abundance; therein she received the light, with which afterward she enlightened others." In the third phase of her heavenly glory, "she is called 'enlightened,' because already she is enlightened with the light of perfect knowledge in her mind, and she will be enlightened with the light of glory in her body." This light-filled imagery was adopted by La Tour, whose images of the Magdalene conflate her repentance with her inward contemplation. La Tour did not necessarily turn back to Voragine for guidance: there were many subsequent commentaries on the Magdalene, not least in La Tour's own day.[186] There was also a long-established tradition of pictorial representations of the Magdalene in various states of penance and contemplation.[187]

Possibly the earliest of the existing autograph paintings of the Magdalene by La Tour is *The Repentant Magdalene with a Document*, dating perhaps to the first half of the 1630s, which we exhibit (cat. 21). She appears to be unclothed from the waist upward, but her torso is concealed in shadow as she leans forward over a thick tabletop. Her long hair obscures most of her face, exposing only the profile of her nose, mouth, and chin. The young penitent still has a certain allure; indeed there is usually an element of voyeurism in representations of her, because she had hidden herself away from the eyes of men. The simple surroundings suggest a cave or other retreat. In her hands she holds a human skull. On the table is a large book, the ragged spine and dog-earred pages of which catch the light, reminiscent of the old tome held by the Louvre's *Saint Thomas*. A raised page of the Magdalene's book curls toward the spectator. A lamp is concealed behind the translucent page, and emits a bright flame, which is flickering at the top and emits a twist of smoke. The light cast by the flame illuminates those parts of the scene that are meant to convey its meaning: the skull, the face of the Magdalene, and her arms and upper

body, reminding us of her former fleshly life. The chief visual interest is in the flame and the beautiful illumination it casts through the page – perhaps to suggest the spiritual illumination of the holy text, through which the divine truth is communicated – and on the skull and the face of the young Magdalene. These parts of the painting are well preserved and, glowing with light as they do in the surrounding obscurity, produce an evocative, melancholy poetry. We cannot follow the Magdalene's gaze to know if she is looking at the skull or into the flame, but either way the emphasis seems to be on the contemplation of the mortality of the flesh. Such a nuance of meaning is suggested in a collection of *Emblemata* published in 1596 by Denis Lebey de Batilly of Metz, to whom the flame of an oil lamp caught in a current of air signifies that the life of man after his nourishment of oil will be extinguished by the breeze of death. Yet we have to be cautious in using this emblem to interpret this painting, since other emblems tell us that the flickering flame is an image of conversion; but that is not irreconcilable with the idea of the Magdalene accepting the way of the eternal life of the spirit, rather than the material ways of the flesh.[188]

In what is probably his next depiction of the Magdalene, the vertical composition in the National Gallery of Art, Washington (cat. 22), which may date to about 1635, La Tour explored a greater complex of ideas. The face of the saint, whose long hair is pulled back, is fully visible, and she rests her chin on her hand, a time-hallowed indication of melancholy contemplation. Here the skull rests on a closed book, concealing the oil lamp and most of the flame. The tip of the flame appears at the top of the skull, bending as if by the breath of the Magdalene. On the far side of the table is a mirror propped up by and almost concealing a container that may be an ointment jar, one of the Magdalene's traditional attributes. Reflected in the mirror are the skull and the book. La Tour uses the mirror not just as a pictorial conceit nor a picturesque accessory; rather, it is essential to the composition and the meaning of the painting. As a traditional emblem of vanity, the mirror can allude specifically to the Magdalene's former

vainglorious life, and generally to the brief illusion that is our life on earth. But the light the Magdalene herself must see reflected in the mirror should be understood as a symbol of God, as in Saint John's description: "In him was life, and the life was the light of all people. The light shines in darkness, and the darkness did not overcome it" (John 1:4–5). It is a light that we can come to understand only gradually in this life, after long contemplation such as the Magdalene is undertaking: "For now we see in a mirror, dimly, but then we will see face to face. Now I know in part; then I will know fully, even as I have been fully known" (1 Corinthians 13:12). Such contemplation eventually leads to spiritual enlightenment: "But all of us, with unveiled faces, seeing the glory of the Lord as though reflected in a mirror, are being transformed into the same image from one degree of glory to another; for this comes from the Lord, the Spirit" (2 Corinthians 3:18).

There is no firm evidence of when La Tour painted his several images of the Magdalene: the cautious execution and simplicity in design of the horizontal version (cat. 21) suggest it is early (although it could placed in the late 1640s by the same argument). The vertical picture in Washington (cat. 22) was probably painted a little later, around the mid-1630s. The lower half of this painting was always deep in shadow and is so dark today as to be virtually illegible. The top half of the composition, however, was used by La Tour in what must have been one of his most popular representations of the Magdalene, as we know from three surviving contemporary copies or variants, one of which is illustrated here (fig. 68); and from one of the very rare seventeenth-century engravings after La Tour, exhibited here (cat. 33).[189] We cannot rule out the possibility that at one time there existed another autograph picture, horizontal in format, that may have been the true source of these copies, all of which offer very slight variations on the Washington picture, notably in the depiction of the Magdalene's hair and garment. But these could equally be the negligent variations of copyists. If there were no horizontal "original," these several copies and variants of the Washington picture would be explained by the fact

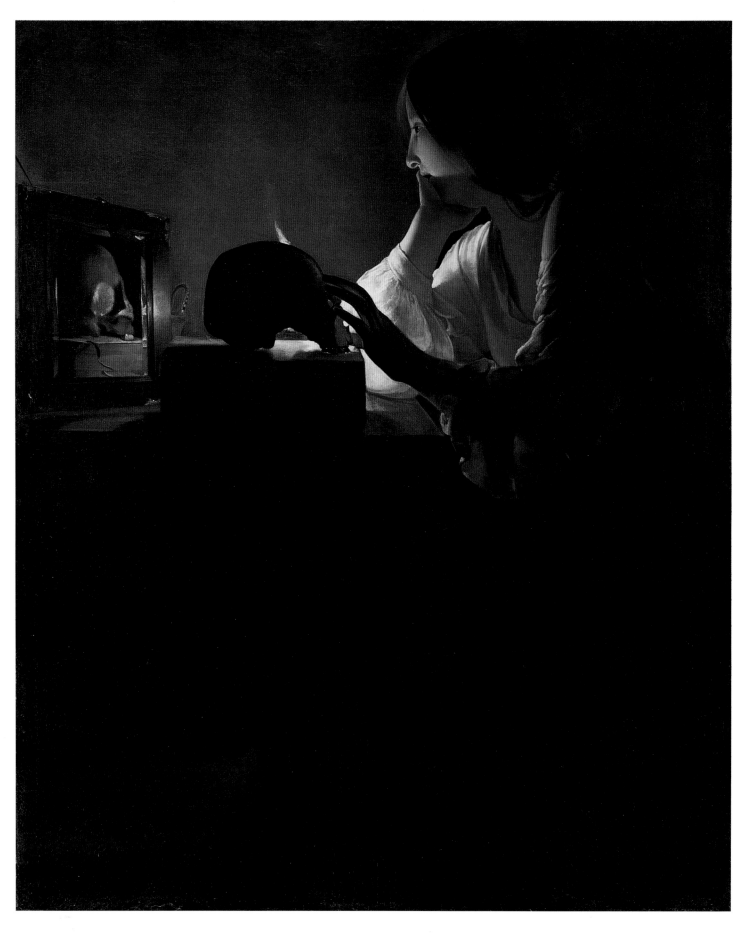

cat. 22. Georges de La
Tour, *The Magdalene at
the Mirror*, c. 1635,
National Gallery of Art,
Washington, Ailsa Mellon
Bruce Fund

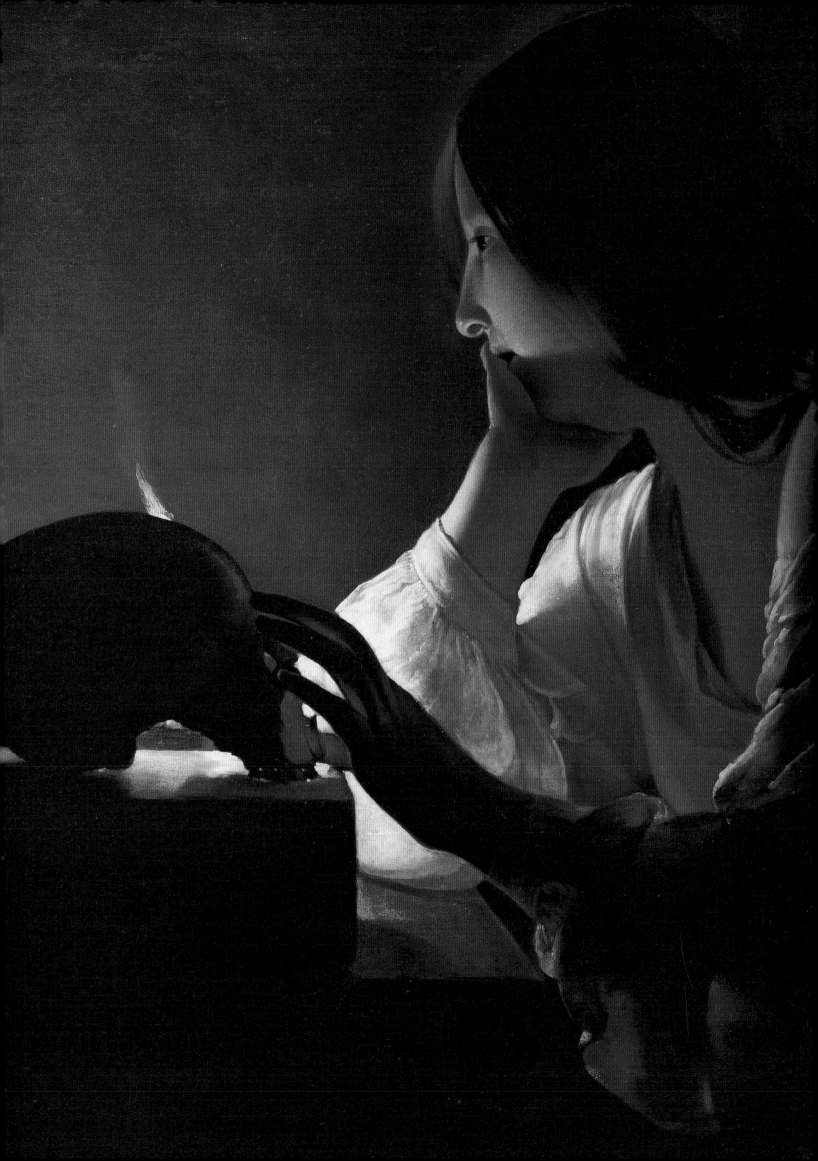

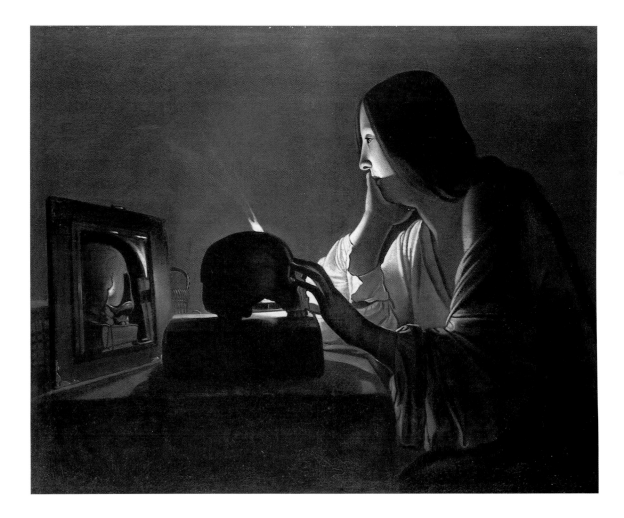

that the lower half of the design was always lost in darkness. The painted copy we illustrate, by an unknown copyist of the seventeenth century, provides an idea of how La Tour's images were disseminated in his lifetime. At first sight it has all the elements of his style, yet on close examination it lacks his sharpness of observation and the finesse of his touch, both in capturing detail and in conveying the subtleties of modeling and light. The conservators Gifford et al. in their catalogue essay have amply confirmed how refined was La Tour's painting technique, built up with thin glazes and finished with lively impasted highlights and accents. By contrast, copies such as this *Repentant Magdalene*, which was most likely not made in the proximity of the master's studio, tend to be executed in thicker, opaque paint, with a consequent loss of La Tour's delicate effects of luminosity. Nevertheless, such a painting could well have supplied the basic needs of devotional imagery for

artistically undemanding viewers, but it would not have insinuated its message so easily into the souls of the socially elevated, educated, and sophisticated people whom we know, in just a few instances at least, to have been La Tour's direct patrons.

In one documented case La Tour painted "un tableau représentant la sainte Magdalene" for his noble friend Chrétien de Nogent, chamberlain of the duke of Lorraine and resident in Lunéville. De Nogent had probably acquired his painting shortly before his death in 1638. A legal document of 1641 shows that La Tour was still trying to obtain the balance owed him for the picture from de Nogent's widow (she was related to La Tour's wife, Diane Le Nerf, who took the painter's part in these negotiations). The painting was deposited with the Minims in Lunéville during the dispute. We do not know its outcome, but one option suggested by the artist was that he take back the work, retouch it if necessary,

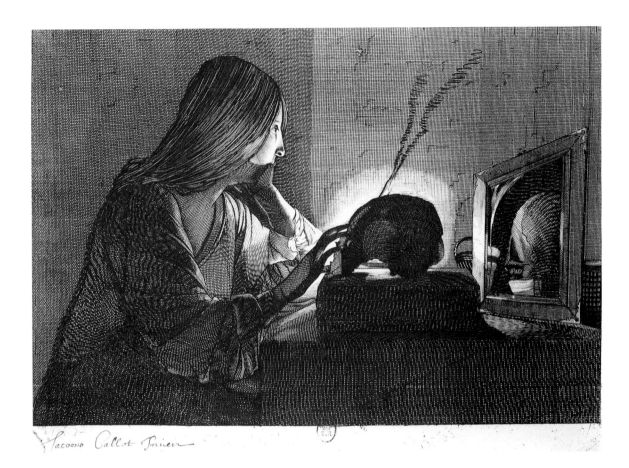

Jacomo Callot Innen

cat. 33. After Georges de
La Tour, *The Repentant
Magdalene with a Mirror*,
Bibliothèque Nationale de
France, Paris

sell it again, and reimburse the widow. What is most interesting about this episode is that the picture had particular value for the artist because it was "de son propre travail" [his own work], a painting "duquel il faisoit cas et estime (pourveu que ce soit en son original)" [which he valued and esteemed (seeing that it is his original)].[190] This insistence on his own hand clearly implies that La Tour acknowledged a market for copies of his works at this time.

The success of the repentant Magdalene subject is attested by the existence of three more full-length versions, variations on the theme by La Tour himself, of which only *The Magdalene with the Smoking Flame* (cat. 23), perhaps 1636–1638, can be included in the present exhibition. The near-replica of this painting in the Louvre (fig. 69) is not at present in a fit state of conservation to travel, and the very different *Magdalene with Two Flames* (fig. 70) cannot be lent under the terms of its donation to the Metro-

politan Museum of Art. In the Los Angeles *Magdalene with the Smoking Flame* the scene is illuminated by an oil lamp of the simplest kind – a glass jar of oil, in which a suspended wick is immersed; the wick is supported by a thin metal rod. The bright, steady flame emits curls of black smoke at the top. This is not a negligible detail if we are aware of contemporary emblem books such as the Jesuit Father Hesius' *Emblemata Sacrada de Fide, Spe, Charitate* (1636), wherein the smoke at the top of the flame is interpreted as signifying renunciation of the mortal life and aspiration for the beyond.[191] This beautifully observed detail of everyday life – a simple domestic artifact pregnant with meaning – epitomizes La Tour's highly concentrated approach to religious subjects in his nocturnes of the 1630s and 1640s. There is no mirror in the Los Angeles picture: rather, the Magdalene stares intently into the flame, resting one hand on a skull lying in her lap, while the other

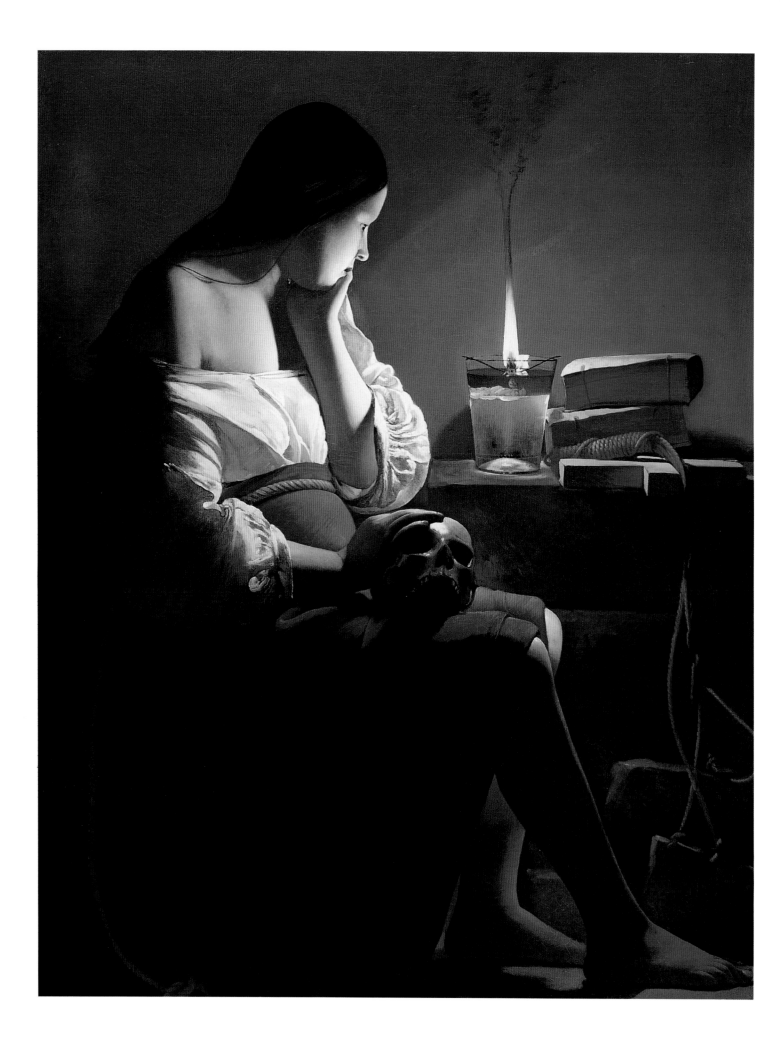

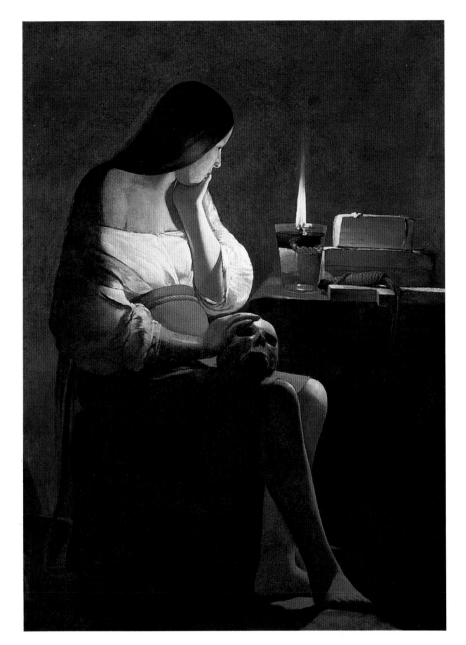

69. Georges de La Tour,
The Repentant Magdalene,
c. 1640, Musée du Louvre,
Paris

cat. 23. Georges de La Tour,
*The Magdalene with the
Smoking Flame,* c. 1636–
1638, Los Angeles County
Museum of Art, Gift of The
Ahmanson Foundation

cups her chin in an attitude of melancholy medita-
tion. The lamp reveals more here than in the earlier
Washington picture – in addition to the holy books
set on a ledge, a plain wooden cross reminds us of
Christ's suffering for humanity, along with a knot-
ted rope, used for flagellation, to mortify the flesh
and simulate something of Christ's agony. *The Mag-
dalene with the Smoking Flame,* which likely dates
from the late 1630s, has quite a different feeling from
the Washington picture. Whereas the latter has a
warm-toned penumbrous atmosphere, and an air of
the mystery of divine manifestation befitting its reflec-
tive imagery, the Los Angeles painting is much cooler
and sharper in detail so that the different aspects of
the Magdalene's repentance and meditations are
spelled out with greater clarity.

Two of La Tour's most moving nocturnes – *Christ
with Saint Joseph in the Carpenter's Shop* and *The
Dream of Saint Joseph* (figs. 75 and 76) – were most
likely painted at about this period of the late 1630s;
but they are discussed below with other images con-
cerning the Holy Family.

The Louvre *Repentant Magdalene* (fig. 69) is a
variant of the Los Angeles picture, and most schol-
ars date it a few years later, perhaps to the early 1640s.
It has a monumentality of form that may reflect
La Tour's experience and absorption of the classi-
cizing aspects of art in Paris around this time. He
has made some adjustments to the still life and the
position of the Magdalene's face and feet; the flame
is not perceptibly smoking; overall the light is more
even, perhaps more warmly evocative. Forms and
the handling of the paint have been simplified, giv-
ing the sense that this is a second version: the con-
tour of the Magdalene's white sleeve, illuminated at
the center of both paintings, is a trilling cascade of
creamy paint in the Los Angeles picture, but is much
more smoothly outlined, and executed, in the Louvre
version.

The fourth painting of the Magdalene in full
length, known as *The Magdalene with Two Flames*
(fig. 70), was likely executed in the early to middle
1640s, not much later than the Louvre's picture. This
date is suggested by the simplicity and monumen-
tality of the design, which seems to take into account

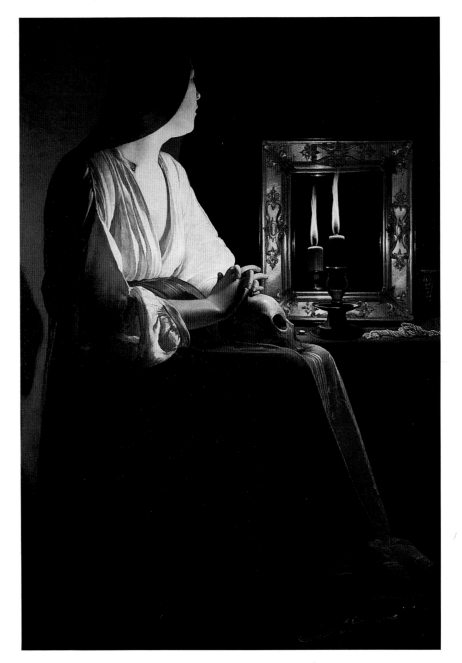

70. Georges de La Tour, *The Magdalene with Two Flames*, c. 1640–1644, The Metropolitan Museum of Art, New York

OPPOSITE PAGE: cat. 24. Georges de La Tour, *Saint Peter Repentant*, 1645, The Cleveland Museum of Art, Gift of the Hanna Fund

reflection are so compelling; we can see both sides of the candle, and the far side best because it is illuminated by the reflected light. Only the skull on the Magdalene's lap suggests that she may be pondering the earthly reality of our mortality and the eternal truth of the spiritual life, while deciding to abandon the blandishments of the material world. The juxtaposition of skull and candle was common in emblem books of La Tour's day. In Daniel Cramer's multilingual *Emblematum Sacrorum* (1624) an emblem showing a skull, surmounted by a candle being lit by a divine hand, illustrates a phrase from the light-filled opening verses of the Gospel according to John, "The light shines in the darkness" (John 1:5); Cramer's accompanying verses add, "sad and pale death cannot frighten whoever becomes familiar with it by frequent reflection; but with Christ in my heart I can overcome it; it is he who will reilluminate my light after death."[192] The context of *The Magdalene with Two Flames* suggests that, rather than possible alternatives such as vanity, fragility, transience, or worthless study, La Tour may have intended this meaning for the candle.[193]

The fact that La Tour's *Saint Peter Repentant* (cat. 24) bears the date 1645 is a precious indication of the artist's style and subject matter at this time. Although we cannot rule out the possibility that he continued to paint daylight scenes during the last decade of his life, all the evidence, especially contemporary inventories, suggests that he was by now settled in his reputation as a specialist of "nights." Like the Magdalene, Saint Peter was an epitome of the repentant sinner. After Christ's arrest Peter had denied his association with his master in the hours of his greatest need. After his denial Peter was consumed with guilt and grief, and lived with his regret for the rest of his life. It is the grief-stricken and repentant elderly man that La Tour depicts. A few years later in 1650 La Tour painted the moment of denial itself, in a more narrative scene (fig. 81). But the *Saint Peter Repentant* is one of those meditative, somewhat emblematic images that characterize La Tour's religious paintings in the later 1630s and 1640s. It is a considerably richer and more complex interpretation of the theme than the *Repentant Saint Peter* he had painted

the angularity and planarity of the basic pictorial form, and perhaps again reflects the idealism of painting in Paris around this time. It shows the saint at an earlier stage of her religious conversion than the previous paintings. Here she is still wearing the fine clothes of her former luxurious existence and has just abandoned her jewelry, which is strewn on the table in front of her. The two flames really dominate the picture, not only because they are the source of light, illuminating the figure of the Magdalene, but also because the repeated image of the flame and its

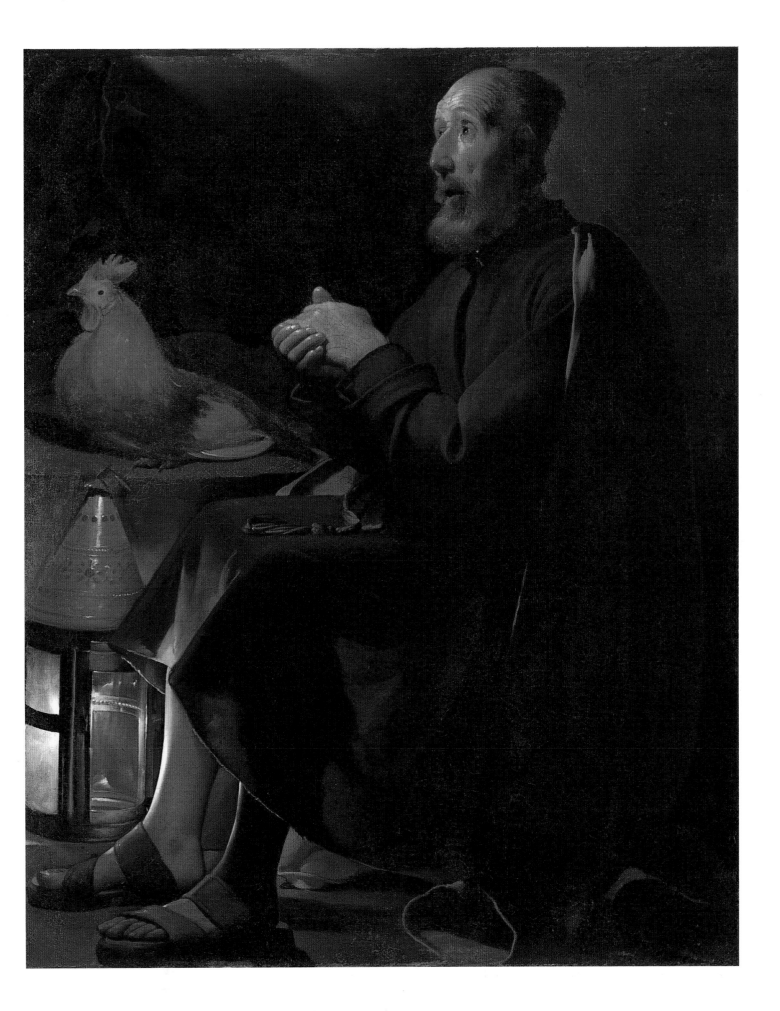

in the 1620s (fig. 26). The cockerel, beautifully observed by La Tour, is a time-honored attribute of this saint, alluding to Christ's prediction at the Last Supper that Peter would deny him three times before the cock crowed the next morning. Less conspicuously, there is a vine growing on the wall just above the fowl, an allusion to Christ's words to his disciples: "I am the vine, you are the branches. Those who abide in me and I in them bear much fruit, because apart from me you can do nothing. Whoever does not abide in me is thrown away like a branch and withers" (John 15:5–6).[194] Indeed this whole chapter of Saint John's gospel is an affirmation of mutual love between Christ and his disciples, and a plea that they remain his loyal witnesses: "You also are to testify because you have been with me from the beginning" (John 15:27). We can imagine these words ringing in Peter's ears, because this is the very witness he denied, within hours of their last meeting together.

Choné has tentatively suggested that the presence of a lantern in this work could be read as an emblem of Peter's heart burning with love, but with an ardor concealed for the moment by the pain of guilt and denial.[195] In support of such a reading we might add that the lantern is not the principal source of light in this picture, which comes from a mysterious, possibly divine source outside the painting. In the earlier discussion of La Tour's *Saint Sebastian Tended by Irene* it has already been observed that lanterns could carry a variety of meanings in the emblem literature of the late sixteenth and early seventeenth centuries. In another case Christ himself was likened to a lantern, with a visible body and the divine light shining from within.[196] As always, context is important in the *Saint Peter Repentant*: in its juxtaposition with the vine and the cock, the lantern, which conceals the source of light within, surely does convey a sense of "hidden light," as opposed to the "manifest light" of the clearly visible burning candles that are contemplated by the Magdalene in *The Magdalene with Two Flames* (fig. 70), *The Magdalene with the Smoking Flame* (cat. 23), or conspicuously placed next to the young woman in *The Flea Catcher* (cat. 20).

On stylistic grounds – for example, in a comparison of the boldly simplified forms of Peter's homespun garments, or the supple impasto that models the saint's face and the soft hairs of his beard – it is probably around this same time, 1645, or a year or two later that La Tour conceived one of his most monumental compositions, which survives in the large *Ecstasy of Saint Francis* in Le Mans (cat. 25). It is clear that La Tour employed the same model for the figure of Brother Leo as he did for Saint Joseph in the Louvre *Adoration of the Shepherds* (fig. 73, discussed below), and the way their heads are broadly modeled is also very similar. The Le Mans painting is a work of fine quality, but after the initial enthusiasm of its discovery in the 1930s, most scholars have considered it to be a good contemporary copy of a lost original.[197] Yet it has fine passages, especially in the highly lit areas – the light fittings, for example, and the face and hands of Brother Leo – which are usually the best preserved parts of original works by the artist. One wonders, however, how much its condition affects its present appearance: the thinly glazed dark areas have probably lost much of their original richness and density due to old abrasion, harsh cleaning, and layers of varnish. The present writer is inclined to keep an open mind about this unusually large work: if it is not a damaged original, it is surely by a close follower, and was perhaps produced in La Tour's studio. It is one of the largest works associated with La Tour's name, so it may have been executed more broadly than usual; but nothing is known of its original destination. Pierre Morracchini has pointed out that the beards and hoods (*capuchons*) of the two protagonists indicate that the painting may have been done for a Capuchin church or monastery, rather than any of the other types of Franciscan house.[198] We should note the fact, but perhaps not attach too much importance to it, that in his will La Tour left a plot of land to the Capuchins in Lunéville, where they had established a monastery in 1632.

The Ecstasy of Saint Francis is another subject that was popular in the period of the Catholic reform and was painted by many artists in the seventeenth century. Through the intensity of his medi-

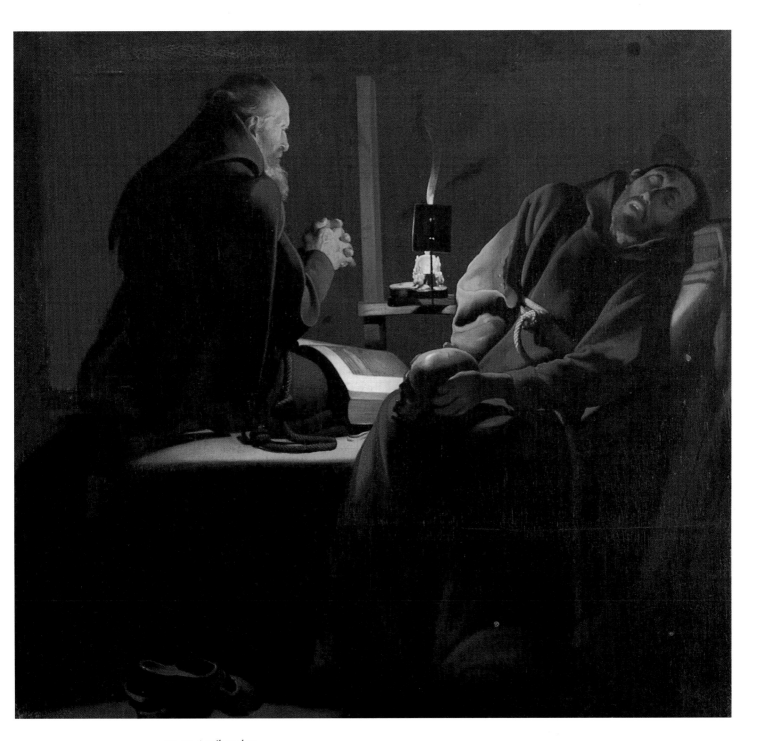

cat. 25. Attributed to
Georges de La Tour, *The
Ecstasy of Saint Francis*,
c. 1640-1645, Musée de
Tessé, Le Mans

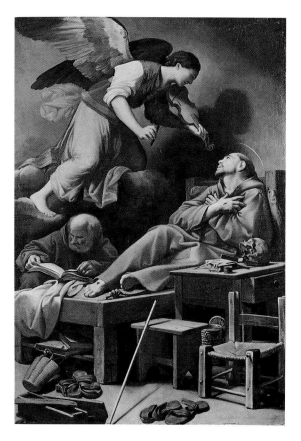

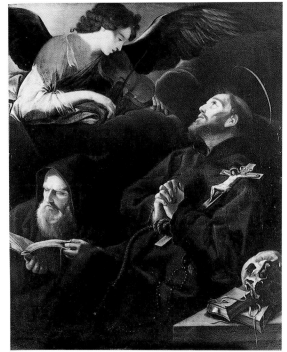

71. Carlo Saraceni, *Saint Francis in Ecstasy*, c. 1615–1620, Alte Pinakothek, Munich

72. Jean Le Clerc, *Saint Francis in Ecstasy*, c. 1625–1633, Parish Church of Bouxières-aux-Dames, Lorraine

tations on the mortality of the flesh and the sufferings of Christ, Francis swooned in a fit of ecstasy, which he likened to divine music; so strongly did he identify with the Christ's suffering on the Cross, that in some accounts, such as *The Golden Legend,* a seraph or angel appeared and transmitted Christ's stigmata to him. A celebrated work by Carlo Saraceni shows this event (fig. 71): in a simply furnished cell that is depicted with a clear sense of actuality, and accompanied by his favorite Brother Leo, who is oblivious to the saint's personal vision, Francis looks up in rapture to the angel hovering overhead, who is playing divinely sweet music on a violin, and displays the stigmata, the wounds on his hands and feet. Saraceni's altarpiece was a model for a much more modest one painted for a parish church in Lorraine by his pupil Jean Le Clerc (fig. 72).[199] It is a simplified and concentrated version of Saraceni's work, but the essence of its meaning is clearly conveyed.

La Tour's approach to the subject is quite different. Characteristically, he has rendered the saint's rapture as an even more inward experience. There is no visionary nor miraculous element to be seen: no angel, no stigmata, no halo above Saint Francis. Rather he has swooned off to one side, away from Brother Leo and into the more shadowy world of his own vision; his open mouth and rolled back eyes tell us that he is in a state of ecstasy rather than just asleep. The inventory of Jean-Baptiste de Bretagne in 1650 lists a "Monk Asleep" by La Tour, which could have been a version of the Le Mans picture or, more likely, a version of the small picture in Hartford (cat. 26), which is a variant of the figure of Saint Francis only. Cusping at the edges of the Hartford painting suggests that it is not cut down from a larger composition, but is an independent single-figure work. The adjustable candelabrum is slightly different in design in the two pictures, as are the light shades. Like the Le Mans picture, the smaller Hartford work is generally considered to be a good early copy of a lost original by La Tour, and the present writer concurs with this view. There is a hard and

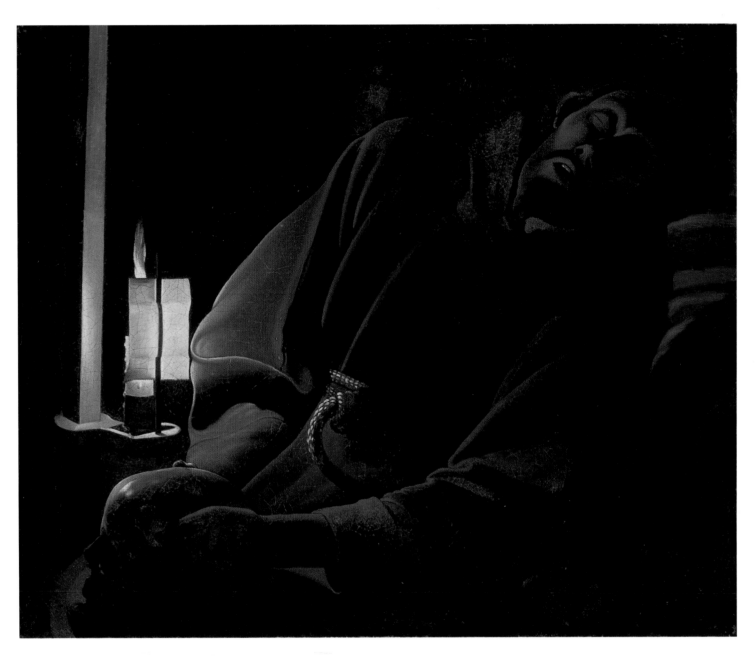

cat. 26. After Georges de La
Tour, *Saint Francis in
Ecstasy* (original c. 1645),
Wadsworth Atheneum,
Hartford, The Ella Gallup
Sumner and Mary Catlin
Sumner Collection Fund

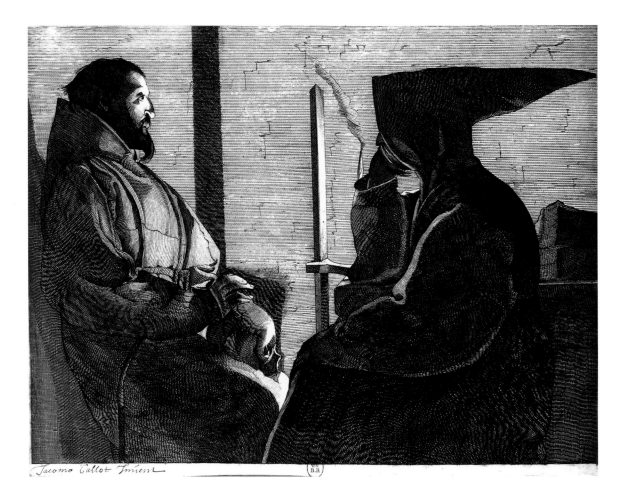

Jacomo Callot Inuent

summary aspect to the handling of the saint's face and garments that points away from the hand of the master.

La Tour probably painted another picture on a closely related theme, *Saint Francis in Meditation*, which is recorded in one of the few engravings after his works (cat. 34). Quite likely this richly contrasted engraving reproduces the painting listed in the inventory of Jean-Baptiste de Bretagne as "Two Capuchins in Meditation by Candlelight."[200] It is the stage of meditation, rather than ecstasy, that is shown in this rather dramatic image, where the two monks are silhouetted against a wall that is illuminated by the light concealed by Brother Leo's arm; the light fixture is of a similar type as that in the Le Mans and Hartford paintings. Francis sits with a skull on his lap, while Leo makes a striking silhouette in his pointed hood. We can imagine that the painting was rather somber, and that the wall was lightened

up for legibility in the print, as it was in the companion prints of *The Repentant Magdalene with a Mirror* and *The Virgin and Child with Saint Anne* (cats. 33 and 35).

The Master of Lunéville

Although we cannot rule out the possibility that La Tour continued to visit Paris during the 1640s, he had ample reasons of family and property to keep him in his native Lorraine. If the artistic opportunities there were not as rich as they had been in the first three decades of the century, there was still a sufficient clientele – French and Lorrainese – for a painter who in any case did not need to rely entirely on his professional income to maintain the life of a minor noble. From surviving documents and La Tour's paintings that can likely be assigned to this period, there is a sense of a return to a more settled

existence in Lunéville and a more regular pattern of work in the early 1640s. In September 1643 La Tour took on a new apprentice, Chrétien Georges, a young man from a local family with roots in Vic to whom La Tour was related by marriage. In 1644 he took a lease on a large abandoned property that belonged to the Order of Saint John of Jerusalem. This commandery of Saint George, as it was known, came with ancient rights and exemptions from taxation. In December 1644 the artist was reimbursed from the public purse of Lunéville for supplying grain and firewood to a French regiment garrisoned in the town: under his privileges, he was exempt from this type of obligation to support occupying forces.[201]

In spite of the external circumstances of his time and place, La Tour seems to have secured a reasonably stable and comfortable life for himself and his household in the 1640s. It can be hard for us to abandon the notion of the bohemian artistic life we have inherited from the nineteenth century, although the myth of the untrammeled and often troubled artistic genius was already developing in the seventeenth century.[202] It is perhaps even harder to reconcile the insightful painter of the *Old Peasant Couple Eating* and *The Hurdy-Gurdy Player*, and the painter of intensely moving religious works, with La Tour the country squire aspiring to nobility. But La Tour likely looked to the example of his compatriot Deruet, who comported himself like a "grand seigneur,"[203] with honors bestowed by the duke of Lorraine, and a house in Nancy splendid enough to host Louis XIII.

La Tour conducted his artistic affairs in a solidly professional way: there were contracts, agreements, and schedules of payment. We know that he ran a small studio – that is to say, he engaged apprentices (one at a time, so far as we know), who helped out in the day-to-day running of his business and learned at least the rudiments of art from him. He presumably trained his son Etienne, and five apprentices he took on are documented by surviving contracts dated between 1620 and 1648: these were Claude Baccarat in 1620, Charles Roynet in 1626, François Nardoyen (who died in an epidemic within a few months) in 1636, Chrétien Georges in 1643, and Jean-Nicolas Didelot in 1648.[204] The contracts with the last two

youths give us a good idea of what was expected on both sides. Basically the parents of the apprentice paid for his keep for three to four years. With the exception of Baccarat, who lived with his parents, an apprentice lived in the La Tour household and worked as a servant: feeding and grooming the artist's horse, acting as a courier for letters, assisting the master on trips, even serving at table, as well as mixing colors, preparing canvases, and doing all that was necessary in the studio, including "serving as a model for painting or drawing from life as occasion presents."[205] In return, the apprentice would be taught all the tricks of the trade, with nothing concealed. In the case of Didelot, a clause was included to say that, in the event of the death of La Tour, his son Etienne (who by now, 1648, was evidently a painter in his own right) would take over and see the apprenticeship through to the agreed date of termination, "according to the same principles and precepts."[206]

The Didelot contract is a document of great interest, because it demonstrates the close professional relationship between Georges and the twenty-seven-year-old Etienne de La Tour in 1648. Etienne was in a position to take over where Georges might leave off in the conduct of their business. For ten years already, since 1638, Etienne had been signing legal documents as "son of Georges." In 1646 father and son jointly signed a witnessing document, which described them as "painters living in Lunéville." From the year of Etienne's marriage in 1647 and after, the professional and familial ties between father and son were close, and their signatures are frequently found side by side on legal documents. In 1648 and 1651 they were both designated "peintre du roy," suggesting that Georges had somehow managed to obtain this privilege for Etienne. Unfortunately, no works of art independently signed with Etienne's name (nor with the joint names of father and son) have come down to us, but there can be little doubt that Etienne was the artistic as well as the family partner of Georges during the last few years of the latter's life.

In 1643 a new French governor of Lorraine was installed in Nancy, and his presence could not have been more significant for the last decade of La Tour's

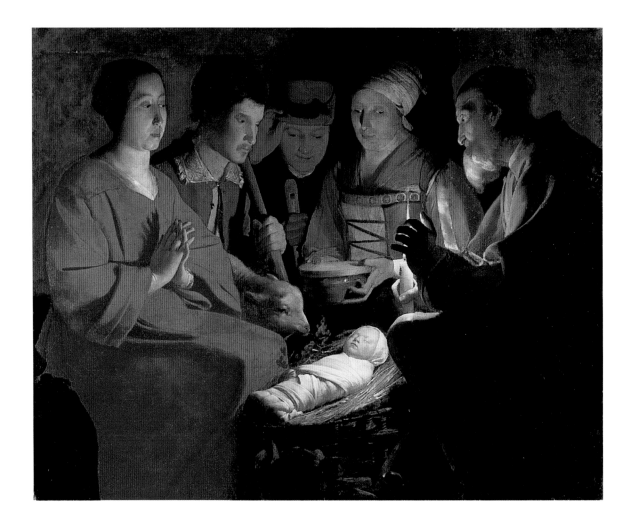

career. Henri II de Senneterre, marquis de La Ferté (known also as Maréchal de La Ferté after he was created Marshal of France by Mazarin in 1651), was the son of a minister of state in the administration of Richelieu, who as one of a circle close to the cardinal, including Claude Bullion, made a huge fortune in office. The son had a military career, and after distinguishing himself in the service of Louis XIII and subsequently during the regency of Anne of Austria, he was rewarded with the governorship of the province. An inventory taken in Nancy in 1653 of the collection of the marquis de La Ferté (on the occasion of a division of property, due to the declaration of his wife's insanity) included no fewer than six paintings attributable to La Tour, four of which can be documented as year-end gifts to the governor from the municipality of Lunéville. A seventh work commissioned from La Tour can be added to

this group. All seven works can be convincingly related to known works or at least known compositions by La Tour. La Ferté perhaps developed a taste for collecting in the Parisian circles of his father, where indeed he could have met La Tour or at least seen his works. As governor, La Ferté looked after his own interests – one of the perks of governorship – but instead of extracting annual tributes in money, he did so unusually in works of art. It was no doubt at his own suggestion that the municipality of Lunéville presented him with paintings by La Tour, just as Nancy gave him paintings by Deruet.[207] Thus, only a matter of months after La Ferté took office, in January 1644, the municipality commissioned La Tour to paint a "Nativity of Our Savior" as a year-end gift to La Ferté, which was duly delivered to him in Nancy in the early days of January 1645. It is quite possible that this painting was *The Adoration of the*

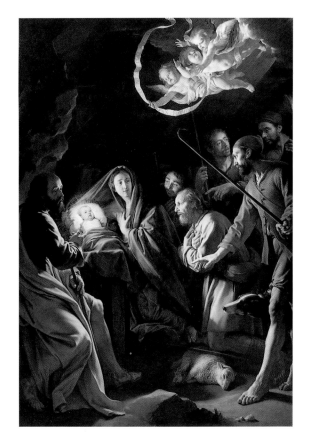

quite common among tenebrist artists of La Tour's own generation, such as Honthorst,[208] or in the work of Philippe de Champaigne in Paris, who painted several versions of *The Adoration of the Shepherds*, of which the example in the Wallace Collection (fig. 74) was painted at about the same time as La Tour's, in the mid-1640s.

La Tour brings a sense of intimacy and tenderness to the scene, and we can admire his powers of observation in the swaddled child (in this detail he follows closely the gospel of Saint Luke 2:12), and in his careful rendering of the two shepherds and the servant girl holding a simple terrine of a type still familiar in France today. This trio, wearing everyday country garments, is subtly distinguished from the more monumental and ideal types of Mary and Joseph to either side. There is no sense of theatricality in La Tour's interpretation: no dramatic gestures or exaggerated expressions, such as we find in Champaigne's *Adoration of the Shepherds*, which is typical of the more rhetorical approach of artists committed to the Catholic reform. The works of La Tour and Champaigne can be compared with a Lorrainese *Adoration of the Shepherds* by Le Clerc (fig. 38), an altarpiece probably painted within a year or two of the artist's return from Italy in 1622, and still containing echoes of his teacher Saraceni and his interest in Correggio.[209] There is an overt emotionalism in his open-armed and open-mouthed shepherd, who approaches the Child in dazzled amazement, but at the same time there is genuinely rustic humility and quiet inwardness of response and mood that is closer to the spirit of La Tour's *Adoration* than to that of the Parisian master. Of course, we must allow that both Le Clerc's and Champaigne's large paintings were intended as altarpieces, while La Tour's *Adoration of the Shepherds* was most likely conceived as a work to be enjoyed and contemplated in a more private setting. La Tour subtly directs our attention not only to the radiant Christ Child but also to Mary, seated at the left, reflective and statuesque in a broad expanse of red drapery. She is boldly illuminated, whereas the shadowed Joseph on the right is given a secondary role, to the extent that he holds the candle and shelters its flame with a

74. Philippe de Champaigne, *The Adoration of the Shepherds*, 1645, The Wallace Collection, London

Shepherds now in the Louvre (fig. 73). The subject of the birth of Christ and his worship by humble shepherds was one of the most popular in Christian art. The story lent itself to a nighttime scene, and there are countless prototypes in the sixteenth and early seventeenth centuries. La Tour has gathered a group of five sympathetically observed worshipers around the Christ Child, who seems to radiate more light than he can possibly simply reflect from the candle held by Joseph. This last detail is significant. Earlier artists generally show the Christ Child as the sole source of light. As the spiritual light of the world, his divinity is expressed in palpable terms as the source of light in the picture, the most famous example being Correggio's *Adoration of the Shepherds*, also known as *La Notte* (Gemäldegalerie, Dresden), painted in the late 1520s and a model for many later artists. The idea was soon assimilated and became

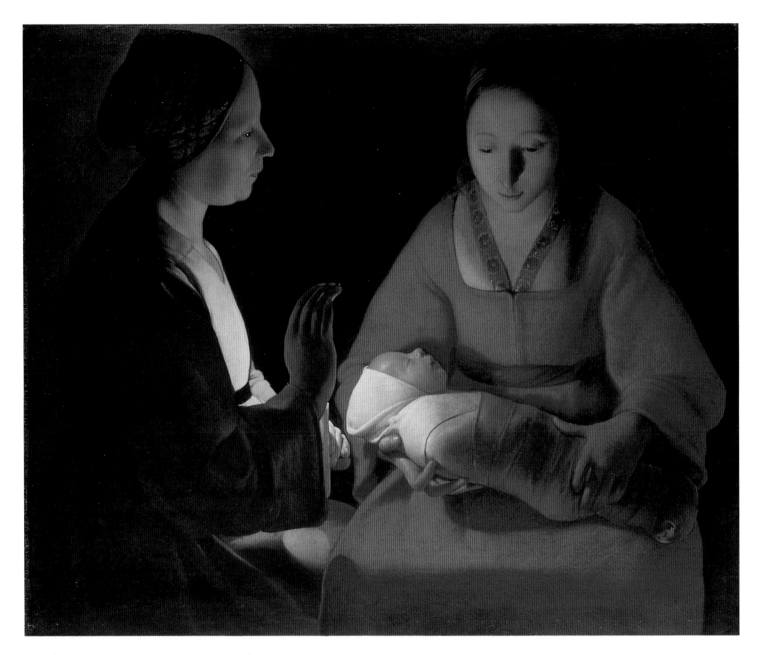

cat. 27. Georges de La
Tour, *The Newborn Child*,
c. 1645, Musée des Beaux-
Arts, Rennes

gesture that seems protective at the same time as it directs light to the Child and Mary: against Joseph's dark foil, they shine more brightly. According to Saint Luke, the shepherds, after they had witnessed the babe in the manger, went off and spread the news excitedly; "But Mary treasured all these words and pondered them in her heart" (Luke 2:19). This Marian emphasis on inward contemplation indicates the meaning of La Tour's interpretation, and is indeed characteristic of all his religious works.

The theme of inward contemplation is taken to its most concentrated degree in *The Newborn Child* (cat. 27), a work whose greater simplification of form and more polished finish has suggested to most scholars that it is later than the *Adoration of the Shepherds*. In *The Newborn Child* La Tour has once again completely rethought and interpreted the subject in his own personal terms, so that Thuillier has discussed it more as a secular than as a religious work.[210] We cannot deny the resonance that this subject has with everyday life and observation: La Tour might well have experienced the sense of an epiphany when he saw any of his own ten children for the first time. From the late 1630s through the mid-1640s La Tour devoted a relatively large number of works to familial themes, centering especially on Joseph, Mary, and the Christ Child. While the subject of the *Adoration of the Shepherds* is evidently based on the Gospels, *The Newborn Child* offers no specific clues that confirm that it is Mary holding the Christ Child, with an only slightly older Saint Anne in attendance to illuminate the scene with a candle. Yet what extraordinary light it casts, miraculous in feeling, and establishing only the quintessential forms needed to convey the immanence, which we are surely meant to feel is before us. We have only the well-tried metaphors of light to assist us in the interpretation of the theme here: there are no attributes, however discreet, to suggest the iconography, as La Tour provided the spectator in his images of the Magdalene, or Job, or Saint Peter. If we consider *The Newborn Child* in the context of La Tour's other religious works, however, its devotional nature is surely confirmed. We have already seen, from early in his career onward, in works as different as *Saint James the Less* or *The Flea*

Catcher (cats. 6 and 20), that La Tour could ever more persuasively represent the numinous in the everyday. Yet *The Newborn Child*, for all that it lacks any of the conventional trappings of religious art, has a perfection of design and execution, a monumentality of form, and an atmosphere of intensely focused reverence that transcend the banality of everyday experience and observation.

La Tour made several variations on the theme of the newborn child, including a lost painting that we know only from an engraving (cat. 35), and a very similar composition, of which only a fragment survives, recently bequeathed to the Art Gallery of Ontario (cat. 28). In the print after La Tour, the older Saint Anne, with a deeply lined face, sits holding a candle over the Christ Child; Mary sits at the foot of the crib, with an open book on her knees.[211] In the Toronto *Saint Anne with the Christ Child*, the subject of which is reversed in the engraving, the knee of the second seated figure, wearing a red dress and supporting an open book, is just visible in the lower left part of the composition, which has evidently been radically cut down. The woman in the painting seems to be much younger than her counterpart in the engraving. This may be due to the fact that the painting has suffered badly in the past and underwent extensive restoration in the mid-1960s. Alternatively, the roles of older and younger woman could have been reversed by La Tour. If the Ontario painting is indeed a damaged and repainted original by La Tour – and old photographs of its cleaned but unrestored state suggest this possibility – it is above all the features of the Child that still radiate La Tour's original poetry.[212]

The marquis de La Ferté owned a painting simply described as "Saint Anne" in the inventory of 1653, which may have been a version of *The Education of the Virgin* in the Frick Collection (cat. 29), given the prominent role assigned to the Virgin's mother in this work. It is generally agreed that the subject of this painting is Saint Anne teaching the Virgin to read (rather than the Virgin teaching the young Christ, which has also been suggested),[213] because it was a popular subject, both tender and didactic, and because another version of the compo-

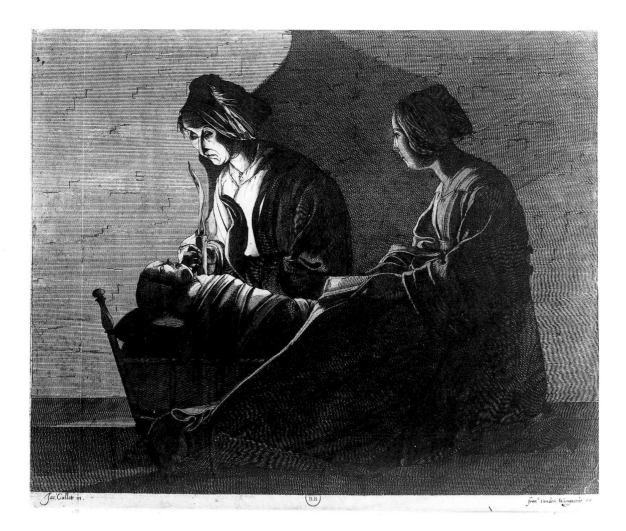

sition shows a sewing lesson in progress.[214] There are two other versions close to the Frick composition,[215] and a third that shows the two figures at full length.[216] Only the Frick painting has been proposed as an original from La Tour's hand. But if this is so, it has been cruelly treated and flattened in relining, and glazes and highlights have been removed in old cleaning. The hands of the Virgin and the thumb of Saint Anne holding the book are the best preserved parts. The unprecedented form of the conspicuous "signature" gives grounds for suspicion, unless it is no more than a clumsy record of a long lost original one. When this *Education of the Virgin* was first published in the 1968 Frick catalogue, it was assigned speculatively to Etienne de La Tour, an idea first suggested by Christopher Wright on the basis of the signature, which he found to be similar to those on documents signed by Etienne.[217] This ingenious at-

tribution awaits confirmation in the discovery of a work that can with certainty be attributed to Georges' son. If we accept the suggestion that the Frick painting is one of several works produced during the last decade of Georges' life, which were in part or entirely painted by Etienne, it does not reveal Etienne to have been a very impressive painter. But its invention, conception, and composition – in a now lost original – could have been due to Georges. We cannot rule out the possibility, and even the likelihood, of some sort of studio production of "La Tours," with Georges as the inventor and Etienne perhaps playing an increasing role as executor. Thuillier has consistently seen the Frick painting as a damaged and repainted original.[218] With all these reservations, La Tour's original conception was a powerful, moving, and evidently appealing one, with its tender relationship between mother and daughter.

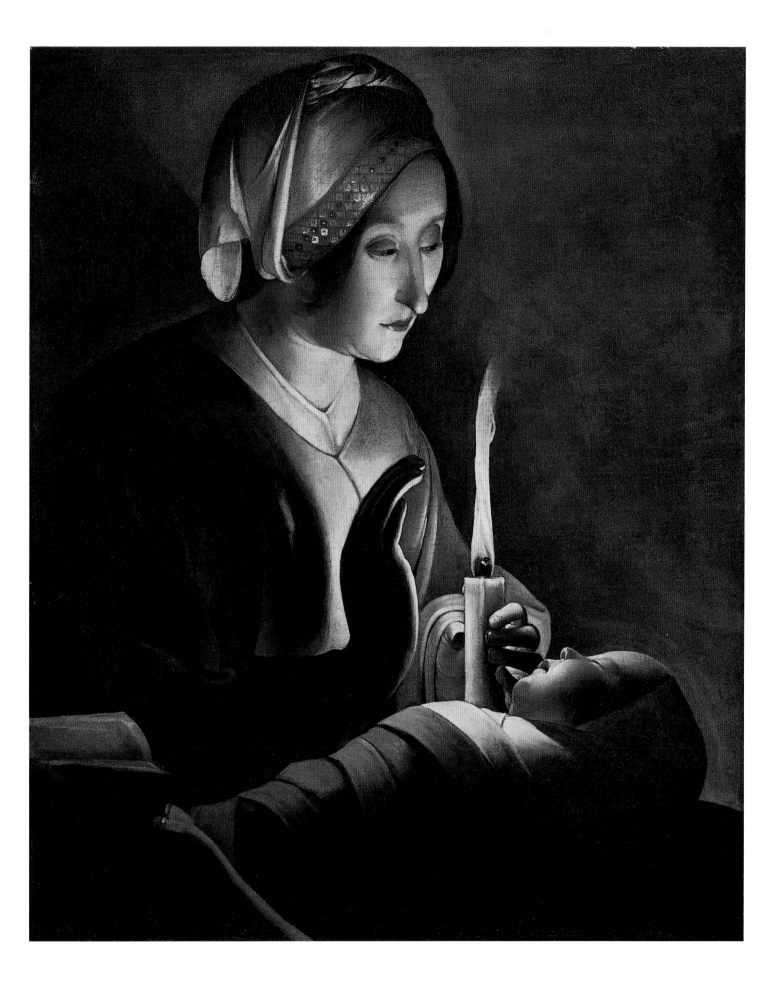

Life and Art of La Tour

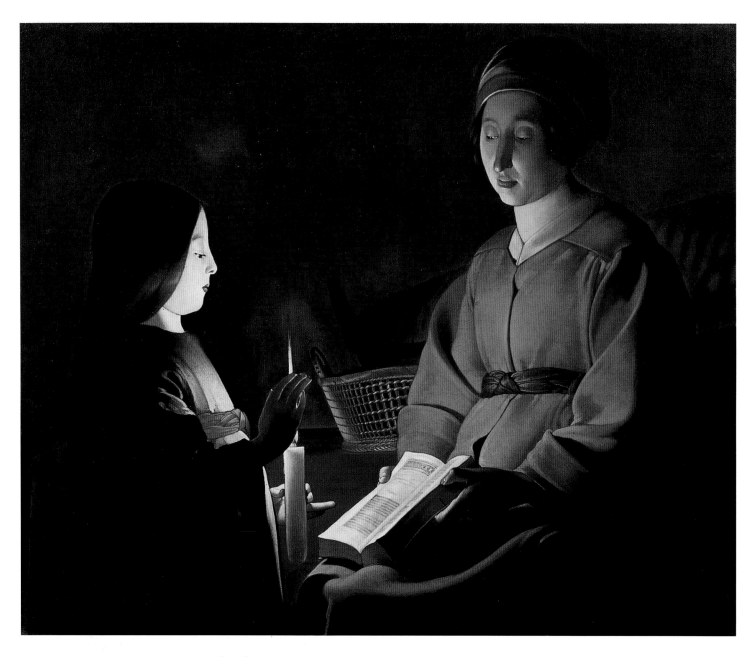

cat. 29. Attributed to
Georges de La Tour, *The
Education of The Virgin*,
c. 1650, The Frick Collec-
tion, New York

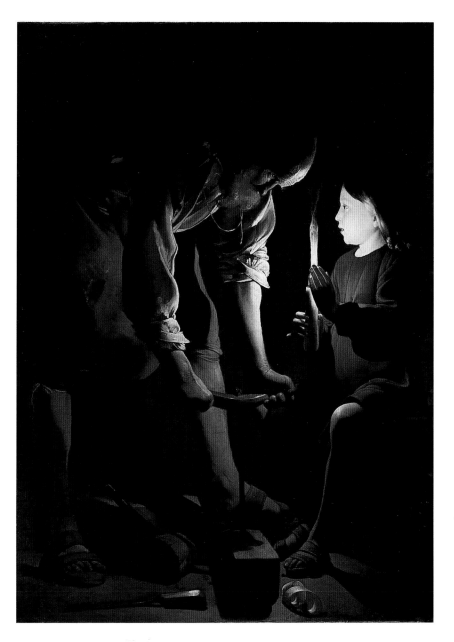

75. Georges de La Tour,
*Christ with Saint Joseph in
the Carpenter's Shop*, c. 1635–
1640, Musée du Louvre,
Paris, Percy Moore Turner
Bequest

Christ with Saint Joseph in the Carpenter's Shop
(fig. 75), one of La Tour's justifiably most famous
nocturnes, probably executed in the late 1630s or
perhaps the early 1640s, represents the masculine
counterpart to his *Education of the Virgin*. The touch-
ing image of caring fatherhood embodied in this sub-
ject had considerable currency in the period of Cath-
olic reform. A down-to-earth image of Saint Joseph
was especially popular among tenebrist painters such
as Honthorst and Trophime Bigot,[219] and we can well
understand the appeal of this approach to La Tour,
who earlier had depicted the Albi Apostles so real-
istically and with such human insight. Devotion to
Saint Joseph had been especially encouraged by
the sixteenth-century Spanish saint Teresa of Avila,
and disseminated through her order of the Car-
melites. A special impetus was given to the cult of
Joseph in 1621, when Pope Gregory XV made his
feast day (19 March) an official celebration of the
church.[220]

It would not be surprising one day to discover
that the Louvre's masterpiece once had a full-length
Education of the Virgin as its pendant, also painted
several years earlier than the Frick and other extant
versions or copies. *Christ with Saint Joseph in the Car-
penter's Shop* and *The Education of the Virgin* share
a virtuoso treatment of the light from the candles,
as it shines through the fingers of the children. The
early education of children in the truths of the faith
was an important goal of the Catholic reform move-
ment, and it was especially encouraged by the Jesuits.
In particular, the Jesuit Pierre Fourier had founded
his Congrégation de Notre-Dame in Lorraine with
a view to educating young girls, and it is quite pos-
sible that the popularity of La Tour's *Education of
the Virgin*, attested by the several copies we know,
is in some way directly connected with the educa-
tional activity of the congregation throughout the
duchy.[221] Not only do these two paintings represent
models of childhood instruction but they exemplify
the ideals of the active (male) and the passive (female)
life, in their themes and in their gendering.

La Tour's tender image of *The Dream of Saint
Joseph* (fig. 76) must have been painted at about the
same time as *Christ with Saint Joseph in the Carpen-*

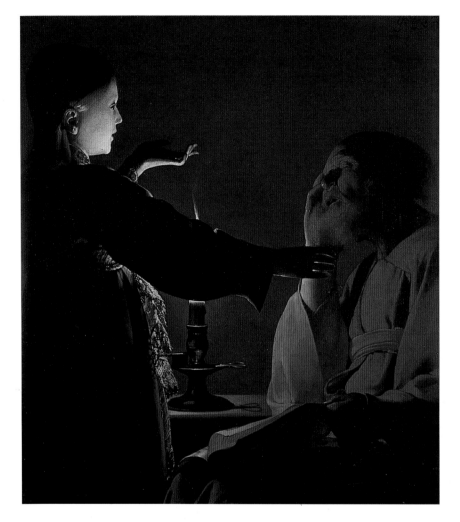

76. Georges de La Tour,
The Dream of Saint Joseph,
c. 1635–1640, Musée des
Beaux-Arts, Nantes

ter's Shop, considering its style and the fact that the same child seems to have served as the model for the angel appearing to the sleeping saint. It is not apparent which of Joseph's three dreams is depicted here: the angel's explanation of the Virgin's holy conception (Matthew 1:20–24), the warning to flee to Egypt (Matthew 2:13), or the news that it was safe to return to Israel (Matthew 2:19–20). The fact that the elderly man has been studying the book that still lies open on his lap suggests the second dream, for we can imagine the carpenter by this time puzzling over the significance of the religious and historical role that had unexpectedly been imposed on him. He has clearly fallen asleep over his book, because he has not used the beautifully observed candle snuffer, which La Tour has depicted resting on the candlestick. It is likely that this motif of the candle snuffer also has an emblematic meaning: if Joseph was fearful of extinguishing the light, he wavered unnecessarily, for the faithful need have no fear.[222] La Tour skillfully employs the candlelight to give the scene a sense of meditation and mystery; his angel is brightly illuminated by the flame: is it the flame, or the light reflected from the angel, that illuminates the sleeping Saint Joseph?

A question mark remains about the identity of La Ferté's "Saint Anne," as it does about an unidentified "Mocking of Christ" and a "Card Players" recorded in the same 1653 inventory.[223] Among other La Ferté works that can be tentatively identified with extant paintings are *The Discovery of Saint Alexis*, presented to La Ferté in January 1649, perhaps the painting now in the Musée historique lorrain (fig. 77); the vertical *Saint Sebastian Tended by Irene* in the Louvre (fig. 78), which is very likely the version of this subject presented at the end of 1649; and the *Denial of Saint Peter* in Nantes (fig. 81), a painting whose date of 1650 corresponds surely more than coincidentally with Lunéville's tribute of a work with that subject delivered to the marquis de La Ferté in January 1651.

The legend of Saint Alexis had been popular in the middle ages and enjoyed a revival under the Catholic reformation. The Jesuits especially revered him as a model of chastity and often acted out his story

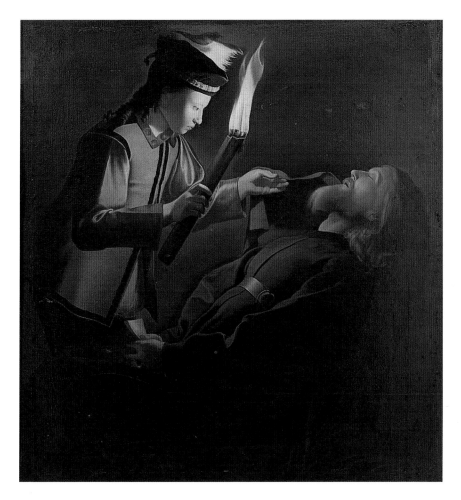

77. Georges de La Tour,
*The Discovery of Saint
Alexis*, c. 1645–1648,
Musée historique lorrain,
Nancy

in their sacred dramas.[224] The son of a Roman patrician, Alexis abandoned his home, family, and new wife on the night of his marriage, gave away his worldly goods, and set off to the Holy Land. Returning from his pilgrimage many years later, he lived unrecognized as a beggar under the stairway of his parent's home. On his death he was found clutching a piece of paper that revealed his true identity. Scenes from the life of Saint Alexis are uncommon in painting, but the discovery of his body is admirably suited to a painter of "nights." La Tour has chosen the moment when a young page boy discovers the body. Illuminating the scene with a torch in one hand, the page leans forward with cautious reverence, lifting Alexis' cloak to reveal his features. The saint's face does not show the marks of experience: rather, his expression is idealized and beatific. The identifying note is still clutched in his hands. *The Discovery of Saint Alexis* in Nancy (fig. 77) has been cut down, and the surface has suffered in places, but it remains a painting of remarkable quality and visual authority. Another version of this painting, now in the National Gallery of Ireland, Dublin, reveals that the composition was originally vertical in format, with the reclining figure of the saint visible to the ground.[225] The Nancy painting shares with *The Newborn Child* the smoothly finished surface we associate with works of this late date, although the blue of the saint's tunic brings a cool note to La Tour's palette that is new.

Continuing his commissions for La Ferté, La Tour also devised two relatively complex narrative scenes of several figures. The *Saint Sebastian Tended by Irene* (fig. 78) is one of La Tour's most monumental and compelling works. Here the themes of the tending of Saint Sebastian and the lamentation over the dead Christ really do seem to be associated. At this moment the mourning women take Sebastian for dead: even Irene is grieving, as she kneels to take his limp arm in her hand. The flaming torch casts a steady glow across the scene, its light drawing from the surrounding darkness the forms of the women, Sebastian, his glinting helmet, the rope, and the tree to which he was bound. The women's grief is made manifest by their gestures and expressions

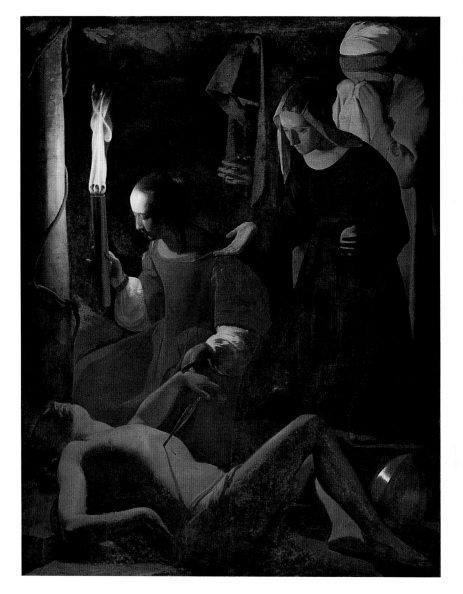

78. Georges de La Tour, *Saint Sebastian Tended by Irene*, c. 1649, Musée du Louvre, Paris

OPPOSITE PAGE:
79. Georges de La Tour, *Saint Sebastian Tended by Irene*, c. 1649–1650, Staatliche Museen zu Berlin, Gemäldegalerie

80. Caravaggio, *Saint John the Baptist*, c. 1603–1605, Galleria Corsini, Rome

and by the descending, collapsing movement of the design, from the figures standing in the back at the right to the recumbent figure at the lower left. It is difficult to imagine that La Tour and the fortunate recipient of this tribute, La Ferté, could not read this group of mourning women dressed in contemporary garb as lamenting the fates of so many in Lorraine in this period of continuing strife. We can see the creation of this masterpiece – monumental in form, tragic in mood, yet also imbued with the stillness and grandeur of steadfast faith – as La Tour's very personal contribution to the great moment of classicism in French art around 1650.

Another version of this composition in Berlin (fig. 79), a little more polished in form and with considerable modifications in color, raises some fine issues of connoisseurship. Is it an autograph version, as we consider the second versions of *Saint Jerome*, the *Cheat*, and the Louvre *Magdalene* to be? Or is it a superb copy by another hand, perhaps that of Etienne? This second option is the one taken by some scholars, but the present writer is in agreement with Thuillier's published opinion, in seeing it as a second version by La Tour himself.[226] After all, it is not a slavish copy, but rather subtly adjusted to a more somber palette. The earlier second autograph versions mentioned above, and the several hurdy-gurdy players, all include differing degrees of variation in design or color. There is little doubt that La Tour had assistance in the studio throughout his career, but as noted above, we have to leave as an open question the degree to which his apprentices, or Etienne, had some hand in particular works in his last years.

It is almost certainly at this late moment in La Tour's career that he painted the recently discovered *Saint John the Baptist in the Wilderness* (cat. 31), a previously unknown and unrecorded work.[227] It is with a shock that the spectator seems to invade a very private, intimate moment of reflection in the young saint's chosen wilderness retreat. The profoundly introspective and meditative mood, conveyed above all by the almost impenetrable gloom of the saint's environment, is close to that of the two late versions of *Saint Sebastian Tended by Irene*, and the simplified, abstracted form of John's bared arm

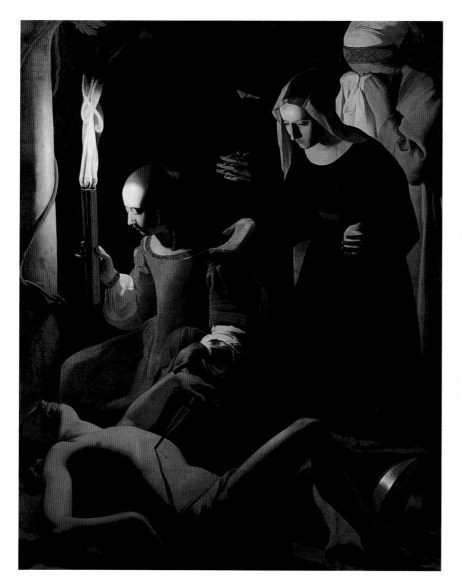

and shoulder can be compared with the forms of Se-
bastian. In his *Saint John The Baptist in the Wilder-
ness* La Tour comes closer than ever before to the
Caravaggesque tradition. The composition has affini-
ties with Caravaggio's *Saint John the Baptist* in Rome,
for example (fig. 80), although La Tour's invention
of the Baptist is more ascetic and spiritual compared
with Caravaggio's shepherd, with his worker's hands
and weathered face and neck.[228]

The 1650 *Denial of Saint Peter* (fig. 81) follows
a well-established tradition of representations of this
subject by tenebrist artists, such as Honthorst (Feigen-
baum fig. 8), Nicolas Tournier, Valentin de Bou-
logne, and especially Gerard Seghers, who made
something of a specialty of this theme.[229] In the
Gospel accounts, Peter followed the arrested Christ
as far as the courtyard of the house of the high priest
Caiaphas, where he waited near the guards and
warmed himself; he was recognized by a serving
woman as one of Christ's followers, but, as predicted
by Jesus, he denied this association. The tenebrist
artists usually show the soldiers and ruffians gam-
bling for Christ's garments, then turning their at-
tention to Peter when they hear his exchange with
the maid. La Tour chose rather to isolate Peter and
the woman, who reveals him by the light of her
candle; but what is gained in the expressive isolation
of the guilty Peter is a loss for the dramatic unity of
this painting. Moreover, it is almost as if La Tour's
reliance on the visual tradition for this image has de-
tracted from his usual originality of conception. Nor
do we sense here the vivid observation of individu-
als, whom we expect this artist to assimilate into his
pictorial world. With the exception of his perceptive
rendering of Peter's guilty expression, La Tour is
more reliant than usual on stock pictorial types for
the cast of villains. Even the handling of paint has
taken on a somewhat coarse quality – in the face of
the leering youth leaning on the table, for example
– and we cannot avoid the awkward anatomy of the
left arm of the silhouetted thrower of dice in the
foreground.

All commentators have felt uneasy in front of La
Tour's *Denial of Saint Peter*, even though it is signed
and dated. Are we witnessing the beginning of a fail-

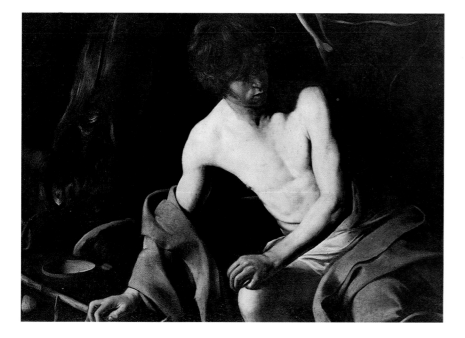

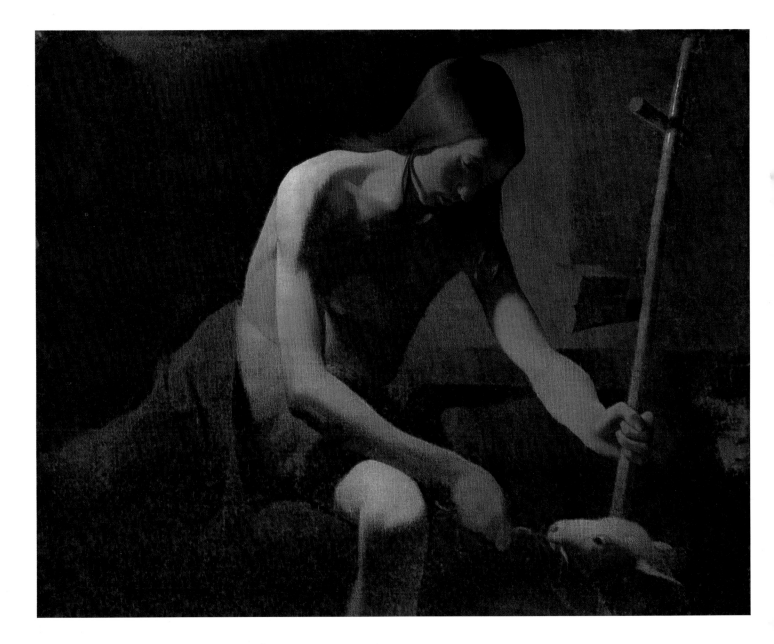

cat. 31. Georges de La Tour,
*Saint John the Baptist in the
Wilderness*, c. 1645–1650,
Conseil Général de la
Moselle

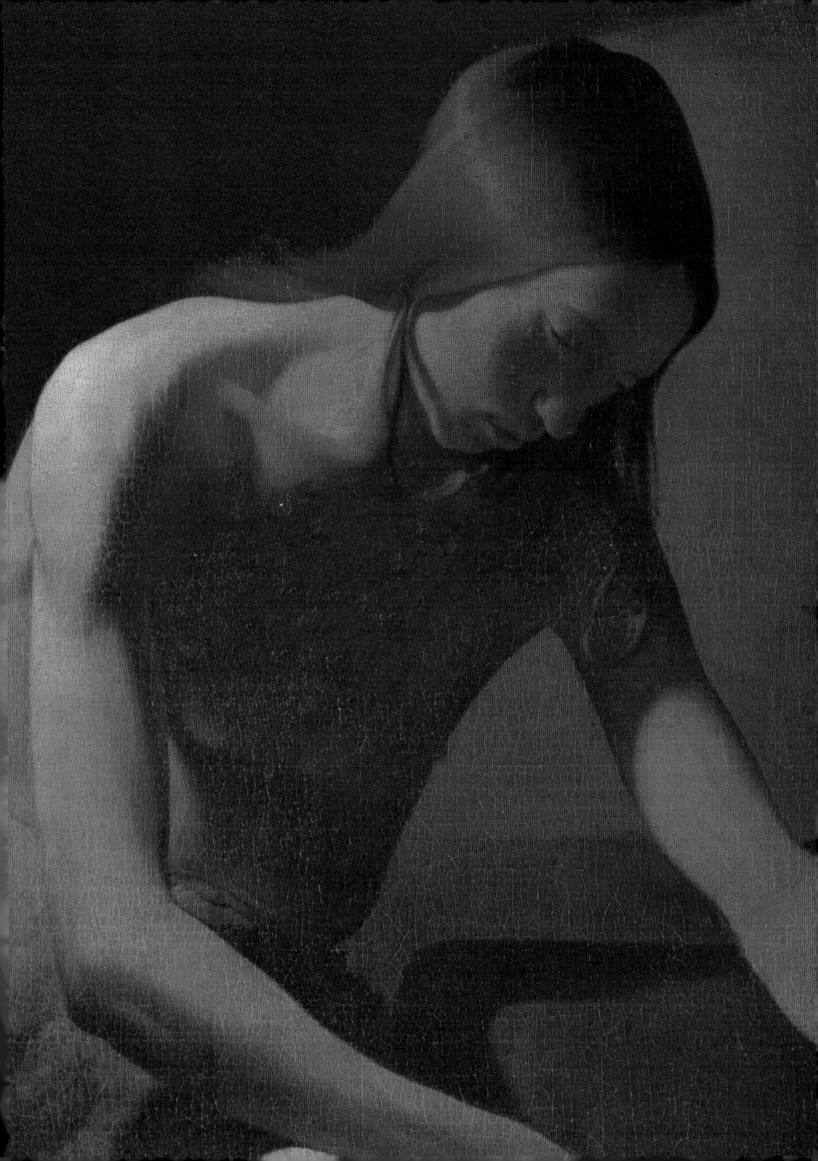

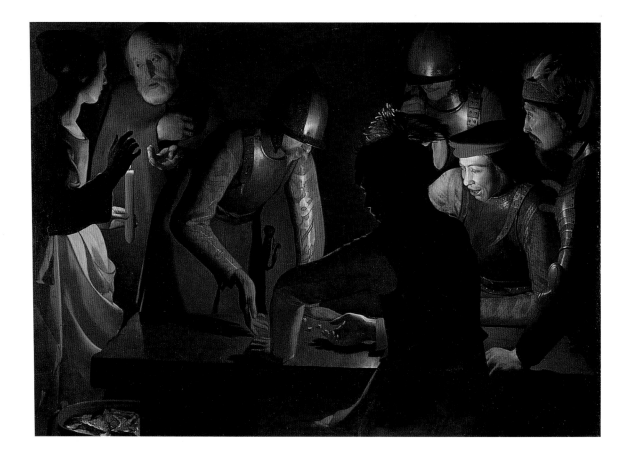

ure of powers, or the intervention of his son Etienne? The opinion – and with our present knowledge it can be no more than that – of the present writer is that we do see the intervention of another hand here, probably that of Etienne. The expressions are rather crude, and the execution is inferior.[230] The clumsy placing of the silhouetted arm in the foreground is repeated in two other works, known only from very rudimentary copies: *Group of Soldiers Playing Cards*[231] and *Dice Players*.[232] The *Dice Players* we exhibit (cat. 32), is also thematically and compositionally related to the 1650 *Denial of Saint Peter*, though it manages to avoid the anatomical difficulties of the above-mentioned works. But there is a superficiality about its high finish and the gleaming highlights on the armor, and its theme is taken from the standard repertoire of tenebrist painters across Europe without much of La Tour's own creative invention. Compared with the much earlier *Fortune-Teller* (cat. 17), there is a curious lack of psychological interaction, as the older man at the left

relieves the young gambler of his purse. For all that the whiff of smoke coming from this old rogue's tobacco pipe is a traditional image of vanity and inconstancy,[233] the painting lacks the intense focus of form and meaning of La Tour's prior religious nocturnes. Its attribution to Georges has sometimes been challenged. The form of the signature is not characteristic, and the rather stiff style and stance of the figures has led some scholars to attribute it to Etienne, or to see it as a collaboration between Georges and Etienne.[234] Compared with the Frick *Education of the Virgin* (cat. 29), which has met with similar doubts, *The Dice Players* is in fine condition, although some scholars have claimed that it has lost some of the delicate glazes that may have modeled it more subtly.[235] So long as we have no idea of what Etienne's paintings were like, it seems to the present writer that *The Dice Players* should be given the benefit of any doubt in its attribution to Georges. There are passages of real beauty, as in the profile of the young man (or woman?) at the right. Quite

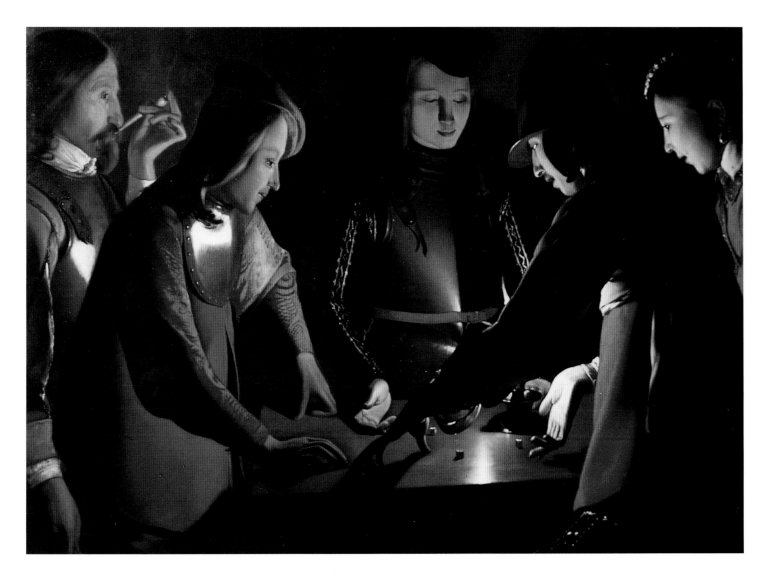

cat. 32. Georges de La
Tour, *The Dice Players*,
c. 1650, Preston Hall
Museum, Stockton-on-Tees

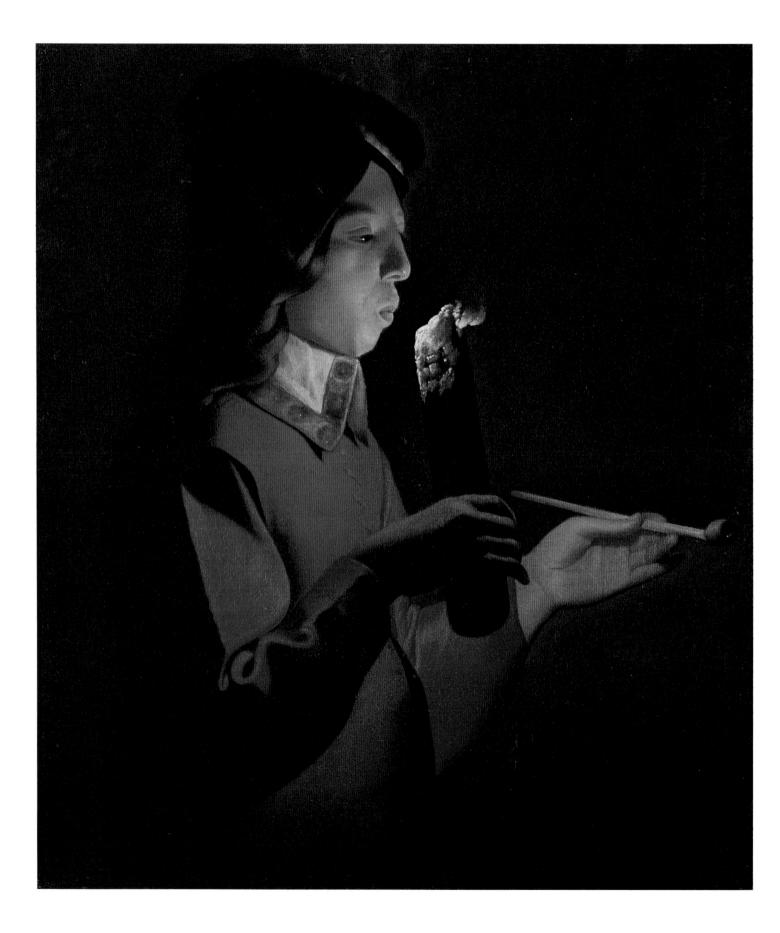

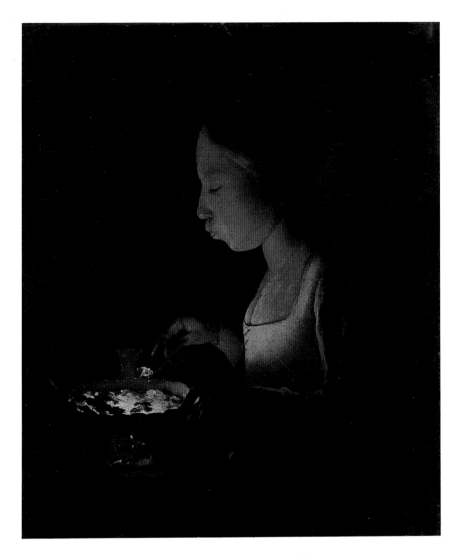

82. Georges de La Tour,
A Girl Blowing on a Brazier,
c. 1645, location unknown

cat. 30. Georges de La
Tour, *Boy Blowing on a
Firebrand*, c. 1645–1650,
Tokyo Fuji Art Museum

work; but Thuillier includes it among the nine versions, none of which he sees as autograph.[236] The boy's face and hands, and the firebrand, are sensitively executed, but a passage such as the highlight on his sleeve is rather heavy handed. This unevenness of quality is found in several late works attributed to La Tour and may indicate the intervention of Etienne or another assistant. The original version, however, must have been comparable with the Nancy *Discovery of Saint Alexis*: the polished surface and simplified forms are similar, and the same model seems to be represented in both works.

We can imagine that such appealing images of young men – and women, as in *A Girl Blowing on a Brazier*[237] (fig. 82) – were quite popular for their beautiful execution and dramatic contrasts of light and shade. An earlier treatment of a similar subject is the signed *Boy Blowing on a Charcoal Stick* (fig. 83) in Dijon, which may date from the late 1630s or early 1640s. They belong to a tradition of such representations developed in the sixteenth century, which looked back to Pliny's descriptions of ancient artists such as Lycius, Antiphilus, and Philiscus, who demonstrated their virtuosity in treating such subjects with skillfully rendered glowing embers and their reflected light.[238] One of the most famous modern prototypes was El Greco's *Boy Lighting a Candle* of about 1570–1575, of which two versions are known. The version that was in the Farnese collection in Rome until 1622 may have inspired a number of northern tenebrist painters, such as the Candlelight Master, Honthorst, ter Brugghen, and Matthias Stomer, while several others took the idea home with them; it was probably by this avenue that La Tour was inspired.[239] In his essay in this catalogue Slatkes suggests ter Brugghen was the originator of the theme of *A Girl Blowing on a Brazier* and provided La Tour with the only prototype showing a female occupied in this pursuit.

Whether or not La Tour intended a moralizing meaning to this theme must remain an open question. The serious and absorbed mood of his young men blowing firebrands does not suggest that any of the playfully erotic connotations of the theme are intended, but it could refer to an admonitory saying

possibly the "signature," which is unusual in its form and lacks any of the calligraphy we expect from Georges' hand, was added by another hand but records an abraded or overpainted original one.

The issue of studio assistance or collaboration arises especially in the multiplication of smaller works of modest ambition. Not all the subjects of La Tour's paintings were as elevated as *Saint Sebastian Tended by Irene* nor as complex as *The Dice Players*. He most likely made many smaller works for collectors of modest means or with modest places for display. Thuillier lists nine examples of his *Boy Blowing on a Firebrand* (cat. 30), although none of the extant versions seems to be the prime one. The example we exhibit, which is signed (or inscribed) *La Tour fec*, was published by Rosenberg in 1973 as an autograph

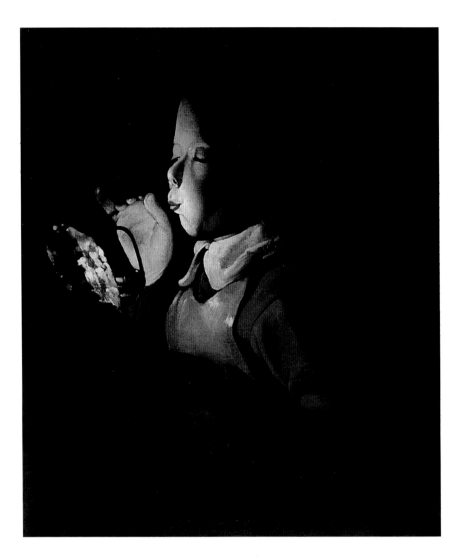

83. Georges de La Tour, *Boy Blowing on a Charcoal Stick*, c. 1638–1642, Musée des Beaux-Arts, Dijon, Donation Granville

sion and execution to the somewhat dry and stiff manner of the exhibited *Dice Players*. It is curious that some of La Tour's most Caravaggesque works – at least in the sense of treating the same subjects and exploring effects of chiaroscuro, which can be traced back to the master's example – should have been painted at this late moment in his career. If it was a lack of invention on La Tour's part that caused him to look for artistic stimulus elsewhere, it is surprising that he turned to models that were certainly old-fashioned by about 1650. Moreover, it does not seem very likely that La Tour made a trip to Italy at this stage of his life. Once more an important aspect of his artistic development remains shrouded in mystery.

Ending

La Tour was almost completely forgotten from the time of his death in 1652 until early in our own century. How can we explain that he is barely even mentioned in the literature of French art that developed in the second half of the seventeenth century? First of all, in his native Lorraine there was no tradition of writing about art and artists, be it academic, critical, or biographical. Yet that is where La Tour mainly worked: a troubled place that was in his lifetime annexed to the great power of France. Moreover, his principal place of activity was Lunéville, not even the main seat of the ducal court at Nancy. But the history of French art that began to be constructed in the seventeenth century was above all a history of art in Paris. Although La Tour was one of the artists privileged as *Peintre ordinaire du Roy* to Louis XIII and at least for a time had an apartment in the Louvre, he seems not to have spent much time in Paris. There is no evidence that he maintained a studio there, with the assistants and pupils who would disseminate his style and extend his influence. Certainly his paintings were admired and collected in Paris, but their owners seem to have been mainly a relatively small circle of individuals who had come into initial contact with La Tour or his art in Lorraine. If La Tour's tenebrist paintings, his "nuits," did indeed represent a signature style – which evi-

or proverb concerning the dangers of playing with fire. There is ample evidence, found in contemporary inventories and in several extant copies, that La Tour painted a number of secular subjects of this type in the last decade of his career, including scenes of cardplayers, musicians, and various gamblers, such as the exhibited *Dice Players* discussed below and in Feigenbaum's essay.[240]

Although we have rather few paintings as evidence, it does seem that La Tour's powers of invention and execution did not continue from strength to strength in the last few years of his life. Insofar as he developed a poetic late style – if an artist in his fifties is allowed a "late" style – it was in the vertical versions of *Saint Sebastian Tended by Irene* and the newly discovered *Saint John the Baptist in the Wilderness;* but thereafter his art declined in expres-

dently had a considerable popularity in Lorraine during the artist's lifetime – there may have been relatively little enthusiasm for it in Paris in the 1630s and 1640s, and even less so at a later date. The subject matter of his nocturnes, especially the dominant religious ones, was conventional within a larger European context. The personal originality with which he treated them may have been lost on an audience outside Lorraine, where he can be seen to have been responding to a local demand for images of a peculiarly intensely contemplative nature. A prominent Parisian painter such as Vouet had been through, and developed beyond, a phase of Caravaggesque *tenebroso* when he was in Rome in the second decade of the century. Tenebrism was an essentially Roman manner, developed there above all by Bartolomeo Manfredi, as Feigenbaum demonstrates in her essay, and was modified by an artist such as Saraceni. But it was also practiced and exported by artists of French origin such as Valentin and Regnier, or it was brought home to provincial centers such as Le Puy (Guy François), Provence (Trophime Bigot as well as Louis Finson, a painter of Flemish origin), Toulouse (Robert Tournier), or Lorraine (Le Clerc, La Tour). But this bold, contrasted, visually dramatic style did not conform to – indeed was even opposed to – the stylistic approaches that gained support in Paris from about 1630 on: a modified baroque classicism, derived from the Carracci and their Italian followers, which was disseminated in France by Vouet and others; or the Flemish naturalistic tendency that was developed by Pourbus and Champaigne. Artists such as the Le Nain brothers, who did not conform to the classicizing norms developing in Parisian art during the 1630s and 1640s, had a certain reputation and standing in the capital, perhaps because they were active there, even to the extent of being among the founding members of the Royal Academy of Painting and Sculpture in 1648. But La Tour was not part of this world: his ties were and remained with his native Lorraine.

All these factors help explain why La Tour was ignored by André Félibien, to mention only the most important critic and historian, who was excellently informed and remains our prime source for knowl-

edge of the artistic ideology of the capital in the second half of the century. As secretary of the recently founded Royal Academy, Félibien was committed to promoting its classicizing ideals and to extolling the virtues of its members, whose role was to add luster and glory to the reign of Louis XIV. Writing during the last decades of the century, Félibien was severe and dismissive of most artists of the earlier part of the century, such as Toussaint Dubreuil and Amboise Dubois of the second school of Fontainebleau, or Lallemant, in spite of the fact that the latter painter from Lorraine had an important and productive studio in Paris. Félibien spoke only slightingly of Lallemant, which set the tone for the rare squibs he would receive from subsequent writers. Typically, a classicizing commentator such as Pierre-Jean Mariette in the early eighteenth century dismissed Lallemant: "His manner was poor and without taste, and yet he had a reputation and was much in demand. His school was frequented, and nothing was more prejudicial to the future of the arts."[241] Only very recently has there been an attempt to reconstruct the career, oeuvre, and importance of a neglected painter such as Lallemant and others of his generation.[242] The eclectic mannerism of all these painters was easily dismissed as irrelevant to the great story of French art under the Sun King that an influential figure such as Félibien was constructing. But as La Tour was not a significant presence nor influence in Paris, it was easy enough to ignore him entirely. Moreover, the decline of the house of Lorraine and the assimilation of its territories into those of France may well have diminished and even disadvantaged the reputation of any artist from that sad region.

The movement represented by Vouet especially, an impressive baroque classicism with all the weight of the Italian tradition behind it, did render other modes of artistic production redundant: even Rubens' great Marie de' Medici cycle of paintings, installed at the Luxembourg palace in Paris in the mid-1620s, drew virtually no response from French artists, at least until the breakdown of academic classicism at the close of the century. We have already noted that the invitation of the famous Poussin to Paris in 1640 was a challenge to Vouet's position and style and was

recognized as such in the intensely political art world of the capital. Once the Royal Academy was an established and dominant feature of artistic life in the 1650s, it was indeed the Poussinist, classical aesthetic that would prevail as the greatest single influence on the course of French painting. In the sphere of propagandistic decoration on the monumental scale, the bombastic baroque grandeur of Charles Le Brun would prevail. The austere naturalistic observation of Champaigne served for certain types of devotional art and for portraiture. La Tour, soon ignored in Paris and in Lorraine, where his works were scattered and often destroyed, was left without an artistic legacy, champion, or even obituarist. It is little wonder that his art disappeared into a long dark night of neglect. If justification of academic pursuits were needed, the recovery of this great painter is due entirely to the diligence of an Alexandre Joly and his many dedicated followers in the dusty archives of Nancy, Lunéville, and Vic-sur-Seille, and to Hermann Voss, peering with a flashlight in the gloom of the Nantes museum just before the outbreak of the First World War.

Notes

1. On Claude Lorrain between Rome and Nancy, see Rome/Nancy 1982, 275–323. Claude is documented on a return trip to his native Nancy in September 1625, when the court painter Claude Deruet engaged his assistance in painting the ceiling of the Carmelite church (Nancy 1992a, 395). He probably returned to Rome in 1626; he remained in Italy for the rest of his life. See Poussin's letters in Jouanny 1911.

2. Thuillier 1993, 24–25. Bajou 1993, 77, is cautious about the identity of the Georges de La Tour mentioned in this document. If it were a Roman document, would it have received more attention?

3. My discussion of La Tour's life is based mainly on the documents published in Rosenberg and Thuillier 1972, Reinbold 1991, and Thuillier 1992, so it seemed both unnecessary and unwieldy to justify every stated fact with a citation from them; the rich and carefully ordered documentation of these indispensable publications means that the pioneering contribution of Pariset 1948 tends to be ignored by recent writers, but his important contribution is acknowledged here.

4. See Cabourdin 1977, 1:77, for a map of international trade routes through Lorraine at the end of the sixteenth century.

5. On Rambervilliers see Rosenberg and Thuillier 1972, 60; Thuillier 1993, 20–22; as an acquaintance on 18 January 1594 see Reinbold 1991, 174; as a witness see Rosenberg and Thuillier 1972, 61–62.

6. Alphonse de Rambervilliers, *Les dévots élancemens du poète chréstien présentés à très-chréstien, très-auguste, & très victorieux Monarque, Henri IV, Roy de France, et de Navarre par Alphonse de Rambervillier doct.eʒ drois, Lieuten.gnal au baillage de l'Evesché de Metʒ 1602* (Pont-à-Mousson, 1603), was the published version, with engraved illustrations after the author: see Pariset 1948, pl. 1, figs. 1–2. On this and other publications by Rambervilliers and on his religious beliefs see Cullière et al. 1989.

7. On Rambervilliers' inventory see Reinbold 1991, 26, 214.

8. Tribout de Morembert 1974, 212–214.

9. Bellange took on an apprentice on 1 January 1595 for four years; on 19 February 1605 he took on Claude Deruet for four years (see Nancy 1992a, 383–384); La Tour's apprentices also had four-year contracts (see note 199 below).

10. Reinbold 1991, 25; Sylvestre 1985, 50.

11. The best summary of recent scholarship, much of it by the author himself, is Mérot 1995.

12. On Bellange see Jacques Thuillier in Nancy 1992a, 134–192, 310–331; Pierre Rosenberg in Meaux 1988, 106–107; Boston/Des Moines/New York 1975; Walch 1971; and Comer 1980.

13. On Wayembourg, Constant, and other artists in early seventeenth-century Nancy see most recently Nancy 1992a. On the decoration of the ducal palace in Nancy, especially by Bellange, see Lepage 1852, 78–82, 93–94, 107–108.

14. Nancy 1992a, 366.

15. On Lallemant see Denis Lavalle in Nancy 1992a, 194–209, 399–400; Patrick Ramade in Meaux 1988, 118–137. On Büsinck see Stechow 1938.

16. See Pariset 1948, 98–100, for a discussion of La Tour and Bellange; Rosenberg leans heavily toward a connection between the two artists in Meaux 1988, 110; and see Reinbold 1991, 30–31.

17. On Deruet see Jean-Claude Boyer in Nancy 1992a, 210–217, 337–349, 394–398.

18. Nancy 1992a, 146–147.

19. See note 16.

20. The fundamental article is by Linnik (1973), who, with Rosenberg in Meaux 1988, 110, accepts *The Lamentation* as Bellange; Thuillier in Nancy 1992a, 142, suggests it may be a copy.

21. Meaux 1988, no. 25.

22. Linnik 1973, 69–70, questions the identity of the donor and the patron saint and gives the picture a late date, perhaps 1616.

23. See Shearman 1967; the present writer uses "mannerism" in the same sense as Shearman does: the "stylish style" (p. 23).

24. Meaux 1988, no. 27, for a discussion of *Judith and Her Servant*.

25. Voss 1915.

26. On Lorrainese artists in Rome in the seventeenth century see Rome/Nancy 1982.

27. For a discussion of the ducal palace, its artists, and its collections see Lepage 1852 and Lepage 1853; Lepage 1852, 74, records the first mention, in 1590, of a Galerie des Peintures to house the collection of Charles III.

28. For the contract see Thuillier 1993, 245–246.

29. Although Etienne is already referred to as "noble Estienne Joseph La Tour" in a document of 1654, he was actually given his letters of nobility by Charles IV in 1670 (Rosenberg and Thuillier 1972, 88).

30. The translation is taken from Thuillier 1993, 41–42.

31. On Le Clerc see Claude Petry in Nancy 1992a, 218–238, 405–408, and Rome/Nancy 1982, 73–102.

32. See Nancy 1992a, 394–395 (Deruet), 406 (Le Clerc).

33. For *The Payment of Taxes* and other works in the exhibition, the various dates assigned by earlier scholars are listed in the catalogue entries. Foucart 1978, 59, and 62 n. 63, dates *The Payment of Taxes* to "before 1620." Elisabeth Martin in Reinbold et al. 1994, 18 n. 2, has tentatively suggested reading the date as 1614, which would not surprise the present author. We have adopted the harsher title, *The Payment of Taxes*, rather than the bland *Payment of Dues* used by Nicolson and Wright 1974 and the English edition of Thuillier 1993.

Martin (pp. 23–25) has observed that *The Payment of Taxes* has a light-toned ground, containing chalk, which is typical of Franco-Flemish preparations of the sixteenth century, and she suggests this is an indicator of an early date. Recent research published by Gifford et al. in this catalogue reveals this same type of preparation in the San Francisco *Old Man* and *Old*

Woman, discussed below as early diurnal works. Martin also compares the preparation of *The Payment of Taxes* ("un nocturne précoce") with that of the diurnal *Hurdy-Gurdy Player with a Dog* in Bergues (cat. 5); although the present author agrees, on stylistic grounds, that all these works are among the earliest known in La Tour's career, the preparation of the canvas is not in itself conclusive evidence of an early date, as the artist could have used the same preparations and techniques at different dates. Reinbold et al. 1994, 33–36, supports Martin's distinction between the early nocturnal *Payment of Taxes* and the mature nocturnes of the 1630s and 1640s.

34. First suggested by Nicolson and Wright 1974, 16, and fig. 12.

35. Marlier 1969, 435–440.

36. See Bellange's *repoussoir* figures in *The Martyrdom of Saint Lucy*, *The Adoration of the Magi*, or *The Raising of Lazarus* (Walch 1971, nos. 16, 20, and 47).

37. Linnik 1973, 68.

38. As observed in Thuillier 1993, 285.

39. Kellog Smith 1979; but the prints Smith reproduces, figs. 19–23, all show theatrical or narrative scenes. La Tour does not provide a narrative context, although some sort of relationship is surely intended between his two protagonists.

40. F. Bologna 1975, 440 n. 37.

41. Further on *Georges and the Bowl of Soup* see Nancy 1992a, no. 85. Verses on an engraving by Pierre Daret after this design are ribald. "Georges" may be a character from the popular theater of the time.

42. I would like to thank Erich Schleier for discussing his reconstruction with me. Of the copies, all inferior in quality to the Berlin original, one is in Musée historique lorrain, Nancy; another in a private collection in Compiègne; and another in a private collection in Germany.

43. F. Bologna 1975, 437.

44. On account of the preparation of its light, chalky ground, Martin in Reinbold et al. 1994, 24, places *Hurdy-Gurdy Player with a Dog* with the early diurnal pictures.

45. Pariset 1948, 310, and pl. 47, fig. 2, as "School of La Tour"; yet his illustration was taken from Jacquot 1900, which gave the correct attribution. Gilles Chomer, who deciphered the signature and date of 1628, kindly drew my attention to the fact that this work recently sold at auction (Lyon-Brotteux, Lyon, 5 December 1993, no. 196, illus. in color, as Vincenzo Campi); it is now in a private collection in Lorraine. La Tarte was working in a northern tradition, exemplified by a similar picture, once called "Cat Worship at the Feast of Corpus Christi," which sold at Christie's (New York, 12 January 1994, no. 135), as School of Utrecht or Haarlem (and a copy, Drouot-Richelieu, Paris, 8 July 1992, no. 24). For a north Italian version of this subject and further references see Sarrazin 1994, 132–133, 53. Chomer (letter to the author, 22 April 1995) has convincingly attributed two other works to La Tarte on the basis of the rediscovered *Feeding the Cat*: the Crakow *Concert*, previously given to the

School of Lorraine (Nancy 1992a, 276–277, no. 88), and *The Musical Party*, recently acquired by the Nationalmuseum, Stockholm: see Sotheby (London, 9 December 1992, no. 2, as "School of Lorraine circa 1620").

46. Pariset (1948, 303–305, 419) noted two versions of *The Market Stall*, which he called "Studio of La Tour," discovered in Nancy in 1938. See also *The Card Players* (Musée historique lorrain, Nancy), a rather crude work tentatively attributed to La Tarte by Pariset, illustrated in Pariset 1976, 140. The numerous inventories published in Wildenstein 1950 and 1951 indicate the popularity of genre subjects in Paris in the late sixteenth and early seventeenth centuries.

47. See Nancy 1992b, 267, and no. 299. I have used Paulette Choné's brilliant catalogue of the superb exhibition held in Nancy in 1992 as the work of reference on Callot throughout the present publication.

48. Schleier 1976, 239; Nancy 1992b, 276, and no. 325.

49. Nancy 1992b, nos. 331 and 336.

50. Nancy 1992b, no. 305, although the identification of Madame Callot is speculative.

51. Stechow 1938, 397–411.

52. Thuillier 1993, 249; in the payment document of 1623, the words *peintre de Lunéville* are crossed out and *de ce lieu* substituted, suggesting La Tour was resident in Nancy at that time (Rosenberg and Thuillier 1972, 67).

53. Lepage 1875, 2, says Henri II commissioned the painting of *Saint Peter* for the Church of the Minims; and see Rosenberg and Thuillier 1972, 67.

54. The miniature is reproduced in color in Thuillier 1993, 60; for a thorough discussion of the Archduke Wilhelm's painting by La Tour see Grossmann 1958.

55. Aubry and Choux 1976, 155; Thuillier 1993, 263.

56. For a reference to La Tour as a pupil of Reni see Pariset 1948, 111, 365 n. 18.

57. Suggested in Blunt 1972, 523.

58. The original is lost but was published in Nicolson 1989, no. 1135; Rosenberg 1993, 404, and fig. 13, made the comparison with La Tour.

59. Reinbold 1991, 48–49.

60. Choné 1992, 518.

61. Choné 1992, 517.

62. Paris 1989a, no. 17.

63. The contract with Didelot is transcribed in Thuillier 1993, 272–273.

64. For *Saint Andrew* see Thuillier 1993, 283, no. 6; the painting reappeared at Sotheby's (Monaco, 21 June 1991, no. 108, as *Saint Bartholomew*), allegedly from an old family near Albi.

65. The discovery that the canvas of *Saint Philip* was prepared with a predominantly chalk ground, as revealed by Melanie Gifford and her colleagues elsewhere in this catalogue, aligns it with works such as *Old Man*, *Old Woman*, *Hurdy-Gurdy Player*

with a Dog, and *The Payment of Taxes* mentioned above, which were similarly prepared and which Elisabeth Martin considers to be early in his career.

66. For the recently established provenance of the Albi Apostles see Jean-Claude Boyer in Reinbold et al. 1994.

67. See Boyer in Reinbold et al. 1994, 64–65; Schnapper 1988, 279–282.

68. On series of Apostles see Urbach 1983, 14–17.

69. We see a similar striking realism at this time in the art of a painter such as the Italian Tanzio da Varallo, who worked in the Varese region near the border with Switzerland. Tanzio was motivated to bring the divine down to earth and into the recognizable forms of modern life in the face of threatening reform in the nearby Swiss Protestant valleys, as in his *Adoration of the Shepherds with Saints Francis and Carlo Borromeo*. See Conisbee, Levkoff, and Rand 1991, 79–82, no. 19.

70. Washington 1990, no. 19.

71. Stechow 1938, 351–352, nos. 5–17.

72. On Le Clerc's *Nocturnal Concert* see Rome/Paris 1973, no. 11; Nancy 1992a, nos. 89–90. Martin in Reinbold et al. 1994, 25, makes the observation that Le Clerc, on his return to Lorraine from Venice in about 1621, was employing an Italian method of preparing paintings with earth-colored grounds (as opposed to the prevalent northern practice of employing light, chalky grounds), but only *The Adoration of the Golden Calf* in the Musée des Beaux-Arts, Nancy (see Nancy 1992a, 224, no. 61, conservation notes), had been tested at the time of her article. Further on seventeenth-century painting grounds and on La Tour's use of potter's clay see Gifford et al. in the present catalogue; it seems to the present writer that not enough comparative evidence exists on this topic to draw any conclusions.

73. Nancy 1992b, no. 542.

74. Thuillier 1993, 297, nos. A14 and A15.

75. See Nicolson and Wright 1974, 192, no. 56.

76. The piper is usually said to be holding a stone, but the suggestion of a lemon came from Jennifer Montagu, reported in Cuzin 1982, 527. The object is more or less concealed by the man's hand.

77. See Choné's suggestion in Nancy 1992b, 276, with further references; and nos. 318 (Callot's *Hurdy-Gurdy Player*); 319 (false *Pilgrims*); and 324, 328 (falsely devout beggars with rosaries); see Thomas 1932 for a modern critical edition of *The Book of Vagabonds*.

78. See The Hague/Antwerp 1994, no. 43; and the pendant illus. 308, fig. 1. Further on the theme of hurdy-gurdy players in Dutch art see Dordrecht 1992, 243–244.

79. Blunt 1972, 519; see Marlier 1969, 362 (illus.), 363, where it is described as "une sorte de nocturne," although in fact it is a painting in distemper, which has darkened with age.

80. Sold at Hôtel Drouot (Paris, 28 June 1993, no. 22), as "Ecole Lorraine vers 1630"; Eric Turquin kindly supplied a photograph. See also Cuzin and Rosenberg 1978, 3:194, fig. 21, where

the work is attributed to "Jean Leclerc(?)" and fig. 22 reproduces an anonymous engraving after it, with moralizing verses on the ill effects of drink.

81. Manfredi's now lost *Taking of Christ* was in the collection of Archduke Leopold Wilhelm, along with La Tour's lost early *Repentant Saint Peter;* for an engraving by David Teniers after the *Taking of Christ* see Cremona 1987, 40.

82. The use of opaque impasto, rather than subtly layered glazes, distinguishes such a copy from La Tour's own painting techniques. But while the execution of the Chambéry picture seems heavy-handed in comparison with La Tour's work, Thuillier has suggested that its good state of preservation may give a sense of the original color in the jacket of the central fighting flautist: see Thuillier 1993, 283; however, the present author would argue to the contrary, that the copyist has not understood La Tour's employment of red lake glazes to suggest the wear and greasiness of the flautist's old jacket; on the Getty and Chambéry pictures, see also Vic-sur-Seille 1993, 48–52.

83. Ottani Cavina 1972, 7, fig. 4; Nicolson and Wright 1974, 58, accept the print as "after La Tour"; Pariset 1976, 138–139, reproduced it again as "La Tour?" but also suggested it might be by another French Caravaggesque artist around 1620; it is included in Nicolson 1989, no. 896, as "after La Tour."

84. See Stechow 1938, 392 (illus.); and Stechow 1939, 353, no. 23. The proud calligraphic flourishes of the signatures of Lallemant and Büsinck in this print can be compared with the signatures of La Tour on such paintings as the Louvre's *Saint Thomas* and the Metropolitan's *Fortune-Teller*.

85. Thuillier 1993, 62–63, 284, no. 17; Madrid 1994, no. 3.

86. Thuillier 1993, 286, no. 26; first published by Rosenberg 1991, 703–705.

87. Nancy 1992a, no. 84.

88. See Pliny's *Natural History* 35.65–66 for the story of how Parrhasios' illusionistic painting tricked Zeuxis into thinking a painted curtain was real.

89. See Washington 1989, nos. 1 (Ast), 3 (Beert), and 7 (Bosschaert).

90. Thomas 1932, 123.

91. Ribault 1984, 1–4.

92. For an excellent general discussion of the hurdy-gurdy see Winternitz 1967, 66–85; for its later history in France see Leppert 1978; and Antonio Gallego in Madrid 1994, 59–67.

93. Marlier 1969, 365–368.

94. Foucart 1978, 60 n. 13, notes that by 1659 Van de Venne's *Hurdy-Gurdy Player* was in the collection of Archduke Leopold Wilhelm in Brussels – along with La Tour's early *Saint Peter Repentant*.

95. Quoted in Ribault 1984, 2.

96. Voss 1931, 99.

97. Rosenberg and Thuillier 1972, 90.

98. For recent discussions of the Prado and Remiremont pictures see Nancy 1992a, nos. 95, 96, and Madrid 1994, nos. 4, 5.

99. Blunt 1972, 519–520, and fig. 6, drew attention to the School of Fontainebleau, *Scene from the Commedia dell'Arte* (The John and Mable Ringling Museum of Art, Sarasota), as another compositional and thematic prototype for La Tour's three moralizing scenes of modern deception and duplicity.

100. Voss 1931, 98–99.

101. Voss 1915.

102. See Voss 1924, 448, which discussed La Tour in three brief lines among the French followers of Caravaggio, without suggesting La Tour went to Rome; Voss described Valentin as "more Italian than French" and set up La Tour against him as "original and specifically French," although it is Honthorst who is proposed as the source for La Tour's use of light.

103. For early dating see Blunt 1972, 523; and Nicolson and Wright 1974, 188–190, nos. 48 and 49. For later dating see Rosenberg and Thuillier 1972, nos. 12 (*The Fortune-Teller*, "autour de 1630"); 13 (*The Cheat with the Ace of Clubs*, "assez voisine en date"); and 14 (*The Cheat with the Ace of Diamonds*, "dans les années trente, avant les premiers grands nocturnes").

104. Thuillier 1993, 286, under no. 31.

105. Nancy 1992a, under no. 98.

106. Reinbold 1991, 250, 252.

107. Klein and Zerner 1966, 120–121.

108. This clear formula comes from Wittkower 1965, 2.

109. See the murals executed in the Gesu, Rome, in the 1580s and 1590s, discussed in Hibbard 1972, 29–49.

110. On the classicizing tendencies of Italian painting after the Council of Trent see Zeri 1957; and Herwarth Röttgen in Rome 1973. Mérot 1995, 47–93, addresses this phenomenon in French painting of the early seventeenth century. The so-called Serrone Master's *Christ and the Virgin with Saint Joseph in His Workshop* (Santa Maria Assunta, Serrone), with its curious mixture of archaism, a self-consciously clear organization of forms, and vivid observation of detail, is an example of the post-Tridentine reaction to mannerism; Thuillier 1993, 28–33 (illus.), has proposed it as an early La Tour, but this attribution has not gained general acceptance; see also Toscano 1994 for a discussion of this work.

111. For example, the deliberations of the Council of Trent were reported in *La saincte, sacré, universel, et générale concile de Trente* (Pont-à-Mousson, 1584), cited in Choné 1991, 486.

112. Quoted in Brémond 1916, 4:32.

113. See René Taveneaux in Lunéville 1993.

114. Nancy 1992b, no. 673.

115. Quoted in Choné 1991, 486.

116. Nancy 1992b, no. 449.

117. Nancy 1992b, no. 667, and see Choné 1991, 486.

118. See Thuillier 1993, 277–278; and Pierre Morracchini in Reinbold et al. 1994. For La Tour's purchase of the land see also Reinbold 1991, 50, 190.

119. See Choné 1991, 521, on Saint-Jean-lès-Marville as a strong-hold of the faith; also 518–519 on the influence of Spanish mysticism on the religious life of Lorraine.

120. Quoted by René Taveneaux in Nancy 1992a, 50.

121. On La Tour and Fourier see Bougier 1958; Reinbold 1991, 52–55; Choné 1991, 497; Thuillier 1993, 253.

122. Choux 1995 has established an identity and an oeuvre for Claude Bassot.

123. See "Saint Jerome" in *The New Catholic Encyclopaedia*, 16 vols. (Washington, 1967), 7:872–874.

124. Thuillier 1993, 284, no. 15; the painting has been harshly cleaned and abraded in the past.

125. Thuillier 1993, nos. 36 (Louvre), and 65 (Musée historique lorrain); the latter painting is inscribed *La Tour fecit*. For a discussion of this and similar signatures/inscriptions, see Anne Reinbold in Vic-sur-Seille et al. 1993, 67–75, and Roze 1993, 114–120.

126. For documents recording a work by La Tour in the abbey of Saint-Antoine-en-Viennois in the eighteenth century see Nicolson and Wright 1974, 170–171.

127. Grate 1959, 17.

128. Levi 1985, 66. On Richlieu's collection in Paris see Boubli 1985.

129. Pariset 1948, 216–221, thought the Stockholm painting came first; but Grate 1959, Rosenberg and Thuillier 1972, Nicolson and Wright 1974, Thuillier 1993, and Vic-sur-Seille 1993, all place the Grenoble version first; recently Rosenberg in Nancy 1992a, 246, has opted for Stockholm first but without giving reasons.

130. For a discussion of the x-rays see Vic-sur-Seille 1993, 87–89, 118–121; and Martin in Reinbold et al. 1994, 19.

131. Claire Barry's research on *The Cheat with the Ace of Clubs* and *The Cheat with the Ace of Diamonds*, published in an appendix to this catalogue, points to the use of cartoons by La Tour.

132. Reinbold 1991, 61–63; Thuillier 1993, 96–102.

133. Reinbold 1991, 79–80.

134. See Levi 1985 for the inventory of Richelieu's collection at the Palais Cardinal.

135. See Reinbold 1991, 107, and also Nancy 1992a, for the Parisian careers of Lorrainese artists.

136. For the citation in French see Rosenberg and Thuillier 1972, 90.

137. The six examples of this composition seen by the present author include the exhibited work; those in the museums of Rouen (see Rosenberg 1966, 75–77), Orléans (see Rosenberg and Thuillier 1972, no. 47; and Lunéville 1993, no. 34), Evreux, and Detroit; and in a private U.S. collection (formerly with Julius Weitzner and then Wildenstein). Nicolson and Wright 1974, 186, lists three other copies in private collections (nos. 43E, 43H, and 43 7I).

138. Wright's article is scheduled to appear in *Apollo* in June

1996, after the present catalogue has gone to press; I am grateful to Mr. Wright for allowing me to see a draft of this article. Pariset 1948, 128 and 370, noted that the work referred to by Calmet was also documented in Houdemont in 1736.

139. It is hoped that studying the Kimbell painting (and other attributed works) further in the exhibition alongside undisputed works by La Tour will help to resolve the question of whether or not it is a damaged original by the master. It has not been exhibited in the company of works by La Tour since 1971, when Richard Spear wrote that it "is unquestionably among the best versions, and probably is the finest," without attributing it to the master. It was not included in the La Tour exhibition in Paris in 1972, but it was discussed in the catalogue as a copy, along with versions in Orléans and Rouen, but as "the closest evidence of the lost masterpiece." Rosenberg and Thuillier 1972, 246; only the version in Orléans was exhibited (no. 47).

140. Pierre Chanel in Lunéville 1993 states that the Kimbell's *Saint Sebastian Tended by Irene* was offered to the king in Paris in 1638–1639; but Pariset 1948, 55–56, and Spear in Cleveland 1971, 116–117, opt for a presentation to Louis XIII in Lorraine in the early 1630s.

141. Pariset 1948, 56, 342; Nancy 1992b, 332.

142. Meaux 1988, 110.

143. The Ponce *Saint Sebastian Tended by Two Angels*, previously given to Claude Vignon, was attributed to Lallemant by Rosenberg in Paris/New York/Chicago 1982, 354; on Lallemant see Patrick Ramade in Meaux 1988, 118–137, esp. 124 on the Ponce picture, and Mérot 1995, 56–57.

144. For the popular dissemination of images of Saint Sebastian see Paris 1983.

145. Reinbold 1991, 220; Thuillier 1993, 259.

146. Pariset 1948, 52–53.

147. Taveneaux in Lunéville 1993; on religious confraternities in Lorraine, see Frédéric Schwindt, "Les confréries de saints et de saintes dans le diocèse de Verdun du XIV⁰ au XX⁰ siècle," in Jarville/Saint-Dié/Verdun/Sarrebourg/Nancy 1993, 207–221.

148. Nancy 1992a, no. 150. In a poor copy of this painting made in 1639, another citizen, Willemin Richardot, and his wife are depicted as donors, praying to the three saints for their intercession; it was probably a votive offering of thanks for their survival in good health. See Paris 1983, no. 128.

149. For several treatments of *Saint Sebastian Tended by Irene* by this master, see Nicolson 1989, nos. 841, 848, 849.

150. Choné 1991, 524.

151. Pariset 1948, 393–394, and Rosenberg 1966, 75, both remark on the number of examples of *Saint Sebastian Tended by Irene* found in Normandy: at Rouen (Rosenberg notes no fewer than three examples, possibly though not necessarily connected with La Tour, listed in inventories of works of art seized in Rouen during the Revolution), Evreux, Honfleur, and a private collection in Caen; Orléans is not so far to the south. Moreover, the later version of this subject, most likely painted for

Maréchal de La Ferté in 1649 and now in the Louvre, was found in the parish church of Bois-Anzeray in Normandy in 1945. It is worth noting other works by La Tour found in this part of France: *The Flea Catcher* (cat. 20) was discovered in Orléans in the 1920s; *The Ecstasy of Saint Francis* (cat. 25) in Le Mans; *Saint Thomas* and *The Fortune-Teller* (cats. 13 and 17) near Le Mans; and *The Newborn Child* (cat. 27) in Rennes. In addition, the three paintings by La Tour acquired by Nantes with the collection of François Cacault in 1810 – *The Hurdy-Gurdy Player* (cat. 11), *Saint Joseph and the Angel*, and *The Denial of Saint Peter* – could have had local origins (see Rosenberg and Thuillier 1972, 140). On the Maréchal de La Ferté's collection see Boulmer 1988.

152. Weisbach 1932 identified the subject. See Rosenberg and Thuillier 1972, no. 29, for a discussion of the stylization of the picture, down to the wife's right hand as "un volume de bois mal dégrossi."

153. See Thuillier 1993, 224.

154. Choné 1991, 510 n. 413.

155. Rosenberg and Macé de l'Epinay 1973, no. 42, suggested a biblical subject; Picard 1972, 214, and Charpentier 1973, 104, the Magdalene; Wright 1985, 196, the Virgin; and Adhémar 1972, 220, a pregnant girl.

156. Rosenberg and Thuillier 1972, 179.

157. Adhémar 1972, 220–221.

158. Wind 1978; Moffitt 1987.

159. Honthorst treated the erotic flea hunt several times (see Nicolson 1989, nos. 1249, 1254). I thank Professor J. Richard Judson for discussing Honthorst's *Flea Hunt* with me and for sharing the entry in the forthcoming revised edition of his *catalogue raisonné* of Honthorst's works.

160. Choné 1992, 86–87, quoting Gilles Corrozet, *Hecatomgraphie, c'est-à-dire les descriptions de cent figures & hystoires* (Paris, 1540).

161. Choné 1992, 87, quoting Etienne Tabourot, *La touche du seigneur des Accords* (Rouen, 1616), 1:32–33.

162. Rosenberg in Nancy 1992a, 302, inclines toward the simplest descriptive title.

163. Reinbold 1991, 72. Unfortunately these works are unattributed in the inventory, suggesting that La Tour's name had already slipped into obscurity by the 1670s, if indeed any of these works were by him or in his style.

164. On Bullion see Reinbold 1991, 88; Thuillier 1993, 296; and Schnapper 1994, 35.

165. Pariset 1948, 344.

166. Schnapper 1988, 178, 195; Schnapper 1994, 173–174.

167. We cannot rule out the possibility that it was through de Sourdis, who later became governor of the Orléanais, that works by La Tour seem eventually to have found their way to that area of the country (see note 151 above).

168. Reinbold 1991, 89–90.

169. Thuillier 1993, 110.

170. Mignot 1984; Reinbold 1991, 89, 168.

171. Mignot 1984; Schnapper 1994, 35, 111–112, 178–179.

172. For Louvois and Le Nôtre see Rosenberg and Thuillier 1972, 89.

173. Thuillier 1993, 264–265.

174. Thuillier 1993, 182.

175. Thuillier 1993, 183, 270.

176. Reinbold 1991, 222; Thuillier 1993, 105.

177. Reinbold 1991, 226.

178. First published by Antoine 1979; Thuillier 1993, 109, 261.

179. Thuillier 1993, 262.

180. On these French Caravaggesque painters see Rome/Paris 1974; and for a recent summary see Mérot 1995, 81–86.

181. For the most recent account of Vouet see Paris 1990.

182. See Choné 1991, 515, 520, and 798–800 (citing *La Saincte Apocatastase*); Choné discusses the availability of the writings of Saint John of the Cross in Lorraine. See also Michel Sylvestre in Madrid 1994, 47–58, stressing the connections to the Spanish mystics.

183. Quoted in Choux 1973, 112; see also Choné 1991, 508.

184. For the three copies not exhibited nor illustrated here, see Thuillier 1993: nos. 33, *Repentant Magdalene with the Crucifix* (private collection, France); 42A, *Repentant Magdalene with a Mirror* (formerly Terff Collection, Paris); and 44, *Repentant Magdalene* (Musée des beaux-arts, Besançon).

185. The edition used here is Ryan and Rippenberger 1969.

186. See Mâle 1951, 68; and Bardon 1968, 31:274–306. Notable commentaries on the Magdalene were: Nicolas Coëffeteau, *Tableau de la Pénitence de la Madeleine* (1625); Cardinal Pierre de Bérulle, *Les élévations à Jésus-Christ Notre Seigneur, sur la conduite de son esprit et de sa grâce vers sainte Madeleine* (1627), quoted in part in Thuillier 1993, 152–154; and Charles de Saint-Paul, *Tableau de la Magdeleine en l'esprit de parfaite amante de Jésus* (1628). In Lazare de Selve's *Les oeuvres spirituelles sur les évangiles des jours de caresme: & sur les festes de l'année* (1620), this counsellor of Louis XIII and his representative in Metz, Toul, and Verdun devoted Canticle 12 "To the Magdalene" and Canticle 13 to "The Tears of Saint Mary Magdalene." Paul de Barry devoted canticles to the Magdalene in his *La dévotion à la glorieuse sainte Ursule* (Lyon, 1645), quoted in part in Brémond 1916, 4:1, 206–207.

187. For a brilliant study of the Magdalene from ancient to modern times see Haskins 1993.

188. Choné 1991, 531 n. 505, 538. While the present catalogue is in its proof stage, May 1996, after discussion with Pierre Rosenberg and considering Thuillier 1995 on the recently discovered *Saint John the Baptist in the Wilderness* (cat. 31), I am inclined to revise the date of *Repentant Magdalene with a Document* to much later than I previously thought (see also Washington 1993) and to place it in the late 1640s – between La Tour's *Magdalene with Two Flames* (fig. 70) and *Saint John the Baptist*

in the Wilderness, and close in date to the attributed *Education of the Virgin* (cat. 29).

189. For two other copies see Thuillier 1993, nos. 42 and 44.

190. Reinbold 1991, 116, 150–151; Thuillier 1993, 263.

191. Guilielmus Hesius, *Emblemata Sacrada de Fide, Spe, Charitate* (Antwerp, 1636), 2:22, cited in Choné 1991, 532.

192. Daniel Cramer, *Emblematum Sacrorum* (Frankfurt, 1624), 52–53, Emblem 10.

193. See Choné 1991, 528–529, for the alternative meanings.

194. These references were first noted by Richard Spear in Cleveland 1971, 118.

195. Choné 1991, 537.

196. See especially Choné 1991, 522–525.

197. First published with some doubts about its authenticity by Charles Sterling in 1938, this painting has had few supporters, but they include Pierre Landry (see Landry 1942, 22–26), Paul Jamot (see Jamot 1948, 34–38), and Vitale Bloch (see Bloch 1972, 222–223). It was sent to Washington, Toledo, and New York in 1960 (no. 24) in an exhibition organized by Michel Laclotte, where it was catalogued as by Georges de La Tour, although the catalogue entry notes some of the doubts about the picture. Accepted in Nicolson and Wright 1974, no. 13, it is dismissed as a copy after a lost original in Rosenberg and Thuillier 1972, no. 51, and Thuillier 1993, no. 45. The Musée de Tessé, Le Mans, stands by the excellent catalogue entry in Foucart-Walter 1982, no. 63, where it is called "une copie ancienne . . . le brillant écho d'une toile importante de Georges de La Tour aujourd'hui disparue."

198. Morracchini in Reinbold et al. 1994, 41.

199. Nancy 1992a, no. 66.

200. Mignot 1984, 73–74; Thuillier 1993, no. A3.

201. Reinbold 1991, 236; Thuillier 1993, 266.

202. See Wittkower 1963.

203. Félibien 1725, 3:377.

204. Contracts with La Tour's apprentices are published in Thuillier 1993, 248 (Baccarat), 252 (Roynet), 259 (Nardoyen), 108, 266 (Georges), and 272–273 (Didelot).

205. Thuillier 1993, 273.

206. See Thuillier 1993, 184–185, for Georges and Etienne; I also thank Professor Thuillier for a helpful discussion of their likely collaboration.

207. On La Ferté see Rosenberg and Thuillier 1972, 87–88; Bodmer 1988; Thuillier 1993, 187–188.

208. For versions of the *Nativity* by Honthorst see Nicolson 1989, nos. 1235, 1242, 1262; Judson 1959, nos. 17–20.

209. Nancy 1992a, no. 65.

210. Thuillier 1993, 210.

211. The engraving is one of three powerful prints issued in Antwerp by the prolific publisher François van den Wyngaerde, which included *The Repentant Magdalene* and *Saint Francis in*

Meditation (cats. 33 and 34). The existence of the three prints testifies to the appeal of these works. If indeed they are after paintings, which seems most likely, the originals are lost. It is unlikely that La Tour himself had anything to do with the engraving of *The Newborn Child*, for it carries an inscription in the plate falsely attributing its design to Callot. We shall probably never know if this was a deliberate attempt to deceive (there was always a ready market for works by Callot), or a simple misattribution of the painting (or drawing) that served as the engraver's model. In style and technique, however, the print is similar to Callot's nocturne prints such as *Le Brelan* and *Le Bénédicté* (figs. 36 and 37).

212. The author would like to thank Martha Kelleher at the Art Gallery of Ontario for making available the curatorial and conservation files on *Saint Anne with the Christ Child*.

213. Pariset 1948, 401; Rosenberg and Thuillier 1972, 254.

214. Thuillier 1993, no. 57.

215. For the versions in the Musée des Beaux-Arts, Dijon, and in a private collection, Paris, see Thuillier 1993, no. 62, and under no. 60 (a copy, according to Thuillier, but it found more favor in Rosenberg and Thuillier 1972, no. 54).

216. Thuillier 1993, no. 61.

217. Frick 1968, 148; Wright 1969; Thuillier 1993, no. 60.

218. Most recently in Thuillier 1993, in his discussion of no. 60.

219. See Nicolson 1989, nos. 1232 and 1234, for depictions of *Christ in the Carpenter's Shop* by Honthorst; and no. 860, for a version by Bigot.

220. On the cult of Saint Joseph see Pariset 1948, 246, 404; and Mâle 1951, 313–325. A typical example of the cult is Paul de Barry, *La dévotion à St. Joseph, le plus aymé et le plus aymable de tous les saints, après Jésus et Marie, avec l'assistance miraculeuse qu'il rend à ses dévots et à ceux qui le réclame* (1639).

221. Pariset 1948, 236.

222. Choné 1992, 538, and fig. 101.

223. Thuillier 1993, nos. A1 and A16.

224. Pariset 1948, 262, 410.

225. See Pariset 1935, for the first publication of the Nancy version of *The Discovery of Saint Alexis;* Pariset 1955b published a newly discovered version, which he called a "brother" to the Nancy picture, but "superior"; after its acquisition by the National Gallery of Ireland, Dublin, doubts were expressed, about both versions in Nicolson 1969, while Wright 1969 gave the Dublin version to Etienne de La Tour; see also Rosenberg and

Thuillier 1972, nos. 59 and 60. Thuillier 1993, no. 65, discusses both works but dismisses the Dublin picture as a copy. See Vic-sur-Seille 1993; Reinbold et al. 1994, 31–33, which both make a good case for reconsidering the Dublin picture as autograph, in spite of its relatively poor surface condition. The present writer has not had a recent opportunity to study the Dublin picture, but from photographs it seems to be after the Nancy original.

226. Thuillier 1993, 294. The Paris and Berlin paintings were brought together for a few days on the occasion of a La Tour symposium in Vic-sur-Seille, 9–10 September 1993.

227. The painting was first identified by Pierre Rosenberg in a sale viewing at the Hôtel Drouot in October 1993, but was withdrawn from sale; sold at Sotheby's (Monaco, 2 December 1994, no. 39), and preempted by the Louvre; see Brigstocke 1995, Cuzin 1995, Lacau St. Guily 1995, and Thuillier 1995.

228. See Fumaroli 1994, 241–248, for a brilliant discussion of Saint John the Baptist in seventeenth-century painting.

229. Bieneck 1992, nos. A11–A13.

230. Is the Nantes *Denial of Saint Peter* a copy of a lost work? Martin in Reinbold et al. 1994, 58–59, hints at this possibility.

231. Thuillier 1993, no. 77.

232. Thuillier 1993, no. 79.

233. See Choné 1991, 538 and n. 528.

234. See especially Thuillier 1993, no. 78, which suggests it was begun by Etienne and given finishing touches by Georges.

235. See Thuillier 1993, no. 78.

236. For the attribution of *Boy Blowing on a Firebrand* see Rosenberg and Macé de l'Epinay 1973, no. 53; this attribution is maintained by the Tokyo Fuji Museum, but see the comments in Thuillier 1993, no. 74. It seems to the present writer that *La tour fecit* (and its various forms), which appears in several works, is neither an autograph signature nor an attempt to deceive, but rather an acknowledgment of the invention; in some cases it may indicate an authentic studio production.

237. Thuillier 1993, no. 73.

238. See Pliny's *Natural History* 34.79 on Lycius, 35.138 on Antiphilus, and 35.143 on Philiscus.

239. See Edinburgh 1989.

240. See Thuillier 1993, nos. 77, 79, and A15–A18.

241. Mariette 1851–1860, 3:54.

242. See Mérot 1995.

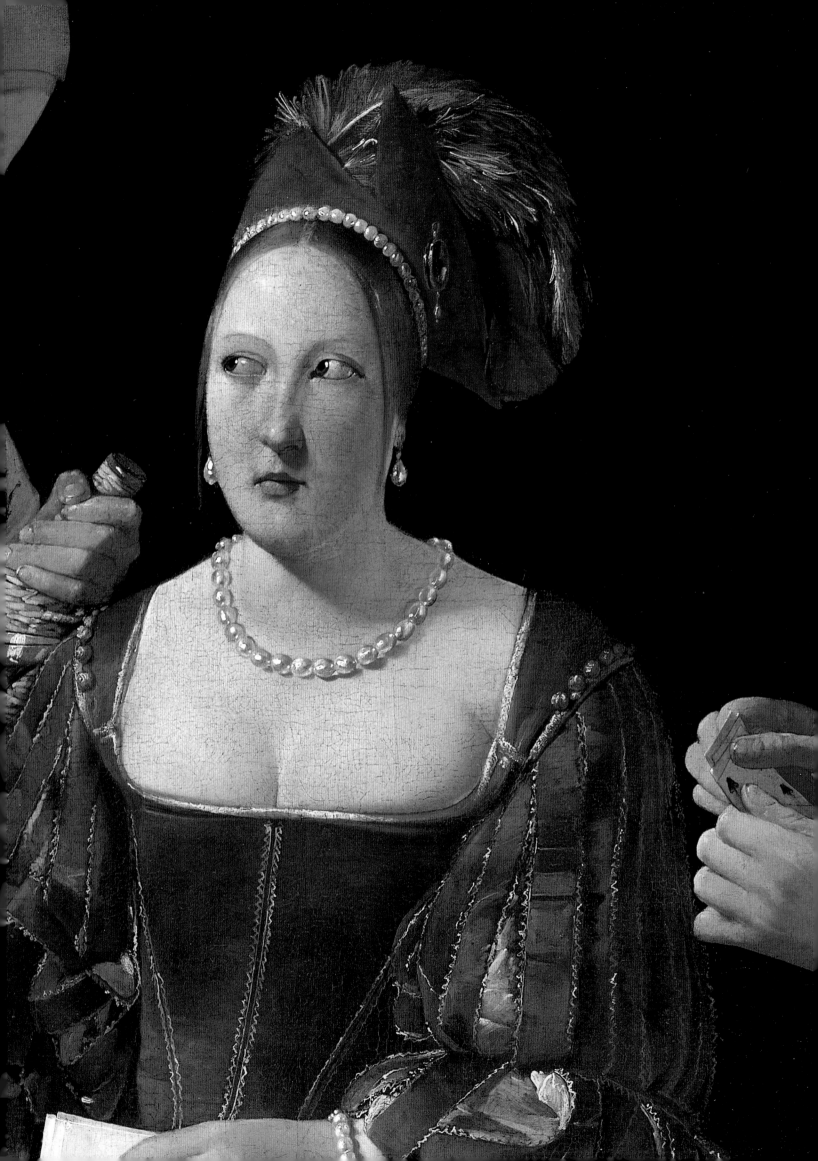

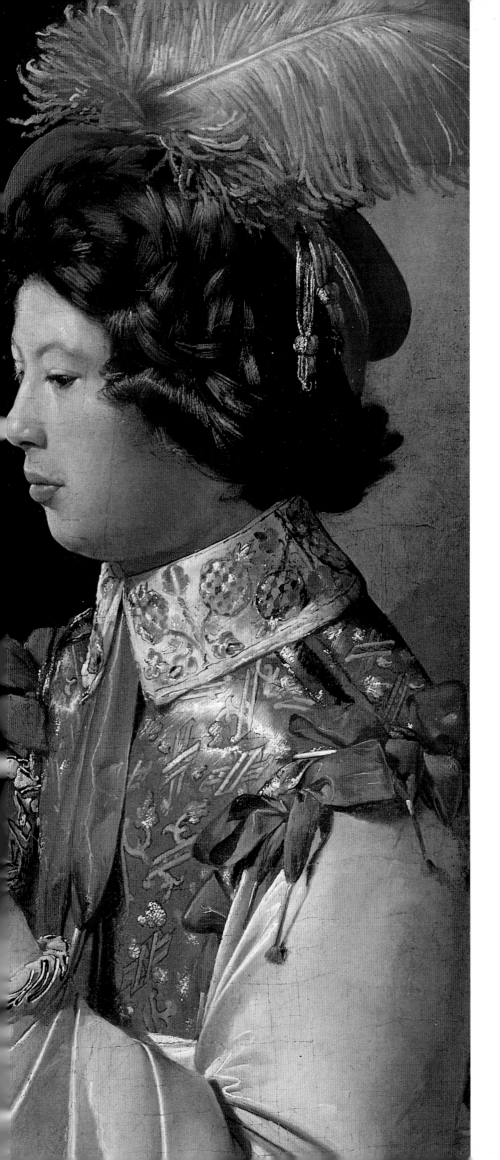

Gamblers, Cheats,
and Fortune-Tellers

GAIL FEIGENBAUM

The plot is ancient. A young man, handsome, confident, naive, and dressed in fine clothes, falls in with worldly company and is relieved of his fortune. The story figures in the New Testament (Luke 15:11) as the parable of the prodigal son, a memory of which persists in the shadows of most, if not all, of the paintings of gamblers, cheats, and Gypsy fortune-tellers in this exhibition. Yet, despite its being a theme from time immemorial and despite its rich potential for visual presentation, the story of the callow youth, all-too-willing to be deceived and led astray, caught fire for artists only in the sixteenth century. The early wave of representations were by northern artists such as Lucas van Leyden or Frans Francken II, portraying the prodigal son squandering his fortune, often at the gaming table, the debauchery encouraged by wine and seductive women.[1] Such paintings were ensconced in a strong tradition of more widely disseminated, usually moralizing prints illustrating the parable. Late in the century a new conception of the subject emerged in Italy, detached from the biblical narrative and couched as a scene from everyday life. The veritable mania for such paintings in Italy, France, and the low countries during the first half of the seventeenth century constitutes a chapter in the history of art still to be written. Even a brief exploration of the phenomenon reveals that all of the fortune-tellers, gamblers, and cheats, the innocent youths and those who exploit them, belong to one extended iconographic family. The paintings partake of the same themes woven into contemporary literature, ranging from popular lyrics, poems, and the novellas of Cervantes to written and improvised plays. They speak vividly also, in the visual idiom of their time, of social problems and moral issues that were matters of daily concern. The seminal images of the genre were Caravaggio's, the most exquisite crystallizations, La Tour's. In between were a myriad of inspired variations on the theme by the leading painters of the age.

Here [Caravaggio] represented a simple youth holding cards and dressed in a dark suit, his head well drawn from life. Opposite him in profile, a dishonest youth, who leans with one hand on the gaming table while with the other behind him, slips a false card from his belt. A third man near the boy looks at the points on the cards and with three fingers reveals them to his companion, who, as he leans on the table exposes to the light the shoulder of his jacket striped with black bands. There is nothing false in the coloring of this work. These are the first strokes from Michele's brush in the pure manner of Giorgione with tempered shadows.[2]

Young Michelangelo Merisi da Caravaggio had been struggling in Rome to make his living as a painter when a picture dealer sold his *Cardsharps* (cat. 41) — described above by an early biographer, Giovanni Pietro Bellori, in 1672 — to Cardinal Francesco del Monte. The broad-minded cardinal was so impressed that he took the young artist into his household and became his protector and most important patron. This episode, and the *Cardsharps* itself, can be dated around 1594.[3] In the late nineteenth century Caravaggio's famous *Cardsharps* disappeared, and for a long time it was known only from its many copies — more than thirty survive — and an old photographic print. A few years ago the missing original resurfaced and was acquired by the Kimbell Art Museum.[4]

At about the same time del Monte bought the *Cardsharps*, he purchased another of Caravaggio's paintings, *The Fortune-Teller* (fig. 1). In this composition of two half-length, life-size figures, a pretty Gypsy tells the fortune of a comely youth while surreptitiously teasing the ring off his finger. Beguiled by her beauty and clairvoyance, the boy is caught up in tender reverie and suspects nothing.[5]

From a very early moment Caravaggio's *Fortune-Teller* and *Cardsharps* have been linked. It was once thought that Caravaggio conceived them as pendants, but the recovery of the original *Cardsharps* now makes this seem unlikely, for the canvases are of different sizes and proportions.[6] Cardinal del Monte hung both pictures in the same room of his Roman palace, however, and the two novel and clearly allied subjects became associated in the minds of the painters and patrons who were captivated by

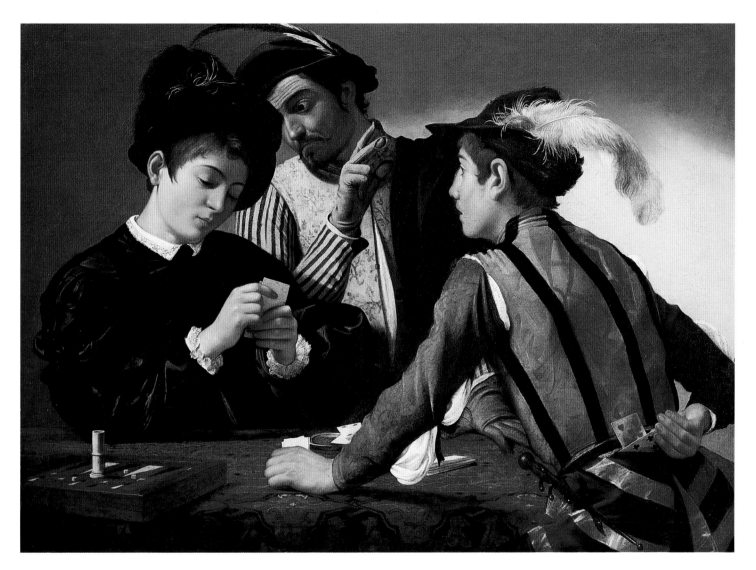

cat. 41. Caravaggio, *The Cardsharps*, c. 1594, Kimbell Art Museum, Fort Worth

1. Caravaggio, *The Fortune-Teller*, c. 1594–1595, Museo Capitolino, Rome

the dramatic manner of Caravaggio. Some three decades later Georges de La Tour turned his brush to the same pair of subjects. It has also been speculated that his *Fortune-Teller* (fig. 2) and either the Kimbell (fig. 3) or Louvre (fig. 4) version of the cheats were conceived as pendants.[7] If true, La Tour's linking of the subjects can be traced to the pairing of Caravaggio's two pictures in del Monte's palace.

Caravaggio's *Cardsharps* established the essential formula for paintings of cheaters at the gaming table, with the dupe, his cheating opponent, and the nefarious accomplice immortalized as the stock characters in the drama. In Caravaggio's picture focus is trained on the victim, a sweet-faced adolescent. Costume is a key to characterization here and continued to be in subsequent depictions of such subjects by other artists. Caravaggio lavished great care upon the rendering of the expensive finery in which the

2. Georges de La Tour, *The Fortune-Teller*, c. 1630–1634, The Metropolitan Museum of Art, New York [see also cat. 17]

3. Georges de La Tour, *The Cheat with the Ace of Clubs*, c. 1630–1634, Kimbell Art Museum, Fort Worth [see also cat. 18]

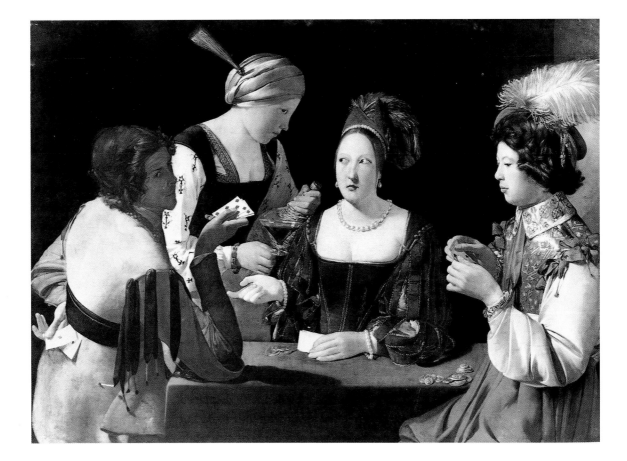

4. Georges de La Tour, *The Cheat with the Ace of Diamonds*, c. 1630–1634, Musée du Louvre, Paris [see also cat. 19]

boy appears a bit self-conscious. Glinting highlights enrich the deep burgundy velvet of the sleeves. Dainty lace trims the cuffs, and a delicate collar sets off the victim's creamy, vulnerable neck and blushing ear. His crushed beret adorned with airy feathers completes the effect. In contrast to the ingenuous absorption of the victim, the cheat fairly quivers in a state of high alertness.

In the wide dark bands over rich brocade, bright sleeves, and showy plume, a contemporary would have recognized the outfit that identified the cheat as a *bravo*, a soldier of fortune, or perhaps a retainer to a Roman nobleman.[8] Such youths in domestic or mercenary service, notoriously inclined to disorderly conduct, circulated in considerable numbers through the streets of Rome in the 1590s. They were permitted to bear arms, and this one has a dagger close at hand. Bold, arrogant, irreverent, they swaggered about the city in groups, fighting duels and passing their evenings in bordellos and taverns, where they dedicated themselves to playing cards or dice. Giovanni Cardano must have had such men in mind when, in his treatise on gambling published in 1565, he warned of the perils of playing with those who had the edge of greater experience, skill, and trickery.[9]

Gambling was so pervasive in Europe during the Renaissance that not to engage in it would have been considered exceptional. Some knowledge of the contemporary history of gambling helps in sorting out the relationship between the social reality of the activity and its depiction in the visual arts, not to mention literature. Card playing first became widespread in Europe the fifteenth century, though dice had a longer tradition.[10] Already in 1423 Saint Bernard of Siena was prompted to preach against the use of cards. The virtually continuous state of war in the sixteenth century resulted in large uprooted populations of soldiers, mercenaries as often as not, and gambling was a favorite diversion.[11] Contemporary depictions of troops in their camps and barracks frequently included vignettes of soldiers gambling on a table improvised on a battle drum or similar prop. Caravaggio's Rome was crowded with displaced young men who loitered about with little to do but pick fights, womanize, and play cards or dice while they waited for opportunity to knock, be it service in a noble household or a call-up of troops.[12] (Pope Clement VIII's condemnation and efforts to repress or control these behaviors in the 1590s were a failure.) Recruiting mercenary troops was often quite informal. A representative of one of the factions would simply circulate through the streets and taverns and call up conscripts.[13] Sometimes life in the ranks was little different from that at the margins of society from which the conscripts had come. Having spent their idle hours gambling before enlisting, the soldiers continued to do so afterward. La Tour's war-ravaged Lorraine was overrun with troops whose least offensive conduct, given the depredations of the siege of Lorraine, may have been gambling.

Gambling was equally pervasive on the upper end of the social scale. Pope Clement VIII's condemnation of cards and dice made slight impression even on the cardinalate in his own back yard. In August 1597 Caravaggio's protector Cardinal del Monte, by then the owner of the *Cardsharps*, wrote to a friend that he had been at dinner with the pope's nephew, Cardinal Pietro Aldobrandini, and Cardinal Odoardo Farnese. The evening concluded with a game of chance: "We had a great battle and Aldobrandini and I lost — I more than he."[14] Might the high-spirited cardinals ever have played cards in del Monte's palace, with Caravaggio's *Cardsharps* before their eyes? In Lorraine no less an eminence than the governor, Maréchal de La Ferté, was an aficionado of gambling and kept company with well-born friends devoted to a life of dissipation.[15] The novel gambling pictures must have had an added piquancy for patrons who were themselves no strangers to the tables.

Where there was gambling there were cheats. The criminal records hint at the scope of the problem. In 1349 in Augsburg, for example, cheats composed the second largest category of criminals after thieves.[16] By the middle of the fifteenth century organized cheating sprang up in France and Italy. Bands of cheaters included specialists — the leader, the one who enticed the victim into the game, the one who introduced counterfeit money into play, and so on. A distinct argot had developed to denote the roles and the techniques employed to trick the victims —

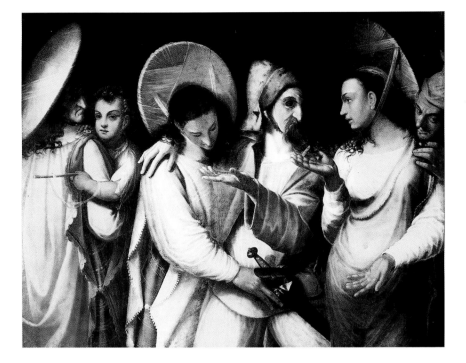

5. Artist unknown, *Scene from the Commedia dell'Arte*, c. 1595–1605, John and Mable Ringling Museum of Art, Sarasota

such as different ways to mark cards or alter dice.[17]

Returning to Caravaggio's *Cardsharps*, the depiction of the youths might be described – as by Bellori – as portraitlike and naturalistic, even if the characterization of type is, to some extent, overstated. In contrast, the features of the mustachioed accomplice are exaggerated in a villainous mask. Overtly theatrical, this fiendish figure, crowding the innocent boy with his dark cloak raised like a bat wing, has been linked to the commedia dell'arte.[18] Caravaggio's blending of sharply wrought naturalism and theatrical characterization creates an ambiguous pictorial conceit that purports to record neither everyday life nor a performance. If it does not depict a commedia dell'arte skit per se, it does share elements of this type of representation, known mainly from a handful of earlier Franco-Flemish works: a close-up, three-quarter-length view, for example, as in the *Scene from the Commedia dell'Arte* (fig. 5).[19] The theatricality undermines the ostensible naturalism; what at first glance had seemed natural, upon further scrutiny, seems posed. Through the villain's gesture the viewer is let in on the secret, and the whole tableau reveals itself to be set up, staged. The note struck is lightly comical, as the cheat is a little too nervous, the victim a little too pretty, impossibly in-

nocent. Caravaggio constructed a self-conscious, heightened enactment, removed – but not too far – from daily life. Walter Friedlaender perceived a parallel with Cervantes' (slightly later) *novelas ejemplares,* which treat the inconsequential adventures of young cavaliers in a similar "gentle and romantic manner, smilingly and ironically."[20] For Friedlaender, a painting like Caravaggio's *Cardsharps* was "novelistic," a visualization of a scene that might have been inspired by reading such a story. Ultimately the theatrical connection might prove more explicit, keeping in mind the type of play published by Venturino da Pesaro, *La Farsa Satyra Morale,* which features the bravo Spampana, "a confirmed gambler and cheat who attempts to lure the pure youth, Asuero, to the card table."[21]

Caravaggio's representations of card cheats and fortune-tellers as well as other genre subjects (for example, his *Toothpuller* in Florence) portray humanity in a less than noble light. As such, it has been argued, they correspond to the description of comedy set forth in Aristotle's *Poetics,* which would "make its personages worse than the men of the present day."[22] Aristotle even names painters who rendered their actors as either better (which conforms to the mode of tragedy) or worse "than we are." The links of Caravaggio's genre subjects with comic theater, the analogies of stock characters, and perhaps even the reliance on, and amplification of, gesture strongly suggest a cognizance of a comic mode that could be translated into painting. Despite the clear hierarchy of genres that relegated comedy to the bottom, because "comic purgation was effected without the use of reason" and was aimed at a vulgar audience, the rubric of the *Poetics* itself carried weight. Construed as the embodiment of a poetic mode according to a scheme sanctified by Aristotle, a painting of a low or risky subject – especially if painted in a refined, "high" style, as is the case here – might acquire a legitimacy or seriousness that would increase its appeal to a sophisticated collector. If anyone could have appreciated the irony in this paradox, it would have been Caravaggio.

Depictions of card cheats relevant to Caravaggio's painting are so rare that a fragmentary fresco

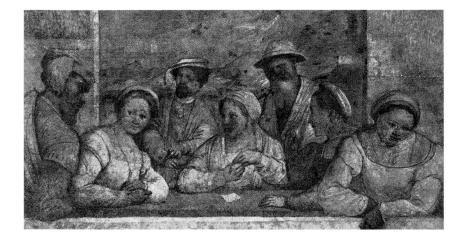

6. Girolamo Romanino,
The Card Party, c. 1560,
location unknown

of a card party painted by a fellow Lombard artist, Girolamo Romanino, in the mid-sixteenth century (fig. 6), takes on special importance.[23] Romanino's three men and four women play cards around a table set in a balcony or loggia. One woman is distracted from her cards by the flirtations of a soldier at her elbow. A man behind her in a plumed hat touches two fingers to the back of his other hand, evidently signaling her holdings. He seems to be catching the eye of the woman at the right, whose shaded profile is etched sharply against the pale drapery. Her hand resting tensely on the table and her watchful expression imply complicity. The analogies with Caravaggio's *Cardsharps* are tantalizing if not sufficient to prove Caravaggio's knowledge of the earlier work, the original location of which is uncertain. Romanino's painting most likely formed part of a fresco cycle with other scenes of delicately amorous mixed company, such as groups of musicians. Romanino's frescos were akin to the type made famous in palace decorations by Niccolò dell'Abbate in nearby Emilia, such as those in the Palazzo Poggi, Bologna, which incorporated a party of tarocco players. This northern Italian tradition of profane, large-scale wall decoration is surely part of the prehistory of Caravaggio's paintings, and Romanino's scene of gallant badinage undercut by duplicity is a significant ancestor of Caravaggio's treatment both of cardsharps and of fortune-tellers.

One note of realism in Caravaggio's *Cardsharps* is the way the gloves worn by the mustachioed cheat are shown open to expose the fingertips and especially the pad of the thumb. Usually described by modern writers as torn or worn out, they more likely have had the seams deliberately slit to facilitate certain manipulations common to card cheats of the period. At least two methods of marking a deck of cards at this time required direct touch for detection: rubbing of the backs of the low value cards with an abrasive; or pricking cards with a needle to leave an impression too fine to be distinguished by the eye. It was common practice for cheaters to remove the upper layer of epidermis on the thumb and fingertips to expose more sensitive skin underneath, the better to detect the marks.[24] If Caravaggio's cheat wears gloves that call attention to his bare fingertips, it is not by accident.

The card game depicted here is most likely primero, a game that had been refined to virtually an art form in Rome. A 1526 treatise on the game remarks that the mode of play, differing in Lombardy, Naples, Venice, France, and Spain, could nowhere be superior to that of the court of Rome, where primero had "its liberty, its reputation, its decorum, its full numbers and figures, and all its parts."[25] We shall come back to the details of the game, for they are crucial to La Tour's paintings.[26]

Caravaggio became a painter of extraordinary, international influence, and the *Cardsharps* burned its way into the imaginations of his most gifted followers. Del Monte's palace must have been relatively easy for artists to visit, but for those who could not see the picture for themselves, scores of copies disseminated the image far and wide. Yet, ironically, the original and replicas of this work may have been less consequential for the subsequent transmission of the idea than were the transformations of this subject by Caravaggio's early, immensely influential follower, Bartolomeo Manfredi.[27] A Lombard painter about whom rather little is known, Manfredi seems to have been directly associated with Caravaggio in Rome shortly after 1600. Two decades later he was a prolific inventor of variations on Caravaggio's themes, devising what the seventeenth-century German historian Joachim von Sandrart called the "Manfrediana methodus" (Manfredi manner). This consisted in taking up the genre subjects of Cara-

vaggio's early works, such as the *Cardsharps* and *The Fortune-Teller*, but setting these subjects in the midst of the dramatic dark and light contrasts of Caravaggio's later works. Manfredi's habit of grouping figures in contemporary dress around a table derived from a painting notable for its radical chiaroscuro, Caravaggio's *Calling of Saint Matthew* of 1600, but his close-up, three-quarter-length views and profane subjects stemmed from Caravaggio's genre pic-

8. Gerrit van Honthorst,
The Denial of Saint Peter,
c. 1620, private collection

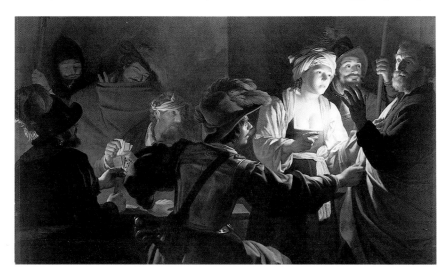

tures of the mid-1590s. Manfredi was inclined to complicate the powerful simplicity of Caravaggio's prototypes, adding plot twists and turns, augmenting the cast of characters. In one very direct translation of Caravaggio's *Cardsharps* Manfredi substituted a wench in daring décolletage for the mustachioed villain, who signals the cards in the dupe's hand.[28] In another version (fig. 7) the deception is more intricate, involving all six figures in the composition. Manfredi also made large canvases combining various genre subjects, such as gambling with Gypsy fortune-tellers, as in his *Fortune-Teller*, a destroyed work formerly in the Gemäldegalerie, Dresden. He also embedded the motif of gambling, interpreted in a tavernlike genre setting, in larger scenes of *The Denial of Saint Peter* (Herzog Anton Ulrich-Museum, Braunschweig), where the vignette of soldiers playing dice was a traditional episode in the narrative. The same idea was taken up by the Netherlandish Caravaggisti, a most remarkable example of which is a little-known *Denial of Saint Peter* by the Utrecht painter Gerrit van Honthorst (fig. 8).[29] Honthorst's large horizontal composition

is split neatly into two, the right half containing a candlelit portrayal of the saint's confrontation with his accusers, and the other half, with its separate artificial light source, depicting a table of card cheats faithful to the Manfredi model, the victim momentarily distracted by the spiritual drama taking place at his elbow. Manfredi's *Denial of Saint Peter*, which includes a gaming scene, was a crucial early precedent for La Tour's similar interpretation (Conisbee fig. 81). Engravings of Manfredi's compositions were circulated internationally, finding their way to northern and central Europe and inspiring an odd lot of imitations. For the Netherlandish followers of Caravaggio who came to Italy and for some of the Frenchmen who came there also, especially Nicolas Tournier and Nicolas Régnier, the Manfredi manner was at least as vital an inspiration as any direct experience of Caravaggio's art.

The *Cardsharps* and the *Fortune-Teller* were early works in which Caravaggio allowed his brush to linger over sensuous details of appearances and in which his delight in subtle blond tonalities kept the harshness of the subject at bay. Later his palette darkened, the contrasts of light and shadow strengthened, and the exposition became so elliptical that in the end the subjects – virtually all religious late in his career – were almost consumed by the fevered intensity of his vision. There is none of that passion in Manfredi. For most of the painters inspired by Caravaggio, it was enough to experiment with his chiaroscuro, naturalistic types, and new genre subjects, flirting charmingly with sensuality, vice, and treachery. Filtered through Manfredi, Caravaggio was less radical, more domesticated, more formulaic: imitable. Only a few artists could take up the challenge of Caravaggio's more extreme and troubling emotional content, especially that of the late work, and make of it something personal and new.

One of these exceptional artists was the French painter Valentin de Boulogne, who was one of Caravaggio's most devoted yet original emulators. Valentin arrived in Rome probably early in the second decade of the century and never left, taking up a study of Caravaggio that even survived his associations with the arch-classicists Nicolas Poussin and Cassiano dal Pozzo. Inspired directly by Caravaggio's *Cardsharps*, Valentin took up the same subject in a work now in Dresden (cat. 44).[30] Like most of the so-called Caravaggisti, Valentin, painting around 1615 – 1617, responded to the tenebrism of Caravaggio's later work. He plunged his gamblers into darkness, evoking a gritty tavern frequented by dangerous types.

Valentin's young dupe is, like Caravaggio's, sweet-faced and elegantly dressed, but he has lost his freshness. A stubble sprouts above his red lips, and he looks tired and a little worried. His opponent prepares to draw a diamond, half concealed in his sleeve, from behind his back. He too is young, and he wears a jaunty red beret. But the dark circles under his eyes and grim features bespeak his dreary history of professional experience. By comparison, Caravaggio's cheat looks like an excited novice playing at the sport of cheating. Behind them is a dark figure who has flung his cloak dramatically across his face to hide all but his slightly crossed eyes and two fingers signaling the cards in the victim's hand. Valentin's villain is a direct descendant of Caravaggio's, but the concealing cloak derives from the personification of winter in Manfredi's *Allegory of the Four Seasons* (Dayton Art Institute). Valentin made the gesture more sinister and melodramatic. A sophisticated viewer paying close attention might have noticed that the dupe's hand includes a card marked by the standard method of a slight cut on the border.[31] So the cheating includes at least three of the typical tricks of the time: "holding out" cards, signaling the victim's hand, and playing with a marked deck.

The potential for violence, merely allusive in Caravaggio, is palpable and encroaching in Valentin's painting, again mediated by the sinister atmosphere of Manfredi's pictures. At the side of the young victim is the prominent hilt of a sword, a proto-rapier, while the dark figure behind him grasps the hilt of his own sword. This gives the sense that at any second the deception might be discovered and a fight break out.

Valentin's *Cardsharps*, an early work by this artist, is among his most acute and concentrated compositions. It was not long before Manfredi's propensity

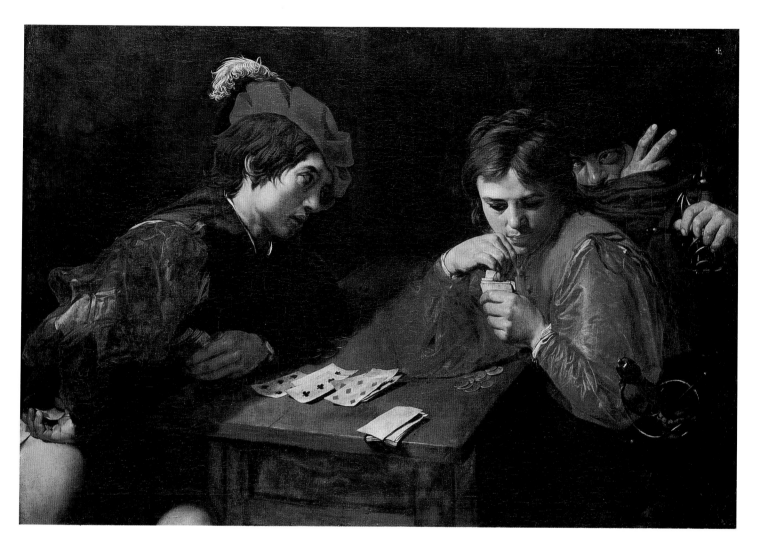

cat. 44. Valentin de
Boulogne, *The Cardsharps*,
c. 1615–1617, Staatliche
Kunstsammlungen,
Dresden

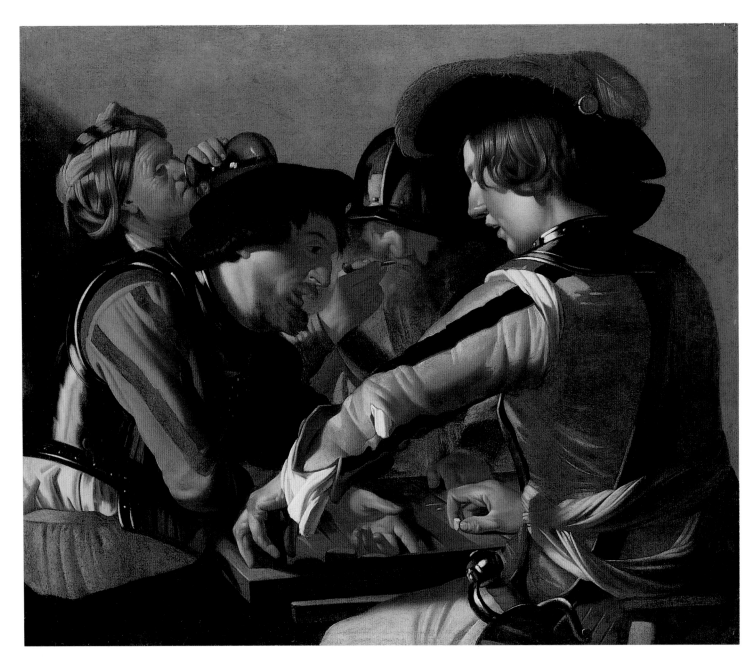

cat. 36. Dirck van Baburen,
The Backgammon Players,
c. 1624, Saul P. Steinberg

to amalgamate subjects, multiply subplots, and increase the population of his Caravaggesque compositions began to exert an irresistible pull on Valentin. Like Manfredi, Valentin began to produce compound genre subjects, a fortune-telling scene coupled with a concert, for example, or religious subjects such as the *Denial of Saint Peter* and *Soldiers Playing Dice for Christ's Garments* in which the gambling scene dominates the Gospel episode. But the emotional heat in Valentin's work was far more compelling than in Manfredi's. Valentin's scenes are on the verge of erupting into a brawl, infused with an urgency that functions as a correlative to the passions inherent in the religious narrative.

The low-life aspect of the Caravaggesque gambling scene, especially as interpreted by Manfredi, appealed to Netherlandish painters as well as to the French. Artists of both nationalities had established thriving colonies in Rome in the first half of the seventeenth century. Other French painters besides Valentin, Tournier, and Régnier who found Caravaggio's manner alluring included Trophime Bigot, Claude Mellan, the so-called Pensionate de Saraceni, and especially Simon Vouet and Jean LeClerc. Among the most important Netherlandish painters who embraced this iconographic trend during their Roman sojourns and imported it back to their homeland were Honthorst, Dirck van Baburen, and Hendrick ter Brugghen. By the time Georges de La Tour first took up the Caravaggesque subjects, in the third or fourth decade of the century, a thriving market for gambling subjects existed in the low countries. It is more than likely that excellent examples of such Netherlandish pictures would have been available to La Tour, whether at home or during his travels.

Decisive for the genre of gambling pictures in the Netherlands was the work of Dirck van Baburen. Details of his origins are scarce, but it is known that Baburen was trained in Utrecht, the Catholic city in the predominantly Protestant northern Netherlands that became the de facto headquarters of the Dutch followers of Caravaggio. Baburen was in Rome during most of the years in which Manfredi was developing his influential brand of Caravaggism. Baburen, along with his fellow countryman Hont-

horst and probably ter Brugghen, was among the most gifted foreigners to become engaged with the new subjects and manner. He returned to Holland around 1620 and shortly after painted *The Backgammon Players* (cat. 36), one of the first depictions of gambling in the Utrecht circle.[32]

Baburen transposed the gambling subject into the luminous key of Utrecht Caravaggism. His palette was gorgeous but soft and pearlescent, as seen in the raspberry pink sleeve, cornflower blue breeches, and robin's-egg blue vest of his *Backgammon Players*. Baburen repeated the hues in slightly grayed variations to unite the surface composition and evoke the mellow interior atmosphere. The light raking across the neutral back wall had become the identifying badge of Caravaggio's devotees. Baburen's strong, *X*-shaped composition is constructed entirely by the four boldly posed figures. At its center is an elbow that punches aggressively out toward the picture plane. Baburen's handling of the flesh is distinctive, broadly and strongly modeled, with the thick hands mobile and rubbery-looking. His figures appear slightly larger than life, occupying their own skins with assertive confidence to dominate the space of the picture.

The two foremost figures in Baburen's painting are rough and coarse, one with a slumped posture, the other with heavy, lank, not-very-clean locks of hair. Their postures suggest that something has gone wrong with the backgammon play. An accusation hangs in the air, and the figure holding what is probably chalk for keeping score bristles at the charge. A man who looks older than the players smokes a pipe and peers down at the board, while an elderly turbanned figure of indeterminate sex ignores the game, tipping up a flask for a long draft. Is this a barracks scene? Presumably the players are soldiers. Not only are they dressed in the broad, by now familiar stripes that indicate military service while also tying the picture firmly to Caravaggio's Rome, but each man at the table wears a single piece of armor. One has donned the helmet, the other the breastplate, and the third the gorget of what would appear to be the same suit of armor. This may identify them as irregular troops who were not issued full uniforms

9. Hans Sebald Beham, *Gamblers*, 1512, Ashmolean Museum, Oxford

and equipment by their sponsors and were expected to scavenge armor and weapons from the fallen soldiers of the enemy.[33] The northern tradition provides ample precedent for soldiers at the gaming table. Pertinent to Baburen, and perhaps even more so to ter Brugghen's *Gamblers* (cat. 38) was Hans Sebald Beham's print *Gamblers* (fig. 9) of a dispute breaking out between two heavily armed German mercenaries who have been playing cards on a parade drum. A third man stands behind them while a small demon hovers in the air over one of the players. Little demons would have spoiled the illusion of naturalism that the seventeenth-century Utrecht painter was striving to achieve, but the knowledge of this still-active tradition of moralizing prints informed both the painter and his audience.[34]

If Baburen's demons were latent rather than depicted, the artist nonetheless operated squarely within the Dutch convention of multiple moralizing themes. An allusion to transience and to the ages of man is recognizable in the juxtapositions of youth, maturity, and old age in the cast of actors. The theme of *vanitas* is signified by the smoker. The harmful consequences of drink are introduced. The blunt message is that gambling is evil, and anyone who engages in this vice can expect cheating, which is apt to lead to violence. In Baburen's painting one player has already wrapped his hand around the handle of his sword as a precaution, while the hilt of his opponent's sword projects conspicuously from his hip. A print made after Baburen's composition by Crispin de Passe supplies the Latin legend: *Irarvm cavsas fvgito* (flee from the causes of anger), reinforced by couplets in Dutch, translated as "A cheater and gambler is a foul wretch, he drinks and gambles his money and beats his wife." Steeped in moral condemnation, Baburen's portrayal of gambling was anything but light-hearted.

Hendrick ter Brugghen's *Gamblers* is signed to the left of that ominous card, the ace of spades, with the characteristic *HTB* monogram, and dated 1623, probably the year after Baburen's *Backgammon Players*. Ter Brugghen's work was akin to Baburen's in spirit and style as well.[35] The two artists worked closely together and may have shared a workshop until Baburen's death in the following year.[36] That ter Brugghen had known and grappled with Caravaggio's art during the decade he spent in Rome, c. 1604–1614, is an inescapable conclusion; but no works from his sojourn have been recognized, and in the paintings he made upon returning to Utrecht, he called upon a much broader range of sources, both Italian and northern.

In *The Gamblers* ter Brugghen's pastel palette is less sweet than Baburen's, with edgy juxtapositions of pale khaki green, mulberry, brick red, and orange. The present appearance of the picture is not as ter Brugghen intended, for at some later moment the original background, probably a neutral tan, was painted over with a layer of sky blue that is at odds with the indoor disposition of light and shade over the figures. Narrow strips of canvas have been added to the left and right. Both alterations tend to mitigate the concentration of the composition.[37]

Ter Brugghen's scene shows three men, head to head, the visors of their helmets almost touching in energetic discussion over a table of dice, cards, and coins. The two foremost figures are soldiers wearing armor and the familiar banded sleeves. In the center behind them is a youth in fancy garb and a

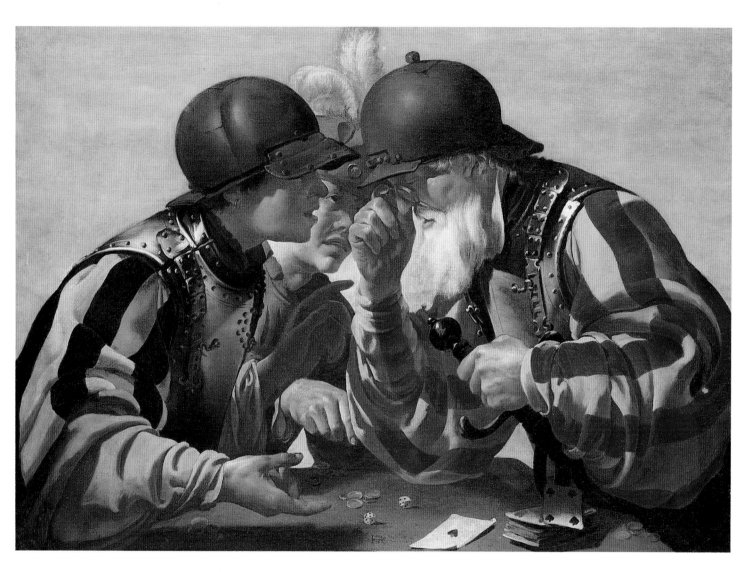

cat. 38. Hendrick ter
Brugghen, *Gamblers*, 1623,
The Minneapolis Institute
of Arts, The William Hood
Dunwoody Fund

plumed hat. The old soldier grasps the hilt of his sword while he studies the elements of the game on the table through spectacles. In Holland eyeglasses were sometimes a symbol of moral or spiritual blindness, often the attribute of an old fool. The phrase "to give (or sell) someone eyeglasses" meant to cheat or take advantage of the person. Presumably he is the one being cheated, as the throw of the dice, a one and a four, matches the exposed cards.[38]

Despite ter Brugghen's dependence on Baburen's example, the emotional force and compositional discipline were all his own. Ter Brugghen's mastery of the play of light transcended that of his sources. Here a shadowed profile is set off against the halo of a bright cheek, while the same shaft of light that brushes that face also drenches the center of the composition, saturating the white beard of the old soldier and ensuring that each gesture and expression is fully individualized. Baburen's composition had an exciting, essentially improvisational sway and swagger that ter Brugghen brought to a commanding, dramatically controlled resolution. Through this mastery of structure, ter Brugghen endowed the scene with a gravity unexpected in a picture of this theme. In consequence, the moralizing message, inevitably packed into all Dutch images of this subject, acquired depth and conviction.

The question of precisely what sort of images of the gambling genre were available to Georges de La Tour remains open. Caravaggesque gambling scenes were so numerous and widely circulated by the 1620s that even without leaving Lorraine, without visiting Paris, much less the Netherlands, La Tour should have been aware of the type. Paradoxically, if one assumes an Italian journey for the artist early in his career, as many scholars do, the question of the sources of La Tour's two celebrated paintings of cardsharps, *Cheat with the Ace of Clubs* and *Cheat with the Ace of Diamonds* (see figs. 3 and 4) becomes more perplexing, for there is nothing in the style or technique of these pictures to suggest a direct experience of Caravaggio, Manfredi, or of most of the French Caravaggisti active in Rome in the 1610s or 1620s. La Tour's distance from these sources argues rather for knowledge at a considerable remove.

One closer connection is provided by the work of the Lorrainese painter Jean Le Clerc, who was a pupil of Carlo Saraceni at the time when the latter was most under the spell of Caravaggio's art. Le Clerc had worked in Rome as well as in Venice before returning to Nancy in the early 1620s to establish himself as an official painter to the court. His nocturnes – subjects such as groups of musicians, a Denial of Saint Peter in a guardroom setting, and a Prodigal Son playing cards – must have been known to La Tour, although when La Tour would have seen them – whether in the early 1620s or later — is less certain. La Tour's *Cheat with the Ace of Diamonds* is closer to Le Clerc's *Prodigal Son Gambling*, also called *Le Brelan*, than it is to the works of the other Caravaggisti.[39] Another of La Tour's countrymen, the celebrated printmaker Jacques Callot, based an etching on Le Clerc's composition, which is also called *Le Brelan* (Conisbee fig. 36). Callot's remarkable nocturne, with virtuoso chiaroscuro effects, is a variation rather than a direct transcription of its source. Within an oval, ringed by a Latin inscription warning of the consequences of dissolute behavior, Callot placed seven figures around a table. As in Le Clerc's painting, women, most conspicuously a luxuriously garbed harpist, make an appearance in Callot's composition. For La Tour, there were distinct qualities that must have made Callot's print a congenial source: a touch of elegance, an attenuation and flourish, the more restrained deportment and slightly courtly, not to say mincing, character of gesture, the essential "Frenchness" of the bearing, all of which departed from the more robust and expansive fashion and behavior of Italy, not to mention Holland. Reminiscences of Bellange's manner in the print must also have appealed to La Tour. In any case Callot's etching, dated 1629, close to the time many scholars place La Tour's compositions, could have been a prime inspiration for his two *Cheat* paintings.

Significant in the connection between Le Clerc and Callot was the explicit expression of the theme of the prodigal son, which had remained unspoken in the Italian tradition. In this regard it is useful to recall the painting by Lucas van Leyden, *The Card-*

players, at Wilton House, an early large-scale version of a prodigal son losing his money at the gaming table and a scene that contains a whiff of cheating as well. Sometimes suggested as a source for La Tour, Lucas' picture, with the cool, impassive faces of the women, the fancy dress of the men around the table, and the choreography of the hand gestures, would indeed seem to have been familiar, if not necessarily directly, to La Tour. The prodigal son tradition was, in any case, widespread in France, diffused in series of prints by Pierre Brebiette and others.

La Tour's two compositions of the *Cheat with the Ace of Clubs* and the *Cheat with the Ace of Diamonds* seem at first glance to be identical twins. The setting is minimally described, a shallow space with a dark wall washed with light only at one end. The four figures surround a plain, narrow table. At the extreme right of the horizontal composition is a youth concentrating on his cards. In both versions his costume is opulent, even flamboyant, embroidered, beribboned, and capped with a plumed beret. Gold and silver coins glitter in a pile on the table before him. At the other end of the table sits his opponent, the cheat, in a plain tan jerkin. His coins are concealed in the shadow of his elbow.

Occupying the center is one of the unforgettable figures in the history of art. The woman, evidently a courtesan, is of substantial proportions, dressed in a russet velvet gown cut low to reveal the tops of her corseted breasts. Her face is a daringly stylized perfect oval, and her skin immaculate if a little sallow. Her yellow brown hair is plastered to her skull, a few limp strands clinging to her cheeks. (In a piquant irony, the model closely resembles one La Tour used in a lost portrayal of the courtesan repentant, a *Magdalene* known only in a copy.)[40] She orchestrates the deception. With her cards hidden from the viewer, she signals to the cheat that it is time for him to make his move. This prompts his sneaky glance around to see who may be watching. Tipping his hand to the viewer, he pulls out one of the two cards tucked under the sash behind his back. The courtesan, without turning her head, shifts her eyes to alert the serving maid that the moment has come to create a diversion. This is accomplished by serving the wine,

which introduces yet another element in the dissipation of the prodigal son or any youth who may stand in for him. La Tour thus brings together themes of wine, gambling, and women. The complex dynamics are portrayed with an exquisite economy, each glance and gesture exact and perfectly tuned.

These two paintings provide a particular set of pleasures and challenges, for both are autograph, virtuoso performances, offering the subtlest of variations, and the question of which was painted first is still very much open to debate among the most perceptive scholars to have written on La Tour. When the *Cheat with the Ace of Clubs*, the painting now at the Kimbell Art Museum, was exhibited for the first time in 1972, Benedict Nicolson reasoned that it followed the *Cheat with the Ace of Diamonds*, now in the Louvre, by as much as fifteen years. Jacques Thuillier argued the reverse, dating the Louvre version years later than its counterpart. Thuillier's view has been supported by Pierre Rosenberg. The results of recent technical examinations are difficult to interpret in this regard, and the question of precedence has not as yet been definitively resolved.[41] What has emerged is strong evidence that La Tour made use of cartoons of individual figures to plot his compositions, and that the same auxiliary cartoons were probably employed for both versions. This also raises the possibility of other versions of the composition that may have existed in relationship to either or both of the surviving pictures.

The new study does show that several passages in the Kimbell picture were first blocked in as they appear in the Louvre version, and then changed in the course of La Tour's work on the canvas. Most of the changes, however – the contour of the cheat's coat or the angle of inclination of the maidservant's head, for example – might better be understood not as changes from one painting to the other but rather as changes made from cartoons common to both. Some alterations in contour from the cartoon-based underdrawing are found in the Louvre composition as well, though not as many. More difficult to interpret in the Kimbell picture are the colors under the cheat's collar – originally red, as in the Louvre version, then covered in black – or the turban, which

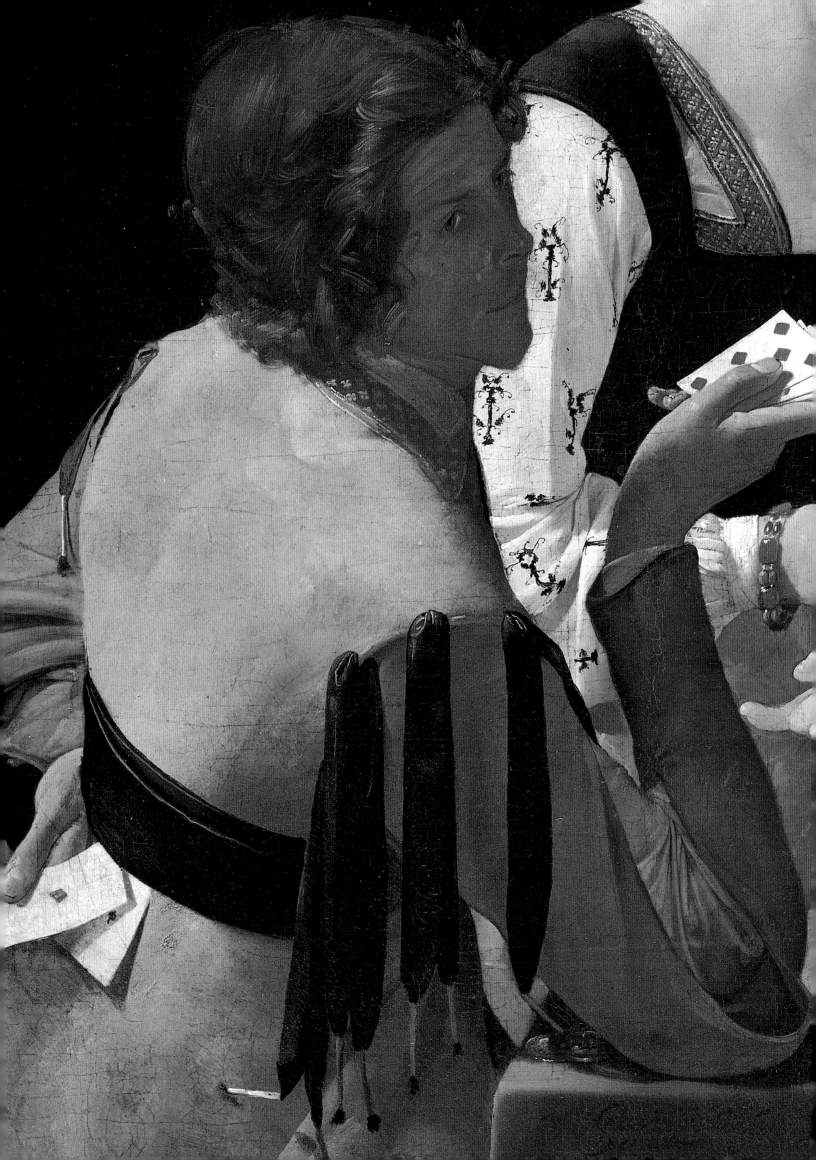

was gold, again as in the Louvre picture, then covered in gray. Such indications might indicate the precedence of the Louvre canvas. On the other hand, microscopic examination has also revealed that the maidservant's green bodice in the Louvre painting covers up a layer of red.[42] Evidently La Tour first made her dress all one color red, as in the Kimbell picture. Although he used different pigments in each case, vermilion for the bright tomato red in the Louvre version versus red lake for a lighter raspberry hue in the Kimbell picture, the idea of a red dress may be sufficiently compelling to counterbalance arguments for the Louvre version's precedence as based on color changes. Ultimately the solution must wait until a more precise chronology can be worked out for La Tour's oeuvre in general.

Leaving aside here the divergences not visible to the naked eye, the changes one can see are intriguing. The cheat appears with and without a mustache and goatee, with his face in half or full shadow. The ribbons fastening his tied-in sleeves hang loose or are done up in bows. His collar is black or red with gold fleurs-de-lys.[43] The maidservant conspires more or less closely with the courtesan, while La Tour has varied the colors of her turban and bodice and the embroidered pattern on her sleeve. (The aigrette and the strip of canvas added across the top of the Louvre picture are not original.)[44] Most of the jewelry is different: a flat strap bracelet versus one studded with large gems, multiple strands of small pearls as opposed to single strands of large pearls. The plume of the courtesan's hat is longer in the Louvre picture, and her face is almost imperceptibly narrower, more youthful, and idealized in the Kimbell picture. She seems sly in one, corrupt in the other. The young victim is more radically differentiated. La Tour rendered one sleeve in ivory satin with broad flat folds, the other in pink silk, with a zigzag of white highlights catching the sheen. In one the embroidered vest stops at the waist, in the other it is a jerkin, flaring at the hip. The slight upturn of his lips and sidelong glance in the Kimbell picture hint that he is pleased with himself and with the cards he holds. This expression is played down in the Louvre picture, where the boy is fully absorbed, his interior life

less accessible. Fittingly, his separateness is stressed in the Louvre picture, with his hands silhouetted against the dark background; in the Kimbell painting La Tour brought him into the group, with his hands overlapping the courtesan's sleeve. The cards were changed, of course, with the cheat playing clubs or diamonds, and the courtesan holding her cards perpendicular to the table in one, and face down in the other. Yet ultimately it is the handling of paint that distinguishes one version from the other. In the Louvre picture the execution is more careful and precise. The brush captures the grain of surfaces, builds up slowly, layering one detail upon another, as in the feathers of the courtesan's hat. La Tour's facture was broader, more dynamic in the Kimbell painting, his brush and the light moving more rapidly across the surfaces. The distinct personality of each picture has its own elusive quality and satisfaction.

In both paintings La Tour's clear, rational composition, with its precisely calibrated intervals and impeccable timing, bespeaks an artistic spirit of a different order from the illusion of spontaneity cultivated by the Caravaggisti. La Tour's play of hands and glances, his nuances of pose, expression, and costume are captured so expertly that the ensemble is poised forever in suspense, the crafty courtesan like a spider luring her prey. Cardplaying may have been a scourge in itself, and cheaters the scourge of cardplayers, but from such vice La Tour created a brilliant theater of social custom, of consciousness and self-consciousness: "the triumph of blasé worldliness over the greedy innocence of youth."[45]

Writers are apt to remark on La Tour's powers of naturalistic observation, but surely the better part of the scene in both *Cheat* paintings is invention and not description. That said, La Tour's realism can be vivid in the details, as demonstrated here by the actual game of cards. This party is playing La Prime or primero, probably the same game as in Caravaggio's *Cardsharps* (cat. 41), which was very much à la mode in the sixteenth and seventeenth centuries in France, Italy, Germany, and England. "To describe what primero is would be less than useless," remarked one Italian commentator in 1526, "for there can scarcely be anyone so ignorant as to be unacquainted

with it."[46] La Tour could count on his audience to know the game and to recognize the dynamics of the play and strategy of the cheaters. A close ancestor to poker, Prime could be played by two to five players, but the "true play" was with two or three. Cards with values above a seven having been eliminated from the deck, each player was dealt two cards, which he could keep or pass until satisfied, at which point two more cards were dealt.[47] Bets were then placed. Each card had a value, and a hand with the highest number of points of the same color won the game. The largest number of points possible was 55 (cinquante-cinque, "le grand point," or "prime"); "he who holds the prime . . . is sure to be successful over his adversary."[48] The cheat in the Kimbell painting holds a six (18 points) or seven (21 points) of clubs, partially hiding another black six or seven, as he prepares to enrich his hand with the ace (16 points) of clubs. In the Louvre version he holds a seven and probably a six of diamonds and prepares to pull the ace of diamonds from his sash. In both versions he would thus have completed the winning combination of 55 or the "grand point."

La Tour invited the beholder's complicity: our knowledge of the particulars of the game; our recognition of the signals passing between the conspirators; our being the eye to which the cheat tips his hand. He must have expected his viewer to be a sophisticated connoisseur, to have the discernment to appreciate how he had raised a banal theme to a new height of wit and genius, to savor the nuances: the gorgeous execution of costume; the characterization of the "Lorrainese courtesan à la mode c. 1630";[49] the touchingly greedy gullibility of the boy; the choreography of furtive looks and gestures.

Both of La Tour's *Cheat* paintings and his *Fortune-Teller* (cat. 17) were quintessential expressions of subjects launched into the mainstream of European painting by Caravaggio. Yet La Tour's interpretations were entirely unlike Caravaggio's and were distinct from the variations on the theme that Caravaggio's followers painted by the score. Speculation that both Caravaggio's and La Tour's cheats and fortune-tellers were pendants has been mentioned, but even if there is no direct evidence to support the conjecture, the subjects were conjoined in the minds of painters and collectors. Caravaggio's invention of *The Fortune-Teller* (fig. 1) sheds light on the peregrinations of the theme to La Tour's Lorraine.

I do not think a more graceful and expressive figure has been seen than the Gypsy who tells the fortune of a youth by Caravaggio . . . who shows the Gypsy's slyness with a false smile as she steals the young man's ring, and shows the youth's naiveté and amorous response to the Gypsy girl who tells his fortune and lifts his ring.[50]

This *Fortune-Teller*, it will be recalled, was purchased by Cardinal Francesco del Monte, who hung it in the same room as Caravaggio's *Cardsharps*.[51] The artist made another version of the *Fortune-Teller*, now in the Louvre (fig. 10), which, while similar, departs significantly in the far denser, more atmospheric treatment and in the use of different models and poses. According to an early biographer, Giovanni Pietro Bellori, Caravaggio began this painting when famous ancient statues were pointed out to him as excellent models for his art, and he gestured to a crowd of men to indicate that nature had provided him sufficiently with teachers. To prove his point, Caravaggio called to a

gypsy who happened to be passing in the street and, taking her to his lodgings, he portrayed her in the act of foretelling the future as is the custom of these women of the Egyptian race. He depicted a youth who puts his gloved hand on his sword and offers the other bare hand to [the Gypsy] who holds and examines it.[52]

The glove links Bellori's anecdote to the Louvre version, for in the Capitoline picture both of the young man's hands are bare. The picture in Paris, somewhat later, has a more stable, almost classical composition, with the Gypsy becoming a large, securely planted form. Details such as the hilt of the proto-rapier or the splendid curls of the youth were rendered with greater care.[53]

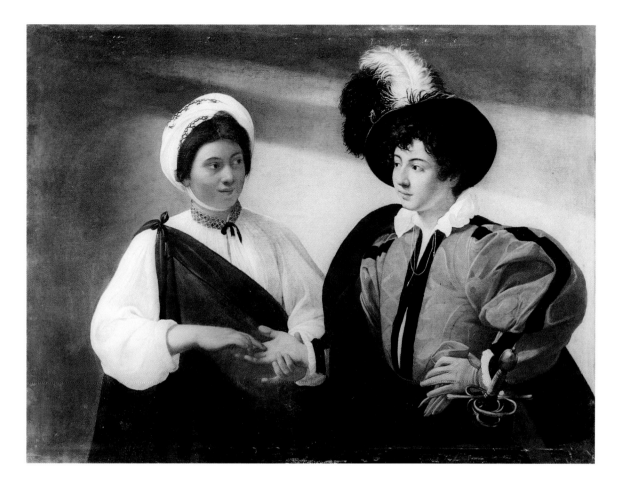

Caravaggio's conception of the beautiful Gypsy telling the fortune of a handsome youth while stealing his money condensed the substance of a long tradition of representations of Gypsies into a genre scene with amorous overtones. Fortune-telling Gypsies in elaborate costumes appeared occasionally in fifteenth- and sixteenth-century northern art, a salient example being a pen drawing by Jacques de Gheyn that depicted an old Gypsy woman reading the palm of a fashionable young woman.[54] Both De Gheyn's and Caravaggio's Gypsies wear the trademark garment, a heavy, full-length robe wrapped under one arm and fastened over the opposite shoulder to cut diagonally across the chest. In Italian art Gypsies — who were believed at the time to have originated in Egypt, from which derived their name — tended to appear in scenes set in Egypt such as the Finding of Moses or a Rest on the Flight into Egypt. In fact, the Gypsies' reputation for evil was at least partly born of the legend that they had failed to help the Holy Family on their flight into Egypt.

Gypsies appeared infrequently in the visual arts in Italy, but were not so rare in the other arts. In northern Italy in the late sixteenth century, for example, there was a vogue of "zingaresche," popular songs relating the predictions of Gypsies. These seem to have consisted of dialogues, performed in masks especially at Carnival, possibly by actors from the commedia dell'arte. Such recitals may have inspired Caravaggio. On the other hand, Bellori's anecdote may have more than a grain of truth in it: real Gypsies were not uncommon in the streets of Caravaggio's Rome.[55]

Friedlaender's notion of an image inspired by literature strikes a chord here as well. Caravaggio could take the theme of the romantic, not especially heroic adventures of a young cavalier, much as Cervantes did in his slightly later *novelas ejemplares,* merging a sweetened literary tone with the grimier reality of Roman street life of the 1590s. The dual tone of Caravaggio's picture is paralleled in Cervantes' *La Gitanilla,* a wildly romantic story of adventure and love

between a Gypsy and a young cavalier. Cervantes idealizes the Gypsies' freedom, bravery, contentedness, and harmony while at the same time establishing their distinct code of conduct.[56] He opens with the lines,

> Gypsies had been sent into the world for the sole purpose of thieving. Born of parents who are thieves, reared among thieves, and educated as thieves, they finally go forth perfected in their vocation, accomplished at all points, and ready for every species of roguery. In them the love of thieving, and the ability to exercise it, are qualities inseparable from their existence, and never lost until the hour of their death.

The encounter of the beautiful Gypsy, born to deceive, and the young cavalier, destined to stray, was a poignant combination for both Caravaggio and Cervantes.

If pictorial sources for Caravaggio's two *Fortune-Teller* paintings are elusive, the pictures themselves were enormously popular and spawned scores of variations on their theme.[57] The ambiguous mingling of hope, desire, seduction, and deception as well as the intimacy and dreamy tone of Caravaggio's encounter of the enchanting thief and her willing victim were perhaps inimitable. Thus it is no surprise that, as was the case for the gambling pictures, the trend of later artists was toward elaboration and complication. Comic subplots were introduced while accomplices and companions, young, old, male, and female, piled into the scene. The mood changed abruptly.

As with *Cardsharps*, the adaption of Caravaggio's idea by Bartolomeo Manfredi – the transformation of daylight to darkness, the multiplication of figures and incident – was crucial in disseminating the theme. Manfredi took two notable steps in this direction when he substituted a grinning bumpkin for the comely youth and a pickpocketing Gypsy crone for the beautiful young woman in his own variation, *The Fortune-Teller* in Florence. More elaborated was his *Fortune-Teller* in the Detroit Institute

of Art (cat. 43), dated c. 1619–1622, which presented a highly individualized Gypsy of dark complexion and exotic features, a little coarse but splendidly dressed, her red sleeves ringed in broad dark bands that recall the vertical stripes of the typical bravo costume.[58] Gazing into the distance, the Gypsy cradles the hand of a youth whose fine clothes are somewhat disarranged. His fleshy face is no longer fresh, and his unhealthy pallor makes more marked the bruised circles around his eyes and the stubble shadowing his mouth. He looks not at the Gypsy but at the hands. Caravaggio's seductive note is absent here. Instead there is a grim, yet starkly beautiful, portrayal of mutual deception and exploitation. The Gypsy's female accomplice has insinuated her light fingers into the youth's pocket to pull out the white handkerchief in which his coins are wrapped,[59] and a rogue takes advantage of the Gypsy's inattention by furtively extracting a chicken (probably stolen) from her robe. In a double twist that became popular in paintings of fortune-tellers, the deceiver becomes the deceived, and vice versa. It seems as if it ought to be comic, but the mood is heavy, even pained.

Valentin too picked up the fortune-telling theme, treating it at least three times.[60] Conspicuously indebted to Manfredi's interpretation is his large *Fortune-Teller* (fig. 11) in which the beautiful Gypsy is so absorbed in divining the fortune of the young cavalier that she fails to notice the scoundrel in the shadows who steals the chicken from her robes. The setting is a tavern, with six people around the table, including two musicians; Valentin populated another version of the theme (Pommersfelden Collection) with fourteen figures.

Valentin's Caravaggism found a poignancy in the sweat and dirt, even the tang of desperation in Rome's streets and taverns. That of his Paris-born compatriot, Simon Vouet, never lowered itself to its subject, never lost its elegance or detachment, no matter what the theme. A cosmopolitan artist, Vouet arrived in Rome around 1613 via Constantinople and Venice. He lived in the parish of San Lorenzo in Lucina, with his countrymen Valentin, Nicolas Tournier, and Claude Vignon among his neighbors. During Vouet's long sojourn in Rome he became quite suc-

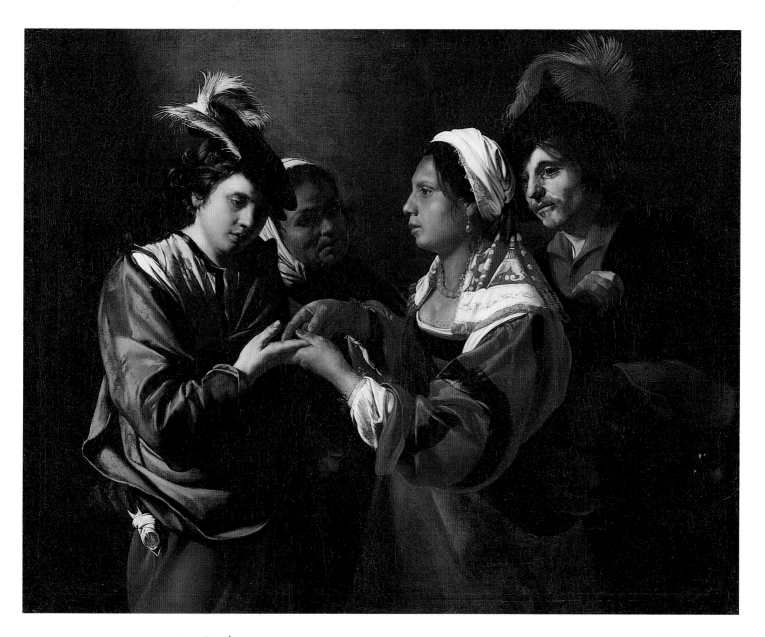

cat. 43. Bartolomeo
Manfredi, *The Fortune-
Teller*, c. 1605–1610?,
The Detroit Institute of
Art, Founders Society
Purchase, Acquisitions
Fund

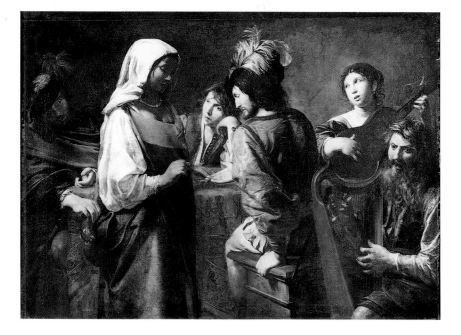

11. Valentin de Boulogne, *The Fortune-Teller*, c. 1628, Musée du Louvre, Paris

12. Pierre Brebiette, *The Gypsy Fortune-Teller*, 1631, Bibliothèque National, Paris

exotic beauty whose handsome gravity sets off to disadvantage the absurd ringlets and foolish grin of the woman whose fortune she divines. The client wears a prominent ring on the fourth finger of her proper left hand, presumably a wedding band. Is she acting the part of a new bride consulting the Gypsy about her future happiness? Beside her, embracing her shoulder and pointing at her, is a man no longer young. He wears a plumed fur hat, and his clothes are the worse for wear. He exchanges a baleful look with an accomplice at the far right, who flashes a merry wink and what appears to be an "okay" gesture to his partner, crowds the Gypsy's back, and reaches in to steal whatever she has concealed in the folds of her robe. Thus the Gypsy is fleeced, the deceiver deceived. Is the woman whose fortune she tells turning her grinning face to the spectator to let us in on the game?

Vouet's palpably burlesque tone sets his picture apart from those by Caravaggio, Manfredi, or Valentin. The double deception scheme in Manfredi's and Valentin's pictures is a subplot that remained in the shadows. In Vouet's picture it became the primary subject. Deception was a favorite *topos* in the popular theater, and the scene is played so broadly that some have suggested Vouet was interpreting a commedia dell'arte skit, perhaps making a nearly direct transcription.[63]

The cluster of paintings of fortune-tellers inspired by Caravaggio's two versions, including works that adhere to the "Manfrediana methodus," is more or less unified, encompassing examples by Valentin, Vouet, and Régnier, not to mention artists of the Utrecht school. Yet once again the trail to Lorraine is cold. It seems neither necessary nor even likely that Georges de La Tour's *Fortune-Teller* (see fig. 2) was directly inspired by any of these Caravaggesque paintings. One graphic parallel is a print by Pierre Brebiette of 1631 (fig. 12) in which a genteel woman, accompanied by her nurse and elaborately dressed baby, meets a Gypsy who holds a naked child of her own. As the lady listens to the Gypsy, two accomplices are rooting around in the lady's pockets.[64]

The protagonists in La Tour's *Fortune-Teller* — a young man, an old Gypsy woman, and her three

cessful and was favored by such distinguished patrons as the Barberini. He was deeply affected by Caravaggio, yet he cast off the dramatic tenebrism and remade his style absolutely after he returned permanently to France in 1627.[61] Around 1619–1620, while in Rome and very much under Caravaggio's spell, Vouet executed his rendition of the *Fortune-Teller* (cat. 45), which is the most overtly comic of the paintings considered thus far.[62] The Gypsy is an

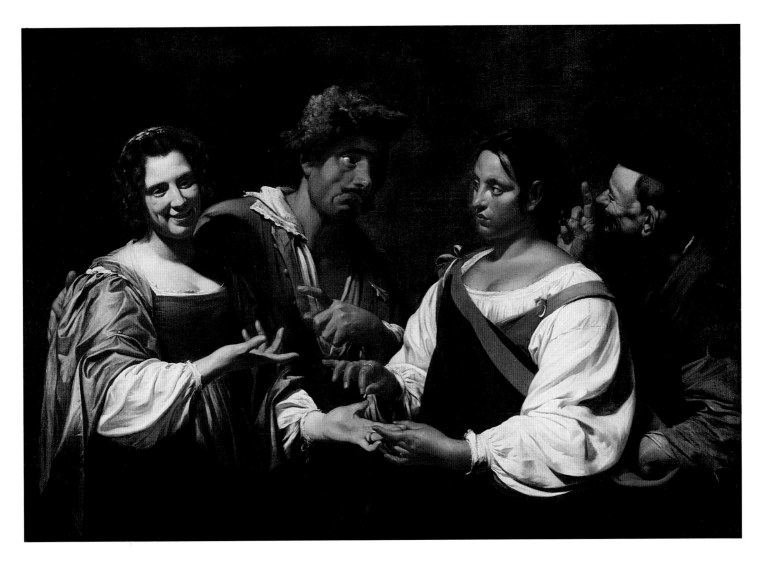

cat. 45. Simon Vouet, *The Fortune-Teller*, c. 1618– 1620, National Gallery of Canada, Ottawa

companions — line up across a shallow stage closed by a neutral tan background. At some point several centimeters of canvas were unfortunately cut from the left side, throwing the composition off balance by pressing the figures against the left margin; a reconstruction that restores the missing strip gives a sense of how the balance and dynamics of the composition originally would have worked (see fig. 13). The youth prepares to have his fortune told by the old Gypsy, who holds a coin above his hand. To tell a fortune, a coin was placed on the upturned palm, which the Gypsy held while she forecast the future. This practice was distinct from palmistry, reading the lines in the palm of the hand.[65] A higher-value coin, which might afterward be given to the Gypsy as a reward rather than payment per se, was alleged to improve the clarity of the prophecy.[66] La Tour's youth stands facing the spectator, barely pivoting toward the old Gypsy. He shifts his gaze sideways to the ancient seer, whose beady stare is fixed on the future. The old Gypsy's visage may convey the rep-

utation that Gypsies had of being "the darkest and ugliest women that one had ever seen in France."[67] Two lovely young Gypsies stand at the left, one deftly lifting the youth's purse from his pocket, the other looking across to a third young woman, who occupies the interval between and just behind the Gypsy and the dupe. Her sidelong glance set in a milk-white perfect oval has become one of the most celebrated passages in the history of French painting. Her hands deftly snip the youth's chain from which hangs a gold medal, the whole vignette set off against the background of her plain dark dress. One can barely make out the words "amor" and "fides" on the links, but La Tour catches a marvelous gleam as the reflection bounces off the gold to backlight the blade of her cutting tool. All the guile and wary watching create an exquisite tension.

As was often the case with La Tour, the costumes are extraordinary creations. They ought not be taken as straightforward transcriptions of authentic clothing in Lorraine around 1630, however, but as the

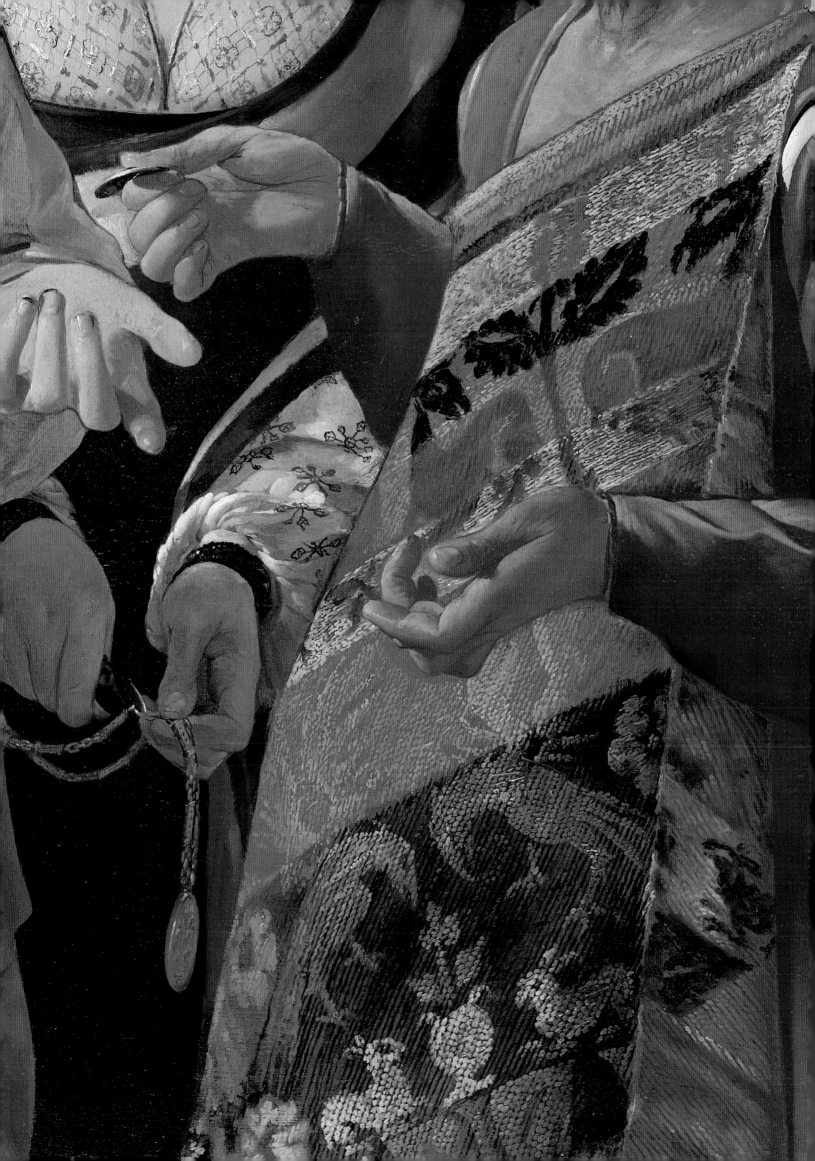

artist's own concoctions, more or less fanciful variations on what would have been relevant and recognizable modes of dress.[68] The old Gypsy's robe or shawl, worn over a red dress and fastened at one shoulder with a round metal clasp, is of bright tapestry, gloriously striped in reds, gold, black, and green and embellished with vegetal motifs, hawks, and rabbits. Do these birds of prey and their victims, the rabbits, echo the theme of the painting?[69] The old woman's damask turban has earflaps embroidered with red and gold. One of the Gypsy maids on the left wears a similar extravagant tapestry robe and cap, with her sleeve embroidered in red and gold. The other's glossy black hair is wound into knots that hang below her chin, one side coming undone and ending in a skinny whip like the tail of a rat. The youth's costume, a tan jerkin over shrimp-colored silk sleeves banded with chartreuse, has proven indeterminate, perhaps a soldier at undress, a cavalier, or an artisan. Slight anomalies suggest that certain details of the costume are improvised, such as a strip of fabric with an ornamental border tucked in such a way to serve as a collar, or the peculiar sash with its bulb-shaped terminals. Such improvisation might support other telling details, particularly the youth's very dirty fingernails so pointedly silhouetted against his white palm, hinting that this young man might not be quite what he purports to be. Even a young man whose background was not exalted could go far on good looks and an elegant appearance in the seventeenth-century court of Lorraine.[70]

The porcelain-skinned maiden is not quite what she first seems either, a member of a Gypsy clan. Her creamy complexion and hazel eyes contrast with the black eyes and dark skin of her companions. There can be little doubt that she is Preciosa, a well-born baby kidnapped and reared by a Gypsy who declared her to be her own granddaughter. Preciosa, the heroine of Cervantes' novella *La Gitanilla*, grew up to be the most beautiful, gracious, and accomplished of all the Gypsy maidens.[71] As Cervantes described her, "Neither sun, nor wind, nor all those vicissitudes of weather, to which the Gypsies are more constantly exposed than any other people, could impair the bloom of her complexion or embrown

her hands." Her Gypsy grandmother had been "careful to teach her how to live by her talons," and in Cervantes' story she easily charmed coins of large denomination from the purses of admiring young cavaliers. In Cervantes' novella, first published in 1613, a young cavalier falls in love with Preciosa, who requires him to prove his mettle by living in disguise as a Gypsy. He gets into various scrapes and escapes with his life only when the grandmother reveals the secret of his noble birth and that of Preciosa as well. *La Gitanilla* was instantly popular. By 1614, de Rosset had published the first French translation, *La Belle Egyptienne*, which went through five editions in La Tour's lifetime, also providing the basis for a number of plays during the same period.[72] La Tour seems to have known at least enough of the story to appropriate the character of Preciosa and substitute an old Gypsy woman for the comely young fortune-teller by now standard in the Caravaggesque pictorial tradition. Cervantes' novella does not center on thievery, however, a fact of Gypsy life that mainly happens offstage or by implication, and La Tour's emphasis on this may derive from the pictorial and commedia dell'arte traditions.

An elegantly scripted signature – Rosenberg called it a "chef d'oeuvre de calligraphie" – prominently placed on the wall in the upper right of the *Fortune-Teller* is unusual in that La Tour identified himself in it as from Lunéville in Lorraine.[73] It was often the case that an artist specified his town in a signature when a work was destined to go where his name might not be well known. It is tempting to speculate that the *Fortune-Teller* was intended for a Parisian audience. A painting of this subject identified as an original by La Tour was given one of the highest valuations in the posthumous inventory of 1650 of the leading Parisian collector Jean-Baptiste de Bretagne.[74]

Difficult though it may be to assign precise dates to La Tour's *Fortune-Teller* and two versions of *The Cheat*, they are vibrantly original inventions executed with elegance and flair, achievements of an artist at the height of his powers. When La Tour turned once more to the gambling theme at the very end of his career, he interpreted the subject in an en-

tirely different vein. *The Dice Players* (cat. 32) may have been among the last pictures on which La Tour worked before his death in 1652. It is a night scene set in an interior lit by a candle, the flame of which is partly blocked by the arm of one of the three players. There are five figures, three young men playing dice around the table, an older man at the left smoking a pipe, and another young person at the right who is most likely a woman but whose gender is somewhat vague. The figure insinuates a sexual subtext, sublimated, ambiguous, and probably mercenary. The attentive spectator soon notices that the smoker, who looks as if he has seen it all, picks the pocket of the youth at the left, who may retain, if not so forthrightly as in the two earlier paintings of card cheats, an identification with the prodigal son. The strong chiaroscuro, the bravura effects of the partly obscured flame, and the extreme simplification of broad, unbroken surfaces relate the picture to other examples of La Tour's latest production. There is a strikingly close relationship with *The Denial of Saint Peter* (Conisbee fig. 81), for example, in both style and subject. The *Denial* follows in the Manfredi tradition of combining a gambling scene in a tavern or guardroom setting with a sacred subject. Numerous versions by the French Caravaggisti and by the Utrecht circle, such as Honthorst (see fig. 5), testify to the international dissemination of the type. In contrast to the earlier *Fortune-Teller* and card cheats, both *The Denial of Saint Peter* and *The Dice Players* testify to La Tour's direct familiarity with works by the followers of Caravaggio by this late moment in his career. The lighting schemes, poses, and deployment of figures, motifs, and iconographic details derive from the repertoire of the Caravaggisti. It is tempting to suggest that La Tour had seen a version of Baburen's *Backgammon Players* after all. The three surviving variations are believed to relate to a common prototype, and the engraving by Crispin de Passe, which also substituted a smoker for the drinker on the left in the painting, enjoyed wide circulation. The prominent arm of the player on the right of La Tour's *Denial of Saint Peter*, braced on the table with the elbow jutting out, corresponds to Baburen's model. As in the Baburen, each of La Tour's three

players wears a different piece of a suit of armor, either scavenged or perhaps even the stakes for which they are gambling, since no money is on the table. Unlike Baburen's figures, La Tour's seem to stand and lean over the table. His more open configuration increases the actors' breathing space in the center and allows a better view of the gambling. The edges are cropped very closely, however, concentrating the composition and allowing only a fragment of the outermost figures to be seen.

The Dice Players was discovered only in 1972 and, like *The Denial of Saint Peter*, it raises the issue of how little is known about La Tour's studio practice at the end of his life. Thuillier observed that while in some areas the brushwork manifested La Tour's refinement, other passages were awkwardly done, and that, "in spite of the beauty of certain faces, we are missing the profound conviction that underlies all of Georges de La Tour's true creations."[75] The explanation Thuillier proposed for the uneven execution of the *Dice Players* is the participation of La Tour's son Etienne. Nearly thirty years old at this time, Etienne had been trained by his father and may have been working under his supervision. *The Dice Players* and *The Denial of Saint Peter* are both among the group of late works in which Etienne's collaboration has been postulated. The possibility should also be considered that *The Dice Players* could have been prepared in part by Etienne, with his father adding the finishing touches.[76]

The portrayals of gamblers, cheats, and fortune-tellers reveal much about Georges de La Tour and his world. La Tour had a unique relationship to the international Caravaggesque phenomenon. Without it he would never have painted the subjects he did, yet for most of his career he guarded his intrinsic stylistic independence both from Caravaggio's original example and from the interpretations of Caravaggio's followers. *The Dice Players* signals a change, suggesting that La Tour was succumbing, quite late in the day, to the lure of the international Caravaggesque fashion of genre pictures. Whether he was prompted by fresh exposure to the novelty and power of works in this style or the marketplace advantage of the type cannot be known. What does seem clear

is that Caravaggio's prototypical fortune-tellers and cheats created a demand all across Europe for such pictures; Caravaggio himself repeated the fortune-teller theme surely knowing it had or would find a customer. Over the next decades the popularity of the genre fed on itself as other artists devised variations on the same themes to satisfy the demands of a new market, to fuel the burgeoning phenomenon of the collector. The genre picture in the Caravaggesque or Manfredi manner was in essence a new concept. It did not replace an older type of picture that had been in vogue. Instead such pictures created their own niche in the market, generating a predictable commodity for new collectors to acquire. Once these paintings had been endorsed by the most progressive and sophisticated connoisseurs, their success was assured. For the French or Dutch artist working in Rome, here was a type of picture that could be made and easily sold on speculation; upon returning home, the novelty of the style and the genre subject that tread lightly on Protestant sensibility found a ready market.[77] The mania for such pictures may have been slow to reach Lorraine. La Tour's *Fortune-Teller* and two *Cheat* paintings divulge only an oblique knowledge of what these subjects had become in the hands of Caravaggio and his followers and bring to bear upon them a fundamentally independent pictorial conception. La Tour's late *Dice Players*, by contrast, is a work that entered wholeheartedly, if belatedly, into the international Caravaggesque spirit.

Notes

1. On the iconography of the prodigal son, see esp. Renger 1970. Lucas van Leyden's *Cardplayers* (Wilton House), presciently seems to combine the prodigal son and themes of cheating. The National Gallery of Art has a variant *Cardplayers* (Samuel H. Kress Collection), considered to be after a lost work by Lucas by Leyden, and close in theme to the Wilton House picture.

2. Giovanni Pietro Bellori, "Life of Caravaggio" [1672], in Hibbard 1983. Hibbard includes a convenient compendium of the early biographies in the original languages and in English translation. My translation differs in small ways from Hibbard's and those in Friedlaender 1955.

3. Two of Caravaggio's most important early biographers, Bellori and Giovanni Baglione, recount this event.

4. On the copies see Moir 1976, 105–106. Complete documentation on the provenance and rediscovery is furnished by Mahon 1988, 11–25.

5. Until the recent restoration, the ring had not been visible. See Mahon 1988, 23–24, and Christiansen in New York 1990, 54–55, for the recent discovery of evidence to support both the attribution to Caravaggio, which had been doubted, and the del Monte provenance.

6. Caravaggio's *Fortune-Teller* is 115 x 150 cm; his *Cardsharps* is 91 x 128 cm. First proposed in Ottina della Chiesa 1967, 88, no. 14. Although they were listed together in del Monte's inventory of 1627 with the same dimensions and identical frames, the technical evidence suggests that the original measurements were not in fact the same. See also Frommel 1971, 16.

7. Nicolson and Wright 1974, no. 50, supported by Spear 1976, 233–235, suggested that the Kimbell version might have been paired with the *Fortune-Teller*, whereas Rosenberg in Nancy 1992a, argued that the style and technique of the Louvre picture made it the more likely candidate. Thuillier tends to favor the hypothesis that La Tour's portrayals belonged rather to larger series treating the same subjects. See also Prohaska 1987.

8. The specific identification of the costumes has not been satisfactorily resolved. They have been described as somewhat out of date and fanciful, or as bearing a resemblance to the conventional costume of Capitano Spavento, a commedia dell'arte player who portrays a mercenary soldier. Certainly the clothes are kin, if not an exact match, to those in prints showing a bravo's uniform. See esp. Christiansen in New York 1990, 17, and fig. 5, who illustrates a "bravo venetiano" from Cesare Vecellio's costume prints apropos the *Cardsharps*. The suggestion has also been made that they are not so far removed from contemporary fashion, especially the livery of noble households. Costume historians have published little research on this particular time and place, and the evidence remains skimpy and inconclusive. There is little doubt that there are meaningful nuances and details in the attire that would have been intelligible to a contemporary but are lost on a modern viewer.

9. Giovanni Cardano, *De Ludo Alea*, translated in Wind 1974, 33.

10. Cards were introduced into France and Germany in the fourteenth century, a little earlier into Italy. They seem to have come to Europe from Arabia. An old but exceptionally informative study is Singer 1816. Attitudes and practices changed in meaning more over time than from place to place within Europe, and by the reign of Louis XIV the culture of gambling seems to have begun a transformation into what it would become during the Enlightenment. The bibliography is decidedly stronger for this later phase, and I am grateful to Jill Caskey for her assistance in culling this literature; for a good general study see esp. Kavanagh 1993.

11. The oldest German card game is called "Landsknecht," which is the term for a German mercenary soldier (Singer 1816, 43).

12. See Hale 1990, 3, fig. 5. Examples include a drawing by Niklaus Manuel, *Scenes from Camp Life*, c. 1520–1522 (Kunstmuseum, Basel); and woodcuts by Anton Woensam, esp. *Soldiers Playing Cards on a Trestle Table*.

13. See Bassani and Bellini 1994, for a fascinating evocation of daily life in Rome in the 1590s, including a description of a recruiting scene. Urs Graf's remarkable drawing of such a scene (Öffentliche Kunstsammlung, Basel) gives a Swiss perspective.

14. Del Monte was just shy of fifty years old; his friends were half his age: Aldobrandini was twenty-six, the same age as Caravaggio, and Farnese was twenty-four. The passage is transcribed in Zapperi 1994, 87.

15. Reinbold 1991, 153.

16. For the early history of this kind of criminality see Jütte 1988, 1–32, which is the source for most of the statistics cited here, including the Augsburg records.

17. A didactic, moralizing literature warning of the dangers of gambling appeared in the sixteenth century (Jütte 1988, 25), coinciding with the emergence of the type of gambling pictures considered in the present essay.

18. Wind 1974; and Frommel 1971.

19. For the tradition of depicting the commedia dell'arte see Sterling 1943. Especially enlightening is Sterling's discussion of the *Recueil Fossard* of 1585, a volume of seventy-nine prints of the Italian commedia dell'arte playing in France beginning in the reign of Henri III. Individual sheets have often been cited as sources or parallels to painted subjects. The prints seem to have been a kind of ancestor to the playbill, with French captions summarizing plot and dialogue, and Sterling shows that several early paintings of the commedia were in fact based on such prints. The relevance of commedia dell'arte to Caravaggio's art is discussed by Mina Gregori in New York/Naples 1985, 218.

20. Friedlaender 1955, 84.

21. Wind 1974, 33. His source is Stoppato 1887, 197–211.

22. See esp. the seminal discussion in Wind 1974.

23. Credit is due to Nancy Edwards for recognizing the pertinence of Romanino's fresco and kindly bringing it to my attention. See esp. Ferrari 1961, 49, pls. 96, 97, which argues that the

fragment must be part of the lost cycle of decoration for the Salotto del Capitano in the Broletto palace in Brescia whose subjects were described by Ridolfi in 1648. Other scenes included men and women amusing themselves by drinking, singing, and dancing, as well as soldiers and other figures. The Broletto cycle was commissioned in 1558, but Nova 1994, 313, argued on stylistic grounds that the fragment must date more than a decade earlier.

24. Jütte 1988, 14–15.

25. Quoted in Singer 1816, 246.

26. But it should be noted that Caravaggio's picture has also been read in terms of traditional card symbolism. Thus the club that Caravaggio's cheat prepares to pull from his breeches belongs to one of the fortunate suits, signifying success, advantage, good fortune, and wealth. The eight of hearts, associated with good news, remains in reserve. The cards on the table are a four of diamonds, another fortunate suit, which casts a shadow on the ace of spades, well known to betoken bad luck. The ace of diamonds is a card of good news. See Wind 1989, 15–18. His major source is Court de Gebelin, *Sur les Cartes à jouer et sur le jeu des Tarots*, a late eighteenth-century dissertation on divination, which is partly reprinted in Singer 1816.

27. See Cremona 1987.

28. Formerly collection Baron Grundherr, Rome. See Moir 1976, fig. 298, and copy at Vassar College Art Museum.

29. See also a very similar treatment of the same subject by Theodor Rombouts (Liechtenstein Collection, Vaduz) in which the balance of interest is tipped in favor of the religious episode.

30. Rome/Paris 1973, no. 37; Mojana 1989, 56, no. 3.

31. This seems to have escaped notice, perhaps being construed as damage caused by use, but it is unlikely that such a telling detail would have an innocent or incidental explanation.

32. Judson 1959, 73 and n. 3, contends that ter Brugghen's *Gamblers* now in Minneapolis was the first of its type painted among the Utrecht Caravaggisti. Subsequent scholars, including Leonard Slatkes, have given precedence to Baburen's painting. The question is complicated by the fact that Baburen's picture is known in three versions, including Bamberg, Residenzgalerie; and The Hague, Stichting Wagner de Wit. Slatkes believes all three to be autograph and possibly deriving from a lost primary version, for which see Slatkes 1965, esp. 72–78, seconded by Spear in Cleveland 1971, 43. A cleaning in 1956 removed a false Honthorst signature and date of 1641, but on several earlier occasions the painting was exhibited as a Honthorst.

33. My thanks to Leonard Slatkes for the information on scavenged armor.

34. There is no mistaking Beham's image as the source of the painting by an as-yet-unidentified southern Netherlandish Caravaggesque artist of *Soldiers Playing Cards on a Drum* (Grisaldi del Taja Collection, Siena), which updates the Renaissance print according to the most flamboyant Caravaggesque formulas.

35. Dayton/Baltimore 1965, and Slatkes 1995.

36. Slatkes 1995, 7.

37. Slatkes 1995, 7.

38. Slatkes 1995, 10.

39. Le Clerc's painting is known in a copy (formerly City Museum, St. Louis) illustrated in Nicolson 1979, vol. 2, fig. 805.

40. Thuillier 1993, 155.

41. For technical evidence see Vic-sur-Seille 1993, and Claire Barry's contributions in the present catalogue. I am grateful to Barry for helping me with this evidence.

42. Vic-sur-Seille 1993, 43–44.

43. Could such a detail betoken a patron sympathetic, or its omission, a patron antipathetic, to the French crown?

44. Vic-sur-Seille 1993, 39.

45. ". . . habiles et des blasés sur l'innocence gourmande de la jeunesse" (Paris 1972).

46. Shakespeare's Henry VIII played primero with the duke of Suffolk, and it was noted by Rabelais in 1611 as one of Gargantua's favorite games (Francesco Berni in Singer 1816, 245). The game in La Tour's paintings was first identified by Thierry Depaulis, who also supplied an eighteenth-century text with the rules of play; letter, 15 December 1988, curatorial file, Documentation, Musée du Louvre. Singer 1816 furnished copious information on the game, having consulted Berni's commentary on primero of 1526, which helped clarify the play in La Tour's and Caravaggio's pictures.

47. Rules differed from region to region, particularly regarding which cards were withdrawn from the deck before play and the procedure for discarding unwanted cards. In Roman rules, play included eights and nines, but Depaulis believed that La Tour's players had eliminated these values.

48. Berni in Singer 1816, 245.

49. Longhi 1935; and Thuillier 1993, 138.

50. Giulio Mancini's account dates c. 1620; reprinted in Hibbard 1983, 350. The theft of the ring can now be seen again, thanks to the recent conservation treatment.

51. When Mancini saw it, the picture had passed to the collection of Alessandro Vittrici in Rome. The Capitoline picture's attribution to Caravaggio had been in doubt, but since the cleaning and recovery of the provenance, its autograph status now seems secure. See Mahon 1988 on the provenance.

52. Bellori 1672, reprinted in Hibbard 1983, 362.

53. See Macrae 1964, 412–416.

54. See Cuzin 1977, 3–52, for a summary of the iconographic history; the De Gheyn is illustrated, fig. 19.

55. One of Pope Clement VIII's aims in the 1590s—along with suppressing gambling, prostitution, and all manner of disorderly conduct—was to exile the Gypsies and other vagabonds (Bassani and Bellini 1994, 16).

56. Cervantes had affirmed in *Don Quixote*, almost as a natural law, that it was right for a Gypsy woman to steal, for such was the law of her people, but that theft was illegal for one who was not a Gypsy.

57 Wind 1974, 32, fig. 7, also proposed as a source for Caravaggio's *Fortune-Teller* a print from the *Recueil Fossard* that portrays the encounter of a prostitute with a flamboyantly dressed young man identified as Julien le Debauche. She touches his outstretched hand to get the coin he proffers, while, at the same time, a scoundrel behind him prepares to steal his purse.

58. See Cuzin 1980, 15–26; Cremona 1987, 78, no. 11.

59. This manner of carrying coins was generally identified as the practice of country folk, which suggests that the youth may be a bumpkin in fancy attire (Gregori in New York/Naples 1985).

60. Rome/Paris 1973, 164–166, no. 51.

61. For Vouet see Crelly 1962; and Paris 1990. For his Caravaggism see Spear 1976.

62. See Paris 1990, no. 8, for complete bibliography and exhibition history.

63. See Cuzin 1977, fig. 24, for the painting in Sarasota. See Spear in Cleveland 1971, 186, and Paris 1990: "Plus encore que d'une histoire, il faudrait parler d'une scène de théâtre, et il est bien possible en effet que Vouet se réfère plus ou moins directement à quelque farce du répertoire populaire."

64. Thuillier 1993, 136 (illus.). The large, oval woven sun hats worn in some depictions of Gypsies, conspicuous in the *Scene from the Commedia dell'Arte* in the Ringling Museum (see fig. 5), were not adopted by the Caravaggesque painters or by La Tour, most of whose Gypsies wore turbans.

65. Thuillier 1993, 136.

66. Cervantes, *La Gitanilla*.

67. Etienne Pasquier [1611] in Crooks 1931, 146. Comparisons have been made by several scholars with the hag seen in profile in Caravaggio's *Judith and Holofernes* and with old women drawn by Lagneau.

68. Allegations of inaccuracies of the costumes in both of La Tour's versions of *The Cheat* and the *Fortune-Teller* were used to challenge the paintings' authenticity in the 1970s and 1980s. See esp. De Marly 1970, 388–391, and De Marly 1981, 1–3. Unpublished comments made by Adolph Cavallo around 1970 (curatorial files, Metropolitan Museum) are ultimately inconclusive. Stella Blum took up this issue in 1982 in an unpublished study of the Kimbell *Cheat with the Ace of Clubs* (curatorial files, Kimbell Art Museum), arguing most convincingly

that the assumption that La Tour would have exactly copied the dress of contemporary Lorraine in such genre pictures is a fundamental misunderstanding. His costumes were imaginative constructions that played on contemporary, historical, local, and ethnic modes of dress. Subsequent discoveries regarding the paintings' provenances have laid to rest the possibility of the pictures being modern fakes as Wright 1985, and Wright and De Marly 1980, 22–24, had once claimed. Recent technical examinations have found no evidence to dispute the early date of the pictures. In the case of the *Fortune-Teller,* such examination has also revealed misleading irregularities in previous treatments, for which see Brealey and Meyers 1981.

69. See De Marly 1970, 388–391, which compared the shawl's design to that on a carpet in a *Madonna* by Joos van Cleve (Weld-Blundell Collection, Lulworth Castle) but maintained that the style of La Tour's costumes did not correspond to contemporary dress.

70. See Thuillier 1993, 37.

71. Cervantes' *novelas ejemplares* had been mentioned as possible influence or at least analogue for Caravaggio's *Fortune-Teller* in Friedlaender 1955, 84; and Cuzin 1977, 22, refers specifically to *La Gitanilla*. Odile Basch Jacobs first proposed the specific identification of La Tour's pale thief as Preciosa in her master's thesis at Queen's College; her unpublished research was conducted under the supervision of Leonard Slatkes, who kindly informed me of her identification.

72. See Crooks 1931, esp. chap. 5, which discusses the influence of the *novelas ejemplares* upon French plays.

73. Rosenberg and Macé de l'Epinay 1973 calls it "un chef-d'oeuvre de calligraphie."

74. Thuillier 1993, 104. Bretagne's inventory included five paintings by La Tour.

75. Thuillier 1993, 228.

76. Thuillier 1993, 295, suggests that some of the finishing touches, being superficial, might have been lost in past cleanings of the picture. Thuillier also questioned the integrity of the signature.

77. In northern Europe, the Caravaggesque genre painting did have an ancestor in comic moralizing subjects such as the ill-matched pair.

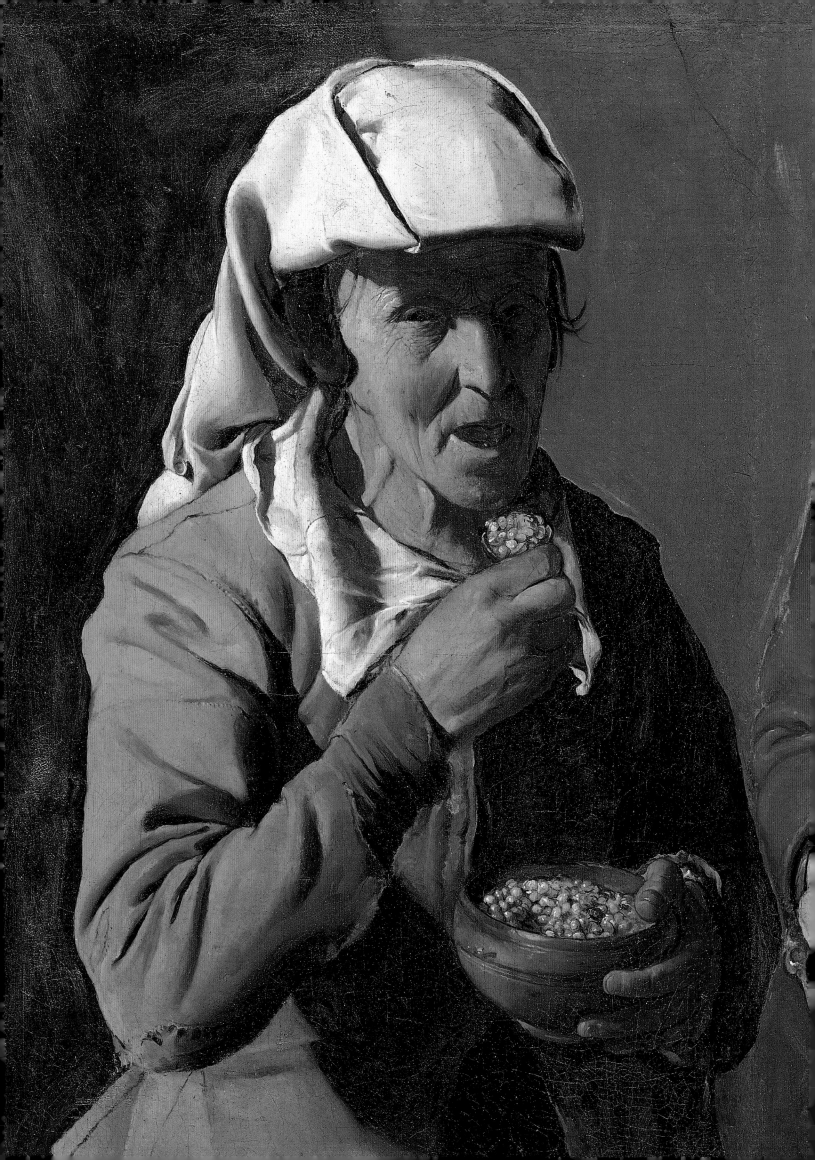

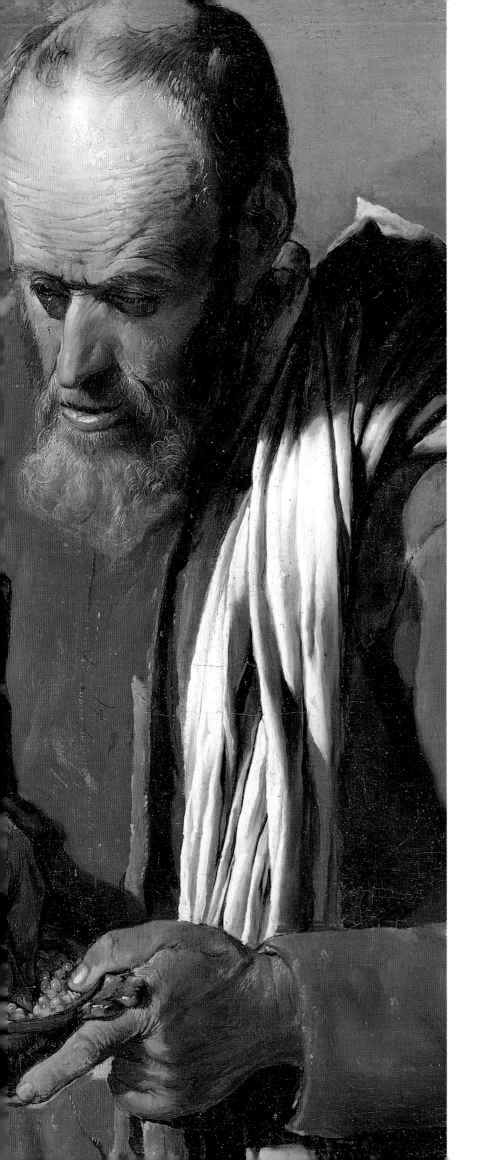

*La Tour Seen
from the North:
Observations on
La Tour's Style and the
Chronology of His Works*

JEAN-PIERRE CUZIN

For want of the discovery of some new document, the longstanding debate between those who argue that Georges de La Tour visited Italy and those who think that he did not cross the Alps has made little progress. In general, scholarly opinion falls into two art historical camps: on one side are the Italians and the French, who believe there must have been such a trip; and on the other side are the Anglo-Saxons, who do not believe La Tour ever traveled to Italy.

A voyage to Italy was "a quasi-certainty" to Jacques Thuillier, writing about La Tour in 1974.[1] Perhaps a document will be found someday to confirm such a voyage. I myself have expressed previously the conviction that it did take place,[2] but I am no longer so sure of this conclusion and believe that even if such a voyage did take place it does not in itself explain La Tour's art. Certainly the lacunae in existing documentation leave enough room for a trip sometime between the years 1613 and 1616. It is also true that most painters from La Tour's province made voyages to Rome, where a Lorrainese colony was well established. Nevertheless I do not find – or rather, I no longer find – any real analogy between La Tour and Caravaggio, Bartolomeo Manfredi, Valentin, or any of the other Roman "Caravaggesques," even in La Tour's earliest known canvases, such as the Albi Apostles or *The Musicians' Brawl* in Malibu (see cats. 6–9). *The Payment of Taxes* in Lviv (cat. 1), a fairly recent addition to the painter's known oeuvre, seems almost the antithesis of what a "Manfredian" painter would have done with a similar subject. If the author of this painting did see Caravaggio's *The Calling of Saint Peter* in San Luigi dei Francesi or a comparable painting by Valentin, Nicolas Tournier, or Nicolas Régnier, he was hardly impressed by the experience. Since La Tour treated precisely those themes most closely associated with Caravaggism – for example, *The Fortune-Teller*, his two versions of *The Cheat*, or his two versions of *Saint Jerome* (see cats. 14–15, 17–19) – we are all the more struck by his independence from, as opposed to his reliance on, Caravaggio and the Caravaggesques.

The visual baggage, if we dare use this term, evidenced in the earliest works that have been firmly attributed to La Tour does not suggest such a so-journ. And we have to concede that the negative argument – the absence of documentation in Lorraine regarding the young artist prior to October 1616 and the fact that most artists from Lorraine made the voyage to Italy – is not convincing in and of itself.

Strictly speaking, there is nothing of the Caravaggesque in La Tour's earliest known works – pictures painted on the very surface of the picture plane, where what counts is the beauty of the paint application, the variety of touch, the elegance and intensity of draftsmanship, and the verve and brilliance of a distinctive palette. And there is nothing of the Caravaggesque in La Tour's startling, almost brutal, humanity; in the place he accords unusual or even theatrical costumes; or in his white light, which flattens to the ground his cutout shadows, which are as severe as metal shards. Caravaggio was an artist who painted the transition from shadow to light, for whom emotion and the human condition were of paramount concern. In La Tour's early works, including the nocturne from Lviv, his divisions are always distinct – he was most interested in the kind of extremes of expression employed in pantomime. What then is the relationship between these tense, constricted figures set within their cramped space, on the one hand, and the softly rounded, elegant figures of Caravaggio, with their smooth modeling and pictorial coherence, entirely devoid of even a single, random touch? If we must look to Italy for prototypes, La Tour's realist, half-length depictions of "beggars," his semi-descriptive, semi-satirical figures that both attract and repel, belong less to mainstream Caravaggism than to the artistic vein in Bologna represented by the work of Bartolomeo Passarotti and Annibale Carracci (we need only think of *The Bean Eater* in the Colonna Gallery, Rome).

Consider Hendrick ter Brugghen, a painter slightly older than La Tour whom we know to have made a voyage to Rome. Though a highly individual artist who remained faithful to his own unique visual language, coloring, and style, ter Brugghen was an authentic Caravaggesque: pictures by Caravaggio, most notably *Christ at Emmaus* (National Gallery, London) or *The Incredulity of Saint Thomas* (Sanssouci, Potsdam), served as the point of depar-

ture for ter Brugghen's own improvisations, which, while thoroughly personalized, nevertheless could not have existed without the prototypes of Caravaggio. La Tour is another matter altogether. If we consider his most perfect daylit masterpieces – *The Fortune-Teller, The Cheat with the Ace of Clubs,* or *The Cheat with the Ace of Diamonds* – we have to wonder what precisely is Caravaggesque about them. Is it the pale background of Caravaggio's *Fortune-Teller* (Capitoline Museum, Rome)? The simple fact that La Tour so elaborately inscribed his signature on his own *Fortune-Teller* transformed its background into something quite different from the luminous space against which – or in which – Caravaggio distinguished his fortune-teller or his celebrated *Basket of Fruit* (Ambrosiana, Milan). La Tour's *Fortune-Teller* seems to be linked to Caravaggio's pictures with light backgrounds, while ignoring the "Manfrediana methodus" whereby figures are conceived purely in terms of well-defined volumes emerging from dark backgrounds. If indeed La Tour did travel to Italy, how is it that only he managed to resist this

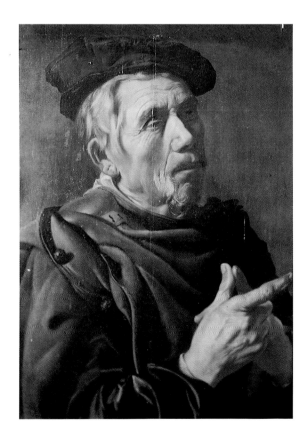

1. Jan Woutersz, called Stap(?), *Old Man with a Toque,* c. 1640(?), Musée du Louvre, Paris

influence that so affected all of the other young painters who came to Rome?

It is rather to the world of northern painting from the sixteenth and early seventeenth centuries that we must turn in order to find a style that unites a relentless realism and geometry of form with a tilting of planes to create plunging views similar to those found in paintings such as the two versions of *Saint Jerome* or *The Payment of Taxes.* In these paintings we find a warping of perspective, a spare, geometric interlocking of forms, and a rejection of spatial recession – which forces objects toward the picture plane (as in the Stockholm *Saint Jerome,* where the large hat placed behind the saint imposes itself authoritatively into the foreground), as well as a shifting of volumes toward the picture plane (think of the shoulder of La Tour's *Saint Thomas,* so monstrously and wonderfully deformed, and of his little book, twisted back upon itself). These "primitive" effects, if we dare use the term, have contributed much to La Tour's glory in our own twentieth century, which so admires early Renaissance art, and with good reason. Yet they also position us in the mid-fifteenth century and the world of Enguerrand Quarton, who constructed forms from light and shadow that are just as realistic and sharply delineated. Look once again at the rigid right arm of the saint in La Tour's two *Saint Jerome* paintings, which recalls that of Christ in Quarton's *Avignon Pietà* (Louvre, Paris), or at the oblique shadows fixed on the ground, so similar to those found in the Requin and Cadard retables (Petit Palais, Avignon, and Musée Condé, Chantilly, respectively). Although active in Provence, Quarton was first and foremost a native of Picardy, a man of the north.[3]

I would like to propose here some images, to be added to those already presented by Anthony Blunt and Benedict Nicolson, that have convinced me that it is definitively in Netherlandish painting that La Tour derived his first visual inspiration.[4] We are now entering into a fragile domain of largely intuitive formal comparisons, where happenstance, fortuitous analogies, and affinities of artistic temperament may come into play and where nothing can be proven with absolute certainty. But the mystery still sur-

rounding the evolution of La Tour's style is such that no avenue should remain unexplored.

It has already been noted that the rustic realism – or more accurately, the popular realism – that characterizes La Tour's *Old Man*, *Old Woman*, *Old Peasant Couple Eating*, and *Musicians' Brawl* (cats. 3–4, 9) finds, if not an equivalent, then at the very least a strong analogy in the *Old Man with a Toque* (fig. 1), attributed to Woutersz Stap, a painter from Amsterdam. If the rounded modeling and the fluidity of the forms remain somewhat removed from La Tour's work, the coldly objective realism and the clear, refined coloring irresistibly evoke the French painter's handling.[5] Comparison of La Tour's "beggars" with those by another of his contemporaries, Jan van de Venne (or van der Vinnen), an artist active in Brussels, is perhaps even more striking. We reproduce here two paintings depicting *The Head of an Old Man*, very characteristic of his style (figs. 2 and 3): the rugged, massive figures, a taste for the peculiar, a fascination with elderly faces scrutinized without pity, combined with a luminism and an an-

imated, calligraphic style that painstakingly records locks of hair and details in dress with an almost sensual paint application – all are qualities quite close to the early works of Georges de La Tour.[6]

In a similar, though earlier comparison, a little-known, unattributed work in Budapest called *The Old Couple* (fig. 4), in which a man appears to be offering a pitcher to his wife (both figures shown in half-length), is remarkably like La Tour's *Old Peasant Couple Eating* (fig. 5).[7] Certainly this work is closer to the tradition of portraiture and requires mention of Jan Gossaert's *Old Couple* (National Gallery, London) as well as the even earlier, more tightly focused bust-length *Double Portrait* by Hans Memling (divided between the Musée du Louvre, Paris, and the Gemäldegalerie, Berlin). The authority of the Budapest painting's imposing composition, the strong sense of plasticity in its direct, symmetrically arranged busts and in the folded arms that advance into the foreground, the abstract background – black, in this case – and the uncompromising realism are quite similar qualities to those seen in the

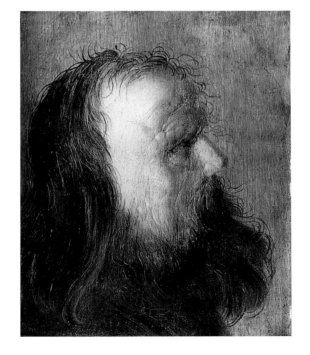

2. Jan van de Venne, *Head of an Old Man*, c. 1620–1630, formerly Brussels art market

3. Jan van de Venne, *Head of an Old Man*, c. 1620–1630, Musée d'Autun

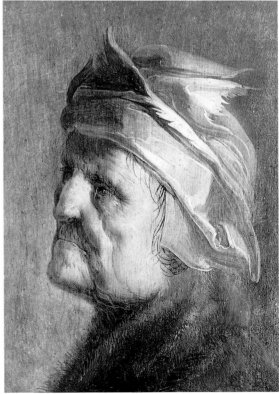

4. Artist unknown, *Old Couple*, c. 1560–1580(?), Szépmüvészeti Múzeum, Budapest

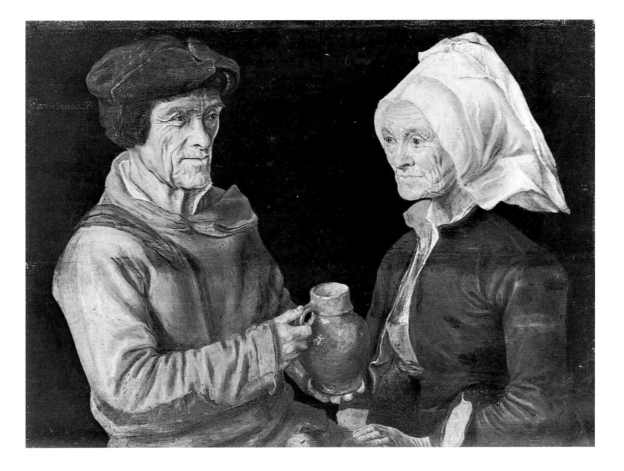

5. Georges de La Tour, *Old Peasant Couple Eating*, Staatliche Museen zu Berlin, Gemäldegalerie [see also cat. 4]

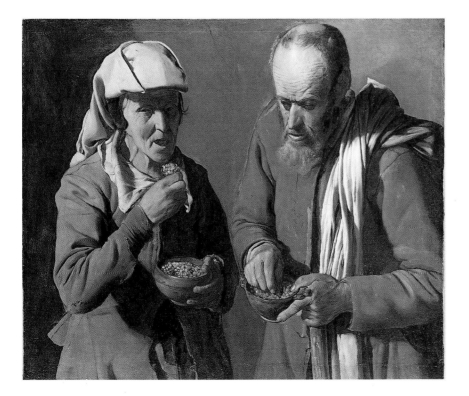

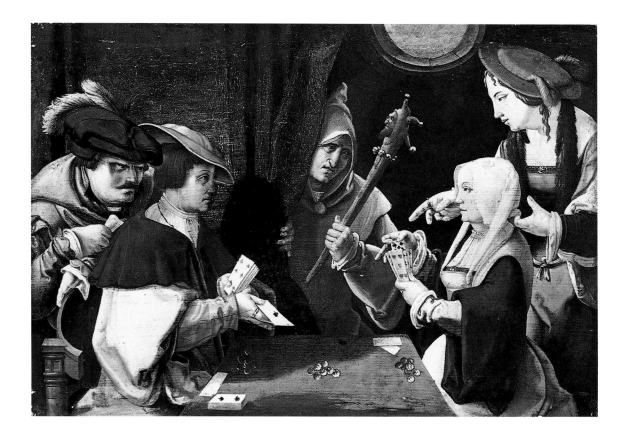

6. After Lucas van Leyden(?), *The Card Players*, c. 1530(?), Szépmüvészeti Múzeum, Budapest

Old Peasant Couple Eating and other works by La Tour, including *The Musicians' Brawl*, *Old Woman*, and *Saint James the Less* (cat. 6). In its mood and in its plasticity, the Budapest painting seems much closer to the early works of La Tour than does any painting in Rome. With this unknown painter, are we perhaps in Antwerp or in Amsterdam, and not far from Pieter Aertsen who died in 1575? Could La Tour have seen such works?

The revelation in 1972 of *The Payment of Taxes* vexed scholars and overturned most of the hypotheses that had persisted until that time regarding La Tour's chronology (to which we will return later in this text) and artistic sources. In this picture, which is undoubtedly a rather early work in his artistic career, the intelligence and confidence of composition, the elegance of its parts, and the sureness of its luminous and colorful harmonies preclude the possibility that it is the work of a true beginner. The rediscovery of this work also destroys the hypothesis of La Tour's voyage to Italy – or at the very least renders such a voyage unnecessary. It would require

considerable effort indeed to find any analogy whatsoever with the multiple scenes of figures grouped around a table, whether sacred or profane, daylit or nocturnal, that were produced by Caravaggio or any number of artists who worked in the circle of, or later followed, Manfredi.

Blunt and Nicolson have established very convincing comparisons between the pictures of La Tour and those of Lucas van Leyden and his milieu. Nicolson pointed out the *Saint Jerome in His Study by Candlelight* attributed to Aertgen van Leyden (Rijksmuseum, Amsterdam), to which *The Payment of Taxes* bears a fascinating resemblance.[8] The notable similarities between La Tour's *Fortune-Teller*, *Cheat with the Ace of Clubs*, or *Cheat with the Ace of Diamonds* and works by Lucas van Leyden also deserve mention once again. Of particular interest is *The Card Players* in Berlin (fig. 6), which appears to be a rather mediocre copy of a lost work by Lucas van Leyden[9] and one that invites comparison with both versions of *The Cheat* in a number of respects: the composition, the play of gestures and glances, the

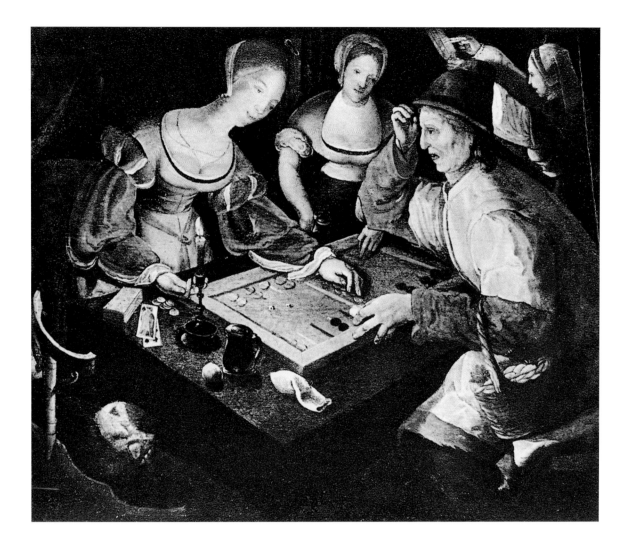

feathered headdresses, the profiles silhouetted against a dark backdrop. The light found in the early works by La Tour – a cold, harsh light, reminiscent of a theater spotlight that silhouettes forms and causes strong colors like vermilion, blue green, pink, and yellow to advance, and in whose company black serves as a color in its own right rather than as a neutral ground or a pocket of shadow – this is what makes the world of La Tour so close to that of Lucas. In Lucas' *Madonna and Child* pictures in Oslo (Nationalgaleriet) and Amsterdam (Rijksmuseum), we find sisters of the woman with the ostrich-egg-shaped face who appears in La Tour's two paintings of *The Cheat*.[10] Not until the *Madame de Sennones* by Jean-Auguste-Dominique Ingres (Musée des Beaux-Arts, Nantes), another realist giant who exulted in formal purity, will we find another compar-

ison as convincing. And how could anyone fail to notice the large insect on the robe shown in the *Saint Anthony* attributed to the circle of Lucas (Musée Royal des Beaux-Arts, Brussels), which so clearly calls to mind the fly on the garment depicted in La Tour's *Hurdy-Gurdy Player* (cat. 11)?[11] Then there is an extraordinary nocturne by a follower of Lucas, *The Game of Backgammon* (fig. 7),[12] which depicts, by all appearances, a man being duped by a group of prostitutes. This work also presents other striking affinities with La Tour's *Payment of Taxes*: the view from above, which accords such prominence to the table's surface and the still life resting on it; the disposition of compositional cutouts in a boldly geometric fashion; diagonals opposing the axes of the figures; the simplification of forms accentuated by distinctive lighting; the pictorial surface filled to

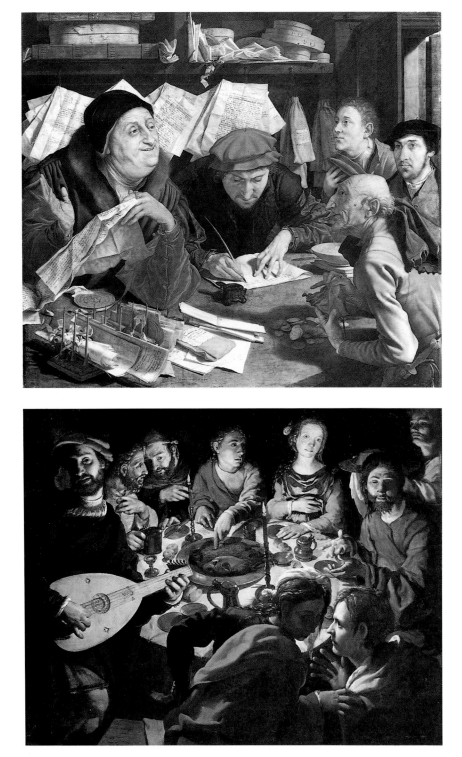

8. Marinus van
Roemersvaele, *A Tax
Collector*, 1542, Alte
Pinakothek, Munich

9. Jan Cornelisz Vermeyen,
The Marriage at Cana,
c. 1530(?), Rijksmuseum,
Amsterdam

its very edges. Such a candlelit scene, with a composition so similar and an unambiguous moralizing message, proves the influence of the north in pictures like *The Payment of Taxes* and suggests a possible relation to La Tour.

Leaving behind the milieu of Leyden for that of Antwerp, we must note here several paintings by Marinus van Roemersvaele, in particular his *Tax Collector* (fig. 8), of which there is another version in Antwerp (Musée des Beaux-Arts). This painting is analogous to *The Payment of Taxes* in its subject, but even more so in the "crammed" appearance of its composition, the naturalism of its individual parts, and the plunging view of the table that is covered with objects and pieces of paper and on which the figures lean.[13] Lastly, we should keep in mind the splendid pictures by Jan Cornelisz Vermeyen, an artist who often displayed a sensitivity for nocturnal effects, as in his *Marriage at Cana* (fig. 9), where the spatial construction of the table viewed from above, the extremely cramped composition, the candlelight illumination, and the richness of the paint application in a beautiful array of reddish tones seem to prefigure La Tour's *Payment of Taxes*.[14]

One singular characteristic found in a number of youthful pictures by La Tour is the daring manner in which figures are viewed from above – or rather the distinctive way in which the ground on which they are placed is tilted almost to the point of verticality, as if it had been pulled downward. With this in mind, consider an *Entombment* from the circle of Albrecht Dürer (fig. 10), to whom it was formerly attributed, which can in any case be placed within the German artist's orbit.[15] The dead Christ, supported by the Virgin and Saint John, is depicted in an elaborate pose, half-seated, half-reclining. In the awkward arrangement of the stiff limbs against the uptilted ground, the harsh light that defines the anatomy and projects shadows on the ground, how could we fail to recognize its correspondence with the two *Saint Jerome* paintings by La Tour (see fig. 11)? Even if the pose of the figure of Christ in the German painting is more contorted, and even if the works are separated by a century, when viewed in purely formal terms, this *Entombment* has a greater

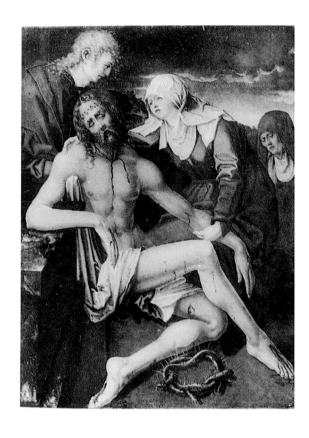

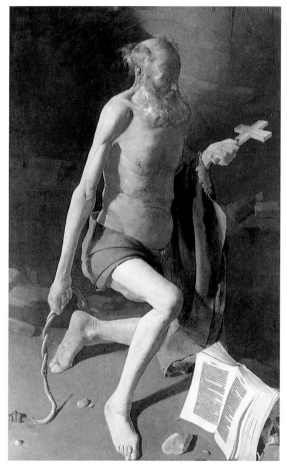

kinship with paintings by La Tour than can be found
in all the Caravaggesque *Saint Jerome* paintings we
could assemble. Although this German connection
may not lead very far, it does point to a rather un-
usual picture, a *Saint Jerome Reading* (fig. 12) that
has rarely been considered, though it has been re-
produced on several occasions. In this picture the
figure is viewed frontally in a manner bordering on,
though not truly comparable to, a version of this
subject in the Louvre, which is a copy of the lost
original.[16] It is difficult to accept this picture as a
faithful copy of a lost La Tour, as we can accept the
Louvre painting. There is something heavy and awk-
ward about it, with its broad, rounded modeling that
gives the whole a decidedly sculptural quality rem-
iniscent of the prototypes of Dürer. Could this some-
what bloated "La Tour" be an interpretation of a
missing La Tour executed by contemporary German
painter? It is difficult to dismiss entirely the possi-

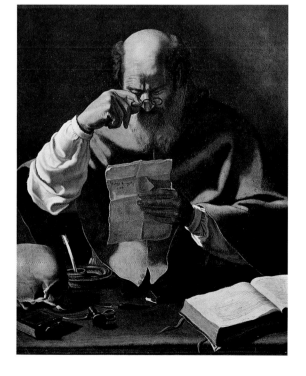

13. Artist unknown, *Scene from a Comedy*, c. 1600(?), Musée de Béziers

bility of some connection. What conclusion can be drawn, without being too presumptuous? We should not forget that the Lorraine region remained imperial territory for a long time and that connections between La Tour and cities in the east were not impossible. Furthermore, engravings by Dürer, like those by Lucas van Leyden, were widely circulated and admired.

This look toward the northern countries of the sixteenth century reveals striking points of convergence that scarcely require us to recall the stylistic similarities between La Tour and Dutch artists such as ter Brugghen and Honthorst, who returned from Italy to the north to work. Let us mention here the *Saint Jerome Writing* by Abraham de Vries (Couvent de la Visitation Sainte-Marie, Mâcon), a fine example, probably dating from the 1620s, painted by a Dutch traveler working in the Caravaggesque style, fully cognizant of his rich northern heritage of the sixteenth century. The engraving after this painting by Sébastien Vouillemont was even identified by

François-Georges Pariset as the reflection of a lost La Tour.[17] The venerable legacy of realist-satirical art that is peculiar to the Netherlands and which can be traced at least as far back as the work of Quentin Metsys, is very much in evidence in the formal solutions of de Vries, such as the silhouetting of forms, the crowded composition, and the still-life elements viewed from above.

Given the frequency with which scholars have expounded the various arguments that so convincingly explicate the ties between La Tour and the art of Lorraine – particularly that of Jacques Bellange,[18] Jacques Callot, and Jean Le Clerc – it seems unnecessary to recount them here. But the role that Paris may have played in La Tour's formation is rarely raised. We can only reiterate once again how incomplete our knowledge remains of pictorial production in Paris during the first two decades of the seventeenth century, to the point that we are unable to judge it. What was portraiture like, outside of the work of François Pourbus? And what of genre paint-

ing, which would certainly have been flourishing at this time alongside portraiture? For every artist such as Georges Lallemant, who is relatively well known owing to numerous recent discoveries and engravings after his works by Büsinck, how many other names are there to which no works are yet attached, and how many works lack names as well as dates? We cannot help but be struck – and here I am simply repeating the intuitions of Blunt and Nicolson – by the coincidence between the northern and Parisian satirical and theatrical subjects (the two often being one in the same) from early in the seventeenth century, and even as far back as the middle of the sixteenth century. The situation is further complicated by the difficulty in distinguishing the hands of northern artists from those of French artists. An engraving by Jean de Gourmont the Younger representing a theatrical scene, for example, resembles La Tour's *Old Man* and *Old Woman*. Another comparable image, a *Scene from a Comedy* (fig. 13), apparently a Parisian picture from c. 1580–1600, possesses a number of visual elements that would have appealed to La Tour: a crowded composition, geometric silhouettes, a strong characterization of the figures with their rather gaudy costumes, a taste for pantomime, and the play of gestures and glances, all of which seem to anticipate directly La Tour's later pictures *The Fortune-Teller* and the two versions of *The Cheat*.[19]

One particularly striking trait that is unique to La Tour, and which appears so forcefully in his Albi Apostles, is his fondness for figures shown in full face while gazing directly forward or side to side, lowering their eyes or inclining their heads. We encounter this in paintings of *Saint Jerome Reading* throughout La Tour's career as well as in some of his most compelling figures from his half-length compositions, among them the old woman in *The Musicians' Brawl*, the young woman with the side-long glance in *The Fortune-Teller*, and the mother in *The Newborn Child* (cat. 27). Because such frontal views are a rarity in the history of painting, it is a stylistic trait that cannot be ignored.

It is perhaps not irrelevant to emphasize the frequent repetition of such a type of representation in drawings of the "Lagneau" group.[20] It is known that this group of drawings includes works of varying quality from a number of artists active between the end of the sixteenth and the middle of the seventeenth centuries, corresponding to the vogue for "expressive faces," which were collected in albums. Whether these drawings are Parisian or Lorrainese is not certain; Paris seems a more likely source, though the two possibilities are not necessarily mutually exclusive. Here it suffices to note the ambiguity between the pursuit of portraiture and that of the character type; the predilection for highly distinctive physiognomies, often those belonging to the elderly, alongside the traditional portrayals in three-quarter length; a penchant for profile views like those favored by La Tour; and above all the predilection for full frontality. We reproduce here three of the most beautiful "Lagneau" drawings (figs. 14–16). In their frank simplification and, if we dare say, their rich human content, they introduce an element of idiosyncracy not far removed from the world of La Tour.[21]

It is very tempting to promote this "Parisian connection" to account for the context in which the young La Tour was formed. That there is a document, one that seems incontestable, proving the artist's presence in Paris at age twenty, which is the age at which a painter in the seventeenth century was already formed or was about to complete his education, lends credence to this position.[22] In brief, the evidence seems to militate in favor of Lorraine, and possibly Paris as well, as the site of La Tour's artistic formation. The question of whether La Tour would have needed to travel in order to see paintings and prints by northern artists is ultimately of little interest, since so many of these works circulated.[23] The originality (and the true genius) of La Tour is certainly this tension, born of the meeting of several stylistic threads, which he was able to garner and then assimilate to create a unique style. Influences ranged from painters in Leyden, Antwerp, and perhaps Germany, active in the sixteenth century and later revived by the Dutch Caravaggesques; to those associated with the Lorraine region, including Bellange, Callot, and Le Clerc; and lastly, to the northern realist-satirical tradition of genre

14. Lagneau, *Head of an Old Man*, c. 1610–1620, Musée du Louvre, Paris

15. Lagneau, *Head of a Man*, c. 1600–1620, Ecole des Beaux-Arts, Paris

16. Lagneau, *Head of an Old Woman*, c. 1600–1620, private collection, Paris

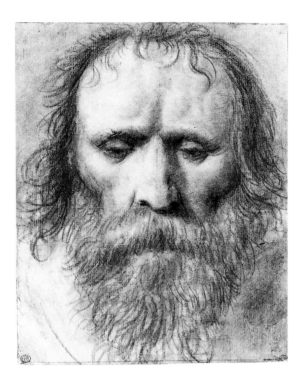

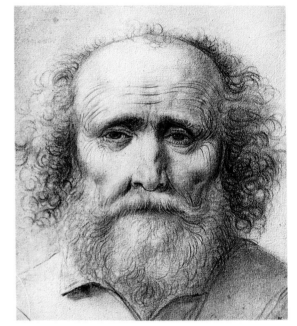

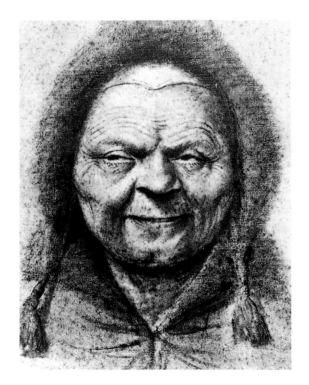

OPPOSITE PAGE:
Detail, cat. 9

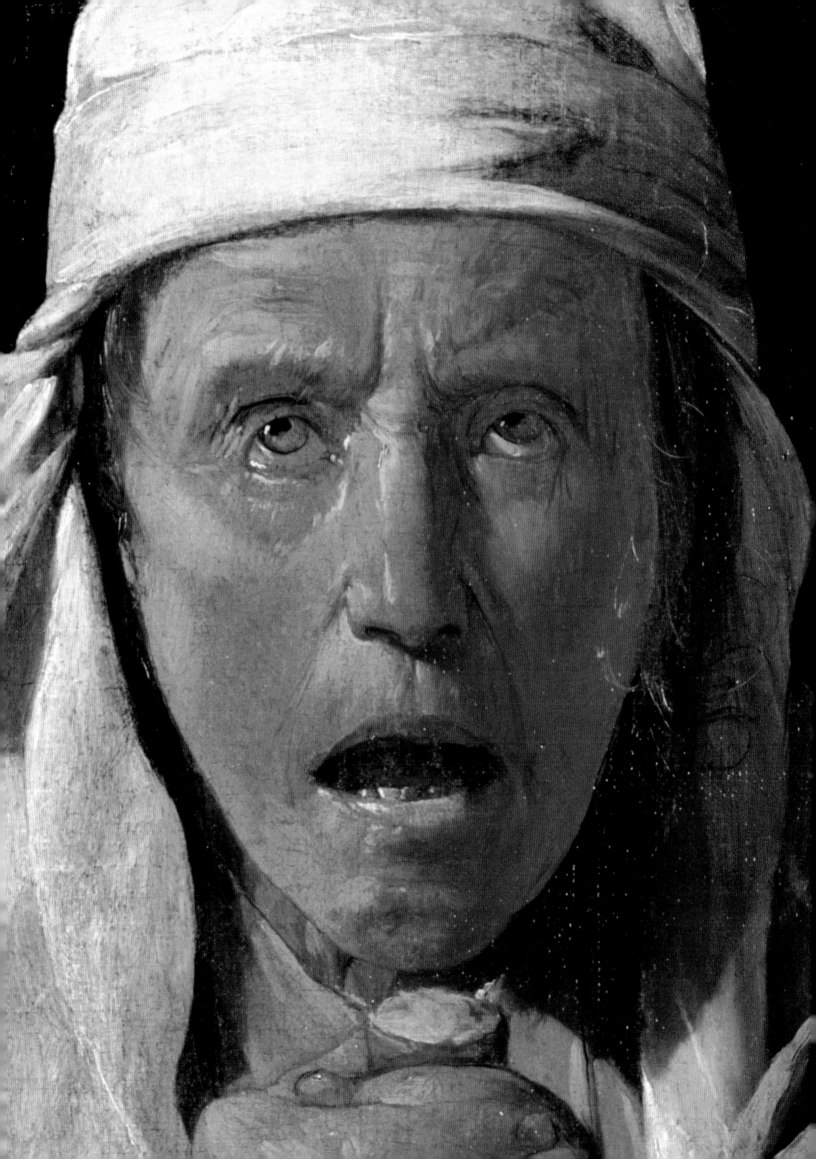

scenes related to the theater, in which proverbs, naturalism, and the grimaces and winks at the spectator all played a part.

If I may be permitted, not in the form of a conclusion, but as a way of advancing this debate through scholarly provocation, I would like to propose some suggestions regarding the chronology of the oeuvre of Georges de La Tour. The difficulties posed by this question are well known: the very meager percentage of extant works (a fifth of his production? a tenth?); the relative lack of secure dates and then only for the later works; the near impossibility of proposing a firm dating for the earliest surviving works; and all of this inhibiting attempts to situate stray works within the artist's chronology.

For a long time, too long perhaps, the division of the artist's oeuvre into two groups – the daylit pictures and the nocturnal pictures – has served to designate two successive periods in his career. Of course, that was until the La Tour exhibition in 1972 when *The Payment of Taxes* entered the fray, causing this delicate structure to teeter, and in my opinion, to collapse completely. Yet it is not an entirely new idea to propose a late date for certain daylit scenes, such as *The Cheat with the Ace of Diamonds*, or an early date for some nocturnes, such as the horizontal *Saint Sebastian* (cat. 16), with its embroidery and delicate brushwork.[24]

The discovery of *The Payment of Taxes* and other paintings since the 1972 exhibition allows us to pose the question of chronology in new terms, if we are willing to examine these pictures on the basis of style as the criterion for dating rather than on their subject or on the loftiness of the spiritual message they impart. Let me state my first premise simply: that La Tour painted both daylit *and* nocturnal pictures throughout almost his entire career, although he seems to have specialized in nocturnes during the last ten years of his life. La Tour was prodigiously creative, but he was also a successful artist, who was often asked to produce paintings similar to those he had executed previously. This practice led him to repeat compositions into which he introduced variations, a fact that is well known. It is my belief, how-

ever, that he often undertook such replicas a considerable time after the original invention of the composition. Catalogues of his oeuvre written up until the present, even when they purport to be chronological, tend to present his canvases according to subject, all too quick to exploit the coherence lent by subject matter; but this perhaps leads to errors. We will return to this question, but at present, I would like to propose dates for two of La Tour's paintings, *Job and His Wife* (Conisbee fig. 65) and *The Hurdy-Gurdy Player* (cat. 12), dates that I believe necessitate a complete reevaluation of the artist's chronology.

To begin, we need to reconsider some old arguments[25] that were never convincing before and propose that the *Job* masterpiece should be dated early in La Tour's career, since striking stylistic peculiarities link it to the two *Saint Jerome* paintings and *The Fortune-Teller*, not to works firmly situated late in the artist's career. The ruined condition of several portions of the canvas may forever obstruct a definitive judgment, but the realistic depiction of the old man's body, the bent and twisted postures, the brutality of the psychological relationship, and the gamut of brilliant reddish tones all suggest an early date comparable to that of La Tour's most masterful daylit pictures. By contrast, *The Hurdy-Gurdy Player*, which has only recently come to light and was acquired by the Prado in 1991, appears, in my opinion, to be a much later work than has been suggested previously: the full, rounded volumes create an almost sculptural sense of solidity; and the brushwork was generally applied in a dense, rich manner that bears no relation to the elegant strokes painstakingly drawn with the tip of the brush so conspicuous in his earliest works. This hurdy-gurdy player, the last in this "series," consequently could be dated to very near La Tour's nocturnal masterpieces, such as *Christ with Saint Joseph in the Carpenter's Shop* (Conisbee fig. 75).

A chronology that interweaves La Tour's daylit and nocturnal pictures to a greater degree should therefore be proposed. Without attempting to cite all of the pictures and without taking a side in the question of the dating of the earliest extant works, the oeuvre would be arranged as follows: the Albi

Detail, cat. 17

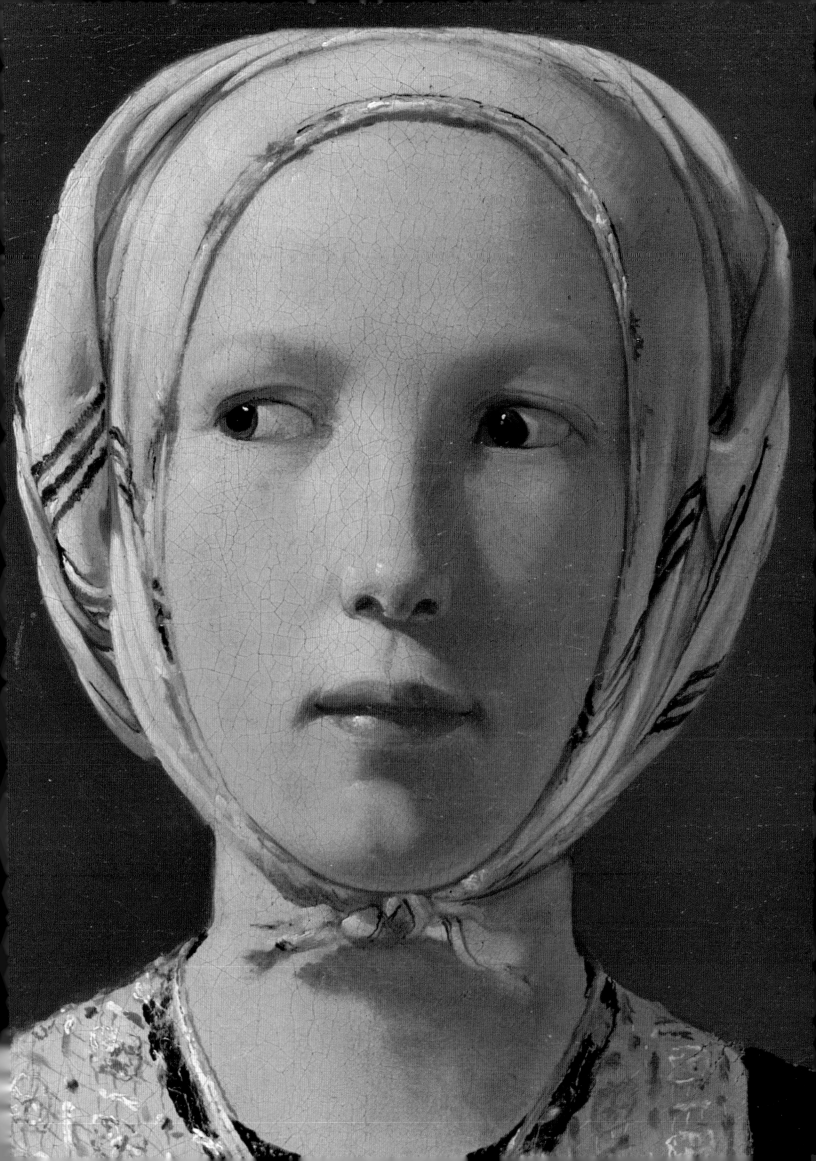

Apostles (cats. 6–8), *The Musicians' Brawl* (cat. 9), *Old Peasant Couple Eating* (cat. 4), *The Hurdy-Gurdy Player* in Nantes (cat. 11), then *The Payment of Taxes* (cat. 1), *Old Man* and *Old Woman* (cats. 2 and 3), followed by the two versions of *Saint Jerome* (cats. 14 and 15), *The Cheat with the Ace of Clubs* (cat. 18), *The Cheat with the Ace of Diamonds* (cat. 19), *Job and His Wife*, *The Fortune-Teller* (cat. 17), and *Saint Thomas* (cat. 13); only slightly later would be the *Saint Sebastian* in a horizontal format of which the original is now lost (but see cat. 16), *The Flea Catcher* (cat. 20), *Christ with Saint Joseph in the Carpenter's Shop* and *The Dream of Saint Joseph* (Conisbee figs. 75 and 76), *The Hurdy-Gurdy Player* in the Prado (cat. 12), the *Magdalene* paintings (see cats. 21–23); slightly later would be *The Adoration of the Shepherds* (Conisbee fig. 75), *Saint Peter Repentant* (dated 1645; cat. 24), followed shortly by *The Newborn Child* (cat. 27) and *The Education of the Virgin* (original version lost, but see cat. 29); finally would follow the *Saint Sebastian Tended by Irene* (Conisbee fig. 78), the newly discovered *Saint John the Baptist in the Wilderness* (cat. 31), and works probably executed by La Tour in collaboration with his son Etienne, *The Denial of Saint Peter* (Conisbee fig. 81) and *The Dice Players* (cat. 32).

It is clear that this debate revolves around the very notion of Caravaggism. La Tour was not a Caravaggist for most of his career. It would be more accurate to say that he masqueraded as one (a "gentleman disguised by Caravaggism," as Roberto Longhi put it in 1935), making admirable use of the various styles of sixteenth-century northern European art, which he in turn applied to particular themes that had been "launched" by the Caravaggists. The refinement underlying the brutality found in the majority of his works, if I may be permitted to make such a claim, seems more the ultimate manifestation of the traditional world of northern painters than the discovery of Caravaggism. The echoes of this Italian phenomenon that Honthorst or ter Brugghen brought back to Utrecht or that Le Clerc brought back to Lorraine would have been sufficient to familiarize La Tour with it, thereby negating the need for a trip to Italy. To be sure, certain scenes illuminated by candlelight that established Honthorst's reputation, such as his *Christ before Caiaphas* (National Gallery, London) or his *Saint Joseph* (Convent of Montecompatri), or those by his imitators such as the "Candlelight Master," Trophime Bigot, and others,[26] correspond rather closely to Roman creations, and their relationship with the nocturnal scenes of La Tour would seem to be a direct, even intimate one. But were there not numerous pictures by Honthorst, Gerard Seghers, and their imitators, in Lorraine, in the north, and in Paris, that would have been accessible to Georges de La Tour?

Nevertheless we are confronted with the fact that La Tour seems to have changed his style in his final works: yet another mystery associated with this artist who remains so enigmatic. Was this transformation an attempt to expand his style, or focus it? It seems to me that it was an attempt to simplify it, liberating it from the burden of excessive realism. In doing so, La Tour was drawing closer to the very essence of Caravaggio, a process that in and of itself did not require him to travel to Rome in the middle of his career in order to come into contact with that artist's work. Already in *The Newborn Child* a new, more refined style is apparent: in the curvilinear and affected drawing as well as in the overall delicacy and finesse. We could almost call this late style an "Ingresque Caravaggism" to best describe the large *Saint Sebastian Tended by Irene* in the Louvre and the *Saint John the Baptist in the Wilderness*, a recent addition to La Tour's oeuvre — a picture without color, imbued with a haunting silence, representing an emotional inwardness upon which night is about to fall. It was only at the end of his career, and not before, that La Tour "met" Caravaggio.

Notes

1. Thuillier 1992, 26.

2. "It is 'reasonable to assume' such a voyage" (Paris 1973, 38 44).

3. See Sterling 1983, esp. 111–116.

4. See Blunt 1972, 516–525; Nicolson and Wright 1974, esp. 16–17, and 27, figs. 8–13, and 44–45.

5. The parallel with the Louvre picture was noted by Michel Laclotte in Nicolson and Wright 1974, 16 n. 4 and 60 n. 6.

6. See, most notably, Foucart 1978, 53–62. Jan van de Venne painted several versions of hurdy-gurdy players (Kunsthistorisches Museum, Vienna; Museum Bredius, The Hague) markedly similar to those painted by La Tour, although the technique is more brilliant and the characterization more anecdotal. Foucart rightly insists upon the affinity of the two artists' styles and does not exclude the possibility that La Tour could have seen paintings by the Flemish artist.

7. In the upper left of this picture (oak panel, 30 x 42 cm) is an inscription in small capital letters, *Petrus Brueghel F*, that was added posthumously. Pigler 1967, 1:103–104, attributes this work to a "Follower of Pieter Brueghel the Elder, second half of the sixteenth century." Susanne Urbach, preparing a catalogue of the Szépmüvészeti Múzeum's northern paintings through 1600, considers it to be a sixteenth-century Flemish or German work. We would like to thank Agnes Szigethi, curator of the Szépmüvészeti Múzeum, for her valuable assistance regarding this picture.

8. Nicolson and Wright 1974, 16, fig. 9.

9. For *The Card Players* (wood panel, 282 x 412 cm) see Pigler 1967, 378–379 n. 7, where the attribution is "School of Lucas van Leyden." We should also mention *The Fortune-Teller* in the Louvre, Paris, and *The Card Players* in the Fundación Colección, Thyssen-Bornemisza, Madrid, which have been frequently cited for their similarity to the compositions by La Tour.

10. See Friedlander 1973, nos. 124 and 126, pls. 98 and 99.

11. See Friedlander 1973, no. 131, pl. 103 (as Lucas van Leyden), as well as supp. pl. 125, for the striking *Saint Paul* (Yale University Art Gallery, New Haven), with clear silhouettes that have a certain affinity with La Tour's work.

12. *The Game of Backgammon* (wood panel, 32.5 x 39 cm) sold at Bohler in Munich, 9 June 1937. Another version of lesser quality sold at Christie's in London, 26 October 1990 (no. 144, as Lucas van Leyden, *A Young Boor Playing Backgammon in a Brothel*). A third version of even poorer quality (wood panel, 48 x 62 cm) sold at the Hôtel Drouot in Paris, 5 June 1967 (no. 33, attributed to the Monogrammist of Brunswick, *The Game of Tric-trac*). This last picture is mentioned in Foucart 1978, 62 n. 63, which notes its similarity to La Tour's *Payment of Taxes*. The very existence of three versions of this composition demonstrates that it was well known.

13. Nicolson compares the Lviv picture with the *Payment of Taxes* by Jan Metsys (Gemäldegalerie, Dresden) and mentions analogous subjects by Marinus (Nicolson and Wright 1974, 16,

14. See Amsterdam 1986, 201–202, no. 76.

15. The painting came with other works of Venetian provenance from the "Ferdinandeische Schenkung" to the gallery of the Vienna Academy, under the name of Dürer (von Lützow 1889, 80), and was subsequently attributed to Hans Weiditz. It was returned to Italy, with the other works of Venetian provenance, in 1919. Its present location is unknown. I would like to thank Renate Trnek, director of the Gemäldegalerie of the Vienna Academy, for her help. In another Dürer – this one undisputably by his hand – namely the splendid *Saint Eustache* from the Paumgartner retable (Alte Pinakothek, Munich), the red-robed figure, viewed against a black background, is firmly placed on a ground strewn with pebbles in a manner that is comparable to that in the two *Saint Jerome* paintings by La Tour. See also the famous *Christ among the Doctors* (Fundación Colección, Thyssen-Bornemisza, Madrid), with its crowded composition, play of gestures, fine detailing in the faces of the elderly characters, and the old man with the bald head and long white beard in the foreground at the right.

16. Pariset 1948, 226, fig. 1, pl. 29; Nicolson and Wright 1974, 23, fig. 38.

17. Foucart-Walter 1982, 130–132, figs. 5, 5bis, and 6.

18. The series, *Mimicarum aliquot facetiarum icones ad habitum italicum expressi*, by Bellange and engraved by Crispin de Passe, shows half-length figures, which, as Thuillier 1992, 61–62, figs. on 64–65, points out, would seem very important for establishing the milieu in which La Tour was formed.

19. See Blunt 1972, 519 nn. 12 and 15, fig. 4. Kellog Smith 1979, 288–294, closely analyzes the theme of scenes from farces and comedies with regard to the *Old Man* and *Old Woman*.

20. Pariset 1948, pl. 48, figs. 8 and 10; Blunt 1972, 521, 524, figs. 9 and 12; Nicolson and Wright 1974, 25, fig. 42. See also Pariset, 1963, 3:118–141, pls. XLII–XLVIII.

21. For the "Lagneau" drawings see the precisely documented notice by Dominique Cordellier in Paris 1984–1985, 22–23, no. 17. For my fig. 15 see Grieten 1989, no. 12. The drawing illustrated as my fig. 16 was in the 1971 exhibition at the Galerie Claude Aubry, Paris (no. 60), where it was shown under the title "Portrait de Marie Vernier ou Lavernier, femme Laporte, actrice du théâtre du Marais."

22. Thuillier 1992, 24, fig. 25.

23. There were numerous genre scenes in Parisian collections in the seventeenth and early eighteenth centuries. See Wildenstein 1950, esp. 208–224, and Wildenstein 1951, 11–343.

24. Thuillier 1992, 287–288, nos. 37 and 30, proposes an early date of c. 1638–1639 for the *Saint Sebastian*, which is not far from *The Cheat with the Ace of Diamonds*, which "may in fact be contemporary with the first great surviving nocturnes."

25. Paris 1973, 39.

26. I have already expressed my conviction that the personalities of the "Candlelight Master" and Trophime Bigot should be distinguished in Cuzin 1979, 301–305.

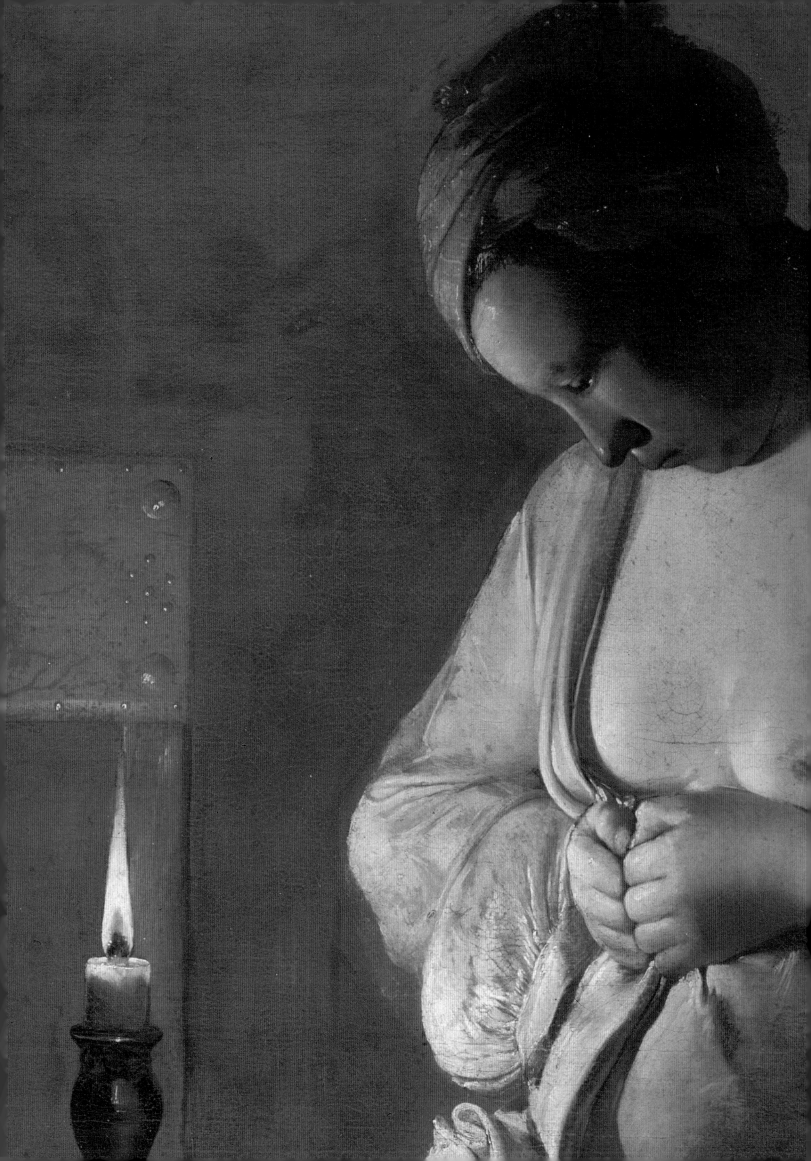

*Georges de La Tour
and the Netherlandish
Followers of Caravaggio*

LEONARD J. SLATKES

A lack of reliable documentation concerning Georges de La Tour's travels has allowed scholars unusual leeway in their speculations concerning voyages the artist might have taken and their presumed dates. Predictably, this has become a contentious area of La Tour scholarship, for, naturally enough, it has been linked to the presence of outside – that is to say non-French – influences on the work of the great Lorrainese painter. Although Pariset's monumental 1948 monograph treated the problem with remarkable balance,[1] recent scholarship has tended to follow national lines. French and Italian writers, including Pariset, have preferred to see La Tour drinking deeply from the stylistic sources of Caravaggism

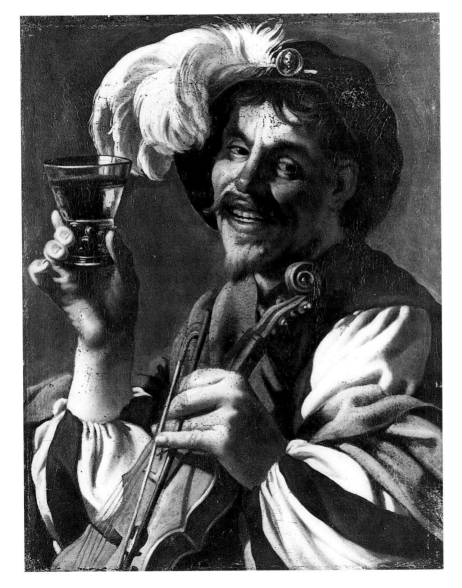

1. Follower of Hendrick ter Brugghen, *Violinist with a Glass*, c. 1627, private collection, Europe

during an early voyage to Rome, while English-speaking scholars on both sides of the Atlantic have called attention to aspects of the artist's works that suggest a trip, or trips, to the Netherlands. Given the complete lack of documentation for any voyage outside France, we must try to coax from La Tour's paintings, still the most viable if not exactly the most forthcoming source available, whatever pertinent information they may provide.

I should declare at the outset – since the title of this essay and the language in which it is written will be categorized by French and Italian scholars as yet another example of what they seem to regard as a peculiarly Anglo-Saxon attitude – that my support for one or more La Tour visits to the Netherlands in no way precludes the likelihood that he also traveled to Italy, probably sometime before 1616. Indeed it is reasonable to assume that it was in Rome that he first met the Dutch and Flemish followers of Caravaggio whose influence has been detected in his pictures. Later he seems to have renewed these associations during relatively short visits to, among other places, Antwerp and Utrecht.[2]

It would make methodological sense to open any discussion of La Tour's travels with his earliest certain works. We are frustrated in this by a lack of scholarly agreement as to which pictures represent his starting point. Rather than blaming this awkward situation on a lack of scholarly sensitivity, it seems more reasonable to suggest that, like that of his Dutch contemporary, Hendrick ter Brugghen – who returned to Utrecht from Rome in 1614 – La Tour's artistic evolution was neither simple nor straightforward but alternated between the revolutionary art he had seen in Rome and the requisites of conservative taste and patronage at home. Significantly, the most direct non-French influence one can identify in La Tour's work is his appropriation of a figure from ter Brugghen (fig. 1).[3] Transformed, but still recognizable, the quoted figure is the violinist on the far right of the Getty *Musicians' Brawl* (cat. 9). With his Burgundian style costume and striped sleeves, one of the hallmarks of Utrecht Caravaggism, La Tour's borrowed musician seems almost out of place among the rough company in the Getty picture.

2. Adriaen Pietersz van de Venne, *All'arm*, 1621, Amsterdam Historisch Museum

to say after 1627.[7] Despite this important chronological indication, some scholars still argue for a date at the very beginning of La Tour's career.[8] Their contention that La Tour was making use of a common Caravaggesque type rather than quoting ter Brugghen misses the point; not only is the visual relationship unmistakable but it is only in Utrecht during the 1620s, with Gerrit van Honthorst, ter Brugghen, and Dirck van Baburen, that this specific musical type is developed.[9]

La Tour's quotation from ter Brugghen lends support for the likelihood that Netherlandish art also contributed to La Tour's approach to the subject matter of the Getty painting. This not to minimize the influence of the Lorrainese graphic artist Jacques Bellange, but merely to call attention to the fact that the wholly negative view of such blind beggars has been a part of Netherlandish art since the early sixteenth century[10] and was still used by the Dutch polemical painter and illustrator Adriaen van de Venne around 1620. A 1621 grisaille painting by van de Venne (fig. 2), inscribed with the punning title *All-arm* – literally "utterly poor," but without the hyphen "attack"[11] – parallels La Tour's attitude and even includes a lamenting old woman, rare in representations of this theme.[12]

It is also possible to relate the Getty painting, in its compact, half-length composition, to several important Caravaggesque works, starting with Caravaggio's own *Capture of Christ* of 1602, the recently discovered prime version of which is now in Dublin.[13] This picture was of some importance to Caravaggio's followers in Rome, for both Bartolomeo Manfredi and Baburen were influenced by it.[14] Significantly, Manfredi's interpretation of the painting soon made its way to the north, and although it has not been possible to ascertain exactly when or from what source, it entered the Antwerp collection of Archduke Leopold Wilhelm, where it is depicted in David Tenier's painting *The Gallery of Leopold Wilhelm*, in Munich,[15] and various printed editions of the *Theatrum Pictorium*.[16] What makes this situation especially intriguing is that Leopold Wilhelm owned La Tour's lost *Saint Peter*, perhaps the picture purchased from the artist by Duke Henri II of Lorraine shortly

Originally an engraving after a lost ter Brugghen painting was proposed as La Tour's source,[4] but it was necessary to reverse the print to make it appear in the same sense as the figure in the Getty picture. The reason given was that it did not require the authors to argue that La Tour took "a second journey to Utrecht in the late 1620s, although he might have made one."[5] More recently, several workshop versions and period copies of the lost ter Brugghen have turned up, revealing that the original composition had indeed been reversed, as is often the case with prints after paintings.[6] This is of some importance, for it confirms not only that La Tour knew the original composition but that *The Musicians' Brawl* must be dated later than the ter Brugghen, which is

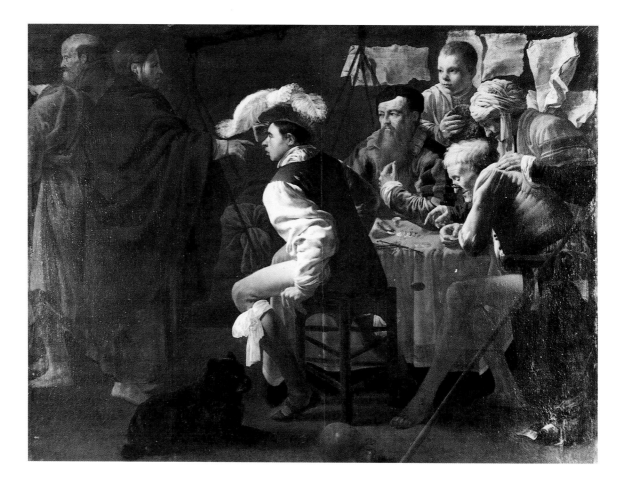

3. Hendrick ter Brugghen, *The Calling of Saint Matthew*, c. 1619, Musée des Beaux-Arts André Malraux, Le Havre

before his death in 1624. This is not to minimize the possible influence on La Tour of such works as ter Brugghen's half-length *Calling of Saint Matthew* of 1621,[17] but to call attention to the fact that the formal structure of the Getty picture may be seen as a genre paraphrase of a Caravaggesque *Capture of Christ*.[18]

More difficult to place in La Tour's development, or explain with French prototypes or Italian Caravaggesque models, is his *Payment of Taxes* in Lviv (cat. 1).[19] In significant aspects of its formal structure this unusual picture, with its crowded, tilted space, flickering artificial illumination, and crisscrossed diagonals reinforced by stark shadow patterns,[20] may be compared to such early sixteenth-century Netherlandish paintings as Jan Cornelisz Vermeyen's *Marriage at Cana* (Cuzin fig. 9)[21] or to elements in ter Brugghen's *Calling of Saint Matthew* of c. 1619 (fig. 3).[22] Ter Brugghen's archaistic rendering of the tax collectors accompanying Saint Matthew is deeply indebted to scenes of tax-paying peasants by such sixteenth-century Netherlandish artists

as Quentin and Jan Metsys as well as Marinus van Reymerswael and his circle.[23] These same Netherlandish artists have been cited as among the sources of the archaizing aspects of La Tour's picture.[24]

It is also of some significance for our understanding of the Lviv picture that between 1615 and 1621 Pieter Brueghel the Younger, the son of the great sixteenth-century Netherlandish artist, executed no fewer than thirty-eight pictures, all more or less in the manner of his father, with themes similar to that of the Lviv painting.[25] That sixteenth-century style pictures and subjects were still being executed well into the seventeenth century clearly indicates that conservative patronage in the Spanish southern Netherlands still wanted traditional themes in an old-fashioned style long after Peter Paul Rubens had returned from Italy to revolutionize Antwerp painting. The situation could not have been very different in Lorraine or Utrecht. In Utrecht a Caravaggesque critical mass was achieved during the summer of 1620, when Honthorst and Baburen re-

4. Claes Jansz Visscher, engraving after Pieter Feddes, *Grace before a Meal*, c. 1615, Rijksprentenkabinett, Amsterdam

turned from Rome to join ter Brugghen. In Lorraine the return of Jacques Callot to Nancy in 1622, and Jean Le Clerc about the same time, seems to have similarly shifted the artistic balance. Nevertheless, ter Brugghen, as late as 1625 – the year he painted his *Saint Sebastian Tended by Irene* (cat. 39) – also produced his most archaizing work, the Metropolitan Museum *Crucifixion*, apparently to satisfy a special commission.[26] Given this situation, there seems to be little reason to resist a relatively late dating of the Lviv painting, probably after 1638,[27] and accept it as an archaizing exercise, perhaps to fulfill some specific commission.

More than twenty-five years ago, before La Tour's *Old Peasant Couple Eating* (cat. 4) came to light, Fritz Grossmann noted that the artist's pendant pair, *Old Man* and *Old Woman* (cats. 2 and 3), was similar "in spirit, though not in subject matter," to Jacques De Gheyn III's popular print of c. 1620 known in Dutch as the *Vreedsamich paer*, the *Peaceable Couple*.[28] With the discovery of the *Old Peasant Couple Eating*, now in Berlin, in which the spirit and the subject matter are indeed related to De Gheyn's print, Grossmann's astute comment requires amplification. Even closer

to the Berlin picture is the work that was De Gheyn's source, a c. 1615 engraving, *Grace before a Meal*, by Claes Jansz Visscher after Pieter Feddes (fig. 4). Not only is the austere, iconic placement of the two figures in the Berlin composition close to the Feddes print, but the all-pervasive sense of a solemn, even a pious moment has been captured by La Tour in this deceptively simple painting. Ferdinando Bologna, who first published the picture, noted that its greater relevance "resides in the solidarity of the two characters who take part in it, binding them together as though they were involved in the rites and ceremonies of prayer."[29] There are, significantly, several seventeenth-century Dutch paintings with similar themes, although the most pertinent of these date later than La Tour's.[30] Nevertheless, it does suggest that an early trip to the Netherlands could have introduced La Tour to new themes as they were emerging in the Dutch republic, themes that were virtually unknown in Lorraine, France, or even Italy.

Despite the pious demeanor of the old couple that La Tour depicted, the Berlin painting has consistently been related to Italian works of kitchen humor such as Annibale Carracci's *Bean Eater*[31] and Vincenzo Campi's raucous *Fish Market*,[32] pictures that differ from La Tour's in every possible way. The lone French example sometimes cited, an odd painting in Warsaw with an uncertain attribution to Georges Lallemant,[33] is also hardly an acceptable prototype. With its festive costume, caricaturelike expression, and gesticulating secondary figures, the Warsaw work could not be further removed from the serious intentions of La Tour's picture.

Other La Tour pictures, part of the series of Christ and the Twelve Apostles, reveal influences from Utrecht Caravaggism in a variety of ways. Although we lack prime versions for the entire series, old copies of most, in the Musée Toulouse-Lautrec, Albi, have allowed for the identification of lost pictures as they turned up. Recent scholarship has tried to situate surviving originals at the beginning of La Tour's career,[34] although Pariset dated them quite late, c. 1640.[35] In 1972, however, Rosenberg and Thuillier assigned three of the pictures a more acceptable date of c. 1625.[36]

5 and 6. Hendrick ter
Brugghen, *Saint Matthew*
and *Saint Luke*, 1621,
Gemeente Deventer

Several surviving originals from La Tour's Apostles series are conspicuous in their novel characterization of the saints and in the way they depart from previous depictions of Apostles, evangelists, and saints. Only in ter Brugghen's innovative 1621 series the Four Evangelists (figs. 5 and 6), do we find a similar inventiveness. Additionally, La Tour's *Saint Andrew* (see Conisbee fig. 33),[37] the original of which recently reappeared, adopts a popular Utrecht genre motif – a large book placed over a foreshortened forearm so that it hangs down on either side – found in a 1622 picture of a singer by Baburen (fig. 7).[38] As ter Brugghen and Baburen shared an Utrecht workshop,[39] this stylistic confluence suggests that La Tour had contact with both artists in Utrecht.[40] Thus his visit must have taken place no earlier than 1622, the date of Baburen's *Singer*.[41]

One of the more successful motifs that La Tour adapted from ter Brugghen's Four Evangelists appears in two closely related works, the *Saint Paul Reading* from his Apostles series[42] and the *Saint Jerome Reading* (Conisbee fig. 60). La Tour's saints, like ter Brugghen's *Saint Luke* (fig. 6), although positioned frontally, are represented completely engaged in reading from a sheet of paper that, like ter Brugghen's propped-up book, forms a physical and a psychological barrier that intensifies the solitary aspects of the act. What makes this arrangement unusual is that it subverts the usual associations of a frontal pose, normally one of contact, and turns it inward.

Although not in perfect condition, the treatment of the saint's face in the *Saint Jerome Reading*, especially the rendering of the deep wrinkles of his brow and the manner in which his gnarled, expressive hand holds the spectacles, is virtually unthinkable without the example of ter Brugghen. Similar elements are exhibited by La Tour's even more unconventional *Saint Thomas* (cat. 8). Like ter Brugghen's *Saint Matthew* (fig. 5), La Tour contrasted the deep and crinkly wrinkles of the Apostle's brow with his smooth, sharply illuminated, bald pate, which is accented by a delicate fringe of hair rendered with feathery brush strokes. As is often the case in ter Brugghen, La Tour provides his *Saint Thomas* with

7. Dirck van Baburen, *Singer*, 1622, Das Gleimhaus, Halberstadt

ern Caravaggism has not received the attention it deserves. Certainly, La Tour and ter Brugghen should be numbered among the great exponents of what can be seen as a notable stylistic development in the north, coloristic Caravaggism. Indeed both artists are linked by their uncommon palette, in which subtle variations of cool reds frequently predominate, and by the way color in the daylight scenes is exploited by a cool raking light. In Italy coloristic Caravaggism developed out of the work of Orazio Gentileschi, Caravaggio's most subtle and independent follower. To Gentileschi's Tuscan transformation of Caravaggio's north Italian color and light, La Tour, like ter Brugghen,[46] adds a northern taste for unusual color relationships, as in, for example, the two *Cheat* paintings and *The Fortune-Teller*. In the Louvre *Cheat with the Ace of Diamonds*, and to a somewhat lesser extent the Kimbell *Cheat*, La Tour's division of the radiant red of the woman's skirt into individual shapes glimpsed between hands and arms is analogous to the way ter Brugghen fragmented Christ's scarlet robe behind the legs of a tormentor in the 1620 *Christ Crowned with Thorns*,[47] or the way he broke up the dazzling red of the table covering with the legs and stool of one of Matthew's accomplices in the *Calling of Saint Matthew* (fig. 3).[48]

Although Caravaggio popularized gambling scenes with his early *Cardsharps* (cat. 41), it is important to remember that the theme had significant forerunners in the Netherlands during the sixteenth century, most notably in the work of Lucas van Leyden.[49] It is likely that these early northern depictions account for the quick popularity and rapid spread of all types of Caravaggesque gaming scenes in both the Spanish Netherlands and the Dutch republic during the first part of the seventeenth century. In Utrecht, Baburen and ter Brugghen produced important, updated versions of Caravaggio's picture with strong moralizing overtones (see cats. 36 and 38). In one element, however, La Tour's related pictures depart from those by Utrecht artists and Caravaggio: costume. Ter Brugghen and Baburen typically use old-fashioned, Burgundian style costume as a distancing device to underscore the moral implications of their pictures. In contrast, La Tour used

wonderfully expressive gestures that serve as a means of conveying internalized emotions.[43]

The two autograph versions of *The Cheat* (cats. 18 and 19) and *The Fortune-Teller* (cat. 17) reunited with its pendant reveal La Tour's further elaborations on ter Brugghen's gestural strategies. The way hands are grouped around the straw-covered flask in the cardplaying scenes and the even more telling gestures of the old gypsy, her beautiful thieving accomplice, and their hapless victim in the *Fortune-Teller* are unthinkable without the expressive hands and gestural devices developed by ter Brugghen and Baburen.[44] Additionally, La Tour's rendering of his cheat with a shadowed face – surely a negative signifier in this context – updates a motif used by ter Brugghen in his *Transverse Fluteplayer* of 1621.[45]

The role of color in the development of north-

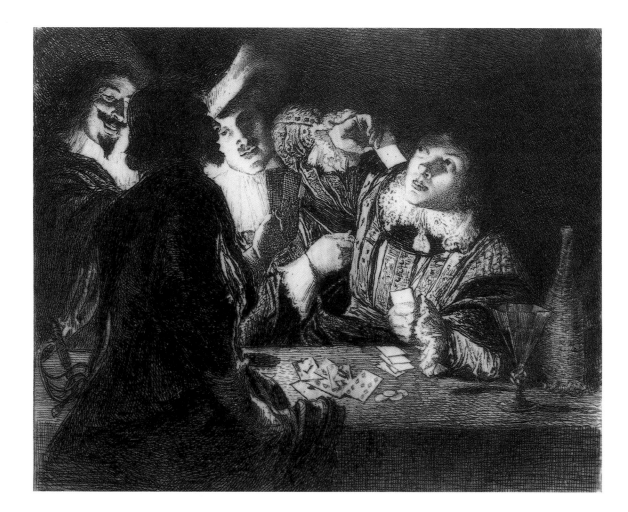

a more contemporary garment, albeit an unusually elaborate, finely embroidered one for his young victim. In this aspect there are striking parallels between the costume found in a print after a lost candlelight cardplaying scene by the Antwerp painter Adam de Coster (fig. 8).[50] Although de Coster's works are difficult to date, the fact he entered the Antwerp guild as early as 1607–1608 numbers him among the earliest exponents of Caravaggism in the Spanish Netherlands.[51] It is also significant that elaborate costumes comparable to those used by La Tour are also found in the fortune-telling scenes of another, somewhat later Antwerp artist, Jan Cossiers.[52]

By now it should come as no surprise to discover that one of La Tour's most unusual works, *The Flea Catcher* in Nancy (cat. 20), has not only been assigned divergent dates but also conflicting interpretations.[53] Again, there is a rift between English-speaking schol-

ars,[54] who date this disconcerting picture in the middle 1630s, and the Francophone position, which places it in the 1640s.[55] More perplexing, however, is how, in complete disregard for art historical common sense, discerning scholars, English- and French-speaking alike, could invoke the erotic background of the flea hunt in Utrecht art and European literature to explain this picture.[56] An objective viewing of La Tour's un-erotic – perhaps even anti-erotic – female, alone and self-involved, should disabuse the viewer of any notion that the picture could ever have been tainted by a prurient purpose or an erotic subtext. Certainly the monumentality of her form and the single-mindedness with which she goes about her task remove any possibility that La Tour conceived of his work either as a parody or a depiction of a popular erotic literary trope.[57] The literary lover's lighthearted desire to live as a flea on his beloved's

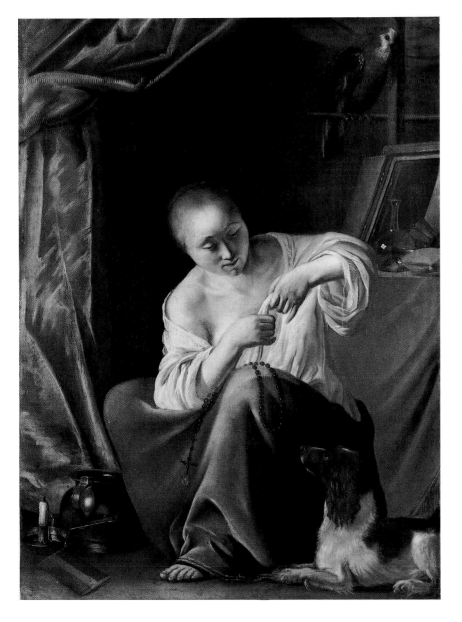

9. Paulus Bor(?), *Young Woman Searching for Fleas*, Museum Bredius, The Hague

various toilet articles. Clearly the cleansing of the body and the soul is linked. Hélène Adhémar, in a provocative article in 1972, suggested that not only was the woman in La Tour's *Flea Catcher* pregnant but she was reciting the rosary, not crushing a flea, as indicated by the position of her hands. In support, Adhémar reproduced a photograph showing a woman's hands in a strikingly similar position while the woman was saying the rosary.[59] Given La Tour's overall sensitivity to gestures and their meaning, not to mention the Bredius Museum painting, it has become more difficult to ignore Adhémar's thesis.[60] Interestingly, her belief that there is a relationship between the painting's subject and the 1624 founding in Nancy of the order of Notre-Dame du Refuge by Marie Elisabeth de Ranfanig has found some acceptance.[61] This order, sanctioned by Urban VIII in 1635, was charged with taking women from the streets who wished to reform. It is thus of significance for our understanding the aspects of this work still in contention: its meaning and its date. The 1635 papal authorization supports the likelihood that La Tour's *Flea Catcher* would have been commissioned at the moment there was strong local interest in the new order, which would favor a date of around 1635, as suggested by Blunt and Nicolson. In the light of the Bredius Museum picture, it has also become more likely that La Tour's woman is reciting the rosary. Perhaps La Tour intentionally conflated the two activities by compounding the gestures, thus suggesting the cleansing of the body and the soul.[62]

During the 1630s La Tour shifted some of his external artistic interests to Antwerp and the work of such painters as Gerard Seghers and Adam de Coster. At least one Seghers painting, a lost *Penitent Magdalene* (fig. 10),[63] has already been suggested as a possible influence on several of La Tour's best known works, his nocturnal depictions of the repentant Magdalene (cats. 21, 22, and 23).[64] Thus it is of more than passing interest that at least two Seghers paintings could have been known to La Tour in Lorraine since they have the same provenance – through various branches of the ducal house of Lorraine – as La Tour's *Payment of Taxes*. They are *Soldiers Playing Cards* and a picture described as "soldiers playing

body could not be further from La Tour's intentions in this painting.

It has escaped notice that there is a painting (fig. 9) with a parallel theme, said to be by or after the Dutch Caravaggesque artist and architect Jacob van Campen, but perhaps closer to his Amersfoort contemporary Paulus Bor, which can help us understand La Tour's *Flea Catcher*.[58] This picture depicts a full-length seated woman hunting for fleas in her garment. The secondary elements, however, make the meaning of the Dutch picture clear. Indeed the woman has a large rosary over one knee, while in the foreground is a dog, traditionally a symbol of faith, and

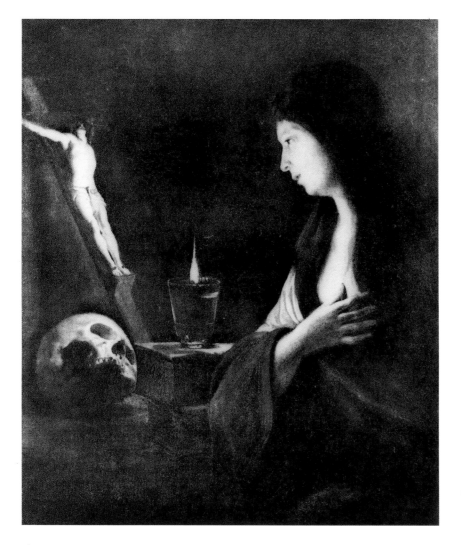

10. Gerard Seghers,
Penitent Magdalene, c. 1625,
location unknown

cards and Saint Peter," certainly a Denial of Saint Peter.[65] Unfortunately, as no sizes are provided and the inventory descriptions are too generic, it is not possible to identify either work with any certainty. The latter could have been one of many variants of Seghers' important nocturnal rendering of this theme, the best known of which is the full-length picture in Raleigh, North Carolina.[66]

Two nocturnal paintings, one by Seghers and the other by ter Brugghen, can be specifically compared with several of La Tour's repentant Magdalene compositions. Seghers' *Penitent Magdalene*, now untraceable, is so close to La Tour's *Magdalene with the Smoking Flame* (cat. 23) in a number of elements that it was once actually assigned to the Lorrainese artist.[67] Like La Tour, Seghers includes a large oil glass with a floating wick as his light source and renders the Magdalene with her profile so subtly turned from the viewer that it cannot be truly termed a lost profile. La Tour's *Magdalene at the Mirror* (cat. 22), with its dramatic artificial illumination, and a light source blocked by a skull in typical Utrecht fashion, offers an image and an attitude reminiscent of one of ter Brugghen's most sophisticated mature works, *Mary Magdalene as Melancholy* (fig. 11).[68] Furthermore, the title of the ter Brugghen might equally be applied to any of La Tour's *Magdalene* paintings, had they, like the former, only included some specific symbol, like the pair of dividers, traditionally associated with melancholia. Aside from their thematic relationship, several of La Tour's *Magdalene* pictures, notably the one in the Metropolitan Museum,[69] make use of an unusual stylistic feature found only in ter Brugghen. In several of ter Brugghen's paintings from around 1625, notably the *Saint Sebastian Tended by Irene* (cat. 39), the artist rendered fingers, limbs, and other areas with translucent highlights and an alabasterlike firmness of form. Did La Tour come in contact with ter Brugghen's *Saint Sebastian* or other comparable works during the 1630s? Since the ter Brugghen was recorded in an Amsterdam collection until 1668, that would imply another trip to the Netherlands. Perhaps when La Tour turned to the theme of *Saint Sebastian Tended by Irene* in the middle 1630s,[70] most likely the composition pre-

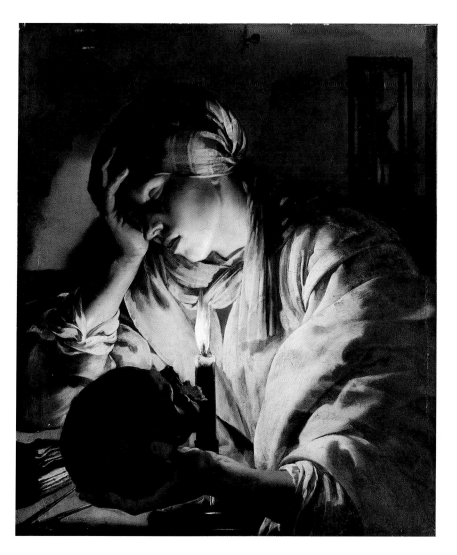

11. Hendrick ter Brugghen, *Mary Magdalene as Melancholy*, c. 1627, Art Gallery of Ontario, Toronto

served in the Kimbell canvas (cat. 16), he was reminded of ter Brugghen's striking use of comparable effects in the earlier *Saint Sebastian*. Whatever the exact path or source, the device proved an effective way of enhancing the simpler, more geometricized forms that make their appearance in La Tour's work during the 1630s.

Two La Tour genre pictures from the second half of the 1640s, *Boy Blowing on a Firebrand* (cat. 30) and *Girl Blowing on a Brazier* (Conisbee fig. 82),[71] can be directly related to Utrecht developments and ter Brugghen. Although both themes can also be associated with works by Jacopo and Francesco Bassano[72] and El Greco's Roman period *Boy Blowing on a Firebrand*,[73] La Tour's treatment of these subjects is dependent specifically on the transformation that took place in Utrecht during the early 1620s. Honthorst's undated *Boy Blowing on a Firebrand* may have introduced the motif in the north,[74] but it was ter Brugghen's *Boy Lighting a Pipe* of 1623 (fig. 12) – perhaps the first painting entirely devoted to tobacco smoking – that provided the theme with its Dutch orientation, the white clay pipe.[75] Given La Tour's ongoing interest in ter Brugghen, it is likely that he once again turned to a familiar source and reinterpreted and updated a typical Utrecht subject. Support for this derivation can be found in the picture that could even be a pendant to La Tour's *Boy Blowing on a Firebrand*: namely, the *Girl Blowing on a Brazier*.[76] Ter Brugghen was the only other artist before La Tour to paint a female version of this popular northern Caravaggesque type.[77]

Although there are a number of other significant relationships we could draw between the late La Tour – Georges with his son and follower Etienne – and Dutch and Flemish Caravaggism, one last example will serve. The candlelight composition entitled *A Young Singer*, with versions in the Leicestershire Museum and Art Gallery (fig. 13),[78] and Adolphseck (Fulda), Schloss Fasanerie,[79] variously assigned to La Tour and his son, is strikingly similar to a much-copied work by Adam de Coster.[80] Although none of the known versions of de Coster's *Young Boy Singing* appears to be completely autograph, all of them faithfully record his style; see the unrecorded

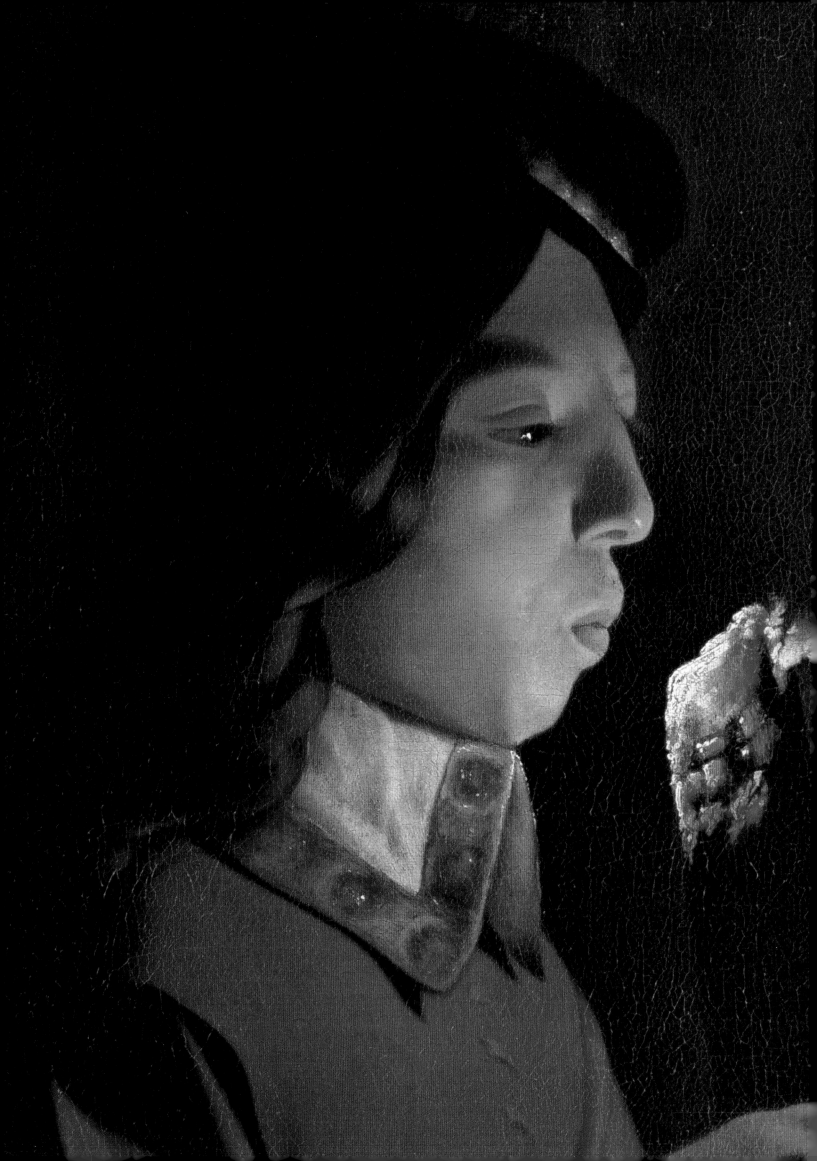

12. Hendrick ter Brugghen, *Boy Lighting a Pipe*, 1623, Dobó István Vármùseum, Eger

13. Georges de La Tour, *A Young Singer*, Leicester Museum and Art Gallery

14. After Adam de Coster, *Boy Singing by Candlelight*, Patrick and Beatrice Haggerty Museum of Art, Marquette University, Milwaukee

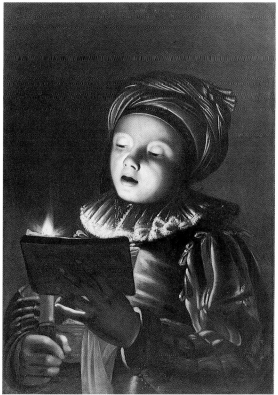

canvas in the Haggerty Museum, Marquette University, in Milwaukee (fig. 14).[81] That de Coster should prove attractive to the late La Tour and his son is hardly surprising, given the Antwerp artist's simplified forms and strong nocturnal effects. Although not nearly as sophisticated as La Tour, de Coster must have provided the young Etienne with another source of inspiration when he grew weary of looking over his father's shoulder. Indeed it is in exactly those late works assigned to La Tour that Etienne's hand has also been discerned – *The Denial of Saint Peter* (Conisbee fig. 81)[82] and *The Dice Players* (cat. 32) – that the influence of de Coster appears the strongest. This is to be expected: only in places like Antwerp could one still find a few northern Caravaggesque painters practicing their now all but defunct Caravaggesque style.

Notes

Some of the research used for this essay was supported by a grant from the Research Foundation of the City University of New York.

1. Pariset 1948.

2. At least one La Tour painting appeared in an old Dutch sale: *Tribute Money*, canvas, 105.4 x 133.6 cm, unfortunately no longer traceable. See Jansen 1992, 48, in the sale of Jonas Witsen, Amsterdam, 16 August 1790 [Lugt 4620], no. 67.

3. Ter Brugghen's *Violinist with a Glass* is oil on canvas, 75 x 59.5 cm. This unpublished picture was in a European private collection in 1987.

4. Nicolson 1958b, no. D88. The print is inscribed *H. Terbrug. pinx / T. Matham sculp.*

5. Nicolson and Wright 1971, 670. The quote is from Nicolson and Wright 1974, 27.

6. There is an old copy, canvas, 105 x 87 cm, in the Musée des Beaux-Arts et d'Archéologie, Boulogne-sur-mer. The composition seems to have had some popularity in eighteenth-century France, although I have found no evidence that any of the painted versions was in France in the eighteenth century or earlier. The Matham print, however, was copied in a drawing attributed to François Watteau (see Marcus 1976, 25, fig. LXIX).

7. The closest parallel is with another ter Brugghen painting of the same subject, *Violinist with a Glass*, one version of which is dated 1627 (see Nicolson 1960b, 466). The engraving itself supports a date of c. 1626–1627. There are two very similar prints by Matham after another Utrecht artist, Gerrit van Honthorst, with short texts by P. Scriverius. One, *Man with a Violin and Glass* (Hollstein 252, no. 39), is dated 1627. The other, also after Honthorst, *Girl Playing a Violin* (Hollstein 252, no. 41), is dated 1626. These works are similar in source, composition, moralizing subscript, and graphic means. The original used for Hollstein no. 39 has survived and is signed and dated 1624 (see Judson 1959, 66 n. 2, and no. 162).

8. Rosenberg and Thuillier 1972, no. 8; and Thuillier 1993, 64–66. Nicolson and Wright 1971, 670, dates the picture 1625–1630.

9. Rosenberg and Thuillier 1972, 135–136.

10. See Hollstein 201, no. 133, *Fight between Beggars and Beggar-women*, a signed and 1539 dated engraving by Cornelis Massys, which, like the Getty picture, includes a woman.

11. Sterkenburg 1977, 10.

12. Later, van de Venne gathered a number of related depictions of beggars together under the title used for the Rijksmuseum panel, "Al-arm," and used them in his book *Tafereel van de Belacchende Werelt endes selfs geluckige Eeuwe* (The Hague, 1635) (see Royalton-Kisch 1988, 88–90).

13. Benedetti 1993, 731–745.

14. For the Baburen see Slatkes 1965, 110–112, no. A7, and fig. 11.

15. Cremona 1987, 39.

16. Cremona 1987, 40. As it appears in reproductions, the picture has a landscape setting that opens the space of the composition in a way unknown in any other Manfredi composition. Could this be a later addition? For a comparable landscape addition in the work of ter Brugghen see Kuiper 1971, 117–135, 139.

17. See Utrecht/Braunschweig 1986, 90–92, no. 5, illus. in color.

18. Blunt and Grossmann called attention to a painting that depicts a group of blind beggar-musicians fighting, attributed to an unknown sixteenth-century Netherlandish artist possibly under the influence of Pieter Bruegel the Elder (see Conisbee fig. 40). Blunt 1972, 519, fig. 5, rejected the old attribution as a copy of a lost Bruegel and assigned it to a follower of the great Netherlandish artist. Grossmann 1973, 580, 581 n. 30, as school of Malines. Marlier 1969, 362–363, fig. 224, suggests that the Basel composition is based on a lost work by Pieter Bruegel the Elder and relates it, in certain stylistic elements, to the work of Pieter Brueghel III. If Marlier is correct, then the Basel painting could date well into the first quarter of the seventeenth century, closer in time to the Getty picture.

19. The English translation of Thuillier 1993, 117, uses the title *The Payment of Dues*.

20. Blunt 1972, 523, was the first to emphasize the mannerist characteristics of the Lviv picture, relating it to Joachim Wtewael's *Adoration of the Shepherds* in Vienna. Thuillier 1993, 117, agrees and cites both the Wtewael and a 1604 *Adoration of the Shepherds* by Abraham Bloemaert in Göttingen. For the Wtewael composition see Lowenthal 1986, no. B8, fig. 142; also no. A83, fig. 116, for the prime version of the same composition in the Musée Magnin, Dijon; and the workshop version in Vienna cited by Blunt and Thuillier. Significantly, Lowenthal dates the Dijon version, and thus also the Vienna repetition, with its false signature and date, between 1620 and 1625.

21. See Kloek 1989, 174–175, fig. 12 (illus. in color); and Horn 1989, 1:23–24, and 2: pl. 4. As with La Tour's picture, there has been some confusion concerning Vermeyen's subject matter, and it has also been identified as *Christ in the House of Mary and Martha*; for a summary of the problem see Amsterdam 1986, 201–202, no. 76. It may also be of significance that Vermeyen was from Malines, a city whose artists had a tradition of using artificial illumination. It was also the hometown of Adam de Coster, another painter who influenced various nocturnal works by La Tour.

22. Nicolson 1958b, no. A36; and Utrecht/Braunschweig 1986, no. 4.

23. See Utrecht/Braunschweig 1986, 92, under no. 5, fig. 70, for Marinus van Roemersvaele's *Tax Collector* (Cuzin fig. 8).

24. Nicolson and Wright 1974, 15–17.

25. Marlier 1969, 435–440; these works are variously entitled *L'Avocat des Paysans*, *Le Percepteur d'impôts*, *L'Avocat des mauvaises causes*, and *L'Etude de notaire*.

26. Wrocht/Braunschweig 1986, no. 21.

27. *The Payment of Taxes* has had an unusually broad spectrum of dates even for La Tour. Nicolson and Wright 1974, 15–17, calls it La Tour's earliest work, c. 1615–1616. Rosenberg and Mojana 1992, 86, no. 28, suggests a date of after 1638 but proposes that it may repeat an undocumented, lost, earlier composition. Thuillier 1993, 285, no. 23, places the work early in his chronological catalogue, between the *Old Man* and *Old Woman* and the *Old Peasant Couple Eating*.

28. Grossmann 1973, 579. For the attribution of the print to Jacques De Gheyn III after a drawing by his father see Amsterdam 1993, 611–612, no. 283.

29. F. Bologna 1975, 437.

30. See, for example, the painting of an *Elderly Couple Saying Grace* attributed to Abraham van Dyck, in a New York private collection, illus. in Franits 1993, 166, fig. 143.

31. F. Bologna 1975, 440; and Thuillier 1993, 72–73, illus. in color.

32. F. Bologna 1975, 440. See Cremona 1985, no. 1.20.15, 207–209 (illus. in color).

33. Thuillier 1993, 72–73, as by Georges Lallemant. According to Thuillier, who calls this work *Georges and the Bowl of Broth* (see Conisbee fig. 14), the subject was inspired by a popular French farce. Bassani 1993, 521, no. R74, rejects the attribution to Claude Vignon and considers it a copy after Lallemant.

34. Thuillier 1993, 282–283, places them first in his chronological catalogue, and they are the first works discussed in his text.

35. Pariset 1948, 232, 300.

36. Three originals from the series were in the 1972 Orangerie exhibition: *Saint James the Less*, *Saint Judas Thaddeus*, and *Saint Philip* (nos. 4, 5, and 6), later than the *Old Man* and *Old Woman*, which were the first two works in the catalogue (the date is given on p. 128). Rosenberg and Mojana 1992, 20, 22, 24, dates several works from the series 1620–1625. Although frequently overlooked in relation to La Tour, other important Apostles series were executed in Antwerp, including those by such renowned artists as Peter Paul Rubens, Anthony van Dyck, and Gerard Seghers. Thuillier 1993, 282, cites only the series by El Greco and Zurbarán among those by non-French artists, and the graphic suites by Bellange and Callot. Callot's series, however, is dated 1631, later than La Tour's. Both French printmakers use elegant, full-length figures that are physically and formally unrelated to La Tour's series. Thuillier's best comparisons – the half-length chiaroscuro woodcuts by Ludwig Büsinck after Lallemant (illus. 48, 49, 58) – were published after the La Tour Apostles were completed. Büsinck's *Saint James the Less* is dated, in the block, 1625 (see Strauss 1973, 160, no. 80). This crudely cut series – the small reproductions in Thuillier are

misleading as to quality – was printed in Paris and was influenced by Hendrick Goltzius; it is reproduced in color in Strauss 1973, nos. 77–91.

37. Thuillier 1993, 285, no. 6, rejects the designation "Saint Bartholomew" and lists the work as "Saint Thomas." Rosenberg and Mojana 1992, 20, no. 4, keeps "Saint Bartholomew."

38. For Baburen's *Singer* see Slatkes 1965, no. A14, fig. 33, noting two workshop repetitions of this composition, unsigned but both dated 1623; also no. D9, fig. 49, for the same motif in a closely related *Singer* by the unidentified follower of Baburen and ter Brugghen to whom I have assigned the name "Master of the Cassel Musicians." The motif also appears in Honthorst's 1622 *Musical Ceiling*, in the Getty Museum, suggesting that it became popular in Utrecht at just this moment.

39. Slatkes 1965, 94–98.

40. As the Four Evangelists series remained with ter Brugghen's family, La Tour would have had to have met the artist in Utrecht to see it. For the early provenance of ter Brugghen's series see Utrecht/Braunschweig 1986, 93–98, nos. 6–9.

41. Blunt 1950, 145, suggested that the *Saint Jerome Reading* (Conisbee fig. 60) dates soon after what the author supposed to be a visit to the Netherlands in the early 1620s.

42. The original is lost, but there is a copy at Albi (see Rosenberg and Mojana 1992, 136, 5A; and Thuillier 1993, 282–283, no. 3).

43. Nicolson and Wright 1974, 24.

44. See ter Brugghen's *Incredulity of Saint Thomas*, in the Rijksmuseum, Amsterdam, and Baburen's *The Young Christ among the Doctors*, in Oslo (Utrecht/Braunschweig 1986, nos. 12 and 34).

45. Utrecht/Braunschweig 1986, no. 11. A similar shadowed face is found in Vermeyen's *Marriage at Cana* (Cuzin fig. 9).

46. See ter Brugghen's 1621 *Calling of Saint Matthew* in Utrecht (Utrecht/Braunschweig 1986, no. 5).

47. Utrecht/Braunschweig 1986, no. 3.

48. Utrecht/Braunschweig 1986, no. 4.

49. Blunt 1972, 520, denies, incorrectly in this case, the influence of northern Caravaggesque art on these La Tour compositions.

50. An etching by Lalauze appeared in the auction catalogue of the collection of Comte de Pourtales, sold at Hôtel Drouot (Paris, 29 March 1886, no. 170, canvas, 98 x 122 cm), incorrectly as Honthorst.

51. Given its compositional relationship to Honthorst's candlelight *Procuress* (Centraal Museum, Utrecht), signed and dated 1625, the de Coster should probably date slightly later. For the Honthorst see Utrecht/Braunschweig 1986, no. 66, illus. 299. There are several painted versions of the de Coster composition, none, in my opinion, autograph.

52. See, for example, Cossiers' *Fortune-Teller* in Munich (Nicolson 1979, fig. 100).

53. Although the vermin in these various paintings and erotic

literary works has always been identified as a flea, it is in reality a louse. Fleas live on animals, lice on humans. The seventeenth century, however, seems to have made no distinction between the two and called them all fleas.

54. Blunt 1972, 523, suggested a tentative date in the mid-1630s; Nicolson and Wright 1974, 196, no. 60, as c. 1635.

55. Rosenberg and Macé de l'Epinay 1973, 152, no. 52, as slightly before 1644; and Rosenberg and Mojana 1992, 78, no. 26, as c. 1640. Thuillier 1993, 292, no. 59, places the picture immediately after the 1645 *Saint Peter Repentant* (cat. 24).

56. Nicolson and Wright 1974, 27, 31, and fig. 55, cites Honthorst's versions of this theme, dated 1621(?) and 1625. There are variants of this composition, with and without the snickering bystanders who watch the old procuress hunt for fleas on a half nude, smiling young prostitute. There are also half-length, upright depictions by Honthorst, or more likely his workshop, with only the old procuress and the young prostitute (see Nicolson 1989, figs. 1249 and 1254). Blunt 1972, 523, discusses the allegorical, literary significance of fleas, as does Wind 1978, 121–122. Thuillier 1993, 196, notes the erotic literary aspects of the theme by citing *The Flea of Madame Desroches* published by Etienne Pasquier in 1583.

57. See Wilson 1971, 297–301; and Brumble 1973, 147–154.

58. The painting does not appear in the recent catalogue raisonné of van Campen's work; see Quentin Buvelot in Amsterdam 1995, 105–119, who includes a list of lost works known only through prints, copies, and archival references. The van Campen association was made in Blankert 1980, 39, no. 29, as after Jacob van Campen. Blankert cites several opinions concerning the subject and the attribution, including one by Georges Keyes, who suggested the name Paulus Bor. J. Foucart's opinion that the figure might represent Mary Magdalene is also noted, although the way the woman is depicted, and the secondary attributes, seems to make that identification unlikely. In the light of the recent Jacob van Campen exhibition and catalogue, I must withdraw my earlier acceptance of the attribution of the Bredius picture to van Campen in favor of a tentative assignment to Bor (see Slatkes 1981–1982, 176).

59. Adhémar 1972, 219–222, esp. 220 and 221. The photograph of hands with a rosary is fig. 5.

60. Thuillier 1993, 196, rejects the possibility both that the figure is reciting the rosary and that she is pregnant.

61. See Rosenberg and Mojana 1992, 78, no. 26. The authors, however, believe that it is of secondary importance if the woman is reciting the rosary or killing a flea.

62. Choné 1992, 86–87, notes contemporary texts where the flea and the used candle were "deux symboles de la servitude avilissante et miséable."

63. The Seghers composition is preserved only in a mezzotint by Jean Baptiste Massard (see Bieneck 1992, no. A3, with the subscript "Gerard Segers Pinx"). Bieneck dates the lost painting before 1620, and others have also placed it in Seghers' Italian period (see Roggen and Pauwels 1955, 273, 275–277, and fig.

4). Nevertheless, a date between 1620 and 1625 is also possible.

64. Zolotov 1974, 61.

65. Zolotov 1974, 62–63. Perhaps the *Denial of Saint Peter* is Bieneck 1992, no. A17, formerly in the collection Rouge, Mâcon, present location unknown. This possibility is strengthened by the formal relationship of this work to the 1650 Nantes La Tour of the same subject. The *Soldiers Playing Cards* might be Bieneck 1992, no. A18, *Cardplayers*, sold at Dorotheum (Vienna, 13–16 September 1960, no. 112), fig. 14, present location unknown.

66. Bieneck 1992, no. A16.

67. The Seghers picture was sold at Gallery Fischer (Lucerne, 21–25 and 27 June 1960, no. 2055) as Georges de La Tour. The attribution to Seghers, apparently overlooked by Bieneck, was proposed in Nicolson 1989, 1, 174.

68. See Utrecht/Braunschweig 1986, 146–148, no. 25 (illus. in color).

69. Thuillier 1993, 159.

70. As is often the case in La Tour scholarship, there is no consensus concerning the date. Most scholars do, however, place the picture in the 1630s. For a summary of the situation see Thuillier 1993, 288, no. 37. Thuillier himself prefers a date of 1638–1639.

71. Thuillier 1993, 234, and no. 73; Rosenberg and Mojana 1992, 118, no. 41. The picture is in an American private collection.

72. See *Boy Blowing on a Firebrand*, formerly on the New York art market (Fort Worth 1993, 142, 143–144, and fig. 63).

73. See Thuillier 1993, 172.

74. Judson 1959, no. 161, fig. 16, dates the work (private collection, Brussels), c. 1620. The same subject was painted by Adam de Coster, unfortunately also undated. It is possible, however, that the de Coster versions are earlier than Honthorst's, given the fact that Rubens also used the motif as early as 1616–1617. For the de Coster see Nicolson 1989, 1, 101, and fig. 1592; for Rubens see Jaffé 1989, 228, no. 429B.

75. Utrecht/Braunschweig 1986, no. 13.

76. Rosenberg and Mojana 1992, 118, no. 41; and Thuillier 1993, 294, no. 73.

77. The ter Brugghen picture, untraceable, was sold at Dorotheum (Vienna, 3 December 1959, no. 52) as Honthorst. See Nicolson 1960b, 466, fig. 3, where the work is dated to 1623–1624. I would date it slightly later, c. 1626. This picture and the Eger *Boy Lighting a Pipe* both had pendants. Given the other relationships with ter Brugghen, this could support a pendant relationship between the two La Tour compositions.

78. See Thuillier 1993, 236, 295, no. 80 (illus. in color). Rosenberg and Mojana 1992, 131, no. 46, dates the picture between 1640 and 1650.

79. This version appears only in the French edition of Rosenberg and Mojana, where it replaces the Leicestershire picture as no. 46. The authors suggest that the Adolphseck picture is a

fragment of a larger composition, perhaps a Nativity scene, although they provide no physical evidence in support. Given the fact that the Leicestershire composition is the same as the Adolphseck picture, it seems highly unlikely that both would have been cut down in exactly the same way. Although the Adolphseck picture is known to me only in reproduction, it seems of slightly higher quality than that of the painting in Leicestershire. That the two works are independent compositions rather than fragments is supported by their close relationship to similar compositions by Adam de Coster.

80. Nicolson 1989, 1, 100, lists four versions of the *Singer* but not the one in Milwaukee.

81. Close to La Tour and de Coster is another half-length *Boy Holding a Candle*, with A. J. Seligmann in Paris in 1936, as Georges de La Tour. A variant of the Seligmann picture, with a different costume and hat, appeared in a Sotheby's New York sale, 6 December 1980, no. 45, illus. as Lorraine school.

82. See Thuillier 1993, 228–233; and Rosenberg and Mojana 1992, 123, no. 43.

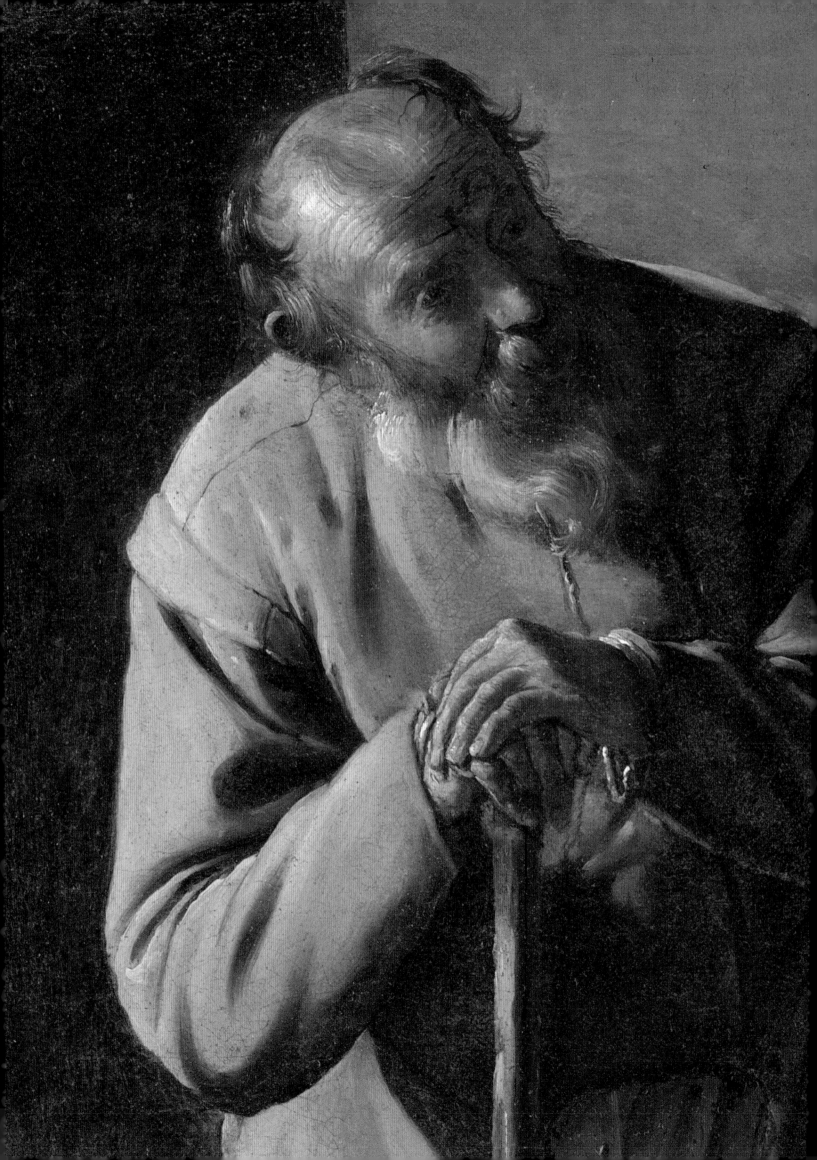

*Lorraine in the
Time of
Georges de La Tour*

PATRICIA BEHRE MISKIMIN

It is one of the ironies of history that human creativity, particularly in the plastic and literary arts, often takes place in periods of the most intense turmoil and disorder. Germanic Europe, among the most divided and divisive regions of the Continent in the fifteenth and sixteenth centuries, spawned some of the greatest artists and thinkers of that age. France produced the Enlightenment on the eve of the Revolution, as much in response to a lack of freedom of thought as to any opportunity offered by the authoritarian Bourbons. Even Italy, in its so-called Renaissance, was a strange, fragmented collection of states, led not by the strong single ruler so longed for by Machiavelli but by a mottled collection of warring families and their unreliable *condottieri*. In fact, as an observer of history, one might well ask whether there is not something particularly inspiring about chaos. Whether travail does not impel men to think of the world as it might be and to picture their hopes, more than their observations, in great works of art and writing. Whether, when the world seems least controllable, the compulsion to control the canvas or the page becomes most urgent. If this premise can be accepted, even given the exceptions that might qualify it, it should perhaps not be surprising to find Georges de La Tour painting in the Lorraine of the early seventeenth century.

A once-prosperous and still-proud region, ruled at least in name by the independent dukes of Lorraine, La Tour's home was beset by the most intense vicissitudes of the age. Lying in the northeast corner of current-day France, along the ragged seam separating it from what was then the Holy Roman Empire, Lorraine and its people became unavoidably embroiled in the political, social, and religious crises of the day. In many ways, the place and times were uniquely right to produce La Tour or some artist like him, one who could apply new techniques and sensibilities to the task of preserving key elements of the world that had been.

By the time of Georges de La Tour's birth in 1593, Lorraine was already a region more accustomed to warfare than to peace. And its various towns and villages were caught in a state of flux, with some still controlled directly by the dukes of Lorraine, some more closely influenced by the Holy Roman Emperors, and some, since 1552, under the protection of the kings of France. Several industries of the area, including ironworks, the production of armaments, and the livestock trade, reflected this bellicose reality. Located in a fertile region, with ample water for agriculture and transport, the Lorrainese also participated in the production of glass and salt, the latter an essential commodity for preserving food before refrigeration. In fact, the remaining prosperity of the dukes of Lorraine in the early seventeenth century owed much to their ability to control the salt marshes and the production of salt in the region. Ducal lands produced, by one estimate, between eight and nine thousand tons of salt annually, and this allowed the dukes largely to set prices and dominate the market in salt.[1]

Of course, many in the duchy held more mundane occupations. Like most Europeans at the end of the sixteenth century, the majority of Lorrainese were farmers, in this case growing grapes and other crops in the gently rolling hills for their own and others' use. In the region's major cities — the ducal capital Nancy, Lunéville, Toul, and nearby independent Metz — inhabitants engaged in the usual menu of daily pursuits as tradesmen, shopkeepers, and artisans, filling the stomachs of their children by filling the needs of their neighbors. Records from these urban areas reveal the variety and tempo of town life. Cobblers, butchers, nail makers, and tailors coexisted with the town's more notable citizens, the wealthier merchants, local officials, clergy, and occasional hangers-on at the duke of Lorraine's court.

Particularly in the countryside, but even in these cities, early modern life was lived far more communally than today. Inhabitants depended more obviously on each other for their daily needs and fashioned their identities from their more proximate relationship to each other. A bread maker's daughter in Toul would probably marry the son of another baker known to her family through her father's *corps de métier*. The couple, like their parents, would regularly join neighbors in their nearby church for Mass

and certainly for special holidays (for the vast majority of Lorrainese remained Catholic throughout this period). Children would be born at home, with minimal privacy, pulled into the world by midwives known in the community. And godparents would probably be chosen from among the same circle of professional friends and neighbors. Market days lured town residents to a central square to buy and sell goods, to gossip, fight, flirt, and scrutinize the clothing and customs of their neighbors. Religious processions took place throughout the year and brought the opportunity not only for public devotion but for diversion and entertainment as well. Birth, marriage, death, all were experienced "in the streets," as it were, in open association with one's fellows.

This was, then, a corporate society with the full range of corporate realities, including, ironically, a host of man-made barriers delineating the boundaries that predetermined daily life and made it comprehensible. Townspeople and rural folk lived in a world of more constant association but also of clearer stratification than is apparent today, of less social mobility, and perhaps, most importantly, less veneration or even awareness of individual action for individual gain. Perhaps precisely because of the intense proximity and communality of life in the early modern period, men created, accepted, and even clung to their own rigid divisions between different groups.

What were the various strata in Lorrainese towns in this century? The answer is not as clear as scholars seeking understanding might like. Although there was indeed a hierarchy, made up in broadest terms of the nobility and clergy, a trade and merchant class in the middle, and the urban and rural poor, there were also subtler gradations known only to those alive at the time. Looking closely at one Lorrainese city, the historian Guy Cabourdin systematically described the various castes in the community. While his outline is not precisely valid for all towns in the region, it does serve as a rough blueprint for most of Lorraine and France.[2]

Exempting for now the clergy, there was first the nobility, made up of several subgroups. The ancient *chevalerie*, or old-line nobility, held their feudal claims

to privilege from a source so distant that virtually no one could remember its origin. Along with a second rank of nobility of almost equivalent pedigree, these families owned extensive land in the countryside and drew their income from the rent of that land, and, in areas controlled by France, they were exempt from major taxes. They usually were entitled to a portion of their resident peasants' crop yields and as owners of rural mills they reaped profits there as well (peasants were usually required by custom to grind their grain at the lords' mills). Provoking awe and fear, as well as hostility, the great lords usually held hunting rights on their lands even to the disruption of peasant agriculture, were subject to having their property confiscated only if convicted of treason, and enjoyed a variety of other privileges, formal and informal.[3] In exchange for these extensive advantages, nobles did contend with, if not exactly suffer, several restrictions. They were not free to enter professions or engage in trade without losing their claim to nobility. In times of inflation, which haunted the sixteenth and early seventeenth centuries, this was a real disadvantage.[4] Land rents in this period were not quickly responsive to economic shifts. The payment or portion of crop yields due from a farming peasant to his noble landlord was customarily set for a lifetime. Those pursuits that might produce an income that could grow with inflation were forbidden to nobles, again by custom; at once weaker and stronger a constraint than any modern statute. Thus many nobles, including dukes, emperors, and kings, were watching their real wealth decline. Many of their activities, both economic and military, grew from their urgent efforts to reverse this trend.

Another important group within the nobility by La Tour's time was a growing cadre of newly ennobled families who owed their claims to special letters provided by the duke of Lorraine or the king of France, often in exchange for a price. These parvenus were called robe nobility in France to distinguish them from the older feudal sword nobility whose pedigrees stemmed from their ancient military function. And the increase in their numbers throughout the late sixteenth through eighteenth

centuries shocked and appalled several contemporary commentators.[5] Many older noble families were dying out or "daughtering out," a crude description of the harsh realities of rank and gender. Auguste Digot estimated that in the Middle Ages 291 families composed the ancient *chevalerie* of Lorraine. By the late sixteenth century their numbers had greatly diminished.[6]

The wave of new elevations was seen by older nobles as a sign of societal decline, and many complained that the *nouveaux*, who were in many cases wealthier than the blue bloods, were secretly engaging in trade and commerce, conducting themselves improperly, or misunderstanding the duties of their rank.[7] But from the point of view of princes, including the dukes of Lorraine, this new nobility brought real advantages: a hedge for them against inflation and, even more important, a tribe of loyal followers more reliable than the often independent-minded ancient nobles. No one is more devoted, it was proven, than a man under an obligation. The sale of noble titles was not exclusive to Lorraine or even to France. England's newly minted baronets produced much the same consternation in roughly the same period. In France, though, the creation of a new robe nobility helped the kings extend their absolute power in the seventeenth and eighteenth centuries while slowly and perniciously eroding the tax base, contributing to the economic crisis that ultimately produced the Revolution.

Georges de La Tour did not belong to even this lesser, newer group of nobles. But he aspired to this station. Some Lorrainese artists were ennobled by the dukes. Claude Deruet is a good example: ennobled by Henri II in 1621, he was portrayed two years later in all his swaggering glory by his friend Jacques Callot (fig. 1). La Tour was born to people most aptly described as comfortable bourgeois, working as tradesmen but diversifying their wealth and buying land and procuring rents as they could.[8] By marrying well, they attained economic status commensurate with upward social mobility (Georges' mother was a *veuve aisée*, a well-off widow, before his parents wed). Georges, of course, continued this climb, first by marrying Diane Le Nerf, the daugh-

ter of a recently ennobled family, and later through the fame of his art and the newly growing sense that artists were more than craftsmen and deserved special regard. This was a critical period in Lorraine: an age that was redefining the role of the artist in society much as the Renaissance period had begun to do earlier. Artists were beginning to be ennobled for their own sakes. Georges did obtain some tax relief during his lifetime, largely because of his wife's status, but it was not until the lifetime of his son that the family attained true heritable ennoblement.[9] Their social contacts, however, were drawn from the robe nobility that made up Diane's family orbit and that of the courtiers to the duke of Lorraine. At court, where Georges worked and found some of his patrons, he could essentially live the life of a robe noble. Thus for La Tour, and for others, the divisions within the nobility were more fluid than modern observers

might assume. Even wealthier members of the middle class could aspire to some elevation.

This middle class comprised the largest and most diverse group in Lorrainese society. It included fairly wealthy individuals like La Tour or even more prosperous merchants, perhaps with hopes of advancement. It included middling tradesmen, with the means to own their own businesses if not to expect contact with courtiers. And it included those, from printers to philosophers, increasingly likely to be literate and to draw sustenance and inspiration from the new ideas that literacy brought them.[10] Historians of this region in this age typically spend less time writing about an undifferentiated middle class than about groups within that category, especially the upper echelon of "notables": families of some wealth and civic standing whose influence was often substantial and growing. These were the men who typically participated in local government, held local office, and, by virtue of their place in their professions, set the tenor of daily life. Pillars of the community, they were entitled to march not at the head of holiday processions, but surely not far back.[11] One generally held a place in this group through inobvious attributes – longevity of one's family in the community or an often inscrutable willingness of one's neighbors to accept one as such – and by strictly obvious ones – wealth, the procurement of civic office, marriage into the right family. Cabourdin noted that in Toul the principal office holders in the local bureaucracy were usually notable businessmen, merchants, and tradesmen, as well as, on occasion, men of letters and robe nobles. The last held the higher and more costly, more remunerative offices.[12] A wealthy merchant's name might appear in written records (parish registers, civil court cases, probate proceedings) with the title *honorable homme*, presumably reflecting the term contemporaries would have used to describe him. Those lesser residents, in the trades, would more likely have been referred to as simply *honnêtes hommes*. A hierarchy existed even among these tradesmen. A draper with enough money (for example, the means to purchase a house), might attain the title *honorable homme*. But at all levels, formal and informal, definitions abounded. Ac-

cording to Cabourdin, it was the subtle and connected interplay between wealth and access to power that determined one's place in the society: "An undefined boundary thus separated men, even of the same profession."[13]

The critical elements to note about this complex reality are limited to a few points worth reiterating. First, early modern society was highly stratified. But individuals understood their places not according to written placards or official titles so much as through the treatment they expected and received from neighbors. In this sense, their identities were formed not unlike those of current-day men and women. Second, specific visible rights and obligations and assumed behaviors were attached to each rank. This was far more obvious and strictly observed than in any modern society. Third, there was some room for movement and change, certainly across generations. Then, as now, wealth could always propel one upward. Finally and most important, a great widespread assault on customary rankings was already under way by the late 1500s. Whether through artificial royal or ducal manipulation of the nobility, or through more gradual changes wrought by economic and intellectual forces (such as those associated with the Reformation and Counter-Reformation), an upending of the most basic definitions in Lorrainese life was developing during Georges de La Tour's lifetime.

Rural life, even more than that in the towns, was still intensely dominated by customs and traditions that bound villagers together, for good or for ill. French farming practices, so comparatively backward and inefficient, appalled the English traveler Arthur Young as late as the eighteenth century. While English yeomen experimented with new inventions and new crops to replenish the soil and allow winter foddering of animals, Lorrainese peasants were still scratching at the earth with hand tools and living or dying at the mercy of each year's weather. It was not, of course, that all peasants were poor, for some built up fortunes large enough to warrant writing wills and to allow buying land to rent out to other peasants.[14] But virtually all rural denizens still lived lives of remarkable vulnerability. A good harvest

one year might preserve one's family that winter only to be followed by an excessively dry spring and summer that brought famine the next. And with famine came death. Malnourished women produced sickly or stillborn infants or died themselves in childbirth. Malnourished children developed crippling or disfiguring diseases or simply died well-shy of adulthood. Malnourished men and their families fell prey to sporadic waves of disease, their immunity eroded by hunger. Hence bubonic plague might still strike, particularly in the summer, though far less pervasively than in the infamous medieval outbreaks. Influenza might easily kill, especially in the winter. Epidemics produced notable ill effects in Lorraine in 1574, 1585, 1587, 1594, and 1597, for example.[15]

Step-families were common. And sudden crises of disease or accident were sufficiently likely and inexplicable to lend credence to notions of an omnipotent and avenging God, or the efforts of a potent local witch. Belief in witches was on the wane in cities during Georges' lifetime, but it hung on in the countryside with ample testimony to its validity. A cow might suddenly go dry or a husband impotent; how else to explain such an event except by supernatural evil or divine retribution? And how else to cure it but by charms, potions, or prayers? More than in the rapidly changing cities, rural areas in seventeenth-century Lorraine were known for holding fast to their folklore and their piety, the two expressions related in their insistence on the daily manipulation of the natural world by supernatural forces.[16] A directly intervening God still toyed with men's and women's lives in rural villages. A village wise woman might similarly cure or harm through her contacts with that God's evil analogue, the Devil.

But just as life in Lorraine's cities was changing, so changes were coming, if more slowly, to the countryside as well. The most immediate cause of rapid change to both spheres came through the extraordinary events of war and its effects.

The Thirty Years' War (roughly 1618–1648) was a struggle among the major powers of Europe for preeminence in the western portion of the continent.

Spain, France, the Netherlands, Denmark, Sweden, and England all participated, either directly or indirectly. It was fought largely on German soil and therefore devastated that region most dramatically.

The two critical preconditions for this war as it affected Lorraine were fragmentation in the Holy Roman Empire and the voracious political and military ambitions of Spain and France. The Spanish Habsburgs, under Philip III in 1618, wanted easier access by land to the commercial centers of Germany. This region was controlled by the Austrian branch of the same family, but so loosely that the opportunity for political turmoil was great. Individual areas of the so-called Empire were autonomously held by local princes, bishops, dukes, and assorted feudal nobles, each with a desire to protect his economic and political interests. The French under Louis XIII wanted at all costs to prevent Spanish success, which would have surrounded them on three sides with Habsburgs at a moment when royal desires inclined toward consolidation and even expansion of the kingdom. In this age of inflation, monarchs, with their land-based wealth (and with new, more expensive military technology developing), were eager to increase revenues. It was not a time likely to breed pacifism. It was still an age of deep antagonism between Catholics and Protestants and among the different Protestant sects. And still, to some extent, an age certain that there could be only one true religion. If it took mortal combat to preserve it, so be it. Catholics and Protestants generally shared this intractable view. Religious pluralism was slowly becoming a fact of life in Europe, but no one intended to abide it in any particular region. Hence, when Europeans and European monarchs could least afford the economic hardship of going to war, they could least resist the temptation to do so.

Strife between Catholics, Lutherans, and Calvinists in the Empire during the early seventeenth century opened the way for outside interference. When Germans split over two claimants to the imperial throne (the Catholic Ferdinand II and the Protestant Frederick V), Spain rushed in with troops to aid the Catholic cause. France confined itself primarily

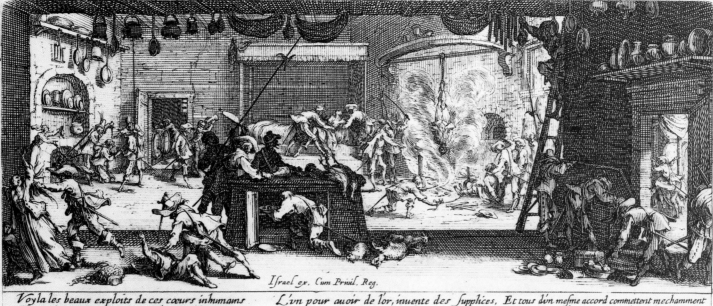

Voyla les beaux exploits de ces cœurs inhumains
Ils rauagent par tout rien nechappe a leur mains

L'vn pour auoir de l'or, inuente des supplices,
L'autre à mil forfaicts anime ses complices;

Et tous d'vn mesme accord commettent mechamment
Le vol, le rapt, le meurtre, et le violement. 5

Israel ex. Cum Priuil. Reg.

2. Jacques Callot,
*Plundering a Large
Farmhouse*, c. 1633,
National Gallery of Art,
Washington, R. L.
Baumfeld Collection

to investing money in the early stages of the war, but incongruously to the aid of Protestant participants such as Denmark and Sweden.

Catholic France's willingness to bankroll Protestants and then, by 1635, to send troops openly against Catholic Spain was only the most obvious sign of the religious complexities of this conflict. The Protestant mercenary Albrecht of Wallenstein, in the service of the Catholic emperor, marched against the Lutheran Danes, then considered offers to switch his allegiance back to the Protestants before he was eventually assassinated by his patrons. In France the most overtly pro-Protestant policy was pushed by Jean Armand du Plessis de Richelieu, cardinal of the Catholic Church. It is no wonder that many historians consider the Thirty Years' War the last great religious battle in early modern Europe as well as a pivotal event on the road to modernity. What began as a religious crusade for many participants revealed itself increasingly clearly over three decades as a contest for wealth and dominance. By the time the Treaty of Westphalia ended open warfare in the Empire in 1648, the map of Europe was redrawn, Germany was laid waste, with its population reduced by roughly thirty percent, and France was the dominant power on the Continent. More important, the

disillusionment that began in the sixteenth century was even more widespread. The earlier view of the *politiques* in France, that religion was perhaps too volatile a force to dominate political life, was gaining ground in Europe as a whole. Thus this war, ignited and stoked by religious fervor, ironically contributed to the trend toward secularization that already concerned some of the pious, and that would ultimately find expression in the intellectual movement known as the Enlightenment.

In Lorraine the Thirty Years' War exaggerated certain features of daily life and dramatically changed others. Historians generally use the war as a marker for the beginning of serious financial and political decline there. In rural areas peasants' typical vulnerability intensified with the presence of soldiers who lived off of the land and stole food indiscriminately. Victims of pillage and violence, tillers of the fields often fled their homes, causing widespread disruption of agriculture that ultimately affected cities as well. The soldiers of this war were particularly destructive. By some estimates, farming in neighboring Germany did not recover for almost a century. A well-known seventeenth-century novel based on the events of the war, *Simplicius Simplicissimus*, recounts the brutal victimization of a fanciful Can-

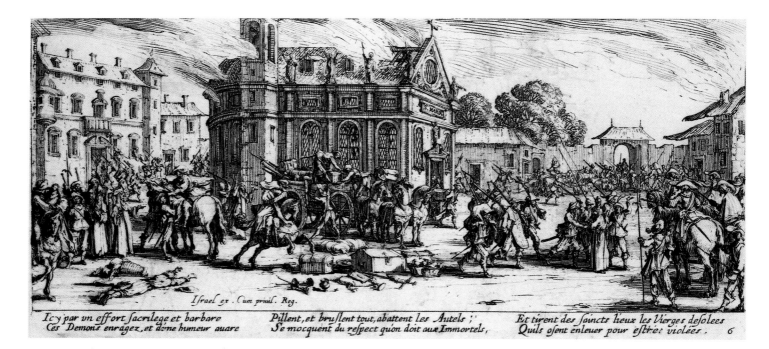

Icy par un effort sacrilege et barbare
Ces Demons enragez, et d'vne humeur auare

Pillent, et bruslent tout, abattent les Autels ;
Se mocquent du respect qu'on doit aux Immortels,

Et tirent des saincts lieux les Vierges desolees
Qu'ils osent enleuer pour estre violées. 6

Israel ex. Cum priuil. Reg.

3. Jacques Callot, *Destruction of a Convent*, c. 1633, National Gallery of Art, Washington, R. L. Baumfeld Collection

dide-like protagonist as he travels rootlessly through a countryside ruined by war and warring men. One can only suspect that the author, Hans Jakob von Grimmelshausen, based his tale on the world he saw around him.[17] Callot graphically described the depredations of these wars in Lorraine in his celebrated etchings of *Les misères de la guerre* (figs. 2 and 3).

More objective details of the war's effects are also available. In 1621 and 1622, for example, the effect of various armies crossing through Lorraine contributed to a doubling in the price of wheat, notable outbreaks of plague and other unspecific lethal illnesses, and, when combined with the general economic strain of this period, a significant financial crisis.[18] In such times of epidemic the Lorrainese offered prayers to Saint Sebastian, but apparently to little lasting effect. In the summer of 1631 imperial troops brought another outbreak of plague specifically to Lunéville, which was looted and burned by soldiers a few years later.[19] In fact, the movement of troops through Lorraine could be charted by a statistical map of the incidence of disease.[20]

In the cities, at least in the short term, the war brought mixed results. When the war began, times were still good, at least at the court of Duke Henry II and his Catholic second wife, Marguerite of Gonzaga. The couple spent a good deal of time in Luné-

ville, gathering around them a vibrant community of artists (among them Georges de La Tour), wealthy churchmen, and nobles. They supported several restoration projects and, along with the Church, funded new building efforts that provided steady employment for artists and artisans, stonecutters and architects. Henry II also expanded his holdings, acquiring new lands during the early part of his tenure. He kept trade and commerce fairly healthy by negotiating agreements between various Lorrainese towns.[21] War also internationalized Lunéville society, and Georges benefited from this dynamic climate.

But the seeds of hardship were also planted in cities for members of the less elite classes. Increasingly, town residents were forced to house soldiers in their midst and to suffer the consequences. Disruption in the countryside had its effect in the cities. Besides producing food shortages, fleeing peasants often went to towns, which made for large numbers of loose people, desperate for work or food, susceptible to criminal activity and prone to disorder.[22]

By and large, the Catholic dukes of Lorraine sided with the Habsburg emperors in the Thirty Years' War, sensing the very real threat otherwise of being swallowed up by the French. Their gamble did not pay off. When Duke Henry II died in July of 1624, his son Charles IV was even freer to pursue

an anti-French policy.[23] A combatant at the Battle of White Mountain in 1620, Charles did his best to uphold Catholic orthodoxy and Lorrainese independence at the same time. Allied with the enemies of Richelieu, he hired mercenaries, cracked down on Protestants in his own territories, and prepared for armed resistance to the French, based in Metz since 1552.[24] This assertion of autonomy proved the duke's undoing. Sternly, Louis XIII reminded Charles of his feudal obligations, for the dukes of Lorraine were arguably the vassals of French kings.[25] When Charles continued to fight in Germany, with and for the emperor, a superior French army continued into Lorraine and absorbed it, city by city. By January of 1632 Charles was forced to sign a treaty promising neutrality and free passage across his lands to French troops.[26] Within two years he had lost his capital. And by 1642 he had even lost his claim to Catholic rectitude, suffering excommunication for bigamy and abandoning his duchy for exile in Germany. The French king's takeover of Lorraine was clearly part of his broader domestic agenda, but it was the Thirty Years' War, and the duke's alliance with the emperor, that gave Louis the excuse he needed to act.

The Thirty Years' War contributed to the trend toward secularization in Europe, and that secularization represents another larger change occurring in this region in this age. In Lorraine, proof of secularization exists more in the reaction against it than in any avowed support for it. The Lorrainese were reputedly far more faithful, and driven by faith, than many of their neighbors. And they resisted, for the most part, Protestant overtures beginning in the sixteenth century. Cabourdin felt justified in labeling Lorraine "a bastion of catholicity" throughout our period.[27] The fervor of the Counter-Reformation ran particularly strong there. The later sixteenth century saw the founding of new religious orders and new church building in Lorraine, another element of life that helped keep La Tour and fellow artists and craftsmen employed. But ironically, the burst of religious enthusiasm behind such projects helps to explain the eventual decline of faith in daily life.

After its formative phase in the ancient and early medieval periods, the Christian Church in Europe produced a steady dynamic, a balance between religious zeal and the more secular response to the excesses wrought by that zeal. This crudest of reductions serves to explain one feature of the evolution of Christianity in this society. If the Middle Ages produced a flowering of religious fervor and the attending extension of the Church's presence, the Renaissance might be said to have injected a more secular outlook and approach. This characterization has been overstated, but it still has some validity as a generalization. Humanism was indeed partially a response to medieval scholasticism. In turn, the blatant worldliness of many Renaissance churchmen and the worldly abuses and unseemly riches that accrued to the Church following the Black Death, brought their own reaction. Propelled by Augustine's emphases, Martin Luther's Reformation sprang from yearnings for a more introspective, fundamental, and faith-centered church. The Catholic analogue, or Counter-Reformation, produced similar calls to renewed spirituality: new religious orders, better priestly education, and a clearer definition of Catholic doctrine.[28]

But this is where the pendulum swung toward the secular and arguably never returned again. Ironically, the Reformation and Counter-Reformation, considered together as a general movement of renewed religious commitment, ultimately led many Europeans away from religion. The century after Luther's Ninety-five Theses, of course, produced an explosion of religiosity. But the intensity of the wars that subsequently consumed Christians led to widespread revulsion, particularly among the growing literate classes of society. Reformation and Counter-Reformation sprang from zeal and produced zeal. Zeal produced violence. And violence produced, in some, a willingness to relegate religion to a lesser role. By the mid-seventeenth century Europeans were increasingly willing to countenance the extreme expansion of secular rulers' dominion in order to counteract and control religious excess.

Other larger trends in agriculture and science contributed greatly to secularization. While a local

official might still in the seventeenth century ascribe a death by drowning or lightning to divine retribution for the victim's sin, increasingly, scientific explanations based on empiricism were gaining adherents. Man's manipulation of agriculture and improved ability to explain his own physiology could not help but diminish the perceived mystery and omnipotence of the Almighty. The Reformation and Counter-Reformation's joint attack on magic also ultimately undercut religion. For as the English historian Keith Thomas has noted, even rural theologians came to see that if the people rejected devils, they might also reject, to some extent, God.[29] Perhaps most critically, the Reformation and Counter-Reformation boosted literacy rates, and this also proved detrimental to the Church and to religion. The Bible readers of one century would give way to the *Encyclopedia* readers of the next.

It was against this backdrop of burgeoning secularism that La Tour and his fellow Lorrainese struggled. Their efforts were perhaps less a renewal of Christian devotion than a last beleaguered effort to stem an unstemmable tide. This is more apparent through hindsight, of course, than it was to those alive at the time. Pierre Bergeron, a seventeenth-century Parisian lawyer cited by Yves Le Moigne, remarked on the healthy proliferation of churches and monasteries in Lorraine.[30] And while Metz (which housed a small Protestant and even smaller Jewish community) could never serve as a true Catholic bulwark, Nancy could. According to Le Moigne, the capital of Lorraine stood as "the triumphant pivot of a frontier of catholicity."[31] Other signs of Catholic vigor abounded. Jesuit colleges were founded and prospered in the early seventeenth century in Pont-à-Mousson, Bar, Nancy, and Metz, so that by 1629 more than two thousand students were receiving instruction from this rigorous and often controversial order.[32] New communities of religious were established, including Franciscans, Capuchins, and Minims. Pilgrimages to venerate particular saints in Lorraine increased, and this period also saw increased devotion to the Virgin there.[33]

Religious strife, in its way a sign of sectarian enthusiasm, also continued to grow from its roots in Lorraine. The most obvious examples appear in reluctantly diverse Metz, where the Catholic majority consistently worked, through means legal and otherwise, to purge the community of Protestants and Jews. In Lorraine at large, the influx of soldiers brought a greater Protestant presence as well. Protestant combatants passed through Lorraine with some frequency.[34] The efforts of Duke Charles III, who forbade Protestant worship in Toul in 1569 and officially purged Lorraine of its remaining Protestants sixteen years later, testify to some degree to Catholic-Protestant struggle there.[35] There were intra-Catholic controversies as well. Jansenism, a Roman Catholic movement centered in France, espoused Augustinian austerity and opposed Jesuit relativism in religion. Its roots were therefore similar to those of early Protestantism, a fact not lost on its opponents, who often deemed Jansenists "crypto-Protestants." As a movement, Jansenism did not have its full impact until after La Tour's death, but the impulses driving it were already evident earlier in the seventeenth century and can be said to have derived from the same resistance to secularization described above.[36]

In the pronounced religious expression of Catholic Lorraine one senses a tendency to idealize a supposedly unified Christian past and an almost desperate desire to insist on the Catholic Church's impregnability. Do La Tour's paintings reflect this? The viewer must decide. Is the calm strength of his portraits of saints an outgrowth of spiritual security or an attempt to ignore and thereby erase the religious turmoil of the day? Lorraine was a Catholic fortress in this period, as historians point out, but it was a fortress under siege from within as well as without. And its denizens, seemingly safe inside their battlements, nonetheless had something of the air of the condemned partaking of one last sumptuous meal.

The major political shift in Lorraine in this period, the French takeover, cannot be divorced from the war, or from growing secularization. For the French absorption of the duchy was fed by both the specific realities of the war and the more gradual replace-

ment of religious icons and authorities with secular ones. In Lorraine, French centralization proceeded even more swiftly and obviously than in the rest of the kingdom. The exigencies of war allowed for blatant conquest there, while a subtler administrative absorption was necessary elsewhere. The Bourbons' cult of personality, which reached its apex under Louis XIV, drew strength from Catholic unity even as it sapped the Church of much of its preeminence. The specific steps in the French annexation of Lorraine make these points clear.

French kings had established their rule in Metz from 1552, through a garrisoned army and a royal governor who oversaw military security and therefore civic law and order as well. But for the balance of the sixteenth century, the rest of Lorraine, including the bishoprics of Toul and Verdun, remained under the control of the dukes and through them aligned in the German orbit.[37] War in the seventeenth century and the dukes' alliance with the emperors allowed French kings to change this reality and to assert their claim to Lorraine, which they traced from Charlemagne's control of that region in the eighth and ninth centuries. Between 1633 and 1648 French dominion was asserted, pursued, and achieved. The program, directed by two successive monarchs (Louis XIII and Louis XIV) and their shrewd advisors (Cardinals Richelieu and Jules Mazarin) began with two highly effective moves in 1633: the movement of French soldiers into Lorraine (including the takeover of Nancy in September) and the establishment of the Parlement of Metz, a court of last resort for the whole region, with judges handpicked by the crown. This last measure, consistent with the establishment of similar courts elsewhere in the realm, allowed French monarchs to impose their authority indirectly but ingeniously. By creating a higher court, they had no immediate need to dismantle the traditional local courts and thereby incur the wrath of local notables. They merely preempted local administration.

By 1634 the ducal family had been dispersed and their fortified mansion occupied by French troops.[38] Lorrainese nobles, clerics, and officeholders were then required to swear an oath of loyalty to the king

and a French-controlled council housed in the former ducal palace in Nancy. While some Lorrainese resisted, most notably the Capuchins who were banished for their refusal to take the oath out of lingering loyalty to the duke, the vast majority, including the nobility and lesser notable officeholders, seem to have complied.[39] An administrative officer was established in Nancy in 1637 to send regular reports to the king and to help enforce royal orders in the region. And at roughly the same time, traditional magistrates were ousted and replaced with men more reliably loyal to France and with a structure more like that existing in Paris.[40] The royal governor's power was extended to all of Metz, Toul, and Verdun. And while French efforts were hindered during the minority of Louis XIV and the Parisian noble rebellion known as the Fronde, by 1648 the treaty that officially ended the Thirty Years' War included the formal French annexation of these three bishoprics, virtually all of the traditional lands of the dukes of Lorraine.

Writing of Georges de La Tour, Anne Reinbold refers to the state of equilibrium in which he lived, the "profound stability" of his life. Given the previous discussion of the perils and complexities of life in Lorraine, the surface changes and the fundamental shifts taking place in this era, how can this claim be made? Or if it is fair to make it, how could the artist's existence have been so anomalous? In fact, La Tour's life was one of real stability. He was born into a milieu that he expanded and bettered somewhat, but through a roughly predictable and known path. He married, raised children, and made professional and social contacts within his community. His talent informed his life, but his ending was not a radical departure from his beginning. Even the manner of his death, by illness that almost simultaneously took the lives of his nearest relations, was a common if not everyday occurrence in this region in this age. Within their own lifetimes, the same predictable patterns would have held true for most other Lorrainese as well. They would probably not have defined their age as one of irremediable change. Certainly once

the war was over, most would have expected a period of calm and found it.

However, if La Tour was not destroyed or harshly buffeted by the very real shifts occurring around him, it is a testament to his flexibility, not his stable and predictable life. He bent, and this allowed him not to break. He began his career with one set of patrons, watched those patrons lose their preeminence, and found another set among the new French ascendants. The dissipation of the court of the dukes of Lorraine gave way to new patrons among the *parlementaires* of the new judicial court at Metz. The reversal of fortune of several of the religious orders who gave La Tour his first commissions did not prevent him from finding new subjects for inspiration in the war years and new buyers for those works. The flight of the duke, rather than a disaster for La Tour, aided his and his son's evolution into *Peintres ordinaires du Roy*.[41]

Other Lorrainese may not have been as fortunate as La Tour, but they also made the transition into a new political age without great obvious turmoil. Religious changes were similarly incremental and therefore bearable. So the new reality took shape, under the noses of people only somewhat aware of the import of their era. There were complaints and reactions against the subtle changes occurring. But the full scope of the transition could not be easily discerned by the actors most involved. This is perhaps a good thing. For if they had understood the violent transformation, of religious verities particularly, more violence and despair might have ensued. And if La Tour had been more overtly aware of standing on the edge of a precipice, the contemplative power and strength implicit in his works might not have survived. However chimerical, the certainties he and those around him clung to produced his unique and revealing vision of his age.

Notes

1. Le Moigne 1978, 269–313.

2. Cabourdin 1977, 460.

3. Cabourdin 1977, 459–492.

4. Miskimin 1977, 20–46.

5. Cabourdin 1977, 462.

6. Digot 1856, 53–152.

7. Cabourdin 1977, 476.

8. Reinbold 1991, 20–21.

9. Reinbold 1991, 43.

10. Cressy 1980. Cressy's figures, albeit for England, suggest that while this middling group was not the stratum most likely to be literate (that distinction belonged to the [Protestant] clergy), it was the group for which the rate of literacy was rising the fastest. French scholars have similarly shown that this was the group that, in the eighteenth century, was most attracted to the ideas of the Enlightenment *philosophes*.

11. Diefendorf 1991; Norberg 1985 are just two of the many studies of French life that have looked at processions and festivals as indicators of social ranking and reality in this period.

12. Salmon 1967, 21–43.

13. Cabourdin 1977, 513.

14. Darnton 1984, 9–74.

15. Digot 1856, 53. See also Laperche-Fournel 1985, 1–153.

16. Behre 1991, 1–2.

17. Hans Jakob Christoph von Grimmelshausen, *Simplicius Simplicissimus*, John P. Spielman, trans. (New York, 1981).

18. Le Moigne 1978, 287.

19. Reinbold 1991, 63–65.

20. Cabourdin 1977, 104.

21. Le Moigne 1978, 276.

22. Reinbold 1991, 63–65.

23. Le Moigne 1978, 288.

24. Le Moigne 1978, 288.

25. Le Moigne 1978, 289.

26. Le Moigne 1978, 289.

27. Cabourdin 1977, 49.

28. Delumeau 1977.

29. Thomas 1971, 469–501.

30. Le Moigne 1978, 279.

31. Le Moigne 1978, 279.

32. Le Moigne 1978, 280.

33. Le Moigne 1978, 281.

34. Behre 1991 and Cabourdin 1977, 59–62.

35. Cabourdin 1977, 50.

36. Based on the theology of the bishop of Ypres, Cornelius Jansen (d. 1638), Jansenism sought to arrest what its followers saw as a trend to moral laxity, typified by the Jesuits' flexibility on matters of salvation and grace. Critics of Jansenism, however, saw the movement as a refuge for clerical martinets, whose grim piety was out of touch with spiritual realities and whose daily efforts in France, at least, were downright politically treasonous. See Alexander Sedgewick, *Jansenism in Seventeenth-century France: Voices from the Wilderness* (Charlottesville, 1977). See also René Taveneaux, *Le Jansenisme en Lorraine, 1640–1789* (Paris, 1960).

37. Le Moigne 1978, 286–287.

38. Le Moigne 1978, 292–293.

39. Le Moigne 1978, 293.

40. François-Yves Le Moigne, *La Lorraine, Passionnement* (Metz, 1993), 11.

41. Reinbold 1991, 136–160.

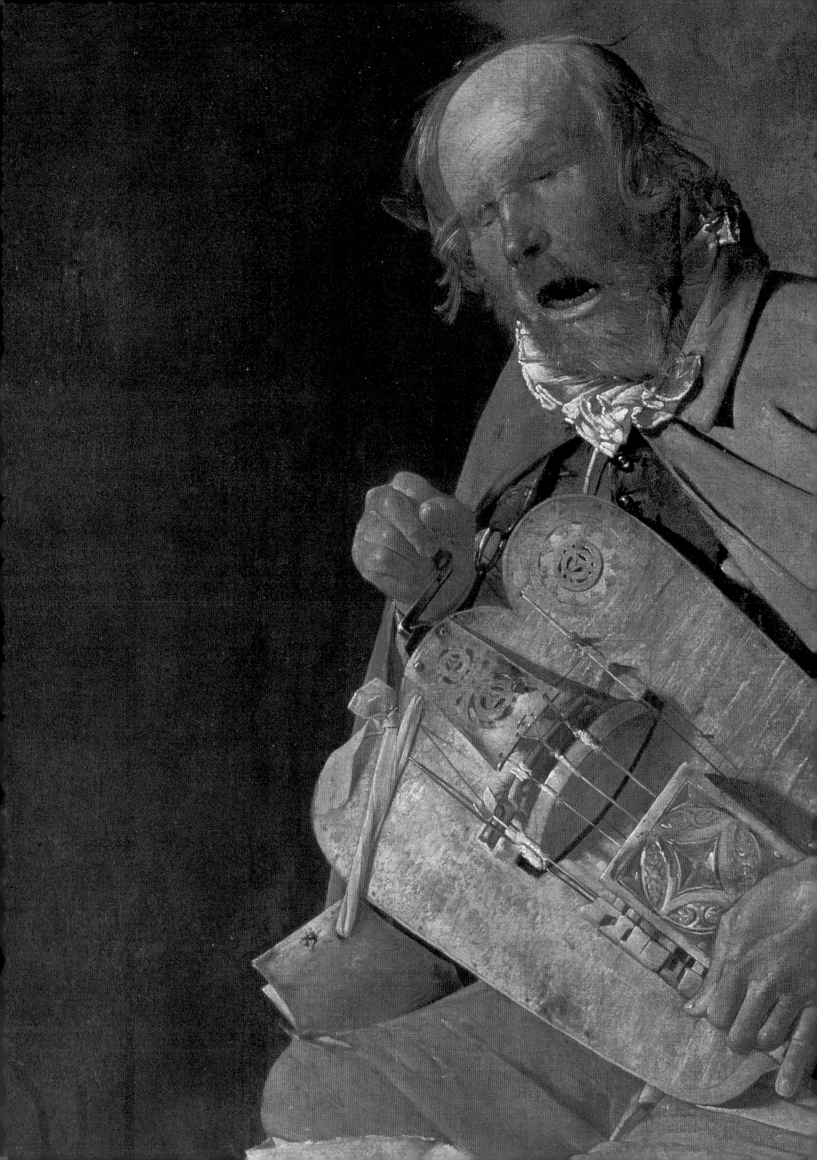

Condition and Quality

EDMUND P. PILLSBURY

Every country swears by its own lawyers,
by its own philosophers, and even by its own
picture-restorers, and has far more confidence
in their wisdom than in that of foreigners.

Giovanni Morelli, 1889

Judgment regarding the performance of
restorers is even more unreliable than that
regarding works of art.

Max Friedländer, 1942

The task of criticism is nothing other than
to retrieve the artist's intentions.

Richard Wollheim, 1979

Few major artists have posed as many challenges to connoisseurs as Georges de La Tour. While we know the dates of his birth and death and the names of his wife and children and quite a few details about his connections in the local society of Vic-sur-Seille and Lunéville, we have little information to help us understand his artistic development. Who were his teachers? His patrons? His imitators? How did he absorb the lessons of Caravaggesque lighting: as a result of a trip to Italy, or possibly Holland, or through a local intermediary such as Jean Le Clerc? What prompted him in the first part of his career to adopt modern moralizing subject matter, extolling the vicissitudes of beggars and blind musicians, only to turn away from the external world in favor of his own personal meditations on suffering, death, and human frailty? What induced him to abandon a so-called daylight manner to explore the effects of candlelight? How did he evolve from the descriptive realism of his youth, if you will, to the ascetic realism of his full maturity?

Thanks to the relentless effort of archivists and the keen eye of curators and dealers, we are learning more and more concerning the whereabouts of La Tour's work in the seventeenth century, and it would seem that he was far more famous and successful in his own day than had previously been thought. Consensus, however, exists today for the

acceptance of only a small nucleus of works – some thirty to forty from an oeuvre of an estimated several hundred. This situation is exacerbated by the popularity of particular subjects, of which early copies abound, and by La Tour's own apparent practice of producing autograph variants and perhaps, on occasion, even replicas. There survive, for example, two fully accepted versions of the *Cheat* (Paris and Fort Worth), the *Saint Jerome* (Grenoble and Stockholm), and the *Magdalene* (Paris and Los Angeles). Moreover, judging by the number of early painted or engraved copies, repetitions by La Tour or his studio of certain subjects – such as *Saint Sebastian Tended by Irene* (both upright and horizontal), *The Education of the Virgin*, and so on – may have been considerable.

The present inquiry does not intend to dwell on the phenomenon of multiple versions or studio replicas per se, but to examine the relevant criteria for judging the originality of individual works. In the case of La Tour, the problem is critical because of the great number of important works known today only through what appear to be very early and seemingly faithful records or copies. In the most recent catalogue (Thuillier 1993) nearly two dozen compositions are so described. But how, in the absence of documentary or other evidence, is a painting to be viewed as a copy if the original has perished or is untraced? When is it correct to label a work a copy by an imitator, follower, or studio assistant? How much weight should be accorded inscriptions? Is there a single work that can be assigned to La Tour's son and artistic heir, Etienne, with any degree of confidence? Clearly the issue becomes one of quality, but the condition of a painting is an all-important factor when the connoisseur comes to make a judgment about quality.

To be sure, there is agreement among scholars on a substantial number of issues, but various key works remain under discussion. *The Education of the Virgin* at the Frick, for example, is one of several La Tour compositions considered a damaged original by some and an early, perhaps studio replica by others. Similarly, the status of the Le Mans *The Ecstasy of Saint Francis*, one of the artist's most imposing com-

PRECEDING PAGE:
Detail, cat. 11

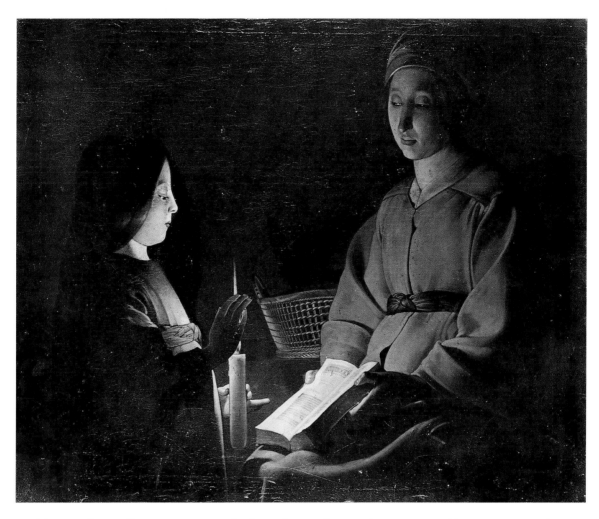

1. Attributed to Georges de La Tour, *The Education of the Virgin*, c. 1650, The Frick Collection, New York (before conservation treatment)

positions, and a smaller variant in Hartford, vacillates between being considered a work that records a lost original and being an accepted work by the master. The question of original versus copy has been particularly vexing in the case of the more than ten surviving versions of *Saint Sebastian Tended by Irene*, among La Tour's most famous compositions, which displays (*pace* Thuillier) his poetic talent to the full; originals of this subject were presented by La Tour to Duke Charles IV of Lorraine (probably in 1631–1632) and shortly thereafter to King Louis XIII of France.

While benign neglect accounts for the demise of La Tour's reputation in the eighteenth and nineteenth centuries, the enthusiasm that greeted the artist's rediscovery in the 1920s and 1930s has exposed La Tour's work to some of the most egregious excesses of certain conservation practices common in the past half-century. Lining and sometimes even transfer,

often employing unsuitable (wax resin) adhesives and too much heat and pressure, have had serious, often irreversible, consequences, such as the flattening of the surface to eliminate cupping and other effects of the picture's natural aging, thereby damaging the impasto, which alters the ability of the brush strokes to scatter light as the artist intended. Cleaning of La Tour's paintings has been widespread, often resulting in abrasion in thinly applied passages of darker pigment and in the glazes used to achieve subtle modeling effects; this is sometimes aggravated by the application of inappropriate solvents. La Tour's pictures have also been the victims of the once common, but now less accepted, practice of applying synthetic surface coatings, which discolor at a reduced rate but fail to saturate the surface to reveal the subtlety of the artist's palette. These coatings can attract atmospheric particles over time or even become clouded or turn gray.

The presence of these factors, if undetected, severely affects our perception of the quality of any work, original or copy. The above-mentioned picture at the Frick, for example, was lined prior to its acquisition. A comparison of the appearance of the work before this treatment (in a so-called "neglected" state photograph, see fig. 1) with its impression today reveals a radical change. In 1947 the picture showed some minor surface undulations as well as stretcher-bar marks and raised crackle, but none of the unnatural smoothness that it has since acquired and that, like a face-lift, robs the work of its age. It can never be forgotten that paintings, in fact, are three-dimensional objects, and a thinly painted work like *The Education of the Virgin* loses much of its vibrancy and excitement as a result of being flattened. Often in the process such a work takes on something of the appearance of a copy, with a more uniform paint application and more summary handling of details.

If a picture's integrity has been compromised through structural changes, our ability to appreciate its character and true quality can also be affected by the condition of the paint surface. The problem of abrasion of paint is pervasive in La Tour's night scenes since he used so many thin, darker pigments that employ very little lead white in their composition and are particularly vulnerable to abrasive solvents and the darkening effects of time. Not surprisingly, the Le Mans *Saint Francis* as well as most versions of the horizontal *Saint Sebastian* are almost illegible in the darkest passages, and the figures no longer possess a sense of solidity or full plasticity. The transitions from light to dark have also changed. The only areas on which quality judgments can still be made are those restricted to the passages built up in lead-based lighter pigments. The sinking of dark pigments over time as well as their vulnerability to strong solvents accounts for the unsightly overpaints and toned varnish that have been applied by restorers. The Frick picture as well as Cleveland's *Saint Peter Repentant*, both restored by the same conservator, are two examples.

It is not enough to examine pictures under x-radiographs to decide if they are originals or copies. Allowance must be made for the consequences of interference as well as aging. Until recently, it was not widely known that one of the versions of the horizontal *Saint Sebastian Tended by Irene* (cat. 16), although widely accepted at one time as an original, had been subjected to a treatment that radically transformed its appearance: the paint was separated from its original linen support and transferred to an entirely new backing. In an effort to bring the surface of the painting into perfect plane, the original linen supporting the painting was sanded away, and the surviving wafer-thin layers of paint and ground were re-adhered with gesso to a new canvas. The process involved impregnating the paint layers with a wax resin adhesive against a solid facing, whose removal severely abraded the entire surface of the original, especially the shadows, and required the conservator to conceal the abrasion with glazes. The *coup de grace* was the surface coating: a synthetic polymer that muted the tonal range and robbed the composition of its spatial recession.

Despite all these disfiguring changes, however, is the work a self-evident copy? Judging from its appearance today, we might be hard-pressed to accept it as an original. If enough allowance is made for its condition, though, a different assessment might be admissible. In the arrangement of the principal figures the picture exhibits a consistent pattern of reworking, or *pentimenti* (e.g., the head and dress of Irene and the openings in the metal lantern) and also employs painted lines to establish the contours, a working method of the artist more fully described in the following essay. The presence of the rich palette of crimson and magenta on Irene's dress, the virtuoso modeling of the light reflections from the lantern, and the convincing and fully resolved treatment of the arrow wound and the blood stains from it on Sebastian's body, all find parallels in La Tour's fully accepted works. The absence of the nervous brushwork so characteristic of the painter does not in itself preclude La Tour's authorship; witness the newly rediscovered and fully accepted *Saint John the Baptist in the Wilderness*, now in Vic-sur-Seille, a night scene of great subtlety and quiet beauty, which may also date from the early 1630s. In any event, the well-preserved passages of the work under discussion are

far superior to comparable parts of the ten or more surviving copies, as was recently confirmed by a scholar with firsthand knowledge of all the best versions (formerly Poggi collection, Rome; private collection, New York, formerly Julius Weitzner; Orléans; Rouen; and Fort Worth, formerly Kansas City).

Clearly the future of La Tour attributions depends upon the ability of art historians to understand the intentions of the artist, notwithstanding the fundamental changes wrought by age and inherent vice on the one hand and misguided preservation schemes on the other. In the absence of documentary records that could tell us how La Tour's works have come down to us, we have to rely more on the visual and technical evidence of how he painted them. If the above examples are any indication, no effort should be spared to assess the condition as part of the overall evaluation of the authorship and date. A recent, quite insightful study of La Tour's work by means of x-radiography is to be applauded, but given what we have since learned from neutron-activation autoradiography and from other tests presented in this volume, this investigation may be only the beginning and should, in any case, be used with caution in reaching judgments about an artist whose materials and working procedures, like those of Vermeer, still remain so mysteriously elusive.

Some Observations on Georges de La Tour's Painting Practice

MELANIE GIFFORD

CLAIRE BARRY

BARBARA BERRIE

MICHAEL PALMER

In preparation for this exhibition researchers from the National Gallery of Art and the Kimbell Art Museum studied ten paintings by La Tour in American collections. With the generous support of the lending institutions, each work was examined by at least two members of the research group. We examined the paintings using the stereomicroscope, x-radiography, infrared reflectography, and (in two cases) neutron autoradiography, and we analyzed a limited number of paint samples from almost every work.[1]

By studying La Tour's choices of materials and techniques, we have gained new insights into his working process in these paintings. In this essay we have selected certain aspects of the technique of each painting for detailed discussion. From our research, which complements the results of recent technical research at the Louvre,[2] we have also been able to draw some conclusions on the range of La Tour's painting practice through his career. The essay concludes with a summary of La Tour's methods and materials: those features that varied during his career, and those that can be seen as threads of his personal approach running through his oeuvre.

The works we discuss below are arranged in the chronological sequence suggested by the catalogue of this exhibition, with two provisos: only one painting, *Saint Peter Repentant* (cat. 24), is securely dated, thus any discussion of La Tour's chronology and development is speculative; and in our essay the *Saint Peter* opens our discussion of the nocturnes and precedes our observations on the *Magdalene* paintings, which precede it.

Old Man and Old Woman

Both *Old Man* and *Old Woman* (cats. 2 and 3) depict single, evenly lit figures.[3] The handling of paint is more refined in these works than in other works we examined, with careful attention to detail. Though the canvases are similar in size to those of a number of La Tour's presumed early paintings, the actual figures of the man and the woman are among the smallest in scale of any in known works, and the refined brushwork was necessary to effect modeling

and suggestions of detail on this smaller scale.[4] Both are paintings of full-length figures standing in a substantial space; other paintings by La Tour of similar size show figures that either are seated or are half-length to three-quarter-length representations and that fill most of the painted surface.

In both paintings we identified a chalk ground that contains small amounts of lead white, yellow orange ochers (iron oxide earths), and bone black. The minute particles of bone black are evenly distributed throughout the single ground layer, imparting a cool grayish white tonality. La Tour used the ground's light grayish white in the finished work by allowing it to show through his thinly applied paint and glazes and by leaving it exposed in gaps between forms.

La Tour began the composition of the *Old Man* and *Old Woman* not with an underdrawing but with a painted sketch, colored dark red brown through brown black, applied directly on the ground. This sketch had two functions: not only did La Tour delineate some of the forms with broad lines of paint, but he also applied a wash of the same paint to establish the shadows in flesh tones, garments, and walls. Although the brown painted sketch, which the artist left visible in places, plays a role in the final appearance of both paintings, it is neither a fully worked underpainting nor a grisaille. This technique was widely used in the seventeenth century.[5] An unfinished painting by the Le Nain brothers reveals such a sketch (fig. 1). La Tour also prepared his composition with an incised line in the *Old Man*, which he used to define the space. A discontinuous line at the junction of the floor and illuminated wall was scored directly into the ground between the figure's legs and to the left of the proper left leg, suggesting that the space the figure would occupy was already determined. No such device was observed in *Old Woman*.

The two paintings show La Tour's interest in the texture of fabric. This is particularly evident in the woman's apron. Here the brushwork models the many folds and shadows, while low, wet-in-wet impasto suggests braid around the waist (fig. 2). La Tour also used this subtle impasto to reinforce high-

of the painted sketch as necessary. He used transparent glazes generously in the two paintings, particularly in the woman's skirt and vest, to unify the presentation. These purple red glazes consist of mixtures of red lake and azurite; an additional blue pigment, possibly ultramarine, was found in glazes used on the skirt.

Examination at low magnifications revealed that La Tour approached the two paintings as careful arrangements of a series of discrete passages. Using the painted sketch as his guide, he painted the faces first, the clothing next, and the backgrounds last. In each the general sequence was to paint lighter passages before the darker: the white blouse and apron of the woman were painted before her darker vest and skirt. The execution of the man's walking stick is particularly interesting, for it was painted after the figure and wall had been completed but before the floor had been painted: that is, the walking stick does not lie over the paint of the floor but is painted directly on the ground. There are only a few minor *pentimenti*, and where two compositional elements abut, there is little overlap of the paints at the border. More often small gaps occur between elements, allowing the ground to show and thus reinforcing an edge or contour by creating a halo-like quality. This is particularly evident along edges of a figure's head and shoulder in shadow, where the gap aids in separating the figure from the background.

1. The Le Nain brothers, *Three Men and a Boy*, National Gallery, London, an unfinished painting in which the painted sketch, similar to that La Tour used, remains exposed.

lights in both paintings, and he created detail in the red design on the vest front in *Old Woman* by dragging tiny scratches across the line of wet paint.

La Tour's painting procedure began with opaque paints, which he used to create the midtone values of the garments while leaving the existing painted sketch to serve as the shadows. He then applied the first highlights, often wet-in-wet with the midtone paint. He applied final highlights in fluid lines of both thin and thick paint, while reinforcing the shadows

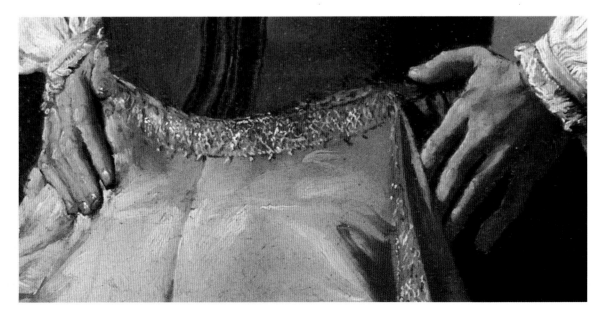

2. Detail from La Tour's *Old Woman* (cat. 3), showing the use of calligraphic impasto to suggest a richly detailed fabric surface.

3. Photomicrograph (magnification x14) of *Saint Philip*, showing the incised line that defines the outer edge of the staff. The line was scored directly into the ground preparation and subsequently filled by the overlying paint layers of the staff and Saint Philip's drapery.

4. Cross section from *Saint Philip* taken through a midtone value in the saint's red garment (magnification x175), showing *a*) pale gray ground of calcium carbonate and lamp black with small amounts of lead white and yellow orange ocher (iron oxide earths); *b*) red glaze of organic red lake with vermilion; *c*) red glaze as in layer b; *d*) opaque orange red layer of vermilion with some red lake; and *e*) red glaze as in layer b.

A vibrant palette of pigments such as azurite, vermilion, red lake, and red and yellow ochers provides a contrast between the figures and their matter-of-fact backgrounds. This combination of materials and techniques succeeds in conveying compositions that are both simple and pleasing.

Saint Philip

Any discussion of a painting's technique and handling must necessarily allow for its condition, and *Saint Philip* (cat. 7), a work from the Albi series of the Apostles, is no exception. The painting is abraded and overpainted. Nevertheless, an examination of this work offers insight into the materials and methods used by La Tour relatively early in his career.[6]

La Tour prepared his canvas with a chalk ground similar to those found in the *Old Man* and *Old Woman*. Lamp black, however, rather than bone black, was used to tint the ground.[7] During the examination we detected neither an underdrawing nor a painted sketch, which the artist might have used to lay out his design on the prepared canvas. This suggests that La Tour used some other method, which our examination methods cannot detect, to plan most of his design. We did observe that in this painting, as in the *Old Man*, La Tour used incised lines to plan one part of the composition: the position of the staff was established by scoring straight lines directly into the ground before painting (fig. 3). These lines not only define the outer edges of the staff but also show the approximate position of the boundary between the shadow and highlight on the shaft.

Saint Philip is thinly painted, with modeling of midtone, highlight, and shadow values achieved through a variety of techniques. Although La Tour painted passages wet-in-wet (see the folds of skin in the hands and facial features), he accomplished much of the modeling through layering of paint. In some areas he laid thin, opaque scumbles over broader passages, as in the gray green cloak, where thin, opaque scumbles of highlight and shadow values were laid over the broader midtone passages. In other areas he used more sophisticated glazing: in the red garment, for example, glazes and opaque paint, used either separately or in combination, establish shadow, midtone, and highlight values. The artist painted a deep red glaze, consisting of an organic red lake with small amounts of vermilion, directly on the ground to create the shadow value. Highlights on the garment were created using semi-opaque paint consisting chiefly of vermilion with a red lake component. It is the middle value, however, that exhibits the most complex layering (fig. 4). Here the transparent red glaze was applied over the ground and allowed to dry; a thin, opaque layer of vermilion was then dragged over the glaze, and this was in turn covered with glaze. This relatively complex scheme allowed La Tour to create a midtone value that very successfully set the transition from shadow into highlight.

5. Photomicrograph (magnification x5) of *Saint Philip*, showing the highlight formed by the glass button, which focuses light onto its own cast shadow. The effect was created by a low impasto application of lead white paint followed by a mixture of vermilion and lead white. Minimal wet-in-wet blending mirrors the color of the garment beneath.

La Tour used sparingly a characteristically thin impasto, primarily in the suggestion of textile effects and in final reinforcement of highlights. Two different uses of impasto are found in the yellow sash and in the highlight details in shadows cast by the glass buttons. The sash was painted in a series of stages, a process that we observed in several paintings. In a first stage La Tour laid in a base tone of light yellow (a mixture of massicot and lead white), and blended pure lead white wet-in-wet into the base tone to establish the midtones and limited highlight effects. Next he applied the dark shadow lines and details, working both wet-in-wet and with wet paint over nearly dry paint. After these paints had dried, he added the bright white highlights. The striking detail in which the glass buttons seem to transmit

gleams of light onto their own cast shadows was painted entirely wet-in-wet. To create these points of light, the artist touched a thick white paint into the wet paint of the shadows, then swirled a mixture of vermilion and lead white, only minimally blended, into the highlight to echo the color of the garment below (fig. 5).

Through the application of thin layers of paint and the use of glazes, La Tour exploited the tone of the cool, light ground. This, along with an uncomplicated background, adds to the starkness of the painting. The addition of brightly colored pigments, such as vermilion, red lake, and massicot, to an otherwise somber palette focuses the viewer's attention on the figure. In a relatively early work the layering of glazes and opaque paints to achieve subtle gradations of value already suggests a considerable level of technical sophistication.

The Musicians' Brawl

The canvas that La Tour used for *The Musicians' Brawl* (cat. 9)[8] was primed with a white chalk ground[9] and painted while it was laced in a strainer, the only painting among those examined here that bears evidence of this practice.[10] As in the *Old Man* and *Old Woman*, no underdrawing is visible with infrared

6. Detail from the lower edge of *The Musicians' Brawl*, after cleaning and restoration in 1989. Unpainted margins along all four edges expose the off-white ground. Note here the design lines of the painted sketch that extend into the unpainted margin.

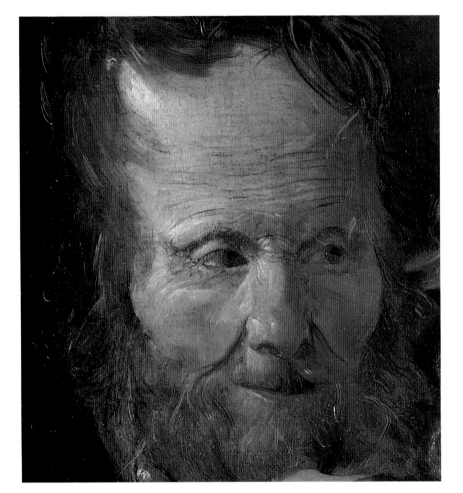

the painted sketch serving as a guide, the composition was painted one section at a time, the colors being applied judiciously in discrete areas. The violinist's breeches were created with vermilion, but this pigment was not identified in any other area of the painting. La Tour rarely overlapped or blended adjacent colors. In places (e.g., around the hand of the violinist) the chalk ground, which has yellowed with age, remains visible between adjacent forms. La Tour painted the highlights in the blue sleeve of the combatant on the right using azurite, but for the dark red shadows of that same blue sleeve he used a transparent red, which gives a deep wine color.

The flesh tones in *The Musicians' Brawl* were first laid in with thin lead white paints (in the x-radiograph they are only slightly opaque).[11] Over this base La Tour created the distinctive wrinkles that line the faces using fine brown brush strokes that resemble drawing more than painting. Then, with great economy, the artist applied highlights to the flesh tones. He defined the hair of the two protagonists with a few bold, loaded brush strokes of opaque paint over the sketchy dark underlayer, working from shadow into light (fig. 7).

Two Versions of the *Cheat*

La Tour's famous composition of a cheat conspiring with a courtesan to fleece a well-dressed young man in a game of cards survives in two autograph versions, *The Cheat with the Ace of Clubs* now in Fort Worth and *The Cheat with the Ace of Diamonds* in Paris (cats. 18 and 19).[12]

The two versions of the *Cheat* were painted on different grounds, a distinction that may contribute to the darker tonality of the Paris composition when compared with the blond appearance of the Fort Worth version. The ground of the Paris version was applied in three layers: red ocher, followed by chalk, and finished with a chalk and lead white layer toned gray with a small amount of black.[13] The Fort Worth painting was prepared with white chalk.[14] Close comparison of the two works reveals that the compositions could be superimposed with only minor variations of detail, which might suggest that the design

7. Detail from *The Musicians' Brawl* in which the bagpipe player's face is described with fine dark lines for wrinkles and highlights that suggest leathery skin. The hair is defined with just a few bold, loaded brush strokes of opaque paint over a sketchy dark underlayer.

reflectography. Also as in those works, La Tour began painting *The Musicians' Brawl* by laying out the principal forms in a painted sketch, this time using brown black. He closely followed the sketch in painting: x-radiographs reveal only minor *pentimenti*. The sketch includes both outlines for the composition, some of which can be seen extending into the unpainted margin along the bottom edge, and thin, feathery, washes defining areas of shadow (fig. 6). These can be seen in the lower jacket of the blind musician as well as beneath the shadowed wall and in the hair of the central musicians, where they enhance the plasticity of the forms.

After the initial blocking-in, the composition was painted very simply and directly, often in a single layer of paint. The overall tonality is based on a somber range of gray green tones, with primary colors reserved for a few passages in the costumes. With

was transferred directly from one to the other, perhaps through the use of a cartoon (see also the appendix to this catalogue). A treatise by Philippe de La Hyre, probably based on the practice of his father, Laurent de La Hyre, in the second·quarter of the seventeenth century, described several such methods, most of which would not be perceptible by standard examination methods.[15] The recent technical study of *The Cheat with the Ace of Clubs* revealed that if La Tour did first use a cartoon, he next laid in the figures with a painted sketch. In this painting he did not sketch shadows but used only fine lines of brown paint for the servant and the cheat and red lake to sketch the courtesan.[16] A number of incisions, primarily in the ground, which do not seem to relate directly to the composition, are harder to explain.[17]

The palette in the Fort Worth *Cheat with the Ace of Clubs* includes lead white, lead-tin yellow type I, azurite, vermilion, red and yellow lake, ocher, and charcoal black. In a typical seventeenth-century practice the artist combined azurite, lead-tin yellow, and a yellow glaze to produce green and blue green shades.[18] The pigments in the Paris *Cheat with the Ace of Diamonds* include lead white, lead-tin yellow type I, azurite, vermilion, red and yellow lake, yellow and red ochers, and carbon or bone black.[19] Although the two paintings employ similar palettes, there are bolder color contrasts in the Paris version, where the servant's brilliant vermilion skirt appears somewhat out of balance with her dark blue green bodice and gold turban, and the cheat's coat and the table have a greenish tonality absent in the Fort Worth painting. The color scheme in the Fort Worth *Cheat* is restricted to a carefully blended range of reds and golds, and the light is more silvery and cool.

In the Fort Worth *Cheat* the pinkish gray turban balances subtly with the raspberry red dress. This dress was painted with a thinly applied, opaque crimson paint over a light gray underpaint. This represents a more complex structure than that found in earlier paintings such as *The Musicians' Brawl*, which is painted very directly. Azurite added to the courtesan's face and bust imparts coolness to her porcelain skin tones. La Tour also exploited the whiteness of the ground to portray light in the Fort Worth

Cheat: the thin margin of exposed ground above the dupe's left shoulder creates a halo of light that helps set off the figure from the background.

In the final stage of painting both of these works, La Tour added highlights and inserted details in the costumes with low impasto and free brushwork. This brushwork, however, is more dazzling and refined than the artist's bold treatment of highlights in the flesh tones and hair of the figures in *The Musicians' Brawl*. The cheat's creased forehead was created with impasted brushwork, brown paint softly blended into the furrows between brush strokes; the manner is quite different from La Tour's more graphic treatment of the wrinkled brow of the bagpipe player in *The Musicians' Brawl* (compare figs. 7 and 8). In the Fort Worth *Cheat* the costumes and jewels are more sumptuous than in the Paris version; in passages such as the gold braid of the courtesan's bodice the delicate, flickering highlights were freely applied wet-in-wet.

The two versions of the *Cheat* – the only surviving examples of his repetition of a complex, multifigured daylight theme – provide rare insights into the planning, creation, and alteration of an ambitious design. The significant changes between the two paintings testify to La Tour's desire to vary or improve elements when repeating a composition.[20] Although Benedict Nicolson in 1974 concluded on stylistic grounds that the Paris version was painted first, his opinion has not been widely accepted.[21] *Pentimenti* have been noted in the x-radiograph of the Fort Worth version. Since *The Cheat with the Ace of Diamonds* appears to follow the final form of *The Cheat with the Ace of Clubs*, Elisabeth Martin presented this as evidence that the latter predated the Paris painting.[22] Nicolson's arguments should be reconsidered, however, given additional information revealed by the recent technical study.

One piece of evidence is the presence of some of the colors of the Louvre painting beneath those in the Fort Worth version: the cheat's collar was changed from red to black (fig. 8), and the servant's turban from gold to pinkish gray.[23] Another is the presence of a brown brush sketch in the Fort Worth painting, where La Tour first planned the hem of the

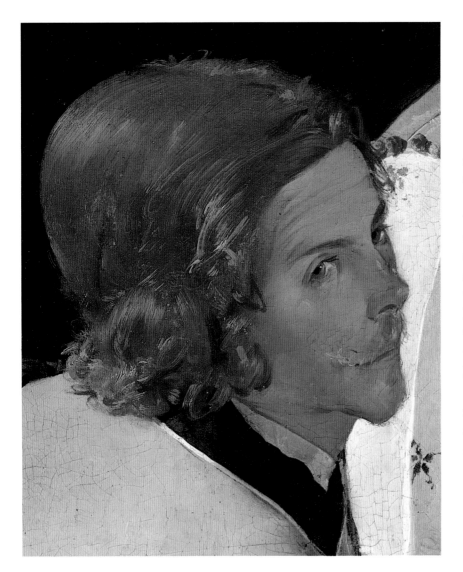

8. Detail from *The Cheat with the Ace of Clubs* in which the creased forehead of the cheat is formed with impasted brushwork, brown paint blending softly into the furrows between brush strokes. La Tour also converted the collar from red to black, the initial color visible on the inner right edges of the collar.

cheat's coat in the same position as in the Louvre *Cheat* (see appendix fig. 4); the artist ultimately painted the hem in a higher position in the Fort Worth version and included a bossed chair below. From the technical evidence presented above and elsewhere in this catalogue, there would appear to be a case for considering the Paris version the earlier of the two paintings.[24] Whereas the small shifts in the positions of the figures in the Fort Worth *Cheat* noted by Martin are evident from x-radiographs, these *pentimenti* may reflect an interest in refining or varying the Paris design rather than being signs of an initial formulation of the scene.

The Fortune-Teller

La Tour's interest in depicting the costumes in *The Fortune-Teller*, which has been described as a still-life painting of fabric, surpasses that in either version of *The Cheat*. It is a tour de force in the depiction of the play of light on the surface of textiles;

nevertheless, La Tour's basic technique in *The Fortune-Teller* is similar to that used in the two *Cheat*s.

As in the Fort Worth *Cheat*, the light color of the white chalk ground of *The Fortune-Teller* contributes to the bright tonality of the painting.[25] In localized areas, however, La Tour also applied a light gray underlayer on top of the ground, possibly to adjust the tonality of the upper paint layers. Along the forehead of the young, black-haired gypsy girl the off-white ground is left in reserve, while to the left of the old gypsy woman's eye a darker, medium gray layer of underpainting is exposed.

As we have seen in virtually all La Tour's paintings, the execution of *The Fortune-Teller* reflects close adherence to the planned design; the figures are carefully abutted with a minimum of overlap. The x-radiograph shows that *The Fortune-Teller* is built up in a manner similar to the two *Cheat*s and has very few *pentimenti*. A number of incisions, even more obvious than those observed in the Fort Worth *Cheat*, can be seen throughout the composition, but here, too, their function is unclear.[26]

La Tour's use of color is more expansive in *The Fortune-Teller* than in the Fort Worth *Cheat*, though the palette is very similar; it includes chalk, lead white, lead-tin yellow type I, azurite, smalt, vermilion, yellow lake, ocher, umber, and charcoal black.[27] The artist also used underpainting more liberally than in the works discussed previously. He used vermilion intentionally as an optical underlayer to render light on the leather vest of the dupe here; and an underlayer of vermilion, visible around the raspberry sash of the young man, creates a vivid red halo. His treatment of the young man's raspberry sleeves in *The Fortune-Teller* is very similar to that seen in the dupe's sleeve in *The Cheat with the Ace of Clubs*; he applied a thin layer of red lake on top of a light, opaque underlayer containing lead white and red lake. As in the case of *The Cheat*, however, the thin layer of red lake, which is light-sensitive, has faded with the passage of time. La Tour applied lead-tin yellow to intensify golden highlights here and mixed it with azurite and yellow lake to produce the blue green panel of the old gypsy's shawl.[28] He employed red lake to create shadows in the folds of the dupe's

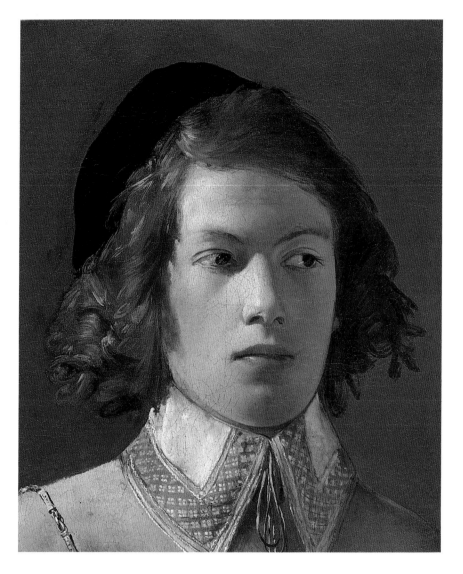

By manipulating the focus of the image, La Tour developed the forms in space. He created the richly patterned shawl of the old gypsy woman with crisp brush strokes and impasto applied over flat layers of color, while suggesting the overturned right edge of the textile by treating the pattern of the underside of the fabric in a soft, indistinct manner. The lower left edge of the shawl, with a slightly blurred embroidered pattern, suggests the textile wrapping around the gypsy's figure. In the young man seen half in light and shadow, who turns slightly to the right (fig. 9), La Tour manipulated brushwork and impasto to bring into sharp focus details on the brightly lit side. He emphasized the red-and-white checkerboard pattern on the lighted side of the collar with tiny dabs of white paint, which recall the highlights on the courtesan's pearls in the Fort Worth *Cheat*. The shadowed side is treated more thinly, with a softer checkerboard that lacks the precise detail. La Tour also painted the brightly lit bauble suspended from the sash with crisp brush strokes and impasto, while the one in shadow is less distinct.

La Tour's preoccupation with light can be seen in a detail as minor as the young man's eyelashes, rendered with flesh color in the light, and dark brown in shadow. He set off the old gypsy woman against the light background with an aura of white along the right side of her turban, as in the Fort Worth *Cheat*, while he applied a gray outline to set off the right side of the central gypsy's neck from the dark background.

Saint Peter Repentant

This painting (cat. 24) is one of only two extant that were signed and dated by La Tour (fig. 10), making it a crucial work for studying the artist's use of materials and methods in the last decade of his life. Microscopic examination of the surface and the analysis of paint cross sections helped us understand how La Tour used materials to create the dramatic lighting effects and deep spirituality that typify his nocturnes.[29]

The lamp-lit scene of Saint Peter weeping after his denial of Christ demands the limited, warm palette typical of La Tour's nocturnal pictures, relying heav-

9. Detail from *The Fortune-Teller*, showing the varied handling of paint in the collar of the young man, which suggests a softer focus on the shadowed right side.

breeches and the old gypsy woman's sleeves, applying it on top of the vermilion in a linear manner, as in the Fort Worth *Cheat*.

La Tour's final brushwork in *The Fortune-Teller* was carefully thought out and controlled. In a seemingly effortless manner, he created a range of textures and materials, using sparing, yet highly effective impasto. His liberal use of this brushwork disguises the fact that there are few and relatively thin paint layers. Some of the most beautiful passages occur where the artist worked very freely, wet-in-wet, in the last stage of painting: in the red and gold patterns on the gypsy's sleeve at the far left, for example, or in the white on black netting in the collar of the gypsy in the background.

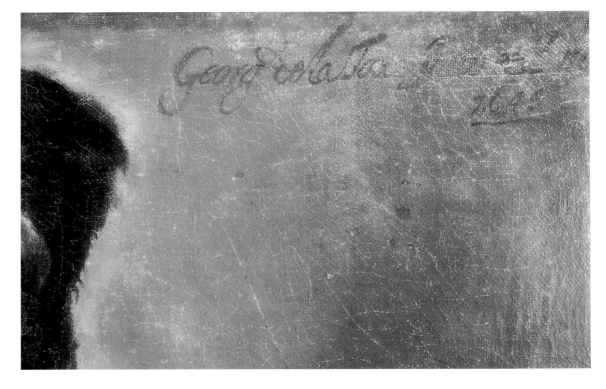

10. Infrared photographic detail from the top right corner of *Saint Peter Repentant*, showing the signature, painted with a black pigment mixed with a little green (probably verdigris). Because the signature was painted in black but the background is brown, an infrared photograph shows it very clearly.

ily on red and yellow ochers, bone black, charcoal, vermilion, and red lakes with less lead white, lead-tin yellow, and azurite. La Tour also mixed significant amounts of chalk and sand into his paints as extenders to obtain saturated colors, which, despite their deep hue, are relatively transparent; he then handled these paints in a specific way to achieve luminous effects.[30] La Tour developed his remarkable light effects by layering paint. In *Saint Peter*, however, he did not use a brown sketch to lay out the composition and plan the play of light and shadow, as he did in a number of earlier paintings, including his *Old Man*, *Old Woman*, and *Musicians' Brawl*.

La Tour was able, through the use of several devices, to give the impression that light emanates not only from the lantern but also, in a spiritual sense, from Saint Peter himself. He exploited the fact that the color of a paint layer is modified when it is painted over a different color, and in places he enhanced the effect by adding colorless extenders, creating paints

with a low hiding power. Working with a few thin paint layers,[31] La Tour built up the tone; if he had mixed several pigments together, he would have obtained muddy and opaque colors, but his inherently translucent paints, thinly applied over areas of different colors, create rich and clear tones. Thus, La Tour lent a luminous quality to dark objects lit by lamplight and even conveyed on canvas the effect of warm light penetrating shadows.

La Tour painted *Saint Peter* on a canvas that had been prepared with a ground of a siliceous earth, very similar in composition to the grounds of other night scenes that we and other researchers have examined.[32] A cross section from the pink light inside the lamp (fig. 11) shows that this is a predominantly a pale gray material to which a small amount of transparent brown earth, yellow ocher, lead white, and a fine-grained black were inhomogeneously added. The image obtained in the scanning electron microscope shows that the gray majority component includes lathlike particles of alumino-silicate minerals identified by energy dispersive spectroscopy (figs. 12 and 13). Quartz and calcite, often present in siliceous earths, are also observed. The yellow ocher appears as small bright dots in this image. Pierre Le Brun, describing French painting practice in 1635, related that canvases could be prepared with *terre du potiers*, or potter's clay.[33] In fact, analysis of pottery clays from France is completely consistent with the material found used as a ground here.[34]

11. Cross section from within the lantern in *Saint Peter Repentant* (magnification x110), showing *a*) the gray ground with yellow cast, consisting of siliceous earth (magnesium-alumino silicates, quartz, and calcite) with small amounts of yellow ocher and black; *b*) a reddish underlayer of yellow ocher, vermilion, lead white, and bone black (similar in composition to the flesh paint); and *c*) pink (light), made up of lead white, minor amounts of vermilion, red lake, and lead-tin yellow.

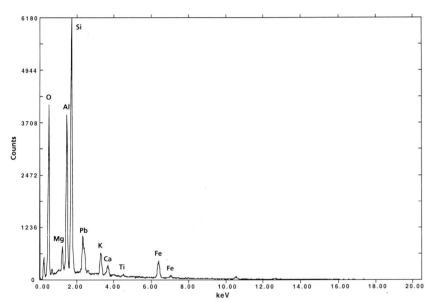

12. Back-scattered electron image of the cross section in fig. 11, showing the ground of *Saint Peter Repentant*. Yellow ocher, which appears as small bright dots, is scattered among laths of siliceous minerals. The image was obtained using a JEOL 6300 scanning electron microscope equipped with a Link Tetra BSE detector.

13. Energy dispersive spectrum of the siliceous material in the ground of the cross section in fig. 11. Its composition is consistent with Pierre Le Brun's description of "potters' earth" as a possible preparatory layer on a canvas and with the elemental compositions of French sources for pottery materials. The spectrum was obtained using a Link Super ATW detector (polymer window), Link eXL II spectrometer, and JEOL 6300 SEM, accelerating voltage 20 kV.

In some areas of *Saint Peter Repentant* this gray ground contributes to the tone of the final paint, but in other areas La Tour covered the ground with localized underpaints to modify the color of his final paint layers. Where the light is cooler — either because a hot light source is very close, such as within the greater part of the lantern itself, or because the area is far from the light source, such as Saint Peter's head and the background – the gray tone of the ground suffices for La Tour's illuministic effects. In other places an underpaint lends warmth to the overlying paint layers. The cross section from a midtone in Saint Peter's hand (fig. 14) shows that here La Tour used a warm black paint mixed with a large proportion of red lake as an underlayer. In the hands and also the legs this underpaint warms the flesh color while avoiding the dull tone that would have been created by mixing. The pink light in the lantern is painted over a flesh-colored layer. Elsewhere a light-colored underpaint lends luminosity to final paints executed in transparent glazes. In the x-radiograph the shape of the rooster can be perceived, although with difficulty, since its form was laid in using a mixture of ochers, blacks, extenders, and lead white (the latter providing the x-ray opacity). The feathers were created with brown and red glazes laid over the underpaint, and the background was brought up to the edge of the rooster's shape, which was then outlined with black paint.

As in several of the earlier works, La Tour made extensive use of red glazes for various purposes. They were used to give dimensionality to Saint Peter's calves and to link the darkest flesh tones to the midtones (see fig. 14). The front edge of Saint Peter's robe was marked with a long, broad stroke of deep red lake to give depth to the color and thus weight to the fabric. Throughout the drapery La Tour used red glazes to deepen colors for shadows and to create folds.

Though the saint's simple clothing seems far removed from the rich fabrics of earlier paintings, La Tour gave the same attention to depicting texture. To create the frayed edge of the saint's robe, for example, he suggested loose threads by dragging a dry tool across a line of wet red paint (fig. 15). This is

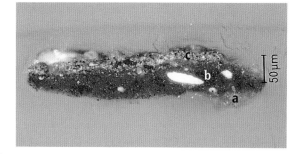

14. Cross section from *Saint Peter Repentant* taken from the back of the saint's left hand (magnification x150), showing *a*) a gray ground with a slight yellow cast, consisting of siliceous earth (magnesiumalumino silicates, quartz, and calcite), yellow ocher, and a little bone black; *b*) black underpaint of charcoal, red lake, a little bone black, and vermilion; and *c*) flesh tone made up of yellow ocher, vermilion, red lake, a little black, and lead white.

the same technique he used for the braid on the bodice of the *Old Woman*.

In a departure from his usual technique, La Tour underpainted Saint Peter's cuff with a thick layer of lead white. This was covered by a layer of pure azurite, and the shape of the cuff was defined by glazing the azurite with layers of red lake. Unfortunately, much of the glaze has been abraded. The technique of underpainting blue areas with lead white, otherwise unknown in La Tour's work, was not unique and was described in contemporary literature.[35]

Technical examination of *Saint Peter* shows that La Tour carried over certain aspects of his working methods from his earlier work but developed others to meet the requirements of an intensely emotional night scene. In *Saint Peter Repentant*, as throughout his oeuvre, the artist used thin layers of paint with little impasto. For details he manipulated wet paint with a very small brush; final touches – such as the eyelashes and sharpening the edges of the metal bars in the lantern – were made over dry paint. In changes from his earlier practice, La Tour no longer used a white or gray chalk ground but replaced it with a siliceous earth toned with a little yellow ocher and some black. He did not use a monochromatic sketch but expanded on a technique that appears in earlier paintings such as *The Cheat*. In *Saint Peter* the technique of underpainting certain areas for specific optical effects was skillfully used to create the evocative lighting of the final composition.

Three Versions of the *Magdalene*

The technical studies included three paintings of the repentant Magdalene (cats. 21, 22, 23).[36] A comparison of these three night scenes with similar com-

positions gave us an opportunity to focus on La Tour's handling of light in his nocturnes, which revealed subtle but striking differences in tonality. Just as the paintings discussed above show important variations in La Tour's techniques in painting daylight scenes, these works make clear that the artist did not use identical procedures to paint his night scenes.

The effect of the Washington *Magdalene at the Mirror*, with its limited pool of light from a hidden flame, is warm and translucent. By comparison, the effect of the Los Angeles *Magdalene with the Smoking Flame*, where the stronger light from the exposed flame spills out through more of the composition, is cool and opaque. There is evidence that these differences are not accidental but were achieved through deliberate choices of materials and their use. The paint of the privately owned *Repentant Magdalene with a Document*, which shares to some degree the opacity of the Los Angeles painting, has not been analyzed, but a close examination of the handling confirms that analogies can be made to the technique of the other versions of this theme.

La Tour created the intended tonality of his paintings from the very first layer. The canvases of all three paintings were prepared with a gray ground; analysis of samples from the Washington and Los Angeles *Magdalene*s (as well as the Cleveland *Saint Peter* discussed above) shows a very similar composition of a siliceous earth with quartz and small amounts of calcium carbonate (and in one case dolomite), tinted with black and earth colors.[37] La Tour painted the Los Angeles and privately owned *Magdalene*s directly on this cool gray surface, but before painting the warmer Washington painting, he applied a strongly yellow second ground dominated by yellow ocher (fig. 16). In shadowed passages of this work, such as the hair of the Magdalene falling against her cheek, he used translucent paints, including resinous earth colors, that exploited the warm color below. As in the *Saint Peter*, there is no evidence for how La Tour laid out his composition; we observed no underdrawing or painted sketch. The dark tone of the gray grounds would have been less suited for a dark preparatory design than the chalk grounds of the brightly lit paintings.

These three nocturnes are based on a limited, warm palette; the pigments identified in both the Washington and Los Angeles paintings include chalk, lead white, lead-tin yellow, earth colors (including ochers), vermilion, red lake, and black.[38] Medium analysis, carried out on the Washington painting only, indicated the use of walnut oil, which was preferred by artists of the period since it tended to yellow less than linseed oil.[39] In all three paintings light passages, such as white drapery or a page of parchment, were built up in a characteristic sequence. La Tour had used this basic structure earlier in his career in the *Saint Philip*, where the yellow sash was painted in the same way. The area was first painted wet-in-wet with a range of midtones and lights; when this was dry, shadowed passages were painted in a dark paint; in the final stage the lightest highlights were laid in with a creamy paint. Here again La Tour's variations from one painting to another clearly further the differences in tonality. The parchment leaf of the *Repentant Magdalene with a Document* and the Magdalene's sleeve in the Washington work give the impression of light transmitted through, rather than reflected off, the surfaces; this warm glow was created from the very first layer of paint in these areas. In each, the first midtone layer was painted with warm peach-colored paint; the brushy shadows of the sleeve were painted with reddish brown paint. In rendering the Magdalene's shift in the Los Angeles painting, the artist emphasized the direct play of light on the fabric. He first laid in the drapery with a cool range of whites and grays; again the shadows were painted with a loose, brushy handling, but here he used a gray, rather than reddish, paint. Only near the outer shadows is there a suggestion of light transmitted through the cloth; interestingly, the few peach-colored touches of paint in this passage are not integral to the paint sequence but were added as a final touch.

A final step was centrally important to La Tour's rendering of the light effects in these paintings. In each he returned to highlight areas, reworking and reinforcing the lights with additional, creamy highlights. This can be seen most clearly in the Washington painting, where the artist repainted the tri-

15. Detail from *Saint Peter Repentant*, showing the ragged edge of the saint's cloak catching the lamplight, described by blending a light red line at the brown edge of the fabric and hatching across it using bright red paint. A similar technique was used in the braid at the waist in *Old Woman* (fig. 2).

Instead the artist used localized underpaints in certain passages in each painting and, through his choices, furthered the differences in tonality between the *Magdalene*s. The hard-edged pool of light on the rear wall of the Los Angeles painting was created with a patch of light gray underpaint beneath the warm brown of the background. The pool of light behind the flame in the Washington painting was also created with an underpaint, but here the artist used a warm reddish tone, feathering out the underpaint at the edges to create a softer, diffuse glow. In the flesh tone of the Los Angeles work and the privately owned *Magdalene* La Tour also used an underpaint. In what initially seems a counterintuitive technique, he underpainted only the highlights with a layer of black (fig. 17); light paint over a dark layer, however, appears distinctly cool. While La Tour had added blue azurite to the flesh of the courtesan in the colorful Fort Worth *Cheat*, in the far more subdued *Magdalene*s he used this more indirect technique to heighten the pallor of the skin.

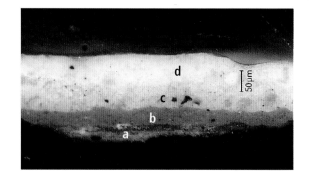

16. Cross section from the highlight on the sleeve in *The Magdalene at the Mirror* (magnification x110), showing
a) a gray lower ground of siliceous earth (magnesiumalumino silicates, quartz, and calcite), black, and earth colors;
b) yellow upper ground made up of yellow ocher with quartz, calcium carbonate, and black;
c) a first layer of highlight consisting of lead white with lead-tin yellow, vermilion, black, and small amounts of calcium carbonate; and
d) a revised highlight of lead white with lead-tin yellow, vermilion, black, and a substantial proportion of calcium carbonate.

angular glimpses of light seen between the silhouetted fingers, heightening the contrast between the rich light and the smooth dark paint (fig. 18). A comparison of the pigments in these final highlights in the Washington and Los Angeles paintings was revealing. The highlight on the white surface of the books in the Los Angeles work was painted with lead white toned with a very small amount of vermilion. The slightly pinker highlights from the Magdalene's shift in the Washington painting included a similar pigment mixture with a slightly higher proportion of red and with a little brown earth and charcoal black. The revised highlight is a light version of the same mixture, but with two significant additions: lead-tin yellow warmed the tone of the pigment mixture, and a substantial addition of chalk gave the paint a subtle translucency.[40] With this small modification, La Tour increased the impressions of bright, direct illumination in the Los Angeles painting, and of a warm hidden light source in the Washington painting.[41]

In one other aspect La Tour adapted an element that had appeared in a number of earlier works: he refined his very specific emphasis on the contours of

17. Photomicrograph (magnification x7) of the tip of the nose in *The Magdalene with the Smoking Flame*, showing that a layer of black underpaint lends pallor to the flesh highlight.

forms outlined against a background to the special requirements of representing night illumination. In earlier works La Tour set figures off from the background by leaving a small gap of ground between the two areas of paint or by outlining the form with light-colored paint against a shadowed rear wall. In the privately owned *Repentant Magdalene with a Document,* the light transmitted through the lifted leaf of parchment seems to spread into a glow above its contour. La Tour painted this light-colored halo at the same time as the background, rather than suggesting it in an underpaint layer as he did in the more generalized pools of light in the other two *Magdalene*s. In an earlier painting, the Fort Worth *Cheat,* the artist used red lake rather than brown for the preliminary sketch of the courtesan; this underlayer can be glimpsed at the edge of a finger. In the *Magdalene*s he instead used a final outline of red lake on the finished painting in an extraordinary way.[42] In the Los Angeles *Magdalene,* for example, a line of deep, transparent red along the figure's hand that rests on the skull and along the contours of the legs suggests the glow of light, warmed as it passes around the flesh; to the viewer the Magdalene herself seems lit from within.[43]

Summary of La Tour's Technique

This survey of ten paintings has given us insights into La Tour's creative process in these specific paintings. From these studies, moreover, we can draw some conclusions on the artist's painting practice. In general, La Tour's materials were typical for a French artist of the period;[44] the ways in which he used those materials, however, were more personal. Although there are important differences from painting to painting, practices that reappear in many paintings reveal characteristic choices through which La Tour constructed his personal vision.

All of La Tour's works were painted on canvas, the typical support for French paintings of the time, and the type of canvas was not critical to the final image. The fabrics we have examined all are moderately coarse and loosely woven, and some are markedly irregular.[45] Although the ground prepa-

18. Detail from *The Magdalene at the Mirror*, showing the area of the hand, where La Tour, in a final stage, reinforced the highlights seen through the figure's silhouetted fingers.

rations fill the openings in the weave, La Tour did not go to great lengths to secure completely smooth painting surfaces, nor does the artist consciously exploit the canvas texture in his images.[46]

La Tour did, however, choose the ground, or preparatory layer, for his canvases at least in part taking into account its effect on the final tonal appearance of the painting. The grounds of the paintings we have examined fall into two types, which relate as much to the settings as to the generally accepted dates of the paintings.[47] The daylight scenes examined were painted on white or light gray grounds, made almost entirely of chalk, sometimes tinted with greater or lesser amounts of black or earth. The first preparatory layer of the three nocturnes that we examined is a gray ground based on a siliceous earth with quartz and small amounts of calcium carbonate (and sometimes dolomite),[48] tinted with black and iron earth colors. In all of La Tour's paintings that we examined the tone of the ground (generally off-white in the natural light scenes and darker in the night scenes) contributes to the tonality of the finished image through the artist's thin paint layers.

There is only sporadic evidence for the way La Tour laid out his composition on the canvas before painting. To date, our examinations have revealed no preparatory underdrawings in ink or a dry material. We did discover, however, fine brush preparatory outlining of contours in red lake and brown

paint in *The Cheat with the Ace of Clubs*. Some of the earlier paintings, such as *Old Man* and *Musicians' Brawl*, were begun with a brown black painted sketch and include broadly painted outlines to define the composition. Some include broader areas of the same paint to define the pattern of light and dark; frequently these sketched shadows show through in the shadowed parts of the final image. In some of the earlier paintings we observed ruled lines incised into the ground, which served to position major compositional elements, and we observed other incised lines, more difficult to explain, in both *The Fortune-Teller* and *The Cheat with the Ace of Clubs*. But in the nocturnes our examinations have not yet revealed any evidence for a preparatory design below the paint. One possibility is that an underdrawing was used, but in a material that our examination methods cannot detect.[49] Another possibility is that a design was transferred from a cartoon in such an undetectable material; study of the two versions of the *Cheat* revealed that a number of features in one version could be exactly superimposed over the other, which could be evidence for the use of a cartoon.

The fact that our examinations did not always reveal the method by which La Tour laid out his composition does not imply that the artist worked experimentally, developing his composition directly on the canvas as he painted. On the contrary, all of these paintings give the impression of an artist with a definite idea of his final composition. In all works

the forms almost never overlap one another; the *pentimenti* we observed include only minor shifts of position, never a major reworking of the composition. The precision of La Tour's working procedure implies very strongly that even when our examinations did not reveal a preparatory design below the paint, La Tour's compositions were planned out in detail.

From the paintings examined, we feel that La Tour used a consistent palette throughout most of his career. The pigments massicot and malachite (yellow and green, respectively) were identified in a relatively early work (*Saint Philip*, cat. 7) but were replaced in later works by the more common lead-tin yellow and mixed greens. Otherwise, the pigments identified (the white pigments, chalk and lead white; the red pigments, vermilion and red lake; the blue pigment, azurite [and ultramarine in one painting]; a range of earth colors from yellow to brown; and blacks) appear to some degree in almost every painting. Though the balance of pigments chosen varies from a generous use of the brighter pigments in the most colorful daylight pictures to only small admixtures of these pigments in the muted nocturnes, the artist's choice of pigments seems to have been determined less by changes in his practice over time than by the requirements of the subjects he depicted. Brighter colors illuminated by the direct fall of natural light, especially in the decorative costumes of works such as *The Fortune-Teller*, require more strongly colored pigments; the simple costumes and subdued tonalities of the nocturnes call for a muted palette.[50]

Of the paintings we examined, the presumed earlier paintings, most particularly *The Musicians' Brawl* (cat. 9), are most loosely handled, while later works, such as the *Saint Peter Repentant* (cat. 24), are far more smoothly worked. But all the paintings are thinly worked over most of the surface, often in single layers of paint. By contrast with these thin paints, the artist's delicate final accents are applied in a richer, slightly impasted paint. La Tour used this final stage of painting to vary the surface and catch the light, with details such as corded braid on a costume (cat. 3) or a frayed edge of fabric (cat. 24). In night scenes he reworked highlights in this final stage to emphasize the light effects (cat. 22). A concern for silhouette appears in all the paintings, with figures set off from light backgrounds by a contour of lighter background paint, or dark forms lit from behind outlined with a warmer paint.

Though La Tour often applied his thin paints in single layers, it was characteristic of his practice occasionally to superimpose paint layers for very specific optical effects. Often these layerings seem counterintuitive, but their function is the modulation of tone as much as the creation of lights and darks. Liberal use of red lake glazes to emphasize shadows and folds of blue draperies appears in paintings throughout La Tour's career, and a black underpaint beneath the flesh has been observed in three of the nocturnes that have been examined. Under the shadows in the flesh of *Saint Peter*, the very dark paint contributes to the tone of the surface paint; under the highlights of two versions of the *Magdalene* it emphasizes the pallor of the flesh.

Technical investigation of these paintings has shown that shifts in the appearance of La Tour's paintings are mirrored by changes in his painting practice, from changes in the preparations of his canvases to changes in his palette. The individual appearance of the paintings is not only the result of his artistic vision but is clearly due also to his painting methods. The variations of La Tour's materials and technique that we observed from painting to painting can be explained by the varied needs of his compositions – from daylit scenes of richly dressed figures to night scenes of somberly dressed saints – but all are drawn from a consistent repertoire and applied with a remarkably consistent sensibility.

Notes

The close examination of these paintings would not have been possible without the generous cooperation of the staff at each of the lending museums. For their assistance and thoughtful discussions of the paintings we would like to thank Kenneth Bé, Alan Chong, and Marcia Steele at the Cleveland Museum of Art; Robert Frankel, Jefferson Harrison, and Catherine Jordan at the Chrysler Museum; Elisabeth Mention, Andrea Rothe, Yvonne Szafran, and Arie Wallert at the J. Paul Getty Museum; Isabelle Tokumaru at the Kimbell Art Museum; Joseph Fronek and Virginia Rasmussen at the Los Angeles County Museum of Art; Charlotte Hale, Dorothy Mahon, and Hubert von Sonnenburg at the Metropolitan Museum of Art; Marika Spring at the National Gallery, London; David Bull, Glenn Gates, and Suzanne Quillen Lomax at the National Gallery of Art, Washington; Carl Grimm and the late David Skipsey at the M. H. de Young Memorial Museum. Richard Collins and Joseph Baillio also facilitated examinations. Photographic departments of the Kimbell Art Museum and the National Gallery of Art have been most helpful. We are particularly grateful to our colleagues Philip Conisbee and Edmund Pillsbury, who read and commented on drafts of this essay.

1. Analytical techniques included reflected light and transmitted polarized light microscopy, scanning electron microscopy with energy dispersive x-ray powder spectroscopy (SEM/EDS), and x-ray diffraction (XRD).

2. La Tour's painting practice has been the object of heightened interest since the 500th anniversary of his birth in 1993. See the catalogue of the Vic-sur-Seille exhibition (1993), and the publication of papers presented at a colloquium held in conjunction with the exhibition, Reinbold et al. 1994.

3. These two paintings were examined in the conservation department of the M. H. de Young Museum, San Francisco. Paint cross sections and dispersed pigment samples were taken for analysis at the National Gallery of Art by Michael Palmer.

4. *Old Man* measures 91 x 60.5 cm, and *Old Woman*, 91.5 x 60.5. Our conclusion is based upon a survey of the measurements given for the illustrated works in Thuillier 1992, 281–297.

5. Bergeon and Martin 1994, 70–71, cites a number of examples in French paintings, both of a purely linear compositional sketch and of a more fully worked grisaille, which established patterns of light and shadow.

6. This painting was examined in the painting conservation department of the National Gallery of Art. Paint cross sections and dispersed pigment samples were taken for analysis at the National Gallery of Art by Michael Palmer.

7. Jean-Paul Rioux in Vic-sur-Seille 1993, 34–47, n. 15, describes similar, predominantly chalk grounds on paintings that are generally felt to fall early in La Tour's career, including two other works from the Albi series of Apostles, *Saint James the Less* and *Saint Judas Thaddeus*.

8. This painting was examined in the conservation department of the J. Paul Getty Museum. We were able to consult paint cross sections analyzed by Arie Wallert during the course of conservation treatment by Elisabeth Mention in 1987.

9. The off-white ground was applied in several layers. The layers were applied separately with different amounts of binding medium. The ground is not toned, but it has yellowed and has a translucent quality.

10. Although it is possible that La Tour painted other works in this way, this evidence is not preserved. In *The Musicians' Brawl* unpainted margins along all of the edges expose the ground. During conservation treatment in 1987 a narrow strip of canvas that had been added to the upper edge in an old restoration was removed (conservation report by Elisabeth Mention, on file at the J. Paul Getty Museum).

11. This is similar to the appearance of the faces in the x-radiograph of the Lviv *Payment of Taxes*. See the x-radiographs of *The Musicians' Brawl* and *The Payment of Taxes* published in Vic-sur-Seille 1993, 51 and 111.

12. *The Cheat with the Ace of Clubs* was examined in the conservation department of the Kimbell Art Museum. A number of paint cross sections were analyzed by Joyce Plesters at the National Gallery, London, in 1981 during the conservation treatment by John Brealey at the Metropolitan Museum of Art (analysis results reported in unpublished letter, Joyce Plesters to John Brealey, dated 1 May 1981, registrar's files, Kimbell Art Museum). We were able to consult these samples with Marika Spring at the National Gallery, and further analysis was carried out by Barbara Berrie at the National Gallery of Art, Washington. *The Cheat with the Ace of Diamonds* was examined visually while hanging in the galleries at the Louvre. The results of a technical study of that painting were published by Rioux in Vic-sur-Seille 1993, 34–47.

13. Rioux in Vic-sur-Seille 1993, 39–40.

14. The chalk layer appears somewhat yellowish through staining by old varnish or paint medium; and medium from an added secondary support appears gray when viewed with a stereomicroscope on the painting itself. There are traces of the lining adhesive in some of the cross sections.

15. La Hyre 1730, [423]–488 (the pagination of different editions dated 1730 seems to vary; we are grateful to Jo Kirby and Ashok Roy for this information). La Hyre reports that one can retrace a drawing on which the reverse has been rubbed with black or white chalk, or one can dust color through holes pierced in a cartoon. He also describes stretching a thin veil over a painting and tracing the composition with chalk, then laying the silk over a new, primed canvas and gently rubbing the silk to transfer the design (pp. 432–436). After it had been painted over, chalk would be imperceptible with infrared reflectography, x-radiography, or microscopic examination.

16. Bergeon and Martin 1994, 70, notes such painted sketches in red lake as well as brown. The authors have observed painted sketches varying from brown to red within one work (for example in a painting attributed to Johannes Vermeer, *Young Girl with a Flute*, National Gallery of Art, Washington, 1942.9.98) La Tour shifted the maidservant and the left arm of the cheat

to the right, and here the brown brush sketch corresponds with the second positions of these figures. Infrared reflectography revealed that the maidservant's profile was laid out using a broad linear brush sketch. Since the Paris painting was not examined microscopically, it is not yet known whether a brown or red sketch exists in this painting as well.

17. One possibility is that these incisions served in some way as markings to place a cartoon. The x-radiograph of *The Cheat* revealed a painted vertical line at the center of the composition, which could also have served as a placement guide. See the appendix to the present catalogue for further discussion.

18. Plesters 1981.

19. Rioux in Vic-sur-Seille 1993, 40–43.

20. The approach conforms to La Tour's usual practice, as seen in the Grenoble and Stockholm versions of *Saint Jerome* or in the Paris and Los Angeles versions of *The Magdalene with the Smoking Flame*. See Rodis Lewis 1993, 69–84; Elisabeth Martin in Reinbold et al. 1994, 17–40. See p. 19 for a discussion of two versions of the *Saint Jerome*.

21. See also Nicolson and Wright 1974, 20.

22. Martin in Vic-sur-Seille 1993, 89–91.

23. It is true that an earlier state of the Paris version can be related to the final Fort Worth composition in one detail: in the Louvre version, the color of the servant's bodice was changed from red to blue. Examination of craquelure with a binocular loupe reveals the presence of a bright red layer underlying the blue bodice. This detail appears very light in the x-radiograph, owing to the presence of vermilion, which is radiopaque. None of the pigments present in the dark blue bodice (including azurite) is x-ray opaque.

24. See also the appendix to this catalogue for further discussion on the relationship between these two paintings. When a tracing of the Fort Worth *Cheat* was superimposed over the Paris painting, all of the heads and hands (with the exception of the dupe's hands, which are shifted slightly away from his body, and the courtesan's left hand) overlapped.

25. See Plesters 1981: Plesters reports that the ground is similar to that of *The Cheat with the Ace of Clubs* (although she describes it as "brown"), which has an off-white (now yellowed) chalk ground.

26. Most of the incisions in the New York painting appear in the red dress of the old gypsy woman on the far right, where some of the lines, visible below her elbow, seem to follow the contour of her sleeve. There are also crisscrossed incisions in the right hand (holding the clippers) of the young gypsy woman in the center; another crossed incision appears slightly below and to the right of this. A diagonal incision runs through the loop of hair in the black-haired gypsy on the left, and another incision intersects the top of her head, running diagonally down to the right.

27. *The Fortune-Teller* was examined in the painting conservation department of the Metropolitan Museum of Art, New York. We were able to consult a sample that had been analyzed by Joyce Plesters at the National Gallery, London, at the time of the conservation treatment by John Brealey in 1981 (see Plesters 1981). The results of a full technical study of this painting were published in part in Brealey and Meyers 1981, 422, 425.

28. Individual pigments in *The Fortune-Teller* were identified by micro-chemical tests, x-ray powder diffraction analysis, and examination of paint cross sections (Plesters 1981; Brealey and Meyers 1981).

29. The painting was examined in the conservation department of the Cleveland Museum of Art. We were able to consult dispersed pigment samples taken by Bruce Miller. Additional paint cross sections were taken for analysis at the National Gallery of Art by Barbara Berrie. The picture was recently cleaned and restored by Kenneth Bé, Cleveland Museum of Art, who removed opaque overpaint, which covered La Tour's translucent paints, especially in the lantern and on Saint Peter's cloak; this has revealed the luminous effects of the original. The condition is generally good, though there is general cracking and slight lifting of the paint. A heavy lead white adhesive lining somewhat obscures the image in x-radiographs.

30. These materials would have increased the transparency of the paint mixtures. In particular chalk, which appears white in air, is virtually transparent when used in an oil medium, because its refractive index is very close to that of oil.

31. The layers of this painting each measure only 10 to 20 microns (thousandths of a millimeter) thick.

32. Martin and Reinbold 1994, 79–84, describes similar grounds on the *Hurdy-Gurdy Player* in Remiremont; the *Magdalene with the Smoking Flame* at Los Angeles (which we have also analyzed: see text); the *Saint Jerome* at Nancy; *The Newborn Child* at Rennes; and the *Job and His Wife* at Epinal (82 and n. 22). The composition of the particles we observed is comparable to a group of grounds that have low iron content in a published survey of French seventeenth- and eighteenth-century grounds; in this survey of 155 paintings such grounds were infrequently found compared to red and yellow ocher grounds. See Duval 1992, 239–258, esp. 252.

33. Pierre Le Brun (1635), reprinted in Merrifield 1967, 759–841. "The Brussels Manuscript" is a manuscript housed in the Public Library in Brussels, no. 15552, titled *Recueil des Essaies des Merveilles de la Peinture*, by Pierre Le Brun, an artist.

34. Dubus, Bouquillon, Querré 1994, 111–124.

35. Le Brun in Merrifield 1967, 820–821, and de Mayerne 1974, 146, both describe a special way of creating blue draperies by underpainting in black or bright white and then strewing powdered azurite onto the underpaint. We do not know if this is exactly how La Tour created the cuff, though he did use a bright white underlayer.

36. Analysis of the Washington *Magdalene at the Mirror* was undertaken in conjunction with the conservation treatment by David Bull in 1992. The Washington and Los Angeles paintings were examined in the conservation department of the National Galley of Art. Dispersed pigment samples and paint cross sections were taken for analysis at the National Gallery of Art

by Melanie Gifford. The privately owned painting was examined at the National Gallery without taking paint samples, thus only limited conclusions can be drawn about the painting materials of this work. Preliminary reports on the technical studies of the Washington and Los Angeles paintings appeared in papers presented at the annual meetings of the American Institute for Conservation in Nashville in 1994 and the College Art Association in San Antonio in 1995.

37. The ground of the Los Angeles work includes a small amount of dolomite, $CaMg(CO_3)_2$, as well as calcium carbonate, $CaCO_3$. In cross section these grounds appear amorphous brown, but on the painting itself – the color that the artist would have seen while working – they are distinctly gray.

38. As noted, paint samples were not taken from the third, privately owned, painting. Through the stereomicroscope, however, the paints are very similar to the other two works, both in the color and size of the pigment particles.

39. Suzanne Quillen Lomax carried out medium analysis by gas chromatography on samples from the Washington painting; the results are consistent with a walnut oil medium, which seems to have been the preferred medium for French painters of the period (La Hyre 1730, 472–473; Bergeon and Martin 1994, 72).

40. As noted above (note 30) chalk is virtually transparent in oil paint.

41. A number of La Tour's paintings show a form of crackle that seems primarily restricted to this final reworking of the highlights, as it is in the Washington Magdalene. Analysis of the lightest undegraded highlights on the Washington painting and the undegraded Los Angeles painting were compared to a degraded highlight from the Washington work. No difference in paint medium between degraded or undegraded paint was found, nor was a layer between the two types of paint found that could explain the damage. To date, the only difference appears to be the addition of lead-tin yellow and a substantial proportion of chalk to the pigment mixture. The crackle could have been caused by a fast-drying paint used over a slower-drying one.

42. Though the Washington painting is abraded, traces of such red lines can be seen, for example, along the heel of the hand on which the Magdalene rests her chin.

43. Another privately owned painting, a copy after a composition close to the Washington Magdalene at the Mirror, was also examined at the National Gallery conservation department; no paint samples were taken. The handling of this painting, which closely reproduces a composition by La Tour, is instructive, for the handling does not correspond to the other nocturnes, in particular the Magdalenes, which we have examined. The paint of the copy is generally opaque – for example, in the hair falling against the cheek. This passage in the Washington painting is almost transparent, exploiting the warmth of the yellow upper ground below; even in the more opaque Los Angeles work the loop of hair falling forward is painted in a transparent red lake. The basic painting sequence begins with midtones, as does La Tour's sequence, but highlights were laid on next, and the painting was finished with the darkest shadows. Most tellingly, there is no sign of La Tour's almost obsessive reworking and amplification of the final highlights.

44. Bergeon and Martin 1994 is a very useful survey of many technical studies by researchers at the Louvre.

45. The weave density of the canvas La Tour used for the Saint Peter Repentant changes midway through the painting.

46. The weave texture of the paintings has almost certainly been somewhat exaggerated through old restoration treatments, but it is no more pronounced than many canvas paintings of this period.

47. Elisabeth Martin has put forward a theory of chronology based on the composition of the grounds, from early chalk grounds, through increasingly toned grounds, to late colored grounds (see Martin 1994, 23–24, for a summary). In the small number of paintings we have examined, our findings generally do confirm the use of chalk grounds in some earlier pictures and gray grounds in three nocturnes. Further studies may confirm these general trends, but it is unlikely that the artist's choice of materials followed a strictly linear development at every point in his career.

48. Martin and Reinbold 1994, note the presence of dolomite in the grounds of a Hurdy-Gurdy Player in Remirement and of the Saint Jerome in Nancy (82 n. 21).

49. Both red and white chalk, for example, would not be visible using infrared reflectography, as an underdrawing in a black material would be. Neutron autoradiography has great potential for imaging hidden sketches using the manganese-containing brown pigment umber, but only two paintings attributed to La Tour have been examined with this technique to date (see appendix to this catalogue).

50. In this context it is worth emphasizing the importance of a light colored ground for true color rendition in thinly handled paintings. La Hyre noted that some artists chose white distemper grounds (which must be similar to La Tour's chalk grounds) to maintain the purity of their colors (La Hyre 1730, 476).

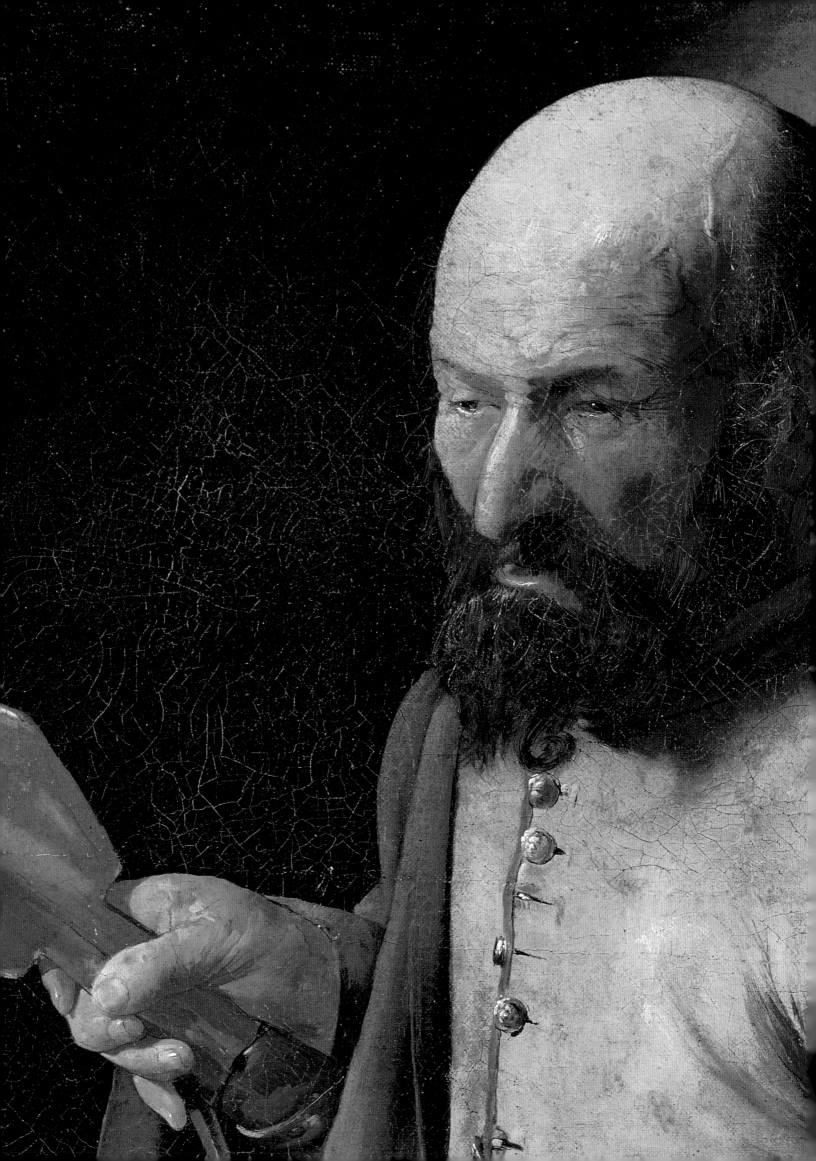

Catalogue of
the Exhibition

PHILIP CONISBEE

Works by, after, or attributed by some authorities to Georges de La Tour

Listed in chronological order. In the absence of secure dates (with the exception of cat. 24, *Saint Peter Repentant*, dated 1645), the given dates for works by and attributed to La Tour are the author's suggestions.

1. Georges de La Tour, *The Payment of Taxes*, c. 1618–1620

canvas, 99 x 152 (39 x 59^{13}⁄₁₆)

signed lower left: *De la Tour* [and illegibly dated]

Lviv Picture Gallery, Ukraine

DATING: La Tour attribution, mid-1640s (Tcherbatchova 1970); 1616–1620 or after 1633, or 1638? (Rosenberg and Thuillier 1972); 1616–1625 (Blunt 1972); c. 1616 (Rosenberg and Macé de l'Epinay 1973); early 1620s (Ottani Cavina 1972); 1616–1618 or 1621–1624 (Thuillier 1973a); 1615–1616 (Nicolson and Wright 1974); 1634 (Linnik 1975); c. 1615–1616 (Rosenberg and Mojana 1992); early period (Thuillier 1992); the earliest surviving painting by La Tour (Rosenberg in Nancy 1992a).

PROVENANCE: Reportedly, General Charles Eugène Lambesc (1754–1825) of the house of Lorraine (Nancy 1992a, 282). At the beginning of the nineteenth century acquired by L. Dombsky (1751–1824), Lviv, under the name of Honthorst (appeared as no. 26 in an inventory of his collection). Passed later to the Lubomirski museum, a dependency of the Ossolinski museum; 1940, to the museum of Lviv, attributed to Theodore Rombouts.

EXHIBITED: Paris 1972, no. 32; Nancy 1992a, no. 91.

SELECTED LITERATURE: Tcherbatchova 1970, 108–114 [first attribution to La Tour]; Bloch 1972, 292; Blunt 1972, 516, 519, 523, 525; Ottani Cavina 1972, 6–7; Pariset 1972, 210; Rosenberg and Thuillier 1972, 236–237, no. 32; Grossmann 1973, 583; Rosenberg and Macé de l'Epinay 1973, 88–89, no. 1; Solesmes 1973, 22, 154; Thuillier 1973a, no. 1; Nicolson and Wright 1974, 190, no. 51; Zolotov 1974, 62–63; F. Bologna 1975, 438; Linnik 1975, 56–59; Rosenberg 1976, 453; Schleier 1976, 237; Spear 1976, 234–235; Wright 1977, no. 20; Zolotov 1977, 75; Brigstocke 1982, 10; Cuzin 1982, 527; Solesmes 1982, 154; Schleier 1983, 197; Sylvestre 1985, 49–50; Thuillier 1985, no. 19; Wright 1985, 43–44; Nicolson 1989, 35; Rosenberg and Mojana 1992, 86–87, no. 28; Thuillier 1992, 117, 285, no. 23; Vic-sur-Seille 1993, 110–111.

PRECEDING PAGE:
Detail, cat. 13

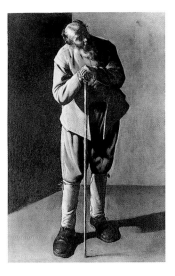

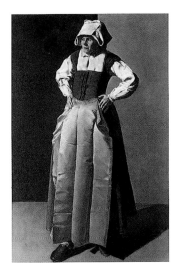

2. Georges de La Tour, *Old Man*, c. 1618–1620

canvas, 91 x 60.5 (36 x 23⅝)

The Fine Arts Museums of San Francisco, Roscoe and Margaret Oakes Collection

3. Georges de La Tour, *Old Woman*, c. 1618–1620

canvas, 91.5 x 60.5 (36 x 23⅝)

The Fine Arts Museums of San Francisco, Roscoe and Margaret Oakes Collection

DATING: 1620s (Bloch 1954); earliest surviving peasant scenes, 1616–1625 (Blunt 1972); earliest surviving genre pictures, slightly before the Albi Apostles and *The Musicians' Brawl* (Rosenberg and Thuillier 1972); very early works (Thuillier 1973a); among La Tour's earliest works, after the *Payment of Taxes* and just before the Albi Apostles (Rosenberg and Macé de l'Epinay 1973); c. 1618/1619 (Nicolson and Wright 1974); after 1620 (Rosenberg and Mojana 1992); "perhaps somewhat earlier than has always been admitted" (Thuillier 1992).

PROVENANCE: 1949, Holzscheiter Collection, Meilen (Switzerland). Acquired in 1956 by the De Young Memorial Museum, San Francisco, with funds from the Roscoe and Margaret Oakes Foundation.

EXHIBITED: Rome 1956, nos. 158 and 159; Cleveland 1971, nos. 40 and 41 ("attributed to"); Paris 1972, nos. 1 and 2; Denver/New York/Minneapolis 1978–1979, nos. 25 and 26; Paris/New York/Chicago 1982, nos. 35 and 36.

SELECTED LITERATURE: Bloch 1954, 81–82; Pariset 1955c, 86–87; Grossmann 1958, 91; Tanaka 1969, 181; Blunt 1972, 519, 523; Nicolson 1972, 117; Pariset 1972, 207; Rosenberg and Thuillier 1972, 119–121, nos. 1 and 2; Solesmes 1973, 38–39, 154; Thuillier 1973a, 87, nos. 2 and 3; Rosenberg and Macé de l'Epinay 1973, 90–91, figs. 2, 3; Nicolson and Wright 1974, 196–197, nos. 61 and 62; Wright 1977, nos. 2 and 3; Kellog Smith 1979, 288–293; Paris/New York/Chicago 1982, 253–254; Rosenberg and Stewart 1987, 61–64; Rosenberg and Mojana 1992, 27–29, nos. 8 and 9; Thuillier 1992, 77, 79–81, 285, nos. 21 and 22.

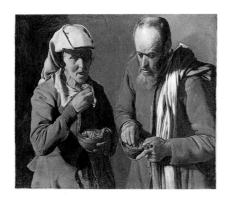

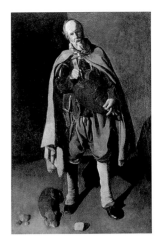

4. Georges de La Tour, *Old Peasant Couple Eating,*
c. 1620–1622

canvas, 74 x 87 (29⅛ x 34¼)

Staatliche Museen zu Berlin, Gemäldegalerie

DATING: Before 1618–1619 (F. Bologna 1975); early 1620s
(Schleier 1976); c. 1618 (Rosenberg and Mojana 1992);
early period (Thuillier 1992); after our cats. 6–9 (Rosen-
berg in Nancy 1992a).

PROVENANCE: Discovered and identified by Ferdinando
Bologna in a private collection at Lugano in 1971 (cut
vertically in two pieces; brought together again and re-
stored by John Brealey); acquired by the Berlin Museum
in 1976.

EXHIBITED: Berlin 1980, no. 7; Nancy 1992a, no. 93.

SELECTED LITERATURE: F. Bologna 1975, 434–440; Rosen-
berg 1976, 452; Schleier 1976, 231–241; Spear 1976, 235;
Nicolson 1979, 65; Wright 1977, no. 4; Solesmes 1982, 154;
Schleier 1983, 197; Bajou 1985, 9; Sylvestre 1985, 53; Thuil-
lier 1985, no. 1; Prohaska 1987, 14; Rosenberg 1991, 705;
Rosenberg and Mojana 1992, 14–15, no. 1; Nancy 1992a,
286, no. 93; Thuillier 1992, 73–75, 285, no. 24.

5. Georges de La Tour, *The Hurdy-Gurdy Player
with a Dog,* c. 1620–1622

canvas, 186 x 120 (73¼ x 47¼)

Musée de Bergues

DATING: c. 1622 (Rosenberg and Thuillier 1972); c. 1622
(Rosenberg and Macé de l'Epinay 1973); earliest version
of this subject, just before the Albi Apostles (Thuillier
1973a); c. 1616–1619 (Nicolson and Wright 1974); c. 1622
(Rosenberg and Mojana 1992); earliest version of this
subject (Thuillier 1992); c. 1620–1625 (Rosenberg in
Nancy 1992a).

PROVENANCE: Mentioned in 1791 in an inventory of furni-
ture and works of art held at the abbey of Saint-Winoc in
Bergues. Cited in 1795 among the paintings seized during
the Revolution in the District of Bergues. Allocated to the
museum of Bergues in 1838.

EXHIBITED: Paris 1934 (not in catalogue); London 1958,
no. 27 ("atelier"); Paris 1958, no. 75 ("atelier"); Paris 1972,
122–125, no. 3; Paris 1980–1981, no. 195; Nancy 1992a,
288–289, no. 94; Madrid 1994, 70–71, no. 1.

SELECTED LITERATURE: Pariset 1948, 298–299; Bloch 1950,
51, no. 3c; Sterling 1951, 152; Rome 1956, 151–152; Nicolson
1958a, 98; Pariset 1962b, 148; Bougier 1963, 145–146;
Rosenberg and Thuillier 1972, 122–123, no. 3; Rosenberg
and Macé de l'Epinay 1973, 102–103, no. 17; Solesmes
1973, 59, 154; Thuillier 1973a, 87, no. 6; Nicolson and
Wright 1974, 195, no. 58; Wright 1977, no. 8; Rosenberg and
Mojana 1992, 30–31, no. 10; Thuillier 1992, 284, no. 16;
Nancy 1992a, 288–289, no. 94; Vic-sur-Seille 1993, 82, 83.

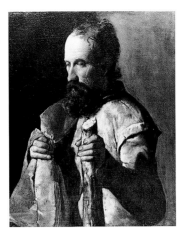

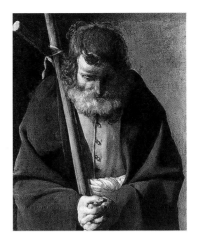

6. Georges de La Tour, *Saint James the Less,*
c. 1624

canvas, 66 x 54 (26 x 21¼)

Musée Toulouse-Lautrec, Albi

DATING: c. 1625 (Rosenberg and Thuillier 1972); 1620–1627
(Blunt 1972); early period (Thuillier 1973a); c. 1620–1625
(Rosenberg and Macé de l'Epinay 1973); c. 1621–1623
(Nicolson and Wright 1974); c. 1620–1625 (Rosenberg and
Mojana 1992); early period (Thuillier 1992); 1620–1625
(Rosenberg in Montreal/Rennes/Montpellier 1993).

PROVENANCE: Part of a series of thirteen paintings representing Christ and the twelve Apostles, mentioned at the
cathedral of Albi as early as 1698 and still there until at
least 1795, when they are mentioned in an inventory after
the French Revolution. About that time or shortly afterward the canvases underwent restoration, and nine were
replaced by copies. *Saint James the Less* is one of the two
originals still in Albi. Rediscovered in the museum of Albi
and published by René Huyghe in 1946.

EXHIBITED: Paris 1948, no. 482 (as "Saint André"); Paris
1972, no. 4; Montreal/Rennes/Montpellier 1993, no. 25.

SELECTED LITERATURE: A) On the whole series Christ and
the Apostles (copies and originals), Huyghe 1946, 255–258;
Jamot 1948, 83; Pariset 1948, 231–235, 399; Bloch 1950,
52 (copies); Sterling 1951, 150 (copies); Pariset 1955c, 84;
Tanaka 1969, 27–28, 119–120; Bougier 1963, 93–97;
Rosenberg and Thuillier 1972, 127–134, 239–240,
nos. 4–7, 34–42; Pariset 1973, 69–70; Thuillier 1973a, 88,
nos. 7–19, copy no. 16; Rosenberg and Macé de l'Epinay
1973, 92–99; Nicolson and Wright 1974, 164, no. 8, 187, no.
45. B) On this painting, Huyghe 1946, 256; Rosenberg and
Thuillier 1972, 126–128, no. 4; Thuillier 1973a, no. 12;
Rosenberg and Macé de l'Epinay 1973, 92–93,
no. 4; Nicolson and Wright 1974, 168–169, no. 17; Rosenberg and Mojana 1992, 24–25, no. 6; Thuillier 1992, 52,
56–57, 283, no. 7.

7. Georges de La Tour, *Saint Philip,* c. 1624

canvas, 63.3 x 53.3 (25 x 21)

The Chrysler Museum, Norfolk, Gift of Walter P.
Chrysler Jr.

DATING: See cat. 6.

PROVENANCE: See cat. 6. In 1941 acquired in an auction by
M. Czinober. Private collection, U.S., 1971; private collection, Switzerland, 1973; collection of Walter P. Chrysler,
1975. Entered the Chrysler Museum in 1977.

EXHIBITED: Paris 1972, no. 6.

SELECTED LITERATURE: A) On the whole series of Christ
and the Apostles (copies and originals): see cat. 6. B) On
this painting: Bloch 1947, 137; Pariset 1948, 234–235; Bloch
1950, 52, no. 6; Sterling 1951, 155; Bougier 1963, 95; Blunt
1972, 523; Rosenberg and Thuillier 1972, 130–131, no. 6;
Rosenberg and Macé de l'Epinay 1972, 92–93, no. 6; Thuillier 1973a, 88, no. 13; Nicolson and Wright 1974, 181–182,
no. 40; Rosenberg and Mojana 1992, 18–19, no. 3; Thuillier
1992, 55, 283, no. 9.

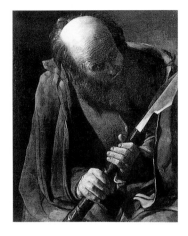

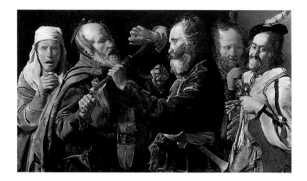

8. Georges de La Tour, *Saint Thomas*, c. 1624

canvas, 64.6 x 53.9 (25⁷⁄₁₆ x 21¼)

Ishizuka Tokyo Collection

DATING: See cat. 6.

PROVENANCE: See cat. 6. Christie's, London, 10 December 1993, no. 41.

EXHIBITED: Never.

SELECTED LITERATURE: A) On the whole series of Christ and the Apostles (copies and originals): see cat. 6. B) On this painting: Rosenberg and Mojana 1992, 22–23, no. 5; Thuillier 1992, 51, 283, no. 8.

9. Georges de La Tour, *The Musicians' Brawl*, c. 1625–1627

canvas, 94.4 x 141.2 (37³⁄₁₆ x 55⁵⁄₁₆)

Collection of the J. Paul Getty Museum, Los Angeles

DATING: Late 1620s (Nicolson and Wright 1971); c. 1625–1630 (Rosenberg and Thuillier 1972); 1620–1627 (Blunt 1972); c. 1625–1630 (Rosenberg and Macé de l'Epinay 1973); c. 1625–1630? (Thuillier 1973a); c. 1627–1630 (Nicolson and Wright 1974); c. 1620–1625 (Schleier 1976); closer in date to the Albi Apostles (Cuzin 1982); c. 1625–1630 (Rosenberg and Mojana 1992); early period (Thuillier 1992).

PROVENANCE: Lord Trevor, at Brynkynallt, Chirk, Denbighshire, Wales, in 1928, inventoried as a Caravaggio. Christie's, London, 8 December 1972, no. 99, and acquired by the J. Paul Getty Museum.

EXHIBITED: Paris 1972, 134–137, no. 8; Tokyo/Kyoto 1976, 17, no. 29; Paris/New York/Chicago 1982, 77, 255, no. 37; Nancy 1992a, 284–285, no. 92; Vic-sur-Seille 1993, 48–52; Madrid 1994, 73–75, no. 2.

SELECTED LITERATURE: Arland 1953, no. 3; Pariset 1958, 106; Schleier 1976, 238; Nicolson and Wright 1971, 668–670; Blunt 1972, 519, 523; Rosenberg and Thuillier 1972, 135, no. 8; Solesmes 1973, 55, 154; Thuillier 1973a, 89, no. 22; Rosenberg and Macé de l'Epinay 1973, 110–111, no. 21; Nicolson and Wright 1974, 192–193, no. 56; Wright 1977, no. 5; Nicolson 1979, 65; Cuzin 1982, 527; Ribault 1984, 1–4; Rosenberg and Mojana 1992, 33–37, no. 11; Thuillier 1992, 283–284, no. 14; Nancy 1992a, 284–285, no. 92; Vic-sur-Seille 1993, 48–52, 84, 86; Madrid 1994, 73–74.

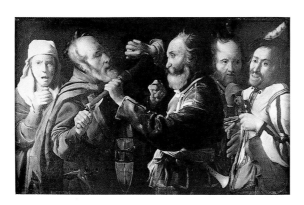

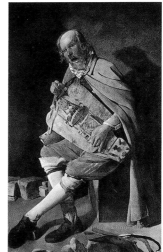

10. After Georges de La Tour, *The Musicians' Brawl* (original c. 1625–1627)

canvas, 83 x 136 (32¹¹⁄₁₆ x 53⁹⁄₁₆)

Musée des Beaux-Arts, Chambéry

PROVENANCE: Donated to the museum by Etienne Rey in 1832.

EXHIBITED: Paris 1934, no. 50; Paris 1972, no. 46.

SELECTED LITERATURE: Nicolson and Wright 1971, 669–670; Rosenberg and Thuiller 1972, 244, no. 46; Rosenberg and Macé de l'Epinay 1973, 110–111; Thuillier 1973a, 89, no. 22a; Nicolson and Wright 1974, 193, under no. 56; Rosenberg and Mojana 1992, 33; Thuillier 1992, 283, under no. 14; Nancy 1992a, 284; Vic-sur-Seille 1993, 48–53.

11. Georges de La Tour, *The Hurdy-Gurdy Player*, c. 1628–1630

canvas, 162 x 105 (63¾ x 41⁵⁄₁₆)

Musée des Beaux-Arts, Nantes

DATING: Late 1620s (Blunt 1972); c. 1630 (Rosenberg and Thuillier 1972); c. 1631–1636 (Thuillier 1973a); relatively early (Rosenberg and Macé de l'Epinay 1973); c. 1631–1634 (Nicolson and Wright 1974); c. 1620–1625 (Rosenberg and Mojana 1992); c. 1631–1636 (Thuillier 1992); the latest of the known paintings of this subject (Rosenberg in Nancy 1992a).

PROVENANCE: 1810, acquired with the Cacault Collection by the town of Nantes; 1830, transferred to the recently established museum in Nantes.

EXHIBITED: Paris 1934, no. 51; London 1958, no. 24; Paris 1958, no. 72; Paris 1972, 138–141, no. 9; Nantes 1980, 93–97; Bourg-en-Bresse 1985, no. 19; Nancy 1992a, 294–295, no. 97; Madrid 1994, 84–85, no. 6.

SELECTED LITERATURE: Voss 1931, 99–100; Blunt 1945, 108–111; Pariset 1948, 290–297; Blunt 1972, 523; Rosenberg and Macé de l'Epinay 1973, 108–109, no. 20; Solesmes 1973, 52, 154; Thuillier 1973a, 89, no. 25; Nicolson and Wright 1974, 193–194, no. 57; Wright 1977, no. 9; Rosenberg and Mojana 1992, 44–45, no. 15; Thuillier 1992, 284–285, no. 20; Vic-sur-Seille 1993, 108–109.

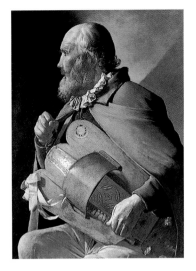

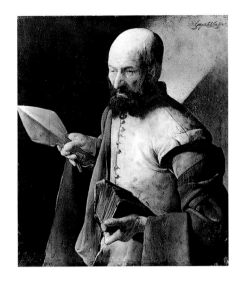

12. Georges de La Tour, *The Hurdy-Gurdy Player*, c. 1630–1632

canvas, 84.7 x 61 (33⅜ x 24)

Museo del Prado, Madrid

DATING: Latest of extant paintings of this subject, c. 1620–1630 (Rosenberg and Mojana 1992); before the Nantes *Hurdy-Gurdy Player* (Thuillier 1992).

PROVENANCE: British art market, 1986; private collection Japan; Christie's, London, 13 December 1991, no. 54, and acquired by the Prado.

EXHIBITED: Nancy 1992a, 290–291, no. 95; Madrid 1994, 81–83, no. 5.

SELECTED LITERATURE: Rosenberg 1990, 169–178, 248–249; Rosenberg 1991, 704–705; Rosenberg and Mojana 1992, 42–43, no. 14; Thuillier 1992, 284–285, no. 19; Nancy 1992a, 290–291, no. 95; Madrid 1994, 81–83, no. 5.

13. Georges de La Tour, *Saint Thomas*, c. 1628–1632

signed upper right: *Georguis de La Tour fecit*

canvas, 69.5 x 61.5 (27⅜ x 24³⁄₁₆)

Musée du Louvre, Paris

DATING: Later than Albi Apostles (Thuillier 1973a); between the *Hurdy-Gurdy Player*s and the *Saint Jerome*s (Rosenberg and Macé de l'Epinay 1973); c. 1620–1621 (Nicolson and Wright 1974); 1625–1630 (Rosenberg and Mojana 1992); later than Albi Apostles (Thuillier 1992); 1625–1630 (Rosenberg in Nancy 1992a).

PROVENANCE: Before the Second World War in the collection of the Marquis de Ruillé, Château de Gallerande, near Luché-Pringé, France; by inheritance to the Order of Malta; acquired in 1988 by the Louvre through a national subscription.

EXHIBITED: 1988, shown in Paris, Nantes, Bordeaux, Lyon, Marseille, Saint-Etienne, Nancy, Roubaix, Lille, and Toulouse; Paris 1989a (without catalogue); Paris 1991–1992, 78–80; Nancy 1992a, 244–246, no. 70.

SELECTED LITERATURE: Pariset 1955c, 84; Pariset 1963a, 60; Pariset 1973, 69; Rosenberg and Macé de l'Epinay 1973, 118–119, no. 25; Solesmes 1973, 151, 157; Thuillier 1973a, 90, no. 27; Nicolson and Wright 1974, 187–188, no. 46; F. Bologna 1975, 438; Spear 1976, 235; Nicolson 1979, 65; Solesmes 1982, 151, 157; Bajou 1985, 113; Rosenberg 1988, 83, 325–330; Nicolson 1989, 134; Rosenberg and Mojana 1992, 50–51, no. 18; Thuillier 1992, 120–123, 286, no. 29; Nancy 1992a, 244–246, no. 70; Vic-sur-Seille 1993, 112–113.

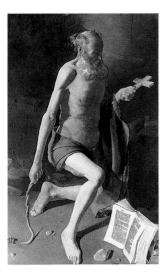

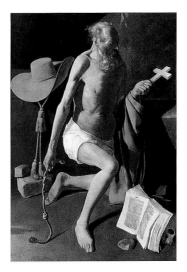

14. Georges de La Tour, *Saint Jerome,*
c. 1628–1630

canvas, 157 x 100 (61¹³⁄₁₆ x 39⅜)

Musée de Grenoble

DATING: c. 1630–1635 (Rosenberg and Thuillier 1972);
late 1620s (Blunt 1972); earlier than the Stockholm version
(Rosenberg and Macé de l'Epinay 1973); later than the
Stockholm version (Thuillier 1973a); earlier than the
Stockholm version, 1621–1623 (Nicolson and Wright
1974); earlier than the Stockholm version (Spear in Cleve-
land 1971); 1625–1630 (Rosenberg 1992); earlier than
the Stockholm version (Thuillier 1992); earlier than the
Stockholm version (Rosenberg in Nancy 1992a).

PROVENANCE: Probably belonged originally to the Abbey
of Saint-Antoine-en-Viennois, where works by La Tour are
mentioned in 1701 (see Nicolson and Wright 1974, no. 21).
Confiscated during the Revolution and given in 1799 to the
museum of Grenoble.

EXHIBITED: Paris 1935, no. 72 (Juan Bautista Mayno?);
Paris 1937, no. 88; Zurich 1946, no. 51; Rome 1956, no. 162;
London 1958, no. 22; Paris 1958, no. 69; Stockholm 1958,
no. 33; Berne 1959, no. 42; Paris 1972, 142–143, no. 10;
Nancy 1992a, no. 71.

SELECTED LITERATURE: Voss 1931, 99; Pariset 1948, 214–
222; Grate 1959, 15–24; Blunt 1972, 523; Rosenberg and
Macé de l'Epinay 1973, 124–125, no. 28; Solesmes 1973, 50,
158; Thuillier 1973a, 91, no. 31; Nicolson and Wright 1974,
170–171, no. 21; Spear 1976, 234; Rosenberg and Mojana
1992, 48–49, no. 17; Thuillier 1992, 125, 287, no. 32; Nancy
1992a, 246–247, no. 71; Vic-sur-Seille 1993, 97, 118–121.

15. Georges de La Tour, *Saint Jerome,*
c. 1630–1632

canvas, 152 x 109 (59¹³⁄₁₆ x 42¹⁵⁄₁₆)

Nationalmuseum, Stockholm

DATING: Later than Grenoble version (Grate 1959); c. 1630–
1635 (Rosenberg and Thuillier 1972); late 1620s (Blunt
1972); later than Grenoble version (Thuillier 1973a); earlier
than Grenoble version, 1630s (Rosenberg and Macé de
l'Epinay 1973); c. 1624–1627 (Nicolson and Wright 1974);
later than Grenoble version (Thuillier 1992); c. 1625
(Rosenberg and Mojana 1992).

PROVENANCE: Before 1917, Count Axel Bielke; the painter
J. Boklund; his stepson, also a painter, Oscar Björck; en-
tered the Nationalmuseum in 1917.

EXHIBITED: Paris 1934, no. 52; Paris 1972, no. 11; Stockholm
1988, no. 20.

SELECTED LITERATURE: Voss 1931, 99; Pariset 1948, 214–
222; Grate 1959, 15–24; Thuillier 1973a, 90, no. 26; Rosen-
berg and Macé de l'Epinay 1973, 122–123, no. 27; Solesmes
1973, 49, 158; Nicolson and Wright 1974, 171–172, no. 22;
Grate 1988, no. 16; Rosenberg and Mojana 1992, 46–47,
no. 16; Thuillier 1992, 288, no. 38; Vic-sur-Seille 1993,
120–121; Granath et al. 1995, 52, 53.

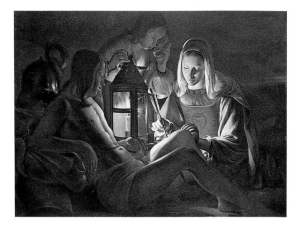

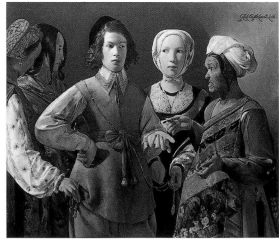

16. Attributed to Georges de La Tour, *Saint Sebastian Tended by Irene*, c. 1630–1633

canvas, 104.8 x 139.4 (41¼ x 54⅞)

Kimbell Art Museum, Fort Worth

ATTRIBUTION AND DATING: Perhaps original, c. 1632–1633 (Cleveland 1971); copy, original dated 1638–1639, among the first night scenes (Rosenberg and Thuillier 1972); copy, original dated c. 1638–1639 (Thuillier 1973a); copy, original dated 1638–1639 (Rosenberg and Macé de l'Epinay 1973); copy, original dated 1636–1638 (Nicolson and Wright 1974); copy, original dated c. 1639 (Rosenberg and Mojana 1992); copy, original dated c. 1638–1639 (Thuillier 1992); attributed to Georges de La Tour, in or before 1633 (Wright 1996);

PROVENANCE: Reportedly from a convent in Marseille 1918 (see Nicolson and Wright 1974, 185, Copy D); 1918, private collection, Paris; c. 1950, De Boer, Amsterdam; acquired by the Nelson-Atkins Museum in 1954 from Hanns Schaeffer; Sotheby's, New York, 15 January 1993, no. 14, and acquired by the Kimbell Art Museum.

EXHIBITED: Montreal/Quebec/Ottawa/Toronto 1961, no. 37; San Francisco 1964, no. 144; Cleveland 1971, no. 38.

SELECTED LITERATURE: Bloch 1950, no. 19; Pariset 1955a, 83; Rosenberg 1966, 77; Nicolson 1969, 87–88; Nicolson 1972, 117; Rosenberg and Thuillier 1972, 246, under no. 47; Rosenberg and Macé de l'Epinay 1973, 138–139, no. 35; Thuillier 1973a, 93, no. 41; Nicolson and Wright 1974, 185, 43D; Paris/New York/Chicago 1982, 354, no. 11; Rosenberg and Mojana 1992, 144–145, under 15A; Thuillier 1992, 288, no. 37.

17. Georges de La Tour, *The Fortune-Teller*, c. 1630–1634

signed upper right: *G. De La Tour Fecit Lunevillae Lothar*

canvas, 102 x 123 (40⅛ x 48⅝)

The Metropolitan Metropolitan Museum of Art, New York, Rogers Fund, 1960

DATING: 1620–1625 (Pariset 1961a); c. 1630 (Rosenberg and Thuillier 1972); 1616–1625 (Blunt 1972); c. 1636–1639 (Thuillier 1973a); c. 1620–1621 (Nicolson and Wright 1974); after 1630 (Rosenberg and Macé de l'Epinay 1973); 1632–1635 (Rosenberg in Paris/New York/Chicago 1982); 1632–1635 (Rosenberg and Mojana 1992); 1636–1638 (Thuillier 1992).

PROVENANCE: Succession of M. Lemonnier de Lorière; c. 1917–1918, General de Gastines, whose mother was the daughter of M. de Lorière; Château de Denisière, and then Château de la Vagotière, Sarthe; Wildenstein; acquired in 1960 by the Metropolitan Museum.

EXHIBITED: Washington/Toledo/New York 1960, no. 168 (supplement); Boston 1970, no. 292; Paris 1972, 148–151, no. 12; Leningrad/Moscow 1975, no. 47; Paris/New York/Chicago 1982, 257–258, no. 39.

SELECTED LITERATURE: Bloch 1950, 74–75; Sterling 1951, 149–152; Pariset 1961a, 198–205; De Marly 1970, 388–391; Blunt 1972, 519–520; Ottani Cavina 1973, 17–18; Solesmes 1973, 71, 155; Thuillier 1973a, 90–91, no. 29; Rosenberg and Macé de l'Epinay 1973, 120–121, no. 26; Nicolson and Wright 1974, 188–189, no. 48; Wright 1977, no. 15; Wright and de Marly 1980, 22–24; Paris/New York/Chicago 1982, 257–258, no. 39; Rosenberg and Mojana 1992, 58–62, no. 20; Thuillier 1992, 286–287, no. 31; Vic-sur-Seille 1993, 116–118.

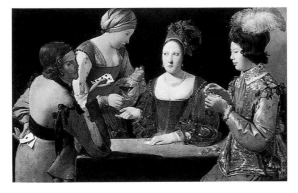 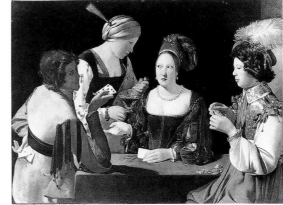

18. Georges de La Tour, *The Cheat with the Ace of Clubs*, c. 1630–1634

canvas, 97.8 x 156.2 (38½ x 61½)

Kimbell Art Museum, Fort Worth

DATING: 1616–1625 (Blunt 1972); after Metropolitan *Fortune-Teller* (Rosenberg and Thuillier 1972); before Louvre version (Rosenberg and Macé de l'Epinay 1973); 1636–1639, before Louvre version (Thuillier 1973a); c. 1620–1621, after Louvre version (Nicolson and Wright 1974); 1625–1630 (Rosenberg and Mojana 1992); before Louvre version (Thuillier 1992); before Louvre version (Rosenberg in Nancy 1992a).

PROVENANCE: Probably collection of Count Isaac Pictet (1746–1823) at Repossoir, his residence in Prégny, Switzerland; Mme. A. Marier (née Pictet); acquired by the Kimbell Art Museum in 1981.

EXHIBITED: Paris 1972, 152–153, no. 13; Paris/New York/Chicago 1982, 256–257, no. 38; Nancy 1992a, 296, no. 98.

SELECTED LITERATURE: Paris 1934, 78; Pariset 1948, 218, 414; Blunt 1972, 523; Rosenberg and Macé de l'Epinay 1973, 116–117, no. 24; Thuillier 1973a, 90, no. 28; Nicolson and Wright 1974, 190, no. 50; Wright 1977, no. 17; Rosenberg and Mojana 1992, 53–57, no. 19; Thuillier 1992, 286, no. 30; Vic-sur-Seille 1993, 114–115.

19. Georges de La Tour, *The Cheat with the Ace of Diamonds*, c. 1630–1634

signed lower left: *Georgius de la Tour fecit*

canvas, 106 x 146 (41¾ x 57½)

Musée du Louvre, Paris

DATING: Slightly later than Fort Worth version, 1616–1625 (Blunt 1972); after Louvre version by several years, around the time of the first great nocturnes (Thuillier 1973a); after Kimbell version (Rosenberg and Macé de l'Epinay 1973); c. 1619–1620 (Nicolson and Wright 1974); closer in date to mature works (Rosenberg and Mojana 1992); after Fort Worth version, contemporary with the first great nocturnes (Thuillier 1992); after Fort Worth version (Rosenberg in Nancy 1992a).

PROVENANCE: Pierre Landry, Paris, 1926; acquired by the Louvre in 1972.

EXHIBITED: London 1932, no. 118; Paris 1934, no. 53; New York 1936, no. 6; San Francisco 1939a, no. 103; San Francisco 1939b, no. 36; Detroit 1941, no. 35; Pittsburgh 1951, no. 55; Paris 1972, 154–156, no. 14; London 1973; Nancy 1992a, 297, 299, no. 99; Vic-sur-Seille 1993, 34–47.

SELECTED LITERATURE: Voss 1931, 97–100; Pariset 1948, 273–281; Blunt 1972, 523–524; Thuillier 1973a, 91, no. 30; Rosenberg and Macé de l'Epinay 1973, 126–127, no. 29; Solesmes 1973, 65, 155; Nicolson and Wright 1974, 189–190, no. 49; Rosenberg and Mojana 1992, 63–67, no. 21; Thuillier 1992, 288, no. 39; Nancy 1992a, 297, no. 99.

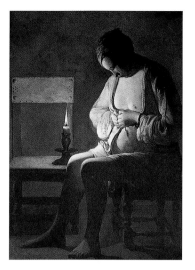

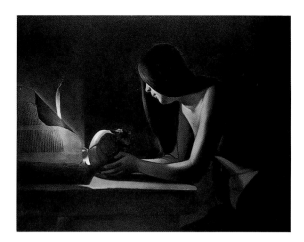

20. Georges de La Tour, *The Flea Catcher*,
c. 1630–1634

canvas, 120 x 90 (47¼ x 35⁷⁄₁₆)

Musée historique lorrain, Nancy

DATING: c. 1635 (Blunt 1972); early 1640s (Rosenberg and
Thuillier 1972); c. 1640s (Rosenberg and Macé de l'Epinay
1973); middle period (Thuillier 1973a); c. 1635 (Nicolson
and Wright 1974); c. 1640 (Rosenberg and Mojana 1992);
middle period (Thuillier 1992); c. 1640 (Rosenberg in
Montreal/Rennes/Montpellier 1993).

PROVENANCE: General Aubry, Orléans before 1929; private
collection, Rennes; acquired by the Musée historique
lorrain in 1955.

EXHIBITED: Bordeaux 1955, 102 bis; London 1958, no. 20;
Paris 1958, no. 71; Washington/Toledo/New York 1960,
no. 20; Paris 1972, no. 20; Nancy 1992a, no. 101; Montreal/
Rennes/Montpellier 1993, no. 65.

SELECTED LITERATURE: Blunt 1972, 525; Charpentier 1973,
101–108; Rosenberg and Macé de l'Epinay 1973, 152–153,
no. 42; Solesmes 1973, 2, 156; Thuillier 1973a, 94, no. 46;
Nicolson and Wright 1974, 196, no. 60; Rosenberg 1976,
453; Wind 1978, 115–124; Bajou 1985, 56; Wright 1985, 196;
Moffitt 1987, 90–103; Rosenberg and Mojana 1992, 78–81,
no. 26; Thuillier 1992, 197–199, 292, no. 59; Vic-sur-Seille
1993, 130–131.

21. Georges de La Tour, *The Repentant Magdalene
with a Document*, c. 1630–1635 (or 1645–1650)

signed upper right: *Gs de La Tour F.*

canvas, 78 x 101 (30¹¹⁄₁₆ x 39¾)

private collection

DATING: Early in the series of nocturnes (Thuillier 1973a
and 1992); 1630–1635 (Rosenberg and Mojana 1992);
c. 1630–1634 (Conisbee in Washington 1993); perhaps late,
analagous to *Saint John the Baptist in the Wilderness*, our
cat. 31 (Thuillier 1995).

PROVENANCE: Private collection, France.

EXHIBITED: Never.

SELECTED LITERATURE: Rosenberg and Macé de l'Epinay
1973, 132 (lost: copy reproduced fig. 36a); Thuillier 1973a,
92, no. 32 (lost); Nicolson and Wright 1974, 177, no. 31
(lost); Rosenberg and Mojana 1992, 142, under no. 13A;
Thuillier 1992, 287, no. 34; Washington 1993, fig. 8.

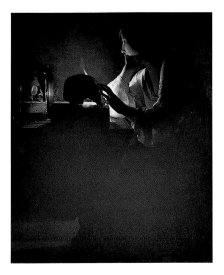

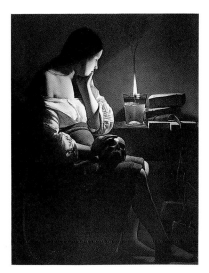

22. Georges de La Tour, *The Magdalene at the Mirror*, c. 1635

canvas, 113 x 92.7 (44½ x 36½)

National Gallery of Art, Washington, Ailsa Mellon Bruce Fund

DATING: 1635–1645 (Sterling 1937); 1628 (Pariset 1948); 1645 (Sterling 1951); 1640–1645 (Rome 1956); 1645 (Pariset 1961b); c. 1645 (Blunt 1972); c. 1638–1642 (Rosenberg and Thuillier 1972); after the Los Angeles version (Thuillier 1973a); c. 1640 (Rosenberg and Macé de l'Epinay 1973); 1639–1641 (Nicolson and Wright 1974); after the version that was in the Terff Collection (Thuillier 1992); 1635–1640 (Rosenberg and Mojana 1992).

PROVENANCE: Marquise de Caulaincourt, by 1877; by inheritance to her sister comtesse de Andigné by 1911; art market, Paris; acquired by André Fabius in Paris, 1936; acquired in 1974 by the National Gallery, Washington.

EXHIBITED: Paris 1937, no. 87; Milan 1951, no. 128; Pittsburgh 1951, no. 56; Brussels 1953, no. 77; Rome 1956, 153, no. 161; Stockholm 1958, no. 35; Paris 1972, 160–162, no. 15; Washington 1993.

SELECTED LITERATURE: Pariset 1935, 234, 243–244; Sterling 1937, 8–14; Pariset 1948, 158; Sterling 1951, 154; Pariset 1961b, 162–166; Blunt 1972, 525; Thuillier 1973a, 93, no. 38; Rosenberg and Macé de l'Epinay 1973, 140–141, no. 36; Solesmes 1973, 77, 159; Nicolson and Wright 1974, 174–176, no. 29; Thuillier 1992, 288–289, no. 43; Rosenberg and Mojana 1992, 72–73, no. 24.

23. Georges de La Tour, *The Magdalene with the Smoking Flame*, c. 1636–1638

signed lower right: *G Dela Tour*

canvas, 118 x 90 (46⅞ x 35⅞)

Los Angeles County Museum of Art, Gift of The Ahmanson Foundation

DATING: Before Louvre version, at the beginning of the nocturne series (Thuillier 1973a); before Louvre version (Rosenberg and Macé de l'Epinay 1973); c. 1637–1639 (Nicolson and Wright 1974); c. 1635 (Rosenberg and Mojana 1992); before the Louvre version, at the beginning of the nocturne series (Thuillier 1992); c. 1638–1640 (Conisbee in Washington 1993).

PROVENANCE: La Haye family, France by 1972; acquired by the Los Angeles County Museum in 1977.

EXHIBITED: Washington 1993.

SELECTED LITERATURE: Rosenberg and Macé de l'Epinay 1973, 132–133, no. 32; Solesmes 1973, 159; Thuillier 1973a, 93–94, no. 38; Nicolson and Wright 1974, 174, no. 27; Paris/New York/Chicago 1982, 354, no. 12; Rosenberg 1984, 41; Conisbee/Levkoff/Rand 1991, 46–50, no. 10; Rosenberg and Mojana 1992, 70–71, no. 23; Thuillier 1992, 289–290, no. 48; Vic-sur-Seille 1993, 53–55.

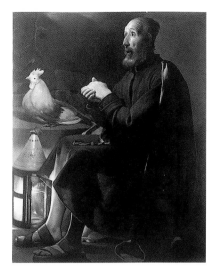

24. Georges de La Tour, *Saint Peter Repentant*, 1645

signed upper right: *Georg de la Tour inve et pinx* (?) *1645*

canvas, 114 x 95 (44⅞ x 37⅜)

The Cleveland Museum of Art, Gift of the Hanna Fund

PROVENANCE: Until 1857 in Alleyn's College of God's Gift, Dulwich (according to Francis 1952, 175; although not documented in extant inventories of the college; see Nicolson and Wright 1974, 179); Rev. William Lucas Chafy (d. 1878); Chafy family until 1951; acquired by the Cleveland Museum of Art in 1951.

EXHIBITED: Cleveland 1958, no. 59; Cleveland 1971, no. 39; Paris 1972, 190–192, no. 23; Paris/New York/Chicago 1982, 258–259, no. 40.

SELECTED LITERATURE: Rosenberg and Macé de l'Epinay 1973, 158–159, no. 45; Thuillier 1973a, 95, no. 51; Nicolson and Wright 1974, 178–179, no. 35; Nicolson 1979, 65; Rosenberg and Mojana 1992, 98–99, no. 32; Thuillier 1992, 292, no. 58.

25. Attributed to Georges de La Tour, *The Ecstasy of Saint Francis*, c. 1640–1645

canvas, 154 x 163 (60⅝ x 64³⁄₁₆)

Musée de Tessé, Le Mans

ATTRIBUTION AND DATING: Original (Jamot 1939; Landry 1942; Huyghe 1945); studio copy (Sterling 1951); Etienne de La Tour (Wright 1969); original (Bloch 1972); some parts by La Tour (Blunt 1972); good old copy, 1640–1645 (Rosenberg and Thuillier 1972); good old copy (Thuillier 1973a); perhaps collective studio copy, original dates to 1640–1645 (Rosenberg and Macé de l'Epinay 1973); unfinished original c. 1640–1642 (Nicolson and Wright 1974); copy (Foucart-Walter 1981: this attribution is still maintained by the Musée de Tessé); good old copy, no date (Thuillier 1992); copy, original dates to 1640–1645 (Rosenberg and Mojana 1992).

PROVENANCE: First recorded at Le Mans in the museum's 1892 catalogue, no. 364, with the suggestion it may be Spanish or Neapolitan seventeenth century.

EXHIBITED: Paris 1948, no. 479; Paris 1952, no. 54; London 1958, no. 25; Paris 1958, no. 70, pl. 10; Washington/Toledo/New York 1960, no. 24; San Diego/San Francisco/Santa Barbara 1967–1968, no. 2.

SELECTED LITERATURE: Sterling 1938, 203; Jamot 1939, 249; Landry 1942, 8; Huyghe 1945; Pariset 1948, 164; Jamot 1948, 34, 59, 67, no. 11; Sterling 1951, 155; Arland 1953, no. 17; Wright 1969, 296; Bloch 1972, 222–223; Blunt 1972, 524; Adhémar 1972, 219–222; Rosenberg and Thuillier 1972, 247, under no. 48 ("Les Deux Moines" engraving), 250–251, no. 51; Nicolson and Wright 1972, 166–167, no. 13; Rosenberg and Macé de l'Epinay 1973, 128–129, no. 30; Thuillier 1973a, no. 36; Rosenberg and Mojana 1992, 143–144, no. 14A; Thuillier 1992, 289, no. 45.

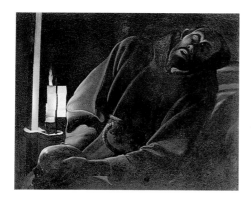

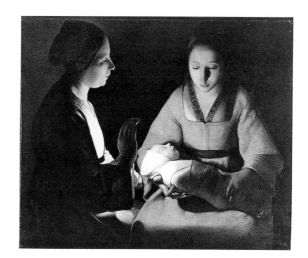

26. After Georges de La Tour, *The Ecstasy of Saint Francis* (original c. 1645)

canvas, 66 x 78.7 (26 x 31)

Wadsworth Atheneum, Hartford, The Ella Gallup Sumner and Mary Catlin Sumner Collection Fund

ATTRIBUTION AND DATING: Fragment of a copy (Rosenberg and Thuillier 1972); probably a fragment, perhaps an "exercise" after the Le Mans original (Nicolson and Wright 1974); fragment of a copy, original 1640–1645 (Rosenberg and Macé de l'Epinay 1973); copy, repainted in part (Thuillier 1973a); old copy, repainted in part (Thuillier 1992).

PROVENANCE: Acquired by the Wadsworth Atheneum in 1940 from Vitale Bloch, Paris.

EXHIBITED: Hartford 1940, no. 97; Hartford 1964, no. 207.

SELECTED LITERATURE: Bloch 1948, 64; Rosenberg and Thuillier 1972, 215, under no. 51; Nicolson and Wright 1974, 167, no. 14; Rosenberg and Macé de l'Epinay 1973, 128–129; Thuillier 1973a, no. 37; Thuillier 1992, 289–290, no. 46.

27. Georges de La Tour, *The Newborn Child*, c. 1645

canvas, 76 x 91 cm (29^{15}⁄$_{16}$ x 35^{13}⁄$_{16}$)

Musée des Beaux-Arts, Rennes

DATING: c. 1649 (Blunt 1972); 1644–1649 (Rosenberg and Thuillier 1972); 1645–1648 or perhaps a later version of about 1648–1651 of an earlier, first version? (Thuillier 1973a); 1646–1648 (Rosenberg and Macé de l'Epinay 1973); c. 1646–1648 (Nicolson and Wright 1974); 1646–1648 (Rosenberg and Mojana 1992); 1645–1648 or perhaps a later version of about 1648–1651 of an earlier, first version? (Thuillier 1992).

PROVENANCE: Entered the museum in 1794 with other works seized during the Revolution.

EXHIBITED: London 1932, no. 129; New York 1936, no. 1; Paris 1948, no. 481; Geneva 1949, no. 32; Paris 1950, no. 65; Rennes 1950; London 1958, no. 23; Paris 1958, no. 74; Paris 1966, no. 21; Paris 1972, 198–201, no. 26; Montreal/ Rennes/Montpellier 1993, no. 67.

SELECTED LITERATURE: Voss 1915, no. 123; Pariset 1948, 181–189; Blunt 1972, 520; Rosenberg and Macé de l'Epinay 1973, 162–163, no. 47; Solesmes 1973, 85, 160; Thuillier 1973a, 96, no. 57; Nicolson and Wright 1974, 160–161, no. 4; Wright 1977, no. 40; Bajou 1985, 80–83; Rosenberg and Mojana 1992, 106–107, no. 35; Thuillier 1992, 292, no. 64; Vic-sur-Seille 1993, 132–133; Patrick Ramade in Reinbold et al. 1994.

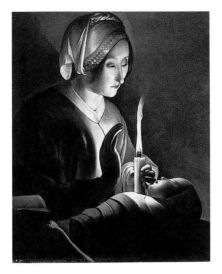

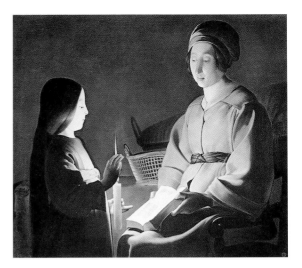

28. Georges de La Tour, *Saint Anne with the Christ Child*, c. 1645–1650

canvas, 66 x 54.6 (26 x 22)

Art Gallery of Ontario, Toronto, Anonymous bequest, 1991

ATTRIBUTION AND DATING: Close in date to *The Magdalene at the Mirror* and the *Angel Appearing to Saint Joseph* (Rosenberg and Macé de l'Epinay 1973); original, c. 1639–1641 (Nicolson and Wright 1974); c. 1640 (Rosenberg and Mojana 1992); copy or repainted original, between *The Education of the Virgin* and *The Newborn Child*, 1640s (Thuillier 1992).

PROVENANCE: New York art market, 1943; Murray Vaughan collection, Montreal; anonymous bequest to the museum, 1991.

EXHIBITED: New York 1943, no. 435; New York 1946, no. 20; Montreal 1960, no. 150; Montreal 1965, no. 59.

SELECTED LITERATURE: Pariset 1948, 188–189, pl. 21; Rosenberg and Thuillier 1972, 249, under no. 50; Rosenberg and Macé de l'Epinay 1973, 144, no. 38B; Solesmes 1973, 160, no. 90; Thuillier 1973a, 96, no. 56; Nicolson and Wright 1974, 40–41, 46, 162–163, no. 6; Rosenberg and Mojana 1992, no. 31; Thuillier 1992, 292, no. 62.

29. Attributed to Georges de La Tour, *The Education of the Virgin*, c. 1650

signed or inscribed, left: *De La Tour f.*

canvas, 83.8 x 104 (33 x 40^{15}⁄$_{16}$)

The Frick Collection, New York

ATTRIBUTION AND DATING: Copy (Sterling 1951); Etienne de La Tour (New York 1968; Wright 1969); lost original dated 1646–1668, after *The Newborn Child* (Rosenberg and Macé de l'Epinay 1973); old copy (Rosenberg) or damaged original (Thuillier) just before *The Newborn Child* (Rosenberg and Thuillier 1972); original, though irreparably damaged (Thuillier 1973a); perhaps by Etienne, lost original dated c. 1646–1668 (Nicolson and Wright 1974); 1645–1650 (Rosenberg and Mojana 1992); heavily damaged original, before *The Newborn Child* (Thuillier 1992).

PROVENANCE: Private collection, France until about 1947; Frederick Mond, New York; Knoedler, New York; acquired by the Frick in 1948.

EXHIBITED: Never.

SELECTED LITERATURE: Pariset 1948, 239, 401 n. 3; Vickers 1950, 114; Sterling 1951, 155; Frick 1968, 147–150; Wright 1969, 295–296; Rosenberg and Thuillier 1972, 255, under no. 54; Rosenberg and Macé de l'Epinay 1973, 166–167, copy A; Thuillier 1973a, no. 52; Nicolson and Wright 1974, 158–160, copy C; Rosenberg and Mojana 1992, 110, no. 37; Thuillier 1992, 210, 292, no. 60.

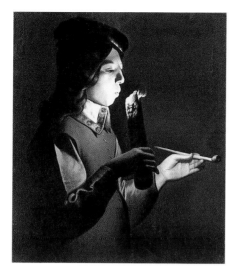

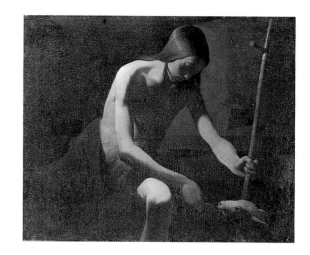

30. Georges de La Tour, *Boy Blowing on a Firebrand*, c. 1645–1650

signed at upper right corner: *La Tour fec* . . .

canvas, 70.8 x 61.5 (27⅞ x 24³⁄₁₆)

Tokyo Fuji Art Museum

ATTRIBUTION AND DATING: Mostly by La Tour, perhaps collaborative work with Etienne?, c. 1650 (Rosenberg and Macé de l'Epinay 1973); studio copy, c. 1648 (Nicolson and Wright 1974); 1646 (Rosenberg and Mojana 1992); studio copy, perhaps Etienne, c. 1648 (Thuillier 1992).

PROVENANCE: Private collection, southern France in 1973; sold Drouot, 3 December 1985, no. 33.

EXHIBITED: Never.

SELECTED LITERATURE: Rosenberg and Macé de l'Epinay 1973, 174–175, no. 53; Nicolson and Wright 1974, 199–200, no. 65F; Thuillier 1985, 96, no. 58; Rosenberg and Mojana 1992, 116, no. 40; Thuillier 1992, 294–295, no. 74.

31. Georges de La Tour, *Saint John the Baptist in the Wilderness*, c. 1645–1650

canvas, 81 x 101 (31¹⁵⁄₁₆ x 39¾)

Conseil général de la Moselle

DATING: c. 1649 (Brigstocke 1995); c. 1649 (Cuzin 1995); c. 1649 (Lacau St. Guily 1995); c. 1649 (Thuillier 1995). All four agree on a late date by comparison with the Louvre *Saint Sebastian Tended by Irene*.

PROVENANCE: Private collection, France; Sotheby's, Monaco, 2 December 1994, no. 39; acquired by the Musées nationaux, the Conseil général de la Moselle, and the Conseil régional de Lorraine.

EXHIBITED: Metz 1995; Vic-sur-Seille 1995 (no catalogue).

SELECTED LITERATURE: Brigstocke 1995; Cuzin 1995; Lacau St. Guily 1995; Thuillier 1995.

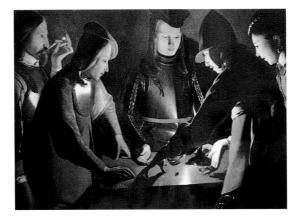

32. Georges de La Tour, *The Dice Players*, c. 1650

signed or inscribed on the left of the board of the table: *George De La Tour Invet et Pinx.*

canvas, 92.5 x 130.5 (36⁷⁄₁₆ x 51⅜)

Preston Hall Museum, Stockton-on-Tees

DATING: 1649–1651, after the Nantes *Denial of Saint Peter* (Rosenberg and Thuillier 1972); c. 1650 (Blunt 1972); c. 1650 (Rosenberg and Macé de l'Epinay 1973); c. 1650–1651 (Thuillier 1973a); c. 1650–1651 (Nicolson and Wright 1974); c. 1650 (Rosenberg and Mojana 1992); c. 1649–1651 (Thuillier 1992).

PROVENANCE: Edwin Clephan J.P. (1817–1906); Annie-Elisabeth Clephan; bequeathed 1930 to the city of Stockton-on-Tees (Durham County). Mentioned in the inventory of the Clephan bequest, dated 19 July 1934, "De La Tour. (Old Painting). Throwing the dice."

EXHIBITED: Fairfield 1944, no. 9; Paris 1972, 218–220, no. 31.

SELECTED LITERATURE: Nicolson 1972, 189; Blunt 1972, 520; Rosenberg and Macé de l'Epinay 1973, 180–181, no. 56; Solesmes 1973, 117, 156; Thuillier 1973a, 98, no. 71; Nicolson and Wright 1974, 191–192, no. 55; Rosenberg and Mojana 1992, 126–129, no. 44; Thuillier 1992, 294–295, no. 78; Vic-sur-Seille 1993, 138–139.

33. After Georges de La Tour, *The Repentant Magdalene with a Mirror*

engraving, 20.4 x 27.5 (8 x 10¾)

Bibliothèque Nationale de France, Paris

Exhibited in Washington only

EXHIBITED: Paris 1948, no. 675 (as Le Clerc); Paris 1972, no. 49.

SELECTED LITERATURE: Meaume 1853–1860, 2, no. 1235; Pariset 1935, 233–234; Pariset 1948, 149–164; Rosenberg and Thuillier 1972, no. 49; Nicolson and Wright 1974, no. 42; Thuillier 1992, no. 42.

This engraving and the two following (cats. 34 and 35) were published in Meaume 1853–1860, the pioneering study and catalogue of Callot's works, not with attributions to the great Lorrainese printmaker, but because of their early association with his name. Cat. 33 carries an inscription in a seventeenth-century hand attributing it to Callot, while cat. 35 has the engraved legend *Jac. Callot in - franc. vanden Wijngaerde ex.* This last attribution to Callot may have been a deliberate falsification on the part of the seventeenth-century publisher, intended to take advantage of Callot's celebrated name; or a misattribution perhaps occasioned by the Lorrainese origin of the image or even the plate; or a misattribution due to misguided association with Callot's prints done in rich effects of chiaroscuro, such as *Le Brelan* and *Le Bénédicité* (Conisbee figs. 36 and 37).

Pariset (1935 and 1948) attributed the prints to Jean Le Clerc on the basis of a stylistically similar engraving, also issued by the famous Antwerp publisher Wyngaerden with an ascription to Callot, but which Pariset believed to be by Le Clerc himself after his *Nocturnal Concert* (see cat. 42; the model for the engraving after Le Clerc's *Nocturnal Concert* was most likely an etching by Le Clerc himself, of which a unique impression is in the Albertina, Vienna [Conisbee fig. 35]).

Thuillier (in Rosenberg and Thuillier 1972, 108–109, 247–249) has thoroughly discussed these related prints, and his conclusion is convincing, that all three engravings after La Tour date from after the deaths of Le Clerc (in 1633) and Callot (in 1635) and are certainly by another hand. Most likely they were published in Antwerp, a major

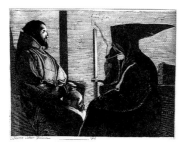

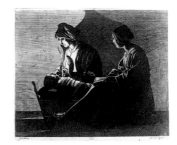

center of the print trade, but it is possible that the plates were produced in Paris.

Cat. 33 follows closely (but in reverse) the design of La Tour's lost horizontal version of *The Repentant Magdalene*, of which we illustrate a copy (Conisbee fig. 68); another copy was formerly in the Terff Collection, Paris (Thuillier 1992, no. 42A). Cats. 34 and 35 seem to be after lost works by La Tour, although cat. 35 perhaps reflects a version of the fragmentary *Saint Anne with the Christ Child* we exhibit as cat. 28.

We have no way of knowing if these prints were made with La Tour's approval. But we cannot rule out the possibility, suggested by Thuillier, that they were made to publicize his art beyond Lorraine, perhaps even during the period he was most likely active in Paris in the late 1630s and early 1640s.

34. After Georges de La Tour, *Saint Francis in Meditation*

engraving, 24 x 31 (9½ x 12¼)

Bibliothèque Nationale de France, Paris

Exhibited in Washington only

EXHIBITED: Paris 1972, no. 48.

SELECTED LITERATURE: Meaume 1853–1860, 2, no. 1236; Pariset 1935, 235–236; Pariset 1948, 164–174; Rosenberg and Thuillier 1972, no. 48; Nicolson and Wright 1974, no. 15; Thuillier 1992, no. 40.

35. After Georges de La Tour, *The Virgin and Child with Saint Anne*

engraving, 26.7 x 33.4 (10½ x 13⅛)

Bibliothèque Nationale de France, Paris

Exhibited in Washington only

EXHIBITED: Paris 1948, no. 476 (as Le Clerc); Paris 1972, no. 50.

SELECTED LITERATURE: Meaume 1853–1860, 2, no. 1234; Voss 1915; Pariset 1935, 233; Pariset 1948, 177–189; Rosenberg and Thuillier 1972, no. 50; Nicolson and Wright 1974, under no. 6; Thuillier 1993, no. 41.

Works by La Tour's Contemporaries

Listed in alphabetical order

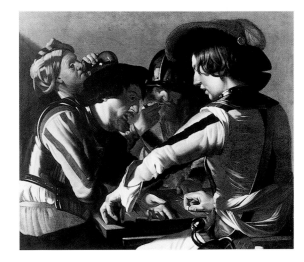

36. Dirck van Baburen, *The Backgammon Players*, c. 1624

canvas, 105.4 x 128.3 (41½ x 50½)

Saul P. Steinberg

PROVENANCE: The Akron Art Institute, Ohio; deaccessioned and sold Sotheby's, New York, 8 January 1981, no. 142.

EXHIBITED: Buffalo 1948, no. 19; Springfield 1958; Seattle 1950, no. 86; Dallas 1951, no. 29; Seattle 1954, no. 16; Pittsburgh 1954, no. 19; Indianapolis/San Diego 1958, no. 74; Sarasota 1960; Seattle 1962, no. 25; Cleveland 1971, no. 2.

SELECTED LITERATURE: Slatkes 1965, A-23A, 127–128.

DIRCK VAN BABUREN (c. 1595–1624): Born near Utrecht, Baburen is first mentioned in 1611, in the records of the Guild of Saint Luke in Utrecht, where he was a pupil of Paul Moreelse. He went to Rome in about 1612. There, between 1615 and 1620, he decorated the chapel of the Pietà in the church of San Pietro in Montorio in collaboration with the relatively little-known David de Haen; Baburen's altarpiece of *The Entombment* (still *in situ*) was probably painted in 1617. In Rome, Baburen was patronized by Cardinal Scipione Borghese and Marchese Vincenzo Giustiniani, both of whom had been important supporters of Caravaggio. Although Baburen arrived in Rome after Caravaggio's death in 1610, he was profoundly influenced by the tenebrism of Caravaggio and his followers, especially Bartolomeo Manfredi, whom he almost certainly knew. He probably returned to Utrecht in 1620, certainly by 1622. From then until his early death in 1624 he shared a studio with ter Brugghen. Along with ter Brugghen and Honthorst, Baburen was one of the leading followers of Caravaggio and Manfredi in Utrecht, whose style he helped to disseminate in northern Europe. Inspired by Caravaggio, he painted genre subjects such as *Backgammon Players* in the present exhibition; and he introduced the theme of *Saint Sebastian Tended by Irene* (Hamburg, Kunsthalle), treated in a bold and Caravaggesque manner, into northern art.

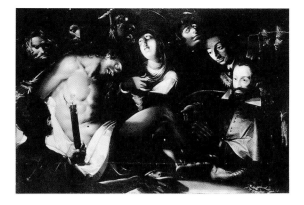 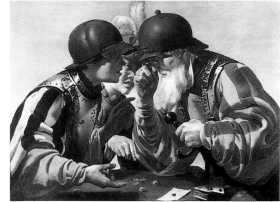

37. Jacques-Charles Bellange, *The Lamentation of Christ*, c. 1616

canvas, 115 x 175 (45¼ x 68⅞)

The State Hermitage Museum, St. Petersburg

PROVENANCE: Khanukian collection in Moscow before 1925; acquired from a private collection in Estonia by the museum in 1967.

EXHIBITED: Leningrad 1973, no. 4; Leningrad 1977, no. 3; Meaux 1988, no. 24; Nancy 1992a, no. 4.

SELECTED LITERATURE: Linnik 1973, 8–11; Linnik 1975; Linnik and Vsevoloshskay 1975, nos. 46 48; Des Moines/Boston/New York 1975, 9, no. 2; Comer 1980, 240–241, no. 61.

JACQUES-CHARLES BELLANGE (c. 1574–1616): Bellange was the dominant figure in Lorrainese art before the generation of Claude Deruet, Claude Lorrain, Jacques Callot, and La Tour. He is documented as having been active at the court of Nancy between 1602 and his death in 1616. Perhaps the greatest loss for our understanding of Bellange as a painter is his cycle of twenty-six mural decorations of the hunt, formerly in the Galerie des Cerfs at the ducal palace in Nancy. His career as a painter has only begun to be reconstructed; a pair of panels representing the *Virgin* and the *Angel of the Annunciation* (Staatliche Kunsthalle, Karlsruhe) are the most sophisticated surviving works, and they situate his art in the same world as the great contemporary mannerist painters of Antwerp and Prague. A documented visit to Paris in 1608 "to study the paintings and singularities of his art, which are in houses and royal palaces, and elsewhere" (Nancy 1992a, 386) shows that the artistic world of Bellange, or of Nancy, was not necessarily an isolated one. A number of works have been identified in recent times, such as the exhibited *Lamentation of Christ*, which show Bellange the painter was interested in effects of artificial light. He is best known, however, as perhaps the most virtuoso of the mannerist etchers of the late sixteenth and early seventeenth centuries.

38. Hendrick ter Brugghen, *Gamblers*, 1623

signed with ter Brugghen's monogram and dated 1623, to the left of the ace of spades

canvas, 83.8 x 114 (33 x 44⅞)

The Minneapolis Institute of Arts, The William Hood Dunwoody Fund

PROVENANCE: Christie's, London, 12 November 1943, no. 36, as Honthorst; Matthiesen Gallery, London; Edward Speelman, London; Germain Seligman, New York, 1955.

EXHIBITED: Flint 1961, no. 5; Dayton/Baltimore 1965, no. 4.

SELECTED LITERATURE: Nicolson 1958b, A52, A69; Slatkes 1995.

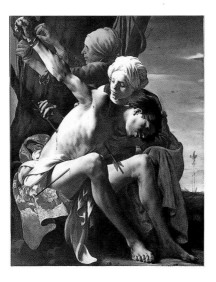

39. Hendrick ter Brugghen, *Saint Sebastian Tended by Irene*, 1625

signed in full and dated 1625, to the right of the three hands at the top left

canvas, 150.2 x 120 (59⅛ x 47¼)

Collection of the Allen Memorial Art Museum, Oberlin College, R. T. Miller Jr. Fund, 1953

PROVENANCE: Collection Pieter Fris, Amsterdam (listed by Bredius, *Kunstler-Inventare* [vol. 6, 1919, p. 1985] as "Een Sint Sebastiaen van Ter Brugghe"); 30 August 1668, Fris gave the painting to Jan de Waale in payment for a debt; sold 12 May 1706 at the Jan de Walé (Waale) sale in Amsterdam (listed inaccurately as "Een doode St Sebastiaen, van Terbrugge"); private collection, France; acquired by Oberlin in 1953.

EXHIBITED: Kansas City 1958, no. 4; Seattle 1962, no. 24; Dayton/Baltimore 1965, no. 10; Utrecht/Braunschweig 1986, no. 20.

SELECTED LITERATURE: See Dayton/Baltimore 1965, 31, no. 10; Nicolson 1958b, 86, no. A54; Slatkes 1973, 272 n. 16; Nicolson 1979, 19.

HENDRICK TER BRUGGHEN (1588–1629): Ter Brugghen was born of a Catholic family near Deventer, who moved to Utrecht when he was a child. There he studied with the leading history painter Abraham Bloemaert, but at about the age of fifteen, c. 1604, he went to study in Italy. He spent ten years in Italy, mainly in Rome, but also visited other cities such as Milan. In Rome he fell under the influence of Caravaggio, who was at the height of his short career. He responded especially to Caravaggio's tenebrism and to his often brutally realistic treatment of religious subjects. In Rome he moved in the circle of fellow Utrecht artists influenced by Caravaggio such as Baburen and Honthorst, and other Caravaggesque painters such as Manfredi. He was the first important Dutch artist to bring back to his native country the tenebrism and the dramatic realism of Caravaggio. About 1622 to 1624 he shared a studio with Baburen, recently returned from Rome, who may have reinforced ter Brugghen's interest in Caravaggesque effects and subjects, as in *The Gamblers* in the present exhibition. Ter Brugghen's *Saint Sebastian Tended by Irene*, also exhibited, was almost certainly inspired by Baburen's treatment of the same theme (Kunsthalle, Hamburg), and by the close, intense focus and carefully meditated realism of Caravaggio's religious works.

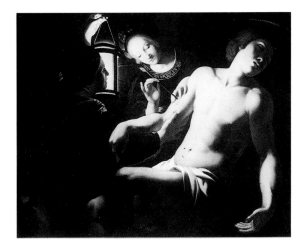

40. The Candlelight Master, *Saint Sebastian Tended by Irene*, c. 1630

canvas, 124.5 x 160 (49⅛ x 63)

The Bob Jones University Collection, Greenville

PROVENANCE: Julius Weitzner, London; gift of Harry and Nathan Dwoskin to Bob Jones University in 1965.

EXHIBITED: Jacksonville/St. Petersburg 1969.

SELECTED LITERATURE: Nicolson 1964a, 131, no. 29; Nicolson 1964b, 102, no. 29; Jones 1968, no. 293, under Théophile Bigot, repro. 138; Thuillier 1992, 174; Nicolson 1989, no. 849.

THE CANDLELIGHT MASTER: Much ink has been spilled over the identity of the so-called Candlelight Master and of Trophime Bigot, who was the same or another artist, as well as the attribution of works to them and perhaps even other hands. Although the painting we exhibit is catalogued in the Bob Jones University Collection as by Trophime Bigot, the present writer considers it to be by the Candlelight Master, who is probably to be identified with the "Jacomo pittore" and "Jacobe" mentioned below.

In 1960 Benedict Nicolson attributed what seemed to him a stylistically coherent group of Caravaggesque scenes, showing half-length figures lit by a candle or a lantern, to an artist he named "The Candlelight Master"; he subsequently assimilated these works into the production of the Provençal painter Trophime Bigot (Nicolson 1964a). The archival research of Jean Boyer confirmed the identity of Bigot as a certain "Trufemondi, [who] concentrated on the representation of nocturnal half-length figures," so described by Joachim von Sandrart (in 1675), who had known him in Rome in about 1628–1634 (Boyer 1964 and Boyer 1965).

Disconcerting stylistic disparities between works executed in Rome between 1620 and 1634, and others painted in Provence after 1634, led to the speculative identification of two Bigots: a supposed Trophime Bigot "the Elder" (born in Arles, 1579; died after 1649) who worked in Provence, and a supposed son or nephew, Trophime Bigot "the Younger," who produced the "candlelight" pictures in Rome from 1620 to 1634 (Nicolson 1972, 113; Rosenberg and Thuillier 1972, 47–48; Thuillier in Marseilles 1978, 6). In 1978 documents were revealed by Olivier Michel, show-ing that a painter called "Maestro Jacomo pittore" (payment in 1634) or "Jacobe" (mentioned in 1653) was the author of the *Lamentation of Christ* in the church of Santa Maria in Aquiro, Rome – a painting previously attributed to Bigot or the Candlelight Master (Marseilles 1978, 3 n. 1).

Jean-Pierre Cuzin distinguished two artistic hands but suggested that a single Trophime Bigot – the same man in Rome 1620–1634 and in Provence 1634–1650 – produced a group of works with rather stiff figures in Rome and all the works in Provence. Cuzin separated a group of Roman works as more sophisticated in style, attributing them to the master Giacomo/Jacopo (Cuzin 1979). Then in 1988 Jean Boyer showed that there was indeed only one Trophime Bigot – who sometimes signed his name "Trufamond Bigoti" (Boyer 1988, 357 n. 11), although there are several variations on this spelling in other documents (Rome/Paris 1974, 9) – active in Rome (about 1600–1605, returning briefly to Provence, but mainly in Rome until 1634), and Provence (Arles, 1634–1638; Aix, 1638–1642; Arles and Avignon, 1642–1650), until his death in Avignon in 1650 (Boyer 1988).

Tiberia 1991 published an altarpiece in San Marco, Rome, signed *Teofilo Trufam . . .* and dated *163 . . .* , which corresponds in style to the Provençal works of Bigot, but not to the paintings by the Candlelight Master, confirming the existence of at least two distinct hands.

The present writer agrees with Cuzin that the master Jacomo/Jacobe is most likely the author of the more svelte paintings attributed to the Candlelight Master, such as the work we exhibit. Two other versions of the same composition are in the Pinacoteca Vaticana, Rome (Rome/Paris 1973–1974, no. 5) and in the Pinacoteca Communale, Bologna (Nicolson 1964a, no. 30); and a variant of the subject in the Musée des Beaux-Arts, Bordeaux (Mérot 1995, pl. 73).

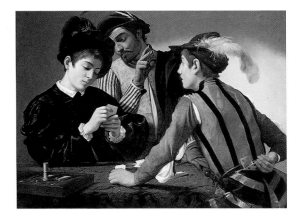

41. Caravaggio, *The Cardsharps*, c. 1594

canvas, 94.3 x 131.1 cm (37⅛ x 51⅝)

Kimbell Art Museum, Fort Worth

PROVENANCE: Cardinal Francesco Maria del Monte; Cardinal Antonio Barberini, 1628; Barberini Collection until 1812; by descent into the collection of the Colonna-Sciarra family in Rome; sold by Prince Maffeo Sciarra in the 1890s; acquired by the Kimbell Art Museum in 1987.

EXHIBITED: Metropolitan Museum of Art, New York, 15 September–15 November 1987.

SELECTED LITERATURE: Friedlaender 1955, 153–154; Moir 1976, 105–107; Cinotti 1983, 554–556; New York/Naples 1985, 217–219; Pillsbury 1987, 190; Christiansen 1988; Mahon 1988; Gregori 1994, 10.

MICHELANGELO MERISI DA CARAVAGGIO, known as Caravaggio (1571–1610): Apprenticed to Simone Peterzano in Milan in 1588, Caravaggio may not have completed the contracted four years. In Rome by the end of 1592, he worked for a time with Giuseppe Cesari, the Cavaliere d'Arpino. D'Arpino had a busy and influential studio supplying altarpieces and decorations for the churches and palaces of Rome, which gave the young artist from Lombardy a good entrance to the Roman art world. But the striking originality of his style and subject matter meant that Caravaggio was soon taken up by important patrons such as Cardinal del Monte, Marchese Giustiniani, and the great papal families of the Barberini, the Borghese, the Massimi, and the Mattei. Caravaggio had a rapid succession of styles in his short career, from the careful observation of his still-life and genre subjects in the early and mid-1590s; to the brilliant dramatic narratives of his chapel decorations such as the Contarelli Chapel in San Luigi dei Francesi (1599–1602) and the Cerasi Chapel in Santa Maria del Popolo (1600–1601), which established his reputation; to the dark and agonized *chiaroscuro* of his late works in Naples, 1607; Malta, 1608; Sicily, 1609; Naples again, 1609–1610. Caravaggio's police record, his brawls, a murder committed, prison and escape, his restless travels, and his volatile temperament seem to be reflected in the passionate variety and intensity of his art. Caravaggio was one of the truly seminal artists of the seventeenth century, and his art resonated from Naples to Utrecht, from Seville to Lorraine. He was innovative and influential in his modern moralizing genre subjects, such as the exhibited *Cardsharps*; in his ability to invest religious subjects with a vivid sense of the contemporary and the everyday; and in his dramatic use of strong contrasts of light and shade, which clarify narrative and bring mystery and tremendous emotional weight to the great tragic themes of martyrdom and mourning, betrayal and doubt.

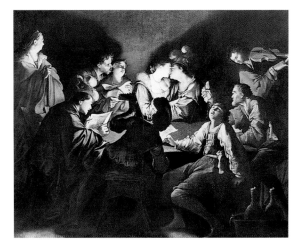 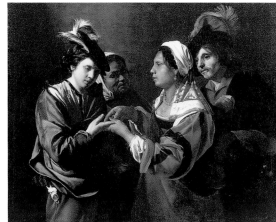

42. Jean Le Clerc, *Nocturnal Concert*, c. 1621–1622

canvas, 137 x 170 cm (53¹⁵⁄₁₆ x 66¹⁵⁄₁₆)

Alte Pinakothek, Munich

PROVENANCE: Since 1767 in the royal collection of Bavaria.

EXHIBITED: Milan 1951, no. 129; Rome 1956, no. 166; Berne 1959, no. 48; Rome/Paris 1973, no. 11; Rome/Nancy 1982, no. 7; Nancy 1992a, no. 90.

SELECTED LITERATURE: Rome/Paris 1973, 47, 48–50, no. 11; Nicolson and Wright 1974, fig. 88.

JEAN LE CLERC (c. 1587–1633): Le Clerc was born into a family that served at the ducal court in Nancy, but nothing is known about his training or his early career. He was in Rome by 1617, perhaps before, and until 1619; he is documented sporadically in Venice between 1619 and 1622. In Rome he lived, studied, and collaborated with Carlo Saraceni, a painter of Venetian origin, who had an important and influential studio and a busy practice supplying altarpieces and decorations for the churches of Rome. Saraceni worked in a softened Caravaggesque chiaroscuro, which he imparted to Le Clerc and other followers, such as the Frenchman Guy François from Le Puy. The exhibited *Nocturnal Concert* by Le Clerc shows his second-hand assimilation of Caravaggio's tenebrism as well as its modification into something altogether gentler. Le Clerc went to Venice in 1619, probably in the company of his master Saraceni, with whom he continued to collaborate. On his return to Nancy in 1622 he worked for Duke Henri II and especially for his brother, François de Vaudémont, which brought Le Clerc financial security and elevation to the nobility. But he worked mainly for the church, notably the Jesuits, and a number of works from his hand or his studio are still to be seen in churches in Nancy and the surrounding towns and villages. They are often reminiscent of Saraceni, but also of the rustic realism of the Bassano family, whose works Le Clerc could have studied in Venice and the Veneto.

43. Bartolomeo Manfredi, *The Fortune-Teller*, c. 1605–1610?

canvas, 121 x 152.5 (47⅝ x 60)

The Detroit Institute of Arts, Founders Society Purchase, Acquisitions Fund

PROVENANCE: Lyons art market; acquired by the museum in 1979.

EXHIBITED: Cremona 1987, no. 11.

SELECTED LITERATURE: Cosnac 1885, n. 1261; Grouchy 1894, 601; Davies 1907, 379–380; Voss 1924, 453; Garas 1967, 339; Cuzin 1977, 27–29; Cuzin 1980, 14–25.

BARTOLOMEO MANFREDI: Few facts are known about Manfredi's life, and only recently was it discovered that he was born in Ostiano, near Mantua, on 25 August 1582. His contemporary biographer, Giovanni Baglione, reports that the young artist studied with Cristoforo Roncalli called Il Pomerancio. Manfredi evidently arrived in Rome shortly after 1600 and probably knew Caravaggio. During the 1610s he seems to have operated a small workshop in Rome where he continued to paint until his death in 1622. Manfredi is best known for his life-sized, three-quarter-length depictions of groups of revelers, musicians, gamblers, and fortune-tellers as well as for sacred subjects in the guise of genre scenes. Typically his strongly modeled figures, recognizably of the Roman streets, are partly swallowed in the shadows of dim, featureless settings. Strong bursts of light play across the compositions to pick out significant details. His repertoire of subjects derived from Caravaggio's genre scenes of the 1590s, but these were assimilated to the vignette of figures at the table in Caravaggio's *Calling of Saint Matthew* in San Luigi dei Francesi, and cast in the same dramatic chiaroscuro. Such success did Manfredi's formula enjoy among northern artists working in Rome – Valentin, Tournier, Régnier, and Baburen to name but a few – that the writer Joachim von Sandrart dubbed his style the "Manfrediana methodus."

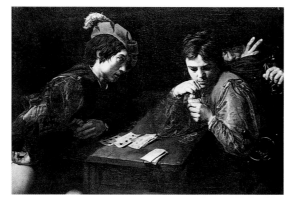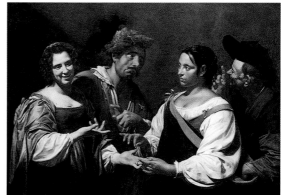

44. Valentin de Boulogne, *The Cardsharps,*
c. 1615–1617

canvas, 94 x 137 (37 x 53¹⁵⁄₁₆)

Staatliche Kunstsammlungen, Dresden

PROVENANCE: Imperial Gallery of Prague; acquired in 1749
for the royal collection in Dresden.

EXHIBITED: Paris 1934, no. 114; Paris 1937, no. 123;
Rome/Paris 1973, no. 37.

SELECTED LITERATURE: Mojana 1989, 56, no. 3.

VALENTIN DE BOULOGNE, called Valentin (1591–1632):
Little is known about Valentin's early life (his family was
from Boulogne in Normandy) or training, but he had
probably settled in Rome before 1614, and he spent the rest
of his life there. In 1624 he was associated with the Bent-
vueghels, an association of mainly Dutch and Flemish
artists in Rome, rivaling the Italians' more official Accade-
mia di San Luca. His work is not well documented until the
last five years of his life, when he worked for such distin-
guished patrons as Cardinal Francesco Barberini. Barberini
obtained for him the important commission of an altar-
piece in Saint Peter's, *The Martyrdom of Saints Processus
and Martinian*, a dark, Caravaggesque work with which he
rivaled the more classical aesthetic of a companion altar-
piece by his compatriot Nicolas Poussin. Although Valentin
could not have known Caravaggio, who died in 1610,
he was one of his greatest followers and interpreters. He
employed Caravaggio's dramatic chiaroscuro to create
a sinister and even frightening world of dark alleyways,
palace guardrooms, and drinking dives, populated by low-
life characters from the streets of Rome. There seems to
have been little difference between the conduct of his own
life and the dissolute world he often chose to depict. The
same cast of characters appears in his powerful religious
works, giving them a vivid sense of contemporaneity.

45. Simon Vouet, *The Fortune-Teller,* c. 1618–1620

canvas, 120 x 170.2 (47¼ x 67)

National Gallery of Canada, Ottawa

PROVENANCE: Private collection, France to 1950s; acquired
by the National Gallery of Canada in 1955.

EXHIBITED: Paris 1955, no. 13 (under the name of Régnier);
Bordeaux 1955, no. 103; Ontario 1964, no. 36 (as Vouet);
Detroit 1965, no. 10; College Park 1971, no. 2; Cleveland
1971, no. 73; Rome/Paris 1973, no. 61/no. 64; Paris 1990,
no. 8.

SELECTED LITERATURE: Crelly 1962, 23, no. 10, 190–191,
no. 92; Laskin and Pantazzi 1987, 295–297.

SIMON VOUET (1590–1649): Born in Paris, the son of a
minor artist, Vouet traveled to Constantinople in 1611, to
Venice in 1612, and settled in Rome in 1614. Apart from a
trip to Genoa in 1620–1621, he remained in Rome until
1627. He associated with the group of French-born artists
in Rome, such as Claude Vignon, Valentin, Nicolas Rég-
nier, and Nicolas Tournier. All of these painters were
affected to a considerable degree by the art of Caravaggio,
especially his dramatic use of light and shade, his genre
subjects with their strong flavor of Roman life, and the
radical way he gave religious subjects a feeling of contem-
porary actuality. He enjoyed a prominent position in the
Roman art world, winning important church commissions,
finding favor with the powerful Barberini family, and
becoming president of the Accademia di San Luca, the
leading association of artists in Rome. His Roman style is
indebted to the tenebrism and the realism of Caravaggio,
exemplified in the exhibited *Fortune-Teller*, but he also
absorbed the classical tradition from Raphael to Guido
Reni, the colorism of Venice, and the nascent baroque
energy of Pietro da Cortona. This eclecticism served
Vouet well on his return to Paris in 1627, when he adopted
a lighter and more colorful style than his Roman one. He
quickly found private and ecclesiastical patrons who re-
sponded readily to his versatility with the latest Italianate
manners, and he undertook altarpieces and secular deco-
rations with equal gusto. As First Painter to the King and
head of a large and influential studio in Paris, Vouet effec-
tively determined the official style of French painting in
the first half of the century. He died in 1649, a year after
the foundation of the Royal Academy of Painting and
Sculpture.

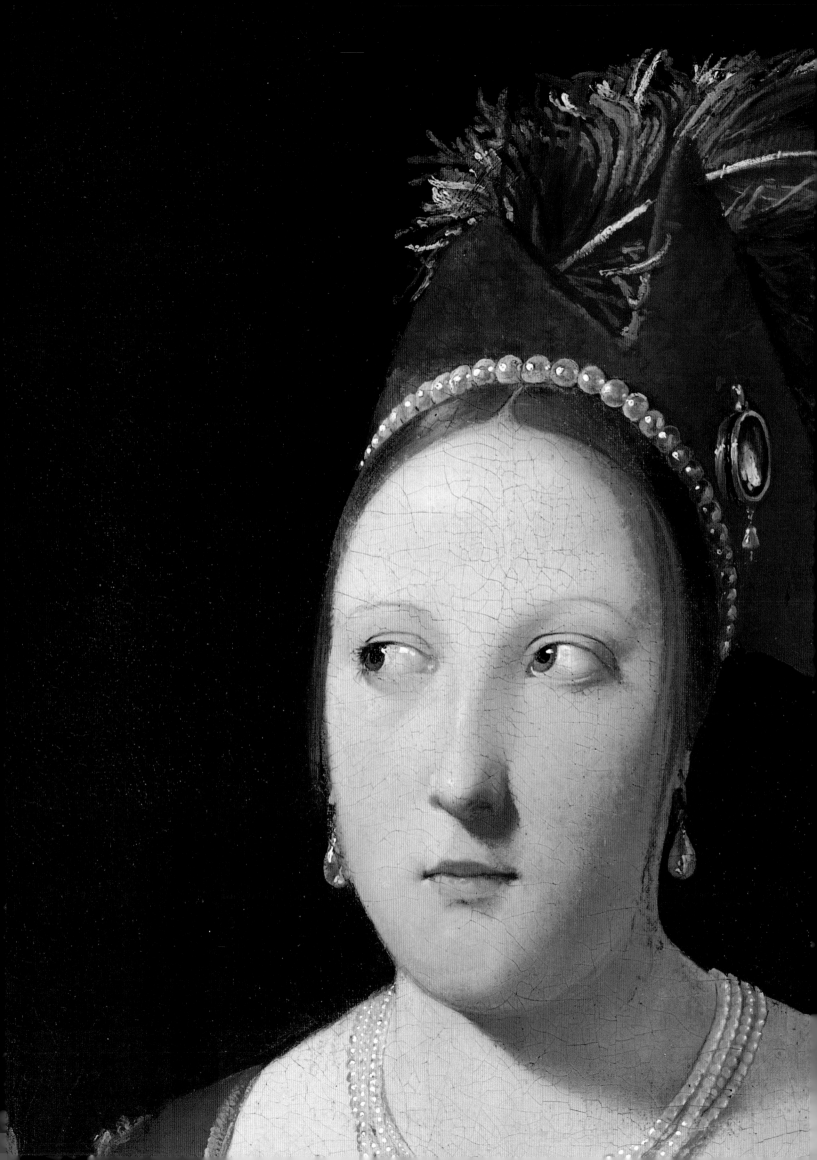

Appendix:
La Tour and
Autoradiography

CLAIRE BARRY

Although neutron activation autoradiography, commonly known as autoradiography, has yielded information about the working methods of Rembrandt and selected other artists since the late 1960s, the widespread application of the experimental technique as an investigative tool has been hampered by cost and other considerations.[1] The purpose of the present study is to make known the results of two autoradiographic examinations undertaken at the National Institute for Standards and Technology (NIST) in Gaithersburg, Maryland, in 1993 in preparation for this exhibition. It is the first time this invaluable means of examination has been applied to the study of Georges de La Tour's work, and the information gleaned challenges certain traditional views of the artist while placing our knowledge of his output on a more solid foundation. In one case autoradiography offered the opportunity to substantiate the presumed relationship of two variants of a famous moralizing scene of gambling at cards – *The Cheat with the Ace of Clubs* in Fort Worth and *The Cheat with the Ace of Diamonds* in Paris (cats. 18 and 19). In the second case autoradiography enabled us to investigate the prevailing view that the *Saint Sebastian Tended by Irene* in Fort Worth (cat. 16), a devotional night scene, was at best a workshop copy of a famous lost original, of which autograph versions were once most likely owned by both Duke Charles IV of Lorraine and King Louis XIII of France. In both cases the results were unexpected.

During autoradiography the painting is briefly (and safely) exposed to a field of thermal neutrons, which interact with some of the elements in pigments, such as manganese in umber and mercury in vermilion, which in turn emit gamma rays or charged particles. The latter can be detected because they fog photographic film. By placing film against the painting, we can determine the locations of elements such as manganese. Sequential exposures of the painting to film over a sixty-day period produce a series, typically of nine autoradiographs, which reveal the presence and location of differing elements and document the artist's use of particular pigments.[2] Some of the pigments most frequently found in La Tour's paintings, including dark ochers and umbers, azur-

ite, and vermilion, are recorded in this process.[3] Even details in brushwork in paint that has been covered can be clearly discerned, as can brushwork that has become less visible in damaged dark passages and in darkened paint layers; this information is particularly relevant in assessing La Tour's candlelight paintings.[4]

The Cheat with the Ace of Clubs

The Cheat with the Ace of Clubs became widely known in 1972 when it was shown for the first time in the La Tour retrospective at the Orangerie in Paris. Yet its relationship to a variant then in the Landry collection and subsequently acquired by the Louvre, *The Cheat with the Ace of Diamonds*, remained a matter of conjecture. On stylistic grounds Benedict Nicolson believed that *The Cheat with the Ace of Clubs*, then in a private collection in Geneva, followed the Landry, now Louvre, version by some fifteen years; he found the Geneva painting "altogether more harmoniously composed, and psychologically more subtle."[5] He also found that the cuffs of the Louvre dupe were painted rather harshly, exactly in the style of the cuffs in the Lviv *Payment of Taxes* (cat. 1; which he supposed to be a very early work).[6] By contrast, Jacques Thuillier concluded that the Geneva painting preceded the Louvre version by some years, citing its blond tonality, delicate facture, and numerous *pentimenti*.[7] Similarly, Pierre Rosenberg argued that the Geneva version predated the Louvre work, noting that "the quality of [the Geneva version] is sufficiently great for one to be able to see an important work – the first version of a theme that will be resumed several years later." Yet he qualified this opinion, maintaining that "only the meticulous restoration of *The Cheat with the Ace of Clubs* will permit the objective comparison of the two paintings."[8] The status of *The Cheat with the Ace of Clubs* as the primary or secondary version continued to be debated through the 1980s, even after the Kimbell Art Museum acquired the painting in 1981 and undertook a careful cleaning with the assistance of John Brealey of the Metropolitan Museum of Art. The numerous *pentimenti* in the Fort

1. X-radiograph of *The Cheat with the Ace of Clubs* (before removal of canvas addition along top edge in 1981).

Worth painting seemed to support the view that this was the prime version (fig. 1). But the presence of some of the colors of the Louvre version under those of the Fort Worth version, discovered in a later examination – the cheat's red collar was changed to black, for instance, and the maidservant's gold turban (excluding the bottom trim) was covered with gray – seems to contradict this view.[9]

In the process of autoradiography, radioactive isotopes for manganese are formed within the first twenty-four hours after activation, and the first four autoradiographs of *The Cheat* yield information about La Tour's use of manganese-based pigments, dark ocher and umber. In the fourth autoradiograph, from a three-hour exposure, ghostly images of the figures emerge, and their silhouettes, particularly the head and hands of the dupe, are discernible (fig. 2).[10] The courtesan's hands stand out as the lightest areas on the film, indicating the absence of dark ocher and umber, and her extended right hand has a cleanly defined, cookie cutter shape. The top edge and right side of her bodice, on the other hand, are the darkest areas. La Tour may have blocked in the right side (shadow side) of the dress with a brown wash, for a

2. Three-hour autoradiograph of *The Cheat with the Ace of Clubs*, which principally shows the distribution of manganese (present in dark ochers and umbers).

3. Detail of fig. 2, showing manganese-based lines in the maidservant's turban and along the nape of her neck and shoulder.

4. Detail of lower edge of the cheat's jacket flap, showing brown brush underdrawing.

dark pattern is revealed in this autoradiograph that is not visible on the surface of the painting. Indications of the folds in the maidservant's turban and the courtesan's sleeves can also be detected.[11]

The fourth autoradiograph also reveals numerous fine brown brush outlines – resembling drawing more than painting – which the artist applied to establish the contours of the maidservant (fig. 3) and the cheat as well as the top left edge of the table and around the wine flask, glass, and the cheat's cards. These fine, somewhat freely applied brushmarks have the character of a preliminary outline sketch, the first such design ever detected in an autograph work by La Tour. They show that the artist, in one respect, based the initial design of the Fort Worth picture on the final compositional arrangement of the Paris *Cheat*, or that both paintings derived from a common source or cartoon. The flap of the cheat's coat in the Fort Worth version was originally drawn, though not painted, in the same lower position as the coat flap in the Paris version. The brown brush

5. One-day autoradiograph of *The Cheat with the Ace of Clubs*, which principally shows the distribution of copper (present in azurite).

6. Detail of fig. 5, showing the use of azurite in the maidservant's light gray turban.

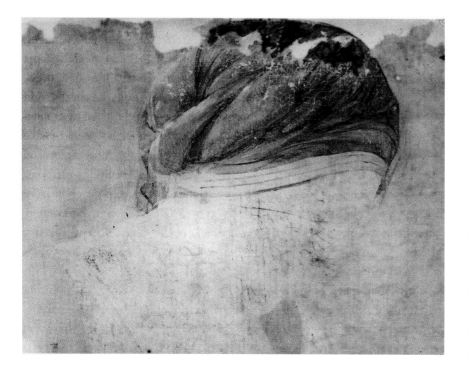

outline of the initial flap can also be detected through the paint layers of the Fort Worth painting, in which La Tour ultimately raised the flap and included a bossed stool or chair below (fig. 4); this is not present in the Paris *Cheat*.[12] The brown preparatory lines exist only on the left half of the composition and cannot be detected in the figures of the courtesan or dupe. It is perhaps relevant that the cheat and the servant are the two figures the artist repainted in a slightly shifted position.

Details painted in azurite also come to light in the fourth autoradiograph, where the blue edge of the courtesan's brooch and elements of the dupe's costume (including the embroidered collar, cuff, and edges of his jacket) can be seen. The graphic brushwork in the collar and cuffs is wholly characteristic of La Tour's spirited handling, particularly his manner of painting surface details, and it can be compared to passages in his *Fortune-Teller* (cat. 17), such as the red embroidery in the gypsy's sleeve at the far left and the shimmering yellow stitching in the dupe's collar, or to details such as the black edging on the violinist's jacket in *The Musicians' Brawl* (cat. 9) or the embroidered band along the top edge of the silk apron in the *Old Woman* (cat. 3). The artist's use of azurite is even more clearly visible in the seventh autoradiograph, a one-day exposure (fig. 5). The modeling of folds in the maidservant's turban and even the narrow stripes along her headband are very distinct because La Tour mixed azurite into the light gray paint (fig. 6). He also added this pigment to the

7. Detail of top edge of courtesan's bodice, showing very fine preliminary underpainting in red lake where it is not completely concealed by the upper layers of paint.

8. Detail of courtesan's index finger (shortened in final painting), showing initial outline in red lake.

ear underpainting in red lake pigment to draw the unbroken contours of the courtesan. This underpainting is visible along the top edge of her bodice (fig. 7), along her proper left shoulder and sleeve where it is not completely concealed by the upper paint layers, and in the initial outline of her proper right index finger (shortened in the final painting) (fig. 8).[15] These brush strokes clearly functioned as preliminary outlines and should be distinguished from La Tour's use of fine brush drawing in red lake as finishing lines on the surface to outline the pearls and the part in the courtesan's hair.

Two types of incisions also came to light in microscopic examination of the Fort Worth *Cheat*, some extremely fine and others thicker. Previously, incisions had been noted rarely in La Tour's work – for example, where the artist delineated straight edges with a rule, such as the floor in the *Old Man*, the cross in *Saint Philip*, the knife in *The Musicians' Brawl*, or the spear in *Saint Thomas* (cats. 2, 7, 9, 13).[16] Most of the incisions recently identified in *The Cheat* resemble the type found in *The Fortune-Teller* (described in note 26 in the essay by Gifford et al.). They were drawn freehand, they are distributed across the paint surface, and they do not clearly relate to the contours. Two slightly curved incisions with hooked ends appear in the dupe's hands and upper torso, while another diagonal incision lies above and parallel to his proper left shoulder. A longer, diagonal incision runs through the courtesan's proper left shoulder and along the inner edge of her dress. Other, shorter incisions appear in the cheat's right shoulder, back, and below his nose. Their exact function is not yet understood, but they seem to have aided La Tour in establishing the composition and may have served as guidelines for placing cartoons. Their purpose seems to have been different from those recently identified in the work of Caravaggio, who often incised lines to establish the pose of a live model or to note the relationship of different areas of the composition.[17]

courtesan's flesh tones for coolness,[13] creating the pale complexion of her face, neck, and chest.[14]

Evidence gleaned through autoradiography of *The Cheat with the Ace of Clubs* – in particular the discovery of brown brush underdrawing – is consistent with information available through microscopic and other examination. From close inspection under high magnification, it is evident that, in addition to preliminary brown brush outlines to define the sketchy contours of the maidservant and cheat, La Tour employed a very fine and precise lin-

Additional *pentimenti* that came to light during the microscopic examination (not visible in the x-radiograph) would argue either that the Paris version preceded that in Fort Worth or that the two orig-

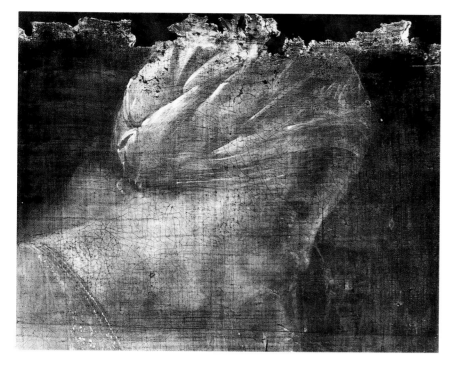

9. Detail of fig. 1, showing *pentimenti* in the maidservant's head, which was shifted to the right.

10. Detail of *pentimenti* in maidservant's head, visible under infrared reflectography.

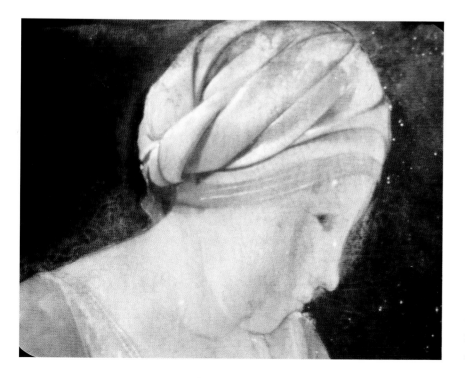

details in the Paris version. The raspberry sleeve of the dupe was originally fuller in the Fort Worth painting, similar to that in the Paris version; the artist narrowed it considerably by overlaying the lower edge with the embroidered jacket. An x-radiograph of the Paris *Cheat* indicates that La Tour also adjusted the dupe's sleeve in that work.[18] A tracing of the first version of the Fort Worth dupe's sleeve appears to follow the first version of the Paris dupe's sleeve, however, suggesting a prototype common to both; La Tour then would have modified this detail in both versions. Other *pentimenti* in *The Cheat with the Ace of Clubs* include the cheat's sash, which was raised, and the dupe's bottom card, originally a diamond, now a spade, in addition to the previously mentioned color changes in the maidservant's turban and the cheat's collar (see Gifford et al. fig. 8).

A comparable color change in the Paris *Cheat* has been used conversely to suggest that the Fort Worth *Cheat* came first. Jean-Paul Rioux and others have noted that the Paris servant's dark green bodice, which was changed from bright red, would have originally appeared closer to the color of the Fort Worth servant's bodice. There is, however, a subtle, yet meaningful difference between the reds of the two costumes. Indeed La Tour often makes distinctions in his use of reds, playing cooler red lake pigments against warmer vermilion ones. The Fort Worth bodice is pale crimson, created with red lake, white, and some vermilion; it falls midway in tone between the dupe's magenta sleeve, painted with red lake and lead white, and his scarlet breeches, made with vermilion. The initial Paris bodice, on the other hand, would have appeared as a bright scarlet, similar to the Paris skirt, which consists primarily of vermilion.[19]

The character of the brown brush underdrawing in the Fort Worth cheat and maidservant and the red lake outlines in the courtesan as well as their correspondence with the painted forms suggest that La Tour transposed these figures from an auxiliary drawing. In the figures of the maidservant (figs. 2 and 9) and the cheat the brush underdrawing relates to the revised contours.[20] La Tour's cartoon may have consisted of multiple individual drawings of the figures

inated from a common model. These *pentimenti* relate principally to adjustments in costume details. Although not major changes, they testify to the artist's interest in making minor refinements to achieve a balance of color and line. Initially the tip of the courtesan's plume and the bottom edge of the dupe's hat in the Fort Worth canvas were lower, following those

and some still-life details. It appears that the artist shifted the spacing or angle of the figures on the canvas like paper-doll cutouts. While he may have repositioned the figures or their hands, altered costume details, or modified colors in the course of painting, however, La Tour remained faithful to the primary conception, including the contours and scale of the figures. The initial profile of the maidservant (visible under infrared reflectography) can be superimposed over the final version (fig. 10). Indeed it seems highly unlikely that a multifigure composition like *The Cheat with the Ace of Clubs* could have been achieved without the aid of preliminary drawings. When a tracing of the Fort Worth painting was placed over the Paris version and shifted so that corresponding figures from the two versions could be compared, almost all of the heads and hands overlapped (with the exception of the dupe's hands and the courtesan's left hand).[21]

This traditional, premeditated working method differs from Caravaggio's practice of using incisions early in the design process as he painted from live models, and often deviating from the design lines in the final painting.[22] Although both artists drew on the canvas prior to painting (with incisions or brush lines), Caravaggio was not necessarily using cartoons, and his working method reflects a greater degree of spontaneity and audacity in transgressing these guidelines. By contrast, La Tour's method was more systematic, and the artist remained more faithful to his brush outlines as he painted his figures.

Previously it was believed that the existence of *pentimenti* always signaled the artist's first treatment of a composition,[23] but perhaps these marks can also be interpreted as the artist's refinements of a preexisting model in a second version. La Tour seems to have never repeated himself slavishly.[24] Instead he introduced variations in coloring, details, and placement in different versions of the same composition. Yet in spite of the well-documented differences between *The Cheat with the Ace of Clubs* and *The Cheat with the Ace of Diamonds*,[25] the contours of the heads and hands of the figures are almost identical in both versions.

Saint Sebastian Tended by Irene

There are more than ten known versions of this important composition, yet they vary considerably in quality, and none has received widespread acceptance as an autograph work by La Tour. It is generally believed that La Tour's two originals perished or remain untraced. Among the best and earliest of the surviving versions is the canvas now owned by the Kimbell Art Museum in Fort Worth (cat. 16), which once belonged to the Nelson-Atkins Museum in Kansas City, where for many years it was exhibited as an original by La Tour.[26]

Based upon information preserved in the files of the Nelson-Atkins Museum as well as corroborating evidence supplied by a former conservator there, we know a good deal about the conservation history of the work.[27] In the mid-1950s, in an effort to stabilize the paint, the work underwent a transfer. In the course of treatment the original support was sanded away, and the remaining, very thin layers of paint and ground were attached with a thick layer of gesso to a gauze veil, which was then lined with wax-resin. The surface of the painting was subsequently restored and the background liberally toned to mask the severely abraded darker passages. Despite the irreversible damage to the surface texture of the painting that resulted, which accounts for the present flattened and unnaturally smooth paint surface, the recent removal of the overpaints as well as several layers of synthetic and natural resin varnishes (in 1993 when the painting was cleaned and restored at the Kimbell Art Museum) has improved the overall appearance of the work and has revealed the survival of passages — mainly those executed with the addition of lead white — whose palette, modeling, and brushwork are of a quality consistent with La Tour's fully accepted work.[28] The subtle treatment of Irene's right hand, with its wet, extruded fingers and dirty fingernails, pulling the arrow from Sebastian's leg, and the daring juxtaposition of reds in Irene's costume, with its magenta sleeves and scarlet bodice, may be compared with the clash of the dupe's magenta sleeve and bright red breeches in *The Cheat* or with the similar contrast of red draperies in La Tour's *Newborn Child* (cat. 27).[29] The irregu-

11. X-radiograph of *Saint Sebastian Tended by Irene.*

lar pinpoint highlights of cream and red and the slightly blurred treatment of the decorative border of Irene's blouse, with its metallic embroidery also recall the similar treatment of this detail in the Madonna's chemise in *The Newborn Child*.

The 1993 restoration was only partly successful in clarifying dark passages in *Saint Sebastian*, which time and abrasion had rendered illegible, and x-radiography provided only information about the lighter passages in the picture (fig. 11). Thus auto-radiographic examination was undertaken to understand better the brush strokes that had become less visible in the damaged dark passages and in the darkened paint layers. This investigation was undertaken with the benefit of the information that came to light when the work was cleaned and restored, which showed that the artist had entirely repainted the eyes and chin of Irene 0.64 cm higher and had raised the bottom edge of the right side of her veil about 0.16 to 0.96 cm (fig. 12). The highlights on the finger-nails of Irene's proper left hand were similarly shifted

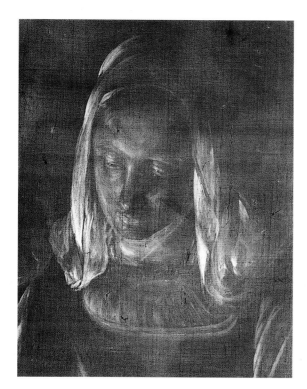

12. Detail of fig. 11, showing *pentimenti* in Irene's head, where her eyes and chin were repainted 0.64 cm higher.

295 *Appendix*

13. Two-and-a-half-hour autoradiograph of *Saint Sebastian Tended by Irene*, which principally shows the distribution of manganese (present in dark ochers and umbers).

14. Detail of fig. 13, showing parallel hatched brush strokes used to block out the hair and shoulder in the maidservant's head as well as fine brown brush outlines around the hair and fingers.

0.16 cm to the right, and her proper left fingers were lowered 0.16 cm. The window on the left side of the lantern was moved 0.48 cm further to the left, while the window on the right was moved further to the right; in addition, the shutter door was lowered 0.64 cm to the top edge of the arrow feathers, and the top edge of the arrow shaft was lowered.[30] The extent of these changes, albeit compositional refinements, were unexpected in a work widely considered to be a copy.[31]

As with *The Cheat*, the fourth autoradiograph of *Saint Sebastian*, a two-and-a-half-hour exposure, which records the use of manganese-based pigments such as umber and dark ocher, was the most informative (fig. 13).[32] The modeling of the figure of Sebastian is particularly coherent, from the subtle shading along the left side of his torso to the quick, parallel, hatched brush strokes used to model his legs and hair. These same decisive brush strokes can be seen in the maidservant's hair and shoulder (fig. 14) and can be read so clearly that it is possible to gauge

15. Detail of fig. 13, showing *pentimenti* in the eyes, chin, bodice, and veil of Irene's head as well as fine preliminary brown outlines along the left edge of her veil.

the width of the artist's flat brush: approximately 0.64 cm. This distinctive brushwork, hitherto unknown, was used to block out the forms as the artist laid in the figures.

With the same brush used to block out the forms, the artist refined the contours of the figures with linear strokes. Some fine lines were produced by ridges of paint left by the outer edges of the flat brush — evident, for example, along Sebastian's right arm and leg and along the maidservant's right shoulder. Other fine outlines, such as those in the lower right portion of the lantern and along the left edge of Irene's veil (fig. 15), appear darker and less fluid than these. They appear to have been created with a fine-pointed brush or to result from incisions that were then filled with dark brown paint.

La Tour employed a similar dark brown painted sketch to define both the forms and the poses of the figures and to establish the shadow values in the flesh tones and garments in the *Old Man*, *Old Woman*, and *Musicians' Brawl*.[33] Although the use of this kind of sketch, as described by Le Brun, was characteristic for La Tour, it was also employed by other French seventeenth-century artists such as Le Nain (see Gifford et al. fig. 1).[34]

Irene's blouse, which has cream-colored pleats and warm brown shadows in the painting, contains a great deal of manganese, for it registered as the darkest element in the fourth exposure. This suggests that the artist modeled the blouse by working from dark into light, a technique that was not uncommon in this period and which indeed was typical for La Tour.[35] The image also records traces of the pattern on Irene's bodice and indications of shadows in her right sleeve, probably because the artist mixed umber with red lake in these details.[36]

This autoradiograph also provided the first glimpse of what the artist intended in the landscape, from the softly rounded and streaky horizontal clouds along the top and left part of the sky to the spiky plant and hillock to the right of Irene. The fluidity and assurance in the handling of the brushwork suggests an artist of considerable competence. Since this composition would be the only example of La Tour's work as a landscapist, this imagery is of particular

16. Three-day autoradiograph of *Saint Sebastian Tended by Irene*, showing the distribution of mercury (present in vermilion).

interest. It also provides a significant point of comparison with the other versions of *Saint Sebastian*, where the landscape is often dark and illegible.

Because the artist employed such a limited palette, autoradiographs after the fourth exposure provide very little new information. The three-day exposure, or eighth autoradiograph, however, documents the artist's use of vermilion, which establishes one of the most important color contrasts in the painting (fig. 16). Irene's red bodice, with its damask pattern, is visible, as are parts of her proper right sleeve and cuff. The vermilion used to create her lips, the base of the candle flame, and the blood on the tip of the arrow and on Sebastian's chest and thigh are also recorded in this eighth autoradiograph.

Reexamination of *Saint Sebastian* under the microscope reveals some dark brown as well as more extensive red lake underdrawing. The choice of this pigment for preparatory brush drawing provides an interesting parallel with autograph works by La Tour, and it appears to be an idiosyncracy of this artist.

Preparatory red lake brush underdrawing is visible beneath Sebastian's profile, his abdomen, and along the back of his head, and also beneath the right edge of the servant's proper right hand, Irene's proper left wrist, and the left edge of her veil (fig. 17). These preparatory outlines should be distinguished from the red lake used as finishing lines along the shaft of the arrow and in Irene's fingers; Sebastian's eyes and navel and the eyes of the maidservant and Irene were also created with red lake. The red lake underdrawing used to lay in the contours of the figures may be compared with that used in the courtesan in *The Cheat*. In *Saint Sebastian*, however, these lines appear more broadly applied and tend to be more concealed by the upper paint layers than in *The Cheat*.

As with *The Cheat* and *The Fortune-Teller*, close inspection of *Saint Sebastian* reveals the presence of incisions, although they are less extensive than in the other two works. Two parallel, diagonal incisions run through the center of the lantern (8.5 cm) and the lower part of the maidservant's sleeve (11 cm),

17. Photomicrograph of the left edge of Irene's veil, showing the preparatory red lake outline.

the latter partly visible in the two-and-a-half-hour autoradiograph (fig. 13). These incisions (0.8 mm wide) were made by an instrument that ploughed through the preparation rather than sharply incising it. They bear a striking similarity to one another; both are parallel, diagonal lines running at a 45-degree angle, which may have helped the artist transfer the composition to the canvas. When the composition, which is based on a 4:6 ratio, is squared, these diagonals bisect two squares in the upper center.[37]

There are obvious differences between the fine preparatory brush lines evident in the autoradiographs of *The Cheat* and the broad brown sketch used in the *Saint Sebastian,* but these may not be irreconcilable. Ultimately the question of the authorship of *Saint Sebastian* can be resolved only through

connoisseurship, which must now allow for the compromised condition of the work (its flattened surface due to transfer and the severe abrasion in all of the dark pigments) as well as recognize the evident quality of the best preserved passages. The subtle modifications in the use of light, the characteristic shifts in contours *(pentimenti),* the expressive use of a broad brown wash sketch to define the forms and establish the shadows, the presence of markings and incisions to establish the composition on the canvas prior to its being painted, and the appearance of pure red lake for brush underdrawing – all of which came to light as a result of autoradiography – establish a new basis for assessing the question of La Tour's authorship of the damaged, but still highly moving, image of the Fort Worth *Saint Sebastian.*

Notes

In support of this study, the National Institute of Standards and Technology (NIST) granted access to its reactor, and Tony Cheng, an independent scientist, conducted both autoradiographic examinations, prepared and developed all exposures, and monitored results. Jacqueline Olin provided guidance throughout, while Edward Sayre, Pieter Meyers, René de la Rie, and Maryan Ainsworth examined and helped interpret results. I would like to thank several colleagues at the Kimbell Art Museum: Michael Gallagher was my collaborator on this project; he and Jeanette Schnell assisted Dr. Cheng at NIST; Michael Bodycomb prepared numerous photographs of the autoradiographs, x-radiographs, and paintings; Nancy Edwards, Edmund Pillsbury, Joachim Pissarro, and Isabelle Tokumaru contributed insightful comments and generous support .

1. The results of a groundbreaking autoradiographic study of a group of Rembrandt paintings and works by Van Dyck and Vermeer, conducted by the Metropolitan Museum of Art at Brookhaven National Laboratory from 1976–1980 and published in Ainsworth et al. 1982, inspired the present study. That publication contains a complete account of the examination process carried out at Brookhaven as well as the results.

Use of a nuclear reactor can be prohibitively expensive; and autoradiography is labor intensive, involving careful handling of the painting and numerous sheets of film and data, a costly undertaking even when the reactor time is donated. The painting must remain at the reactor site for around two months while the exposures are created, and exposing paintings to radiation is a safety concern, although tests carried out in the Metropolitan Museum study showed that the amount of radiation to which paintings are exposed in autoradiography is well below the level at which radiation damage, even to the most sensitive materials, can be detected (Ainsworth et al. 1982, 108).

The State Museums of Berlin is the only institution involved in ongoing autoradiographic examinations, planning to study La Tour's vertical *Saint Sebastian Tended by Irene*. Until 1992 the Conservation Analytical Laboratory of the Smithsonian Institution used the nuclear reactor at NIST to examine nineteenth-century American paintings under the direction of Jacqueline Olin, including works by Thomas Wilmer Dewing and Albert Pinkham Ryder. See also Cheng et al. 1983, 182–189. The application of autoradiography to the study of paintings was introduced in Sayre and Lechtman 1968, 161–185.

2. The first exposure is approximately thirty-five minutes, and each successive exposure is double the previous one, with the last exposure equalling a period of one month.

3. Autoradiography yields information about some but not all pigments in La Tour's paintings. Ainsworth et al. 1982: "Not all elements present in a painting form radioactive products suitable for autoradiography. Examples in this category are lead and iron, even though they are among the most abundant in paintings (i.e., lead in lead white and iron in ochers and umbers). Since carbon, hydrogen, and oxygen are among those elements that do not form radioactive elements useful in au-

toradiography, this technique will generally not yield information about the presence and distribution of organic pigments. (Exceptions are dyes or mordants containing aluminum.)"

4. See also Ainsworth et al. 1982, 12: "Much of the damage usually occurs in the browns and blacks, which are not visible in the x-radiograph. These pigments are by nature fugitive. In addition, some become darker with age (e.g., umbers) or fade to a gray tone with exposure to light (e.g., Van Dyck brown)." Many of these brown pigments are recorded by autoradiography.

5. Nicolson and Wright 1974, 20.

6. Nicolson and Wright 1974, 20.

7. See Thuillier 1973a, 90.

8. See Rosenberg and Macé de l'Epinay 1973, 116.

9. The Fort Worth dupe's bottom card was also changed from a diamond to a spade.

10. The three-hour exposure provides the clearest image of these pigments and is probably the most informative. The dark blotchiness visible across the center of the film is probably related to palette scrapings used as an adhesive in a previous lining rather than to the artist's technique. There is also some fading of the image along the left and right edges because the neutron flux was not even across the surface of the painting.

11. The fourth autoradiograph also provides information about the condition of *The Cheat with the Ace of Clubs*. A series of old tack holes is visible along the top and bottom edges, because they were subsequently filled with manganese-based pigments used in retouching; likewise old tears can also be seen, notably in the upper left background, left arm of the dupe, right sleeve of the cheat and near the center of the table.

12. This evidence suggests that the Thuillier and Rosenberg hypothesis that the Geneva version preceded the Louvre version of *The Cheat* is open to question. See also Rosenberg and Macé de l'Epinay 1973, 116; and Thuillier, 1973a, 90.

13. Azurite was used in the dupe's face to a lesser degree.

14. In the four remaining autoradiographs the figures themselves gradually fade away, while the courtesan's hat and the dupe's pantaloons, both created with vermilion, emerge in the three-day exposure. A smaller amount of vermilion may have been added to the maidservant's raspberry dress, because this detail also registers faintly in contrast to the dupe's breeches, which consist largely of vermilion.

15. Red lake is transparent under infrared, nor can it be detected under x-radiography, which records only very dense pigments such as lead white. Organic pigments are not recorded in autoradiography.

16. See also Vic-sur-Seille 1993, 85. La Tour also employed parallel incisions to bracket the signature in *Saint Thomas*.

17. See Christiansen 1986, 412–445. Caravaggio's well-known practice of incising lines in the preparation as an aid in composing his pictures was previously believed to be unique. Caravaggio's incisions were probably applied at an early stage in

the designing process, because the finished picture frequently departs from them considerably.

18. Jean-Paul Rioux in Vic-sur-Seille 1993, 36, 46.

19. Vermilion is x-ray opaque, while red lake is not. A comparison of the x-radiographs of *The Cheat with the Ace of Diamonds*, where the servant's bodice appears white, and *The Cheat with the Ace of Clubs*, where it appears gray (Vic-sur-Seille 1993, 36, 115), confirms that different pigment mixtures were used to create this element in each version. See also Rioux in Vic-sur-Seille 1993, 43–45. The whitest area in the x-radiograph of the Paris *Cheat* is the servant's bodice, previously bright red (the pigments used in the upper dark green paint layers are x-ray transparent). The presence of a bright red layer beneath the paint surface was confirmed with a magnifying loupe. It is presumed that this thick layer contains vermilion and lead white, both of which are radiopaque.

20. Vic-sur-Seille 1993, 89: "The almost perfect recovery of the protagonists (in different versions of the same theme) seems to suggest at first that the artist or one of his aids utilized, for executing the second version, a system of transport that has not left any traces. The scientific methods utilized do not lead to any element that permits a better understanding of how the artist proceeded, on the one hand to execute a prototype in the absence of a preparatory drawing conserved on a sheet, and on the other hand for reproducing a close variant or a faithful replica."

21. A mylar tracing of *The Cheat with the Ace of Clubs* was overlaid on *The Cheat with the Ace of Diamonds*, with the generous assistance of curator Olivier Meslay, in the Louvre in September 1995. In the Paris *Cheat* the dupe is shown more in profile than in the Fort Worth version, where his proper right cheek is slightly visible. The Fort Worth cheat's hands are similar in contour but farther from his body.

22. See also Christiansen 1986, 412–445.

23. Rosenberg and Thuillier 1972.

24. See also Nicolson and Wright 1974, 20; and Rodis Lewis 1993, 69–84.

25. The differences between *The Cheat with the Ace of Clubs* and *The Cheat with the Ace of Diamonds* include differences in overall tonality, the ground and colors, costumes, and still-life details. *The Cheat with the Ace of Clubs* contains *pentimenti* in the maidservant and the cheat and in the courtesan's proper left hand that are not present in the Paris version.

26. The work was still generally viewed as an original La Tour until 1971, when it appeared in the exhibition "Caravaggio and His Followers" at the Cleveland Museum of Art under La Tour's name. The attribution was questioned in reviews of this exhibition, and the work was not included in the Orangerie exhibition of 1972.

27. Perry Huston, formerly of the conservation department at the Nelson-Atkins Museum, who joined the staff there some years after *Saint Sebastian* was restored, recalled the procedure

apparently used in the restoration of the painting, as it had been described to him. Personal communication.

28. Following the 1993 cleaning, flake losses and some areas of abrasion were inpainted and the painting was varnished with a natural resin varnish. Conservation report, registrar's files, Kimbell Art Museum.

29. Compare also to the fingers in *The Magdalene with Two Flames*, Metropolitan Museum of Art (Conisbee, fig. 70).

30. X-radiography was performed after the painting was removed from the lining canvas and stretcher in order to obtain a more coherent image of the paint layers and support.

31. See also Christopher Wright's forthcoming article on *Saint Sebastian* in *Apollo*.

32. Examination confirmed that *Saint Sebastian* is based on a limited palette, employing pigments commonly used in French seventeenth-century painting, and is consistent with those used by La Tour in his candlelight paintings. The preparation in *Saint Sebastian*, identified by Dr. Barbara Berrie through the scanning electron microscope and energy dispersive spectrometry, is an almost homogeneous opaque yellow iron earth ground with a pinkish tint, containing quartz (sand) and calcite (chalk) particles and consisting of a single, thick layer. It is not dissimilar from the type of ground La Tour employed. In both the Cleveland *Saint Peter Repentant* (cat. 24) and the Los Angeles *Magdalene with the Smoking Flame* (cat. 23), there is a silicious earth ground, while in the Washington *Magdalene at the Mirror* (cat. 22), there is a silicious earth ground covered by a layer of yellow ocher. The preparation layer in *Saint Sebastian* therefore bears some similarity with at least one of the artist's nocturnes among those analyzed here (see Gifford et al.), although it is not identical to the ground of the Washington *Magdalene*. The thickness of the preparation (about 100 microns) is consistent with grounds in La Tour's paintings, both nocturnal and daylight, and is also typical of French seventeenth-century paintings. Personal communication, Barbara Berrie.

33. See Gifford et al. in the present catalogue.

34. See Gifford et al., note 4. Pierre Le Brun recommended the use of such a sketch in 1635.

35. See Gifford et al.

36. This autoradiograph also provides information about the condition of the painting. Areas of flake loss read as white, probably because there is some manganese in the ground that produces a general darkening of the film. There are irregularly spaced, parallel vertical bands of flake loss (probably the result of the painting having been rolled at some point) as well as small scattered ones. Some areas of restoration are also visible, reading as dark spots along the top left edge of the painting and in Irene's right sleeve.

37. The diagonal incision in the maidservant's sleeve continues up to the edge of Irene's veil, where it intersects with the fine dark outline visible in the two-and-a-half-hour, or fourth autoradiograph.

Select Bibliography

Monographs and Articles

Adhémar 1972
Adhémar, Hélène. "La Tour et les couvents lorrains." *Gazette des beaux-arts* 6, no. 80 (1972): 219–222.

Ainsworth et al. 1982
Ainsworth, Maryan. *Art and Autoradiography: Insights into the Genesis of Paintings by Rembrandt, Van Dyck, and Vermeer.* New York, 1982.

Antoine 1979
Antoine, Michel. "Un séjour en France de Georges de La Tour en 1839." *Annales de l'est* 1 (1979): 17–26.

Arland 1953
Arland, Marcel. *Georges de La Tour.* Paris, 1953.

Arland 1965
Arland, Marcel. "Georges de La Tour peintre de Lorraine." *Jardin des arts*, nos. 128–129 (1965): 16–25.

Aubry and Choux 1976
Aubry, Marie-Thérèse, and Jacques Choux. "Documents nouveaux sur la vie et l'oeuvre de Georges de La Tour." *Le pays lorrain* 57, no. 3 (1976): 155–158.

Bajou 1985
Bajou, Thierry. *De La Tour.* Paris, 1985.

Bardon 1968
Bardon, Françoise. "Le thème de la Madeleine pénitente au XVII^ème siècle en France." *Journal of the Warburg and Courtauld Institutes* 31 (1968): 274–306.

Bassani 1993
Bassani, Paola Pacht. *Claude Vignon 1593–1670.* Paris, 1993.

Bassani and Bellini 1994
Bassani, Riccardo, and Fiora Bellini. *Caravaggio Assassino.* Rome, 1994.

Bazin 1936
Bazin, Germain. "The Art of Georges de La Tour." *Apollo* 24 (1936): 286–290.

Behre 1991
Behre, Patricia. "Religion and the Central State in Metz, 1633–1700." Dissertation, Yale University. New Haven, 1991.

Benedetti 1993
Benedetti, Sergio. "Caravaggio's *Taking of Christ:* A Masterpiece Rediscovered." *Burlington Magazine* 119 (1993): 731–745.

Beresford 1985
Beresford, Richard. "Deux inventaires de Jacques Blanchard." *Archives de l'art français* 27 (1985): 107–134.

Bergeon and Martin 1994
Bergeon, Ségolène, and Elisabeth Martin. "La technique de la peinture française des XVII^e et XVIII^e siècles." *Techné* 1 (1994): 65–78.

Bieneck 1992
Bieneck, Dorothea. *Gerard Seghers (1591–1651).* Lingen, 1992.

Blankert 1980
Blankert, Albert. *Museum Bredius catalogus van de schilderinen en teekening.* 2nd rev. ed. The Hague, 1980.

Bloch 1930
Bloch, Vitale. "G. Dumesnil de La Tour." *Formes* 10 (1930): 17–19.

Bloch 1947
Bloch, Vitale. "Georges de La Tour. Twee nieuwe werken." *Nederlands Kunsthistorisch Jaarboek* (1947): 137–142.

Bloch 1948
Bloch, Vitale. "Een verrassend museum." *Maandblad voor beeldende Kunsten* (1948): 64.

Bloch 1949
Bloch, Vitale. "Beschouwingen over Georges de La Tour." *L'art français, Maanblad voor Beeldende Kunsten* 4–5 (1949): 82, 84–99.

Bloch 1950
Bloch, Vitale. *Georges de La Tour.* Amsterdam, 1950.

Bloch 1954
Bloch, Vitale. "Georges de La Tour Once Again." *Burlington Magazine* 96 (1954): 81–83.

Bloch 1972
Bloch, Vitale. "Georges de La Tour (1593–1652). Zur Austellung in Paris, Orangerie des Tuileries 6.5–25.9.1972." *Kunstchronik* 9 (1972): 222–225.

Blunt 1945
Blunt, Anthony. "The *Joueur de vielle* of Georges de La Tour." *Burlington Magazine* 86 (1945): 108–111.

Blunt 1950
Blunt, Anthony. Review of Pariset 1948. *Burlington Magazine* 92 (1950).

Blunt 1972
Blunt, Anthony. "Georges de La Tour at the Orangerie." *Burlington Magazine* 114 (1972): 516–525.

F. Bologna 1975
Bologna, Ferdinando. "A New Work from the Youth of La Tour." *Burlington Magazine* 117 (1975): 434–441.

Boubli 1985
Boubli, Lizzie. "Les collections parisiennes de peintures de Richelieu." In *Richelieu et le monde de l'esprit.* Paris, 1985.

Bougier 1958
Bougier, Annette-Marie. "Entre Vic-sur-Seille et Mattain-

court, Georges de La Tour et Saint Pierre Fourier." *Gazette des beaux-arts* 6, no. 52 (1958): 51–62.

Bougier 1963
Bougier, Annette-Marie. *Georges de La Tour, Peintre du roy.* Paris, 1963.

Boulmer 1988
Boulmer, Francis. "A propos des oeuvres sarthoises de Georges de La Tour." *La revue historique et archéologique du Maine* (1988): 279–311.

Boyer 1964
Boyer, Jean-Claude. "Un caravagesque français oublié. Trophime Bigot." *Bulletin de la Société de l'histoire de l'art français* (1964): 35–51.

Boyer 1965
Boyer, Jean-Claude. "Nouveaux documents inédits sur le peintre Trophime Bigot." *Bulletin de la Société de l'histoire de l'art français* (1965): 153–158.

Boyer 1988
Boyer, Jean-Claude. "The One and Only Trophime Bigot." *Burlington Magazine* 180 (1988): 355–357.

Brealey and Meyers 1981
Brealey, John, and Pieter Meyers. Letter: "*The Fortune Teller* by Georges de La Tour." *Burlington Magazine* (1981): 422–423.

Brejon de Lavergnée 1973
Brejon de Lavergnée, Arnauld. "Tableaux de Poussin et d'autres artistes français dans la collection Dal Pozzo. Deux inventaires inédits." *Revue de l'art* (1973): 79–96.

Brémond 1916
Brémond, Henri. *Histoire littéraire du sentiment religieux en France depuis la fin des guerres de religion jusqu'à nos jours.* 11 vols. Paris, 1916–1933.

Brigstocke 1982
Brigstocke, Hugh. "France in the Golden Age." *Apollo* 116 (1982): 8–14.

Brigstocke 1995
Brigstocke, Hugh. "Georges de La Tour's *Saint John the Baptist.*" In *Shop Talk: Studies in Honor of Seymour Slive.* Cambridge, MA, 1995.

Brumble 1973
Brumble, H. David. "John Donne's 'The Flea': Some Implications of the Encyclopedic and Poetic Flea Traditions." *Critical Quarterly* 15 (1973): 147–154.

Cabourdin 1977
Cabourdin, Guy. *Terre et hommes en Lorraine, 1550–1635.* 2 vols. Nancy, 1977.

Célier 1982
Célier, J. "*La diseuse de bonne aventure.*" *Revue historique et archéologique du Maine*, no. 2 (1982): 160–178.

Charpentier 1973
Charpentier, Thérèse F. "Peut-on toujours parler de *La servante à la puce?*" *Le pays lorrain* 54, no. 2 (1973): 101–108.

Cheng et al. 1983
Cheng, Yu-Tarng, Jacqueline Olin, Robert S. Carter, et al. "Modification of the National Bureau of Standards Research Reactor for Neutron-Induced Autoradiography of Paintings." In *Application of Science in the Examination of Works of Art*, 182–189. Ed. Pamela A. England and Lambertus van Zelst. Boston, 1983.

Chennevières and Montaiglon 1853–1862
Chennevières, Philippe, and Anatole de Montaiglon. *Abecedario de P.J. Mariette et autres notes inédites de cet amateur sur les arts et les artistes.* Paris, 1853–1862.

Choné 1991
Choné, Paulette. *Emblèmes et pensée symbolique en Lorraine (1525–1633).* Paris, 1991.

Choné 1992
Choné, Paulette. *L'atelier des nuits. Histoire et signification du nocturne dans l'art d'occident.* Nancy, 1992.

Choux 1973
Choux, Jacques. "Le miroir de la Madeleine chez Georges de La Tour." *Le pays lorrain* 54, no. 2 (1973): 109–112.

Choux 1995
Choux, Jacques. "Le retable de la Vie de saint Evre, oeuvre du peintre vosgien Claude Bassot, 1616." *Le pays lorrain* 76 (1995): 225–238.

Christiansen 1986
Christiansen, Keith. "Caravaggio e l'esempio davanti del naturale." *Art Bulletin* 68, no. 3 (September 1986): 412–445.

Christiansen 1988
Christiansen, Keith. "Technical Report on *The Cardsharps.*" *Burlington Magazine* 130 (1988): 26–27.

Cinotti 1983
Cinotti, Mia. *Caravaggio. La vita e l'opera.* Bergamo, 1983.

Collin 1984
Collin, Hubert. "Un document nouveau concernant Georges de La Tour, 14 september 1639." *Le pays lorrain* 65, no. 2 (1984): 131–132.

Comer 1980
Comer, Christopher D. "Studies in Lorraine Art, 1580–1625." Dissertation, Princeton University, 1980.

Conisbee, Levkoff, and Rand 1991
Conisbee, Philip, Mary L. Levkoff, and Richard Rand. *The Ahmanson Gifts: European Masterpieces in the Collection of the Los Angeles County Museum of Art.* Los Angeles, 1991.

Cordellier 1984–1985
Cordellier, Dominique. *Dessins français du XVII^e siècle.* Paris, 1984–1985.

Corrozet 1540
Corrozet, Gilles. *Hecatomgraphie, c'est-à-dire les descriptions de cent figures & hystoires.* Paris, 1540.

Cosnac 1885
Cosnac, G. J. de. *Les richesses du palais Mazarin.* Paris, 1885.

Crelly 1962
Crelly, William. *The Paintings of Simon Vouet.* New Haven, 1962.

Cressy 1980
Cressy, David. *Literacy and the Social Order: Reading and Writing in Tudor and Stuart England.* Cambridge, 1980.

Crooks 1931
Crooks, Esther. *The Influence of Cervantes in France in the Seventeenth Century.* Baltimore, 1931.

Cullière et al. 1989
Cullière, Alain, Philippe Le Roy, Michel Sylvestre, et al. *A la rencontre de Georges de la Tour.* Vic-sur-Seille, 1989.

Cuzin 1977
Cuzin, Jean-Pierre. "*La diseuse de bonne aventure* de Caravage." *Les dossiers du département des peintures* 13. Musée du Louvre, Paris (1977): 3–52.

Cuzin 1979
Cuzin, Jean-Pierre. "Trophime Bigot in Rome: A Suggestion." *Burlington Magazine* 122 (1979): 301–305.

Cuzin 1980
Cuzin, Jean-Pierre. "Manfredi's *Fortune Teller* and Some Problems of 'Manfrediana Methodus.'" *Bulletin of the Detroit Institute of Arts* 58, no. 1 (1980): 14–25.

Cuzin 1982
Cuzin, Jean-Pierre. "New York, French Seventeenth-Century Paintings from American Collections." *Burlington Magazine* 124 (1982): 526–530.

Cuzin 1995
Cuzin, Jean-Pierre. "Un Georges de La Tour pour La Lorraine." *Revue du Louvre* 2 (1995): 5–6.

Cuzin and Rosenberg 1978
Cuzin, Jean-Pierre, and Pierre Rosenberg. "Saraceni et la France. A propos du don par les Amis du Louvre." *Revue du Louvre* 3 (1978): 186–196.

Darnton 1984
Darnton, Robert. *The Great Cat Massacre and Other Episodes in French Cultural History.* New York, 1984.

Davies 1907
Davies, R. "An Inventory of the Duke of Buckingham's Pictures, etc., at York House in 1635." *Burlington Magazine* 10 (1907): 376–382.

Delmeau 1977
Delmeau, Jean. *Catholicism between Luther and Voltaire.* London, 1977.

De Marly 1970
De Marly, Diana. "A Note on the Metropolitan *Fortune Teller.*" *Burlington Magazine* 112 (1970): 388–391.

De Marly 1981
De Marly, Diana. "Indecent Exposure." *Connoisseur* 206 (1981): 1–3.

De Mayerne 1974 ed.
De Mayerne, Turquet. *Le manuscrit de Turquet de Mayerne presenté par M. Fiadutti et C. Versini (1620–1646?).* Lyon, 1974.

Diefendorf 1991
Diefendorf, Barbara. *Beneath the Cross: Catholics and Huguenots in Sixteenth-Century Paris.* New York, 1991.

Digot 1856
Digot, Auguste. *Histoire de Lorraine* 5 (1856): 53–152.

Dubus, Bouquillon, and Querré 1994
Dubus, Michel, Anne Bouquillon, and Guirec Querré. "Caractérisation des argiles et identification des manufactures céramiques du Gard (France) au XIXᵉ siècle." *Techné* 1 (1994): 111–124.

Duval 1992
Duval, Alain R. "Les préparations colorées des tableaux de l'école française des dix-septième et dix-huitième siècles." *Studies in Conservation* 37 (1992): 239–258.

Eisendraht 1956
Eisendraht, William N. "*Young Man with a Pipe* by Georges de La Tour." *Bulletin of the City Art Museum of St. Louis* 41, no. 3 (1956): 29–36.

Félibien 1725
Félibien, André. *Entretiens sur les vies et sur les ouvrages des plus excellens peintres anciens et modernes; avec la vie des architectes.* Reprint of 1725 ed. Farnborough, 1967.

Ferrari 1961
Ferrari, Maria Luisa. *Il Romanino.* Milan, 1961.

Foucart 1978
Foucart, Jacques. "Une fausse énigme. Le pseudo et le véritable Van de Venne." *Revue du Louvre* 42 (1978): 53–62.

Foucart 1980
Foucart, Jacques. "Abraham de Vries en France." *Bulletin de la Société de l'histoire de l'art française* (1982): 127–135.

Foucart-Walter 1982
Foucart-Walter, Elisabeth. *Le Mans, musée de Tessé: Peintures françaises du XVIIᵉ siècle.* Paris, 1982.

Francis 1952
Francis, Henry S. "*The Repentant Saint Peter* by Georges de La Tour." *Bulletin of the Cleveland Museum of Art* 39 (1952): 174–177.

Franits 1993
Franits, Wayne E. *Paragons of Virtue.* Cambridge, 1993.

Frick 1968
The Frick Collection: An Illustrated Catalogue. Vol. 2. *Paint-ings: French, Italian, and Spanish.* New York, 1968.

Friedlaender 1955
Friedlaender, Walter. *Caravaggio Studies.* Princeton, 1955.

Friedländer 1973
Friedländer, Max J. *Early Netherlandish Painting.* Vol. 10. *Lucas van Leyden and Other Dutch Masters of His Time.* Leyden; Brussels, 1973.

Frommel 1971
Frommel, Christoph. "Caravaggios Frühwerk und der Kardinal Francesco Maria del Monte." *Storia dell'arte* 9/10 (1971): 5−52.

Fumaroli 1994
Fumaroli, Marc. *L'école de silence. Le sentiment des images au XVIIᵉ siècle.* Paris, 1994.

Furness 1949
Furness, S.M.M. *Georges de La Tour of Lorraine 1593−1652.* London, 1949.

Garas 1967
Garas, K. "The Ludovisi Collection of Pictures in 1633." *Burlington Magazine* 109 (1967): 339−348.

Granath et al. 1995
Granath, Olle, et al. *Nationalmuseum Stockholm.* London, 1995.

Grate 1959
Grate, Pontus. "Quelques observations sur les Saint Jérôme de Georges de La Tour." *Revue des arts* 9, no. 1 (1959): 15−24.

Grate 1988
Grate, Pontus. *French Paintings.* Vol. 1. *Seventeenth Century.* Stockholm, 1988.

Grate 1995
Grate, Pontus. *Nationalmuseum Stockholm.* London; Wappingers Falls, NY, 1995.

Gregori 1994
Gregori, Mina. *Caravaggio.* Milan, 1994.

Grieten 1989
Grieten, Guy. *Maîtres français 1550−1600. Dessins de la donation Mathias Polakovits à l'Ecole des Beaux-Arts.* Paris, 1989.

Grossmann 1958
Grossmann, Fritz. "A Painting by Georges de La Tour in the Collection of Archduke Leopold Wilhelm." *Burlington Magazine* 100 (1958): 86−91.

Grossmann 1973
Grossmann, Fritz. "Some Observations on Georges de La Tour and the Netherlandish Tradition." *Burlington Magazine* 115 (1973): 576−583.

Grouchy 1894
Grouchy, vicomte de. "Everhard Jaback collectionneur parisien (1695)." *Mémoires de la Société de l'histoire de Paris et de l'Ile de France* 21 (1894).

Hale 1990
Hale, J. R. *Artists and Warfare in the Renaissance.* New Haven, 1990.

Haskins 1993
Haskins, Susan. *Mary Magdalen: Myth and Metaphor.* New York, 1993.

Held 1984
Held, Julius S., René Taylor, and James Carder. *Museo de Arte de Ponce: Paintings and Sculpture of the European and American Schools.* Puerto Rico, 1984.

Hibbard 1972
Hibbard, Howard. "*Ut picturae sermones:* The First Painted Decorations of the Gesu." In *Baroque Art: The Jesuit Contri-bution,* 29−49. Ed. Rudolf Wittkower and Irma B. Jaffé. New York, 1972.

Hibbard 1983
Hibbard, Howard. *Caravaggio.* New York, 1983.

Hollstein
Hollstein, F.W.H. *Dutch and Flemish Etchings Engravings and Woodcuts,* vol. 2. Amsterdam, 1955.

Horn 1989
Horn, Hendrik J. *Jan Cornelisz Vermeyen.* 2 vols. Doornspijk, 1989.

Huyghe 1945
Huyghe, René. "Un chef-d'oeuvre de Georges de La Tour . . . *Saint François*" *L'amour de l'art,* no. 1 (1945): 12−15.

Huyghe 1946
Huyghe, René. "L'influence de Georges de La Tour. Une oeuvre perdue de Georges de La Tour." *L'amour de l'art,* no. 9 (1946): 255−258.

Jacquot 1900
Jacquot, Albert. *Essai de répertoire des artistes lorrains.* Paris, 1900.

Jaffé 1989
Jaffé, Michael. *Rubens. Catalogo completo.* Milan, 1989.

Jamot 1939
Jamot, Paul. "Georges de La Tour. A propos de quelques tableaux nouvellement découvertes." *Gazette des beaux-arts* 6, no. 21 (1939): 243−252, 271−286.

Jamot 1942
Jamot, Paul. *Georges de La Tour.* Paris, 1942.

Jamot 1948
Jamot, Paul. *Georges de La Tour.* 2nd ed. Paris, 1948.

Jansen 1992
Jansen, Guido. "French Painting in Dutch Collections:
Appendix." *French Paintings from Dutch Collections 1600–
1800*. Institute Néerlandais. Rotterdam, 1992.

Jardot 1946
Jardot, M. "Le Christ aux outrages de La Tour." *L'amour de
l'art*, no. 46 (1946): 74–77.

Jones 1968
Jones, Beneth A. *Bob Jones University: Supplement to the
Catalogue of the Art Collection, Paintings Acquired 1963–1968.*
Greenville, SC, 1968.

Jouanny 1911
Jouanny, Charles, ed. *Correspondance de Nicolas Poussin.*
Paris, 1911.

Judson 1959
Judson, J. Richard. *Gerrit van Honthorst*. The Hague, 1959.

Jütte 1988
Jütte, Robert. "Die Anfänge des organisierten Verbrechens.
Falschspieler und ihre Tricks im späten Mittelalter und der
frühen Neuzeit." *Archiv für Kulturgeschichte* 70, no. 1 (1988):
1–32.

Kavanagh 1993
Kavanagh, Thomas. *Enlightenment and the Shadows of
Chance: The Novel and the Culture of Gambling in 18th-
Century France*. Baltimore, 1993.

Kellog Smith 1979
Kellog Smith, Martha. "Georges de La Tour's *Old Man* and
Old Woman in San Francisco." *Burlington Magazine* 121
(1979): 288–294.

Klein and Zerner 1966
Klein, Robert, and Henri Zerner. *Italian Art 1500–1600:
Sources and Documents*. Englewood Cliffs, NJ, 1966.

Kloek 1989
Kloek, W. "Jan Cornelisz Vermeyen, De bruiloft te Kana,
ca. 1530." *Bulletin van het Rijksmuseum* 37 (1989): 174–175.

Kraehling 1938
Kraehling, Victor. *Saint Sébastien dans l'art*. Paris, 1938.

Kuiper 1971
Kuiper, L. "Restauratie-verslagvan Hendrick Terbrugghen's
Aanbidding der koningen." *Bulletin van het Rijksmuseum* 19
(1971): 117–135, 139.

Lacau St. Guily 1992
Lacau St. Guily, Agnès. *La Tour, une lumière dans la nuit.*
Paris, 1992.

Lacau St. Guily 1995
Lacau St. Guily, Agnès. "*Saint Jean-Baptiste dans le désert.*
Le chef d'oeuvre inconnu de Georges de La Tour." *Le pays
lorrain* 76 (1995): 79–90.

La Hyre 1730
La Hyre, Philippe. "Traité de la pratique de peinture."
*Mémoires de l'Academie royale des sciences depuis 1666
jusqu'à 1699* 9 (1730).

Landry 1942
Landry, Pierre. "Georges de La Tour et le tableau des 'deux
moines' du Musée du Mans." *Revue historique et archéologique
du Maine*, no. 22 (1942): 14–27.

Laperche-Fournel 1985
Laperche-Fournel, Marie-Jose. *La population du duché de
Lorraine de 1580 à 1720*. Nancy, 1985.

Laskin and Pantazzi 1987
Laskin, Myron, and Michael Pantazzi. *Catalogue of the
National Gallery of Canada, Ottawa: European and American
Painting, Sculpture, and Decorative Arts*. Ottawa, 1987.

Le Floch 1995
Le Floch, Jean-Claude. *Le signe de contradiction. Essai sur
Georges de La Tour et son oeuvre*. Paris, 1995.

Le Moigne 1978
Le Moigne, François-Yves. "La monarchie française et le
partage de l'espace Lorraine (1608–1697)." In *Histoire de la
Lorraine*, 269–313. Ed. Edouard Privat. Toulouse, 1978.

Le Moigne 1993
Le Moigne, François-Yves. *La Lorraine, passionement.*
Metz, 1993.

Lepage 1852
Lepage, Henri. *Le palais ducal de Nancy*. Nancy, 1852.

Lepage 1853
Lepage, Henri. *Quelques notes sur les peintres lorrains des 15ᵉ,
16ᵉ, et 17ᵉ siècles*. Nancy, 1853.

Lepage 1865
Lepage, Henri. *Les archives de Nancy ou documents inédits
relatifs a l'histoire de cette ville*. 3 vols. Nancy, 1865.

Leppert 1978
Leppert, Richard D. *Arcadia at Versailles: Noble Amateur
Musicians and Their Musettes and Hurdy-Gurdies at the French
Court (c. 1660–1789)*. Amsterdam and Lisse, 1978.

Levi 1985
Levi, Honor. "L'inventaire après décès du cardinal de Riche-
lieu." *Archives de l'art français* 27 (1985): 9–83.

Linnik 1973
Linnik, I. "Les lamentations de Jacques de Bellange."
Soolscenija gosudartsvennego tmituŋa 36 (1973): 8–12.

Linnik 1975
Linnik, I. "Un tableau de Jacques de Bellange nouvellement
découvert." *Revue de l'art* 20 (1975): 65–70.

Linnik and Vsevoloshskay 1975
Linnik, I., and S. Vsevoloshskay. *Caravaggio and His Follow-
ers*. Paintings in Soviet Museums. St. Petersburg, 1975.

Longhi 1935
Longhi, Roberto. "I pittori della realtà in Francia ovvero i caravaggeschi francesi del seicento." *Paragone*, no. 269 (1972): 3–18.

Lowenthal 1986
Lowenthal, Anne W. *Joachim Wtewael*. Doornspijk, 1986.

Macrae 1964
Macrae, Desmond. "Observations on the Sword in Caravaggio." *Burlington Magazine* 106 (1964): 412–416.

Mahon 1988
Mahon, Denis. "Fresh Light on Caravaggio's Earliest Period: His *Cardsharps* Recovered." *Burlington Magazine* 130 (1988): 10–25.

Mâle 1951
Mâle, Louis. *L'art religieux de la fin du XVI^e siècle et du XVIII^e siècle. Etude sur l'iconographie après le concile de Trente.* Paris, 1951.

Marcus 1976
Marcus, A. G. "Les Watteau de Lille." *Art et curiosité* 25 (May–June 1976).

Marlier 1969
Marlier, Georges. *Pierre Brueghel le Jeune*. Brussels, 1969.

Martin and Reinbold 1994
Martin, Elisabeth, and Anne Reinbold. "Hypothèse inédite à propos d'un *Vielleur* de La Tour." *Techné* 1 (1994): 79–84.

Meaume 1853–1860
Meaume, Edouard. *Recherches sur la vie et les ouvrages de Jacques Callot, suite au peintre-graveur français de M. Robert-Dumesnil.* Paris, 1853–1860.

Mérot 1995
Mérot, Alain. *French Painting in the Seventeenth Century.* New Haven and London, 1995.

Merrifield 1967 ed.
Merrifield, Mary P. *Original Treatises on the Art of Painting* (1849). Reprint in 2 vols. New York, 1967.

Mignot 1984
Mignot, Claude. "Le cabinet de Jean-Baptiste de Bretagne. Un 'curieux' parisien oublié (1650)." *Archives de l'art français*, n.s. 27 (1984): 71–87.

Miskimin 1977
Miskimin, Harry A. *The Economy of Later Renaissance Europe: 1460–1600.* Cambridge, 1977.

Moffitt 1987
Moffitt, John F. "*La femme à la puce*: The Textual Background of Seventeenth-Century Painted 'Flea-Hunts.'" *Gazette des beaux-arts* 110 (1987): 99–103.

Moir 1976
Moir, Alfred. *Caravaggio and His Copyists.* New York, 1976.

Mojana 1989
Mojana, Marina. *Valentin de Boulogne.* Milan, 1989.

Nicolson 1958a
Nicolson, Benedict. "In the Margin of the Catalogue." *Burlington Magazine* 100 (1958): 97–101.

Nicolson 1958b
Nicolson, Benedict. *Hendrick Terbrugghen.* London, 1958.

Nicolson 1960a
Nicolson, Benedict. "'The Candlelight Master': A Follower of Honthorst in Rome." *Nederlands Kunsthistorisch Jaarboek* (1960): 121–164.

Nicolson 1960b
Nicolson, Benedict. "Second Thoughts about Terbrugghen." *Burlington Magazine* 102 (1960): 465–473.

Nicolson 1964a
Nicolson, Benedict. "Un Caravagiste Aixois." *Art de France* (1964): 116–139.

Nicolson 1964b
Nicolson, Benedict. "The Rehabilitation of Trophime Bigot." *Art and Literature* 4 (1964): 66–105.

Nicolson 1969
Nicolson, Benedict. "A New 'Image Saint Alexis.'" *Burlington Magazine* 111 (February 1969): 86–88.

Nicolson 1972
Nicolson, Benedict. "Caravaggesques at Cleveland." *Burlington Magazine* 114 (1972): 113–117.

Nicolson 1979
Nicolson, Benedict. *The International Caravaggesque Movement: Lists of Pictures by Caravaggio and His Followers throughout Europe from 1590 to 1650.* Oxford, 1979.

Nicolson 1989
Nicolson, Benedict. *Caravaggism in Europe.* 3 vols. Milan, 1989.

Nicolson and Wright 1971
Nicolson, Benedict, and Christopher Wright. "A New Painting by Georges de La Tour." *Burlington Magazine* 113 (1971): 668–670.

Nicolson and Wright 1972
Nicolson, Benedict, and Christopher Wright. "Georges de La Tour et la Grande Bretagne." *Revue du Louvre*, no. 2 (1972): 135–142.

Nicolson and Wright 1974
Nicolson, Benedict, and Christopher Wright. *Georges de La Tour.* London, 1974.

Norberg 1985
Norberg, Kathryn. *Rich and Poor in Grenoble, 1600–1814.* Berkeley, 1985.

Nova 1994
Nova, Alessandro. *Gerolamo Romanino.* Turin, 1994.

O'Neill 1980
O'Neill, Mary. *Catalogue Critique. Les peintures de l'école française des XVIIe et XVIIIe siècles. Musée des Beaux-Arts d'Orléans.* 2 vols. Orléans, 1980.

Ottani Cavina 1972
Ottani Cavina, Anna. "La Tour all'Orangerie e il suo primo tempo caravaggesco." *Paragone* 273 (1972): 3–24.

Ottina della Chiesa 1967
Ottina della Chiesa, A. *L'opera completa di Caravaggio.* Milan, 1967.

Pariset 1935
Pariset, François-Georges. "Effets de clair-obscur dans l'école Lorraine." *Archives alsaciennes d'histoire de l'art* (1935): 231–255.

Pariset 1948
Pariset, François-Georges. *Georges de La Tour.* Paris, 1948.

Pariset 1955a
Pariset, François-Georges. "L'art à la cour ducale de Nancy vers 1600." *Médecine de France* 68 (1955): 17–26.

Pariset 1955b
Pariset, François-Georges. "La servante à la puce par Georges de La Tour." *Revue des arts* 2 (1955): 91–94.

Pariset 1955c
Pariset, François-Georges. "Mise au point-provisoire-sur Georges de La Tour." *Cahiers de Bordeaux, journées internationales d'études d'arts* (1955): 79–89.

Pariset 1958
Pariset, François-Georges. "La servante à la puce." *Le pays lorrain* 3 (1958): 100–108.

Pariset 1961a
Pariset, François-Georges. "A Newly Discovered de La Tour: *The Fortune Teller.*" *Metropolitan Museum of Art Bulletin* 19 (1961): 198–205.

Pariset 1961b
Pariset, François-Georges. "La Madeleine aux deux flammes: Un nouveau Georges de La Tour?" *Bulletin de la Société de l'histoire de l'art français* (1961): 39–44.

Pariset 1962a
Pariset, François-Georges. "La Madeleine aux deux flammes." *Le pays lorrain* 4 (1962): 162–166.

Pariset 1962b
Pariset, François-Georges. "Acquisitions récentes du Musée Lorrain. I. Un vielleur de l'Ecole de Georges de La Tour." *Le pays lorrain* 4 (1962): 145–149.

Pariset 1963
Pariset, François-Georges. "Bellange et Lagneau ou le maniérisme et le réalisme en France après 1600." *Studies in Western Art. Acts of the Twentieth International Congress of the History of Art.* New York, 1963.

Pariset 1972
Pariset, François-Georges. "L'exposition de Georges de La Tour à l'Orangerie, Paris." *Gazette des beaux-arts* 6, no. 80 (1972): 207–212.

Pariset 1973
Pariset, François-Georges. "Comte rendu de l'exposition de Paris." *Journal de la Societé d'archéologie lorraine et du Musée historique lorrain,* no. 2 (1973): 59–86.

Pariset 1976
Pariset, François-Georges. "Georges de La Tour, réflexions sur l'artiste et son oeuvre." *Le pays lorrain* 3 (1976): 136–154.

Picard 1972
Picard, Raymond. "L'unité spirituelle de Georges de La Tour." *Gazette des beaux-arts* 6, no. 80 (1972): 213–218.

Pigler 1967
Pigler, Andor. *Katalog der Galerie Alter Meister.* 2 vols. Tübingen, 1967.

Pillsbury 1987
Pillsbury, Edmund, et al. *In Pursuit of Quality: The Kimbell Art Museum.* Fort Worth, 1987.

Prohaska 1987
Prohaska, Wolfgang. *The Metropolitan Museum of Art, New York. Georges de La Tour. Bei der Wahrsagerin. Das Meisterwerks* 6. Kunsthistorisches Museum. Vienna, 1987.

Reinbold 1984
Reinbold, Anne. "Un document inédit: la prestation du serment à Louis XIII par Georges de La Tour à Lunéville en 1634." *Le pays lorrain* 65, no. 2 (1984): 125–130.

Reinbold 1985
Reinbold, Anne. "Une disposition testamentaire inédite de Georges de La Tour." *Le pays lorrain* 66, no. 4 (1985): 239–241.

Reinbold 1991
Reinbold, Anne. *Georges de La Tour.* Paris, 1991.

Reinbold et al. 1994
Reinbold, Anne, Thierry Bajou, Jean-Claude Boyer, et al. *Georges de La Tour ou la nuit traversée.* Metz, 1994.

Renger 1970
Renger, Konrad. *Lockere Gesellschaft. Zur Ikonographie des Verlorenen Sohnes und von Wirtshausszenen in der niederlandischen Malerei.* Berlin, 1970.

Ribault 1984
Ribault, Jean-Yves. "Réalisme plastique et réalité sociale. A propos des aveugles musiciens de Georges de La Tour." *Gazette des beaux-arts* 104 (1984): 1–4.

Richardson 1949a
Richardson, E. P. "Saint Sebastian Nursed by Saint Irene." *Art Quarterly* 12, no. 1 (1949): 81–89.

Richardson 1949b
Richardson, E. P. "Georges de La Tour's Saint Sebastian
Nursed by Saint Irene." *Bulletin of the Detroit Institute of
Arts* 28, no. 2 (1949): 26–29.

Rodis Lewis 1993
Rodis Lewis, Genevieve. *Regards sur l'art*. Paris, 1993.

Roggen and Pauwels 1955
Roggen, D., and H. Pauwels. "Het caravaggistisch oeuvre
van Gerard Zegers." *Gentse Bijdragen tot de Kunstgescheidenis*
16 (1955–1956): 273, 275–277.

Rosenberg 1966
Rosenberg, Pierre. "Rouen-Musée des Beaux-Arts."
*Tableaux français du XVII^{ème} siècle et italiens des XVII^{ème} et
XVIII^{ème} siècles*. Paris, 1966.

Rosenberg 1976
Rosenberg, Pierre. Review of Nicolson and Wright 1974.
Art Bulletin 58 (1976): 452–454.

Rosenberg 1988
Rosenberg, Pierre. "Pourquoi le *Saint Thomas* de La Tour
aurait-il manqué sur les cimaises du Louvre." *Revue du
Louvre* 4 (1988): 325–330.

Rosenberg 1990
Rosenberg, Pierre. "Un nouveau La Tour." In *Scritti in onore
di Giuliano Briganti*, 169–178. Milan, 1990.

Rosenberg 1991
Rosenberg, Pierre. "An Unpublished Composition by
Georges de La Tour." *Burlington Magazine* 133 (1991):
703–705.

Rosenberg 1992
Rosenberg, Pierre. "Notes sur l'art lorrain au XVII^e siècle
(de Callot à Watteau, de La Tour à Saint-Aubin)." *Jacques
Callot (1592–1635). Actes du colloque organisé par le Louvre et
la ville de Nancy*, 401–422. Paris, 1992.

Rosenberg and Macé de l'Epinay 1973
Rosenberg, Pierre, and François Macé de l'Epinay. *Georges
de La Tour*. Fribourg, 1973.

Rosenberg and Mojana 1992
Rosenberg, Pierre, and Marina Mojana. *Georges de La Tour.
Catalogo completo dei dipinti*. Florence, 1992.

Rosenberg and Stewart 1987
Rosenberg, Pierre, and Marion C. Stewart. *French Paintings
1500–1825: The Fine Arts Museums of San Francisco*. San
Francisco, 1987.

Rosenberg and Thuillier 1972
Rosenberg, Pierre, and Jacques Thuillier. *Georges de La Tour*.
Paris, 1972.

Royalton-Kisch 1988
Royalton-Kisch, Martin. *Adriaen van de Venne's Album in the
Department of Prints and Drawings in the British Museum*.
London, 1988.

Ryan and Rippenberger 1969
Ryan, Granger, and Helmut Rippenberger, eds. Jacobus de
Voragine's *The Golden Legend*. New York, 1969.

Salmon 1967
Salmon, J.H.M. "Venality of Office and Popular Sedition in
Seventeenth-Century France: A Review of a Controversy."
Past and Present 37 (1967): 21–43.

Sarrazin 1994
Sarrazin, Beatrice. *Catalogue raisonné des peintures italiennes
du Musée des Beaux-Arts de Nantes*. Nantes, 1994.

Sayre and Lechtman 1968
Sayre, E. V., and H. N. Lechtman. "Neutron Activation
Autoradiography of Oil Paintings." *Studies in Conservation*
13, no. 4 (November 1968): 161–185.

Schleier 1976
Schleier, Erich. "Georges de La Tour. Essendes Bauernpaar.
Zu einer Neuerwerbung der Gemäldegalerie." *Jahrbuch
Preußischer Kulturbesitz* 13 (1976): 231–241.

Schleier 1983
Schleier, Erich. "La peinture française du XVII^e siècle dans
les collections américaines/France in the Golden Age."
Kunstchronik 36 (1983): 184–197, 227–237.

Schnapper 1988
Schnapper, Antoine. *Le géant, la licorne, et la tulipe. Collec-
tions et collectionneurs dans la France du XVII^e siècle*. Paris,
1988.

Schnapper 1994
Schnapper, Antoine. *Curieux du grand siècle. Collections et
collectionneurs dans la France du XVII^{ème} siècle*. Paris, 1994.

Sedgewick 1977
Sedgewick, Alexander. *Jansenism in Seventeenth-Century
France: Voices from the Wilderness*. Charlottesville, 1977.

Shearman 1967
Shearman, John. *Mannerism*. Harmondsworth, 1967.

Singer 1816
Singer, Samuel W. *Researches into the History of Playing
Cards*. London, 1816.

Slatkes 1965
Slatkes, Leonard Joseph. *Dirck Van Baburen: A Dutch Painter
in Utrecht and Rome*. Utrecht, 1965.

Slatkes 1973
Slatkes, Leonard Joseph. "Additions to Dirck van Baburen."
Album amicorum J. G. van Gelderg. The Hague, 1973.

Slatkes 1981–1982
Slatkes, Leonard Joseph. Review of Nicolson 1979. *Simiolus*
12 (1981–1982): 167–183.

Slatkes 1995
Slatkes, Leonard Joseph. "Hendrick ter Brugghen's *The

Gamblers." *The Minneapolis Institute of Arts Bulletin* 67 (1995): 6–11.

Solesmes 1973
Solesmes, François. *Georges de La Tour.* Lausanne, 1973.

Solesmes 1982
Solesmes, François. *Georges de La Tour.* 2nd ed. Lausanne, 1982.

Spear 1976
Spear, Richard E. "A New Book on La Tour." *Burlington Magazine* 118 (1976): 233–235.

Stechow 1938
Stechow, Wolfgang. "Ludolph Buesinck: A German Chiaroscuro Master of the Seventeenth Century." *The Print Collector's Quarterly* (1938): 392–419.

Sterkenburg 1977
Sterkenburg, P.G.J. van. *Een glossarium van zeventiende-eeuws Nederlands.* Groningen, 1977.

Sterling 1935
Sterling, Charles. "Les peintres de la réalité en France au XVIIᵉ siècle. Les enseignements d'une exposition. I – 'Le mouvement caravagesque et Georges de La Tour.'" *Revue de l'art ancien et moderne* 67 (1935): 25–40.

Sterling 1937
Sterling, Charles. "A New Picture by Georges de La Tour." *Burlington Magazine* 71 (1937): 8–14.

Sterling 1938
Sterling, Charles. "Two New Paintings by Georges de La Tour." *Burlington Magazine* 77 (1938): 203–208.

Sterling 1943
Sterling, Charles. "Early Paintings of the Commedia dell'Arte in France." *Metropolitan Museum of Art Bulletin* 2 (1943): 11–32.

Sterling 1951
Sterling, Charles. "Observations sur Georges de La Tour à prospos d'un livre récent." *Revue des arts* 3 (1951): 147–158.

Sterling 1983
Sterling, Charles. *Engerrand Quarton, le peintre de la Pietà d'Avignon.* Paris, 1983.

Stoppato 1887
Stoppato, L. *La Commedia popolare in Italia.* Padua, 1887.

Strauss 1973
Strauss, Walter L. *Chiaroscuro.* New York, 1973.

Strauss 1977
Strauss, Walter. *Hendrik Goltzius 1558–1617: The Complete Engravings and Woodcuts.* New York, 1977.

Sylvestre 1985
Sylvestre, Michel. "Georges de La Tour. Nouveaux documents." *Bulletin de la Société de l'histoire de l'art français,* (1985): 47–55.

Tabourot 1616
Tabourot, Etienne. *La touche du seigneur des Accords.* Rouen, 1616.

Tanaka 1969
Tanaka, Hidemichi. "L'oeuvre de Georges de La Tour." Dissertation, University of Strasbourg.

Taveneaux 1960
Taveneaux, René. *Le jansénisme en Lorraine 1640–1789.* Paris, 1960.

Tcherbatchova 1970
Tcherbatchova, M. "Une peinture inconnue de Georges de La Tour." *L'art de l'Europe occidental. Essays in Honor of Levinson-Lessing,* 108–114. St. Petersburg, 1970.

Thomas 1971
Thomas, Keith. *Religion and the Decline of Magic.* New York, 1971.

Thuillier 1973a
Thuillier, Jacques. *Tout l'oeuvre peint de Georges de La Tour.* Paris, 1973.

Thuillier 1973b
Thuillier, Jacques. "Georges de La Tour: un an après." *Revue de l'art* (1973): 92–100.

Thuillier 1985
Thuillier, Jacques. *Tout l'oeuvre peint de Georges de La Tour.* 2nd ed. Paris, 1985.

Thuillier 1992
Thuillier, Jacques. *Georges de La Tour.* French ed. Paris, 1992.

Thuillier 1993
Thuillier, Jacques. *Georges de La Tour.* English ed. London, 1993.

Thuillier 1995
Thuillier, Jacques. *Saint Jean-Baptiste dans le désert.* Metz, 1995.

Tiberia 1991
Tiberia, Vitaliano. "Un'aggiunta per Teofilo Trufamond." *Bollettino d'arte* 64 (November–December 1991): 71–72.

Tribout de Morembert 1972
Tribout de Morembert, Henri. "Sibylle de Cropsaux. Mère de La Tour." *Gazette des beaux-arts* 6, no. 80 (1972): 223–224.

Tribout de Morembert 1974
Tribout de Morembert, Henri. "Georges de La Tour, son milieu, sa famille, ses oeuvres." *Gazette des beaux-arts* 6, no. 83 (1974): 205–234.

Urbach 1983
Urbach, Susan. "Preliminary Remarks on the Sources of the Apostle Series of Rubens and van Dyck." *Revue d'art canadienne* 10 (1983): 5–22.

Vickers 1950
Vickers, Elizabeth. "The Iconography of Georges de La Tour." *Marsyas* 5 (1950): 105–117.

Von Grimmelshausen 1981 ed.
Von Grimmelshausen, Hans Jakob. *Simplicius Simplicissimus.* Trans. John P. Spielman. New York, 1981.

Von Lützow 1889
Von Lützow, Carl. K.K. *Akademie der Bildenden Künste. Katalog der Gemäldegalerie.* Vienna, 1889.

Voss 1915
Voss, Hermann. "Georges du Mesnil de La Tour. Der Engel erscheint dem Hl. Joseph; Petrus und die Magd . . ." *Archiv für Kunstgeschichte* 2, fasc. 3–4, 1915.

Voss 1924
Voss, Hermann. *Die Malerei des Barock in Rom.* Berlin, 1924.

Voss 1928
Voss, Hermann. "Georges Du Mesnil de La Tour, A Forgotten French Master of the Seventeenth Century." *Art in America* 7 (1928): 40–48.

Voss 1931
Voss, Hermann. "The Daylight Pictures of G. de La Tour." *Formes* 16 (1931): 97–100.

Voss 1965
Voss, Hermann. "Die Darstellungen des hl. Franziskus im Werk von Georges de La Tour." *Pantheon* 23 (1965): 402–404.

Walch 1971
Walch, N. *Die Radierungen des Jacques Bellange.* Munich, 1971.

Weisbach 1932
Weisbach, Werner. *Französische Malerie des XVII. Jahrhunderts im Rahmen von Kultur und Gesellschaft.* Berlin, 1932.

Wildenstein 1950
Wildenstein, Georges. "Le goût pour la peinture dans la bourgeoisie parisienne au début de règne de Louis XIII." *Gazette des beaux-arts* 37 bis (1950): 153–173.

Wildenstein 1951
Wildenstein, Georges. "Le goût pour la peinture dans la bourgeoisie parisienne entre 1550 et 1610." *Gazette des beaux-arts* 38 (1951): 11–343.

Wilson 1971
Wilson, David B. "'La puce de Madame Desroches' and John Donne's 'The Flea.'" *Neuphilologische Mitteilungen* 72 (1971): 297–301.

Wind 1974
Wind, Barry. "Pitture ridicole. Some Late Cinquecento Genre Paintings." *Storia dell'arte* 20 (1974): 25–35.

Wind 1978
Wind, Barry. "Close Encounters of the Baroque Kind: Amatory Paintings by Terbrugghen, Baburen, and La Tour." *Studies in Iconography* 4 (1978): 115–124.

Wind 1989
Wind, Barry. "A Note on Card Symbolism in Caravaggio and His Followers." *Paragone* 40, no. 17 (1989): 15–18.

Winternitz 1967
Winternitz, Emanuel. *Musical Instruments and Their Symbolism in Western Art.* New York, 1967.

Wittkower 1963
Wittkower, Rudolf. *Born under Saturn: The Character and Conduct of Artists, a Documented History from Antiquity to the French Revolution.* London, 1963.

Wittkower 1965
Wittkower, Rudolf. *Art and Architecture in Italy, 1600–1750.* Harmondsworth, 1958; rev. ed. 1965.

Wright 1969
Wright, Christopher. "A Suggestion for Etienne de La Tour." *Burlington Magazine* 111 (1969): 295–296.

Wright 1970
Wright, Christopher. "Georges de La Tour. A Note on His Early Career." *Burlington Magazine* 112 (1970): 387.

Wright 1977
Wright, Christopher. *Georges de La Tour.* Oxford, 1977.

Wright 1985
Wright, Christopher. *The French Painters of the Seventeenth Century.* Boston, 1985.

Wright 1996
Wright, Christopher. "Georges de La Tour's *Saint Sebastian:* Establishing a Chronology." *Apollo* 143, no. 412 (June 1996): 46–50.

Wright and De Marly 1980
Wright, Christopher, and Diana De Marly. "Fake?" *The Connoisseur* (1980): 22–24.

Zapperi 1994
Zapperi, Roberto. *Eros e controriforma. Preistoria della Galleria Farnese.* Turin, 1994.

Zeri 1957
Zeri, Federico. *Pittura e controriforma. L'arte senza tempo di Scipione da Gaeta.* Turin, 1957.

Zolotov 1974
Zolotov, Youri. "Georges de La Tour et le caravagisme néerlandais." *Revue de l'art* 26 (1974): 57–63.

Zolotov 1977
Zolotov, Youri. "Georges de La Tour: sur la chronologie de l'oeuvre." *Revue de l'art* 38 (1977): 75.

Exhibition Catalogues

London 1932
Exhibition of French Art 1200–1900. Royal Academy of Arts.

Paris 1934
Les peintres de la réalité en France au XVIIe siècle. Musée de l'Orangerie.

Nancy 1935
Jacques Callot et les peintres et graveurs lorrains du XVIIe siècle. Musée historique lorrain.

Paris 1935
Les chefs-d'oeuvre du Musée de Grenoble. Petit Palais.

New York 1936
Loan Exhibition of Paintings by Georges de La Tour, Antoine Le Nain, Louis Le Nain, Mathieu Le Nain. Knoedler and Co.

Paris 1936
Exposition de portraits français de 1400 à 1900. André J. Seligmann.

Paris 1937
Chefs-d'oeuvre de l'art français. Palais national des arts.

San Francisco 1939a
Masterworks of Five Centuries. Golden Gate International Exposition.

San Francisco 1939b
Seven Centuries of Painting: A Loan Exhibition of Old and Modern Masters. California Palace of the Legion of Honor and the M. H. de Young Memorial Museum.

Hartford 1940
Night Scenes. Wadsworth Atheneum.

Detroit 1941
Masterpieces of Art from European and American Collections. Detroit Institute of Fine Arts.

New York 1943
The French Revolution. Wildenstein and Co.

New York 1946
A Loan Exhibition of French Painting of the Time of Louis XIII and Louis XIV. Wildenstein and Co.

Rimswell 1944
Exhibition of Pictures. Rimswell, Bishopton Road, Fairfield.

Buffalo 1948
Sport in Art. Albright Art Gallery.

Paris 1948
Chefs-d'oeuvre de l'art alsacien et de l'art lorrain. Musée des arts décoratifs, Pavillon de Marsan.

Geneva 1949
Trois siècles de peinture française: XVIe–XVIIe siècles. Choix d'oeuvres des Musées de France. Musée Rath.

Paris 1950
La Vierge dans l'art français. Petit Palais.

Rennes 1950
Les chefs-d'oeuvre du Musée des Beaux-Arts de Rennes. Hôtel de Ville.

Seattle 1950
Renaissance and Baroque Art. Seattle Art Museum.

Dallas 1951
Four Centuries of European Painting. Dallas Museum of Fine Arts.

Milan 1951
Mostra del Caravaggio e dei Caravaggeschi. Palazzo Reale.

Pittsburgh 1951
French Painting 1100–1900. Carnegie Institute, Department of Fine Arts.

Paris 1952
Cent tableaux d'art religieux du XIVe siècle à nos jours. Galerie Charpentier.

Brussels 1953
La femme dans l'art français. Palais des Beaux-Arts.

Pittsburgh 1954
Pictures of Everyday Life: Genre Painting in Europe, 1500–1900. Carnegie Institute.

Seattle 1954
Caravaggio and the Tenebrosi. Seattle Art Museum.

Bordeaux 1955
L'âge d'or espagnol. La peinture en Espagne et en France autour du Caravagisme. Musée des Beaux-Arts.

Paris 1955
Caravage et les peintres français du XVIIe siècle. Galerie Heim.

Rome 1956
Il seicento europeo – realismo, classicismo, barocco. Palazzo delle Esposizioni.

Cleveland 1958
In Memoriam: Leonard C. Hanna Jr. Cleveland Museum of Art.

Kansas City 1958
Twenty-fifth Anniversary Exhibition. William Rockhill Nelson Gallery.

London 1958
The Age of Louis XIV. Royal Academy of Arts.

Paris 1958
Le XVIIe siècle français. Chefs-d'oeuvre des musées de province. Petit Palais.

Indianapolis/San Diego 1958
The Young Rembrandt and His Times. John Herron Art Museum, Indianapolis; Fine Arts Gallery, San Diego.

Springfield 1958
Fifteen Fine Paintings. Springfield Museum of Fine Arts.

Stockholm 1958
Fem Sekler Fransk Konst, Miniatyrer, Malningar, Teckningar, 1400–1900. Nationalmuseum.

Berne 1959
Das 17. Jahrhunder in der französischen Malerei. Kunstmuseum.

Montreal 1960
Canada Collects 1860–1960: European Paintings. Montreal Museum of Fine Arts.

Washington/Toledo/New York 1960
The Splendid Century, French Art: 1600–1715. National Gallery of Art; Toledo Museum of Art; Metropolitan Museum of Art.

Flint 1961
Masterpieces in the Midwest. Institute of Arts.

Montreal/Quebec/Ottawa/Toronto 1961–1962
Heritage de France. French Painting 1610–1760. Museum of Fine Arts; Musée de la Province de Québec; National Gallery of Canada; Art Gallery of Toronto.

Sarasota 1960
Figures at a Table. The John and Mable Ringling Museum of Art.

New York 1962
The Painter as Historian: Mythological, Religious, Secular Paintings of the 15th to 19th Centuries. Wildenstein Galleries.

Seattle 1962
Masterpieces of Art. Seattle World's Fair.

Hartford 1964
Let There Be Light. Wadsworth Atheneum.

Ontario 1964
50th Anniversary Exhibition. Hamilton Art Gallery.

San Francisco 1964
Glory, Jest, and Riddle: A Survey of the Human Form through the Ages. California Palace of the Legion of Honor.

Dayton/Baltimore 1965
Hendrick Terbrugghen in America. Dayton Art Institute; Baltimore Museum of Art.

Detroit 1965
Art In Italy 1600–1700. Detroit Institute of Arts.

Montreal 1965
Images of the Saints. Museum of Fine Arts.

Paris 1966
Dans la lumière de Vermeer. Cinq siècles de peinture. Musée du Louvre, Orangerie des Tuileries.

San Diego/San Francisco/Santa Barbara 1967–1968
French Paintings from French Museums: XVIIth–XVIIIth Centuries. Fine Arts Gallery of San Diego; California Palace of the Legion of Honor; E.B. Crocker Art Gallery, Santa Barbara Museum of Art.

Jacksonville/St. Petersburg FL 1969
The Age of Louis XIII. Cummer Gallery; Museum of Fine Arts.

Boston 1970
Masterpieces of Painting in the Metropolitan Museum of Art. Museum of Fine Arts.

Cleveland 1971
Caravaggio and His Followers. Cleveland Museum of Art.

College Park 1971
Simon Vouet 1590–1649, First Painter of the King. University of Maryland Art Gallery.

Paris 1971
Dessins du XVIᵉ siècle et du XVIIᵉ siècle dans les collections privées françaises. Galerie Claude Aubry.

Paris 1972
Georges de La Tour. Orangerie des Tuileries.

Leningrad 1973
Caravage et les caravagesques. Hermitage.

London 1973
Treasures from the European Community. Victoria and Albert Museum.

Rome 1973
Il Cavaliere d'Arpino. Palazzo Venezia.

Rome/Paris 1973
Valentin et les caravagesques français. Villa Medicis; Grand Palais.

Johannesburg/Cape Town 1974
Three Centuries of French Painting: François I.–Napoléon I. Art Gallery; South African National Gallery.

Des Moines/Boston/New York 1975
The Etchings of Jacques Bellange. Des Moines Art Center; Museum of Fine Arts; Metropolitan Museum of Art.

Leningrad/Moscow 1975
Paintings from the Metropolitan Museum. Hermitage Museum; Pushkin Museum.

Tokyo/Kyoto 1976
Masterpieces of World Art from American Museums. National Museum of Western Art; Kyoto National Museum.

Leningrad 1977
Récentes acquisitions. Hermitage.

Paris 1977
"La diseuse de bonne aventure" de Caravage. Musée du Louvre.

San Francisco/Denver/New York/Minneapolis 1978–1979
Masterpieces of French Art. Fine Arts Museums of San Francisco; Denver Art Museum; Wildenstein Gallery; Minneapolis Institute of Arts.

Marseilles 1978
La peinture en Provence au XVIIe siècle. Musée des Beaux-Arts, Palais Longchamp.

Siena 1978
Rutillo Manetti 1571–1639. Palazzo Publico.

Berlin 1980
Bilder vom Menschen in der Kunst des Abendlandes. Staatliche Museen Preußischer Kulturbesitz.

Nantes 1980
Anniversaires. Musée des Beaux-Arts.

Paris 1980–1981
L'instrument de musique populaire. Usages et symboles. Musée des arts et des traditions populaires.

Paris/New York/Chicago 1982
La peinture française du XVIIe siècle dans les collections américaines. Grand Palais; Metropolitan Museum of Art; Art Institute of Chicago.

Rome/Nancy 1982
Claude Lorrain e i pittori lorenesi in Italia nel XVII secolo. Accademia di Francia a Roma.

Paris 1983
Saint Sébastien. Rituels et figures. Musée national des arts et traditions populaires.

Bourg-en-Bresse 1985
La vielle en Bresse. Musée de l'air.

Cremona 1985
I campi. Museo Civico.

New York/Naples 1985
The Age of Caravaggio. Metropolitan Museum of Art; Capodimonte.

Amsterdam 1986
Kunst voor de beeldenstorm. Rijksmuseum.

Utrecht/Braunschweig 1986
Nieuw Licht op de Gouden Eeuw – Hendrick ter Bruggen en tijdgenoten. Centraal Museum; Herzog Anton Ulrich-Museum.

Cremona 1987
Dopo Caravaggio Bartolomeo Manfredi e la Manfrediana Methodus. Museo Civico.

Meaux 1988
De Nicolò dell'Abate à Nicolas Poussin: Aux sources du classicisme 1550–1650. Hôtel Bossuet.

Stockholm 1988
Poussin och hans tid. Franskt 1600-tal i Statens konstmuseer. Nationalmuseum.

Edinburgh 1989
El Greco: Mystery and Illumination. National Gallery of Scotland.

Paris 1989a
Maîtres français 1550–1800. Dessins de la donation Mathias Polakovits. Ecole des Beaux-Arts.

Paris 1989b
Nouvelles acquisitions (no catalogue). Musée du Louvre.

Washington 1989
Still Lifes of the Golden Age: Northern European Paintings from the Heinz Family Collection. National Gallery of Art.

Paris 1990
Vouet. Grand Palais.

Madrid 1990
Velásquez. Museo del Prado.

New York 1990
A Caravaggio Rediscovered: The "Lute Player." Metropolitan Museum of Art.

Washington 1990
Anthony Van Dyck. National Gallery of Art.

Paris 1991–1992
Nouvelles acquisitions du département des peintures 1987–1990. Musée du Louvre.

Dordrecht 1992
De Zichtbaere Werelt: Schilderkunst uit de Goulden Eeuw in Hollands oudste stad. Dordrechts Museum.

Nancy 1992a
L'art en Lorraine au temps de Jacques Callot. Musée des Beaux-Arts.

Nancy 1992b
Jacques Callot 1592–1635. Musée historique lorrain.

Amsterdam 1993
Dawn of the Golden Age: Northern Netherlands Art 1580–1620. Rijksmuseum.

Fort Worth 1993
Jacopo Bassano. Kimbell Art Museum.

Jarville/Saint-Dié/Verdun/Sarrebourg/Nancy 1993–1995
Images de saints vénérés en Lorraine. Musée de l'histoire du fer; Musée municipal; Musée de la Princerie; Musée du pays de Sarrebourg; Musée historique lorrain.

Lunéville 1993
Un Saint Sébastien dans une nuit. Musée du château de Lunéville.

Montreal/Rennes/Montpellier 1993
Le grand siècle. Peintures françaises du XVII^e siècle dans les collections publiques françaises. Museum of Fine Arts; Musée des Beaux-Arts; Musée Fabre de Montpellier.

Paris 1993
Claude Vignon 1593–1670. Musée des Beaux-Arts.

Vic-sur-Seille 1993
Georges de La Tour ou les chefs-d'oeuvre révélés. Musée de Vic-sur-Seille.

Washington 1993
Georges de La Tour's "Repentant Magdalene." National Gallery of Art.

Madrid 1994
Los músicos de Georges de La Tour (1593–1652). Alegoría y realidad en la pintura barroca francesa. Museo del Prado.

The Hague/Antwerp 1994
Music and Painting in the Golden Age. Hoogsteder & Hoogsteder.

Amsterdam 1995
Jacob van Campen het Klassieke ideaal in de Gouden Eeuw. Koninklijk Paleis.

Index of Works

Works by, after, or attributed to Georges de La Tour

Works by La Tour's contemporaries in exhibition

Photographic Credits